Muybridge's
COMPLETE
HUMAN AND ANIMAL
LOCOMOTION

All 781 Plates from the 1887
Animal Locomotion

BY
EADWEARD MUYBRIDGE

Introduction to the Dover Edition by Anita Ventura Mozley
CURATOR OF PHOTOGRAPHY, STANFORD UNIVERSITY MUSEUM OF ART

VOLUME I
containing original volumes
1 & 2: MALES (Nude)
3 & 4: FEMALES (Nude)

DOVER PUBLICATIONS, INC.
New York

Published in Canada by General Publishing Company, Ltd., 30 Lesmill Road, Don Mills, Toronto, Ontario.
Published in the United Kingdom by Constable and Company, Ltd., 10 Orange Street, London WC2H 7EG.

This Dover edition, first published in 1979, is an unabridged republication of the eleven-volume work *Animal Locomotion; an electro-photographic investigation of consecutive phases of animal movements,* originally published under the auspices of the University of Pennsylvania, Philadelphia, in 1887; together with the *Prospectus and Catalogue of Plates,* published separately by the University earlier in the same year. A new Introduction has been written specially for the present edition by Anita Ventura Mozley.

Book design by Carol Belanger Grafton

International Standard Book Number: 0-486-23792-3
Library of Congress Catalog Card Number: 79-51299

Manufactured in the United States of America
Dover Publications, Inc.
180 Varick Street
New York, N.Y. 10014

N 20316 L75 set 2-83

CONTENTS

INTRODUCTION TO THE DOVER EDITION

"The great panorama of life is interesting because it moves."—J. Bell Pettigrew, 1873.[1]

As the nineteenth century progressed, both scientists and artists sought with increasing avidity the graphic representation of motion that was too fast for the human eye to see, and too extreme for any model to pose. The search was spurred by physiologists who strove to comprehend the way animals move, and by those artists who equated truth to nature with art.

The invention of photography in 1839 seemed to be a crucial step toward the scientific rendering of appearances— toward quintessential realism—but from the very introduction of the medium, the camera's inability to record moving figures was lamented, even while its success in reproducing the minutest detail of still objects was hailed as a triumph. A correspondent of the *Foreign Quarterly Review*, while praising all the architectural details that were visible in one of the first daguerreotypes seen by the public, L. J. M. Daguerre's view of a Parisian boulevard, commented in 1839: "In foliage he is less successful, the constant motion in the leaves rendering his landscapes confused and unmeaning . . . the same objection necessarily applies to all moving objects. . . ."[2]

It was not until two decades later that improvements in the state of the art made it possible for the camera to record motion under ordinary light.[3] By then, the photographic process had been made "instantaneous" enough to record human figures performing what now seem to us relatively slow movements (walking, bending, stepping into a carriage, for instance). These figures, caught by the camera while they were strolling in the sun on the streets and boulevards of London and Paris, were seen in pairs of small photographs mounted on a card for viewing in the stereoscope. Although these stereographs were advertised as "instantaneous" views by the London Stereoscopic Company, the exposure time used for them was about 1/10 of a second.[4] The figures in these photographs were tiny and seen from a distance, and their motion had been successfully stopped only when it lay along the line of vision. And faster motion—a running horse, a turning wheel, a man running or walking very fast—was still recorded as a series of connected blurs. "Instantaneity," which really meant taking a photograph in as brief a time as was then possible, was not yet "instantaneous" enough to stop these motions, even on a small plate. As Lake Price, an English photographer, noted in 1858, optical and chemical improvements were still needed to so accelerate the photographic process that "any dimension and class of picture may be taken instantaneously."[5]

Eadweard Muybridge, a British photographer working in California, was the first to photograph fast motion. That was in 1872. In 1878 and 1879, continuing his experiments in California, he so accurately photographed successive phases of the stride of trotting and running horses that the individual photographs could be synthesized—set in smooth and continuous motion in his zoopraxiscope, a projection machine, or in one of the existing devices, the so-called "philosophical toys," that demonstrated the principle of the persistence of vision.[6] In 1883, the University of Pennsylvania invited Muybridge to perform further investigations, more elaborate and extensive than his previous ones. This he did, working for three years under the university's auspices at an experimental setup on the grounds of its hospital, across the street from its new Veterinary School, and at other locations in Philadelphia.

The university published the results of his work in 1887 under the title *Animal Locomotion.* These are the plates that are reproduced here, all 781 of them presented together for the first time since their original publication. The plates were originally printed by a form of gelatin relief called collotype, similar in appearance to photogravure, and were sold in portfolios, or "copies," of 100 plates each.[7] The complete set of 781 plates, printed on fine linen paper measuring 19 by 24 inches, could be had in eight portfolios for $600. Only 37 "perfect" sets of the complete work were produced.[8] This monumental work, composed of 19,347 individual photographs, is the "completion," as Muybridge later said, of his photographic investigation of human and animal locomotion.[9] The results of his work deeply affected artists and scientists at the time of their publication; *Animal Locomotion,* his "electro-photographic investigation of consecutive phases of animal movements," is still the most exhaustive pictorial analysis of the subject ever made, and still the dictionary of form to be used in questions on the appearance of men and animals in motion.

The history of Muybridge's stop-motion photography is one of extraordinary twists and turns, a history as strange as his biography (with which it is, of course, so intimately in-

tertwined) or as the spelling of his first name. When he started as a landscape photographer in California in 1867, he called himself an "artist-photographer"; his pride was that he "advanced photography." In every step of his career he did that, and at the same time, despite adversities that would have wrecked a less determined man, advanced himself from a position of local celebrity as a photographer of views to one of world renown as a scientific investigator of animal locomotion and a commentator on the history of art in regard to his subject. Along the way, he was always his own best publicist, as well as a careful historian of his own achievements. He frequently published anonymous essays praising his work; the most valuable source of information about his career is the annotated scrapbook of press clippings that he gathered throughout his professional life.[10] The story of his successive personal triumphs unfolds episodically, marked as it is by personal tragedy, until the completion of the work by which we best know him, *Animal Locomotion*. After that, he did all he could to give his career the appearance of a smooth and continuous progression.

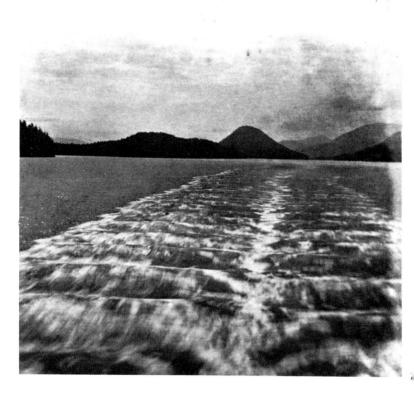

II

"I'm going to make a name for myself. If I fail, you will never hear of me again."
Edward James Muggeridge, ca. 1852.[11]

Eadweard Muybridge was born Edward James Muggeridge in Kingston-upon-Thames in 1830; he came to the United States in about 1852. By then, he had the notion of some day spelling his first name to conform with the Saxon "Eadweard"; this was the spelling used for two of the Saxon kings whose names appeared on the "Coronation Stone," which attracted contemporary attention in 1850 when it was moved from its original location in Kingston to a more prominent site in the marketplace. After a stay of several years on the East Coast, where he was a commission merchant for American and English book publishers, he moved to San Francisco in the mid-1850s. From 1856 until 1860, he was a book dealer and purchasing agent in that city, offering fine illustrated and standard works, both American and English, to "gentlemen furnishing libraries"; he also advertised fine photographic copies of paintings.[12] Early on in this career, he simplified the spelling of his surname: "Muggeridge" became "Muygridge." He was widely known, successful in his business, and highly regarded in the community; in the late 1850s, he was elected to the board of directors of San Francisco's Mercantile Library Association. This was a position of some honor, and implied ability and interest in the Association's benevolent activities, which included sponsoring lectures, dramatic readings and public debates, and maintaining a sizable library "to give persons of every age and occupation the means of mental improvement, and a suitable place for passing their leisure hours."[13]

Although Muybridge had known and worked with photographers in New York and San Francisco, he himself did not seriously take up photography until sometime between 1861 and 1866, when he was in England recovering from a near-fatal stagecoach accident. This was the first of the major disasters that mark his career; he emerged from it radically changed in person and profession. The accident happened on the overland leg of a book-buying trip to England in 1860. The Butterfield Overland Mail coach, which he had boarded in San Francisco, was traveling in the rocky Cross-Timbers section of Texas when the six mustangs bolted, the stage was overturned, and Muybridge was hurled headlong onto a rock. His hair, once blond, turned ashen gray, he later said, He lay unconscious in a hospital in Fort Smith for several days; when he came to, he had double vision; his senses of smell, taste and hearing were impaired. Sufficiently recovered, he went on to New York and then to England, where he was treated by Sir William Gull, a physician known for his belief in "natural therapy"—rest and increasingly active outdoor exercise. After a brief trip to New York, where he collected damages from the Butterfield Company, he returned to England. Letters of the period mention his invention of a superior machine for washing clothes and other textiles, and an apparatus for plate printing. Somewhere along the way, either in England or on the Continent, he seriously devoted himself to the study of photography, and probably concentrated on outdoor views as part of his natural therapy. When he returned to San Francisco in 1867, he had not only a new last name, the one we know him by, but also a new profession, "artist-photographer."

Muybridge quickly became one of the foremost landscape and general view photographers on the West Coast (see Figs. 1–4). Much of his early work was in small photographs for the stereoscope. His first important larger series, *Scenery of the Yosemite Valley*, was made in 1867 and published in 1868. In February of that year he offered his photographs as the work of "Helios," calling them "marvelous examples of

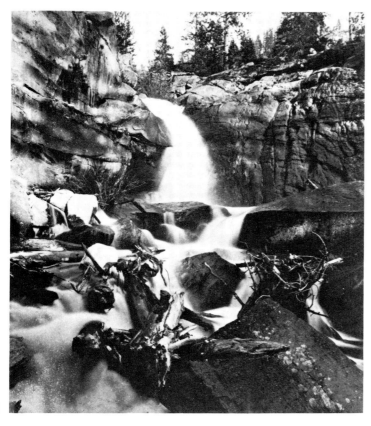

1–3: *Three photographs by Muybridge—all prior to his animal-locomotion studies—that indicate his interest in photographing moving water. 1, "Cone Mountain," British Columbia, 1868 (Bancroft Library, University of California, Berkeley); 2, "Juniper Fall," Yosemite Valley, 1872, from a Bradley & Rulofson stereograph (Stanford Museum); 3, "Pi-Wi-Ack (Shower of Stars), 'Vernal Fall,'" Yosemite Valley, 1872 (Oakland Museum).*

2

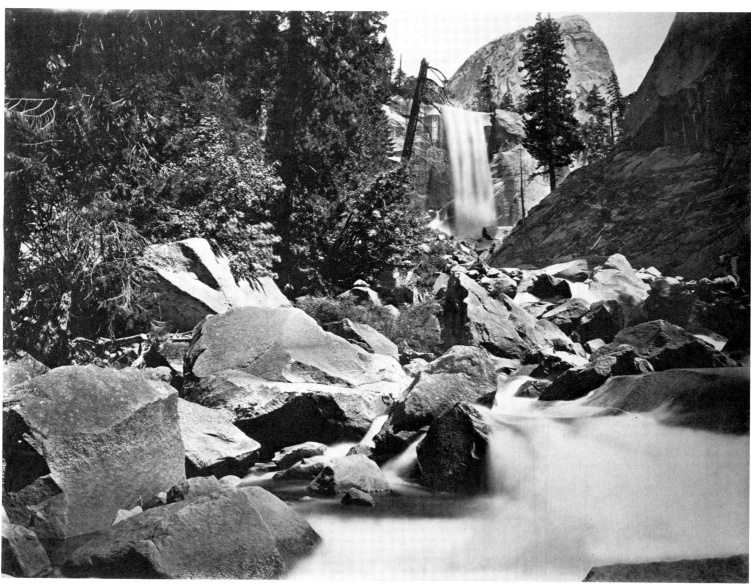

3

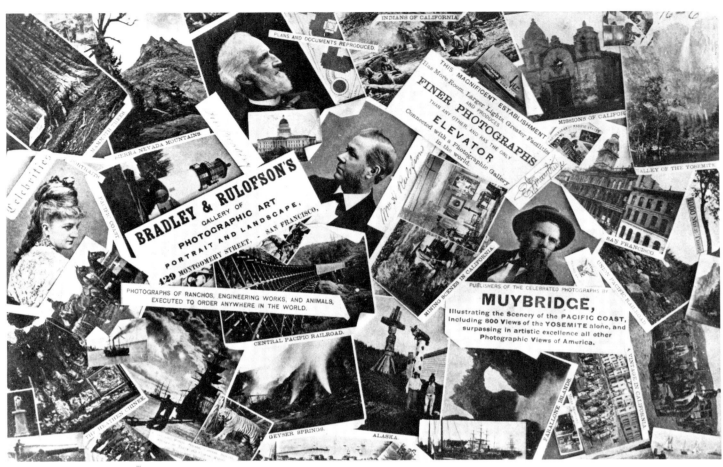

4: *Bradley & Rulofson advertising card, 1873, showing the extent of Muybridge's "view" photography (Bancroft Library, University of California, Berkeley).*

the perfection to which photography can attain in the delineation of sublime and beautiful scenery," and "the most artistic and remarkable photographs ever produced on this coast."[14] As he would for his later photographs of figures in motion, he offered these Yosemite views to subscribers in portfolio; he particularly emphasized the interest of local artists and connoisseurs in his work, hoping to encourage sales by listing their names—Charles Nahl, William Keith, Juan B. Wandesforde, Norton Bush among them—in his broadsides.

The press, both local and national, agreed with Muybridge's estimation of Helios' photographs. The San Francisco *Alta California* reported on 17 February 1868: "The views surpass in artistic excellence, anything that has yet been published in San Francisco. . . . In some of the series we have just such cloud effects as we see in nature or oil-painting, but almost never in a photograph." And the leading American journal of photography, *The Philadelphia Photographer,* was full of praise for his first major photographic production. In the issue of November 1869, the editor noted:

> Through the kindness of Mr. Edward J. Muybridge, San Francisco, California, who has loaned us the negatives, we are enabled to present our readers with a view in the great Yosemite Valley, California. . . . To photograph in such a place is not ordinary work. It differs somewhat from spending a few hours with a camera in Fairmount or Central Park. All the traps, and appliances, and chemicals, and stores, and pro-

vender, have to be got together, and then pack mules secured to carry the load, and drivers to have charge of them. Thus accoutred, the photographer starts out, say, from San Francisco, through hill and vale, across deep fords, over rugged rocks, down steep inclines, and up gorgeous heights, for a journey of one-hundred and fifty miles. Several days are thus occupied, and several nights of rest are needed along the road. . . . "Helios" has outdone all competitors. . . .

III

"It is an important point to consider, that it is useless for photographers to endeavour to increase the energy of their sensitive surfaces, when the chemicals required are not manufactured with that purity and exactitude so absolutely necessary to ensure their success."

Frederick Scott Archer, 1852.

The comments of both the *Alta California* and *The Philadelphia Photographer* glance at the difficulties of producing photographs by the wet-collodion method, which Muybridge used for all of his published work until the investigations of 1884–1886 at the University of Pennsylvania. Indeed, it was these difficulties that eventually made Muybridge believe that the photographic study of men and animals in motion that he had made using wet-collodion plates in California in the late 1870s should be "completed," or done over again, using the more sensitive and handier gelatin process that by the early 1880s had come into general use.

The wet-collodion process of making negatives was introduced by the Englishman Frederick Scott Archer in 1851. It was the "fastest" process yet invented, and although it had its detractors (those photographers who favored the improvement of earlier processes, and those who advocated changes in his method), it was pretty much used as Archer first set it forth in his *Manual of the Collodion Photographic Process* (from which the above quotation is taken), published in 1852. *The Photographic Journal* could state, in an introductory note to the republication of his *Manual* in its 15 August 1864 issue, that "the practical improvements introduced have been quite insignificant in comparison with the great stride in the art which is associated with [Archer's] name." Archer's method, besides being more light-sensitive than earlier processes (thus allowing shorter exposure times), was admired for the fineness of detail it made possible; the prints appeared to be almost like daguerreotypes on paper. And, especially remarkable, wet-collodion negatives produced exquisite gradation of tone, replacing the contrasting masses of light and dark of the calotype with fine shading from light to dark.

Although Archer recommended "the facility of its manipulation," it was still, it seems today, a difficult and finical business to make a wet-collodion negative. This involved careful pouring of the collodion solution (a colorless, glue-like mixture of guncotton and ether mixed with potassium iodide) onto the glass plate, and tipping it at various angles until the plate was evenly coated. Then the coated plate was dipped into a sensitizing bath, a solution of nitrate of silver. The sensitized plate was exposed in the camera while it was still wet, and developed directly after exposure, for the ether in the collodion evaporated quickly, and the plate lost its sensitivity to light as it dried. The minimum time of exposure for landscape was about ten seconds; small portraits could be taken in a minimum time of about two seconds.[15]

Formulae for the coating, sensitizing and developing agents varied from photographer to photographer: there were then no packaged goods, nor, early on, even a standard of manufacture for photographic chemicals. Every photographer was necessarily his own chemist. Good results, moreover, depended upon fastidious attention to detail in each step of the process, from the initial cleaning of the glass to the final varnishing of the negative. Even an operator in a portrait studio, where the problems of producing a negative were so much less arduous than those encountered on a rocky viewpoint high over Yosemite Valley, could say of the wet-collodion process: "Work, *work* does it; *work* is the word with us."[16] One must be, as *The Philadelphia Photographer* said, both "indefatigable and untiring"; one word alone would not comprehend such effort.

We today, used to prepared negatives, chemical solutions and printing paper, and to cameras equipped with exposure meters, marvel at the amount of work entailed in the wet-collodion process; in our era of panchromatic black-and-white film, we may be equally surprised by the above-quoted admiring comment of the *Alta California* on the appearance of clouds in Muybridge's Yosemite photographs of 1867. But the chemistry of photography then produced plates more sensitive to blue than to green; a landscape photographer who

wanted detail in the foreground would get, as a result of the exposure necessary for that, a pale, cloudless sky. Who could imagine the glory of a landscape under a cloudless sky? It was to compensate for this varying sensitivity of his negatives, this lack of clouds, that Muybridge devised in 1867 an attachment to his camera that he called a "sky shade." His sky shade, a further evidence of his mechanical ingenuity, operated as a moving, partial shutter that could be successively lowered to give the suitable exposure time to foreground, middle distance and sky. If this device failed, there was another way to make photographs with fine foreground detail under cloud-lit skys; it was a manipulation during the printing process that Muybridge used in the 1870s, although it was disavowed by some British masters of the photographic view.[17] This method was the use of two negatives for a single print, one of just clouds for the sky, and one of the foreground subject with the sky painted out in the negative. To some eyes, the disadvantages of this troublesome and sometimes unnatural-appearing manipulation were overcome by the superior artistic effect of a cloud-filled sky, however much this might give the lie to the immediacy and accuracy of the photographic process itself. Muybridge was adept at photographic manipulation and, surprisingly, used it in one of his early false starts in the study of animal locomotion.

IV

"The circumstances must have been exceptionally felicitous that made co-laborateurs of the man that no practical impediment could balk, and of the artist who, to keep pace with the demands of the railroad builder, hurried his art to a marvel of perfection that it is fair to believe it would not else have reached in another century."—Edward Muybridge, 1881.[18]

Muybridge's first Yosemite series brought him wide acclaim; in 1868, the year he published it, he was the photographer invited to accompany Major General Henry W. Halleck's expedition to gather information about the recently purchased Alaskan Territories, "for the purpose of illustrating the Military Posts and Harbors."[19] Another important commission came from the United States Lighthouse Board, for which Muybridge made large as well as stereoscopic views of Pacific Coast lighthouses. When he announced, in May 1872, that he planned another, more extensive, photographic tour of the Yosemite area, one on which he would carry equipment for making negatives of 20 by 24 inches, he could boast of "lenses and apparatus superior to any other in the United States."[20]

By that time he had brought his work to the attention of artists, connoisseurs and art patrons, and he had repeatedly announced in his advertisements that "Helios is prepared to accept commissions to photograph Private Residences, Views, Animals, Ships, etc., anywhere in the city, or any portion of the Pacific Coast." By April of 1872, he had already made several mammoth-size negatives in Yosemite. He showed a few of them in Sacramento, where former Governor Leland Stanford, then president of the Central Pacific Railroad, patron of the arts and owner of a famous fast trotting horse, still lived in the "Governor's Mansion." The Sacramento *Union* for 26 April 1872 reported:

We had an opportunity of looking last evening at some very, fine large-sized photographic negatives representing some of the most picturesque views of Yosemite Valley. . . . They are the production of Edward Muybridge.

Muybridge stayed only briefly in Sacramento, which lies about 200 miles northwest of Yosemite; in May, he advertised his forthcoming Yosemite series in San Francisco, and by July he was back at work in the Valley. It was during this short stay that the artist met the railroad builder and began the collaboration that would lead, eventually, to the first photographic analysis of motion.

What Stanford wanted in 1872 was a photograph of his fast horse Occident trotting at full speed. He had a theory, gathered from close observation, that a trotting horse at some point in its stride has all four feet off the ground at the same time. He had tried various mechanical ways of registering the horse's footfalls; none were successful. It was then that he called upon the most publicized and best-equipped photographer on the West Coast. Muybridge was "perfectly amazed at the boldness and originality" of the proposition.[21] He later amplified his initial response, explaining fully his amazement at Stanford's charge to him, and quite frankly describing its outcome. In an excerpt from an essay that he published anonymously, he also reveals his knowledge of the problem Stanford set him to solve, his grasp of public relations and his flair for dramatic monologue:

Mr. Stanford startled the photographer by stating that what Mr. Stanford desired was a photograph of his horse, Occident, and taken while the horse was at full speed. No wonder even the skilled Government photographer was startled, for at that date, the only attempts that had ever been made to photograph objects in motion had been made only in London and in Paris, only by the most conspicuous masters of the art, and only of the most practicable street scenes. And even in these scenes in which the photograph of no objects moving faster than the ordinary walk of a man had been attempted, and in which the legs had not been essayed at all, the objects were taken as they moved towards the camera, in which action, owing to the laws of perspective, the continuous change of place was less noticeable. Occident was then admittedly the fastest trotter in the whole world, having recorded a mile in 2:16¾, which was faster than even the skipping Goldsmith Maid had done. And the picture required to be taken, not as the flyer should bear down on the camera, but as his driver should shoot him at fullest speed past the lens. Mr. Muybridge therefore plainly told Mr. Stanford that such a thing had never been heard of; that photography had not yet arrived at any such wonderful perfection as would enable it to depict a trotting horse at speed. The firm, quiet man who had, over mountains and deserts and through the malignant jeers of the world, built the railroad declared impossible, simply said: "I think if you will give your attention to the subject, you will be able to do it, and I want you to try." So the photographer had nothing to do but "try." He thought over the matter, skillfully made all the then known combinations of chemistry and optics for taking an instant picture, made the trial, and succeeded in getting the first shadowy and indistinct picture of Occident at a trot.[22]

This photograph, unfortunately, remained known only to Stanford and Muybridge. Shadowy and indistinct as it was, it was, nevertheless, satisfactory to Stanford. He could read it well enough to consider it proof of his belief that there was a moment of unsupported transit during the stride of a trotting horse.[23] But the photographer wanted something better, something less shadowy, a photograph that would be proof to a wider audience than merely his patron that he was capable of advancing photography. He tried again, in 1873. This attempt was reported in the *Alta California* for 7 April 1873: "a great triumph as a curiosity in photography—a horse's picture taken while going thirty-eight feet in a second!" But, again, the photograph was not published.

In the following year, 1874, two important events affected the Stanford/Muybridge collaboration: the first expanded their photographic experiments, moving them to a higher level of investigation than Stanford had initially envisioned; the second almost put an end to Muybridge's career, if not to his life.

First came the publication in English of Etienne-Jules Marey's *Animal Mechanism, a Treatise on Terrestrial and Aerial Locomotion,* which had appeared in France the previous year under the title *La Machine animale.*[24] Marey, a professor of natural history at the Collège de France, had devoted himself to the analysis of animal locomotion since the mid-1860s. His method was one of graphic notation derived from ingenious recording devices attached to the animal being studied. An early experimental device of Marey's was the myograph, by which the movement of a frog's muscle was transmitted to a carbon-blackened cylinder. In *Animal Mechanism,* Marey said of the shock resulting from the administered impulse that "it is so rapid that its phases cannot be distinguished by the eye, so that, to appreciate its characteristics aright, recourse must be had to special instruments. Registering apparatus only can supply this need, for they faithfully render all the phases of motion communicated to them. . . ." In his study of the terrestrial locomotion of bipeds, Marey noted the history of investigations of this subject, and, claiming the method of graphic notation as a scientific advance, stated his belief that its use could lead to the definite resolution of all hitherto unsolved questions of animal locomotion. The apparatus he devised for his study was the "experimental shoe," an ordinary shoe under the sole of which was another sole of India rubber. Between them was an air chamber, which was compressed when the foot exerted any pressure on the ground. The air expelled escaped by a tube into a drum with a lever attached, which registered the duration and the phases of the pressure of the foot. The experimental subject, wearing two such shoes, walked around a table which supported the registering apparatus, with which Marey was able to make tracings of the impact and the rise of the two feet in the ordinary walk. To record running, Marey added to the experimental apparatus: the subject carried a portable recording instrument, and also wore one on his head, from which the physiologist obtained tracings of vertical reactions. For the paces of the horse, the apparatus was suitably adapted to the animal's shoe and foreleg and the rider carried the chronographic register in one hand; in the other, the reins. Marey's investigations also included the building of an instrument to illustrate the flight of insects and one to measure the movements of the wings of birds (see Figs. 5–9).

In translating his graphic notations into readily identifiable images, Marey had the help of Emile Duhousset, a colonel in

5–9: *Illustrations from Marey's Animal Mechanism. 5, "Graphic curves and notation of the horse's trot"; 6, "Synoptical notations of the paces of the horse"; 7, "Experimental apparatus to show the pressure of the horse's hoof on the ground"; 8, "Apparatus to give the signals of the pressure and rise of the horse's hoof"; 9, "Horse at full trot" (drawing by Emile Duhousset).*

the French army, and a horseman and student of animal loco-motion of some fame. Using Marey's notations, Duhousset was able to draw the horse at full trot, and in these drawings showed that there is indeed a point in trot when the horse is entirely off the ground. While Marey's published work was accompanied, in the matter of the horse, by Duhousset's drawings as well as by his more abstract "synoptical nota-tions," this visual representation must have been difficult for the popular mind to accept in an age already accustomed to what the nineteenth century called photography: the exact and truthful witness of the sun. It was the veracity of this wit-ness, this "pencil of nature," that carried a conviction of ac-curacy that the errant hand of man could not convey. "The machine cannot lie," as Stanford later put it.[25]

According to Muybridge, Stanford read *Animal Mecha-nism* closely, and no doubt Muybridge did, too, for in al-most every phase of his later career, he adapts to his own experiments the outline for the study of animal locomotion set forth in it. As for Stanford, there is one passage in Marey's publication that could not fail to challenge him: "All the necessary researches into animal locomotion can only be ef-fected by men especially interested in these inquiries, and placed in a favorable circumstance to understand them." Both of these requirements, interest and money, were personified in the wealthy California horseman. Marey also made another suggestion, and it was this that expanded the idea of the Stanford/Muybridge collaboration from the achievement of a single instantaneous photograph of fast motion to the hitherto impossible series of photographs of fast motion:

> Everyone knows the ingenious optical instrument invented by Plateau [in 1832, and also, independently by the Austrian von Stampfer], and called by him "Phenakistoscope." This instrument, which is also known by the name of Zootrope,[26] presents to the eye a series of successive images of persons or animals represented in various attitudes. When these attitudes are coordinated so as to bring before the eye all the phases of movement, the illusion is complete; we seem to see living persons moving in different ways. This instrument, usually constructed for the amusement of children, generally represents grotesque or fantastic figures moving in a ridiculous manner. But it has occurred to us that, by depicting on the apparatus figures constructed with care, and representing faithfully the successive attitudes of the body during walking, running, etc., we might reproduce the appearance of the different kinds of progression employed by man.

What more carefully constructed (that is, accurate) figures might there be than those drawn from photographs? If, of course, the photographs could only be taken. Stanford and Muybridge, having had some success in the single shot, de-termined to try for the photographic series. For Stanford, the data so gathered would be the foundation on which he might build a theory of animal locomotion useful in the breeding and training of fast horses; for Muybridge, the expanded ex-periment was a further chance to prove his superiority as a photographer and to advance his art.

Any advancement, however, was dramatically curtailed by the terrible event of 17 October 1874. The following account

from the *Calistoga Free Press* for Saturday, 24 October 1874, tells the story:

> Early Sunday morning last, the news of a terrible tragedy, which occurred the night previous at about 11 o'clock, at the residence of Wm. A. Stuart, near the Yellow Jacket quicksilver mine, about seven and a half miles west of Calistoga, in this county, was received here. The particulars, as near as we can ascertain, are as follows: On Saturday last, just before the de-parture of the San Francisco boat for Vallejo, Edward J. Muybridge, a well known photographic artist in San Francisco, by means of letters which fell into his hands, made the discovery that his wife, who is now in Oregon, and to whom he was devotedly attached, had been on terms of criminal intimacy, for some time past, with Major Harry Larkyns, formerly connected with several San Francisco journals, but lately engaged in getting up a map of the mines in this and adjoining counties. Frenzied over the discovery, he immediately made his way to Calistoga, and learning here that the destroyer of his peace was at the Yellow Jacket Mine, hired a team at Connelly's stable, and employed Geo. Wolfe to drive him there. Alighting, he knocked at the door, and enquired if Major Harry Larkyns was in. The gentleman that answered the call informed him that he was, and invited him in; he very politely and calmly refused, saying he wished to see the Major only a moment on the outside. The Major, who at the time was engaged in a game of cribbage with a lady, answered the summons. As he opened the door and looked out into the dark, he called out: "Who is it? I can't see you." Mr. Muybridge says "Good evening, Major; my name is Muybridge, and here is the answer to the letter you sent my wife," and fired at the breast of Larkyns. The Major staggered back, and ran through the kitchen and sitting room, and out the front door, and fell close to a large oak tree. Mr. Stacy and others carried him in the house and laid him on a bed, where he breathed his last in about one minute and a half. After firing, Muybridge followed closely, but was at once covered by a pistol in the hands of J. M. McArthur, and surrendered—though making no attempt to escape—and was brought to Calistoga immediately and given into the hands of Constable Geo. B. Crumwell. We are informed that there was talk of lynching Muybridge at the time of the shooting, but through the influence of Mr. Stuart this act of violence was not put into effect.

In an interview given in December in the Napa County jail to a reporter for the San Francisco *Chronicle*, Muybridge told of his young wife Flora's acquaintance with Larkyns, a Scotsman whose title, by his own account, came from service with the French army during the Franco-Prussian War. They had met early in 1873, and during Muybridge's absences from the city, particularly his extended coverage of the Modoc War in April and May of that year, acquaintance become infatuation. The handsome and sociable major, who was then turning his varied talents to writing on art and theater for San Francisco journals, escorted Flora to the theater while the famous English actress Adelaide Neilson was "playing her engagement." Muybridge made his objec-tions known to both of them in the strongest terms, and thought the matter finished. But it was not. On the fatal day, he had received letters from a confidant of the lovers giving proof that the son born in April 1874, whom he had named Florado Helios Muybridge, was not, after all, his. "I loved

the woman with all my heart and soul, and the revelation of her infidelity was a cruel, prostrating blow to me, shattering my idol and blighting the bright affection of my life," he told the reporter. "I have no fear of the result of my trial. I feel that I was justified in what I did, and that all rightminded people will justify my action." The interview was published in the *Chronicle* on 21 December.

Muybridge was tried for murder in the first degree in February 1875. He pleaded not guilty; his counsel pleaded not guilty by reason of insanity, citing the blow Muybridge had received in the stagecoach accident of 1860 as the cause of "mental aberration." William H. Rulofson, the publisher of Muybridge's large Yosemite views, testified to his insanity: Muybridge would not take a picture that he was not interested in, no matter how lucrative the commission; and Muybridge had ventured to precipices high above the Valley's floor in pursuit of views, a disregard of personal safety that no man in his right mind would be capable of. Other witnesses called him eccentric, wavering and excitable. But the prosecution's witnesses cited his calm behavior in jail and the steadiness of his hand as he poured a drink after his arrest; a doctor from the Stockton Insane Asylum testified that he believed the killing to have been premeditated. When the case went to the jury, however, the question put was whether or not the homicide was justifiable. One of the defense attorneys, William Wirt Pendegast, a friend of Leland Stanford's, made an impassioned plea two hours long; addressing the issue of adultery, he said, "It is the weakness of the law that there is no adequate punishment for the seducer." Muybridge trembled and sobbed throughout the lawyer's dramatic oration; when Pendegast finished, applause shook the courtroom. The unanimous verdict of the twelve jurors was returned after thirteen hours of deliberation: "Not guilty."[27]

That was on 5 February. Within the month, Muybridge sailed to Central America, where he took both 6-by-9-inch and stereoscopic views in Panama and Guatemala. The photographs, which he claimed to have taken to interest tourists and businessmen in these countries served by the Pacific Mail Steamship Company, are moody and darkly romantic in feeling, the products of a man in a strange land who must then also have felt a stranger to himself. Even the documentary series on the planting and cultivation of coffee, a crop new to Guatemala, shares in this strangeness of feeling. And as he traveled through these foreign countries, taking photographs of Indian girls, naked from the waist up, bathing in rocky streams; of ruins of Spanish churches; and of solitary figures brooding in cemeteries, he also turned to the work he planned to perfect on his return: to stopping the motion of the wake of the coastwise steamer, or of the little rapids in the river at Mazatenango, Guatemala.

When he returned to San Francisco, he published his Central American photographs, reclaimed his photographic eminence locally by making several 360° panoramas of the city from the top of the tallest building on its highest hill, and again made a photographic record of the architecture and furnishings of a Stanford residence—this time the new Italianate mansion on San Francisco's Nob Hill. He also claimed that he was now prepared to take photographs in the 1/1000 part of a second.

V

"The photographer had made many experiments to secure the highest sensitiveness and the briefest possible exposure, and the result was a novelty in the photographic art, and a delineation of speed the eye cannot catch."—Alta California, 3 August 1877.[28]

Stanford's horse Occident was again Muybridge's subject. The photograph, taken at Sacramento in July, was published in August. The card on which it is mounted carries this legend:

The Horse in Motion, illustrated by Muybridge. Automatic electro-photograph. "Occident," owned by Leland Stanford, trotting at a 2:30 gait over the Sacramento track, in July, 1877. The exposure of the original negative of this photograph was less than the two-thousandth part of a second. The details have been retouched. In this position, the horse is entirely clear of the ground, but just about to alight.

The press received this Occident as a "wonder in photography," and the judges of the San Francisco Industrial Exhibition of 1877 awarded Muybridge a medal for it. There was one exception to the general praise. The author of "Bohemian Bubbles" in the San Francisco *Post* for 3 August thought it had been too much retouched. As it is now evident, he was right. The "photograph" is a photographic copy of a painting in which the only photographic detail is the head of the driver, carefully affixed to the surface of the painted canvas.

Still, what we might brand as fakery was, during this period of wet-collodion plates, accepted in some quarters as artistic finish. Muybridge had never minded using cloud negatives to complement his landscape views when he needed to. He had even violated the sense of the camera's imitation of nature in doing this: in his Central American photographs, the same clouds appear over the Bay of Panama and over Lake Atitlán, in the highlands of Guatemala. If the negative needed help in print production, this was allowable. The Occident print is further removed, however, from the original negative than those allowable composite prints. Evidently, the negative was too weak or indistinct to print. Instead, it was projected onto canvas and traced, then painted in black-and-white gouache by John Koch, the skillful retouch artist attached to Morse's studio in San Francisco, from which the "automatic electro-photograph" was issued.[29]

Although this evidence tells us that Muybridge could not make a clear negative of the horse in motion in 1877, it does tell us something important about his plans for doing it: that he had in mind an electrically triggered system for making instantaneous photographs of Stanford's horses. And publicity around the photographed painting states Stanford's and Muybridge's interest in expanding the experimental setup:

Mr. Muybridge intends to take a series of pictures, showing the step of "Occident" at all the stages, and in this manner, for the first time, the precise differences in the motions of different horses can be clearly represented. . . .[30]

Now Muybridge added a new line to his usual advertisement of "Photographic Illustrations of Alaska, California,

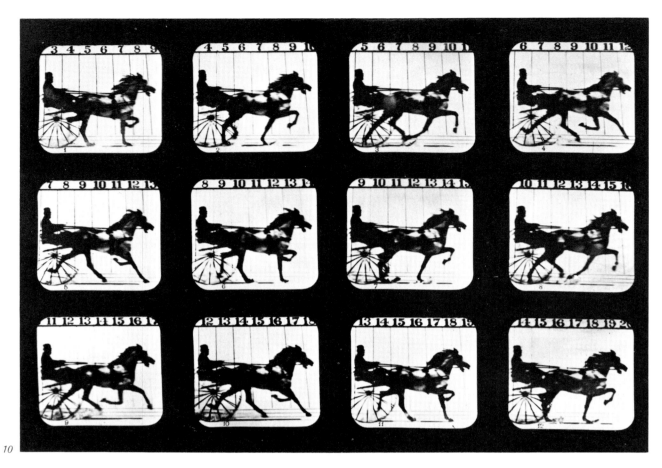

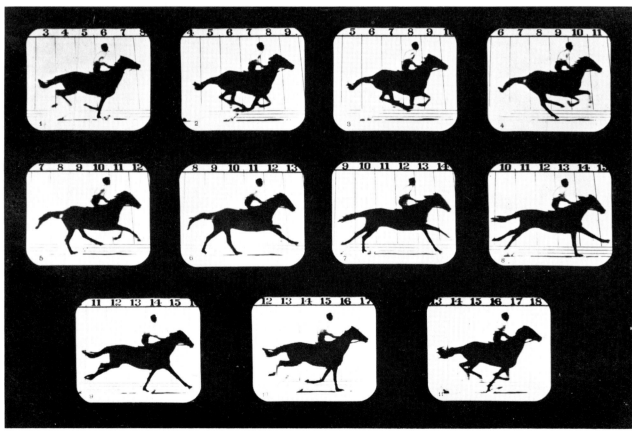

10 & 11: *Photographs made by Muybridge in June 1878 at Palo Alto. 10, "Edgington trotting at a 2:24 gait," 15 June; 11, "Sallie Gardner running at a 1:40 gait," 19 June (Stanford Museum).*

Central America and the Isthmus of Panama": "Horses photographed while running or trotting at full speed."

VI

"It is a new era in photography, and instantaneous is no longer a misnomer."
California Spirit of the Times, 22 June 1878.

In early June of 1878, Muybridge made the first successful serial photographs of fast motion. His success depended not only on his chemical formulae, but also upon the equipment that he had designed and assembled with the help of mechanics and electricians employed by Stanford: twelve Scoville cameras, equipped with "fast" stereo lenses made by Dallmeyer of London, and an electrically controlled mechanism for operating the cameras' specially constructed double-slide shutters.

On 15 June, representatives of California newspapers and journals, of the worlds of art and of sports, gathered at Stanford's recently purchased stock farm at Palo Alto to see successive exposures made of his horses Abe Edgington trotting and Sallie Gardner running. The results were to be developed on the spot; there would be no accusations this time that the photographs were in any way "gotten up."

The day was clear and bright. Edgington was photographed as he was driven over the smooth white surface of a track covered with powdered lime; a fifteen-foot-high white screen, marked with vertical lines 21 inches apart, and a four-foot-high screen, marked with horizontal lines four inches apart, formed the background. As the sulky that Edgington was harnessed to passed over the track, one of its wheels struck the exposed part of wires laid under the ground at 21-inch intervals; this contact released the shutters of the battery of cameras, set at 21-inch intervals on the open front of a low shed facing the track. Edgington trotted at a firm 2:24 gait, exhibiting no "single-footing, hitching or tendency to pace"; the wheels struck the twelve wires with a continuous roll of sound, "a whirr like that made by the wings of a woodcock," and the twelve pictures were taken in just over half a second.[31] For Sallie Gardner, who ran unharnessed, thin threads were stretched three feet above the track at 21-inch intervals; she activated the shutters as she progressed, "taking her own picture," as the press remarked.

By 20 June, Muybridge had produced six serial photographs, each showing progressive positions (the number ranged from six to twelve) of trotting, running, walking or cantering horses (see Figs. 10–12). He then published them as a set of six mounted on separate cards; on the reverse an analysis of the stride was given. From corresponding newspaper accounts, the analysis appears to have been Stanford's. Muybridge titled the set *The Horse in Motion*, thus claiming a continuity with the justly maligned publication of Occident trotting in 1877. Only one of these cards was described as being "retouched." It was of "Sallie Gardner running at 1:40 gait," the one for which he claimed the fastest exposure, "minus 1/2000 of a second." Of all the cards, it is the only one that could be called a silhouette, a term used by his contemporary detractors.

In the following summer, the experimental setup was expanded: 24 cameras were used, set at intervals of twelve inches. In some instances, auxiliary cameras were set at angles to the track, to make synchronized photographs from five different positions. This was a technique that Muybridge would elaborate on in his University of Pennsylvania work; at Palo Alto, it seemed an afterthought. He called the results "Studies of foreshortenings" (Figs. 13 and 14). Animals other than the horse were photographed—deer, dogs, mules, pigs, pigeons, goats—and, in 1879, man entered the motion-picture stage (Figs. 15–18). Members of the Olympic Club of San Francisco performed the running high leap, the back somersault and other exercises; Muybridge himself performed, chopping wood, and Leland Stanford, Jr. rode his pony Gypsy down the prepared track. During the two summers Muybridge made over 200 serial photographs, made up of some 2,000 individual negatives.

He published the results of this early photographic investigation in May 1881, under the title of *The Attitudes of Animals in Motion, A Series of Photographs Illustrating the Consecutive Positions Assumed by Animals in Performing Various Movements*. The edition was small, about ten albums of original photographs, accompanied by the title page, dedication to Stanford, an index and a brief description of the equipment, particularly noting the "clockwork apparatus," which was used to make exposures at regulated intervals of time (rather than distance) for animals whose movements did not make use of the wire-tripping mechanism possible. In all respects, then, the Palo Alto work was an inspired sketch, a necessary preliminary to the more sophisticated and extensive investigation that Muybridge would conduct at the University of Pennsylvania six years later.

VII

"About two years ago I heard for the first time of a photographic achievement which seemed to me at the time scarce credible . . . to wit, the photographic presentation of a galloping horse."—R. A. Proctor, 1881.[32]

The local press reported Muybridge's public demonstration of serial photography in June 1878; brief reports were also carried in national publications. By October, *Scientific American* had received the *Horse in Motion* cards and reproduced Muybridge's photographs on the cover of its issue for 19 October. On 14 December 1878, the French journal *La Nature* published reproductions of the photographs; the journal had published illustrated articles on Marey's investigations earlier in the year. The Muybridge photographs brought forth an admiring response from the French physiologist:

I am impressed with Mr. Muybridge's photographs published in *La Nature*. Could you put me in touch with the author? I would like his assistance in the solution of certain problems of physiology too difficult to resolve by other methods. For instance, on the question of birds in flight, I have devised a photographic gun for seizing the birds in an attitude, or better, a series of attitudes which impart the successive phases of the wing's movement. . . . It would clearly be an easy experiment for Mr. Muybridge. Then what beautiful zootropes he could

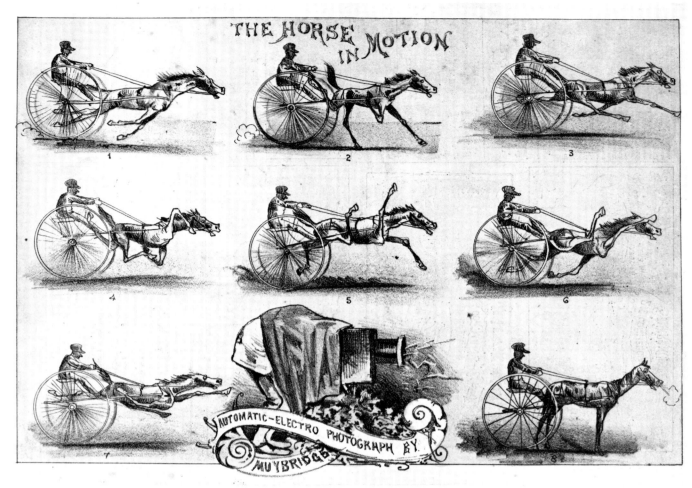

12: *A cartoon reaction to Muybridge's work at Palo Alto; from the 27 July 1878 issue of the San Francisco* Illustrated Wasp.

make! One could see all imaginable animals during their true movements; it would be animated zoology. So far as artists are concerned, it would create a revolution for them, since one could furnish them with true attitudes of movement; positions of the body during unstable balance in which a model would find it impossible to pose.[33]

Marey thus enthusiastically endorsed Muybridge's achievement of the analysis of fast motion, and again suggested the synthesis, but this time with actual photographs in mind. His endorsement reiterates the twofold interest the Muybridge analytic photographs always elicited: the stop-motion photographs of figures in "unstable balance" would serve artists; the synthesized photographs, the "animated zoology," would serve scientists.

Suggestions for the synthesis of Muybridge's photographs came from other sources as well: *Scientific American* had proposed it in October and, with a bearing on Muybridge's later work in Philadelphia, so did Fairman Rogers, chairman of the school committee of the board of directors of the Philadelphia Academy of the Fine Arts. Writing in *The Art Interchange* for 9 July 1879, Rogers reported that the painter Thomas Eakins, who was then teaching at the Academy, had constructed the trajectories of the horses' strides and, compensating for the unequal intervals in Muybridge's 1878 photographs ("owing to a peculiarity of the photographic ap-

paratus"), had prepared figures for the zoetrope.

Muybridge, by that time, was himself working on a device that would project his analytic photographs and set them in motion. Essentially, his machine was a combination of existing "philosophical toys": the phenakistoscope and the magic lantern. It consisted of two counter-rotating disks: a glass disk on which copies of his photographs of a sequence of movement were printed, and a metal disk with radiating slots. These were rotated in front of a condensing lens; the life-size projection by the brilliant light on an oxyhydrogen lamp was reported to be so perfect that Stanford could identify his horses by the projected motion.[34] Muybridge first called his machine the zoogyroscope; he finally settled on the name zoopraxiscope. A distinguished British journalist later called it "A Magic Lantern Run Mad."[35] Although Muybridge never made a claim for this device as an invention, as he had earlier made such a claim in patent applications for his "methods and improvements for photographing objects in motion," he later described it as "the first apparatus ever used or constructed, for synthetically demonstrating movements analytically photographed from life."[36]

VIII

"From the beginning of photography it must have struck many of those who were acquainted with the

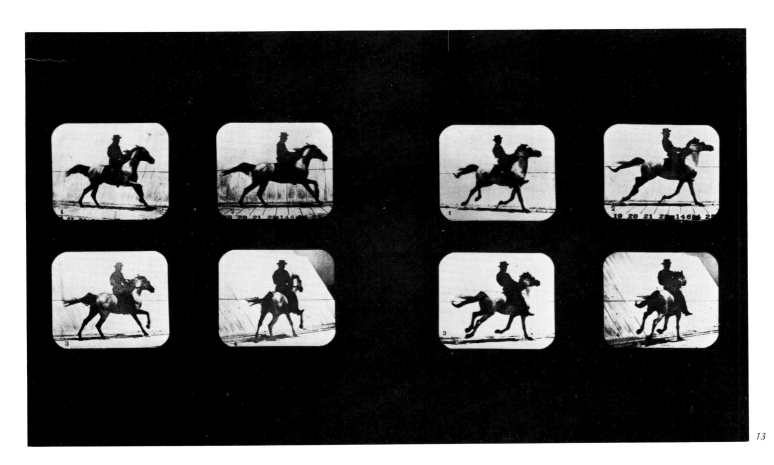

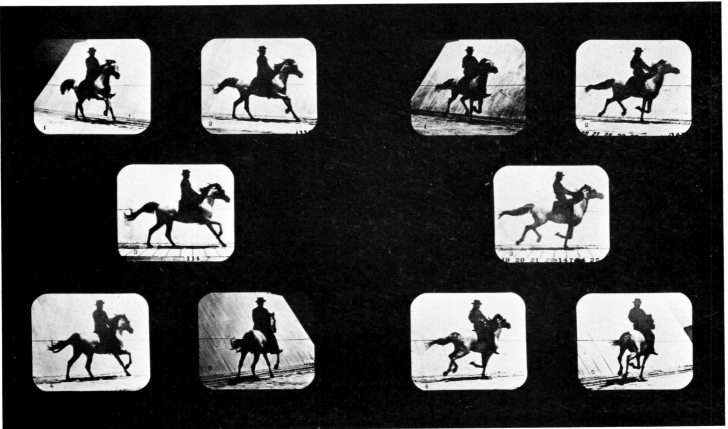

13 & 14: *Two of Muybridge's "Studies of foreshortenings" showing Mahomet running, 1879 (Stanford Museum).*

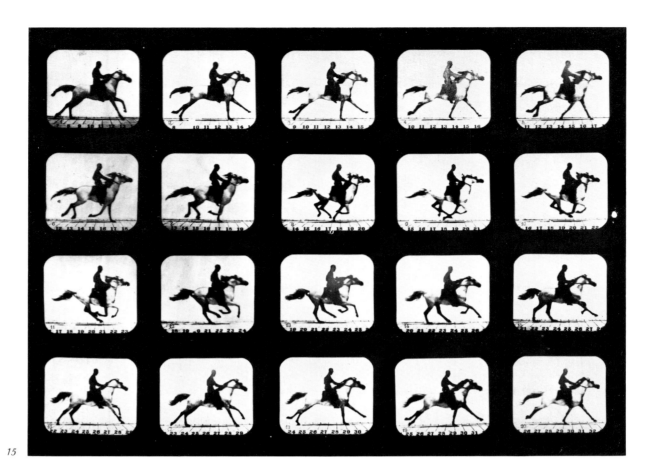

15

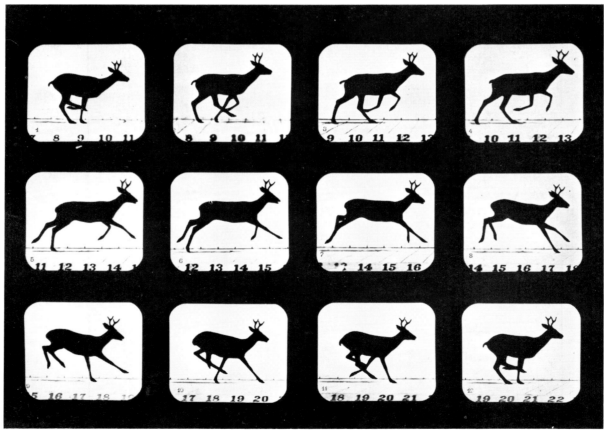

16

15-18: *Muybridge serial photographs of 1879. 15, Mahomet running; 16, deer running; 17, running high leap; 18, back somersault (Stanford Museum).*

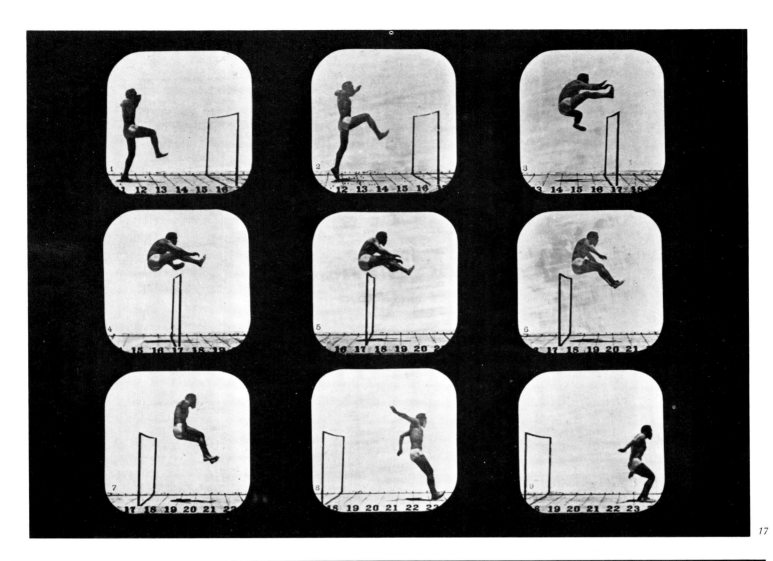

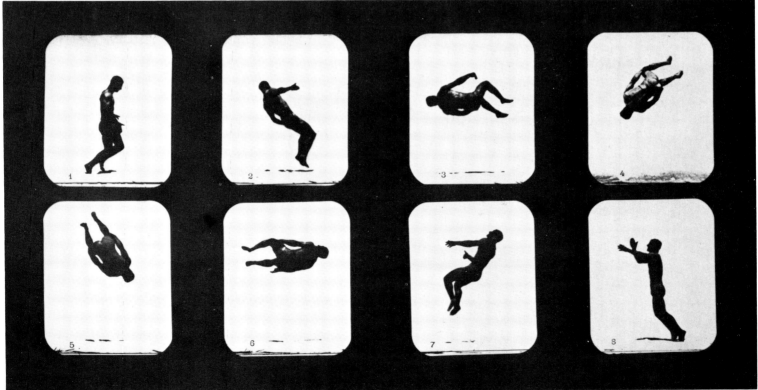

phenomenon illustrated by the Phenakistiscope invented by Plateau, that photography could produce with advantage the series of pictures used in that instrument on account of their possessing a greater degree of accuracy than when made by hand.''—Antoine Claudet, 1865.[37]

The many ingenious scopes and tropes devised during the mid-nineteenth century (the phenakistoscope, thaumatrope, zoetrope, praxinoscope, Kinematoscope, Phasmatrope, among others) testify to the eagerness with which the reproduction of the appearance of motion was then sought. Also, magic-lantern slides were devised that projected simple motion. They operated by means of a rack and pinion, a double-glass system operated by a lever, or a combination of the two. For the most part, these devices were thought of as entertaining toys; their subjects were brightly colored prints or drawings of amusing incidents that could be shown by two figures representing the extreme ends of a single, repeated movement: a man doffing a hat, a lady "flirting" a fan, a pair of frogs leaping over each other. Some of the lantern slides naïvely "demonstrated" scientific principles: "the earth's rotundity" or the movements of planets.

These popular toys used drawings of successive stages of movement; after Archer's introduction of the wet-collodion process, with its promise of a new era of instantaneity, the photographed figure, rather than the drawn one, increasingly seemed attainable. But before Muybridge's serial photographs of 1878, only static poses of successive phases of a motion could be used. Stereoscopic photographs had been set in motion by both Antoine Claudet and Jules Duboscq in 1852, with less than satisfactory results. In 1859, Henry Mayhew produced a stereoscopic phenakistoscope using six stereoscopic photographs of himself in successive stages of performing a bow. The result, said Mayhew, was "a perfect little doll-like figure of oneself performing a series of the most polite corporeal inflections."[38] But, as Mayhew discovered, the range of subjects that could be so photographed was too limited, and the expense of taking the number of photographs needed to make these "moving portraits" too great for general use. In 1861, Coleman Sellers, chief engineer of a machine-tool factory in Philadelphia, patented a "motion-picture" machine he called Kinematoscope. In this machine, a series of static poses—his wife sewing, his son hammering a nail—were mounted on a rotating drum. The photographs were glimpsed instantaneously through slots in a band of steel that encircled the drum, one slot for each photograph. The result was an appearance of unblurred motion. Nine years later, Henry R. Heyl, an inventor, also of Philadelphia, showed moving figures in his Phasmatrope in an evening of entertainment that also included dissolving views, *tableaux vivants* and shadow pantomimes. He described his Phasmatrope as "a recent scientific invention, designed to give various objects and figures upon the screen the most graceful and lifelike movements."[39] One of the motion pictures showed Heyl and his sister waltzing in perfect synchronization with an orchestra that Heyl had hired for the event. The photographs of the waltzers, he said, were "small glass plate positives of selected subjects reduced from wet plate negatives, taken from rapidly succeeding poses by an ordinary cam-

era."[40] For the most part, these novel demonstrations of movement suffered, as Antoine Claudet remarked to a meeting of the British Association in 1865, from the "deficiency of intermediate positions."

During this period, proposals for accurately timed successive exposures of moving objects were also being made, but in the name of science, rather than entertainment. An early theoretical instance is Jonathan H. Lane's publication of 1860, "On a mode of employing Instantaneous Photography as a means for the accurate Determination of the Path and Velocity of a Shooting Star, with a view to the Determination of its Orbit."[41] Lane's proposal, which called for two batteries of cameras operated by timing devices at two different stations, was necessarily theoretical; it could not be experimental until plates sensitive enough to record the meteor had been produced. The same was true of Alfred A. Pollock's "Proposed Process for Photographing Moving Bodies," published in *The Photographic Journal* for 17 December 1867. His ingenious proposal, which anticipates Marey's "photographic gun," was to use as a negative small plates set in a rotating disk whose motion acted as the camera's shutter. The positive images, when used in the zoetrope, would give a record of "the characteristic walk and action of the person photographed." But again, the sticking point was the old question: "Could the required negatives be taken with sufficient instantaneousness?" If they could, he said, "we could have photographs of a horse's limp, or the wag of a dog's tail."

A working prototype of the photographic gun that Marey had mentioned in his response of 1878 to Muybridge's *Horse in Motion* cards was the camera that the French astronomer Pierre Janssen used in December 1874 to record the transit of Venus across the sun. A circular sensitized plate was rotated by clockwork and intermittently stopped for each of the 48 successive exposures of the planet's path. Janssen, too, anticipated the use of his "revolver," as he called it, to record animal movements as data for physiological analysis, if only more sensitive plates were available.[42]

In this brief and selective history of the attempts to analyze and synthesize motion, we see that the problem was, after all, a chemical rather than an optical or mechanical one. It was, then, in his chemistry that Muybridge excelled when he took photographs of moving figures in a previously impossible exposure time: "the minus 1/2000 of a second." But he was wrong to imagine, as he did, that photography would have otherwise been incapable of recording fast motion for yet another century. By 1881, when he was giving zoopraxographic demonstrations in Europe, the gelatin dry-plate process was in use, and Muybridge recognized that it offered the possibility of larger and clearer images, taken with shorter exposures, than the wet-collodion process had afforded. It was then that he conceived of a more extensive photographic investigation, one that would put the Palo Alto experiments "altogether in the shade." The French academic painter Meissonier, Professor Marey and an unidentified "capitalist" were to join him, Muybridge announced, in the production of a publication on "the attitudes of animals in motion as illustrated by both ancient and modern artists."[43]

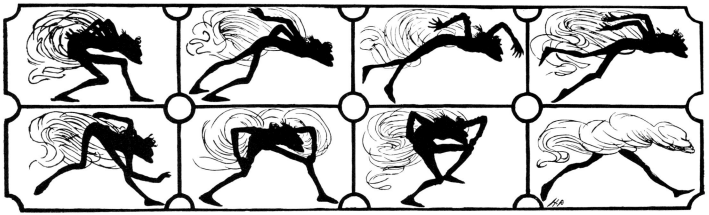

NEW ZOÖPRAXISCOPIC VIEWS OF AN EMINENT ACTOR IN ACTION.

(*By Our Own Zoöpraxiscopist.*)

19: *A London reaction to Muybridge's lectures; a cartoon by Harry Furniss from the 1 April 1882 issue of* Punch.

IX

"Many of the most eminent men in art and science and letters in Europe were present at the exhibition."

E. Muybridge, 1881.[44]

"Mr. Muybridge is at present in Paris," *La Nature* reported on 8 October 1881. He had been there since August, arriving after a brief stop in London. In May, in California, he had published *Attitudes of Animals in Motion,* the album of his Palo Alto work. In May, too, Stanford had, for the sum of $1.00, relinquished "all right to title or claim" to "any and all photographic apparatus, consisting of cameras, lenses, electric shutters, negatives, positives and photographs, magic lanterns, zoopraxiscopes; and patents and copyrights that have been employed in, and about the representation of animals in motion upon my premises at Palo Alto."[45] Muybridge came to Europe, then, as an independent spokesman for the photographic investigation of animal locomotion that had been his and Stanford's concern since 1872.

In Paris, first, and then in London, his slide shows and zoopraxiscope demonstrations were attended by the most eminent scientists and academic artists of the period. The initial showing in Paris was at Professor Marey's home in September: in attendance were Helmholtz, Govi and Bjerknes, among other "savants" who were then in Paris for a conference on electricity. Colonel Duhousset was there, and so were Gaston Tissandier (editor of *La Nature* and first builder of an electrically powered airship) and the aeronaut and photographer Nadar, who had made attempts to photograph fast motion in the 1860s. Exactly two months later, on 26 November, Meissonier gave a reception for Muybridge. This time the audience was composed of eminent artists and literary men: Gérôme, Bonnat, Detaille, Augier, Dumas *fils* and Claretie, among others. Reports of Muybridge's investigations were not confined to scientific journals: *Le Globe, Le Figaro* and *Le Temps* noticed and described the demonstrations at length.

He was, if possible, even more celebrated in London (see Fig. 19). His first showing there was before the Royal Institution on 13 March 1882; the next evening he repeated his performance at the Royal Academy. His first two British audiences included Tyndall, Huxley, Gladstone, Tennyson and Sir Frederick Leighton, as well as members of the royal family: the Prince and Princess of Wales and the three Princesses; the Duke of Edinburgh and his suite. "I should like to see your boxing pictures," said the Prince. Muybridge complied, "to the infinite delight of the audience in general and the Prince of Wales in particular."[46] This was at the Royal Institution show, the first event at which Muybridge publicly used the royal spelling of his first name, Eadweard. It was, one might say, a name he must have felt that he had finally made for himself.

Muybridge's demonstrations and accompanying lectures followed the same pattern in Paris and in England: first he showed slides of the individual photographs, contrasting them with examples of animals in art, from prehistoric times to the present, and pointing out the great difference between conventional understanding of the attitudes animals assume in motion and the attitudes as revealed by instantaneous photography. He described his method and apparatus for taking the photographs, and then, demonstrating their smooth synthesis when they were projected by the zoopraxiscope, analyzed the various gaits shown in motion on the screen. Thus, his lecture instructed artists in the "true" nature of animal movement, and showed scientists how photographs such as his could be used in formulating a theory of animal mechanism. Muybridge appeared to be modest and lucid in his discussions, as well as entertaining:

Mr. Muybridge is not only an original but a daring man. He has smitten one of the gods of British idology. Not the least instructive part of his lecture was his contrast between the positions of animals as shown in ancient or modern art with their true positions as shown by themselves in presence of the

camera. The audience listened calmly enough while Egyptian, Assyrian, Roman and Renaissance artists were put out of court. When Rosa Bonheur's turn came there was a slight thrill. Mlle. Rosa has long been popular in England. But Mr. Muybridge next showed us a photograph from an English picture of a race horse at full speed, with his four legs extended to the utmost limit, and his feet off the ground. He pointed out that the position was impossible, and that if once the animal got into it he would infallibly break his back in coming down. A moment later appeared a photograph of ten such horses; "all as you see," observed Mr. Muybridge, "exactly like the first horse and each other. If it be impossible for one horse to assume such an attitude, to find ten horses doing it all at once would be nothing short of a miracle." This remark the audience applauded, upon which the lecturer added with delusive calmness: "The ten impossible horses, as you see them are photographed from Mr. Frith's well-known picture of "The Derby Day." The audience shuddered. At least half of them must have been in the habit of regarding Frith's "Derby Day" as among the triumphs of modern art. . . . At the Royal Academy this passage was necessarily suppressed.[47]

In these demonstrations, the audience was usually shocked by the revelation of the awkward movements that Muybridge's stop-motion photographs revealed, and then thrilled when, by means of the zoopraxiscope, they saw that the ungainly attitude of an instant did indeed form an integral part of what had always been regarded as graceful movement. "Even the pigs," commented *Le Globe* of 27 September 1881, "showed absurd pretensions to grace and agility" in their gallop.

While the zoopraxiscope convinced Muybridge's audiences that the awkward individual movements were photographically true, discussion arose on all sides about their artistic truth. The stop-motion photograph showed the animal in a position the human eye could never see. Should not the artist, rather, deal with visible sensation? If Muybridge's photographs were to be used by artists, they should be used, it was suggested, in a general way, as information-giving data, not copied: "What is optically true," reported *The Builder* (London) for 25 March 1882, "is not, necessarily, pictorially true." But it was Muybridge's contention that pictorial truth would eventually follow optical truth, once the long-standing habit of conventional and "absurd" representation had been overcome.

Muybridge's celebrity in England continued until 20 April 1882. On that day the London journal *Nature* reprinted Leland Stanford's preface to a book called *The Horse in Motion as Shown by Instantaneous Photography, With a Study on Animal Mechanics, Founded on Anatomy and the Revelations of the Camera, in Which Is Demonstrated the Theory of Quadrupedal Locomotion,* by J. D. B. Stillman, A.M., M.D. The book was "Executed and Published under the Auspices of Leland Stanford." Stanford mentioned Muybridge only as "a very skilful photographer" he had employed: Muybridge's name was not given on the title page. This public denial of Muybridge's crucial role in achieving the sequential photographs arrived in London shortly before he was to read a monograph on animal locomotion before the Royal Society; the monograph, which was already in page proof, was to be published in the *Proceedings* of the Society,

an honor that would have confirmed his contribution to science. As Muybridge later said, "The doors of the Royal Society were thus closed against me, and in consequence of this action, the invitations which had been extended to me were immediately cancelled, and my promising career in London was thus brought to a disastrous close."[48]

X

"I anticipate no difficulty in pursuing the investigation on a larger and more comprehensive scale than has yet been done and to an exhaustive conclusion."
Eadweard Muybridge, 1882.[49]

By mid-July, Eadweard Muybridge was back in the United States. Throughout his European tour, he had looked forward to "extending" or "completing" (those were his terms) his photographic investigation of animal locomotion with the gelatin dry-plate process. He appended his plan to almost all of his lectures, and also sought to interest individuals and institutions in supporting further investigations. He did not, he said, exhibit the photographs taken at Palo Alto as "perfect pictures, but simply as experiments," and he reminded his audiences that they had been taken almost four years ago, and taken with the wet-collodion process: "Future and more exhaustive experiments," he had said at the Royal Institution, "with all the advantages of recent chemical discoveries, will completely unveil to the artist all the visible muscular action of men and animals during their most rapid movements."

Muybridge also made this statement at the end of his lectures in Boston, New York and Philadelphia in late 1882 and early 1883. The earlier proposed publication on the art history of animal locomotion, to be produced in conjunction with Marey and Meissonier, had evidently been deserted by one or another of the several "capitalists" whose financing it had depended upon, and now Muybridge was seeking support through his lectures for extended photographic investigations. He titled his address according to his audience: the popular name was "The Romance and Realities of Animal Locomotion"; when treating the subject more seriously, he called it "The Attitudes of Animals in Motion." When no sponsor could be found, Muybridge decided to raise the money himself. In March 1883, he issued a prospectus for *The Attitudes of Man, The Horse and Other Animals in Motion,* an "edition de luxe"; the subscription price would be $100 for 100 original photographs. Meissonier would lend his "devoted assistance and invaluable advice" in selecting illustrations of the action of men and of horses from ancient to modern times; Professor Marey would contribute an essay on "Zoopraxiology, or The Science of Animal Mechanism," and the art critic Walter Armstrong would contribute a history of the representation of animals in motion, perhaps identical to his "Movement in the Plastic Arts," which was published in *The Art Journal* (London) early in 1883. This publication, then, would strike a better balance than the one proposed earlier; it would be useful to scientists and artists and would, moreover, attact a general audience. "It is intended to make this A Standard Work of Reference for the Painter, the Sculptor, the Anatomist, and the Physiologist," and one "of

interest to the general public, and of especial value to owners and trainers of horses,'' Muybridge announced. In a particularly touching appeal, he declared that he would "endeavor to render a lasting monument to all who assist in its production.'' But, because of the expense of the undertaking, he could not begin until he had received 200 subscriptions, or $20,000.[50]

In fact, Muybridge's prospectus for *The Attitudes of Man, The Horse and Other Animals in Motion* promised serial photographs of the broad range of subjects he finally published in *Animal Locomotion,* as well as some that he did not. He would take serial photographs of horses, men and other animals (both domestic and "wild") in single strides to show gaits peculiar to them, or at "their greatest rates of speed.'' Also, illustrations of men walking, running, leaping, wrestling, boxing, fencing, doing military exercises, rowing, playing polo, baseball and so forth. He would photograph actors performing, ladies playing lawn tennis, dancing and doing "other exercises of muscular action and graceful movement." He would continue his experiments with "Birds on the Wing,'' and would attempt to illustrate the movements in water of birds, seals and other marine mammals. Photographs of the movements of diseased human bodies would be contrasted with the same movements of healthy bodies, and he would even try to record "the successive phases of the Heart and Lungs while in action,'' with an apparatus he had invented for that purpose. A special feature, not part of the standard work, would be photographs illustrating trajectory curves; for this, he would use Marey's "photographic revolver,'' which the physiologist had announced to the French Academy in July 1882. Muybridge had been urged to continue his work, he said, by "the most distinguished authorities and world-renowned men in science and art,'' who assured him of the "vast advantages to be derived from a more exhaustive series of investigations with my improved photographic and electric appliances, which will enable me to obtain Perfect Photographs in less than the one-ten-thousandth part of a second of time.''

It was in Philadelphia that Muybridge's proposal finally found a sponsor. On 7 August 1883, four months after he had published his prospectus, the trustees of the University of Pennsylvania resolved "to arrange with Mr. Muybridge for the prosecution of his work on the investigation of animal motion, within the precincts of the Veterinary Department.''[51] As Muybridge later said:

> This investigation demanded of necessity so large an outlay of money, and the subsequent publication . . . assumed such imposing proportions, that all publishers not unnaturally shrank from entering the unexplored field.
>
> In this emergency the University of Pennsylvania took the prosecution of the investigation under its auspices. . . .[52]

In retrospect, it seems entirely fitting, almost predictable, that the University of Pennsylvania decided to sponsor Muybridge's further experiments, and to find their purposes congenial with the community's long-standing interests. Philadelphia was the home of the oldest scientific society in the United States: the American Philosophical Society, founded in 1743. The Pennsylvania Academy of the Fine

Arts, founded in 1805, was the oldest art institution in the country. Other Philadelphia institutions give evidence of the city's devotion to scientific inquiry: its College of Physicians, founded in 1786; Academy of Natural Sciences, 1812; Franklin Institute for the promotion of the mechanical arts, applied science and technology, 1824; and its university, founded as a college in 1740, designated a university (the first in the United States) after the addition of medical courses to the Philosophical School, in 1779.

Apart from this clear interest in scientific inquiry, Philadelphia was a city of wealth, and the trustees and friends of the university, the Lippincotts, Biddles, Peppers (among other old families, many of whom sent their sons to school there), supported the university handsomely. Dr. William Pepper, a graduate of the medical school, was appointed Provost in 1881; under his guidance, the university entered a period of expansion, in which thirteen new departments were established, including the Wharton School of Business, the first collegiate school of this sort in the United States. The Graduate School, the Veterinary College, the archaeological expeditions to Babylonia, the University Museum—all of these were projects initiated during Dr. Pepper's tenure as Provost.[53] Philadelphia was, as well, the home of the most prestigious journal of photography in America, *The Philadelphia Photographer,* and we have seen how two of its citizens, Coleman Sellers and Henry Heyl, both engineers, used photography to simulate movement in optical devices of their invention.

The setting, then, was generally appropriate. But more particularly, Philadelphia was the home of two men who had used, commented on and encouraged Muybridge's Palo Alto experiments and his subsequent lectures in Philadelphia in February 1883: Fairman Rogers and Thomas Eakins. Rogers, a man of great wealth and then head of the Pennsylvania Academy of the Fine Arts, was also a scientist. He had been professor of civil engineering at the university, had lectured on that subject at The Franklin Institute, and was active in the American Philosophical Society. He was a sportsman, too: a daring rider to the hounds, and the founder of the Coaching Club. He was also a patron of the arts, one of those leading citizens who "managed most of the city's cultural interests.''[54] Rogers had commented on Muybridge's *Horse in Motion* photographs in 1879, and in February of 1883, had invited Muybridge to give two lectures in one week at the Academy.

The painter Thomas Eakins had been a sportsman and a student of anatomy from his youth. After studies with Gérôme in Paris, he had returned to Philadelphia, where he produced paintings of unrelenting (and often unappreciated) realism. Rogers had appointed him professor of drawing and painting at the Academy in 1879; previously Eakins had been instructor in anatomy. In 1878, Eakins had corresponded with Muybridge about his Palo Alto photographs, urging him to use a more legible measuring system, and also to produce "a series showing the changes in the position of the muscles while running, thus supplying a great want of art students.''[55] The understanding of the anatomy and musculature of the human body was crucial to Eakins' painting and to his teaching. His students drew from the nude model, not

from plaster casts, the usual practice. His statement on the importance to painting of an understanding of movement and structure, rather than the classic insistence upon outline, sounds like a description of one of Muybridge's photographs of athletes of 1879:

> The first things to attend to in painting the model are the movement and the general color . . . the movement once understood, every detail of the action will be an integral part of the main continuous action; and every detail of color auxiliary to the main system of light and shade.[56]

The two Philadelphians were also photographers; Muybridge could not have asked for anything more. Both Fairman Rogers and Thomas Eakins, then, found in Muybridge's extended photographic investigation, especially as it was proposed in a prospectus seemingly tailor-made to their interests, an important and worthy project.

It was Rogers who called Muybridge's proposal to the attention of the provost. His long acquaintance, both professional and social, with Dr. Pepper made it possible. Once the trustees had resolved to support Muybridge, Pepper lost little time in writing to him, guaranteeing him $5,000 in advance. Although Muybridge had earlier estimated that the investigations would cost $20,000 (Stanford had spent close to $40,000 for the initial experiments), he accepted the trustees' invitation in a letter of 3 September 1883:

> I will now merely thank you for having so favorably consummated the arrangements for the advance of the $5,000 I estimate as necessary to complete the photographic investigation of the "Attitudes of Animals in Motion" and will reserve for a more fitting opportunity my acknowledgement of your appreciation of the value of the proposed work.
>
> The conditions imposed in consideration of the money being advanced are entirely reasonable, and are much as I should have voluntarily accorded. I therefore accept them without qualification. viz. "That the work is to be done in the enclosure of the Veterinary Department of the University of Pennsylvania" during the spring and summer of 84; that the publication is to be made as "under the auspices of the University of Pennsylvania" and that the money thus advanced is to be secured by the subscription list of the proposed publication which I am to bring up to the point where it will cover the amount advanced. . . .
>
> I agree with you as to the desirability of a consultation as early as convenient with Mr. [Fairman] Rogers and yourself, and other gentlemen whom you may suggest, when I should like to submit some ideas that have occurred to me as being of interest and value.[57]

In March 1884, a university commission was formed to supervise Muybridge's work, and so ensure its scientific character. The nine members included Provost Pepper, six professors of scientific studies at the university and two members from the Academy of Fine Arts: Edward H. Coates, who had succeeded Fairman Rogers as chairman of the instruction committee at the Academy in late 1883, and Thomas Eakins. With the supervisory commission formed, Dr. Pepper could report in April, when it was apparent that the cost of the investigation would be much more than $5,000, that a group of six Philadelphians had guaranteed to contribute $5,000 each to see it through. The guarantors included Charles C. Harrison, who would succeed Pepper as provost in 1894; Thomas Hockley, Samuel Dickson, Coates and the publisher J. B. Lippincott, who agreed to buy the necessary lenses from Dallmeyer of London. Thus, not only were the promised investigation and publication to be more elaborate than the Palo Alto experiments; the financing and the direction of them were, too. The money would not be given from one pocket: it would now come from six, and would be, in some cases, offered as a loan with interest. And instead of Muybridge's making do with his own mechanical ability and the help of electricians employed by the Central Pacific Railroad, there were now professors of anatomy, physics, veterinary anatomy and pathology, civil and dynamic engineering, and people concerned with art instruction to guide him in his work. One sees in this change of patronage and support a leap, accomplished in only five years, from a nineteenth-century form of scientific investigation to a form very much like that practiced now, with the exception that it is now usually the government's role to act as sponsor.

Dr. Pepper, a man of unusual receptiveness to proposals that would advance knowledge, and a brilliant administrator of innovative programs, believed that Muybridge's photographic research was a proper extension of the university's function:

> The function of a university is not limited to the mere instruction of students. Researches and original investigations conducted by the mature scholars composing its faculties are an important part of its work, and in a larger conception of its duty should be included the aid which it can extend to investigators engaged in researches too costly or elaborate to be accomplished by private means.
>
> When ample provision is made in these several directions we shall have the university adequately equipped and prepared to exert fully her great function as a discoverer and teacher of truth.[58]

This, too, is a modern (and particularly American) conception of the university's function.

The city was proud of its university. As the Philadelphia *Inquirer* put it in a review of Muybridge's photographs:

> It is to this university and to its Provost that the credit is due of first making it possible to continue the researches in question in the line of original investigation. Nor is this, by the way, the only science in which, under Dr. Pepper's administration, the University of Pennsylvania is still ahead.[59]

XI

"The work is now going on with a thoroughness and exhaustiveness which promises the most valuable results."
Philadelphia *Ledger & Transcript,* 6 September 1884.

Philadelphians learned of the forthcoming photographic investigations in a lecture Muybridge gave in early February. He then announced that the university had ordered 40 lenses from Dallmeyer, that the work would be done in the coming summer, and that the results would be published in one volume. Although there was as yet "not a stroke of work done," as one report put it, 125 subscriptions at $100 each

ANIMAL LOCOMOTION.
By EADWEARD MUYBRIDGE.
PUBLISHED UNDER THE AUSPICES OF THE UNIVERSITY OF PENNSYLVANIA.

Mr. EADWEARD MUYBRIDGE,

University of Pennsylvania, Philadelphia, U. S. A.:

We, the undersigned, each hereby subscribe for the number of copies written in association with our respective names, of your work on ANIMAL LOCOMOTION; each copy to contain *One Hundred Plates*, as described in the prospectus; at the subscription price of ONE HUNDRED DOLLARS for each copy, payable upon the delivery of the work.

NAMES OF SUBSCRIBERS.	NUMBER OF COPIES OF THE WORK SUBSCRIBED FOR.

The following blank form is intended for the use of *one* subscriber only.

A copy thereof should be written by each additional subscriber whose name is placed on the above subscription list, filled with the necessary instructions, and forwarded with this completed form in one envelope.

The numbers on the other side, through which a line is drawn, indicate the SERIAL numbers of the plates I have selected.

The total number of the PLATES selected is

I have remitted on account of my subscription

I request that you will send the plates to

...................................

...................................

By

20

SERIAL NUMBERS OF THE PLATES IN ANIMAL LOCOMOTION.

Subscribers will please draw a horizontal line **through** the Serial Numbers of the Plates they select; the line should be distinctly made with ink.

Should the subscription list on the other side hereof contain the names of more than ONE subscriber; each additional subscriber should enclose a separate list —in manuscript—of the serial numbers of the plates INDIVIDUALLY selected.

1	41	81	121	161	201	241	281	321	361	401	441	481	521	561	601	641	681	721	761
2	42	82	122	162	202	242	282	322	362	402	442	482	522	562	602	642	682	722	762
3	43	83	123	163	203	243	283	323	363	403	443	483	523	563	603	643	683	723	763
4	44	84	124	164	204	244	284	324	364	404	444	484	524	564	604	644	684	724	764
5	45	85	125	165	205	245	285	325	365	405	445	485	525	565	605	645	685	725	765
6	46	86	126	166	206	246	286	326	366	406	446	486	526	566	606	646	686	726	766
7	47	87	127	167	207	247	287	327	367	407	447	487	527	567	607	647	687	727	767
8	48	88	128	168	208	248	288	328	368	408	448	488	528	568	608	648	688	728	768
9	49	89	129	169	209	249	289	329	369	409	449	489	529	569	609	649	689	729	769
10	50	90	130	170	210	250	290	330	370	410	450	490	530	570	610	650	690	730	770
11	51	91	131	171	211	251	291	331	371	411	451	491	531	571	611	651	691	731	771
12	52	92	132	172	212	252	292	332	372	412	452	492	532	572	612	652	692	732	772
13	53	93	133	173	213	253	293	333	373	413	453	493	533	573	613	653	693	733	773
14	54	94	134	174	214	254	294	334	374	414	454	494	534	574	614	654	694	734	774
15	55	95	135	175	215	255	295	335	375	415	455	495	535	575	615	655	695	735	775
16	56	96	136	176	216	256	296	336	376	416	456	496	536	576	616	656	696	736	776
17	57	97	137	177	217	257	297	337	377	417	457	497	537	577	617	657	697	737	777
18	58	98	138	178	218	258	298	338	378	418	458	498	538	578	618	658	698	738	778
19	59	99	139	179	219	259	299	339	379	419	459	499	539	579	619	659	699	739	779
20	60	100	140	180	220	260	300	340	380	420	460	500	540	580	620	660	700	740	780
21	61	101	141	181	221	261	301	341	381	421	461	501	541	581	621	661	701	741	781
22	62	102	142	182	222	262	302	342	382	422	462	502	542	582	622	662	702	742	
23	63	103	143	183	223	263	303	343	383	423	463	503	543	583	623	663	703	743	
24	64	104	144	184	224	264	304	344	384	424	464	504	544	584	624	664	704	744	
25	65	105	145	185	225	265	305	345	385	425	465	505	545	585	625	665	705	745	
26	66	106	146	186	226	266	306	346	386	426	466	506	546	586	626	666	706	746	
27	67	107	147	187	227	267	307	347	387	427	467	507	547	587	627	667	707	747	
28	68	108	148	188	228	268	308	348	388	428	468	508	548	588	628	668	708	748	
29	69	109	149	189	229	269	309	349	389	429	469	509	549	589	629	669	709	749	
30	70	110	150	190	230	270	310	350	390	430	470	510	550	590	630	670	710	750	
31	71	111	151	191	231	271	311	351	391	431	471	511	551	591	631	671	711	751	
32	72	112	152	192	232	272	312	352	392	432	472	512	552	592	632	672	712	752	
33	73	113	153	193	233	273	313	353	393	433	473	513	553	593	633	673	713	753	
34	74	114	154	194	234	274	314	354	394	434	474	514	554	594	634	674	714	754	
35	75	115	155	195	235	275	315	355	395	435	475	515	555	595	635	675	715	755	
36	76	116	156	196	236	276	316	356	396	436	476	516	556	596	636	676	716	756	
37	77	117	157	197	237	277	317	357	397	437	477	517	557	597	637	677	717	757	
38	78	118	158	198	238	278	318	358	398	438	478	518	558	598	638	678	718	758	
39	79	119	159	199	239	279	319	359	399	439	479	519	559	599	639	679	719	759	
40	80	120	160	200	240	280	320	360	400	440	480	520	560	600	640	680	720	760	

21

20–24: *Insertions in Muybridge's 1887 Prospectus and Catalogue. 20, front of subscription blank; 21, back of subscription blank; 22, front of list of subscribers; 23, back of list of subscribers; 24, instructions to subscribers.*

Animal Locomotion.

By Eadweard Muybridge.

University of Pennsylvania, January, 1887.

It is expected by the author that his work on Animal Locomotion will be ready for delivery to subscribers early in the ensuing summer.

As soon as possible, a complete series of the plates will be deposited in one of the Art Institutions or Libraries of Philadelphia, Boston, New York, Washington, and other large cities of the United States, when those subscribers who prefer to make a personal selection of the plates for their respective copies of the work will be afforded an opportunity of doing so.

Invitations for this examination and selection will be extended to SUBSCRIBERS ONLY, by whom alone copies of the work can be obtained.

It is desirable that intending subscribers should forward their names as early as possible, as *after publication* no guarantee can be given that they will be able to obtain the plates they select.

It is with much gratification that the author is able to announce that nearly one-half of the required number of subscribers have already placed their names on the subscription list. Such general recognition of the value of a work to the *Dilettante*, or of its necessity to the Artist, the Physiologist, and the Naturalist, the author believes to be without precedent. Among the subscribers are the subjoined.

Institutions of Art; Artists; and Publishers and Manufacturers of Works of Art.

[OVER.]

Institutions of Learning; *Literati* and Conservators of Works of Art.

Institutions of Science; and Scientists.

24

had already been received. Muybridge said that he expected to receive 500 subscriptions, from all parts of the country.

The summer of 1884 was a difficult one. Evidently, it took longer than Muybridge had estimated to build his outdoor studio; the work was not finished until late in the fall. His *Prospectus* (reprinted in this edition at the end of the third volume; see also Figs. 20–24) describes his "Studio, Apparatus, and Method of Working." In fact, the studio did not operate effectively until 1885, and most of the photographs that he took in 1884 were not usable. Lacking the setup for the battery of 24 cameras that took lateral views of the subjects in motion, he decided to use an improved "Marey wheel," a development of Marey's photographic gun of 1882 in which Muybridge used two counter-rotating discs (similar to the mechanism of his zoopraxiscope) to obtain more definition in the figures on the glass-plate negative. It was a method of working favored by one of his supervisory committee, Thomas Eakins, who was also using a Marey wheel in his own photographic investigation of motion during that summer. Eakins favored this method over Muybridge's proposed battery of cameras: it afforded closer comparison of the successive phases of motion, because the images were all on one plate; it seemed to Eakins, therefore, to be a more scientific approach to the investigation of motion, one from which trajectories of movement, necessary tools for the physiologist, could be more accurately drawn. In fact, Eakins seems at this time to have become disenchanted with Muybridge's method, and, one feels, with Muybridge himself, whose showmanship was so at odds with his own public reticence. Eakins' attitude is implied in a letter written by his studio assistant, the painter Thomas Anshutz, to J.

Laurie Wallace, an Eakins student who had served as a model for his teacher's motion photography. In mid-June of 1884, Anshutz wrote:

Eakins is on the committee which superintends Muybridge. He is of course much interested in the experiments. Muybridge has not made very rapid progress and the university people seem to be losing faith in him.[60]

Still, at that time, Muybridge's results with his two rotating disks were more clearly defined than were Eakins', who was then using only one disk. But however successful Muybridge was with his revolving-plate camera, this type of photography was not what the university had contracted for. Anschutz, writing again to his fellow student in August, commented on the difficulty:

He had not yet done any work with his series of lenses and I hear they do not work. The shutters are too clumsy and slow. The university people are dissatisfied with the affair as he cannot give them the result they expected.[61]

Muybridge's plans suffered another temporary setback in August, when the Hospital Committee of the Poor Guardians decided, despite the urging of Dr. Francis X. Dercum, professor of nervous diseases at the university, that it would not allow hospital patients to go to Muybridge's studio; he must bring his apparatus to them.

The apparatus was, at that time, hardly portable. Nevertheless, Muybridge and several assistants managed to make 600 negatives at Philadelphia's Zoological Garden in 1884. Most of the photographs were finally discarded: they were taken through the bars of the cages, which gave the animals unnatural stripes. The lion, for instance, was said to be mistaken for a tiger. Muybridge did, however, photograph a real tiger. The dramatic incident was reported in the New York *Times* for 15 November 1884. The tiger was photographed as he leaped upon his prey, an old buffalo being sacrificed at that moment to the cause of the investigation. The *Times* noted that the results revealed a type of motion quite different from that portrayed by romantic artists of the nineteenth century, to whom such a subject had been meaningful:

Almost invariably he is represented as clinging to the back or side of his victim, with his claws buried in its body. As a matter of fact, upon the unimpeachable testimony of the sun, a tiger's hind feet scarcely leave the ground. He simply rears up, hits his prey with a forepaw . . . and drags it down.

The tiger was "seven years of age and in grand condition"; Muybridge's vantage point was near the tethered buffalo. Fortunately, commented the *Times,* the unrestrained tiger preferred the buffalo to the photographer.

Among other animals photographed that summer at the Zoological Garden were the elephant, zebra, deer, llama and sloth. Most attractive to Philadelphia audiences, when Muybridge showed his results in a zoopraxigraphic lecture, were the photographs of various stages of a single bound of a fawn and the series of a flight of a cockatoo, which showed the different phases of the wing in flight for the first time. Doves were photographed during the 1884 sessions at the

zoo, and so were waterfowl on a pond, an eagle, a vulture and even a stork in flight.

During that summer, when most of the members of the Muybridge commission were on vacation, Dr. Dercum helped the photographer in his work, as he would continue to do throughout the investigation. Also, in this initial phase of the investigation, the physiologist Edward T. Reichert was instrumental in helping Muybridge overcome the difficulties presented by what Reichert called "his then rather crude apparatus."[62] Reichert, to whose laboratory Muybridge often came for lunch, gives us an intimate glimpse of the photographer at that time:

> It was during these mid-day hours we discussed almost countless matters connected with his work, and I became intimately acquainted with the most eccentric man I ever knew intimately. He was very much of a recluse, so that few got to know the man, and likely no one ever learned hidden secrets that must have radically influenced his life. . . . He surely was a strange character, but withal very likeable when you knew him well.

Francis Dercum, with whom Muybridge frequently dined, gives a picture of a more robust character:

> He possessed strong and regular features and had a most attractive personality. In his mental make-up, he was more like Thomas A. Edison than any other man whom I ever knew.[63]

The winter of 1884–1885 was spent in perfecting the apparatus. The electromagnetic devices, crucial to the successful achievement of a series of synchronized exposures in several batteries of cameras, were made operative with the help of the mechanics of the university. Muybridge redesigned the portable apparatus, using thirteen connected lenses (one was for focusing) with a single bellows divided into thirteen parts. The plate holder was a long narrow box containing three thin glass strips, each twelve inches long. Cramer, the manufacturer of gelatin dry plates, prepared an extrasensitive emulsion for Muybridge; the especially thin glass was imported from Germany. Although separate pieces of glass were used in this holder, its form and mode of operation, as Dr. Reichert later noted, approached in concept, if not in material, the strip of celluloid that eventually made possible motion pictures as we know them. The result of Muybridge's design was an easily portable, and therefore more useful, battery of cameras for taking photographs of subjects in motion, a situation in which a quick change in camera position was often needed to produce a successful series.

A detailed description of Muybridge's apparatus, discussing his innovative circuit breaker, the mechanism used for making a graphic record of each exposure, and the tuning fork employed for recording the time of each exposure, is given in an essay on "The Mechanism of Instantaneous Photography," by William D. Marks, a member of Muybridge's supervisory committee.[64] A popular account of the operation of the apparatus appeared in the Philadelphia *Times* for 2 August 1885:

> The photographs are taken by three batteries of cameras, with twelve lenses to each battery. These batteries are placed at right angles to each other [actually, the angles varied; 60° angles were also used in the "foreshortenings" at the university

studio] and are all focused on one object. When the model or object under consideration is photographed, thirty-six negatives are obtained, no two of which, however, are alike, but all represent different stages of muscular action from the three different points of view. The lenses are screened with strips of black muslin, which revolve on rollers and are held in place by heavy rubber bands. Each of these thirty-six bands connects with a small electric battery and the wires controlling each battery are conducted through a rubber tube to a common stick, which the photographer holds in his hand. On this stick is a little screw, which, when touched, liberates the rubber bands in turn and for the fraction of a second exposes each camera to the object on which it was focused. . . . The first lens of each battery is exposed simultaneously, and so on through the series of twelve in rotation. In this way thirty-six negatives are obtained, in three series of twelve each, each series being of the same movement from a different point of view, and each of the twelve presents the object in a different stage of muscular motion. . . . In this way every inch of a man's or a beast's progress can be photographed, no matter what the speed. It is simply a matter of the number of lenses used and they can be multiplied indefinitely.

With this improved apparatus, and with the help of five student assistants, two of them maintaining the electrical apparatus, two helping in the field and one in the darkroom, Muybridge's photographic investigation got under way. Records were kept of each session. The notations include remarks on the success of the series; "fogged," "incomplete" or "light struck" appear less and less frequently. As he became more experienced, Muybridge used his full battery of 36 cameras more effectively: by 15 June, he was taking twelve laterals and 24 foreshortenings of such human actions as "ascending steps" or "walk up plank." By July, he had really hit his own stride, so to speak: his record books, now in the International Museum of Photography at George Eastman House, show almost every series making full use of all of his lenses: women placing a chair, dressing, washing, getting up off the ground, ascending and descending steps, scrubbing, throwing water, and so on. In July, too, men were photographed lifting a log, drilling, shooting, walking, performing the broad jump and the high jump, throwing a hammer, a ball, a log, a stone and so forth. Muybridge gives the names of his human subjects; among them are his assistant William A. Bigler, clothed, who walked, lifting his hat; Morris Hacker, nude, batted a ball; Robert E. Glendenning did a handspring, and one of the university's outstanding athletes, George Brinton, threw the hammer and put the shot on 13 June. For a series of extraordinary interest, Muybridge photographed the hands of J. Liberty Tadd, model 51, "a well-known instructor in art." (Tadd, an artist, was principal of the public School of Industrial Art.) The several series, taken at close range, show Mr. Tadd's hands beating time, drawing a circle, playing five notes of a scale on the piano, picking up a ball, clasping his hands together, picking up a pencil with his right hand, putting it into his left hand and writing. (The number system used in Muybridge's laboratory notebooks differs from that used in the published plates; but, with the omission of the piano-playing series, we can readily identify these photographs of 24 July 1885 as Plates 532–536 in the published work.) Mrs. Tadd walked

with her young daughter in her arms, dropped a fan or picked up the train of her long dress; Muybridge himself, model 95, whom he himself described on page 12 of his *Prospectus* as "an ex-athlete, aged about sixty" (he was then 55), climbed up and down stairs, sat down, carried a 50-lb. dumbbell, hammered and sawed (Plates 489–491, 519, 521). Muybridge and his assistants also made notations of the subject's age, weight, height and, in the case of some female subjects, of their measurements: shoulder, bust, waist and hip. Muybridge made a public statement on his models. It was printed in the Philadelphia *Times*, 2 August 1885:

> I have experienced a great deal of difficulty in securing proper models. In the first place artists' models, as a rule, are ignorant and not well bred. As a consequence their movements are not graceful, and it is essential for the thorough execution of my work to have my models of a graceful bearing. I have the greatest difficulty, however in inducing mechanics, at any price, to go through the motions of their trade in a nude condition to the waist only.

This is the sort of statement that must have discouraged Eakins. What could grace have to do with the thoroughness of an investigation whose purpose was to discover muscular action in the human body? Muybridge was a man who assumed a scientific attitude very gradually. It also seems a mean comment on the many artist's models supplied to Muybridge through the kind offices of Mr. Tadd. One artist's model, a Mrs. Cooper, offered herself to an experiment that was especially taxing, as we shall see.

Particularly appropriate to the university's emphasis on the scientific value of the studies is a notation that appears in the laboratory notebooks on 24 June 1885: "Clinical." Dr. Dercum had finally got permission from the hospital authorities to have patients brought to the studio. His patients came, said Dercum, through "a small gate in the north wall of the Philadelphia Hospital."[65] Muybridge photographed various pathological gaits of Dr. Dercum's patients in several sessions in 1885. In all, 20 of the published plates are of the abnormal gaits of these subjects, some of which are incorrectly identified in the catalogue: locomotor ataxia (Plates 546, 549, 550, 554, 560), lateral sclerosis (Plate 548), spastic (Plates 541–543, 547, 552, 553), epileptic (Plate 551), rachitic and hydrocephalic (Plate 561), partial paraplegia (Plate 559), muscular atrophy (Plate 555), stuporous melancholia (Plate 558), infantile paralysis (Plate 539) and local chorea (Plates 556 and 557). Muybridge also photographed a convulsive subject, one in whom the convulsions had been artificially induced by having the subject hold a position in which certain muscles were strained for a period of from several minutes to an hour (Plates 544 and 545). Dercum describes the event, which took place at Muybridge's outdoor studio:

> The subject that I selected was an artist's model. She was one of those which Mr. Liberty Tadd had sent to the studio. She was unusually intelligent and complied with the necessary details of the experiments. . . . Both the beginning of the convulsion as she sat at a table, later in a chair, and finally when she was placed while in convulsion on the mattress before the camera, are illustrated in Mr. Muybridge's plates. I must say that this was

the first time that convulsions of any kind were ever photographed.

Muybridge also obliged Dr. Dercum by using his Marey-wheel apparatus instead of the batteries of cameras to take photographs of tremors. On 5 October 1885 two subjects suffering from paralysis agitans were taken, and from the satisfactory results Dercum concluded that the wheel offered "a valuable and accurate method of studying not only tremors but also other forms of abnormal movement."[66]

Another subject of extraordinary interest to the field of medicine was photographed for the first time in the course of Muybridge's investigation. It was one he had promised in his prospectus of 1883, in which he announced an apparatus for recording "the successive phases of the Heart and Lungs while in action." Lino F. Rondinella, then chief of Muybridge's staff of student assistants, describes the event:

> We devised a carriage to which a large snapping turtle was strapped on his back, his under shell was removed, his heart was exposed, and as his carriage was drawn under one of the portable batteries of cameras pointed downward, we made successful series of twelve photographs each analyzing his heart beats. . . .[67]

Dr. Reichert, who evidently took part in these experiments, also reported similar photographs of a cat's heart. He said that this work "was of a purely experimental and preliminary character," and observed that it predicted techniques that would become essential to medical inquiry in later years.[68] Unfortunately, the negatives of this reported pioneer photographic study of the action of vital organs have not been found.

By 15 August 1885, the Philadelphia *Evening Telegraph* could report that over 15,000 negatives had been taken. By then, Muybridge had almost concluded his sessions at the outdoor studio, and had returned to the Zoological Garden to photograph again those subjects that had not been successfully taken in 1884, and to add new ones to his studies. He had the help of six assistants. Among them were Dr. Dercum and Dr. Andrew J. Parker, professor of comparative anatomy and zoology, for, as Muybridge said, "I am neither a physiologist nor an anatomist, [therefore, they] are assisting in the work to given it additional weight and value."

His subjects were pigeons, a red-tailed hawk, a crow, a falcon, a horned owl, a Bengal tiger, a pine snake, baboons, lions, buffaloes, a donkey and others. The work was done under the hot August sun, which melted the asphalt in the zoo's enclosures, and made it necessary for Muybridge and his crew to wear colored glasses. First, the background screens had to be prepared. They were large wooden frames, 10 feet by 12 feet, covered with black or white muslin, depending upon the lightness or darkness of the subject's coat. Like the studio screens, each of these portable backgrounds was subdivided by thin cords into five-centimeter squares. Then the cameras were loaded, a procedure that the *Telegraph* compared, on 13 August, to the loading of a Gatling gun, only "much more arduous." The newspaper's reporter watched the session at the zoo in which the red-tailed hawk (Plate 763) was photographed:

The Professor, protected from the sun by an old straw hat, walks about the field like a Western stock farmer. He fixes the slides, gives out orders, like the mate of a schooner in a gale, and when everything is ready the Professor sits on a small beer keg, holding an electric key in his hand, and orders up the bird.

"What kind of a one will we call, sir?" says the keeper. . . .

"Give us the hawk," says the Professor. . . . And away [the hawk] goes until he gets to the end of his string, and then he is handed back for another trial. It is a most tantalizing operation for the hawk. He flaps his wings about three times going across the screen. He was subjected to this performance three times and seventy-two successive likenesses taken of himself.

Three weeks were spent working at the zoo. One of Muybridge's assistants, Thomas G. Grier, called working there "one of the most exiting episodes of my life."[69]

Muybridge's next field location was the Gentlemen's Driving Park, where he photographed thoroughbred horses, attempted to reveal the secrets of the individual gaits of fine and fast horses, and so account for their uncommon speed. Other revelations of Muybridge's serial photographs were commented upon as his work drew to a close. Outstanding among them, in Muybridge's view, was the confirmation of his long-held belief that the feathers of a bird's wing move independently of the whole wing during ascent and descent. "In lifting its wing, each feather is turned on edge, as an oar is 'feathered' between the strokes," the Philadelphia *Inquirer* noted. These results must have been particularly pleasing to Muybridge: Marey had first urged him to photograph birds flying in 1878, and another mentor, J. Bell Pettigrew, had made the flight of birds his special study. Muybridge would later propose an investigation devoted entirely to the photographic study of wings in flight, a study, he came to believe, that would help to solve the problems of what was then called aerial navigation.

Among other "curiosities" observed by the popular press were these: the mode of progression of a human being crawling on his hands and knees was identical to the pattern of footfalls of quadrupeds, and, to everyone's surprise, the heavy and clumsy rhinoceros actually moved with a "dainty" grace, supporting its bulk on either both right legs or both left legs, rather than on diagonal legs.

By the end of the season, over 20,000 photographs had been taken. At the close of the summer's work, Provost Pepper asked Dr. Dercum to assist one of the guarantors in looking over the photographs. They met in the room in the university's biology building where Muybridge arranged and classified his photographs. Mr. Harrison, who made the inspection, was satisfied with the quality and the quantity of the photographs, and so were the other members of the financing group, when they received his report. Publication seemed near at hand.

Muybridge himself, however, was not satisfied. From 6 November 1885 to 11 May 1886, he redid more than 500 of the 1,540 subjects he had previously taken; thus he extended his investigation well beyond 1885, the date given for its conclusion in his subsequent publications. But the last plate of *Animal Locomotion,* 781, was taken on the last day of work in 1885: "3 chickens/Startled by explosion" is the way he had noted it in his laboratory book on 28 October 1885. Although at first glance this seems to be a preposterous subject, its motive was scientific. Muybridge later described it in his publication, *Animals in Motion:*

> The rapidity of the transmission of nervous sensation was experimented with. The explosion of a small torpedo in close proximity to an animal or bird started the motor clock and commenced a series of exposures.

H. L. Bell, who did all of the darkroom work, later reported that he developed more than 1,800 dozen dry plates from the spring of 1885, when he started work, to the conclusion of the photographing in May 1886, and that along the way he made positives of those series that Muybridge had designated in his laboratory book as being "zoopraxiscopic." By mid-September 1886, Muybridge could report that the work of photography was all completed, and that Mr. Bell had made all the positive plates. They were arranged in proper sequence on master plates and were ready to have negatives made of them for the collotype plates, which were to be printed by the New York Photogravure Company of Brooklyn. "Then how soon will the work be published?" asked the reporter for *The Pennsylvanian* in an interview in its issue for 28 September. "Not later than next spring," replied Muybridge, "provided the requisite number of subscriptions are secured. There must be at least five hundred at not less than $100 apiece."

Although he needed many more subscriptions than he had received to repay the guarantors, Muybridge must have been gratified by the renown of the institutions and individuals who had already subscribed: Harvard was down for two copies, and its famous Professor Agassiz had subscribed as well; several copies were taken by Johns Hopkins, Princeton, Yale, Cornell and other American colleges; foreign subscriptions included ones from Oxford, London and Cambridge, Lord Rosebery, the Imperial Library and Agricultural College of Berlin and, farther afield, the Khedive of Egypt and the Emperor of China.

XII

"This work is the only basis of accurate criticism of the movements incidental to life as depicted in art designs."—Eadweard Muybridge, 1887.[70]

Animal Locomotion was finally published in November 1887. It had been announced by Muybridge's *Prospectus and Catalogue of Plates,* in January of that year. Beyond its rarity and its usefulness, the *Prospectus and Catalogue* is interesting on another count: in its very design it expresses the combination of motives, artistic and scientific, that guided the investigations, particularly in Muybridge's mind. An entry for a female model is first described: "flirting a fan" or "turning around, act of aversion" in the left-hand column. Then our eyes move to the right-hand columns, with their arrays of letter and number notations, their quantities of movement phases, foreshortenings, time intervals and reference notes. The prose of animal locomotion is thus translated into numbers, and we feel as if we had taken a leap toward a new kind of description, one that we are only now becoming widely familiar with in our daily programs.

In 1888, the university published a tall octavo volume containing three essays on the photographic investigation: *Animal Locomotion. The Muybridge Work at the University of Pennsylvania. The Method and the Result.*[71] Earlier, plans had been made to issue the text in the same format as the photographic plates, but this was found to be awkward, the plates being so large. And earlier, evidently, Muybridge believed that it was he who would prepare " a lengthy introduction," which would be accompanied by a descriptive text prepared by Dr. Andrew J. Parker, who had helped him throughout the investigations. The university, however, chose instead to publish essays by Professors Marks, Allen and Dercum. While he believed that Muybridge's work would "undoubtedly be of lasting service to art and science," Provost William Pepper emphasized the university's interest in the scientific value of the investigation in his introduction to the three essays:

> The mass of novel material presented in this work is so great that it has not as yet been possible to subject any considerable portion of it to critical examination. As, however, the sole object which induced the University to assume supervision of this work was to contribute to the scientific study of animal motions, it has been decided to publish in the present form a brief description . . . of the apparatus and methods employed; a memoir . . . on some of the laws or principles elucidated by Mr. Muybridge's photographs; and an article on the clinical aspects of certain nervous affections as illustrated by instantaneous photography. . . .[72]

Actually, after their study of Muybridge's photographs, all three of the authors commented on the special value of Eakins' work with the Marey wheel. W. D. Marks, in an essay that was written partly by Thomas Eakins,[73] describes the painter's apparatus extensively, and only moves on to a description of Muybridge's method after this statement on the Marey wheel:

> The advantages arising from this method of photography would seem to render its further prosecution desirable, as yielding a means of measurement as near scientifically exact and free from sources of error as we can hope to reach.

Professor Allen, too, favored Marey's wheel:

> No one would pretend that the same accuracy as regards regularity in the sequence of exposures could obtain in a serial battery of cameras as in such an apparatus as used by Marey, in which the sequence of exposures was determined by the fenestra of a revolving wheel.

And we have earlier read Dr. Dercum's statement on the Marey wheel as a valuable and accurate method of studying tremors and other abnormal movements.

Nevertheless, the three found some use in Muybridge's approach to the subject, particularly when his repeated chronographic measurements showed that the differences of the time intervals between exposures was very small, even for rapid movements, and so negligible that they could be overlooked in slow movements. Other possible errors in his method were necessarily cited in this scientific publication, but redeeming features were found in Muybridge's method, and the published studies made use of the information the photographs offered. The general initial response was that these photographs of never-before-seen movements of men and animals were of wide interest and value. In the *Scientific American* for 17 March 1888, Muybridge was said to be entitled to claim "the remembrance of posterity as being a systematic worker in photographic studies of human movements." The New York *Times* for 5 March 1888 summed up popular opinion in a review of *Animal Locomotion:*

> In the studio of Mr. William Bradford, on Union-Square, one finds a stack of enormous folios. They contain the results of experiments in photographing live creatures while in movement . . . at last so perfected that scientists, artists, and those who are curious to learn the facts of existence in the less common forms can use them as treasure stores whence to extract useful information.

Muybridge had placed the "stack of enormous folios" in his friend's studio in an attempt to swell the subscription list to the point where the guarantors' expense of $50,000 would be repaid. As he went about his personal-appearance tour, well-supplied with all the paraphernalia of a distribution agent—billheads, notepaper, envelopes, postcards—he kept in touch with the university. "Business is very slow," he wrote to Jesse Burk, the university secretary, from Bradford's studio in March 1888. I hope it will be brighter after my lectures at the Union League Club and the Century Club." His lectures took him to major cities in this country and abroad. From Milwaukee, in June, he wrote of having got fourteen subscribers and selling two complete series in Chicago. In London, in 1889, he lectured again before the Royal Institution and the Royal Society, vindicating himself after the disastrous denial of authorship of 1882 (see Fig. 25). His topic was "The Science of Animal Locomotion in its Relation to Design in Art."

This was a subject that had been of paramount interest to him since the publication of Marey's article on the graphic representation of animal locomotion in 1878. The article, published in *La Nature,* 5 October 1878, had been accompanied by illustrations of the representation of the horse from the history of art. Muybridge had immediately taken this as a theme for his lectures, and was later encouraged to further emphasize it by Meissonier.

Muybridge's stop-motion photographs had always stirred controversy about their relevance to the depiction of movement in art. In the early 1880s, when he himself was lecturing on the "absurd" positions used by artists for centuries to depict animals in motion, there were those who found the awkward positions revealed by his cameras to be equally absurd. Still, a number of artists of quite different aesthetic intentions did literally copy certain images found in the serial photographs. Meissonier exclaimed, after seeing Muybridge's *Horse in Motion* photographs of 1878, "Oh! If I could only repaint *Friedland!*" Later, he did repaint the huge battle scene, changing some of the horses' positions to conform with photographic evidence. Thomas Eakins used the same set of photographs as sketches for his painting *The Fairman Rogers Four-in-Hand* (now in the Philadelphia Museum of Art), and Edgar Degas made drawings from Plate 620 of *Animal Locomotion,* "Annie G. in canter."[74]

25: *Muybridge lecturing at the Royal Society in 1889; cover of the 25 May issue of* The Illustrated London News.

Muybridge had moved, by the time *Animal Locomotion* was published, to advocating a more general use of his photographs than he had strictly insisted on in his early lectures. Rather than rely on particular images given by them, he suggested that artists study the series of images, become familiar with positions assumed by animals in motion that could not have been seen before, and from this study and their own observation derive a representation of movement that would avoid errors and yet be visually convincing. What he came to in his own understanding, then, is quite compatible with Rodin's famous statement of 1911:

> . . .it is the artist who is truthful and it is photography which lies, for in reality time does not stop, and if the artist succeeds in producing the impression of movement which takes several moments for accomplishment, his work is certainly much less conventional than the scientific image, where time is abruptly suspended.[75]

Still, Muybridge did not foresee, even in his broadened approach to the subject, the use that artists would make of his work. For it was eventually in the visual sense that twentieth-century artists made of the simultaneous presentation of a series of movements through space and time, a compilation of many moments compressed into one tight space, rather than in the direct application of information about movement, that Muybridge's work came to penetrate the very climate of art.

XIII

"The work should belong to every scientific and artistic institution in the country and in the world."
The Nation, 19 January 1888.

Muybridge's European tour was both strenuous and successful. He sent an account of it to the university secretary in 1891:

> It will interest you to know that I have visited nearly all the Universities in Italy, Switzerland and South Germany, and have everywhere obtained for the University of Pennsylvania a recognition of its enlightened and liberal policy. . . . The Universities now on the subscription list are the following.
> Oxford, Berlin, Paris, Munich, Naples, Leipzig, Rome, Bologna, Turin, Bern, Tübingen, Würzburg, Geneva, Freiburg, Basel, Halle, Göttingen, Bonn, Strassburg, Vienna, Heidelberg, Prague, Genoa, Zurich, Pisa, Innsbruck, Budapest, Florence, Padua. . . . In addition to those, the Royal and other academies of art . . . and also such names as Helmholtz, Bunsen, Virchow, Ludwig, du Bois, von Remond, etc., etc. as representatives of science, and nearly all the most eminent artists in Germany, France, Italy and England.[76]

Along the way, he was also trying to sell the lenses that had been purchased for the investigation. He had offered them earlier for the use of the university's Babylonian expedition, but they remained at the university, and were sold piecemeal to interested parties.

In 1892, having made zoopraxographical tours in the United States and Europe, he was back in Philadelphia planning to seek more subscriptions in Australia and the Far East. Before he left Philadelphia, he proposed yet another photographic investigation in a letter on University of Pennsylvania stationery. His letter was addressed to David Starr

26: *Portrait of Muybridge; frontispiece of* Descriptive Zoopraxography, *1893.*

Jordan, president of the Leland Stanford Junior University, which had been founded in 1885 in memory of the Stanfords' only son:

> I am now happy to say that after several years of privations, and laborious exertions, I have recovered the position—at least in reputation—from which I was displaced by the publication of "The Horse in Motion by J. D. B. Stillman"; and have completed under the auspices of this University, a comparatively exhaustive investigation of Animal Movements, and I avail myself of the opportunity to send you two pamphlets on the subject which I think will interest you. I have recently seen both Mr. and Mrs. Stanford, and was very much gratified with the renewed assurance by Mrs. Stanford of her belief that the interest and attention I succeeded in obtaining for my work by the Senator, during a period of great mental anxiety was mainly instrumental in saving his life.
> I am now being urged by many men, eminent in various branches of science—among them are Professors Helmholtz, S. P. Langley, Ray Lankester, Sir Wm Thomson and Sir John Lubbock and Mr. Edison—to undertake an investigation of the flight of insects; they being impressed with the belief that a comprehensive knowledge of the subject will be of much interest and value in many ways, and materially assist in a solution of the problem of aerial navigation.
> With this object in view I have devised an apparatus which will be capable of photographing a dozen or more consecutive phases of a single vibration of the wing of an Insect in flight; even assuming that the number of vibrations exceed 500 in a second, which is far in excess of what Professor Helmholtz believes to be possible with a common house fly.

Finding that both Mr. & Mrs. Stanford maintain an apparent undiminished interest in this subject, will you kindly permit me to inquire whether it is within the province of the Leland Stanford Junior University to prosecute or aid in any marked degree, original research; and whether you would approve—or better be willing to promote and assist such an investigation as I propose. . . . I believe the work can be more successfully carried on in California than anywhere else, and it would be some satisfaction to me and it might be so also to Mr. Stanford that the investigation of this subject of Motion should be completed, where it was commenced.

But there was no favorable reply to this proposal, nor to those he sent to Jordan in April, in which he attempted to schedule a lecture at the university. And instead of touring Australia and the Far East, Muybridge went, in 1893, to the World's Columbian Exposition in Chicago, where he lectured in his Zoopraxographical Hall on the Midway Plaisance. Across the Midway from the Moorish Palace, the Persian Concession and the Natatorium, Muybridge lectured on "The Science of Animal Locomotion, especially in relation to Design in Art." The lectures were given under the auspices of the U.S. Bureau of Education, and they were based upon his University of Pennsylvania studies. For this occasion, which was a further attempt to seek subscriptions for *Animal Locomotion*, the university published Muybridge's *Descriptive Zoopraxography, or The Science of Animal Locomotion Made Popular* (see Fig. 26). For the most part, it was a reprint of material published in his *Prospectus and Catalogue* of 1887. His subscription list, which was printed in facsimile as well as in set type in the booklet, named 376 institutions and individuals; a number of other well-known "*Dilettanti,* Art Connoisseurs, Manufacturers" and "Eminent Men" whose names did not appear on the list must have put the total figure close to 450. Muybridge's hall, of classical design, was not well attended at that World's Fair; the illustrated paper disks for use in the phenakistoscope that he sold in portfolio, and the individual ones sold as fans, were not financially rewarding. Still, his Zoopraxographical Hall was the first motion-picture theater ever built, and his lectures on the Midway the first commercially presented motion-picture shows.

Muybridge returned to Kingston-upon-Thames in the fall of 1894. It was a permanent move; all of his gear had been shipped from Philadelphia in the summer. He continued to lecture. And he also planned further publication of his work on the subject of animal locomotion. He had wanted to be the author of the text for a publication of his photographs since the Palo Alto days, but both Leland Stanford and the University of Pennsylvania had rejected his writing. Edwin F. Faber, who had adapted the *Animal Locomotion* photographs to the zoopraxiscope disks, remembered Muybridge's discussing his proposed publications before the photographer left Philadelphia in 1894:

When I met him, I'm sorry to say, Muybridge's day had passed. [*Animal Locomotion*] had not been sufficiently successful to

insure his future comfort, and society, that had lionized him, had forgotten him. He was in very modest circumstances, every penny's expenditure was of importance. His hopes lay in this new small book. . . .[77]

In August 1895, Muybridge wrote to Jesse Burk again, this time urging that the university undertake the financing of his popular edition of *Animal Locomotion*. It was to be called "The motion of the horse and other animals in nature and in art," he said, and would include many illustrations of the way animal movements had been depicted throughout all the history of art. While he asked for further support, feeling sure it would recover all of the guarantors' expenditures, he expressed his regrets at the undersubscription of the 1887 publication:

Had *Animal Locomotion* turned out a splendid financial, in addition to a brilliant scientific success, I should [have written to Provost Harrison expressing my very humble tribute to his generosity], but I am apprehensive that I am not very high in favor with any of my guarantors, and perhaps shall not be until they have recouped the thousand dollars or so they are each of them out of pocket as contributors to the world's knowledge, and the University's honor. I have done my best and if I did not succeed in making the work pay for itself I cannot bring myself to believe that I am to blame.

Muybridge eventually did publish popular editions of the photographic investigations. *Animals in Motion, An Electro-Photographic Investigation of Consecutive Phases of Animal Progressive Movements* was published in 1899; *The Human Figure in Motion, An Electro-Photographic Investigation of Consecutive Phases of Muscular Actions,* in 1901. In his introduction to *Animals in Motion*, Muybridge reviewed his years of studying motion photographically, and claimed his long history of interest in the particular study that had become of greatest interest to him: aerial navigation. He had first observed the independent motion of the feathers of the wing when he watched a gull soaring around a steamer crossing the Atlantic, he said. And he concluded: "Whether the act of soaring is accomplished by some hitherto improbable motion of the primary feathers may perhaps engage the attention of future investigators."

He was not to be one of the investigators; three years after *The Human Figure in Motion* was published, he died at the age of 64. He had planned to give lecture tours to encourage the sale of his two books. But he did not need to; his judgment of what constituted a popular edition was shown to be correct: *Animals in Motion* went through four reprint editions; *The Human Figure in Motion* went through six. After his many years of persistent effort, certain knowledge of this success, would, one feels, have guaranteed Eadweard Muybridge's final peaceful rest.

ANITA VENTURA MOZLEY

Menlo Park, California
1979

Notes

1. Dr. J. Bell Pettigrew, "Introduction," *Animal Locomotion, or Walking, Swimming, and Flying, with a Dissertation on Aeronautics,* London, The International Scientific Series, Vol. VII, 1873, p. 2.

2. *Foreign Quarterly Review,* April 1839. Cited in B. Newhall, "Photography and the Development of Kinetic Visualisation," *Journal of the Warburg and Courtauld Institutes,* Vol. VII, Nos. 1 and 2, 1944, pp. 40–45.

3. As early as 1851, however, William Henry Fox Talbot, the British inventor of the positive-negative process, whose investigations were contemporaneous with Daguerre's, had used a spark from a battery of Leyden jars to photograph a page of the London *Times* fixed to a rapidly revolving wheel. The negative, exposed at about 1/100,000 of a second, showed a readable image. Sir Charles Wheatstone had suggested the instantaneousness of electric light as a means of observing fast motion in 1834; Talbot's application of it to photography seems to have had no repercussions and never to have been repeated until after the publication of Muybridge's *Animal Locomotion.* H. & A. Gernsheim discuss this application fully in their *History of Photography, 1685–1914,* N.Y., 1969. The author of "Instantaneous Photography," writing in *The Photographic Journal* for 15 April 1862, could say: "Most old photographers have, in fact, occasionally produced instantaneous pictures, either by chance or design. It is only comparatively recently, however, that the art of instantaneous photography has been systematized, or that any attempt has been made to lay down and control the conditions for its successful practice." Because of the difficulty of producing a system of artificial illumination that would flash in a series, the possibility suggested by Wheatstone and Talbot was not pursued as a way of achieving successive instantaneous photographs of animals in motion until after Muybridge's publication of 1887.

4. The term "instantaneous" had no fixed value. As late as 1880, a photograph of a horse standing stock-still was labeled "instantaneous."

5. L. Price, *Manual of Photographic Manipulation,* London, 1858. Cited in B. Newhall, "Photography and the Development of Kinetic Visualisation."

6. Dr. Peter Mark Roget, F.R.S., described the phenomenon of persistence of vision in 1824: the eye for a brief time retains images of objects moving past it at a rate faster than 1/10 of a second; the result of this is an illusion of continuous motion.

7. E. Muybridge, *Animal Locomotion . . . Prospectus and Catalogue of Plates,* Philadelphia, 1887, p. 3. This prospectus is reproduced in its entirety in the present edition.

8. B. Quaritch, advertisement for "Eadweard Muybridge's Great Work on Animal Locomotion," *The Journal of the Camera Club* (London), October 1898.

9. Muybridge noted on the title pages of the two popular publications of his *Animal Locomotion* investigations, *Animals in Motion* (1899) and *The Human Figure in Motion* (1901): "Commenced 1872. Completed 1885."

10. This and all following information about the course of Muybridge's career come from two sources, unless otherwise noted: R. B. Haas, *Muybridge, Man in Motion,* Berkeley, 1976, and A. V. Mozley, R. B. Haas and F. Forster-Hahn, *Eadweard Muybridge: The Stanford Years, 1872–1882,* Stanford, Department of Art, 1972, revised 1973. These sources will not be cited in the course of this history except for directly quoted material. Muybridge's *Scrapbook,* now in the Borough Library of Kingston-upon-Thames, will be cited without reference to its use in these two publications, although both of them depend, as all work on Muybridge must, largely upon it.

11. R. B. Haas, *Muybridge, Man in Motion,* p. 4.

12. E. Muybridge, advertisements, 1859. R. B. Haas, pp. 6 and 9.

13. R. B. Haas, p. 8.

14. E. Muybridge, advertisement, May 1868. Kingston *Scrapbook,* inserted between pp. 14 and 15.

15. H. & A. Gernsheim, *History of Photography,* p. 199.

16. D. B. Taylor, "Operator with B. &. R.," letter published in *The Philadelphia Photographer,* July 1874. Reprinted in *The Stanford Years,* p. 103.

17. Roger Fenton's remarks on this sort of darkroom manipulation were published in *The Photographic Journal* (London), 21 October 1854: "Instead of directing their efforts to improve nature, their object should rather be to copy it as perfectly as possible."

18. E. Muybridge, "Leland Stanford's Gift to Art and to Science, Mr. Muybridge's Inventions of Instant Photography and the Marvelous Zoogyroscope," San Francisco *Examiner,* 6 February 1881.

19. E. Muybridge, advertisement, 1872. Kingston *Scrapbook,* facing p. 15.

20. *Ibid.* His 20-by-24-inch negatives would be larger than any previously made in the American West.

21. *Alta California* (San Francisco), 3 August 1877. Kingston *Scrapbook,* p. 19.

22. E. Muybridge, "Leland Stanford's Gift to Art and to Science," 1881.

23. Contrary to popular legend, there almost certainly was no bet involved in Stanford's interest in having Muybridge take a picture of Occident at full speed. Contemporary accounts indicate that Stanford never bet, not even on his own horses. The notion of the bet seems to be an evasion of Stanford's motive: an understanding of the way horses move. The "bet" notion is a way of underestimating Stanford: "How could a 'robber baron' have an idea that was not connected with making money?"

24. E. J. Marey, *Animal Mechanism,* London and New York, The International Scientific Series, Vol. XI, 1874. *La Machine animale, locomotion terrestre et aérienne,* Paris, 1873. Marey's observations confirmed earlier publications by J. Bell Pettigrew, as Marey himself acknowledged. J. B. Pettigrew, *Animal Locomotion,* London, International Scientific Series, Vol. VII, 1873, p. 16.

25. L. Stanford to E. Meissonier, reported in Sacramento *Daily Record-Union,* 23 July 1881, in an article titled "How Governor Stanford Converted Meissonier. The Great Horse Painter Finds that He has been in Error as to the Horse all His Life."

26. For a discussion of the zootrope (1834; also known as zoetrope) and the phenakistoscope (1832), see O. Cook, *Movement in Two Dimensions,* London, 1963, and D. B. Thomas, *The Origins of the Motion Picture,* London, 1964.

27. San Francisco and Napa County newspapers carried full reports of the trial. Muybridge's wife, Flora Shallcross Stone Muybridge, sued her husband for divorce. She died in July 1875, while Muybridge was in Central America. Florado was raised by foster parents; he always used "Muybridge" as his surname. He died in Sacramento, California, in 1944.

28. Judging from the style, Muybridge wrote this.

29. The Koch painting is in the collection of the Stanford University Museum of Art.

30. San Francisco *Post,* 3 August 1877. Kingston *Scrapbook,* p. 17.

31. *California Spirit of the Times* (San Francisco), 22 June 1878. Kingston *Scrapbook,* p. 24.

32. R. A. Proctor, "Photographs of a Galloping Horse," *Familiar Science Studies,* London, 1882, p. 402. Originally published in *Gentleman's Magazine* (London), December 1881.

33. Translation by J. Sue Porter in *Eadweard Muybridge: The Stanford Years, 1872–1882,* p. 116.

34. "When Mr. Muybridge had achieved success with the zoogyroscope he had one series of photographs done in silhouette on the outer rim of one glass disc, and with the apparatus hastened to Palo Alto to show the result to Mr. Stanford. Across the great screen again and again galloped at full speed the delicate-limbed race mare. Mr. Stanford looked at it. 'That is Phryne Lewis,' said Mr. Muybridge. 'You are mistaken,' said Mr. Stanford; 'I know the gait too well. That is Florence Anderson.' The artist was certain it was Phryne Lewis. Mr. Stanford was equally certain it was Florence Anderson, and it was only after investigation and the discovery that by a misunderstanding it was the pictures of Florence Anderson that had been done in silhouette that the artist was convinced of his error." Muybridge, "Leland Stanford's Gift to Art and to Science," 1881.

35. G. A. Sala, in *The Illustrated London News*, 18 March 1882.

36. Preface to *Animals in Motion*, London, 1899.

37. A. Claudet, "Moving Photographic Figures," *The Photographic Journal* (London), 15 September 1865, p. 143.

38. H. Mayhew, "On Stereoscopic Phenakistoscopy," *The Photographic Journal*, 16 October 1865, p. 171.

39. Program, "Ninth Entertainment of the Young Men's Society of St. Mark's Evangelical Lutheran Church." Academy of Music, Philadelphia, Saturday, 5 February 1870. Archives, University of Pennsylvania.

40. Heyl Papers, The Franklin Institute, Philadelphia. Quoted in M. J. McCosker, "Philadelphia and the Genesis of the Motion Picture," *The Pennsylvania Magazine of History and Biography*, October 1941, p. 407.

41. *The Photographic Journal*, 1 August 1860, p. 302.

42. H. & A. Gernsheim, *The History of Photography*, "The Photography of Movement," pp. 433–446. The physiological analysis of stereographs had earlier been suggested by O. W. Holmes in *The Atlantic Monthly*, May 1863: "We thought we could add something to what is known about [the mechanism of walking] from a new source, accessible only within the last few years and never so far as we know, employed for its elucidation, namely the *instantaneous* photograph." Drawings of the human walk made by the illustrator Felix O. C. Darley from stereoscopic photographs accompanied Holmes's article. Cited in B. Newhall, "Photography and the Development of Kinetic Visualisation."

43. E. Muybridge, letter to Frank Shay (tutor of Leland Stanford, Jr.), Paris, 23 December 1881. C. P. Huntington Collection, George Arents Research Library, Syracuse University.

44. E. Muybridge, letter to Frank Shay, Paris, 28 December 1881. C. P. Huntington Collection.

45. Bill of Sale and Assignment, Leland Stanford to E. J. Muybridge, 30 May 1881. Bancroft Library, University of California. On this same day, Stanford paid Muybridge $2,000 for his two years of work.

46. *The Photographic News*, 17 March 1882. Kingston *Scrapbook*, p. 75.

47. G. A. Sala, in the New York *Tribune*, reprinted in the San Francisco *Bulletin*, 24 June 1882. Kingston *Scrapbook*, p. 84. Stanford had been in Paris just before Muybridge's sensational debut; in the autumn Meissonier had painted his portrait, including in it an open album of *The Attitudes of Animals in Motion* (the painting is now in the Stanford University Museum). Stanford's leaving Paris on the day of the Marey reception reveals his anger at being excluded from the limelight that Muybridge so thoroughly occupied. Reports such as this in a San Francisco newspaper, and letters that Muybridge was then writing to friends of Stanford's about his success, must also have made Stanford eager to publish what he believed to be *his* investigation. He soon did.

48. E. Muybridge, draft of a letter to Leland Stanford, San Francisco, 2 May 1892. Bancroft Library, University of California. Because *The Horse in Motion* contained photographs for which Stanford had sold Muybridge all rights in May 1881, Muybridge instituted a suit against Stanford in October 1882; judgment was rendered in Stanford's favor in 1885. Stanford always believed that his role in the investigation was the primary one. In January 1883, he wrote to Dr. Stillman from New York: "The Muybridge suit interests me. I want to prove up the whole history. The actual facts are from beginning to end he was an instrument to carry out my ideas." C. P. Huntington Collection.

49. E. Muybridge, letter to J. D. B. Stillman, 7 March 1882, London. C. P. Huntington Collection.

50. E. Muybridge, "Prospectus of a New and Elaborate Work Upon *The Attitudes of Man, the Horse and Other Animals in Motion, N.Y.*, March 1883. He offered an added attraction in the prospectus: the subscriber would be able to "send a horse or other subject in motion to my studio for a special photographic analysis of its movements, which will be illustrated without charge." In a broadside issued in April, he offered further enticement to subscribers: they would have free access to the photography sessions.

51. William Pepper Manuscripts. Van Pelt Library, University of Pennsylvania.

52. E. Muybridge, *Animal Locomotion, Prospectus and Catalogue*, p. 3.

53. E. P. Cheyney, *History of the University of Pennsylvania, 1740–1940*, Philadelphia, 1940, Chapter 8, "The Era of Expansion," pp. 285 ff.

54. L. Goodrich, *Thomas Eakins, His Life and Work*, N.Y., 1933, p. 72.

55. *Alta California*, 21 November 1878.

56. L. Goodrich, *Thomas Eakins*, p. 76.

57. Pepper Manuscripts. Van Pelt Library, University of Pennsylvania.

58. W. Pepper, prefatory note, *Animal Locomotion. The Muybridge Work at the University of Pennsylvania. The Method and the Result*, Philadelphia, 1888, p. 5.

59. Philadelphia *Inquirer*, 24 March 1884. Kingston *Scrapbook*, p. 137.

60. Letter of 18 June 1884. Archives, Pennsylvania Academy of the Fine Arts. Cited in G. Hendricks, *Eadweard Muybridge, The Father of the Motion Picture*, N.Y., 1975, p. 159.

61. Archives, Pennsylvania Academy of the Fine Arts. Cited in G. Hendricks, *Eadweard Muybridge*, p. 166.

62. E. Reichert, letter to G. Nitzsche, n.d. (ca. 1929). Archives, University of Pennsylvania.

63. F. X. Dercum, letter to G. Nitzsche, 1929. Archives, University of Pennsylvania.

64. One of the three essays in *Animal Locomotion. The Muybridge Work at the University of Pennsylvania. The Method and the Result*, Philadelphia, 1888.

65. Dercum letter, 1929.

66. F. X. Dercum, "A Study of Some Normal and Abnormal Movements, photographed by Muybridge," *Animal Locomotion. The Muybridge Work*, pp. 103–133; quotation from p. 133.

67. L. F. Rondinella, "More About Muybridge's Work," *The General History and Historical Chronicle*, University of Pennsylvania, July 1929, p. 493.

68. E. Reichert, Letter to G. Nitzsche (ca. 1929). Archives, University of Pennsylvania.

69. T. G. Grier, Letter to G. Nitzsche, 1929. Archives, University of Pennsylvania.

70. E. Muybridge, advertisement for *Animal Locomotion*, October 1887.

71. The book was printed for the university by the J. B. Lippincott Company, Philadelphia. There is a reprint edition, published by Arno, N.Y., 1973. Two of the essays have been named earlier in the text; the third is by Harrison Allen, M.D., emeritus professor of physiology at the university: "Materials for a Memoir on Animal Locomotion."

72. W. Pepper, prefatory note, *Animal Locomotion. The Muybridge Work*, pp. 6–7. "Affections" is used in the sense of "afflictions."

73. L. Goodrich, *Thomas Eakins*, p. 73. G. Hendricks, *Eadweard Muybridge*, p. 173.

74. See A. Scharf, *Art and Photography*, Middlesex, 1974, p. 207, for this particular example and for an extended discussion of the relevance of Muybridge's photographs to art. See also F. Forster-Hahn, "Marey, Muybridge and Meissonier; the Study of Movement in Science and Art," *Eadweard Muybridge: The Stanford Years*, 1973, for a rich discussion of the aesthetic controversy that surrounded Muybridge's revelations.

75. P. Gsell, *On Art and Artists*, London, 1958 (an English translation of the French publication of 1911). Cited in F. Forster-Hahn, "Marey, Muybridge and Meissonier."

76. E. Muybridge, letter to J. Burk, 15 July 1891. Archives, University of Pennsylvania.

77. E. F. Faber, letter to G. Nitzsche, 1929. Archives, University of Pennsylvania.

LOCATION OF PLATES IN THE PRESENT DOVER VOLUME

As in the original edition of *Animal Locomotion,* the numbering of the 781 plates corresponds to that of the *Prospectus and Catalogue of Plates* (reprinted at the end of the third volume of the present edition). However, the plates do not occur in a continuous numerical order within the eleven original volumes (the sequence of which is followed here), so that the following breakdown will be helpful.

VOLUME 1, *Males (Nude),* contains Plates 1, 2, 4–7, 10–12, 27–30, 62–69, 74, 75, 88–91, 109, 111, 113, 114, 125–127, 136, 151, 154, 164–168, 218, 236, 249, 257–260, 273–278.

VOLUME 2, *Males (Nude); continued,* contains Plates 289–294, 300–302, 307–316, 325–328, 343–348, 362–364, 369, 370, 376, 377, 382–385, 387–400, 486, 488–492, 508, 509, 519–522, 529, 530.

VOLUME 3, *Females (Nude),* contains Plates 13–18, 20–25, 32–34, 40, 42, 43, 46, 47, 51, 54, 58, 70, 73, 76–87, 92–94, 96, 98, 99, 101–104, 106, 108, 110, 112, 115–124, 128–133, 137, 138, 144, 145, 147, 149, 150, 155, 171, 176–178, 180, 182–184, 195, 196, 201–204.

VOLUME 4, *Females (Nude); continued,* contains Plates 213, 219–228, 235, 237–239, 244, 245, 247, 251, 252, 254–256, 261–264, 266, 269, 270, 272, 303, 304, 367, 401, 402, 406–416, 418, 419, 425–436, 439–453, 482, 485, 493, 498–501, 514, 525–528, 531.

The Concordance that follows will allow any given plate to be instantly located within the Dover edition.

CONCORDANCE OF PLATE & PAGE NUMBERS IN THE PRESENT EDITION

Plate No.	Orig. Vol.	Dover Pg. No.	Plate No.	Orig. Vol.	Dover Pg. No.	Plate No.	Orig. Vol.	Dover Pg. No.	Plate No.	Orig. Vol.	Dover Pg. No.	Plate No.	Orig. Vol.	Dover Pg. No.
1	1	2	15	3	276	29	1	24	43	3	306	57	7	952
2	1	4	16	3	278	30	1	26	44	7	942	58	3	316
3	5	632	17	3	280	31	5	640	45	7	944	59	5	642
4	1	6	18	3	282	32	3	296	46	3	308	60	5	644
5	1	8	19	8	1136	33	3	298	47	3	310	61	5	646
6	1	10	20	3	284	34	3	300	48	7	946	62	1	28
7	1	12	21	3	286	35	6	778	49	7	948	63	1	30
8	5	634	22	3	288	36	7	938	50	6	786	64	1	32
9	5	636	23	3	290	37	6	780	51	3	312	65	1	34
10	1	14	24	3	292	38	7	940	52	7	950	66	1	36
11	1	16	25	3	294	39	6	782	53	6	788	67	1	38
12	1	18	26	5	638	40	3	302	54	3	314	68	1	40
13	3	272	27	1	20	41	6	784	55	6	790	69	1	42
14	3	274	28	1	22	42	3	304	56	6	792	70	3	318

Plate No.	Orig. Vol.	Dover Pg. No.	Plate No.	Orig. Vol.	Dover Pg. No.	Plate No.	Orig. Vol.	Dover Pg. No.	Plate No.	Orig. Vol.	Dover Pg. No.	Plate No.	Orig. Vol.	Dover Pg. No.
71	6	794	123	3	390	175	6	812	227	4	470	279	1	112
72	6	796	124	3	392	176	3	424	228	4	472	280	1	114
73	3	320	125	1	64	177	3	426	229	6	846	281	1	116
74	1	44	126	1	66	178	3	428	230	7	1002	282	1	118
75	1	46	127	1	68	179	6	814	231	7	1004	283	1	120
76	3	322	128	3	394	180	3	430	232	6	848	284	1	122
77	3	324	129	3	396	181	6	816	233	6	850	285	1	124
78	3	326	130	3	398	182	3	432	234	7	1006	286	1	126
79	3	328	131	3	400	183	3	434	235	4	474	287	1	128
80	3	330	132	3	402	184	3	436	236	1	88	288	1	130
81	3	332	133	3	404	185	6	818	237	4	476	289	2	134
82	3	334	134	7	960	186	8	1082	238	4	478	290	2	136
83	3	336	135	7	962	187	6	820	239	4	480	291	2	138
84	3	338	136	1	70	188	6	822	240	7	1008	292	2	140
85	3	340	137	3	406	189	6	824	241	7	1010	293	2	142
86	3	342	138	3	408	190	6	826	242	6	852	294	2	144
87	3	344	139	7	964	191	6	828	243	7	1012	295	7	1016
88	1	48	140	7	966	192	6	830	244	4	482	296	7	1018
89	1	50	141	7	968	193	6	832	245	4	484	297	7	1020
90	1	52	142	7	970	194	6	834	246	6	854	298	7	1022
91	1	54	143	6	802	195	3	438	247	4	486	299	7	1024
92	3	346	144	3	410	196	3	440	248	6	856	300	2	146
93	3	348	145	3	412	197	7	980	249	1	90	301	2	148
94	3	350	146	6	804	198	7	982	250	7	1014	302	2	150
95	7	954	147	3	414	199	7	984	251	4	488	303	4	514
96	3	352	148	7	972	200	7	986	252	4	490	304	4	516
97	6	798	149	3	416	201	3	442	253	6	858	305	6	866
98	3	354	150	3	418	202	3	444	254	4	492	306	6	868
99	3	356	151	1	72	203	3	446	255	4	494	307	2	152
100	7	956	152	5	648	204	3	448	256	4	496	308	2	154
101	3	358	153	5	650	205	6	836	257	1	92	309	2	156
102	3	360	154	1	74	206	6	838	258	1	94	310	2	158
103	3	362	155	3	420	207	7	988	259	1	96	311	2	160
104	3	364	156	7	974	208	7	990	260	1	98	312	2	162
105	6	800	157	5	652	209	7	992	261	4	498	313	2	164
106	3	366	158	5	654	210	7	994	262	4	500	314	2	166
107	7	958	159	5	656	211	7	996	263	4	502	315	2	168
108	3	368	160	5	658	212	7	998	264	4	504	316	2	170
109	1	56	161	5	660	213	4	452	265	6	860	317	5	666
110	3	370	162	5	662	214	6	840	266	4	506	318	5	668
111	1	58	163	5	664	215	6	842	267	6	862	319	5	670
112	3	372	164	1	76	216	6	844	268	8	1138	320	5	672
113	1	60	165	1	78	217	7	1000	269	4	508	321	5	674
114	1	62	166	1	80	218	1	86	270	4	510	322	5	676
115	3	374	167	1	82	219	4	454	271	6	864	323	5	678
116	3	376	168	1	84	220	4	456	272	4	512	324	5	680
117	3	378	169	7	976	221	4	458	273	1	100	325	2	172
118	3	380	170	6	806	222	4	460	274	1	102	326	2	174
119	3	382	171	3	422	223	4	462	275	1	104	327	2	176
120	3	384	172	6	808	224	4	464	276	1	106	328	2	178
121	3	386	173	7	978	225	4	466	277	1	108	329	5	682
122	3	388	174	6	810	226	4	468	278	1	110	330	5	684

Plate No.	Orig. Vol.	Dover Pg. No.	Plate No.	Orig. Vol.	Dover Pg. No.	Plate No.	Orig. Vol.	Dover Pg. No.	Plate No.	Orig. Vol.	Dover Pg. No.	Plate No.	Orig. Vol.	Dover Pg. No.
331	5	686	383	2	208	435	4	570	487	7	1060	539	8	1088
332	5	688	384	2	210	436	4	572	488	2	244	540	8	1090
333	5	690	385	2	212	437	7	1036	489	2	246	541	8	1092
334	5	692	386	7	1026	438	7	1038	490	2	248	542	8	1094
335	5	694	387	2	214	439	4	574	491	2	250	543	8	1096
336	5	696	388	2	216	440	4	576	492	2	252	544	8	1098
337	5	698	389	2	218	441	4	578	493	4	608	545	8	1100
338	5	700	390	2	220	442	4	580	494	6	918	546	8	1102
339	5	702	391	2	222	443	4	582	495	6	920	547	8	1104
340	5	704	392	2	224	444	4	584	496	6	922	548	8	1106
341	5	706	393	2	226	445	4	586	497	6	924	549	8	1108
342	5	708	394	2	228	446	4	588	498	4	610	550	8	1110
343	2	180	395	2	230	447	4	590	499	4	612	551	8	1112
344	2	182	396	2	232	448	4	592	500	4	614	552	8	1114
345	2	184	397	2	234	449	4	594	501	4	616	553	8	1116
346	2	186	398	2	236	450	4	596	502	6	926	554	8	1118
347	2	188	399	2	238	451	4	598	503	6	928	555	8	1120
348	2	190	400	2	240	452	4	600	504	7	1062	556	8	1122
349	5	710	401	4	520	453	4	602	505	5	762	557	8	1124
350	5	712	402	4	522	454	7	1040	506	5	764	558	8	1126
351	5	714	403	7	1028	455	7	1042	507	5	766	559	8	1128
352	5	716	404	7	1030	456	7	1044	508	2	254	560	8	1130
353	5	718	405	5	760	457	7	1046	509	2	256	561	8	1132
354	5	720	406	4	524	458	7	1048	510	5	768	562	8	1134
355	5	722	407	4	526	459	6	878	511	5	770	563	9	1142
356	5	724	408	4	528	460	7	1050	512	5	772	564	9	1144
357	5	726	409	4	530	461	6	880	513	6	930	565	9	1146
358	5	728	410	4	532	462	6	882	514	4	618	566	9	1148
359	5	730	411	4	534	463	6	884	515	6	932	567	9	1150
360	5	732	412	4	536	464	7	1052	516	7	1064	568	9	1152
361	5	734	413	4	538	465	6	886	517	7	1066	569	9	1154
362	2	192	414	4	540	466	6	888	518	7	1068	570	9	1156
363	2	194	415	4	542	467	6	890	519	2	258	571	9	1158
364	2	196	416	4	544	468	6	892	520	2	260	572	9	1160
365	5	736	417	6	870	469	6	894	521	2	262	573	9	1162
366	5	738	418	4	546	470	7	1054	522	2	264	574	9	1164
367	4	518	419	4	548	471	6	896	523	5	774	575	9	1166
368	5	740	420	6	872	472	6	898	524	6	934	576	9	1168
369	2	198	421	6	874	473	6	900	525	4	620	577	9	1170
370	2	200	422	7	1032	474	6	902	526	4	622	578	9	1172
371	5	742	423	6	876	475	6	904	527	4	624	579	9	1174
372	5	744	424	7	1034	476	6	906	528	4	626	580	9	1176
373	5	746	425	4	550	477	6	908	529	2	266	581	9	1178
374	5	748	426	4	552	478	6	910	530	2	268	582	9	1180
375	5	750	427	4	554	479	6	912	531	4	628	583	9	1182
376	2	202	428	4	556	480	6	914	532	7	1070	584	9	1184
377	2	204	429	4	558	481	6	916	533	7	1072	585	9	1186
378	5	752	430	4	560	482	4	604	534	7	1074	586	9	1188
379	5	754	431	4	562	483	7	1056	535	7	1076	587	9	1190
380	5	756	432	4	564	484	7	1058	536	7	1078	588	9	1192
381	5	758	433	4	566	485	4	606	537	8	1084	589	9	1194
382	2	206	434	4	568	486	2	242	538	8	1086	590	9	1196

Plate No.	Orig. Vol.	Dover Pg. No.	Plate No.	Orig. Vol.	Dover Pg. No.	Plate No.	Orig. Vol.	Dover Pg. No.	Plate No.	Orig. Vol.	Dover Pg. No.	Plate No.	Orig. Vol.	Dover Pg. No.
591	9	1198	630	9	1276	668	10	1354	706	10	1384	744	11	1508
592	9	1200	631	9	1278	669	10	1356	707	10	1386	745	11	1510
593	9	1202	632	9	1280	670	10	1358	708	10	1388	746	11	1512
594	9	1204	633	9	1282	671	10	1360	709	10	1390	747	11	1514
595	9	1206	634	9	1284	672	10	1362	710	10	1392	748	11	1516
596	9	1208	635	9	1286	673	10	1364	711	10	1394	749	11	1518
597	9	1210	636	9	1288	674	10	1366	712	10	1396	750	11	1520
598	9	1212	637	9	1290	675	10	1368	713	10	1398	751	11	1522
599	9	1214	638	9	1292	676	10	1370	714	10	1400	752	11	1524
600	9	1216	639	9	1294	677	10	1372	715	10	1402	753	11	1526
601	9	1218	640	9	1296	678	10	1374	716	10	1404	754	11	1528
602	9	1220	641	9	1298	679	10	1376	717	10	1406	755	11	1530
603	9	1222	642	9	1300	680	11	1416	718	10	1408	756	11	1532
604	9	1224	643	9	1302	681	11	1418	719	10	1410	757	11	1534
605	9	1226	644	9	1304	682	11	1420	720	10	1412	758	11	1536
606	9	1228	645	9	1306	683	11	1422	721	11	1462	759	11	1538
607	9	1230	646	9	1308	684	11	1424	722	11	1464	760	11	1540
608	9	1232	647	9	1310	685	11	1426	723	11	1466	761	11	1542
609	9	1234	648	9	1312	686	11	1428	724	11	1468	762	11	1544
610	9	1236	649	9	1314	687	11	1430	725	11	1470	763	11	1546
611	9	1238	650	9	1316	688	11	1432	726	11	1472	764	11	1548
612	9	1240	651	9	1318	689	11	1434	727	11	1474	765	11	1550
613	9	1242	652	9	1320	690	11	1436	728	11	1476	766	11	1552
614	9	1244	653	9	1322	691	11	1438	729	11	1478	767	11	1554
615	9	1246	654	9	1324	692	11	1440	730	11	1480	768	11	1556
616	9	1248	655	9	1326	693	11	1442	731	11	1482	769	11	1558
617	9	1250	656	9	1328	694	11	1444	732	11	1484	770	11	1560
618	9	1252	657	9	1330	695	11	1446	733	11	1486	771	11	1562
619	9	1254	658	10	1334	696	11	1448	734	11	1488	772	11	1564
620	9	1256	659	10	1336	697	11	1450	735	11	1490	773	11	1566
621	9	1258	660	10	1338	698	11	1452	736	11	1492	774	11	1568
622	9	1260	661	10	1340	699	11	1454	737	11	1494	775	11	1570
623	9	1262	662	10	1342	700	11	1456	738	11	1496	776	11	1572
624	9	1264	663	10	1344	701	11	1458	739	11	1498	777	11	1574
625	9	1266	664	10	1346	702	11	1460	740	11	1500	778	11	1576
626	9	1268	665	10	1348	703	10	1378	741	11	1502	779	11	1578
627	9	1270	666	10	1350	704	10	1380	742	11	1504	780	11	1580
628	9	1272	667	10	1352	705	10	1382	743	11	1506	781	11	1582
629	9	1274												

Volume 1

MALES
(Nude)

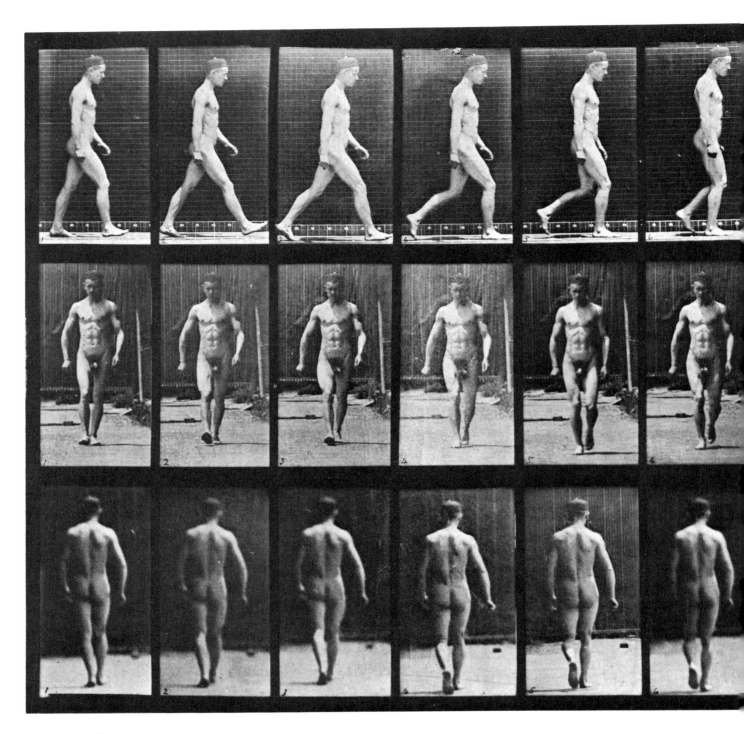

Plate 1. Walking.

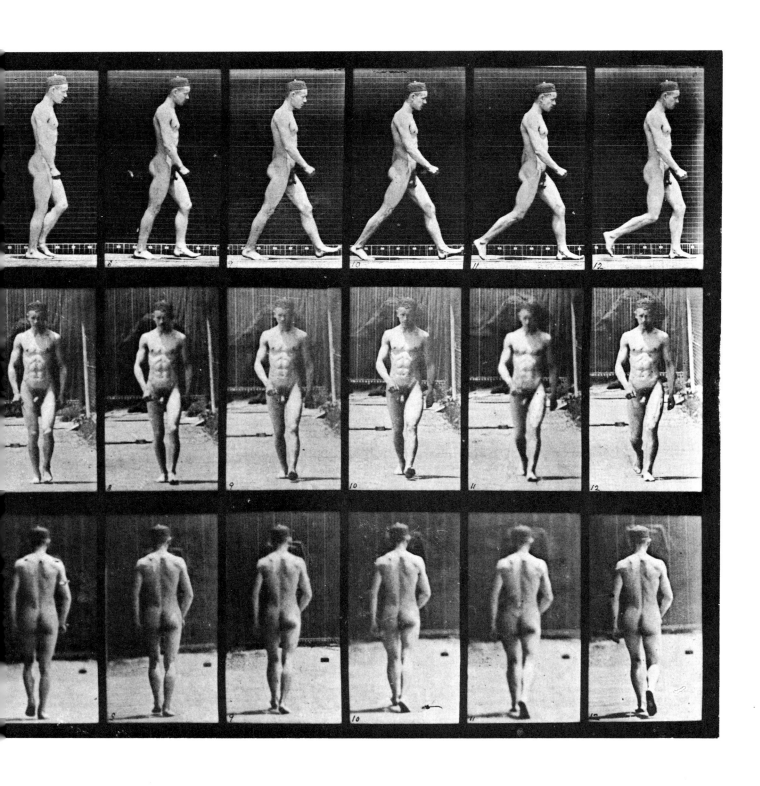

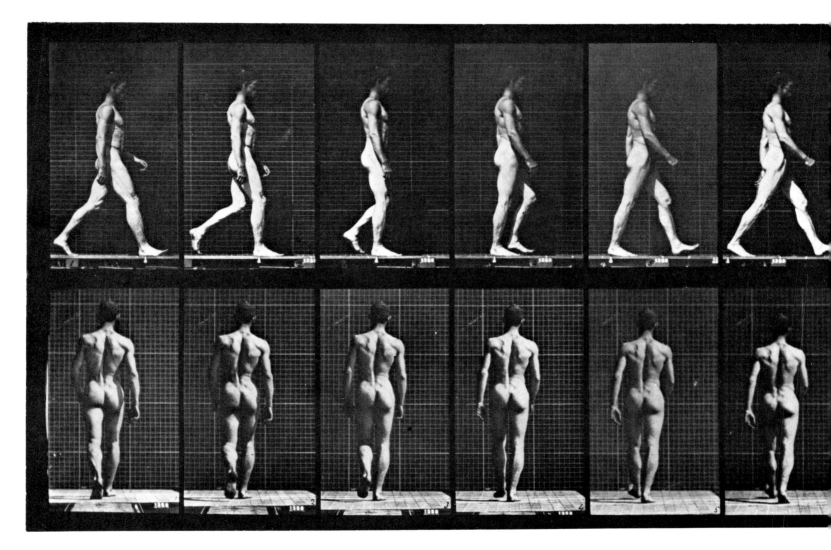

Plate 2. Walking.

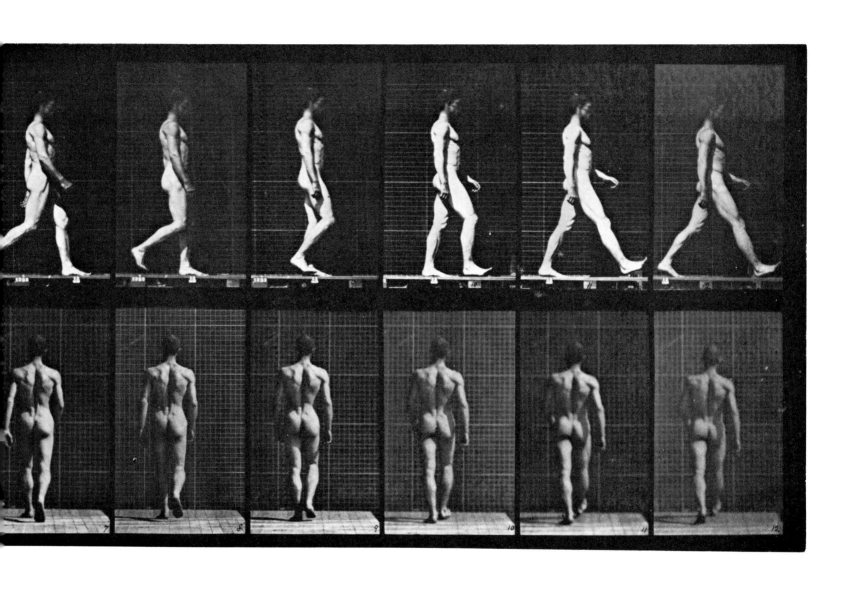

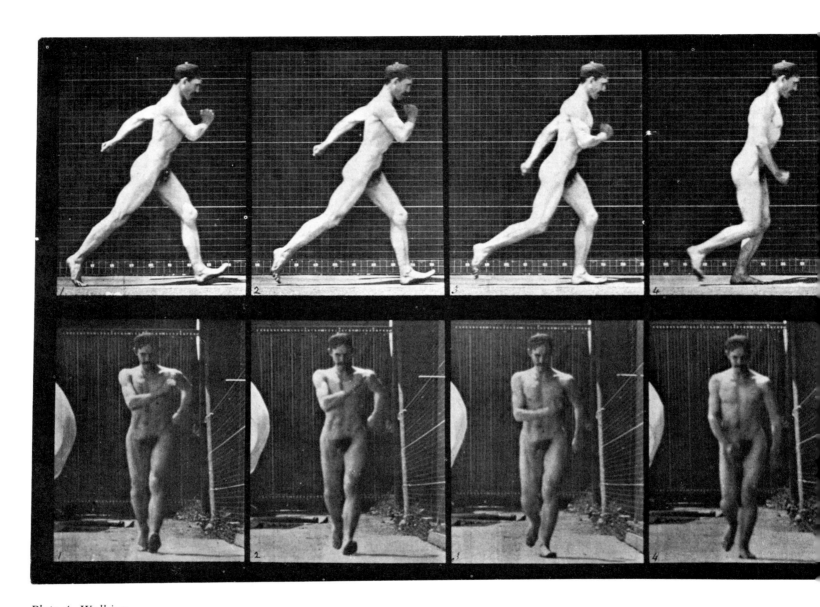

Plate 4. Walking.

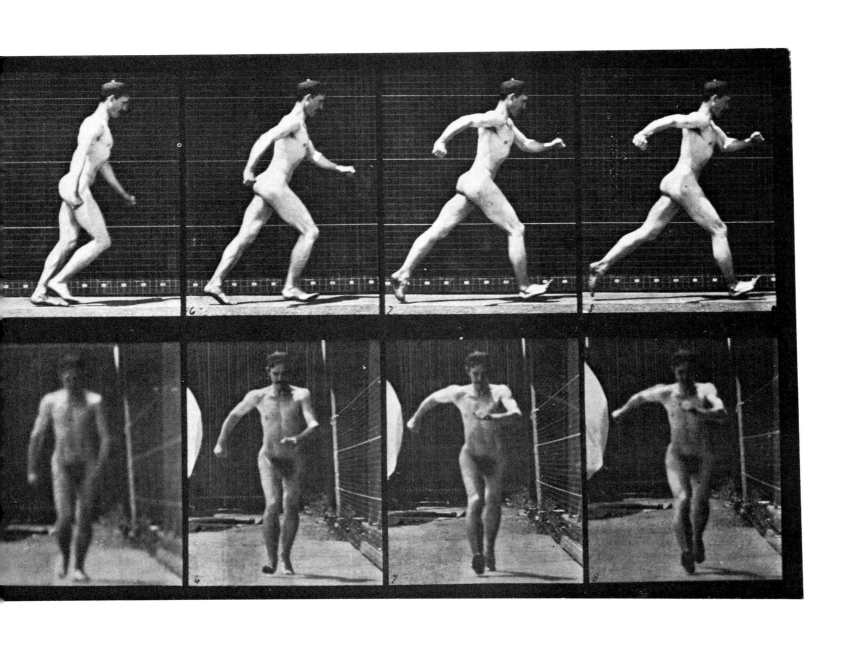

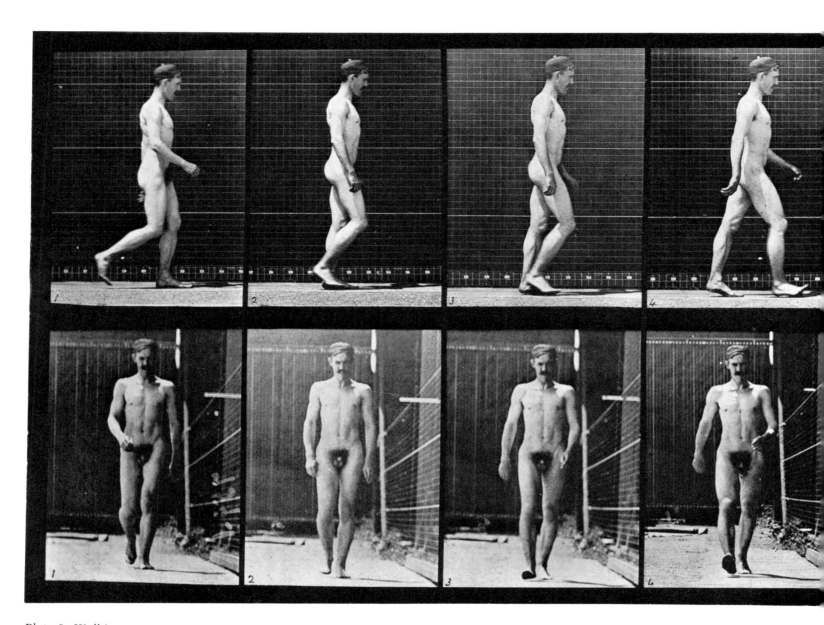

Plate 5. Walking.

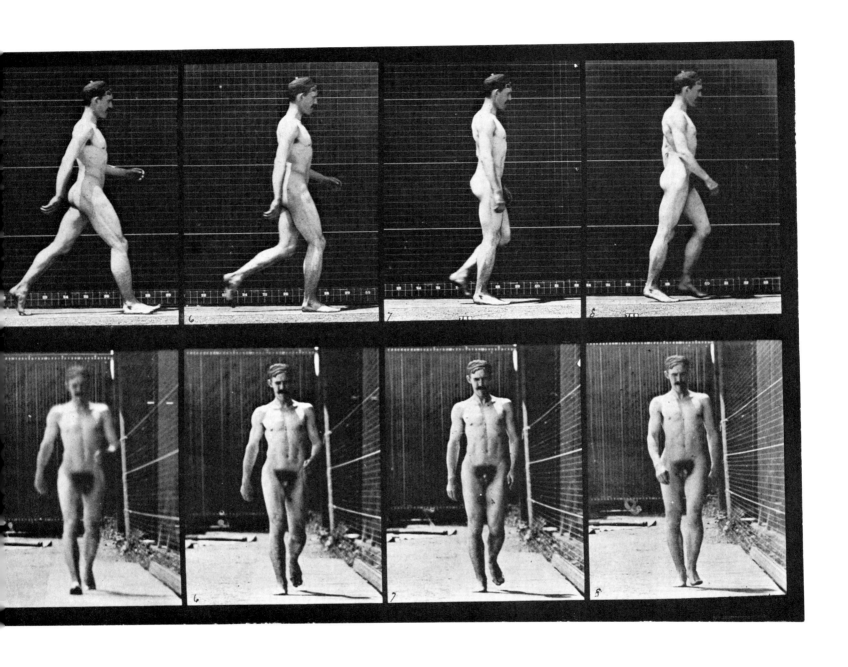

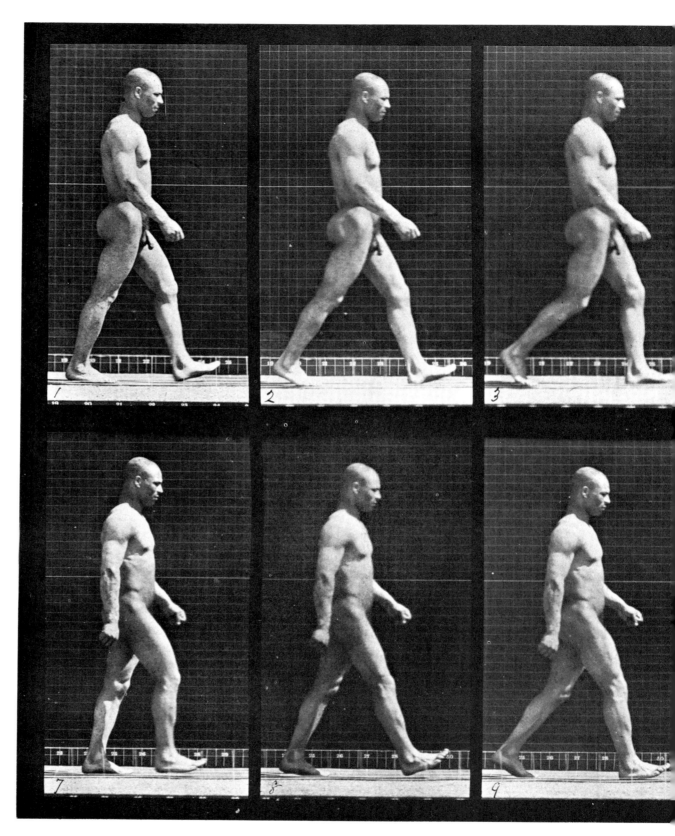

Plate 6. Walking.

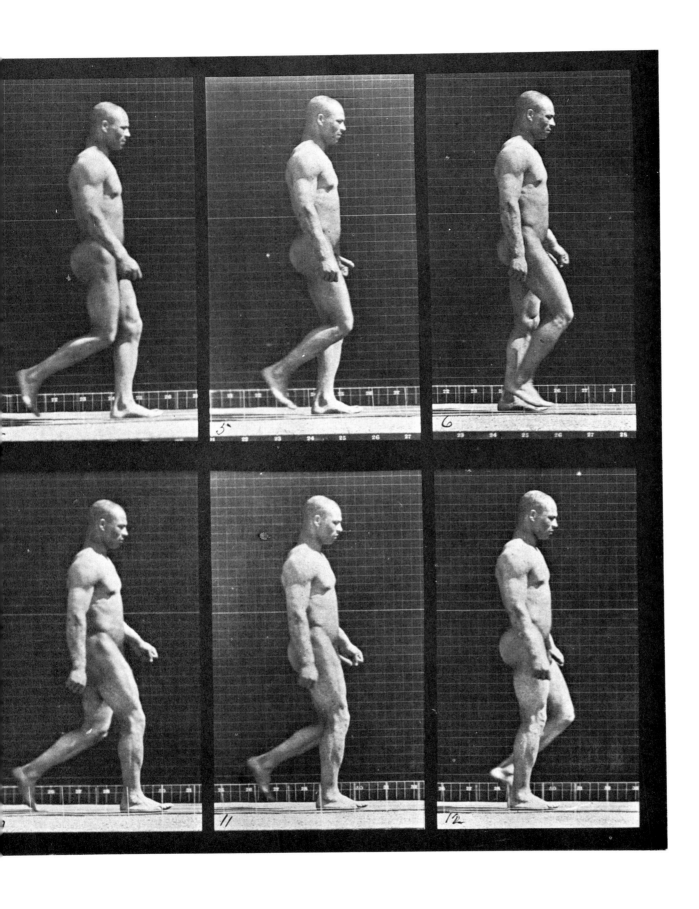

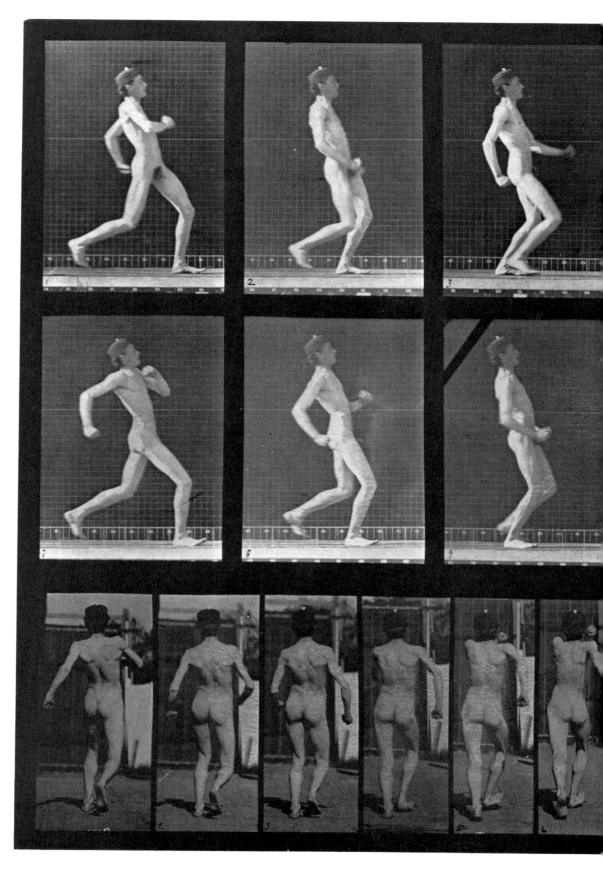

Plate 7. Walking.

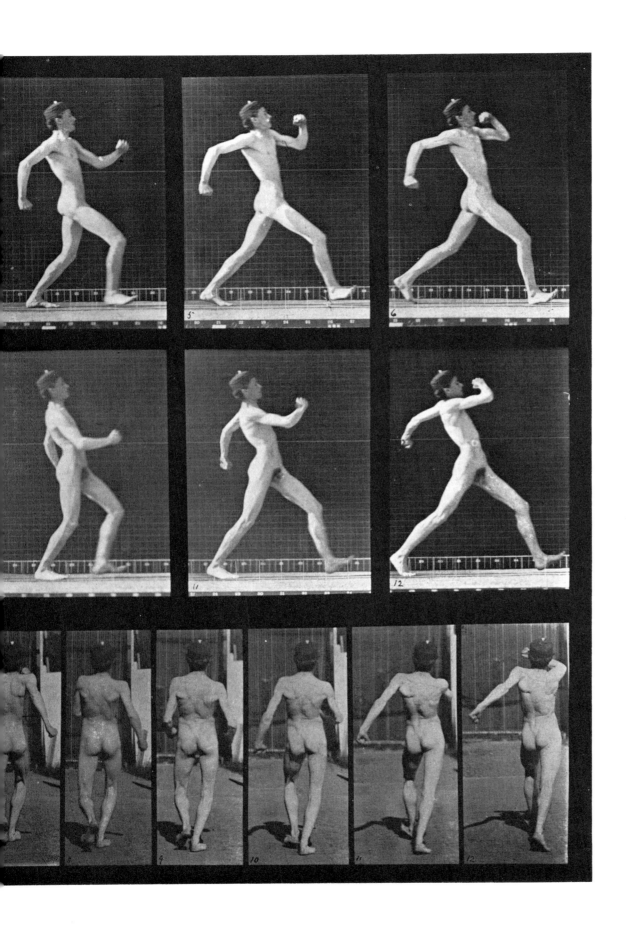

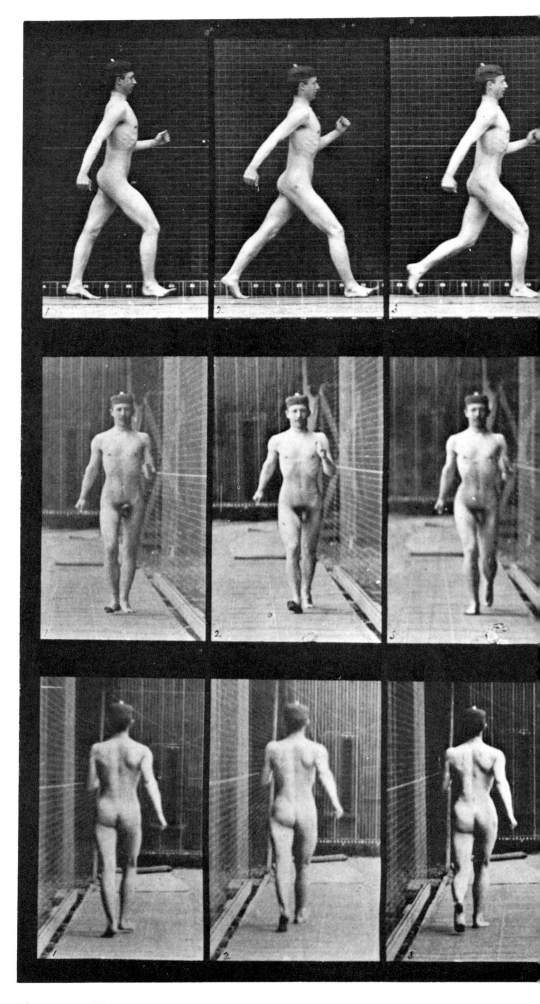

Plate 10. Walking.

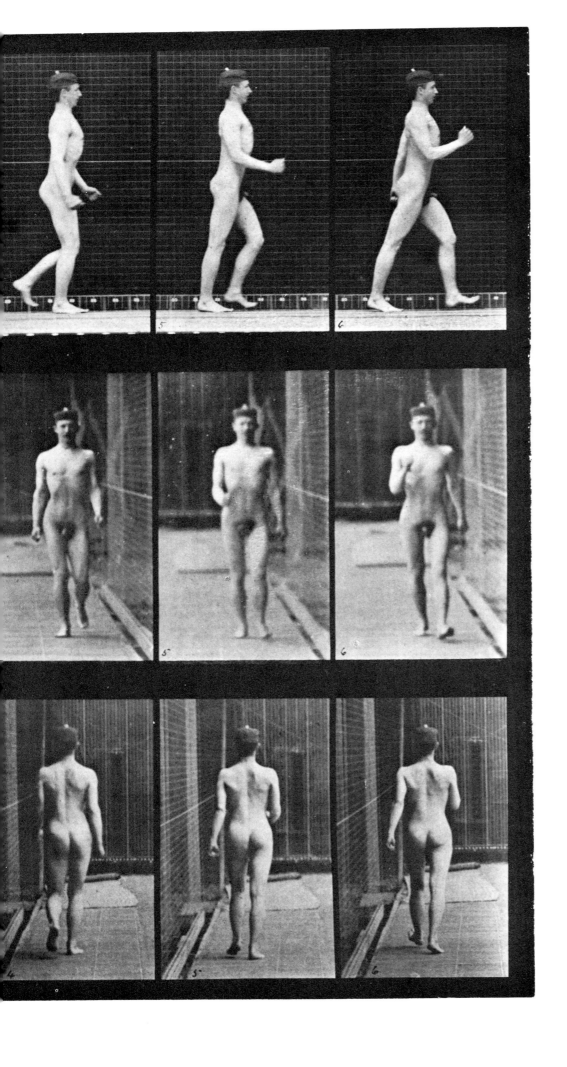

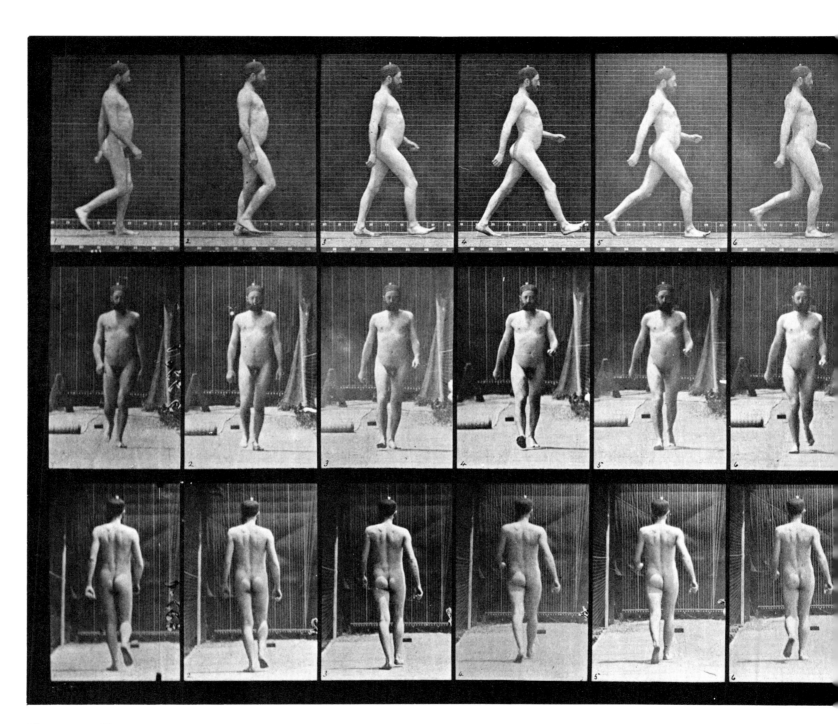

Plate 11. Walking.

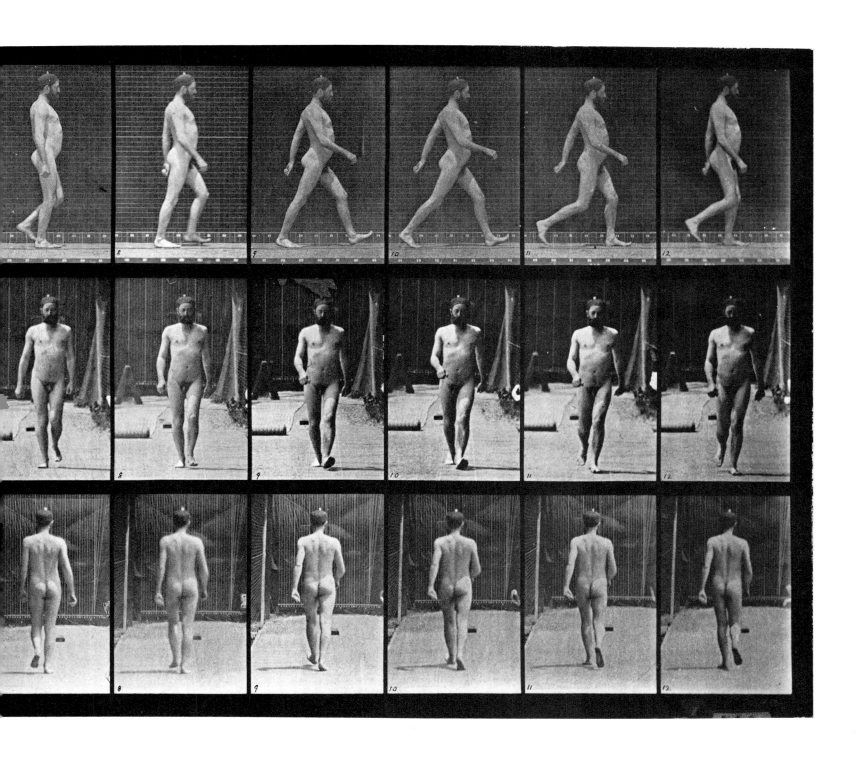

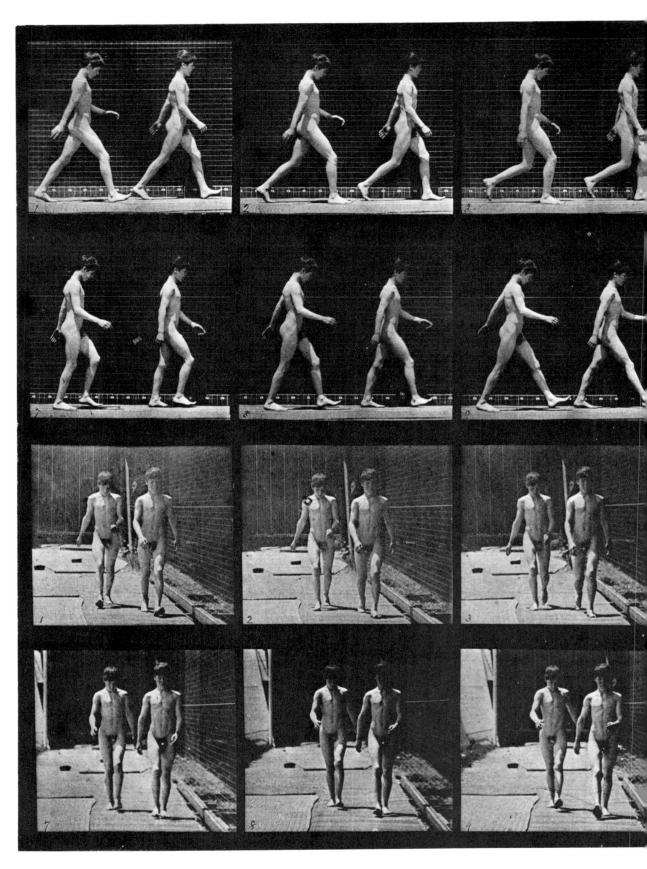

Plate 12. Walking.

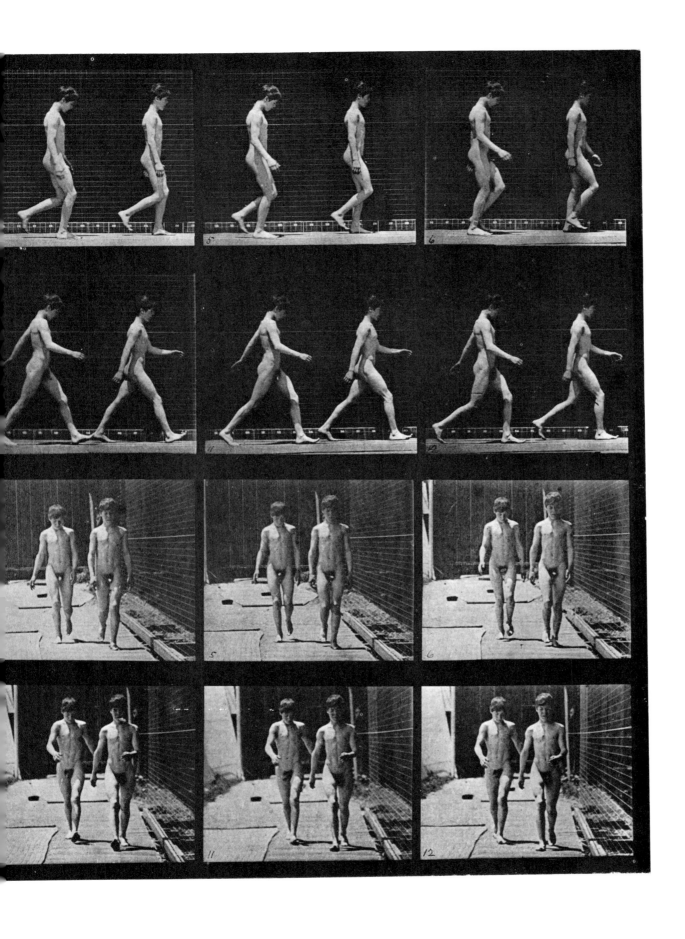

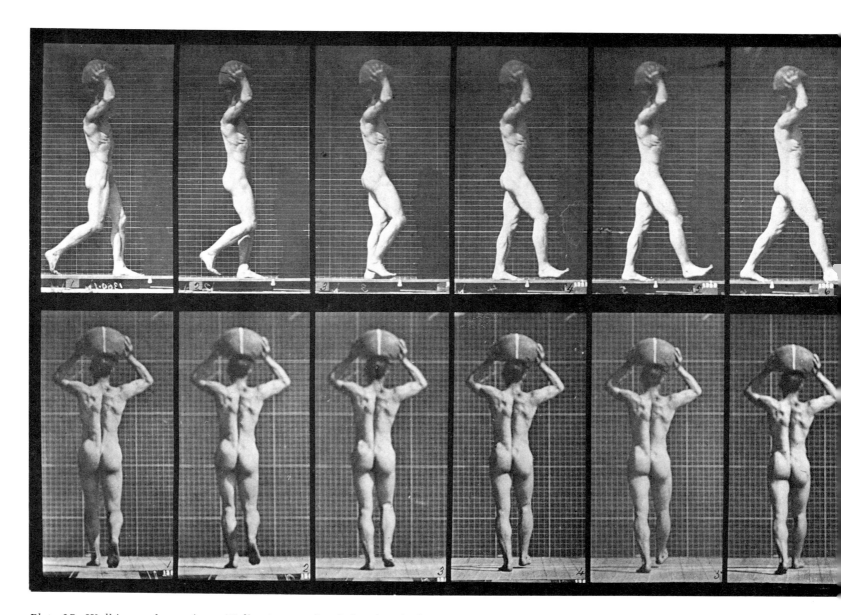

Plate 27. Walking and carrying a 75-lb. stone on head, hands raised.

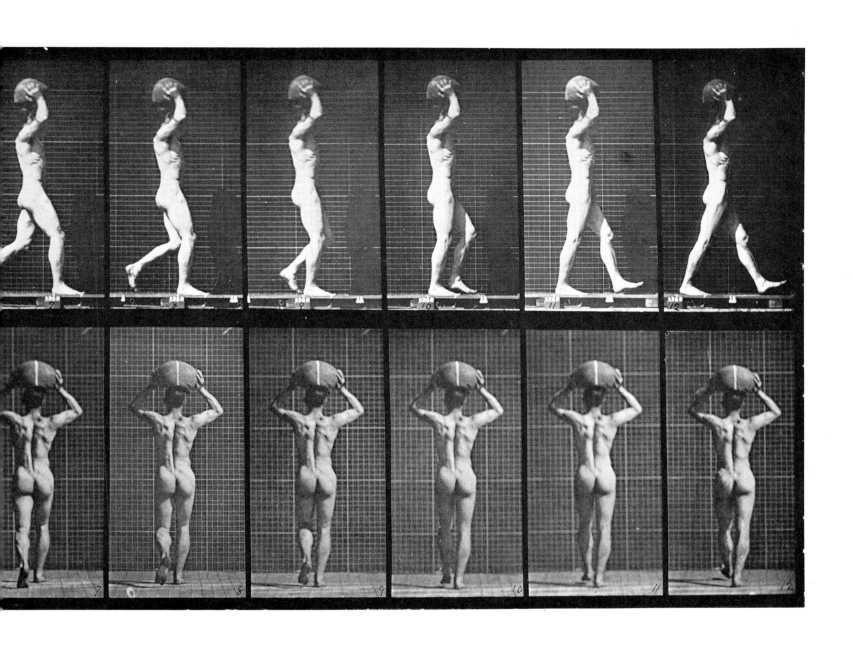

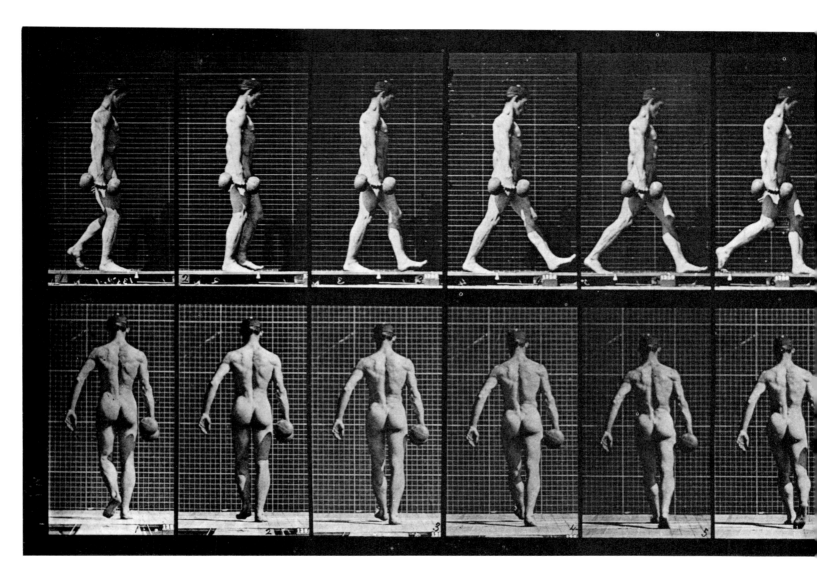

Plate 28. Walking and carrying a 50-lb. dumbbell in right hand.

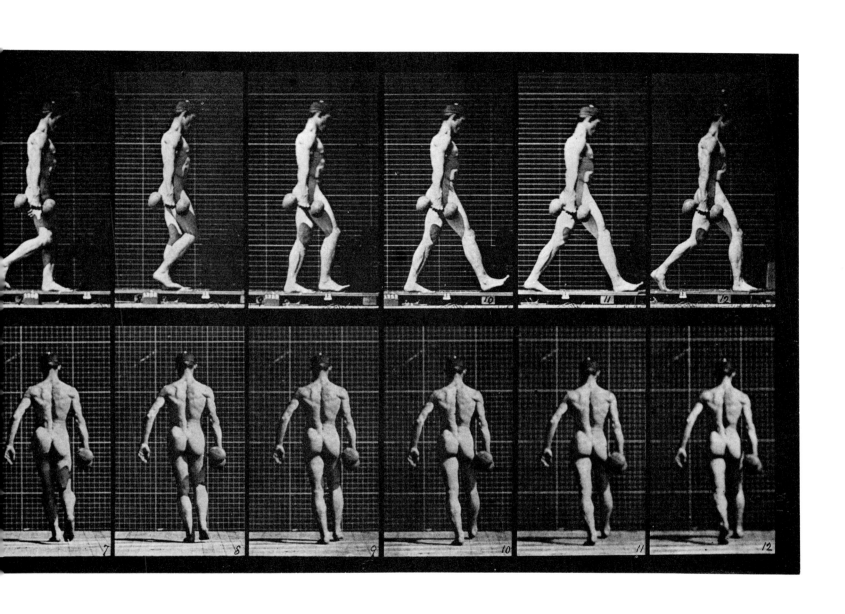

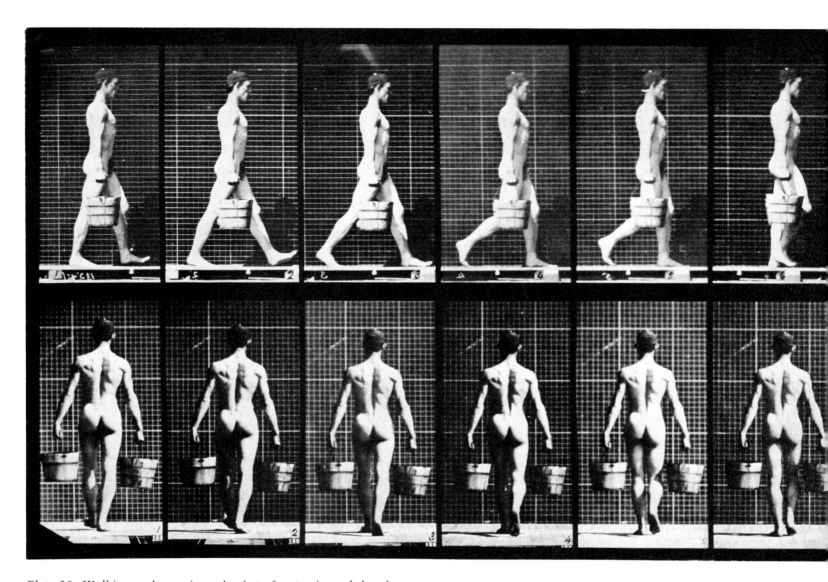

Plate 29. Walking and carrying a bucket of water in each hand.

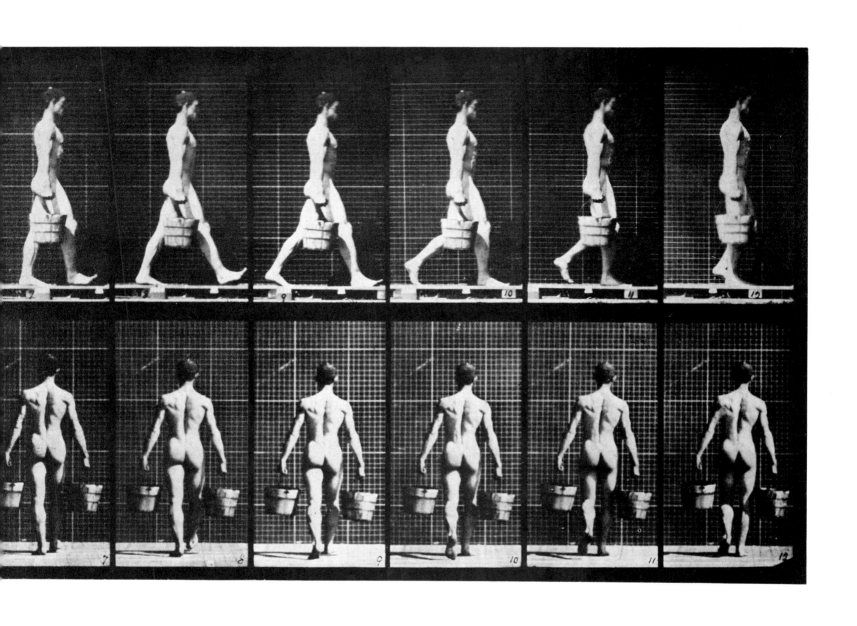

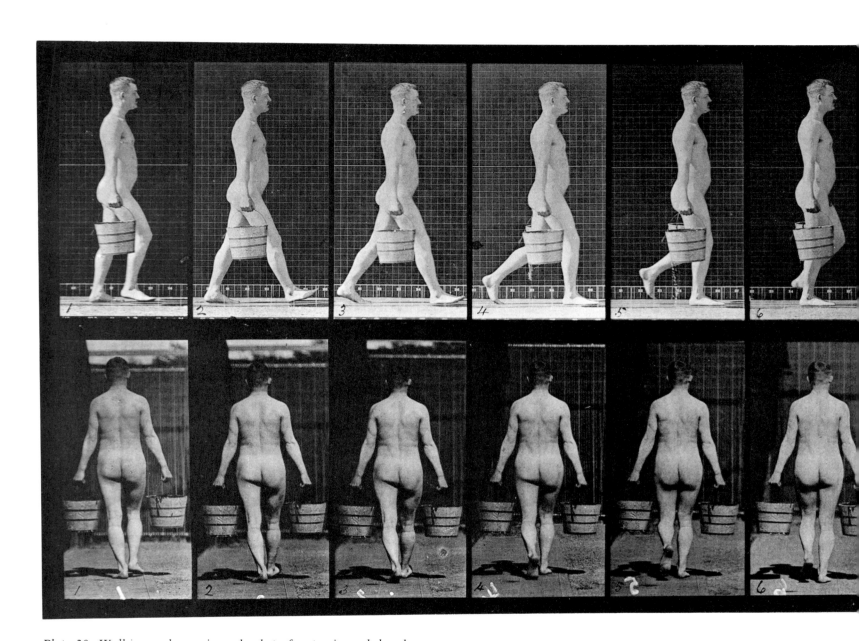

Plate 30. Walking and carrying a bucket of water in each hand.

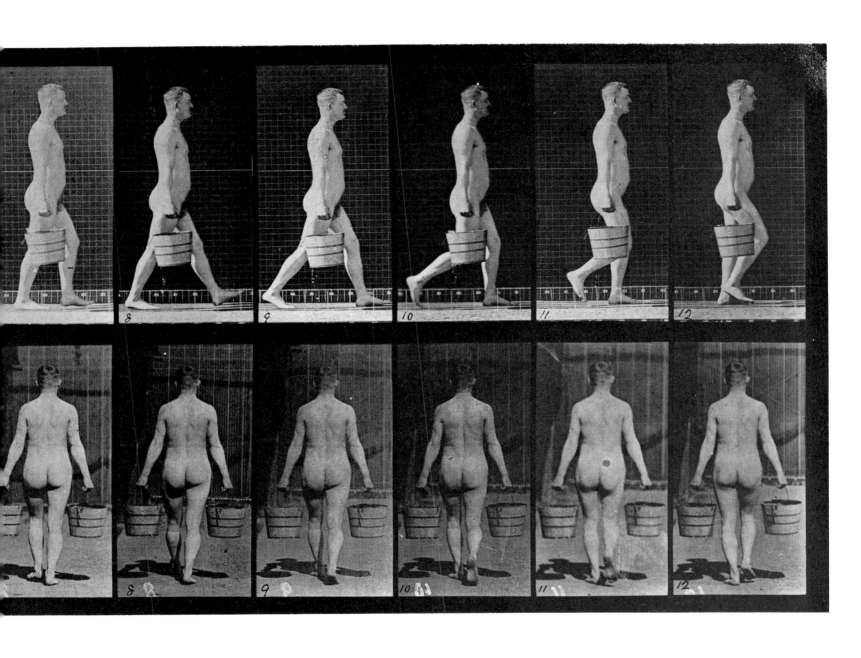

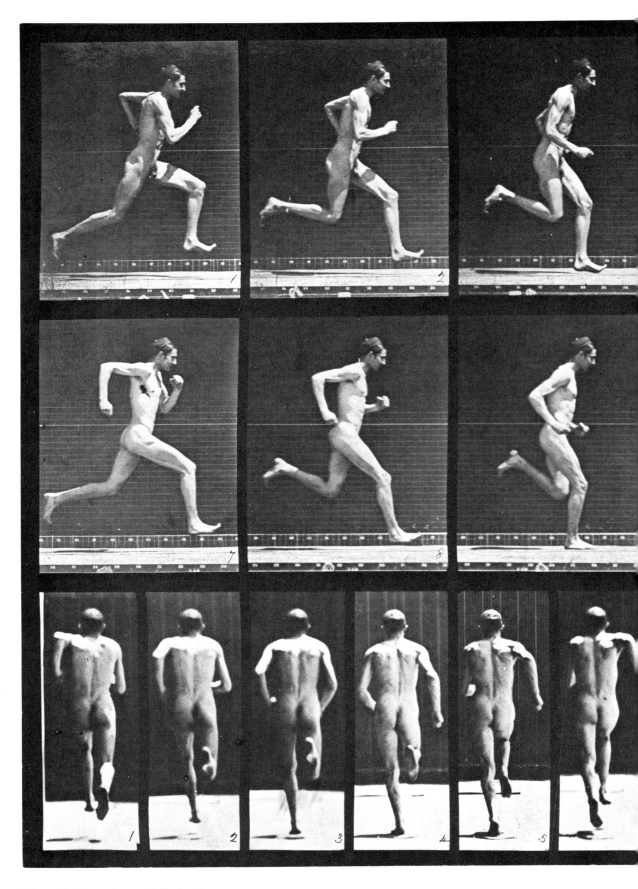

Plate 62. Running at full speed.

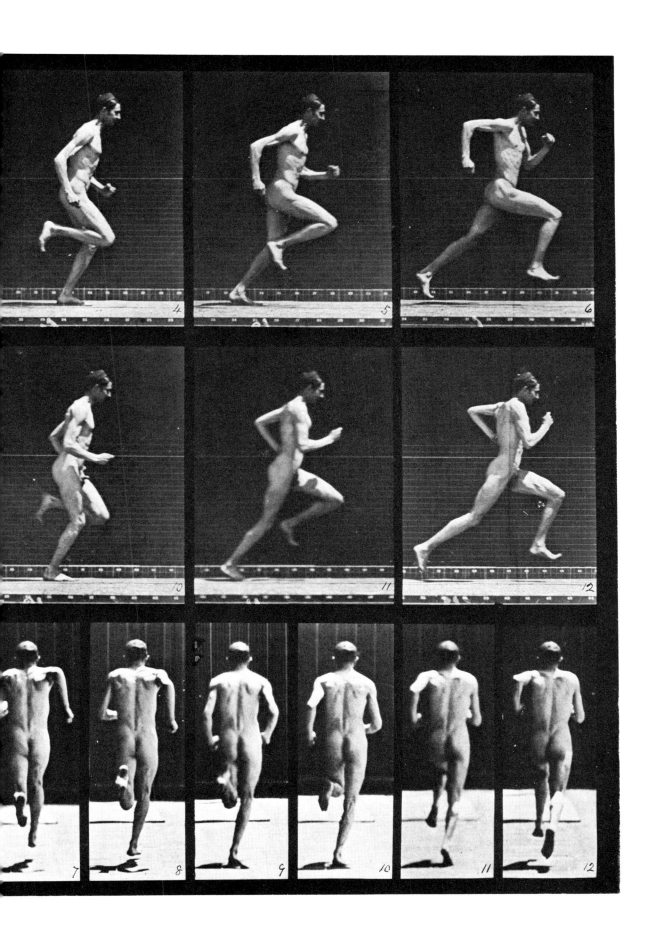

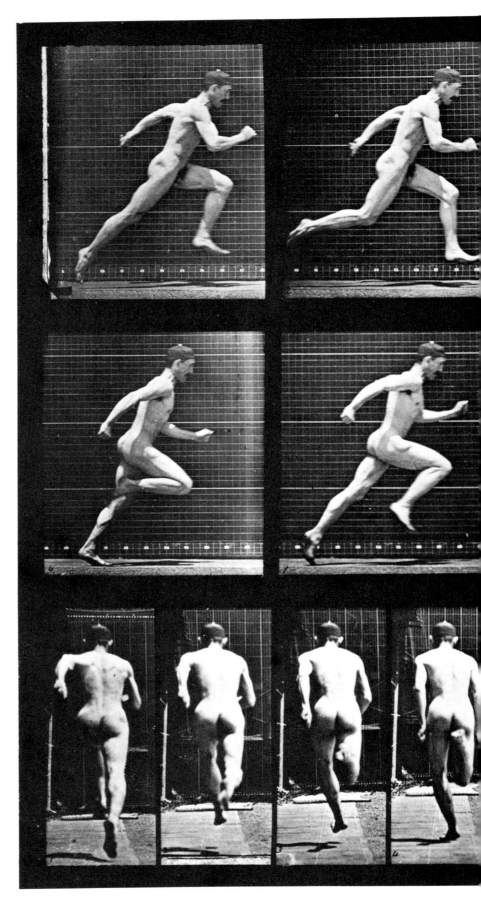

Plate 63. Running at full speed.

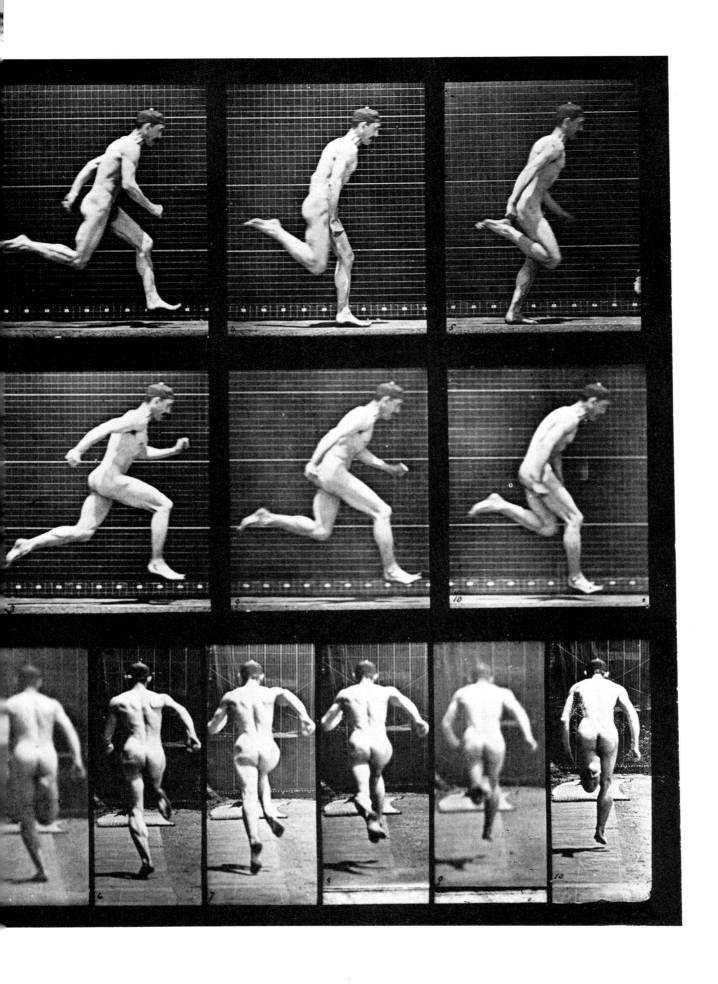

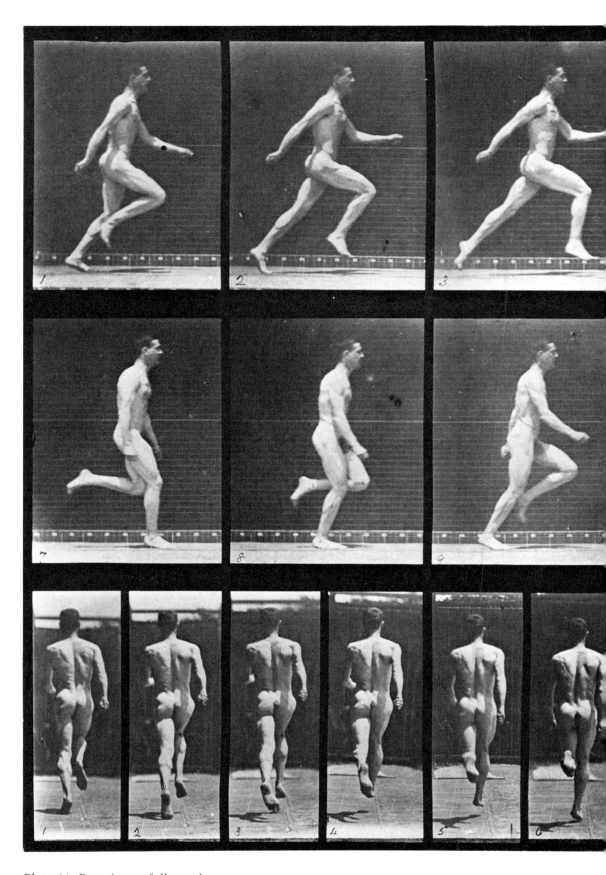

Plate 64. Running at full speed.

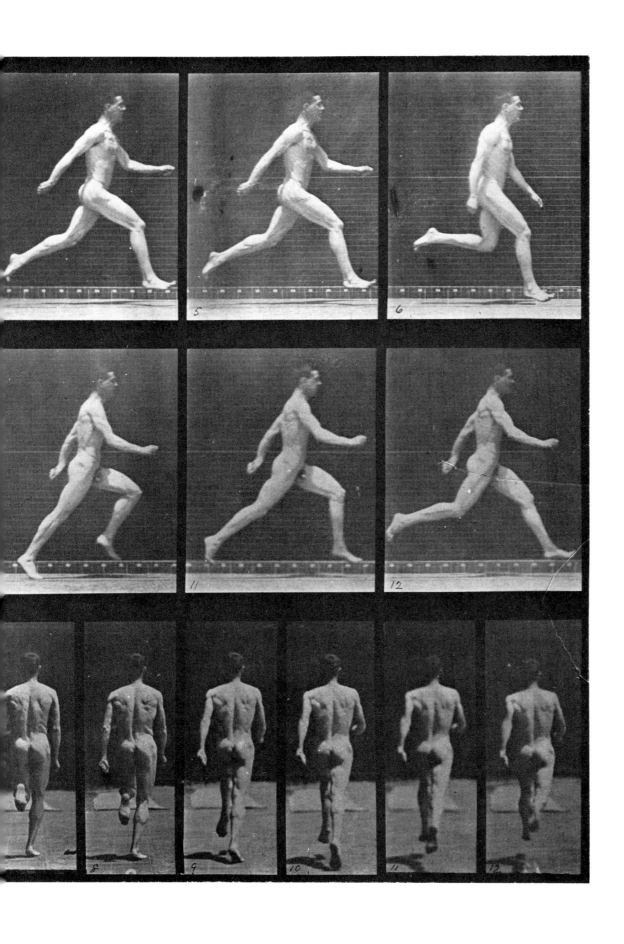

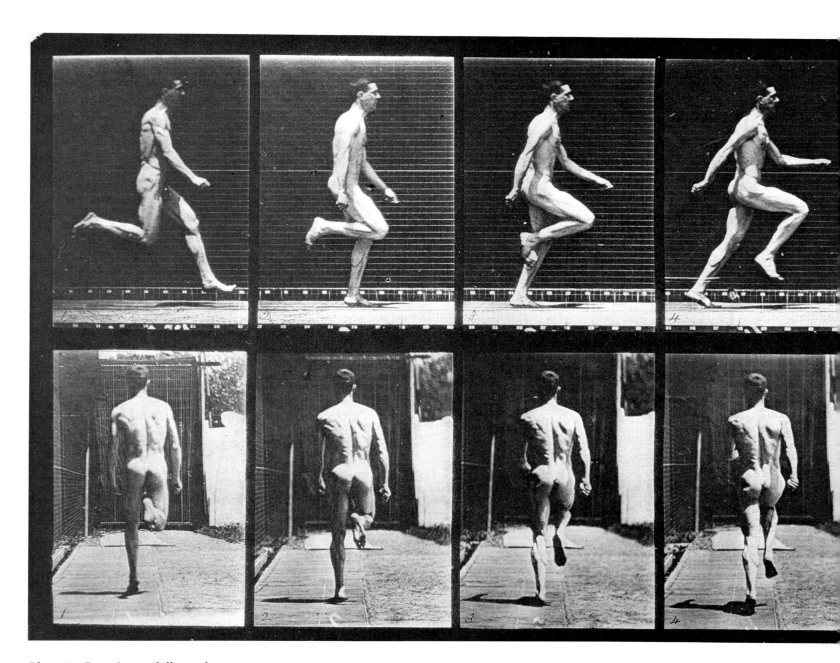

Plate 65. Running at full speed.

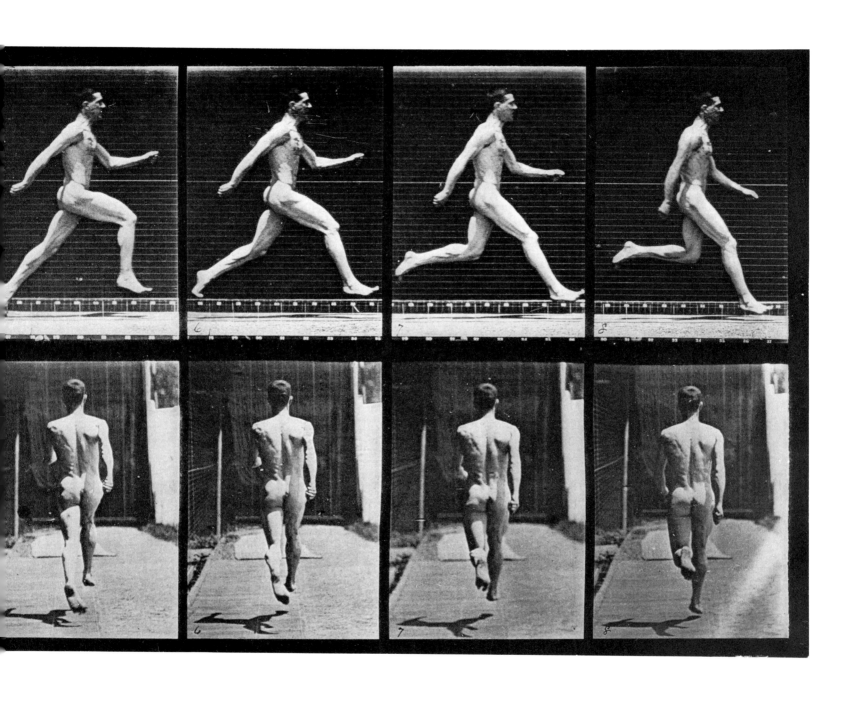

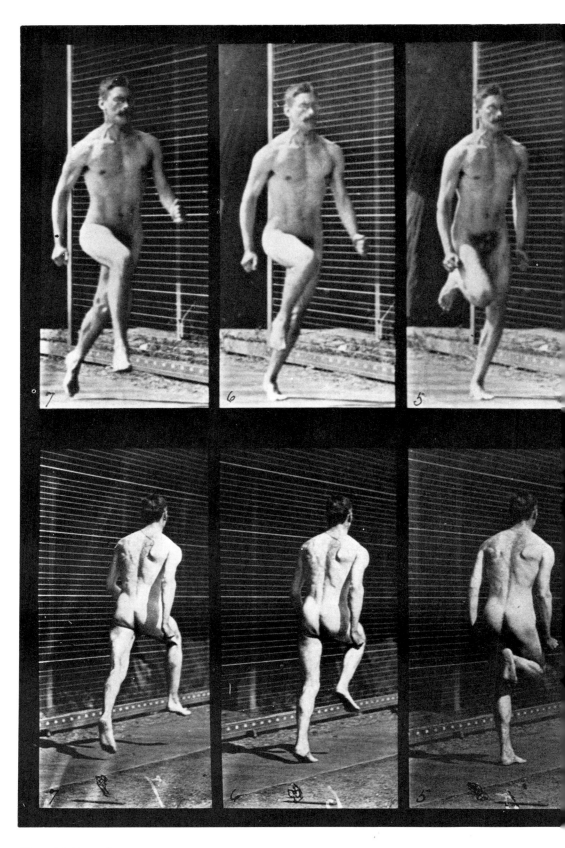

Plate 66. Running.

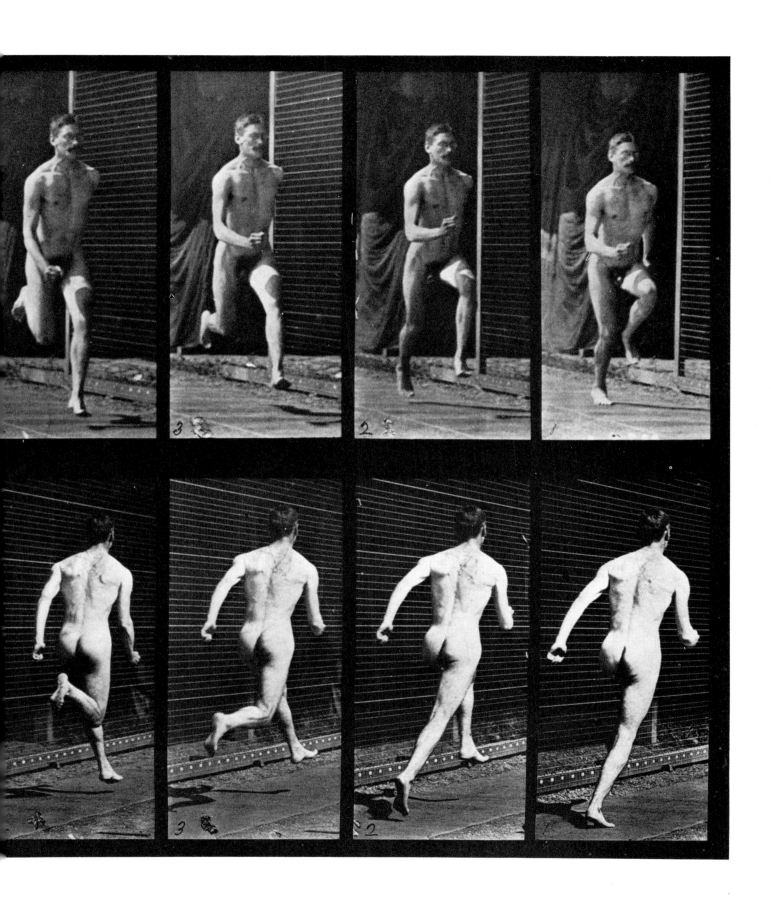

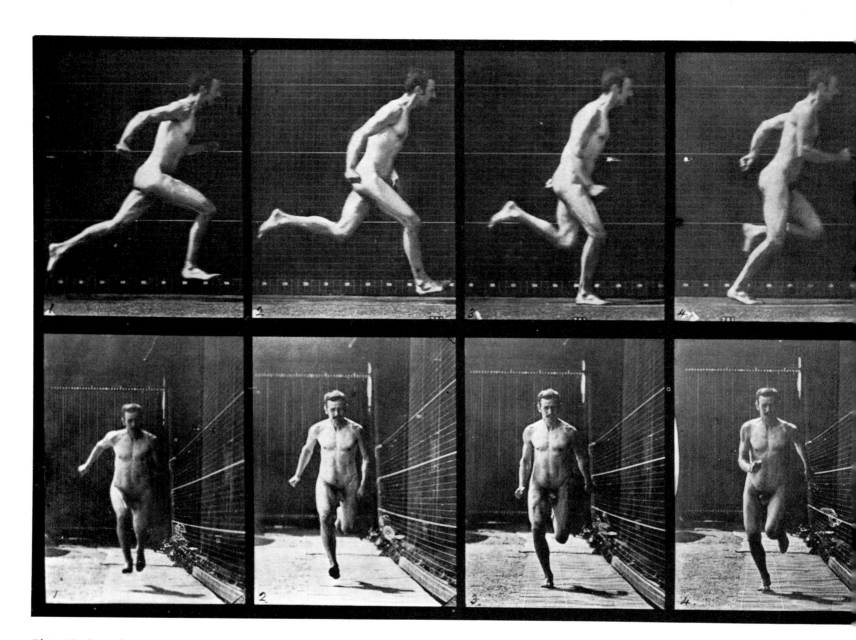

Plate 67. Running.

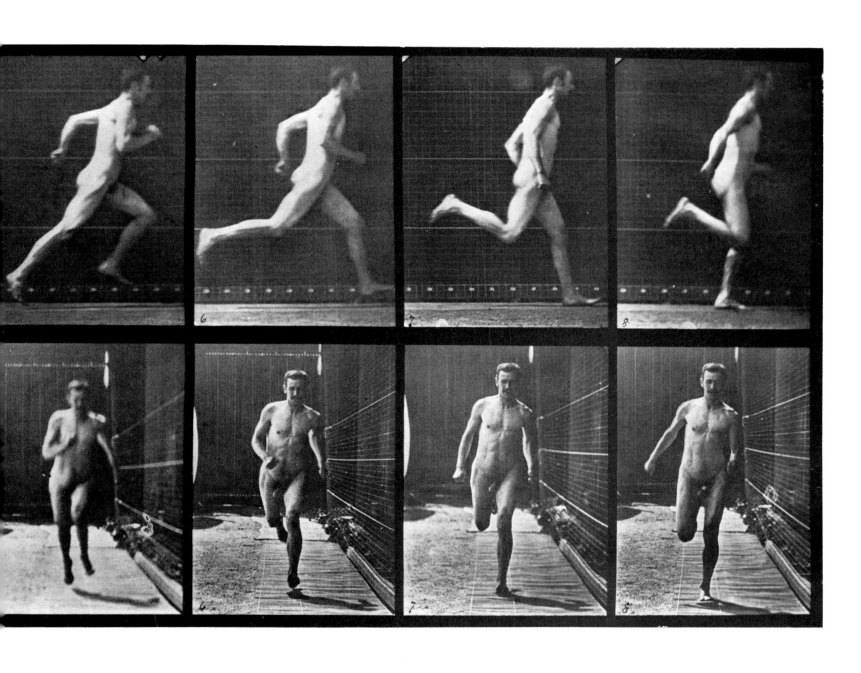

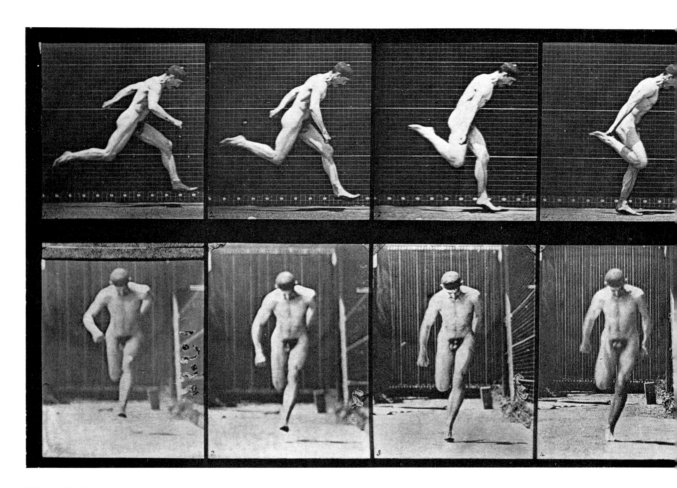

Plate 68. Running.

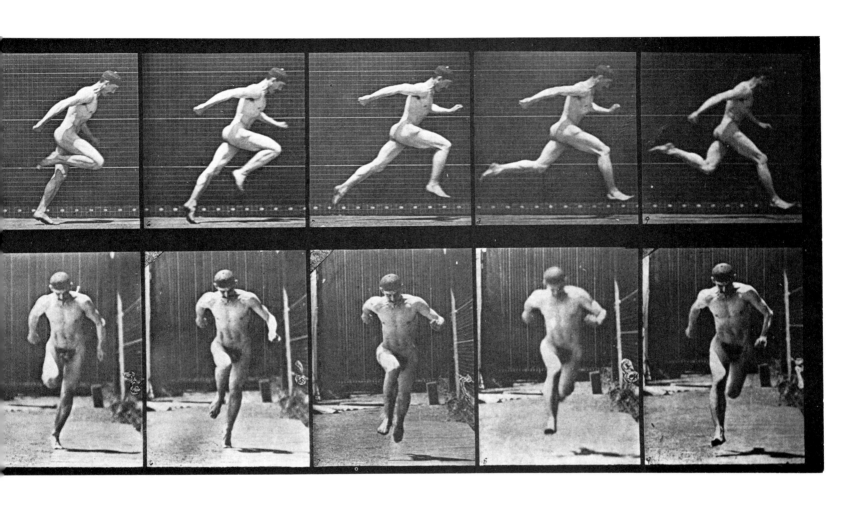

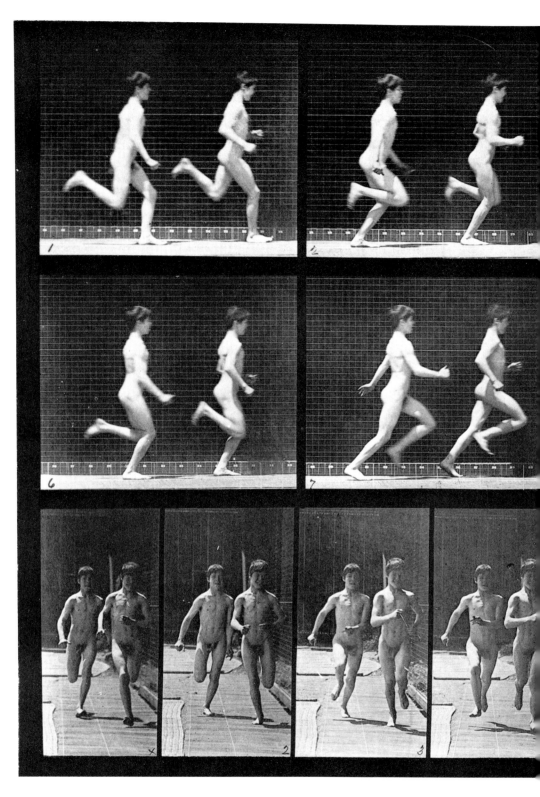

Plate 69. Two men running.

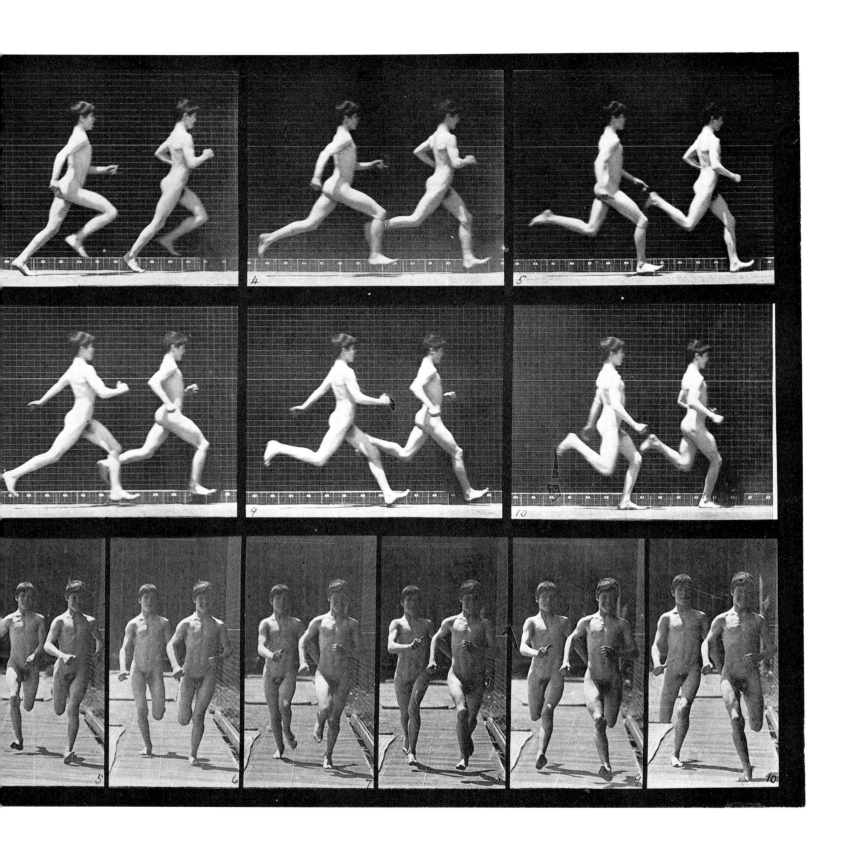

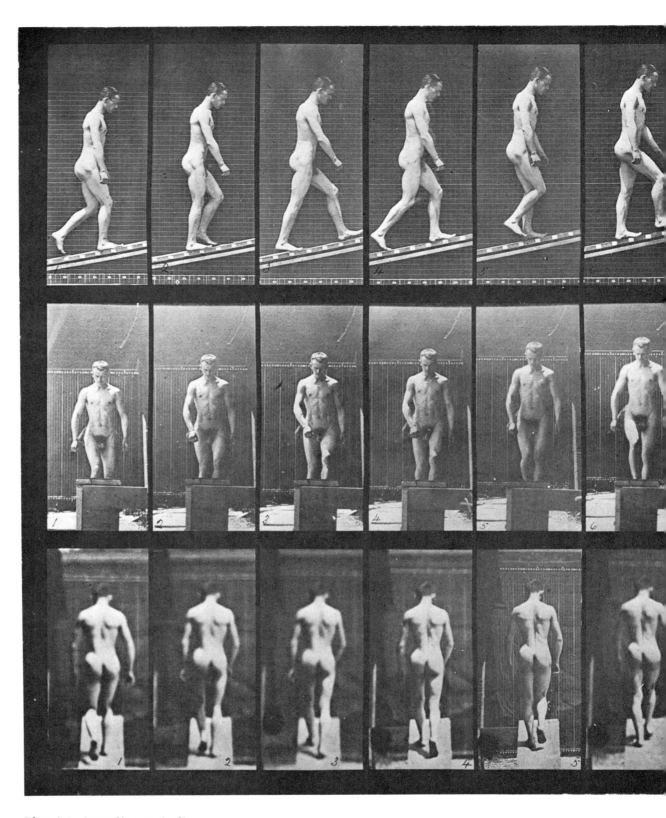

Plate 74. Ascending an incline.

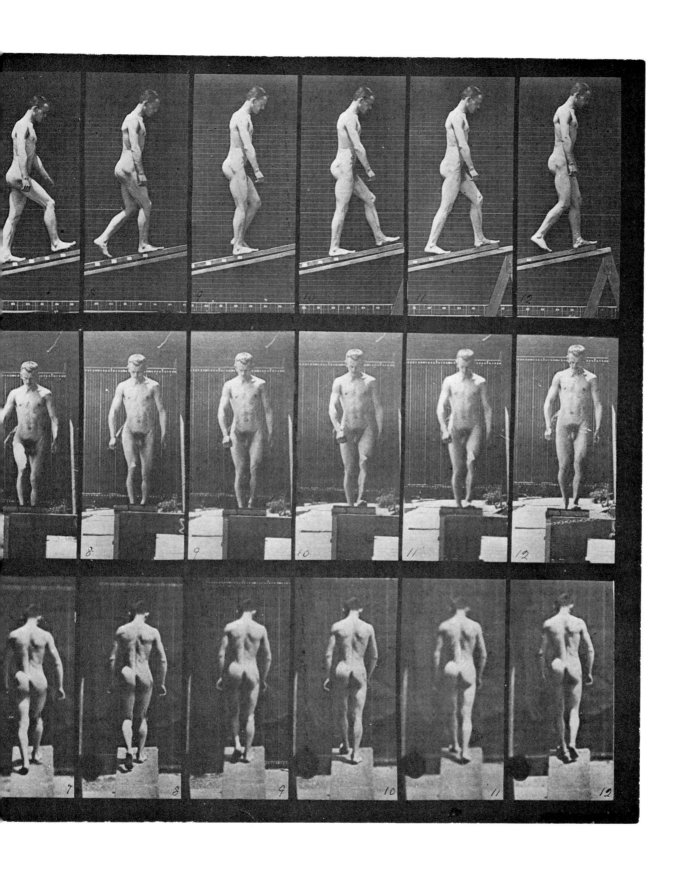

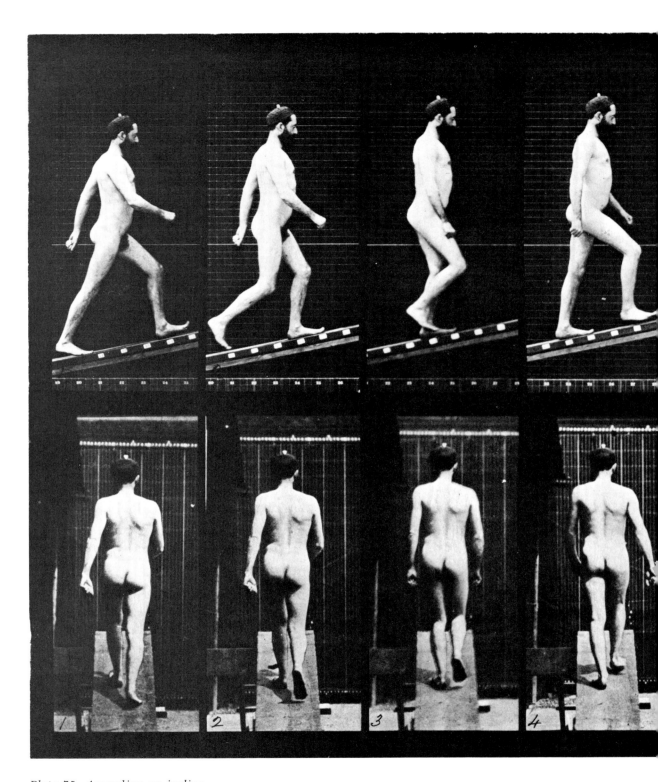

Plate 75. Ascending an incline.

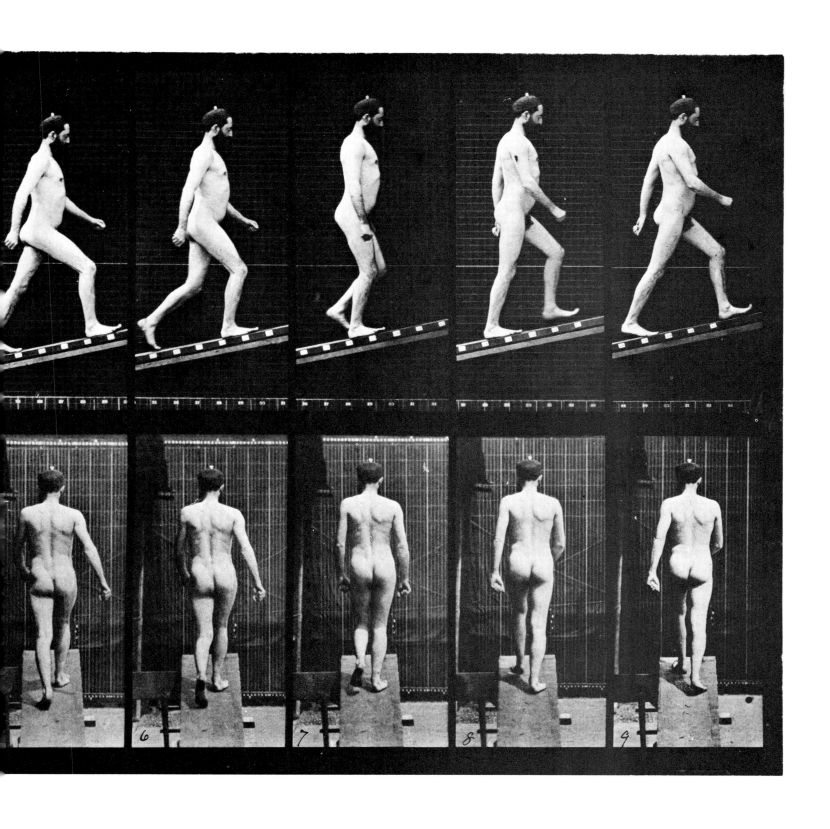

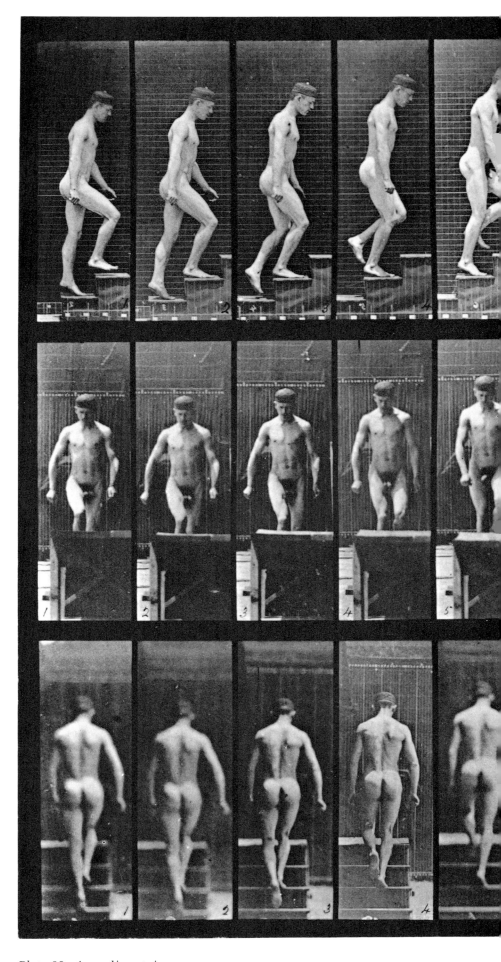

Plate 88. Ascending stairs.

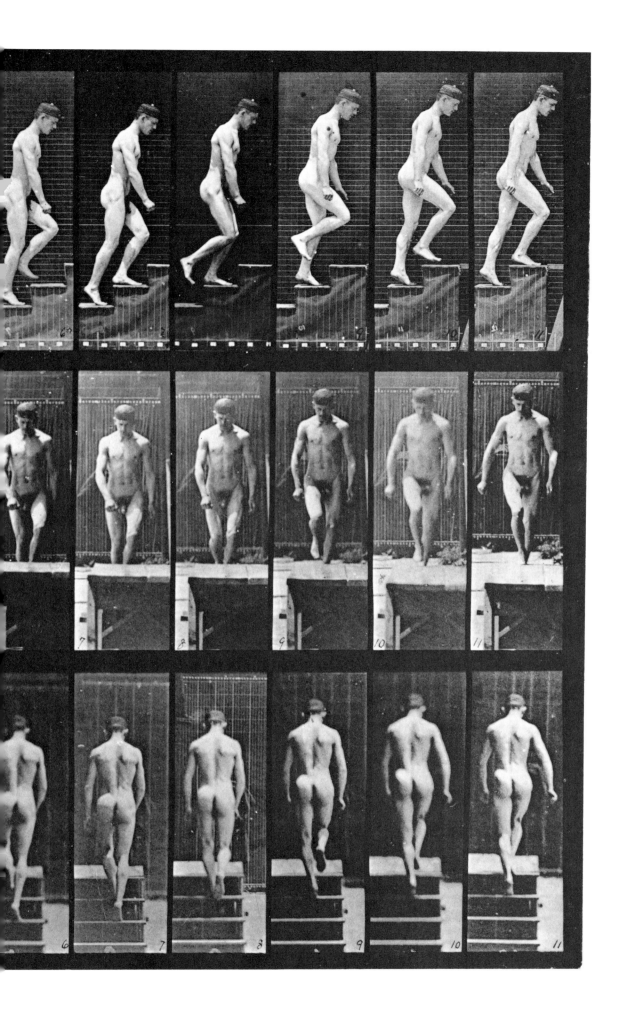

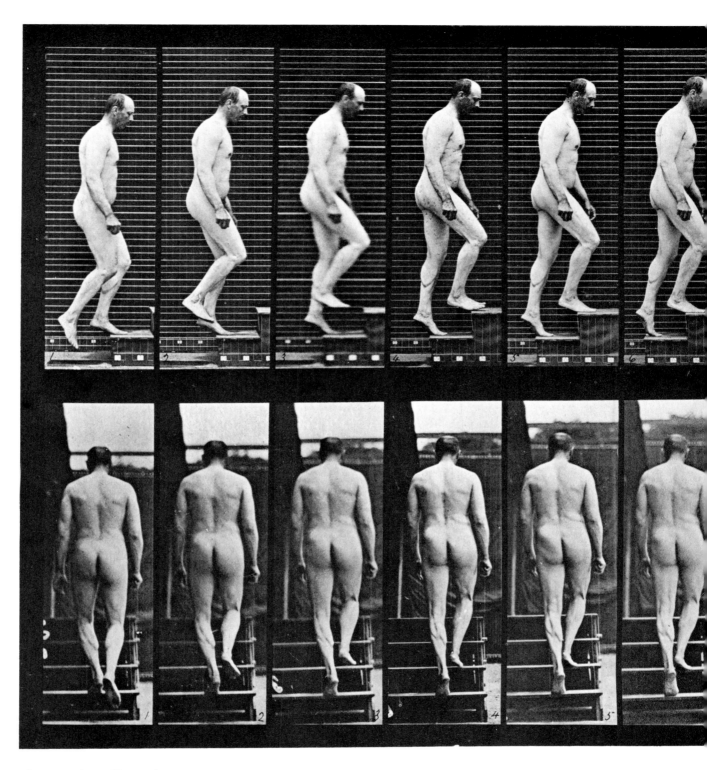

Plate 89. Ascending stairs.

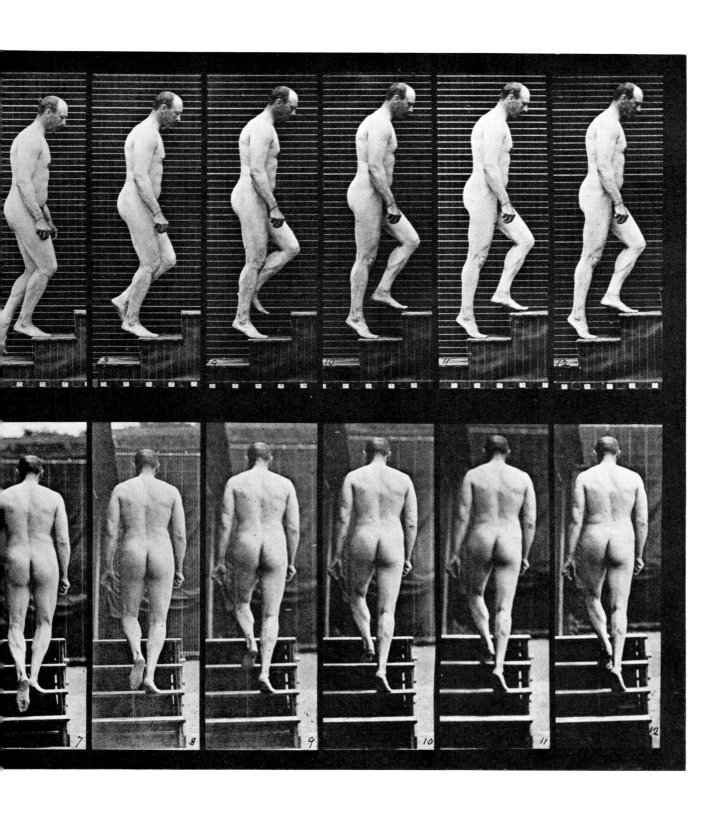

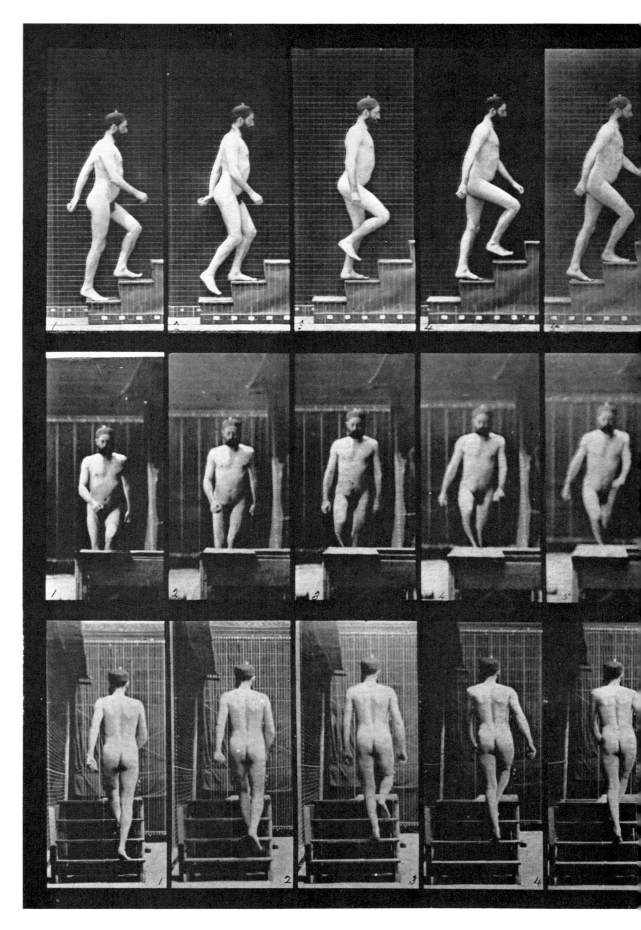

Plate 90. Ascending stairs.

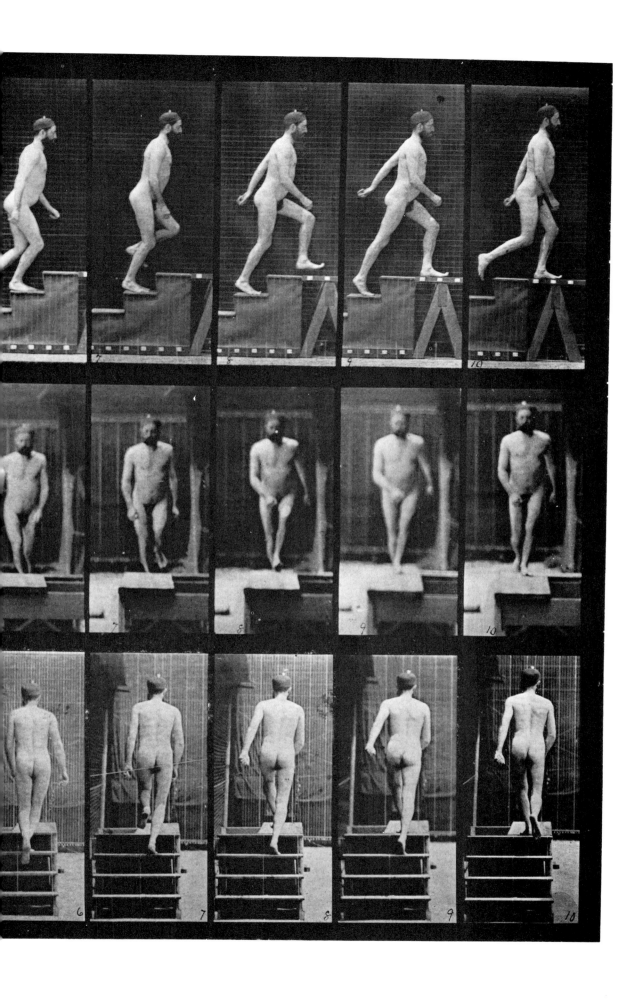

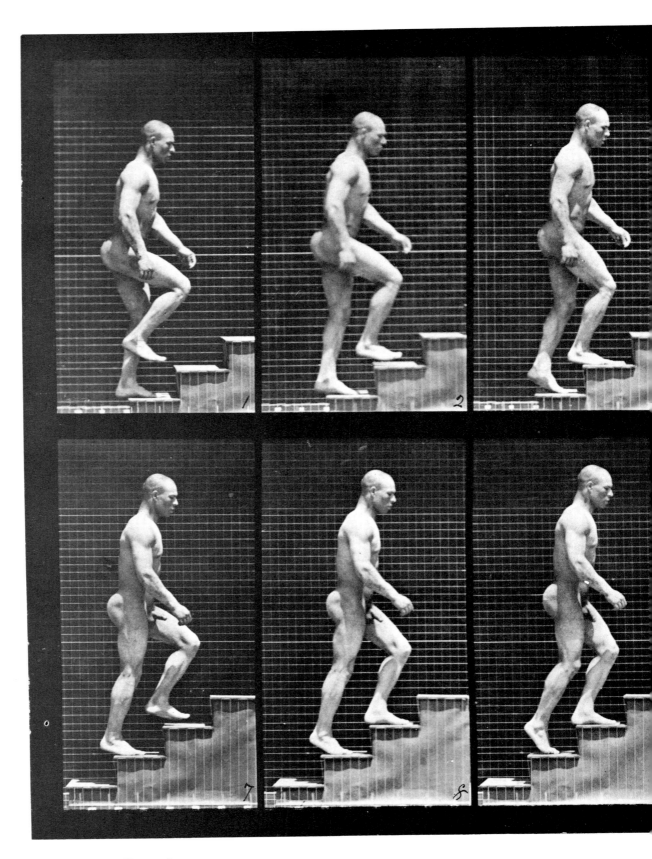

Plate 91. Ascending stairs.

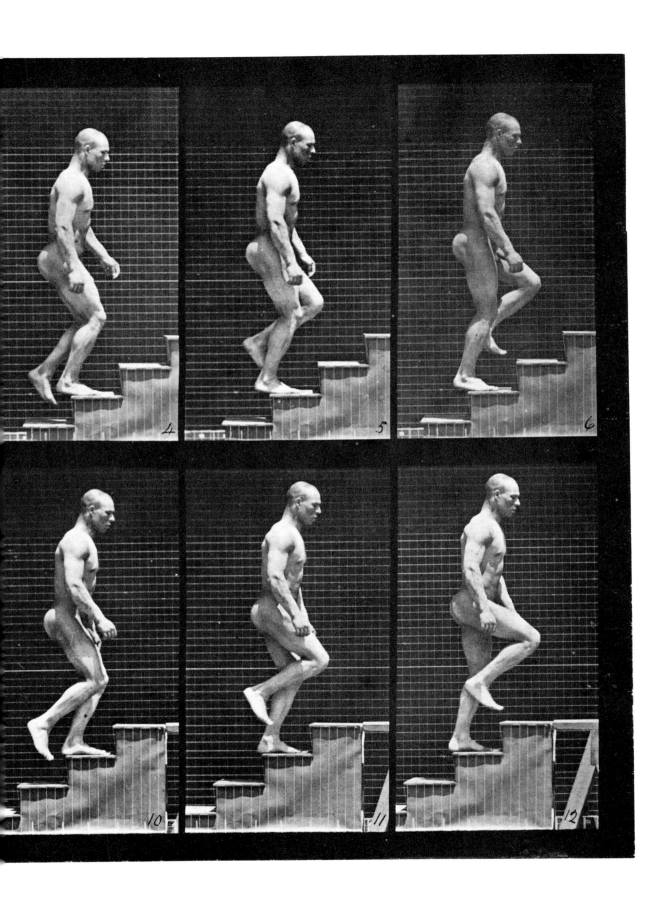

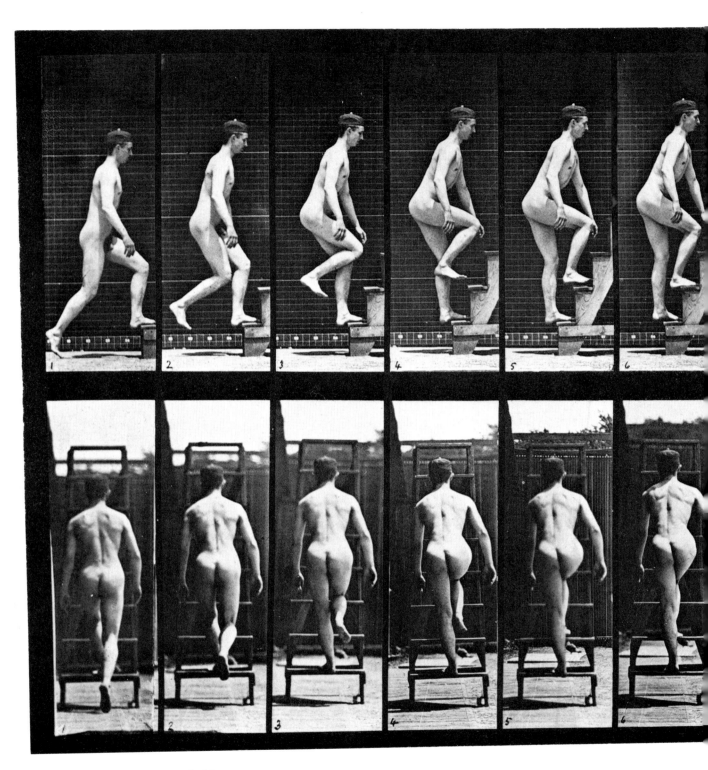

Plate 109. Ascending a stepladder.

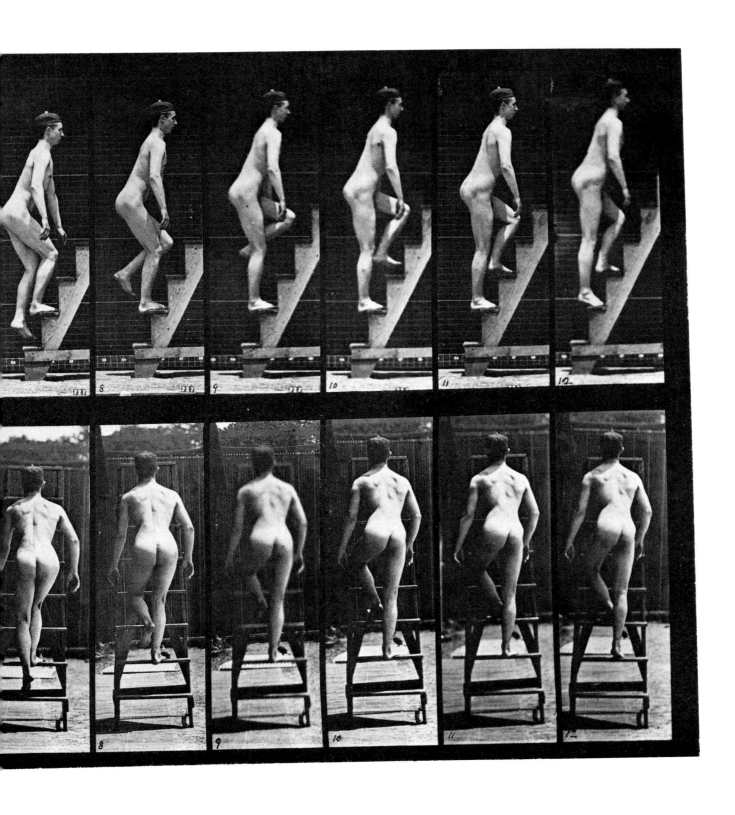

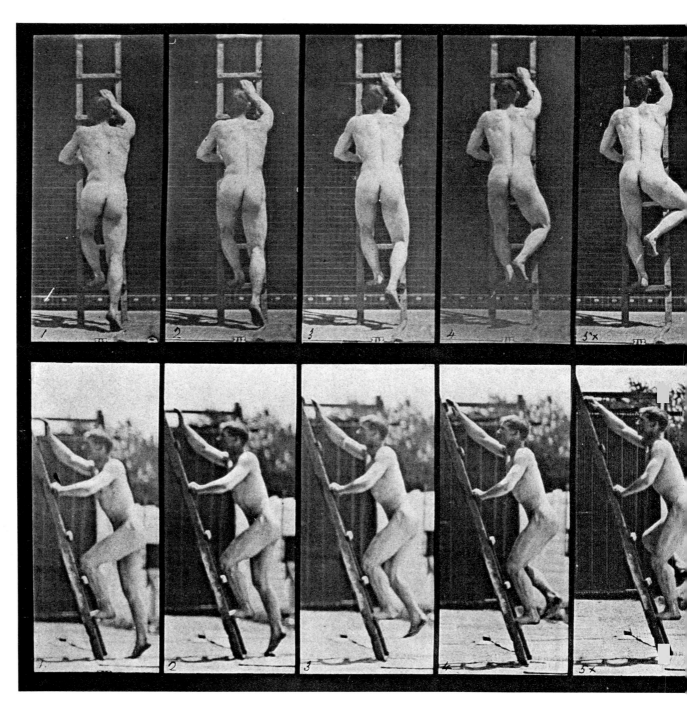

Plate 111. Ascending a ladder.

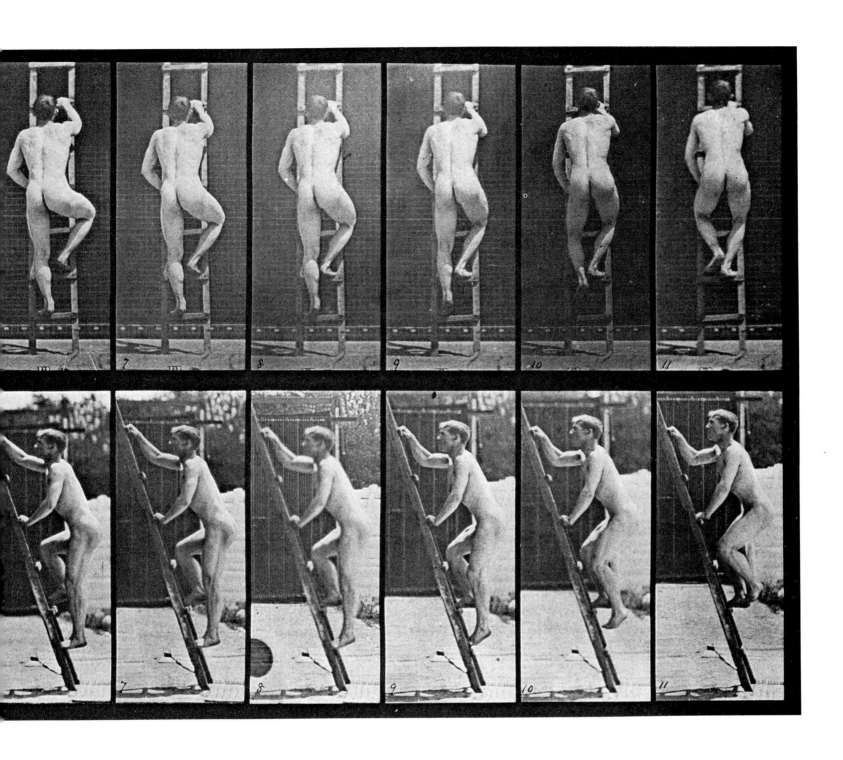

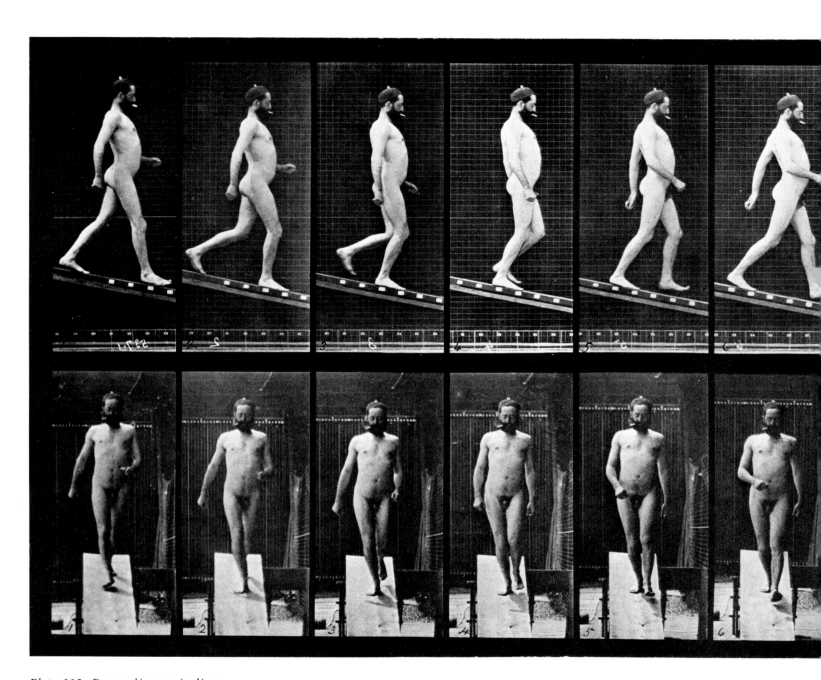

Plate 113. Descending an incline.

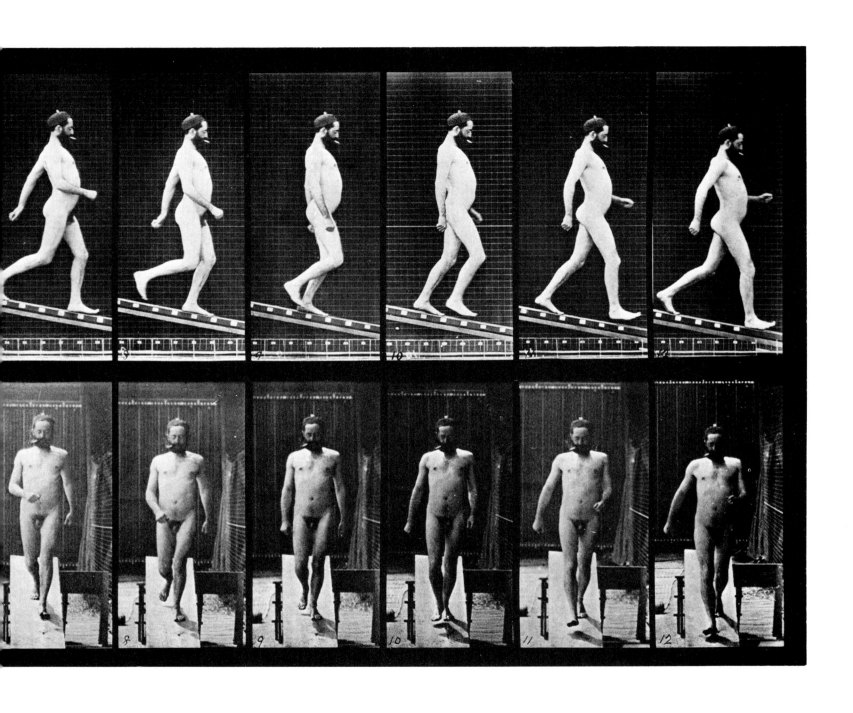

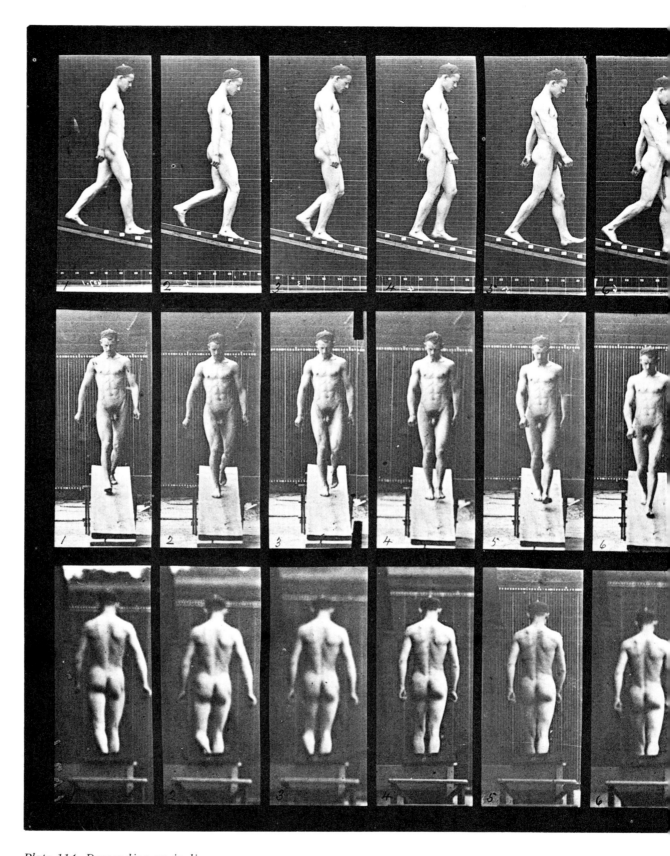

Plate 114. Descending an incline.

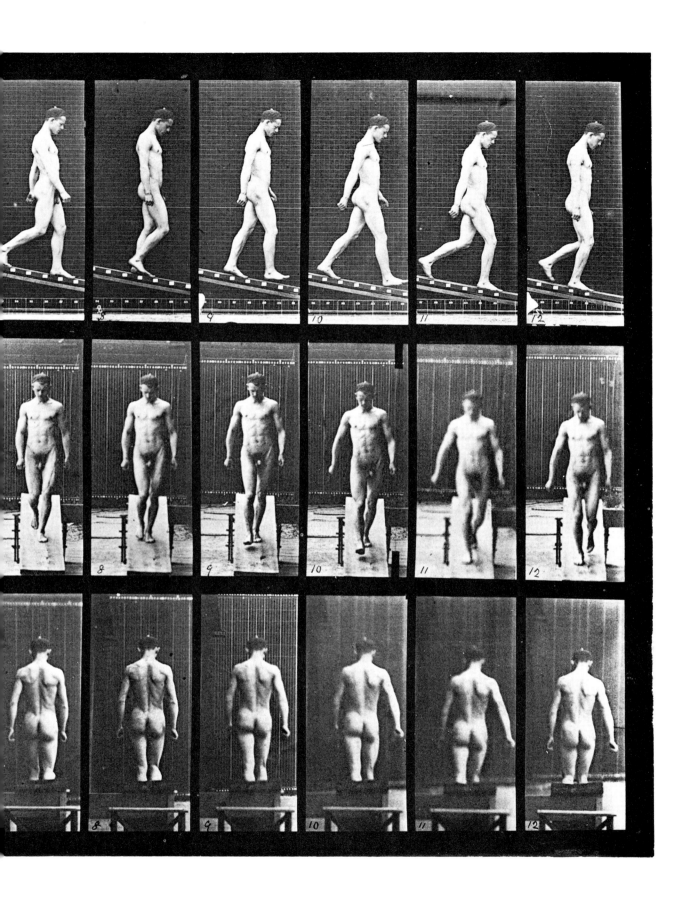

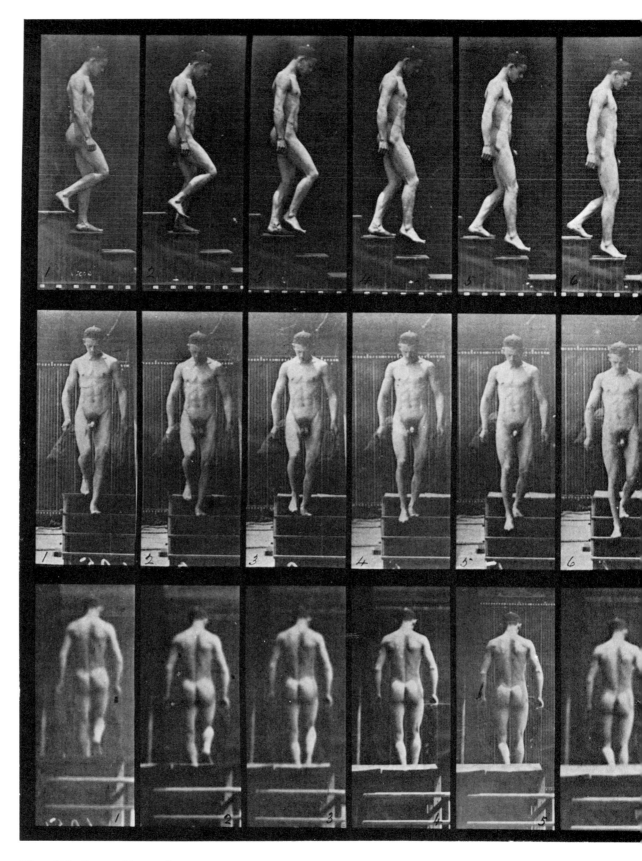

Plate 125. Descending stairs.

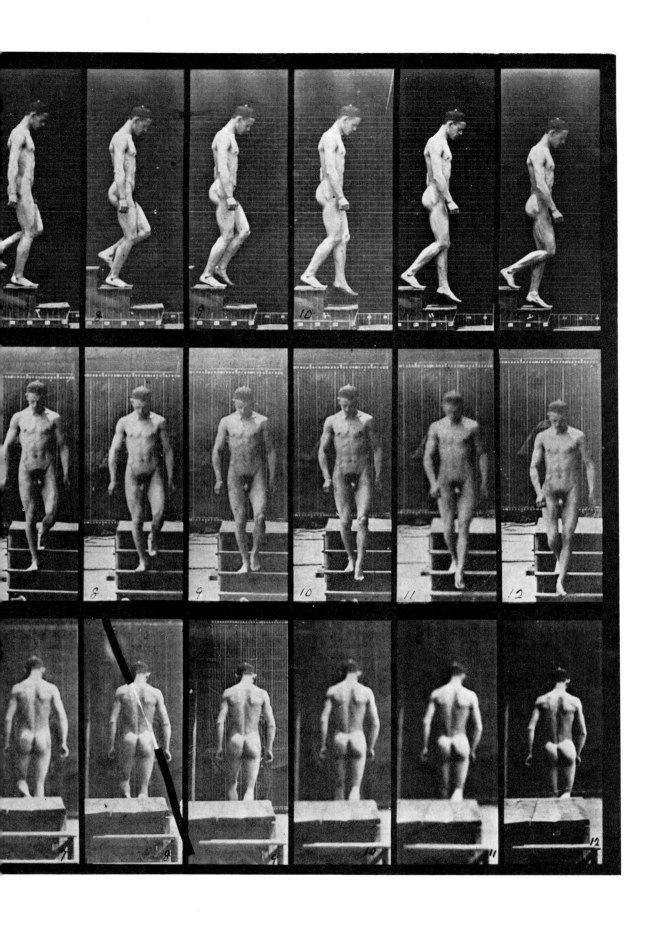

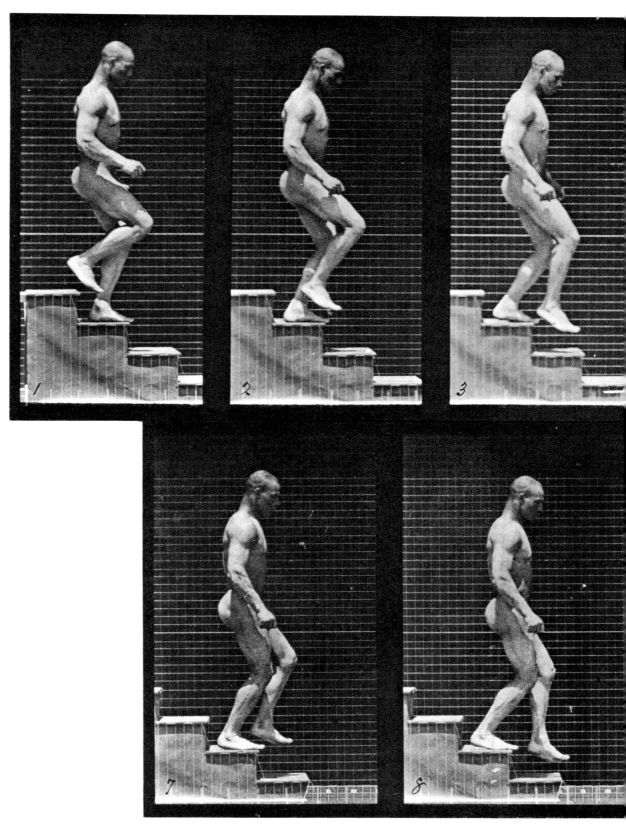

Plate 126. Descending stairs.

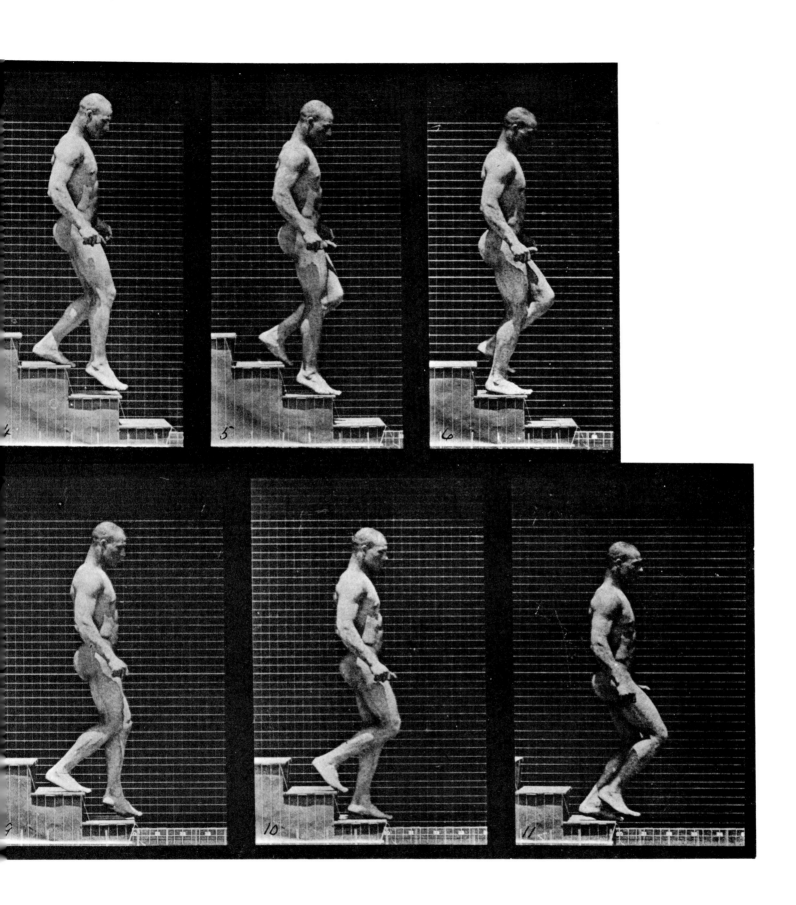

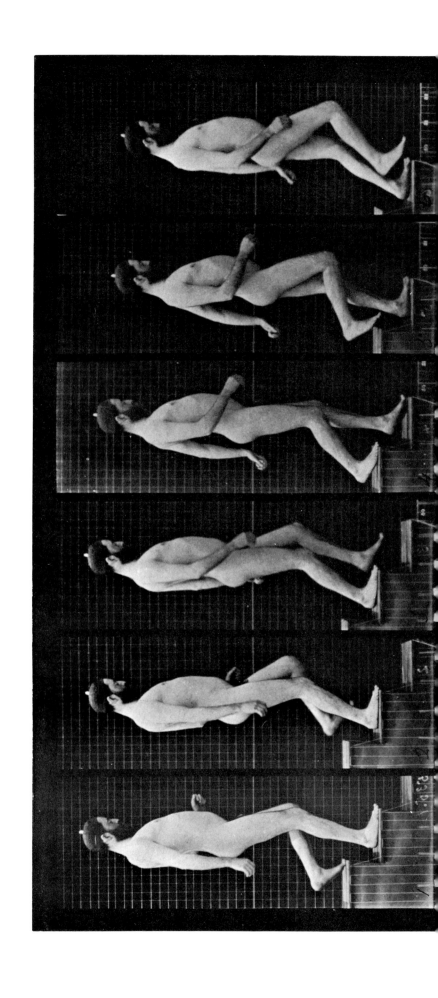

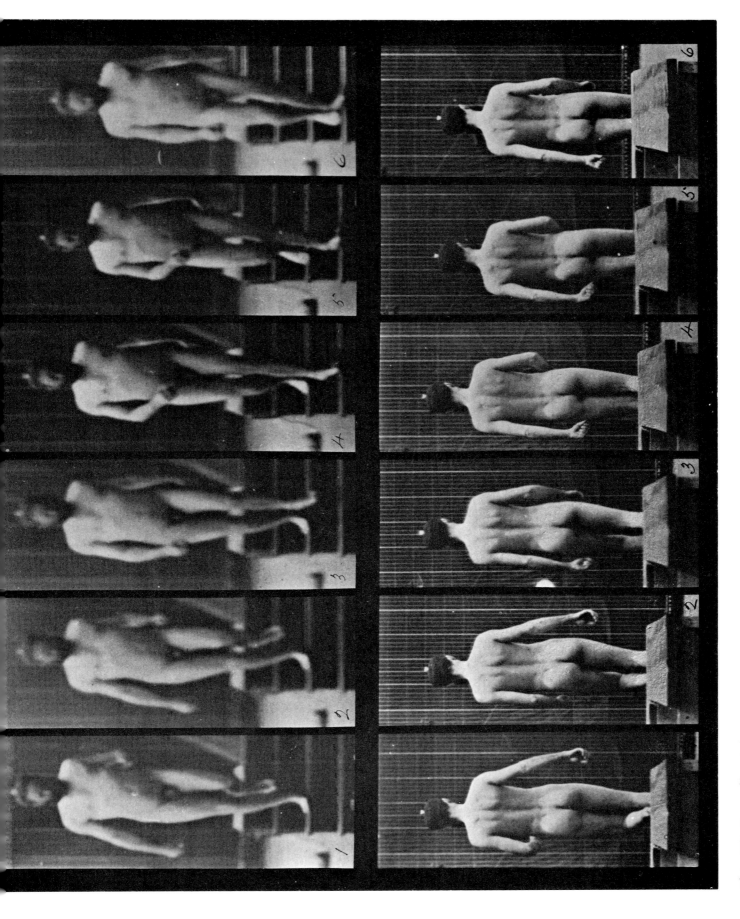

Plate 127. Descending stairs.

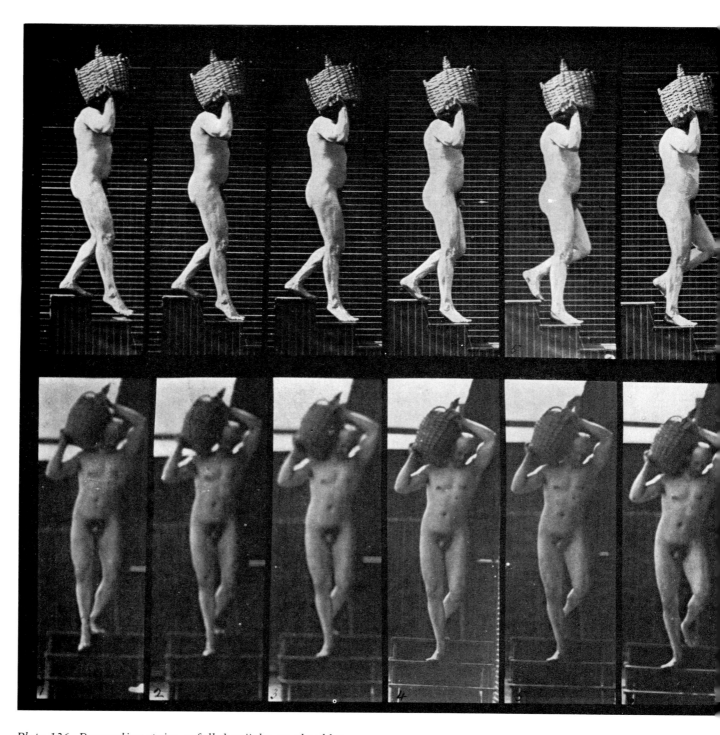

Plate 136. Descending stairs, a full demijohn on shoulder.

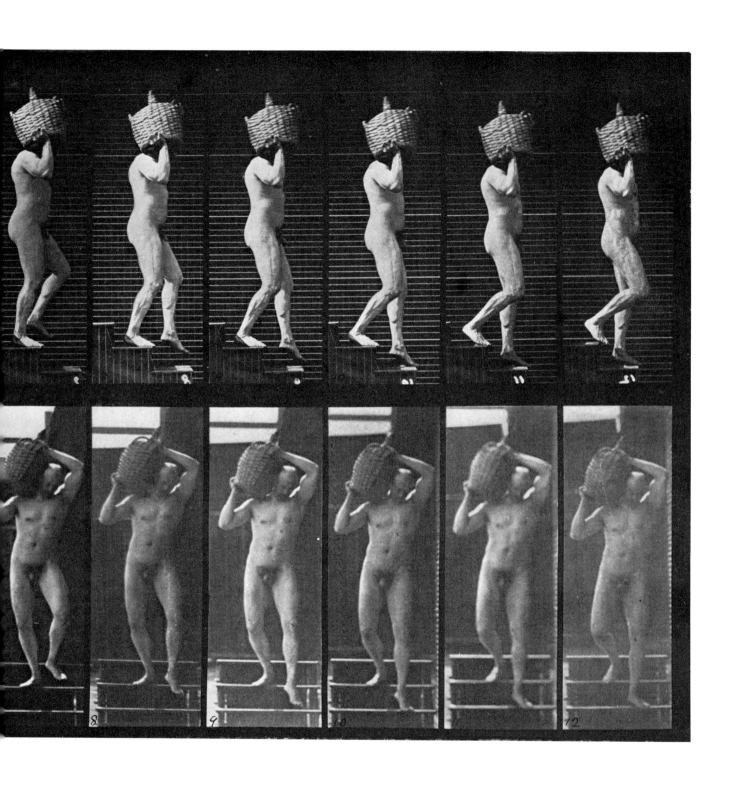

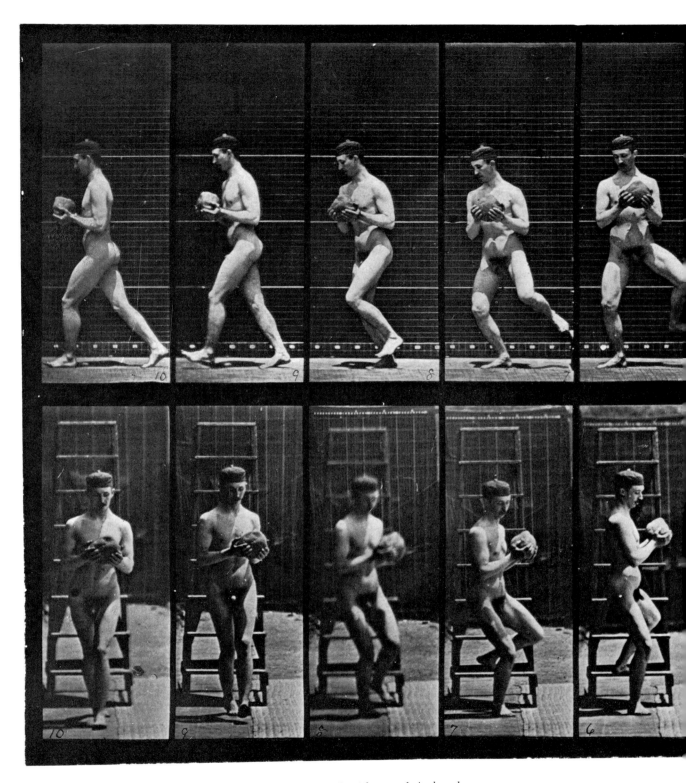

Plate 151. Descending a stepladder and turning around with a rock in hands.

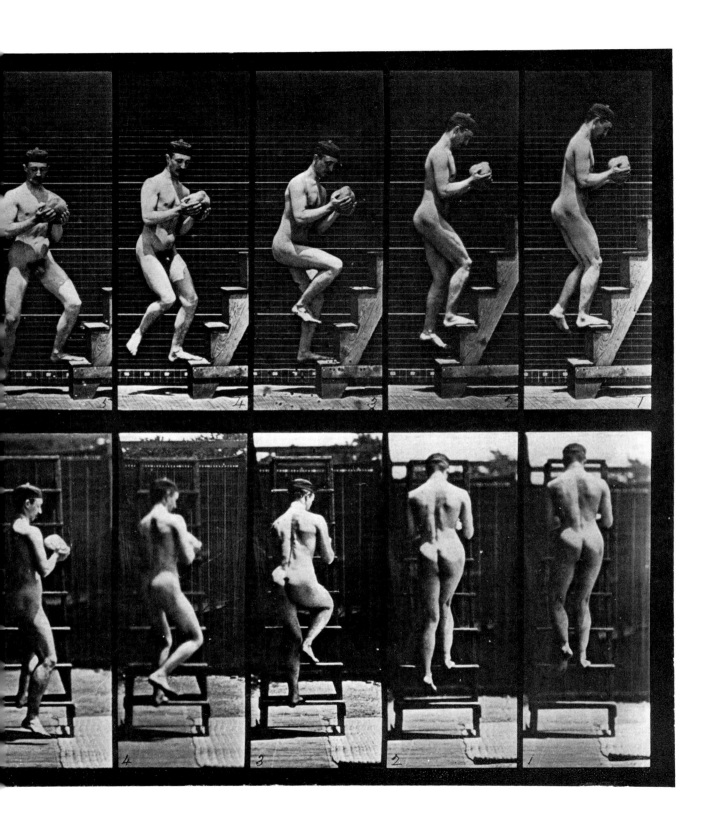

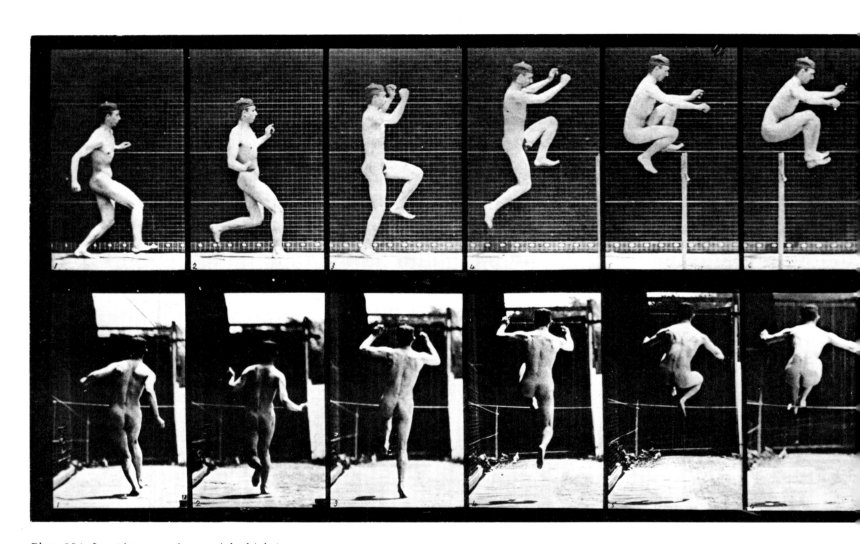

Plate 154. Jumping, running straight high jump.

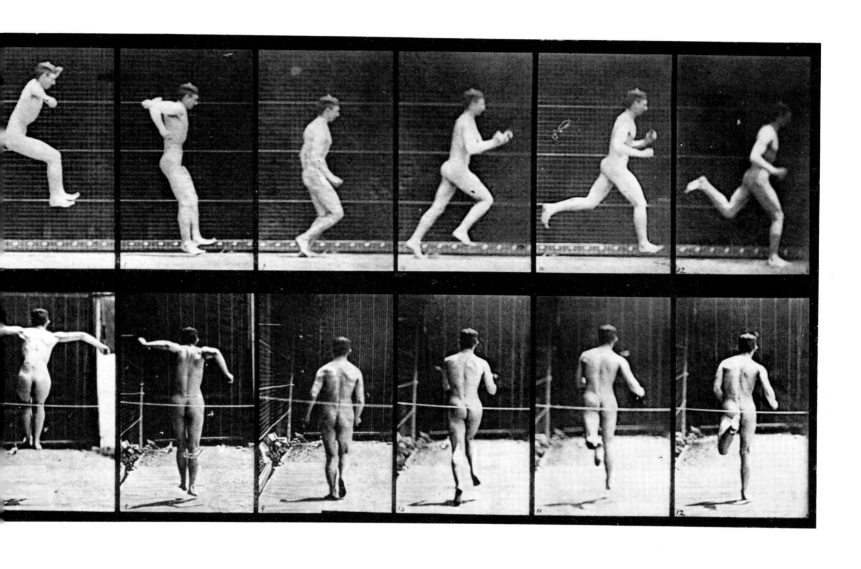

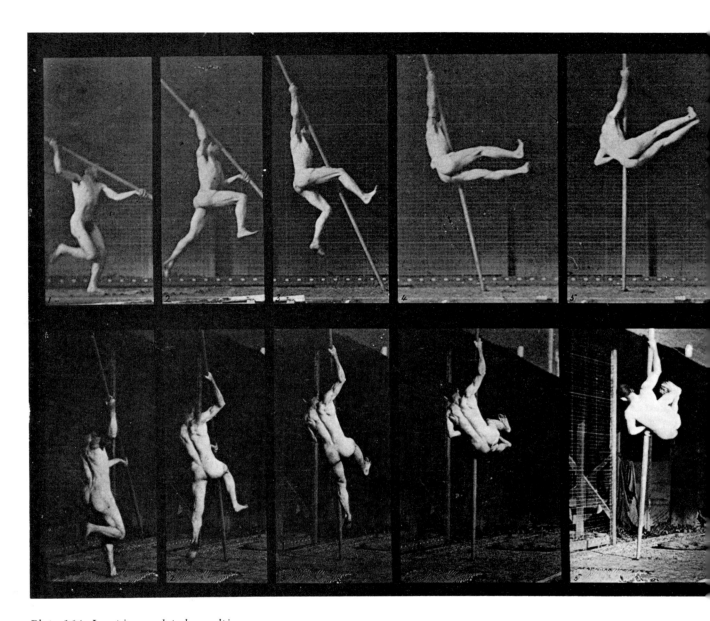

Plate 164. Jumping and pole-vaulting.

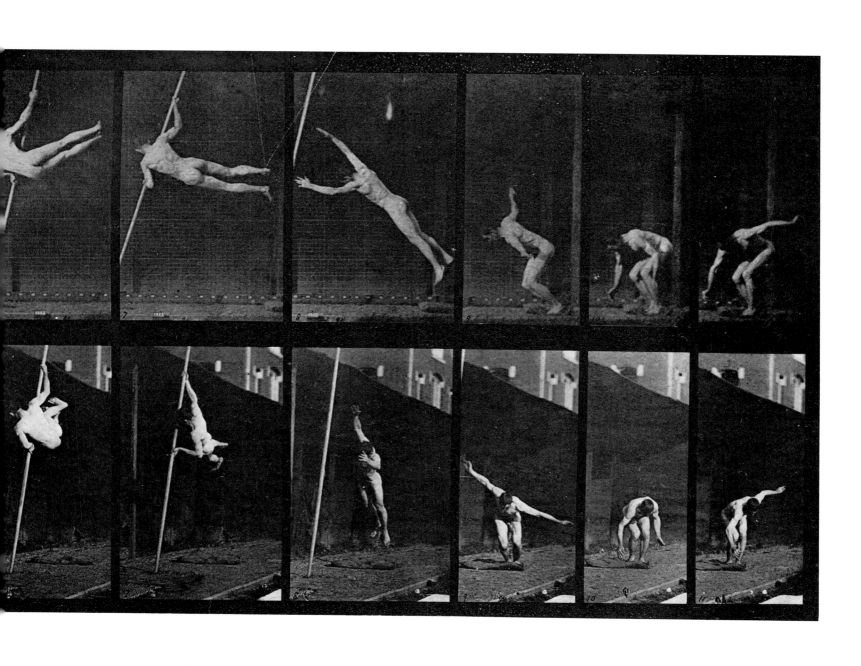

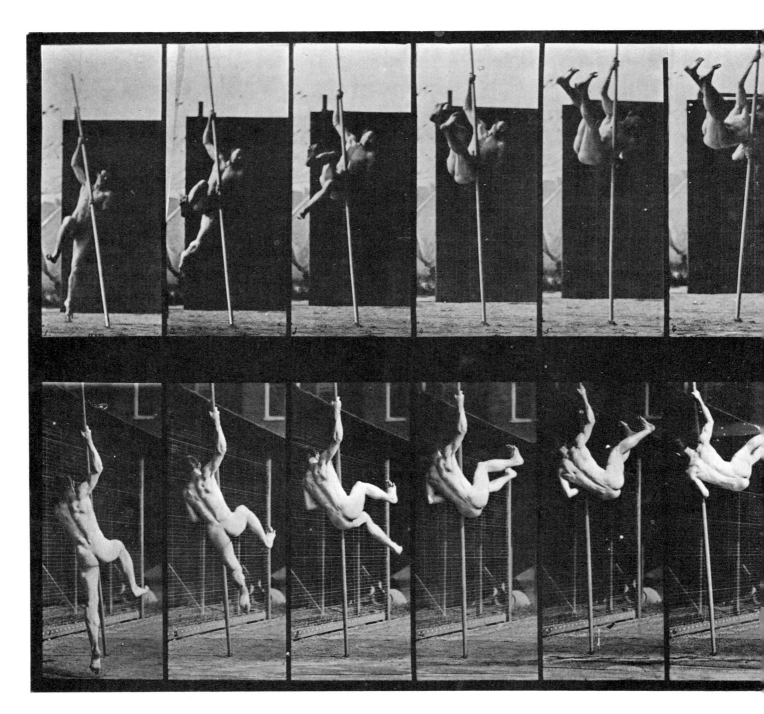

Plate 165. Jumping and pole-vaulting.

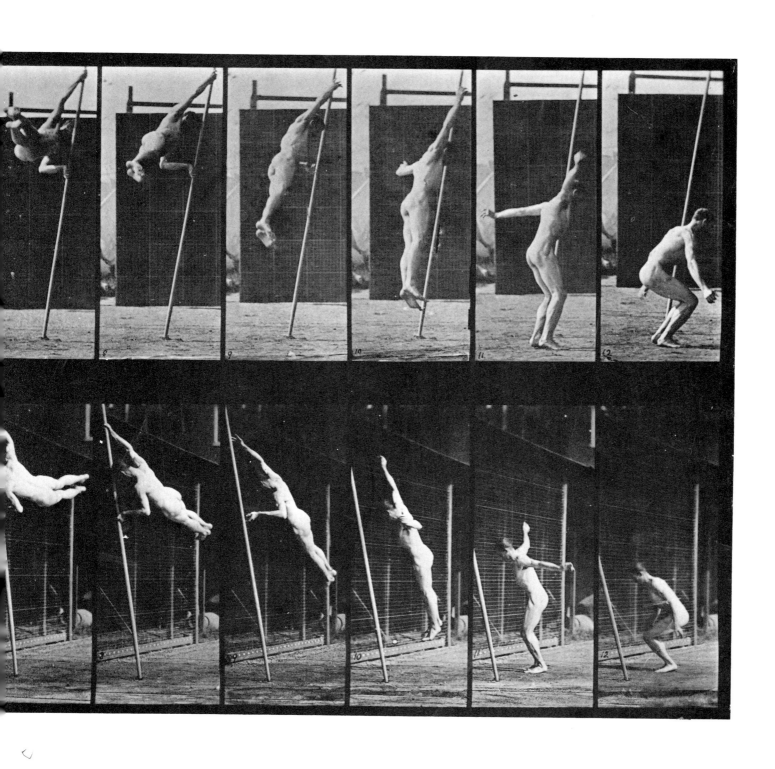

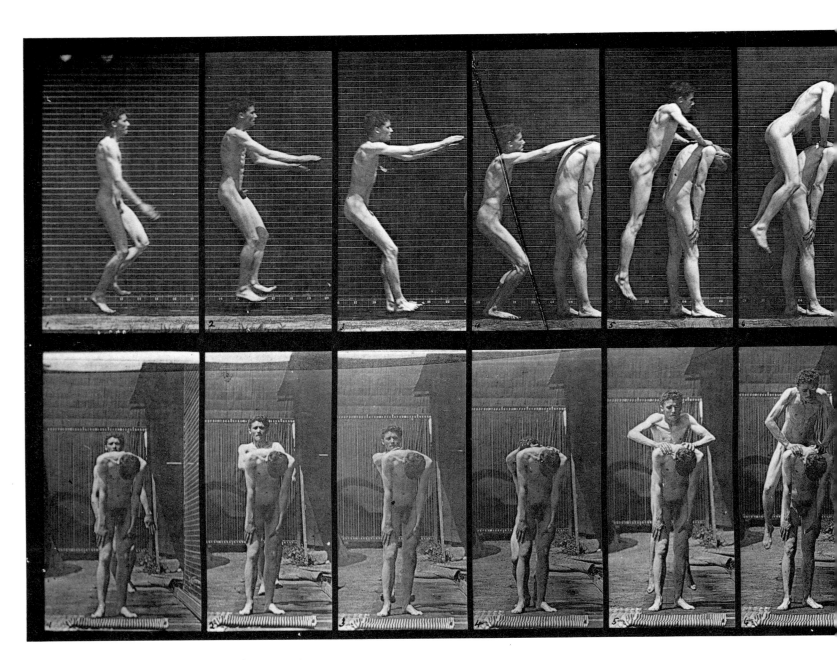

Plate 166. Jumping over a man's back (leapfrog).

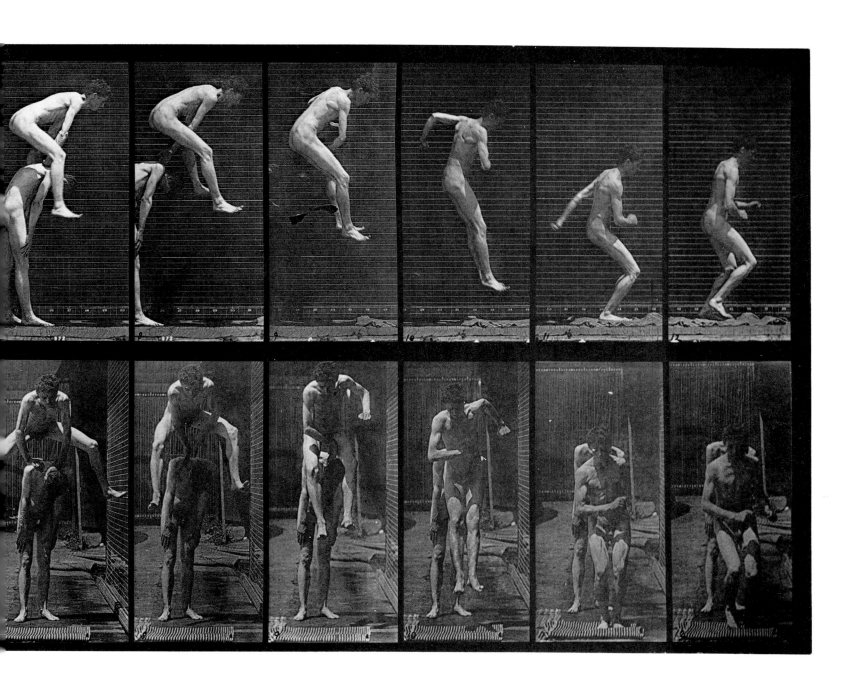

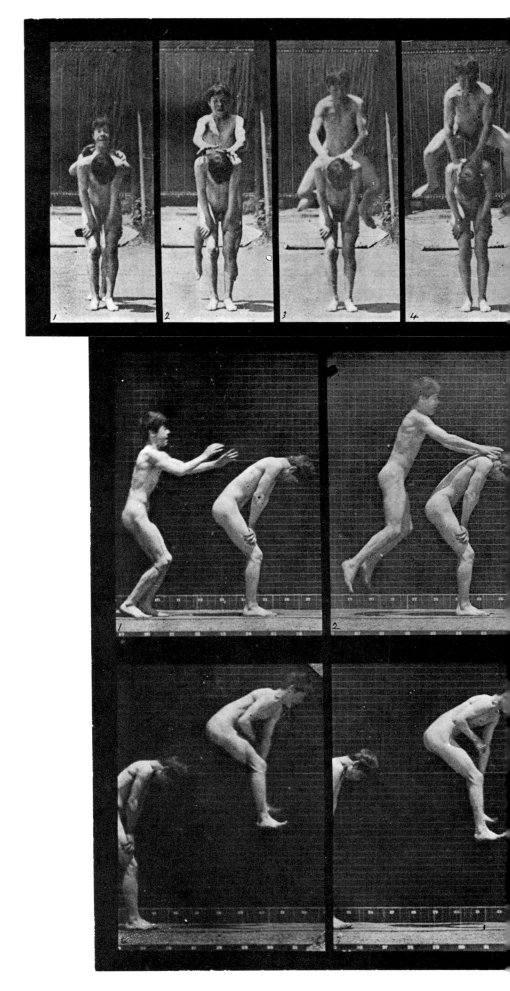

Plate 167. *Jumping over a boy's back (leapfrog)*

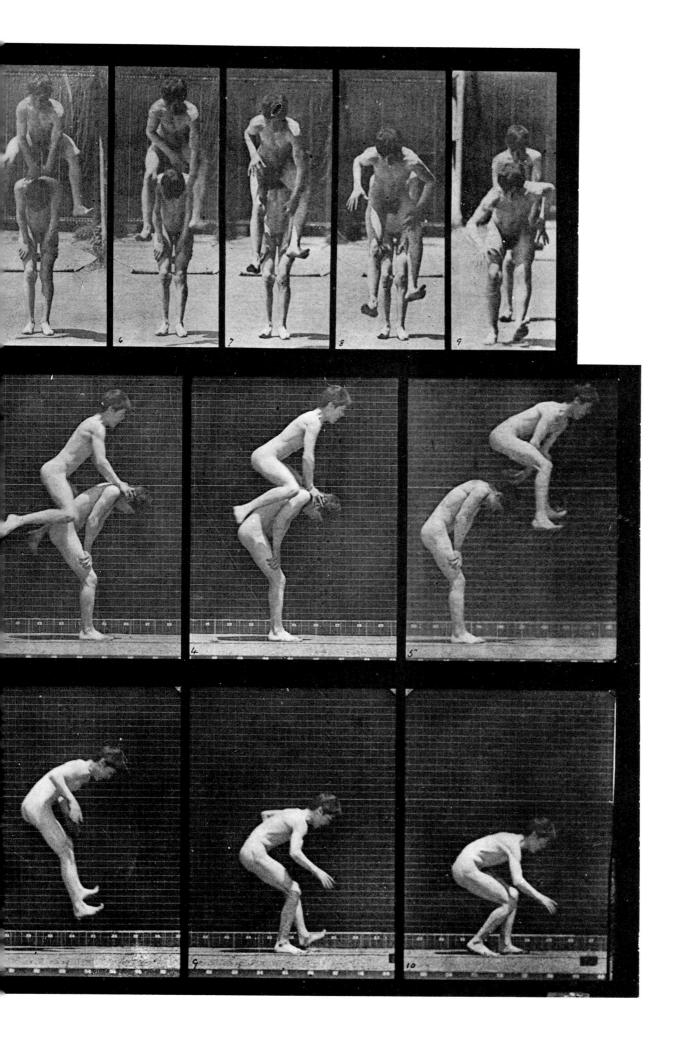

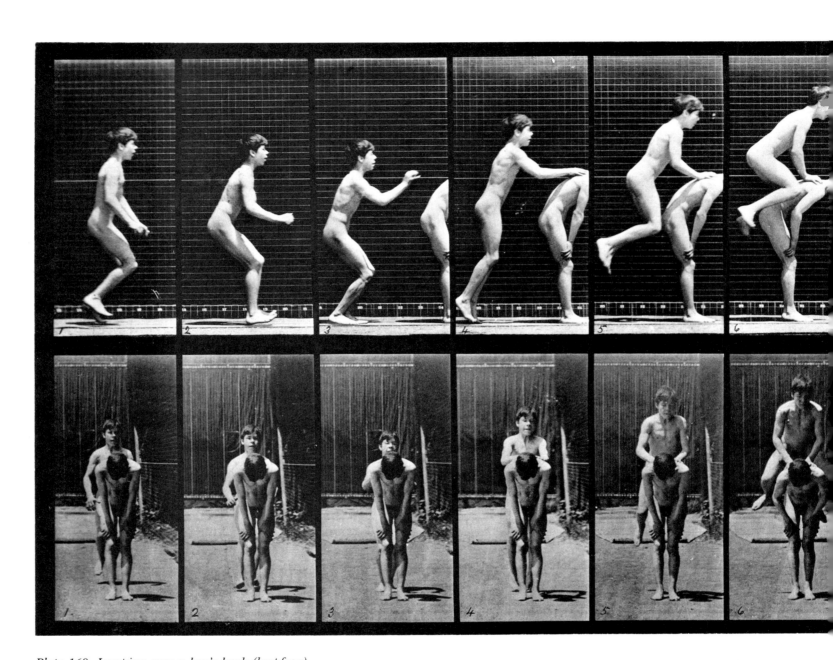

Plate 168. Jumping over a boy's back (leapfrog).

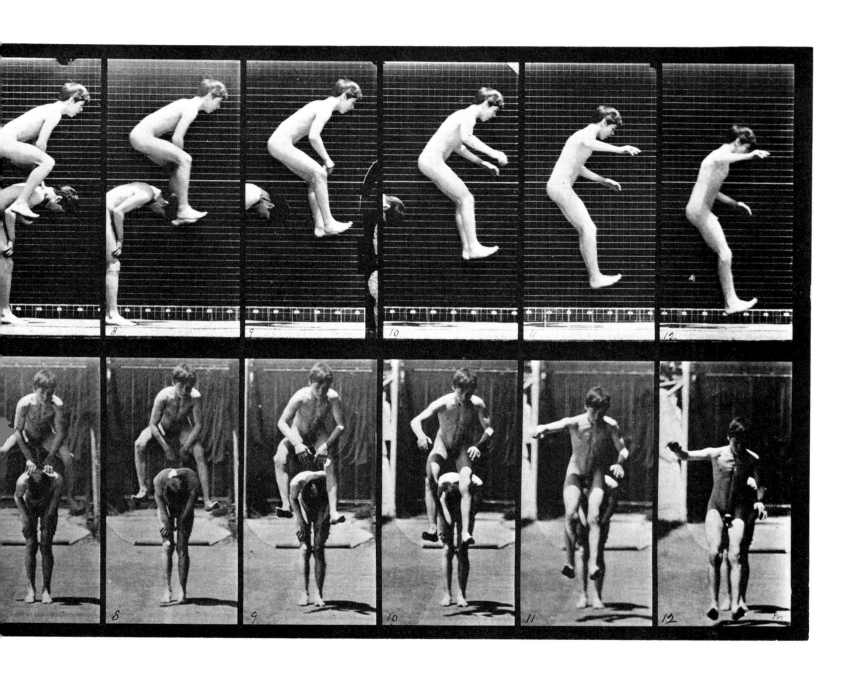

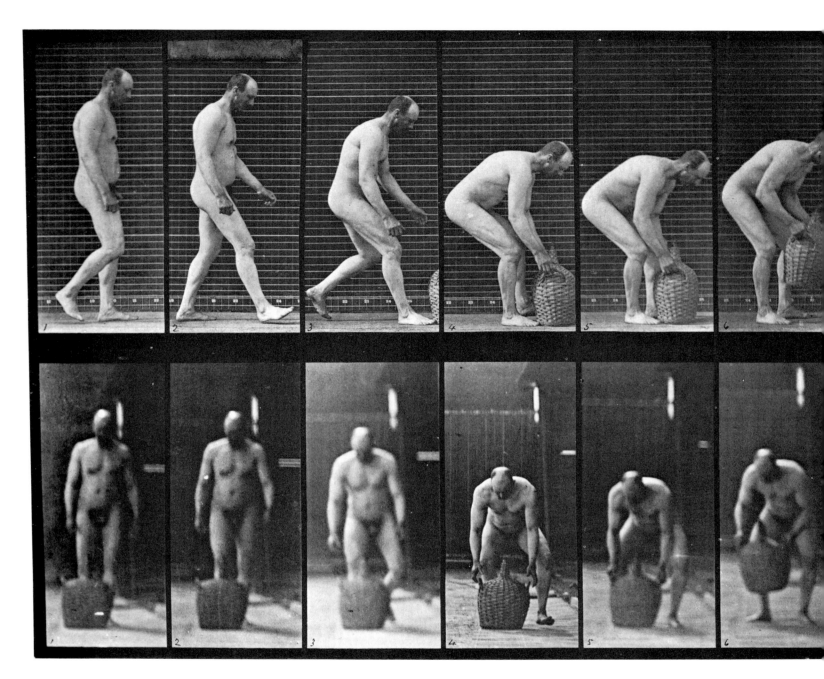

Plate 218. Stooping and lifting a full demijohn to shoulder.

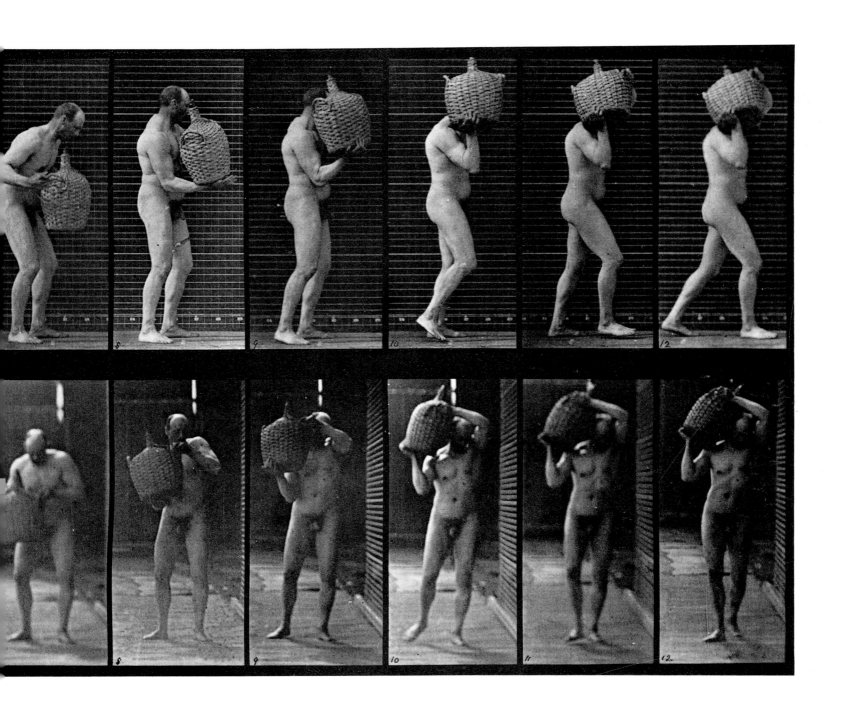

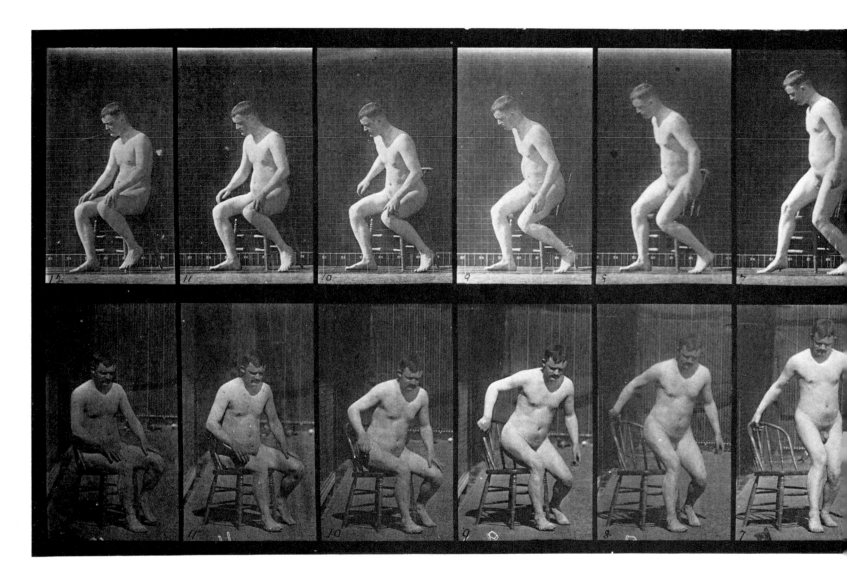

Plate 236. Placing chair and sitting down.

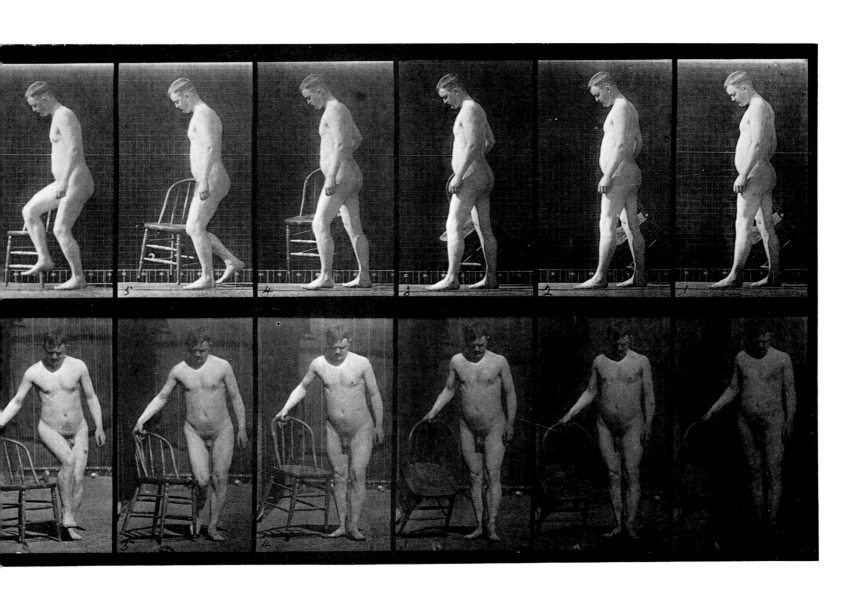

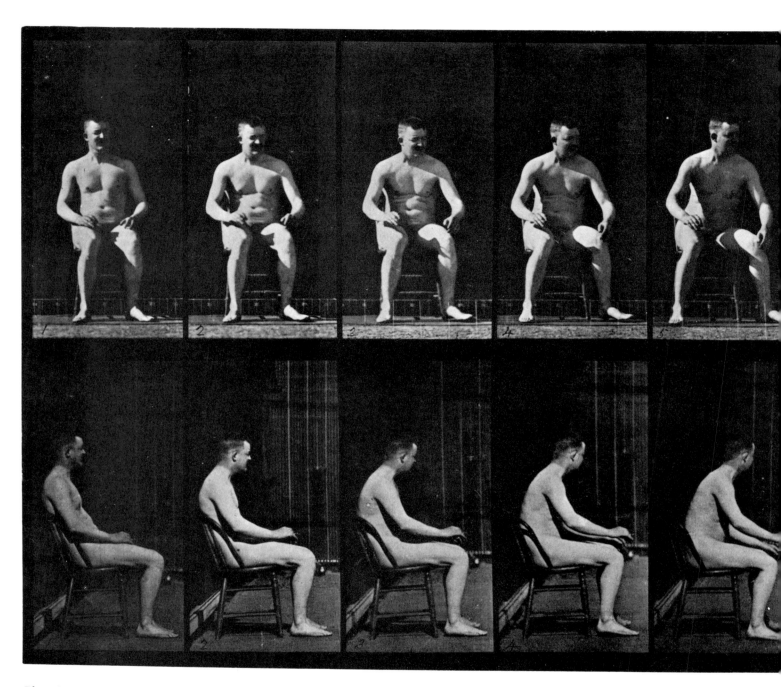

Plate 249. Rising from chair.

90 MALES (NUDE)

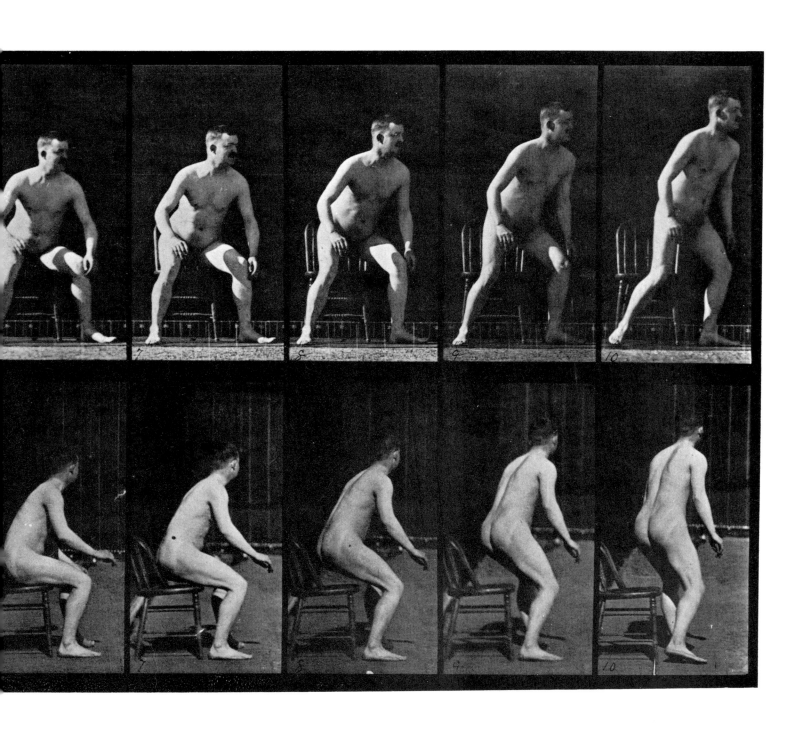

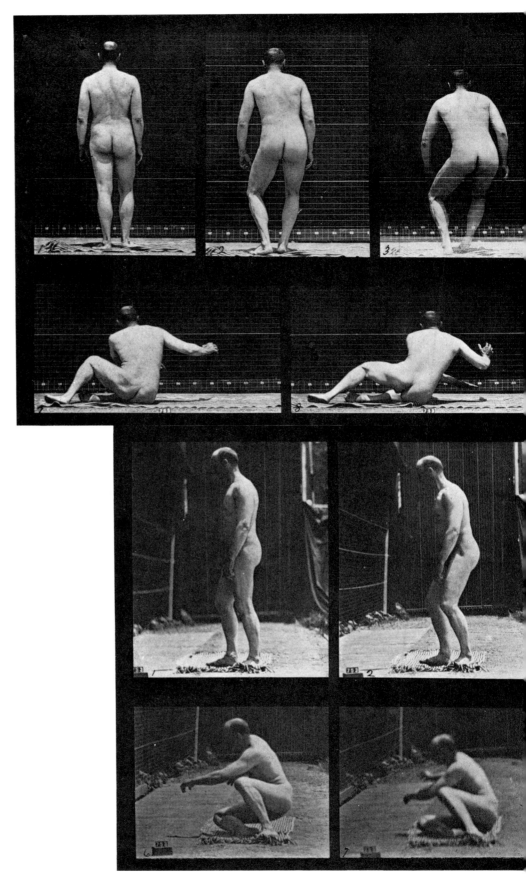

Plate 257. Lying on the ground.

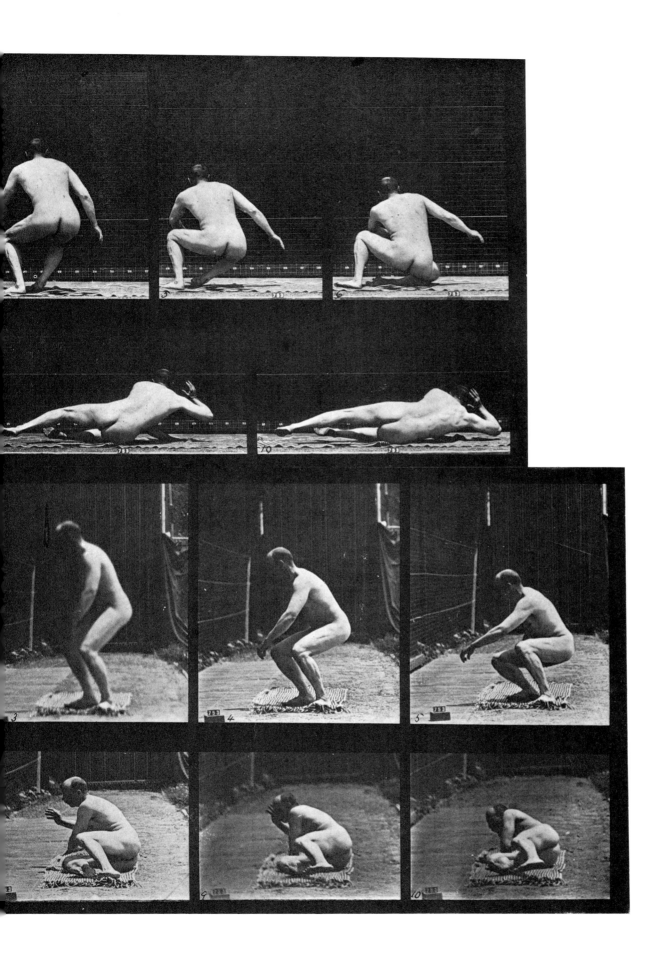

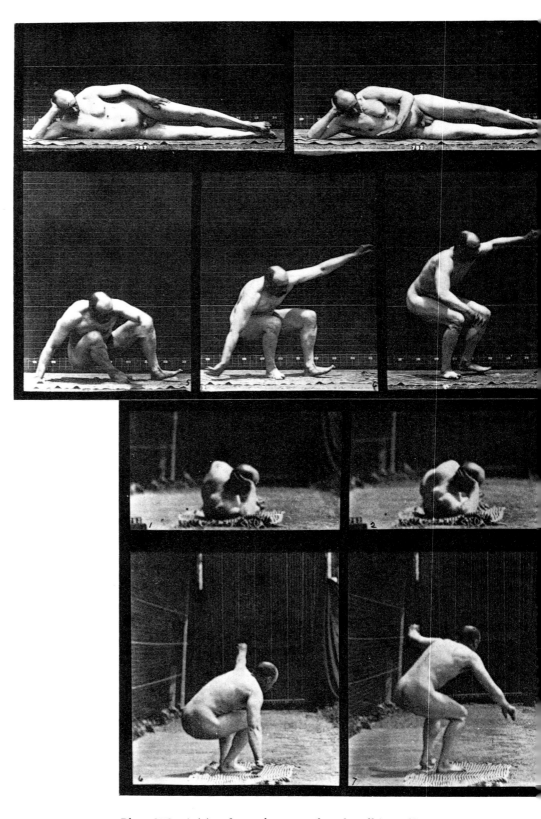

Plate 258. Arising from the ground and walking off.

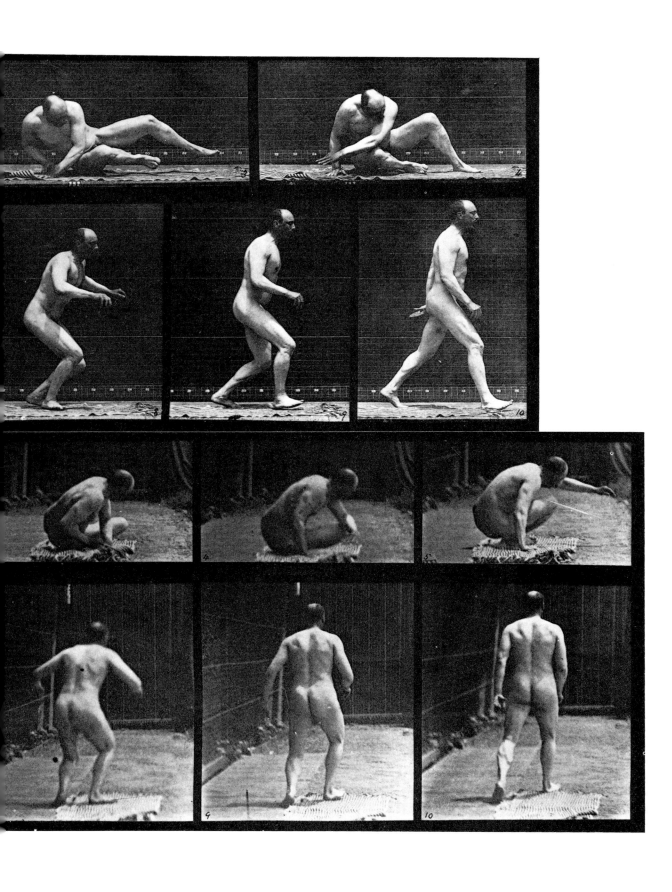

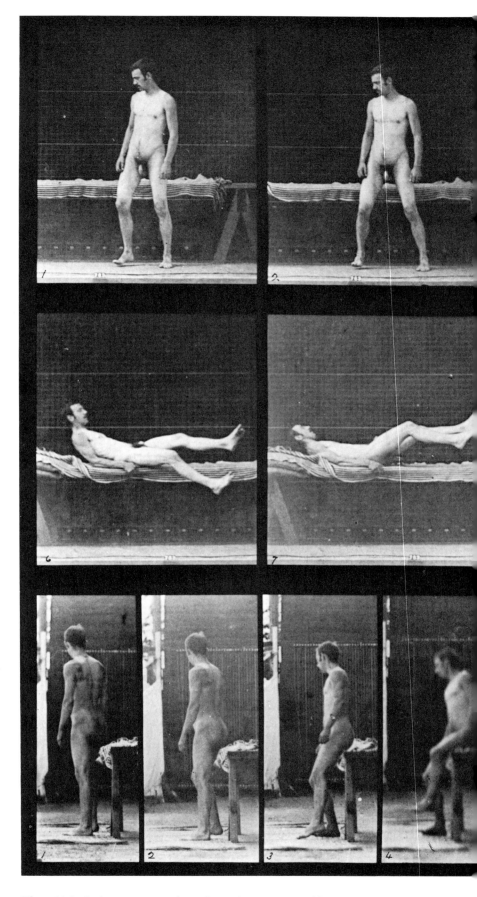

Plate 259. Lying on a couch and turning over on side.

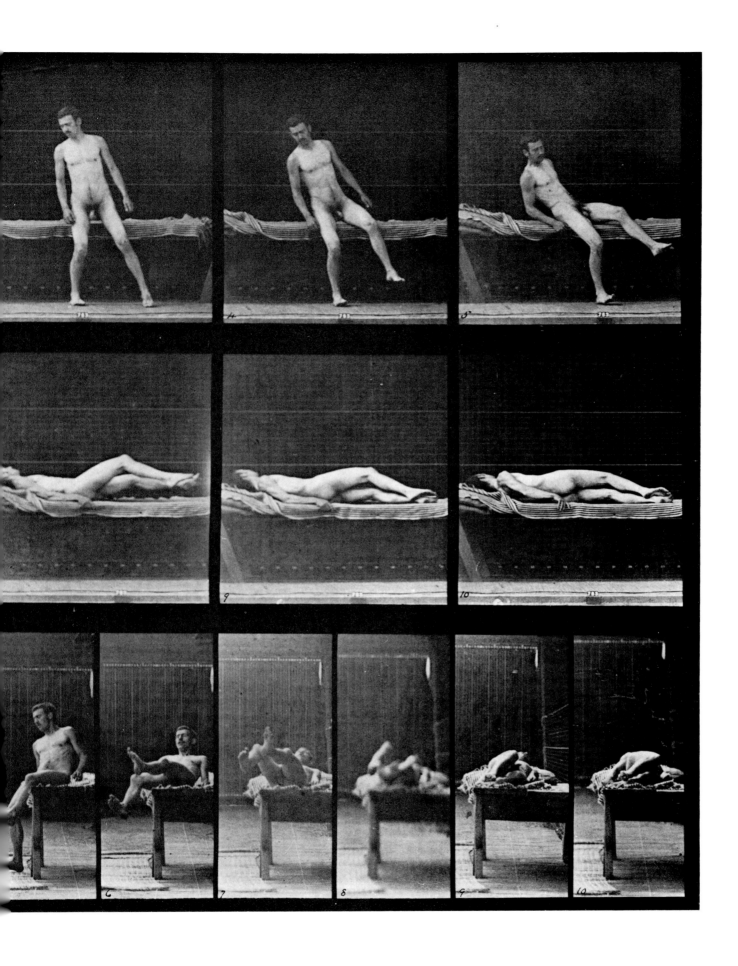

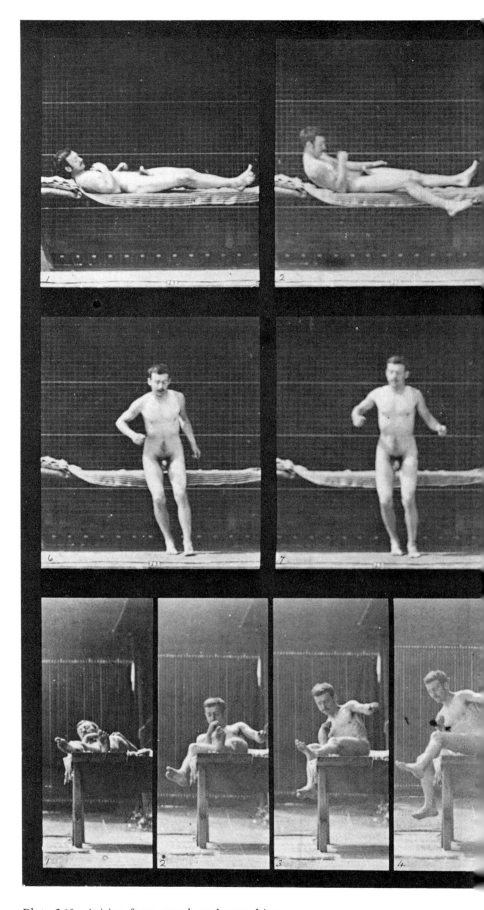

Plate 260. Arising from couch and stretching arms.

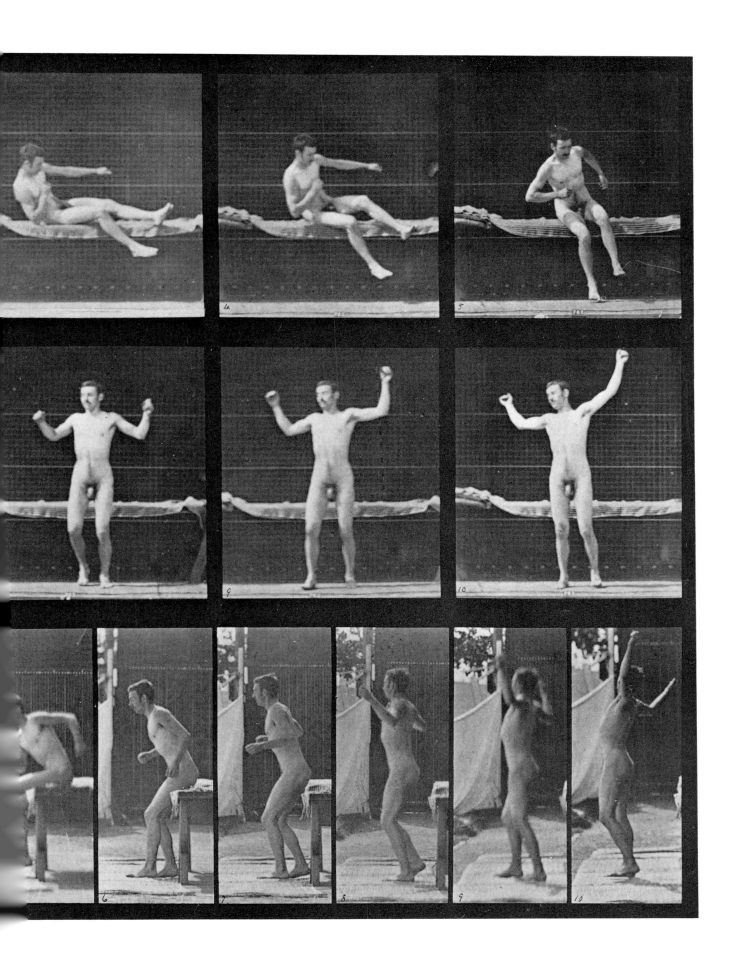

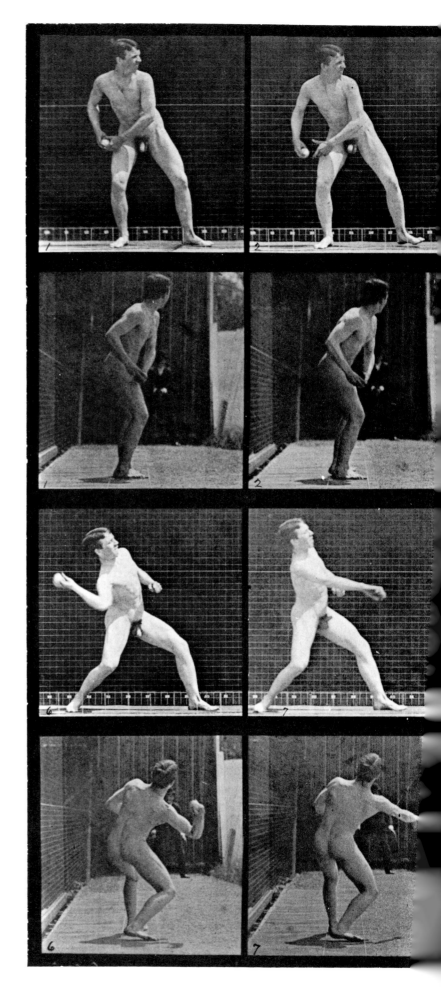

Plate 273. Baseball, pitching.

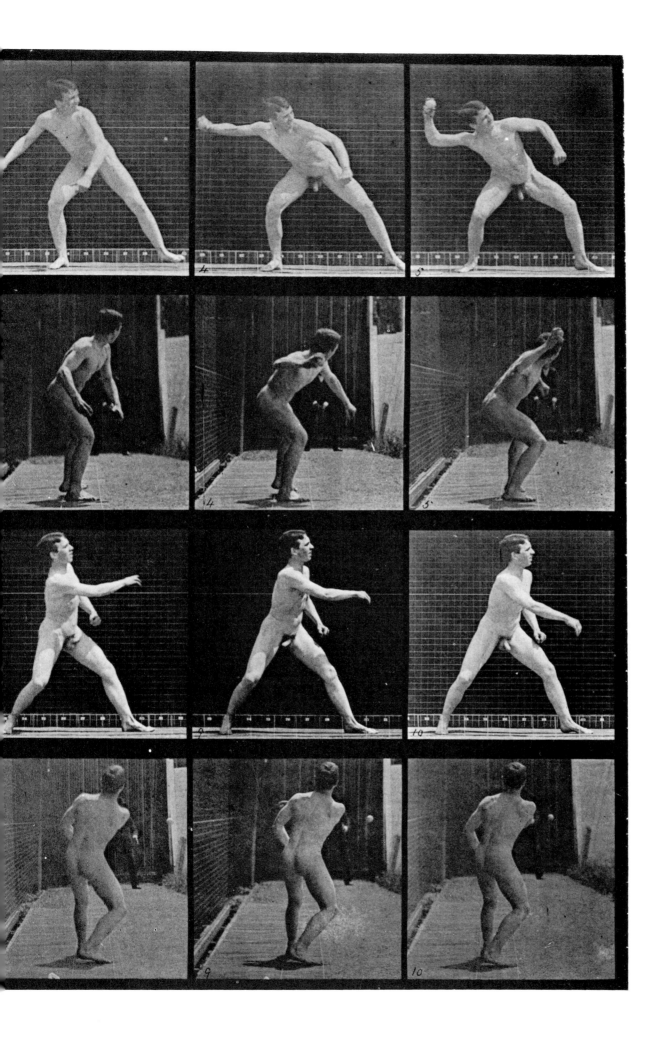

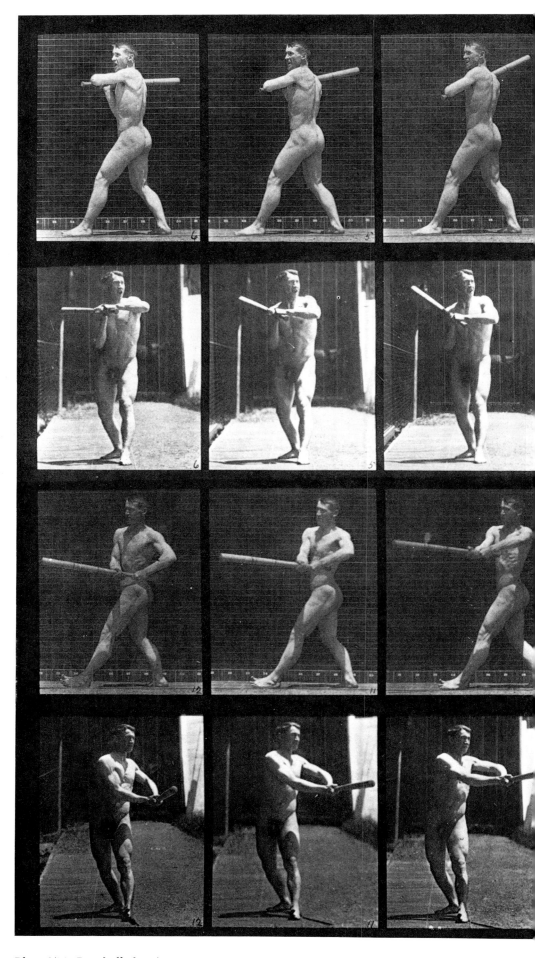

Plate 274. Baseball, batting.

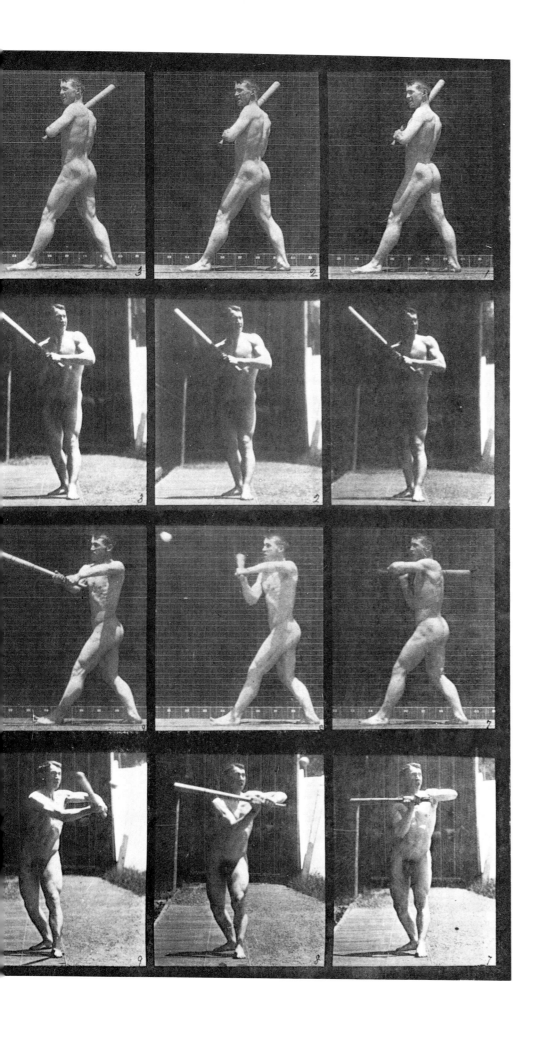

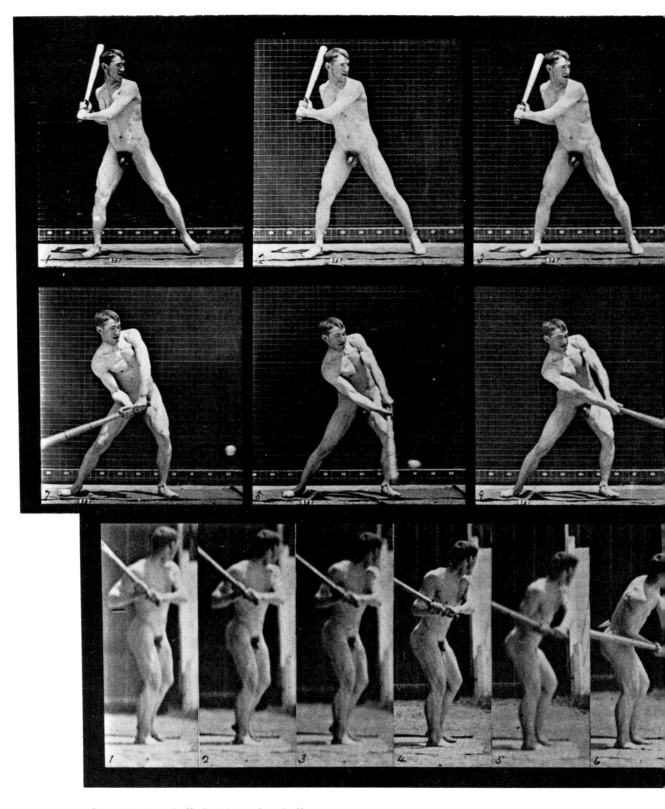

Plate 275. Baseball, batting a low ball.

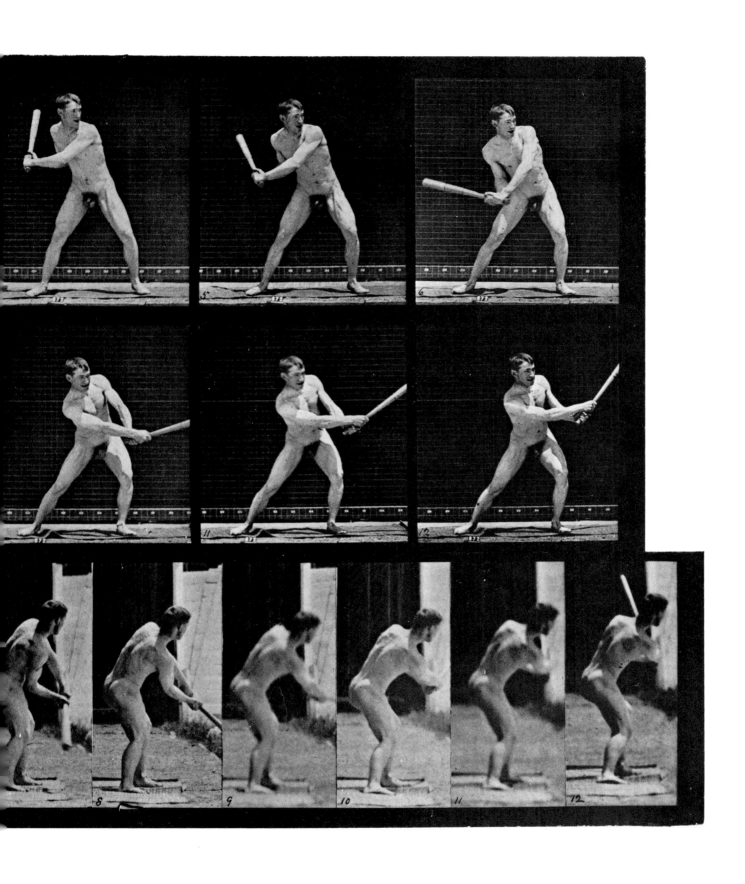

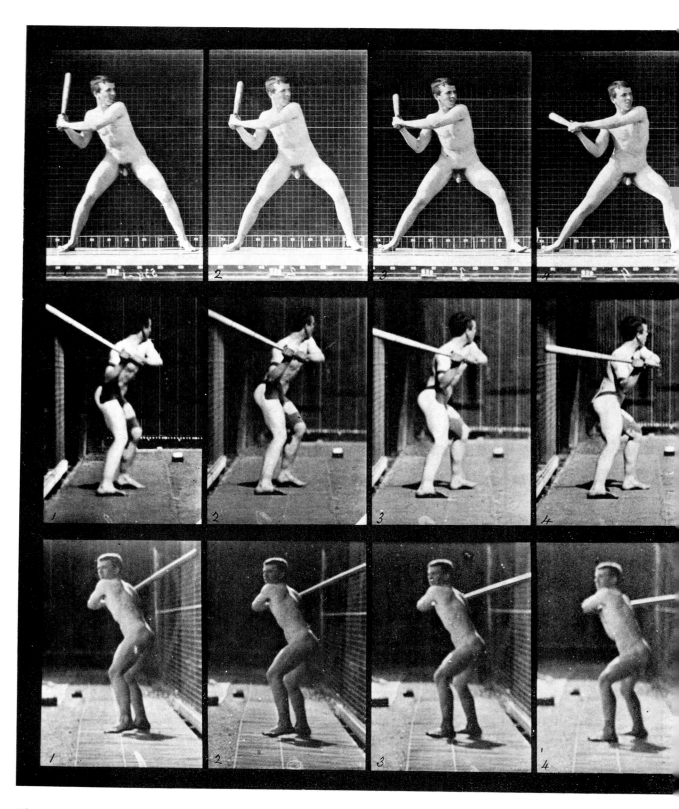

Plate 276. Baseball, batting.

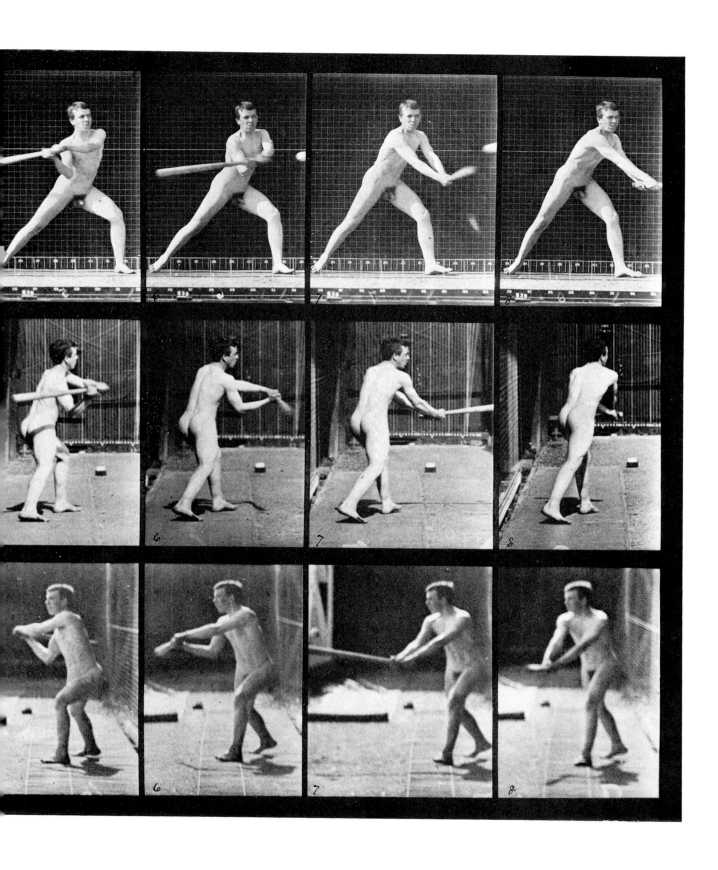

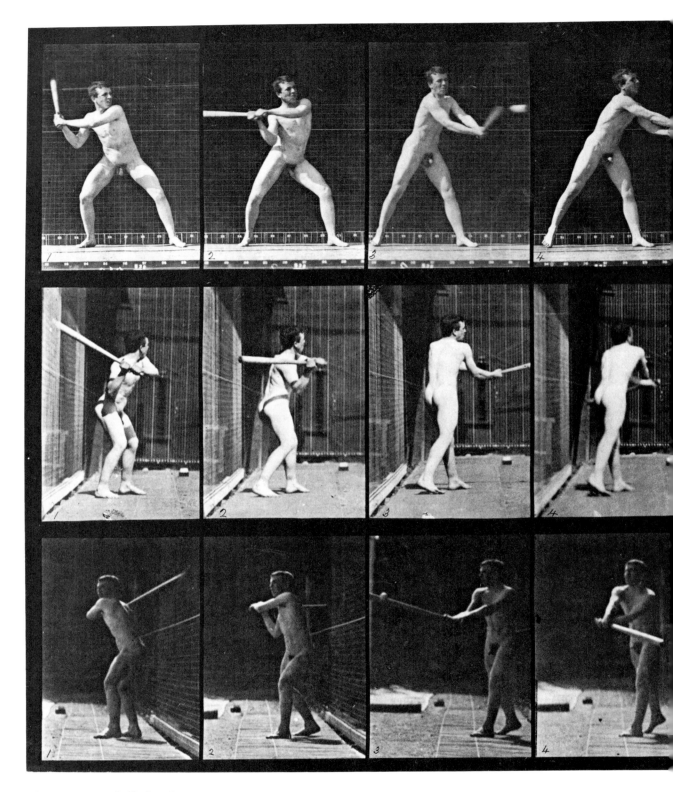

Plate 277. Baseball, batting.

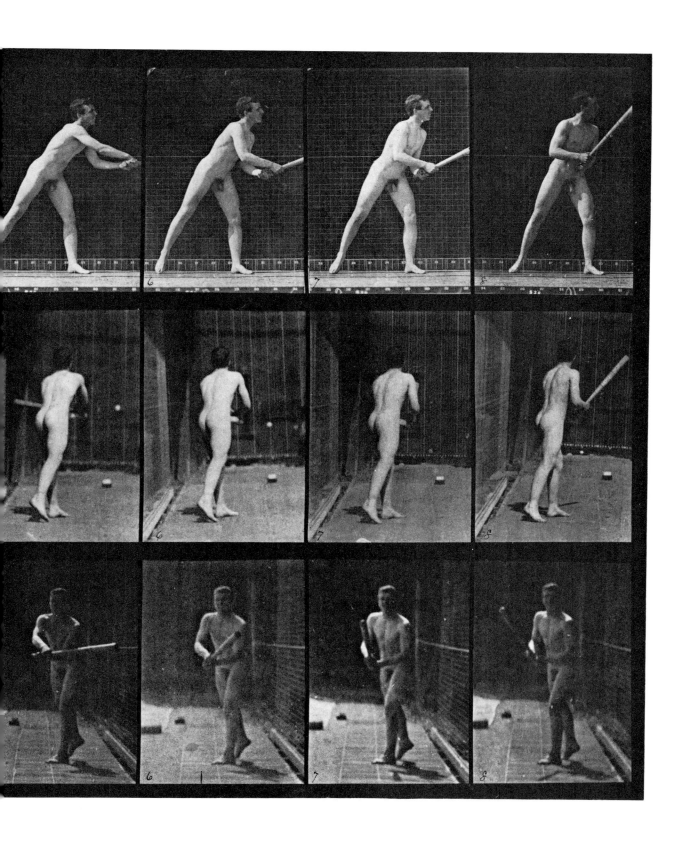

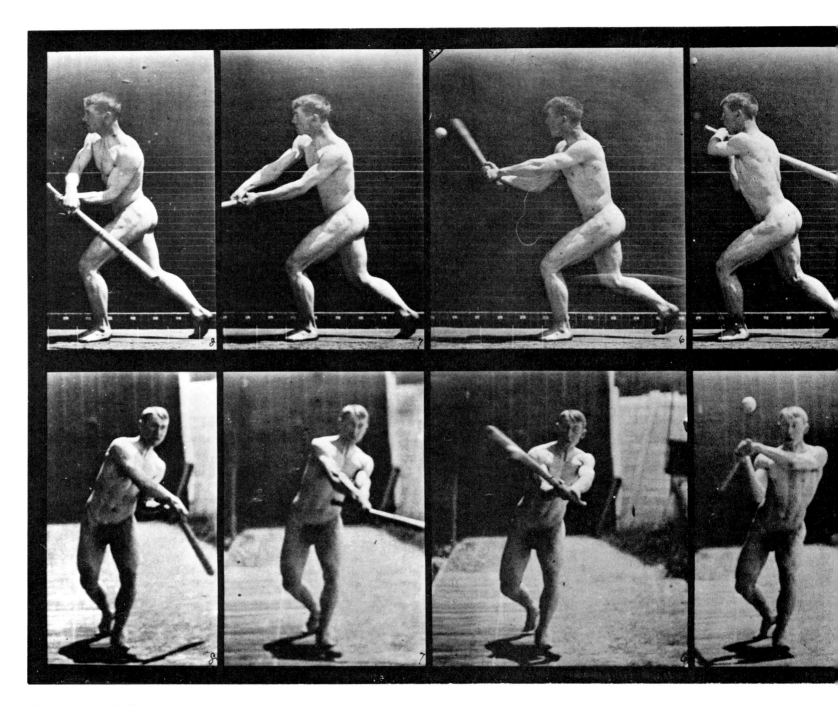

Plate 278. Baseball, batting.

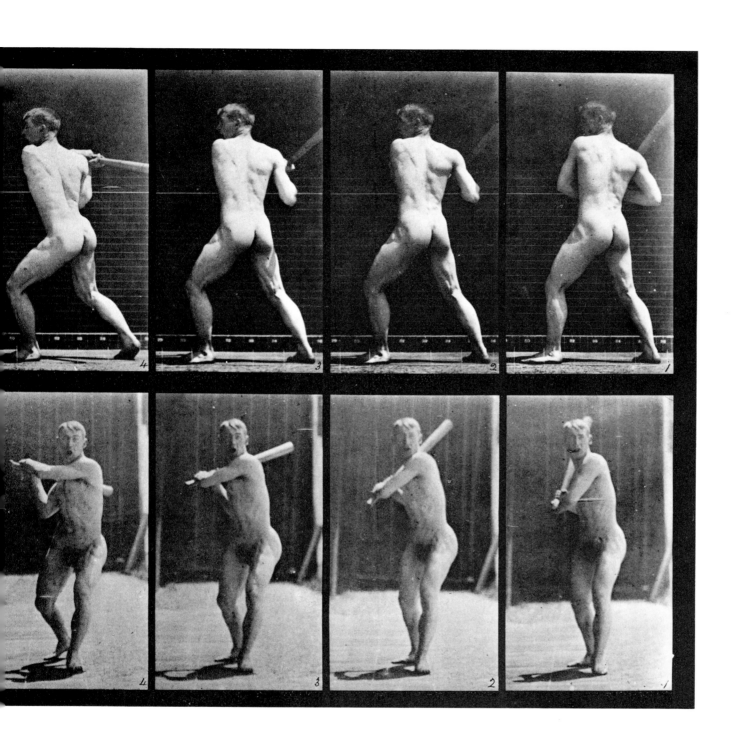

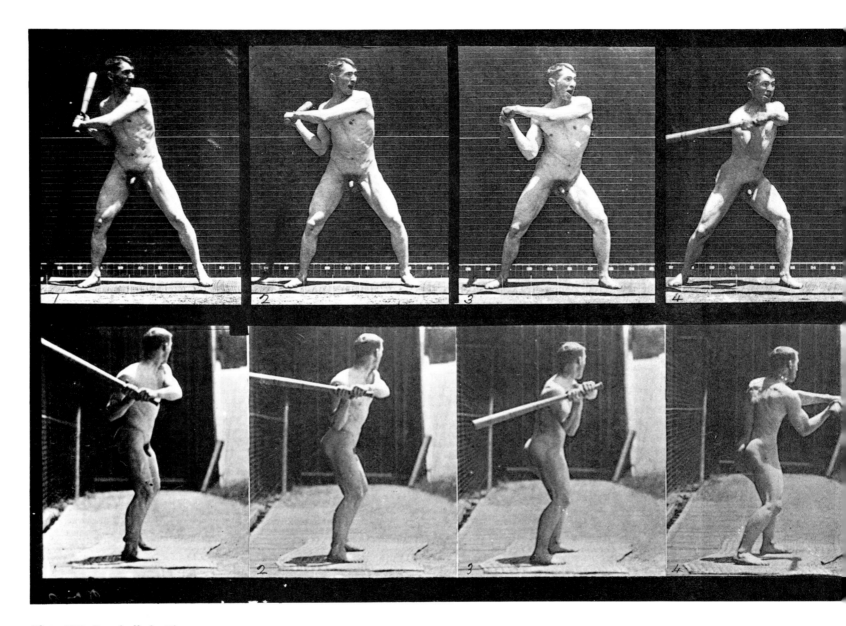

Plate 279. Baseball, batting.

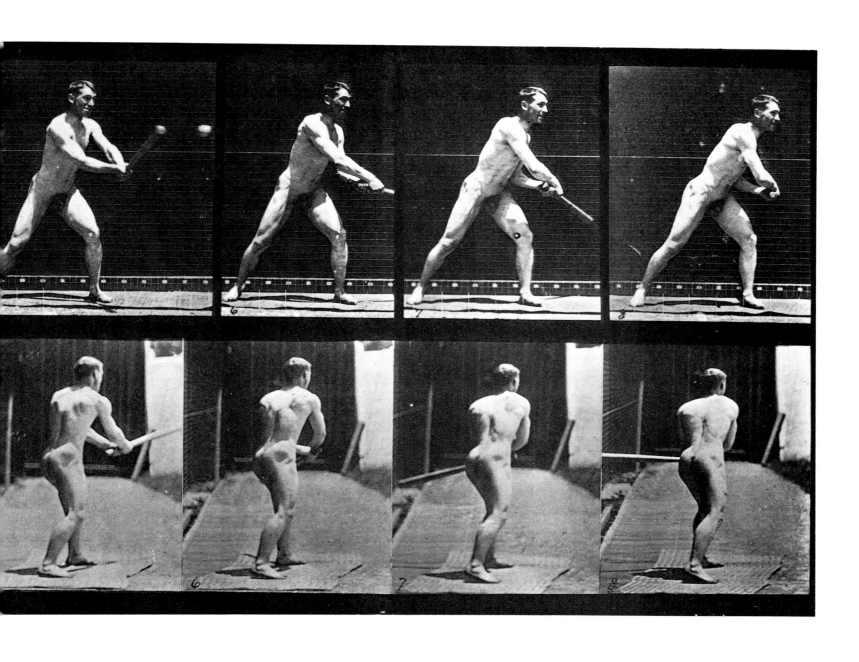

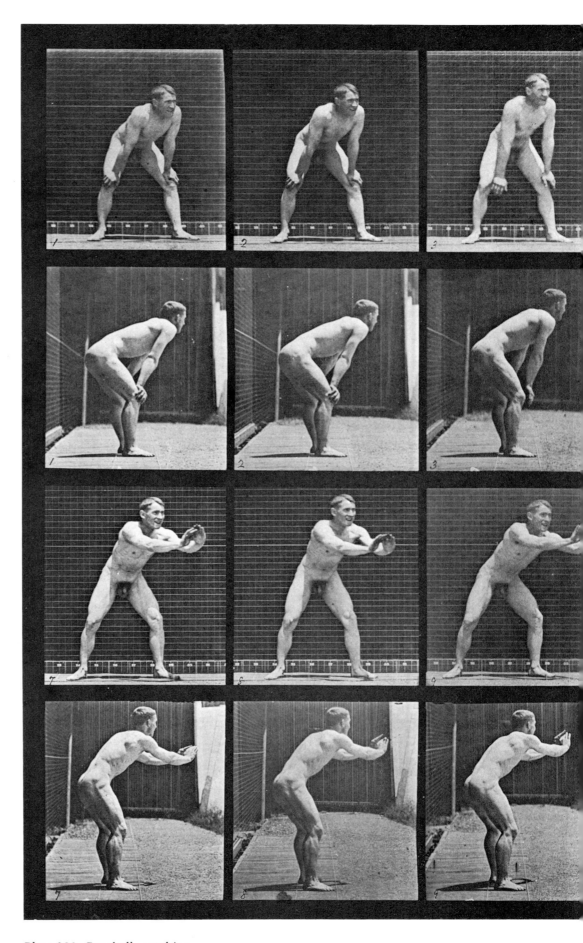

Plate 280. Baseball, catching.

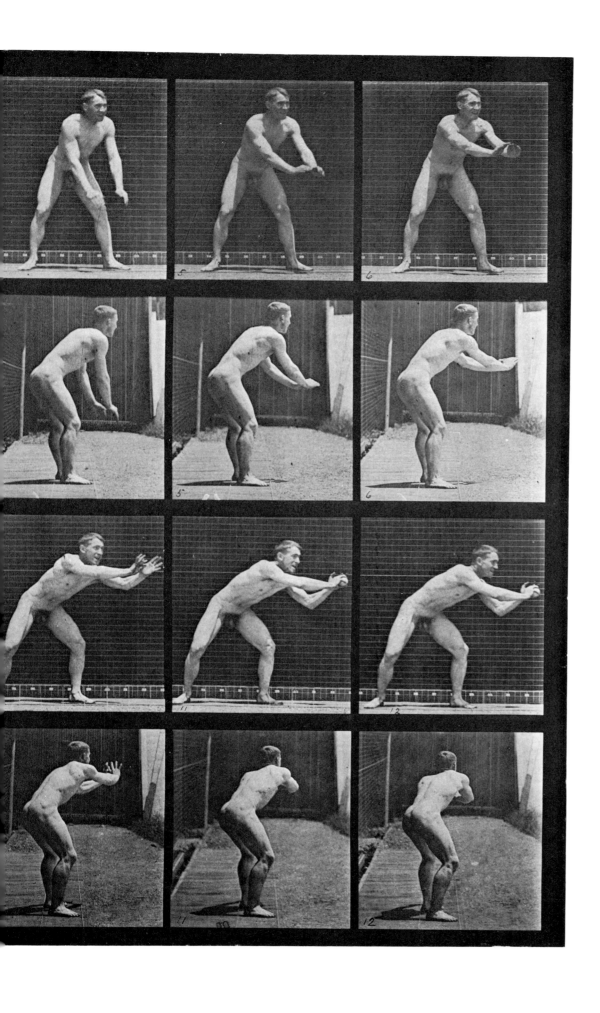

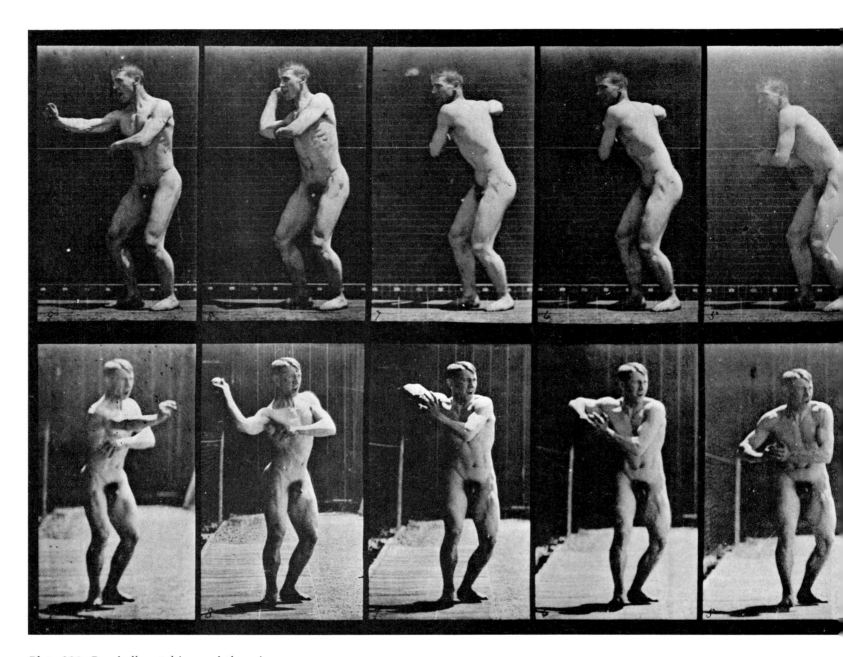

Plate 281. Baseball, catching and throwing.

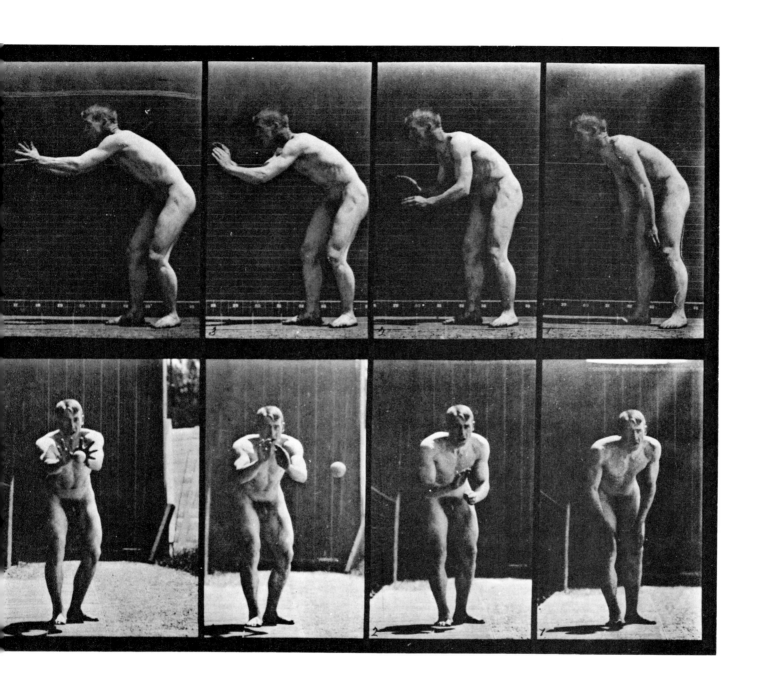

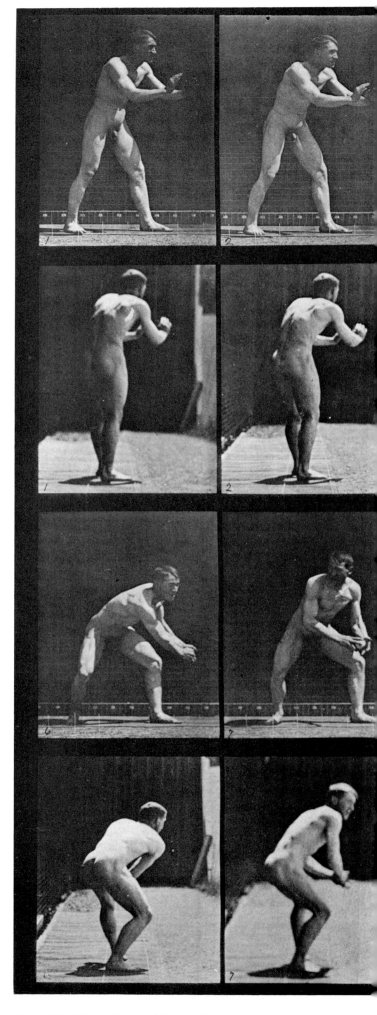

Plate 282. Baseball, catching and throwing.

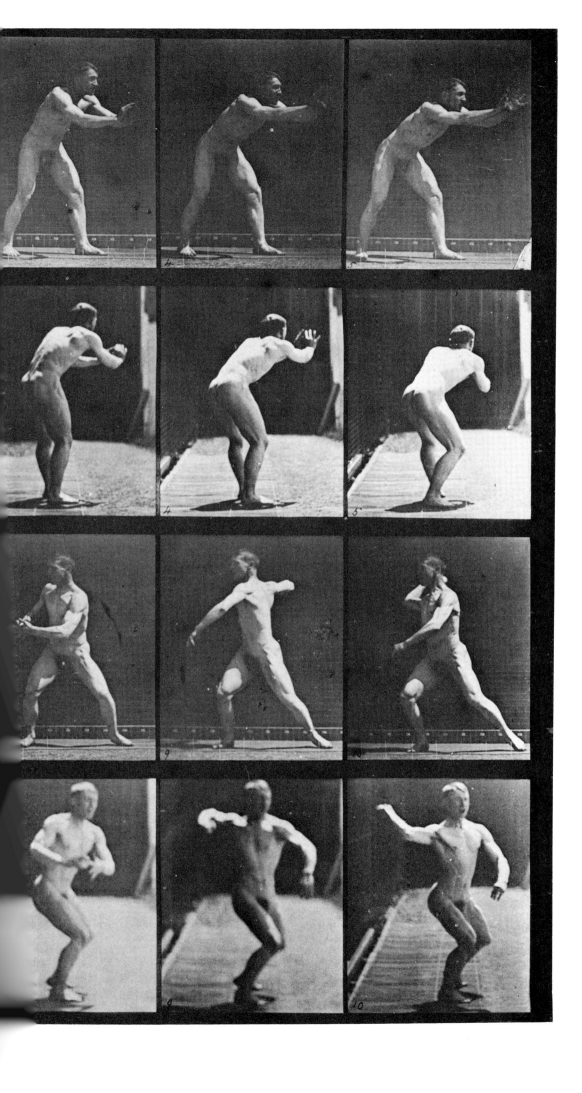

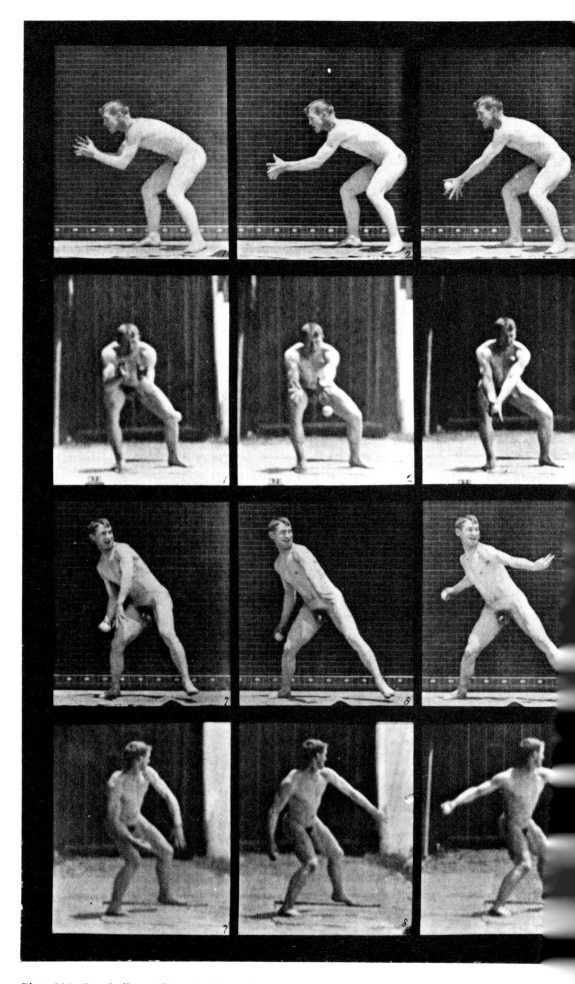

Plate 283. Baseball, catching and throwing.

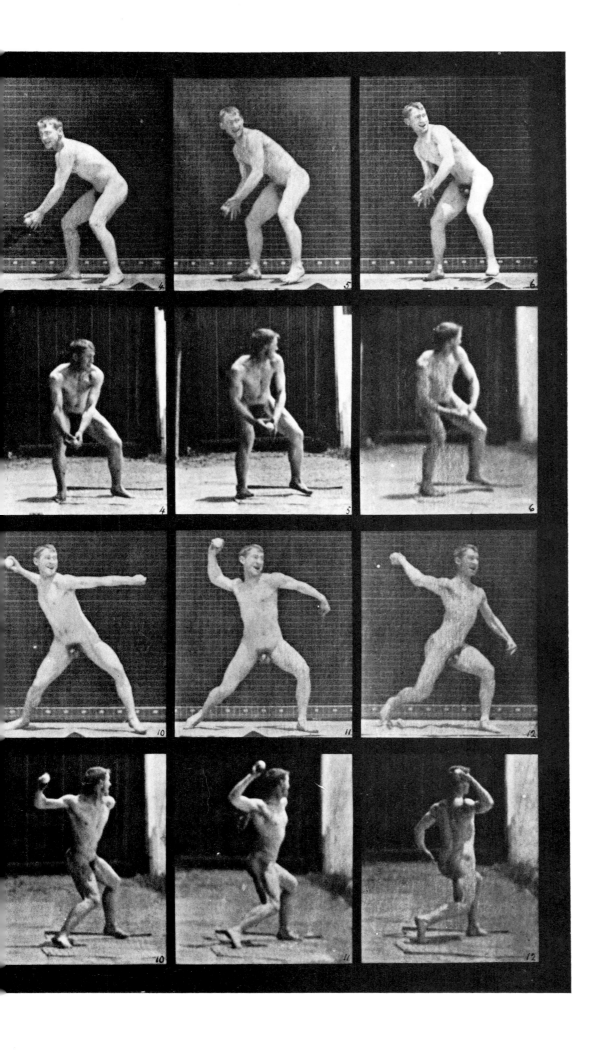

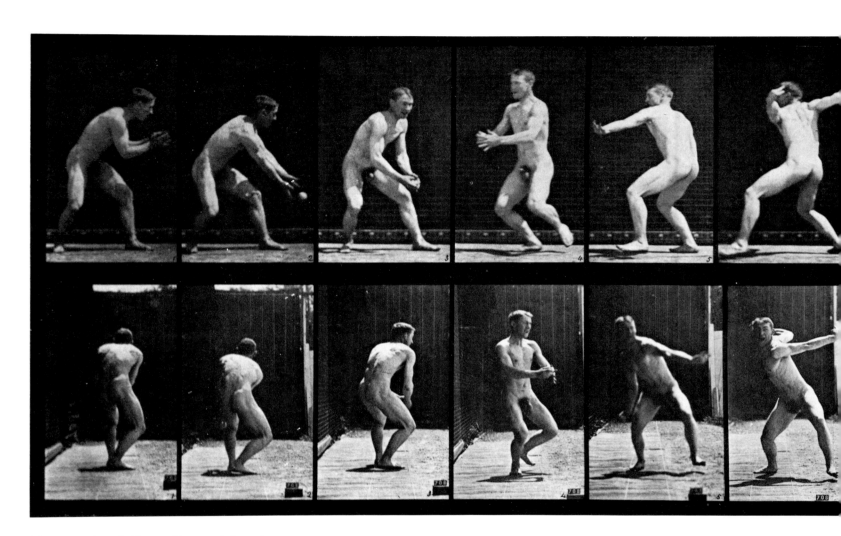

Plate 284. Baseball, catching and throwing.

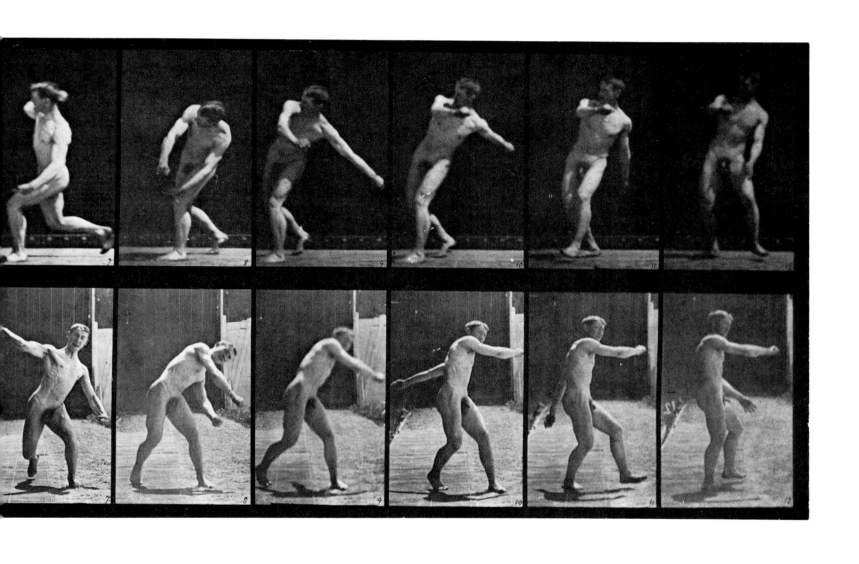

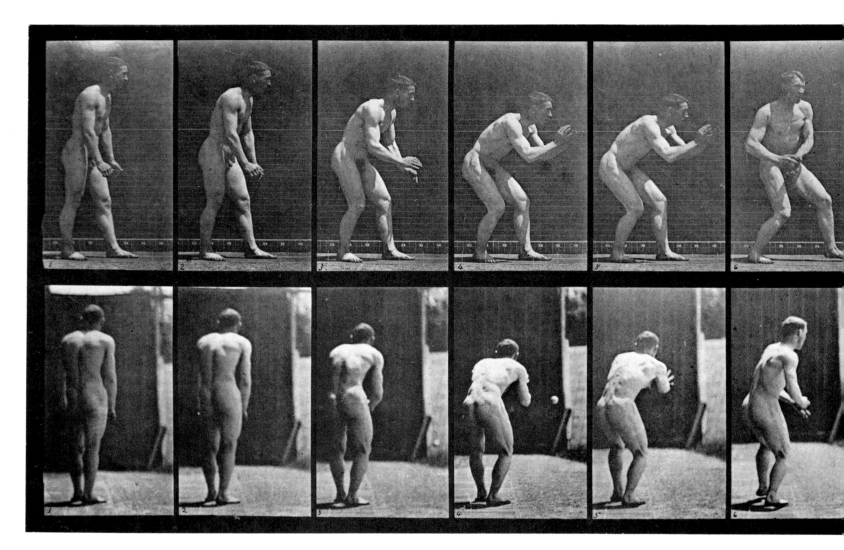

Plate 285. Baseball, catching and throwing.

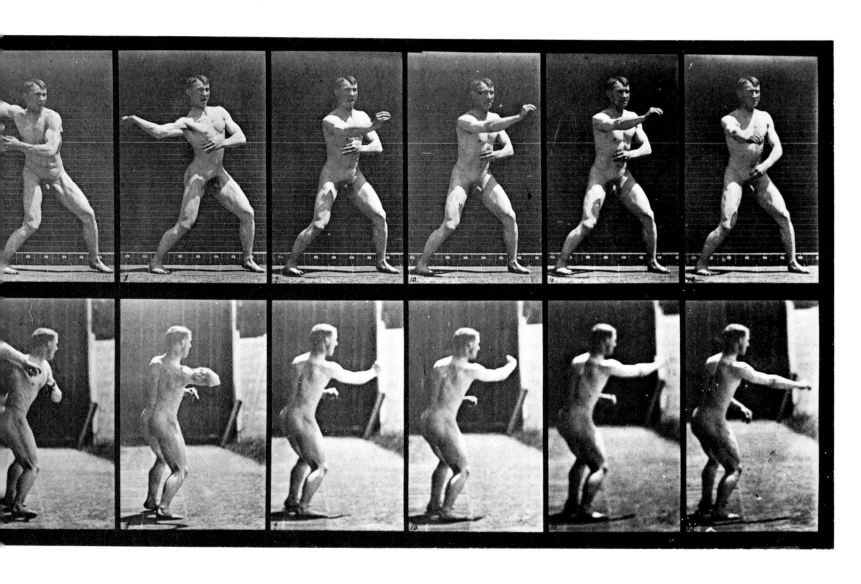

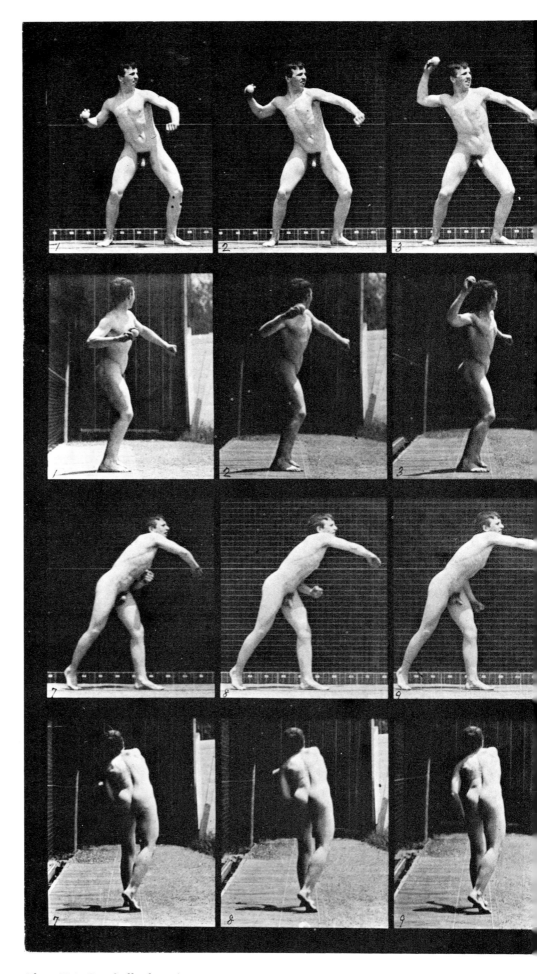

Plate 286. Baseball, throwing.

126 MALES (NUDE)

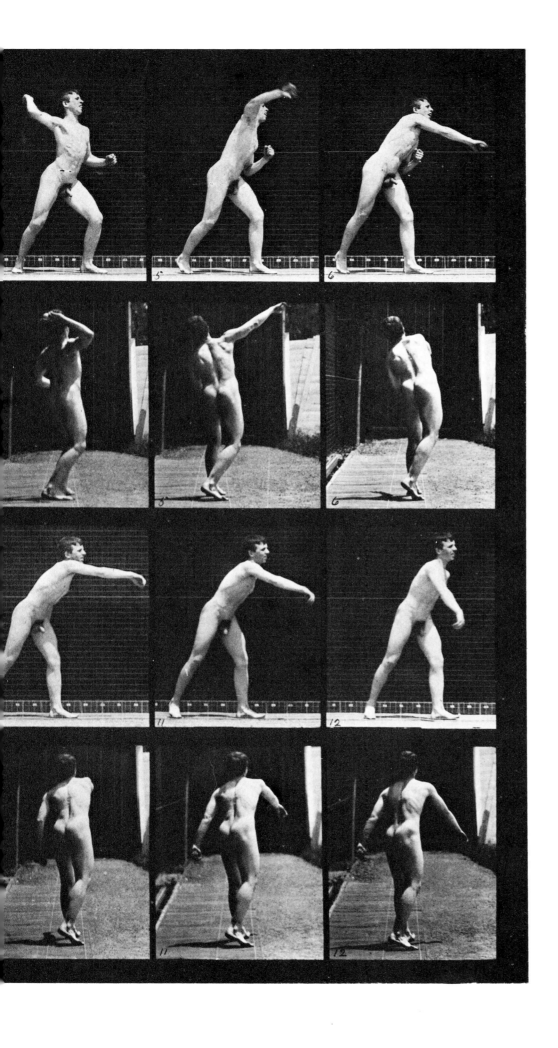

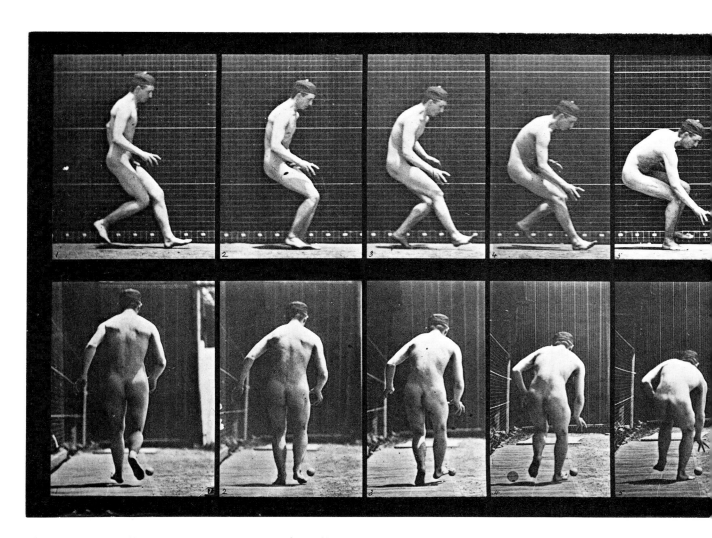

Plate 287. Baseball, running and picking up the ball.

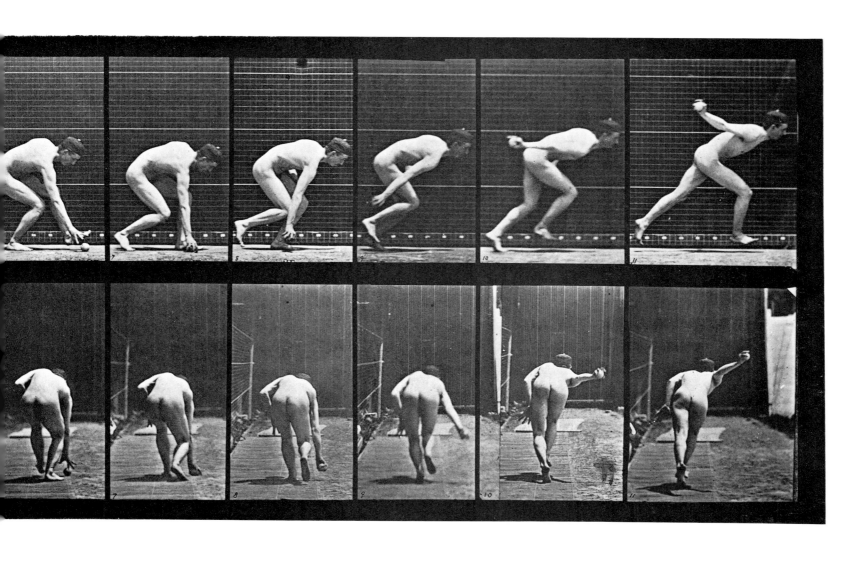

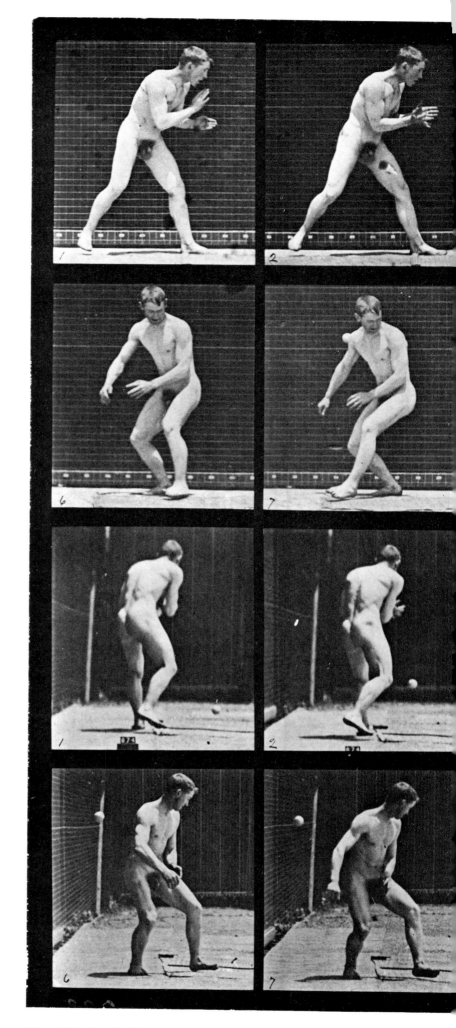

Plate 288. Baseball, error.

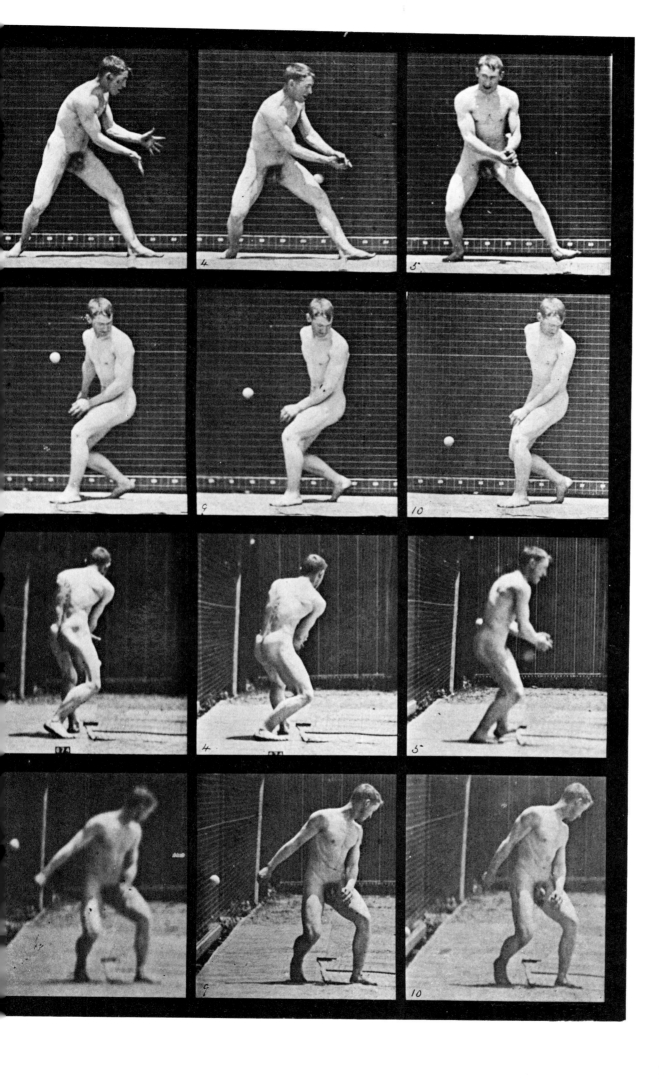

Volume 2

MALES
(Nude); continued

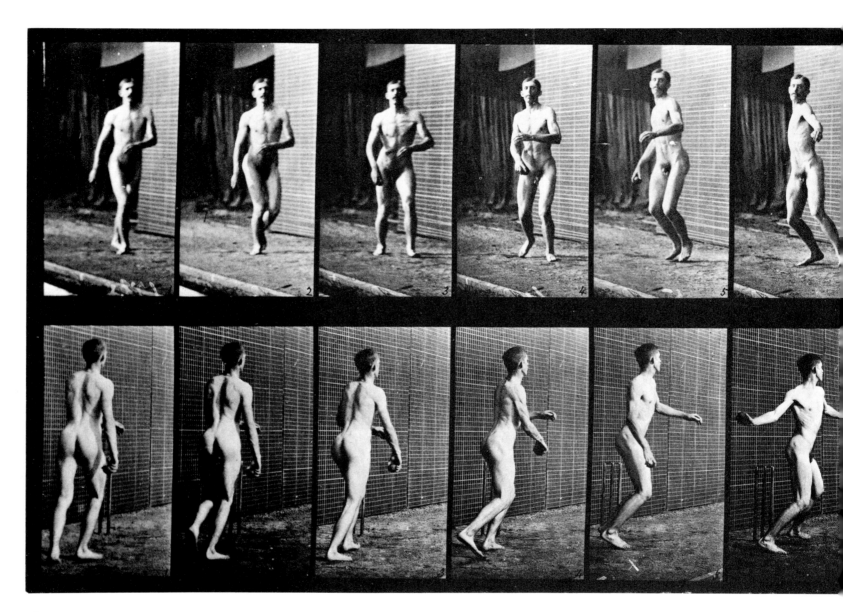

Plate 289. Cricket, round-arm bowling.

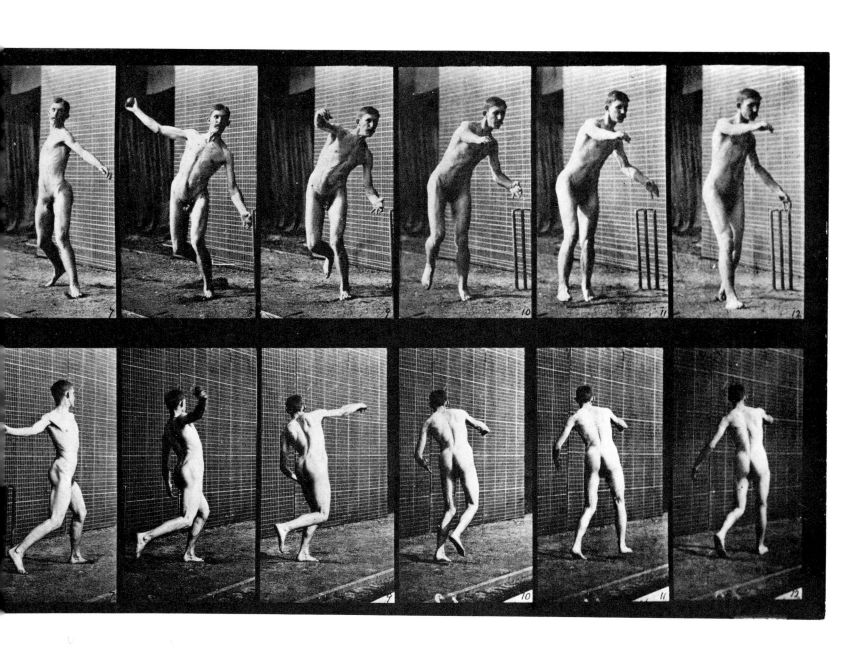

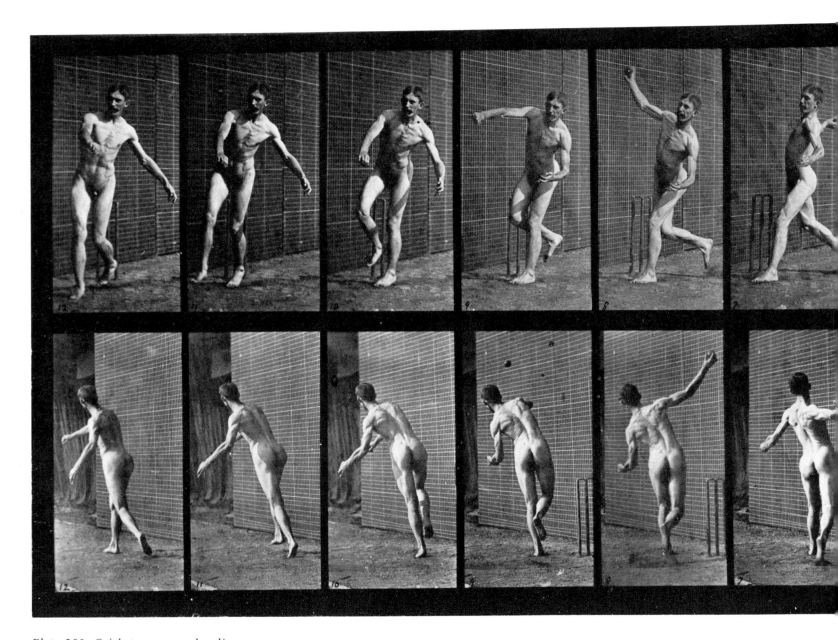

Plate 290. Cricket, overarm bowling.

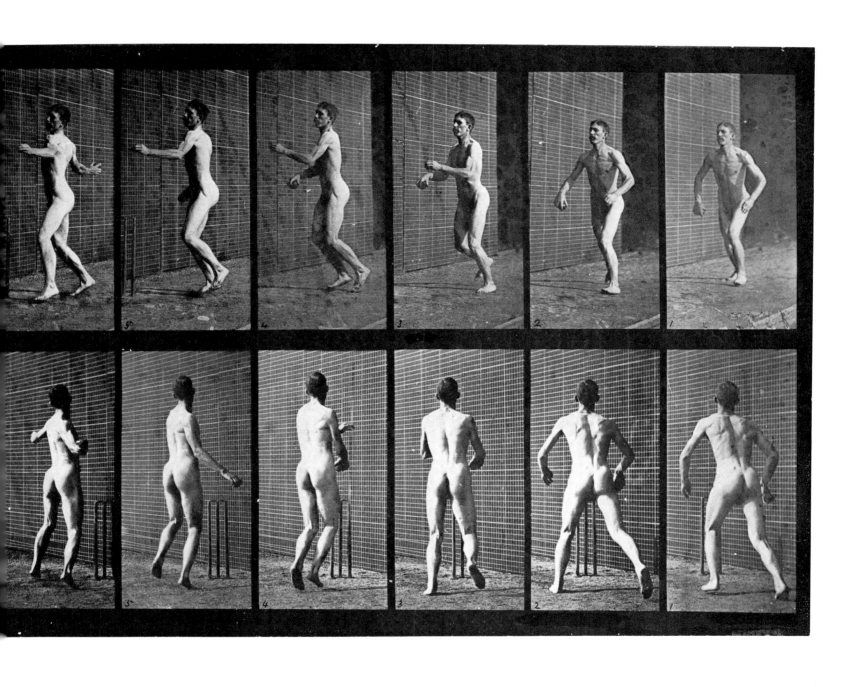

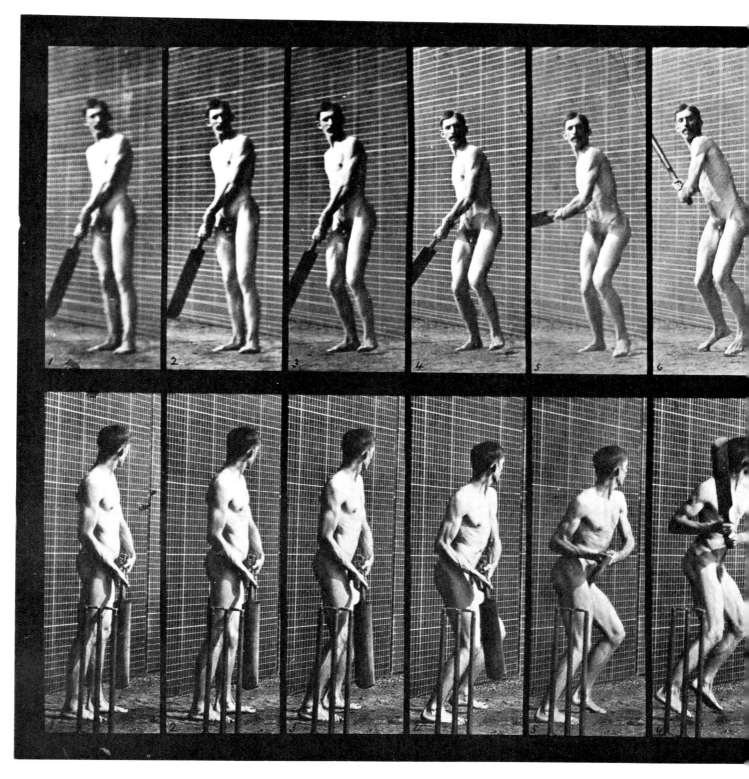

Plate 291. Cricket, batting and drive.

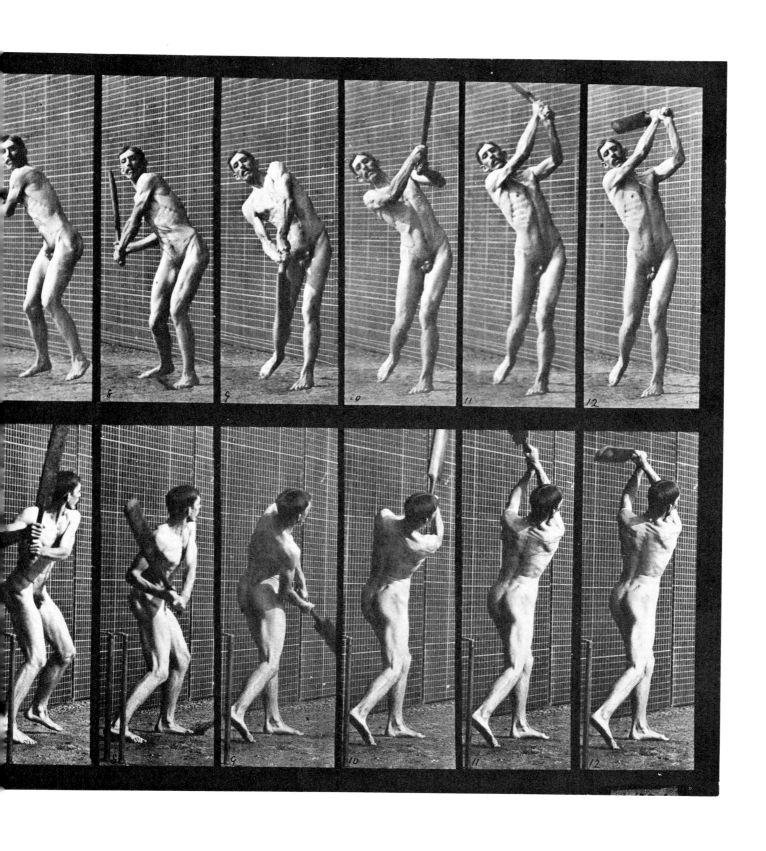

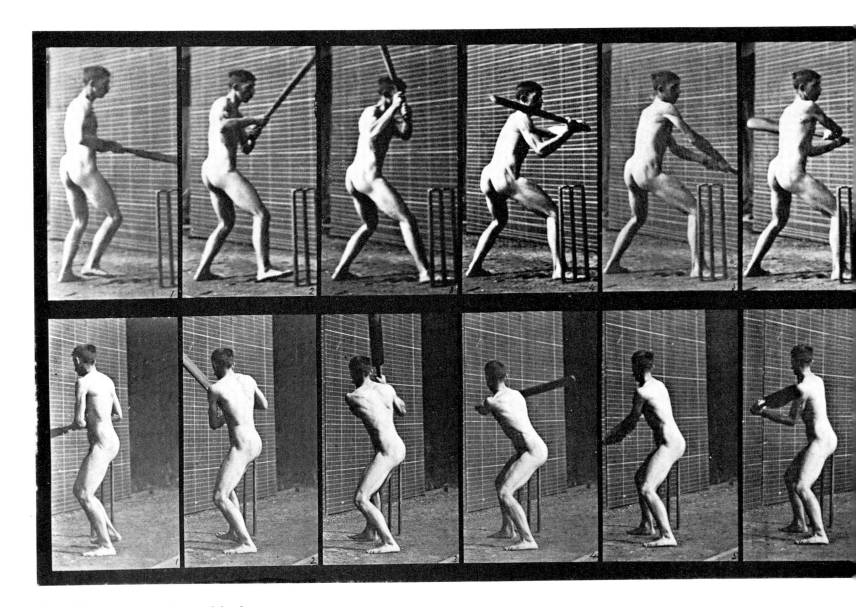

Plate 292. Cricket, batting and back cut.

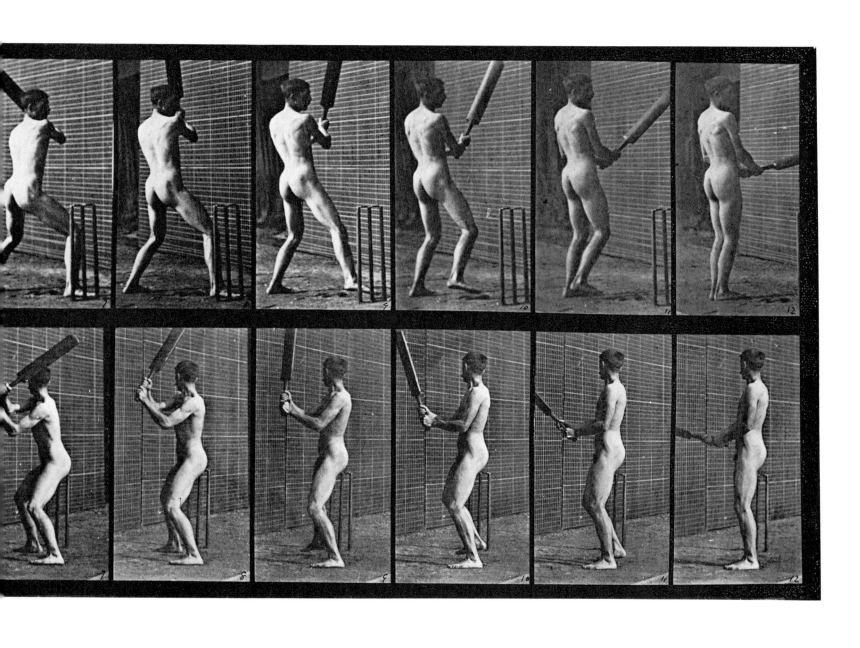

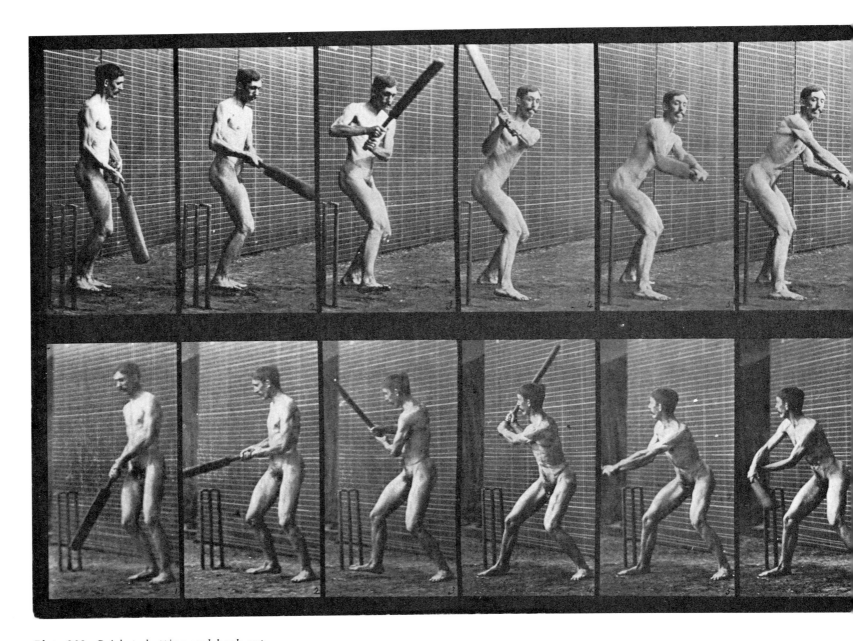

Plate 293. Cricket, batting and back cut.

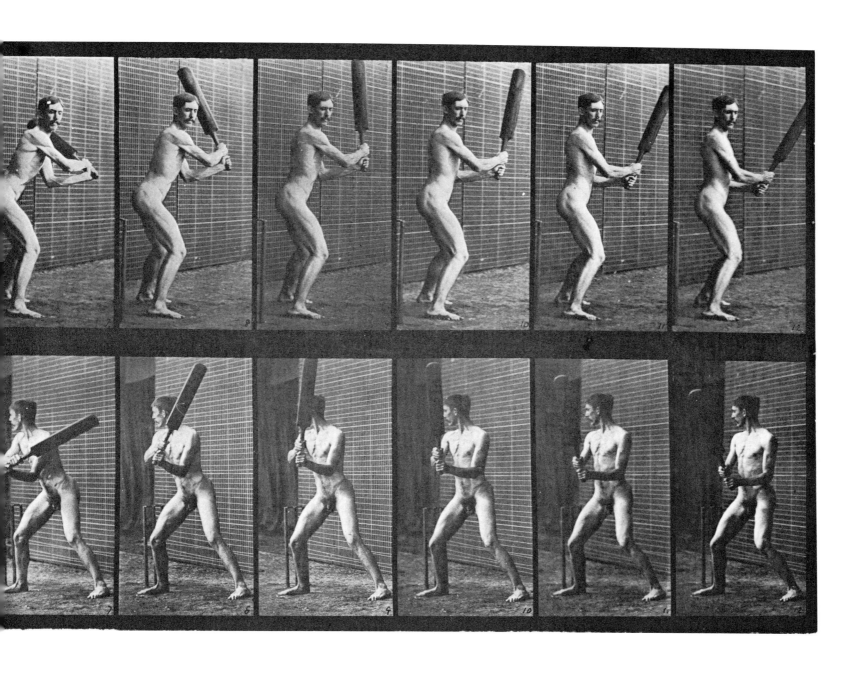

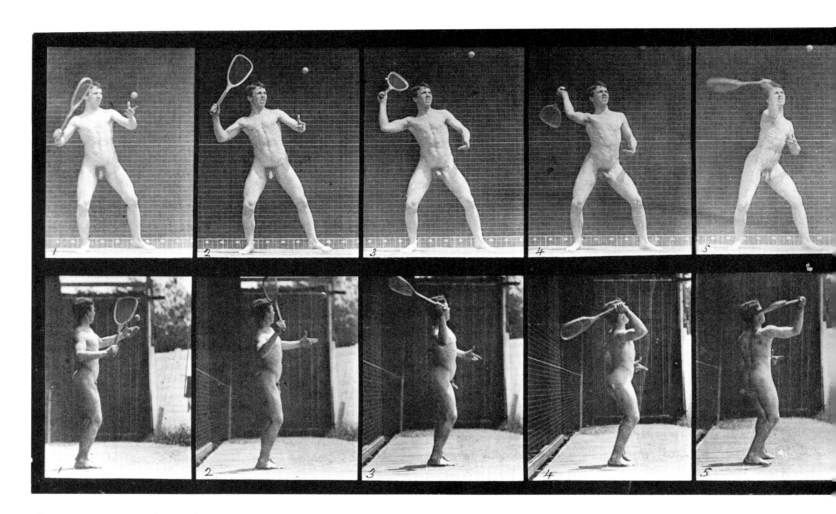

Plate 294. Lawn tennis, serving.

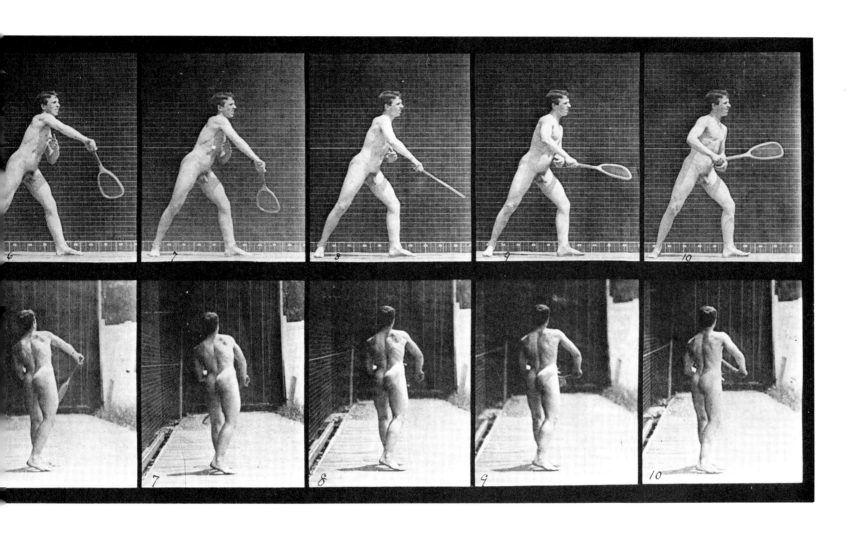

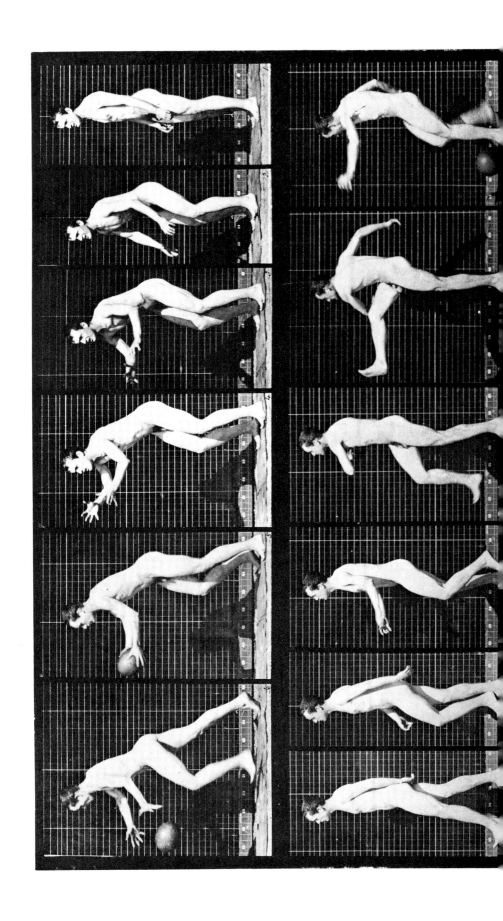

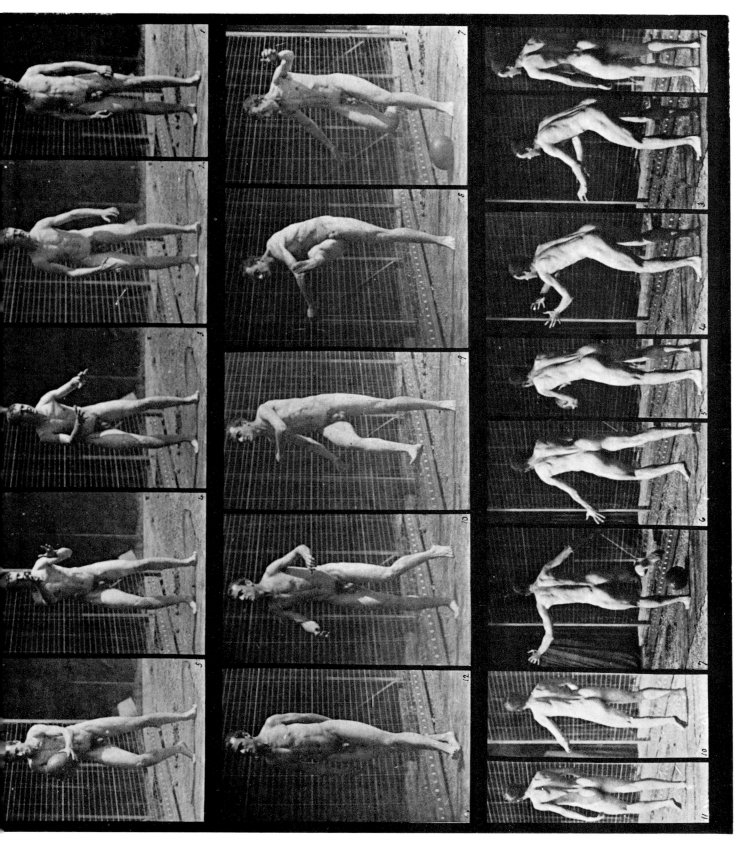

Plate 300. Football, drop kick.

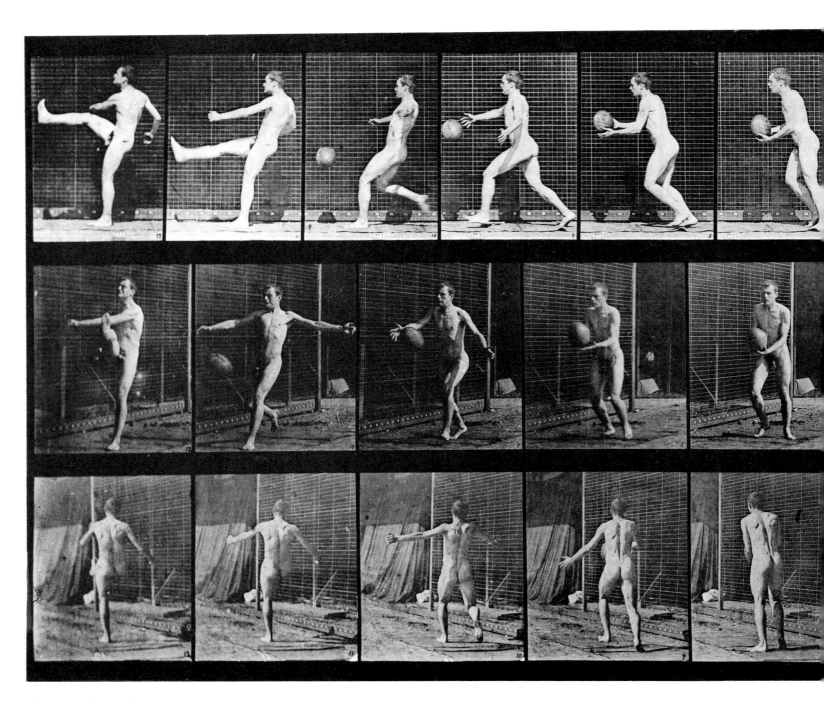

Plate 301. Football, punt.

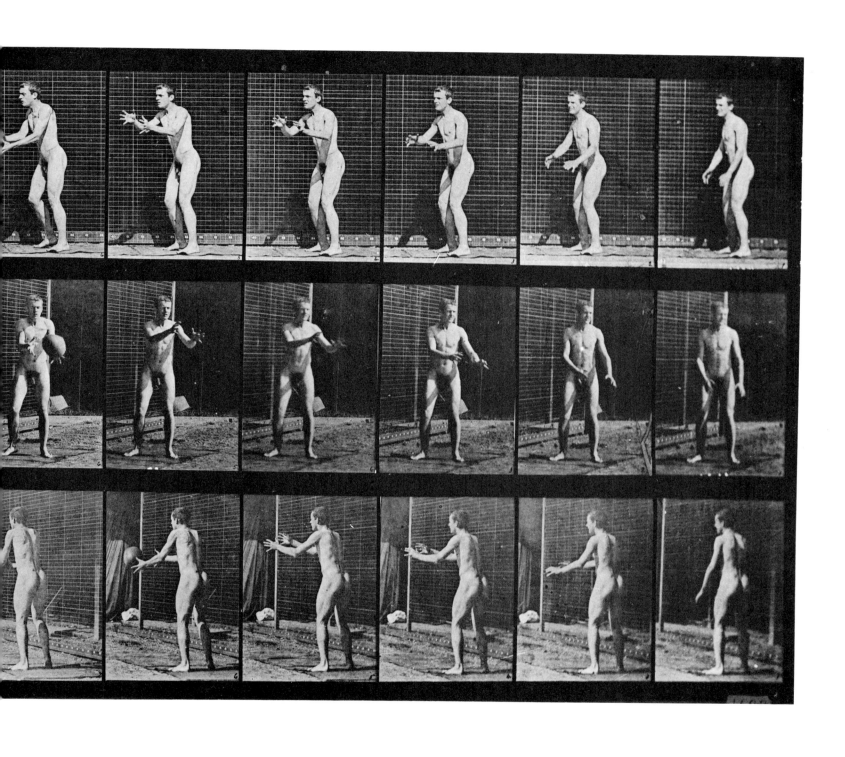

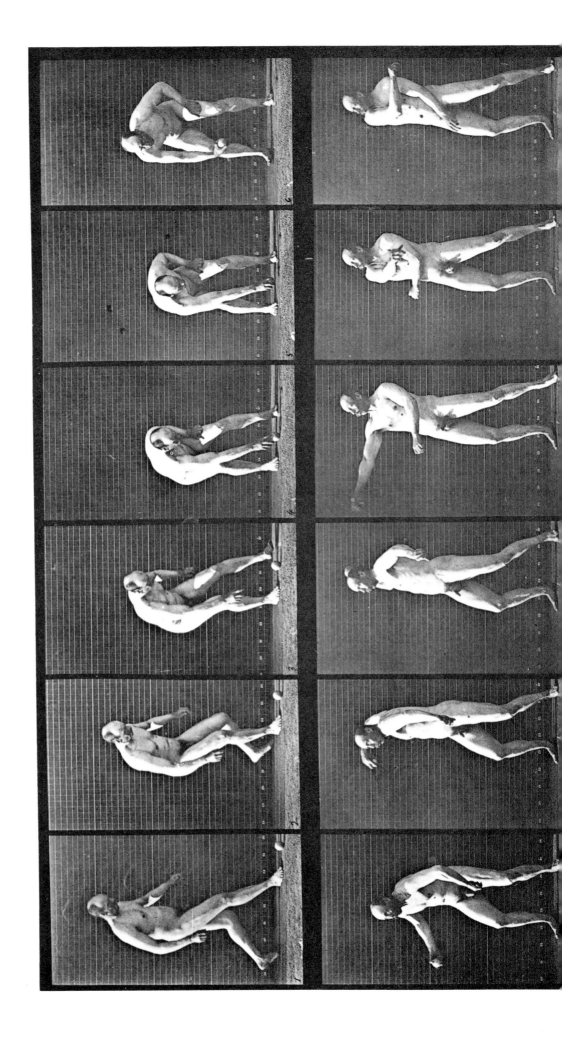

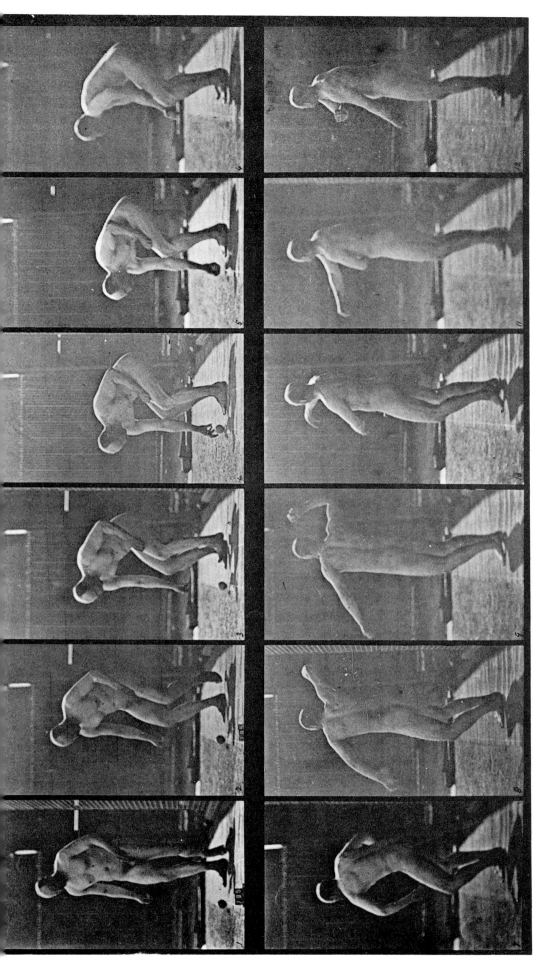

Plate 302. Picking up a ball and throwing it.

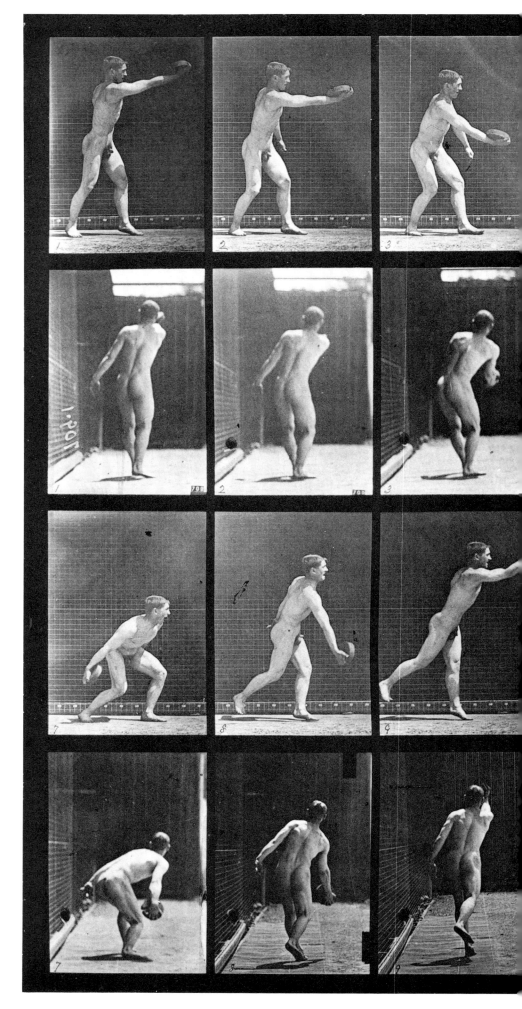

Plate 307. Throwing an iron disk.

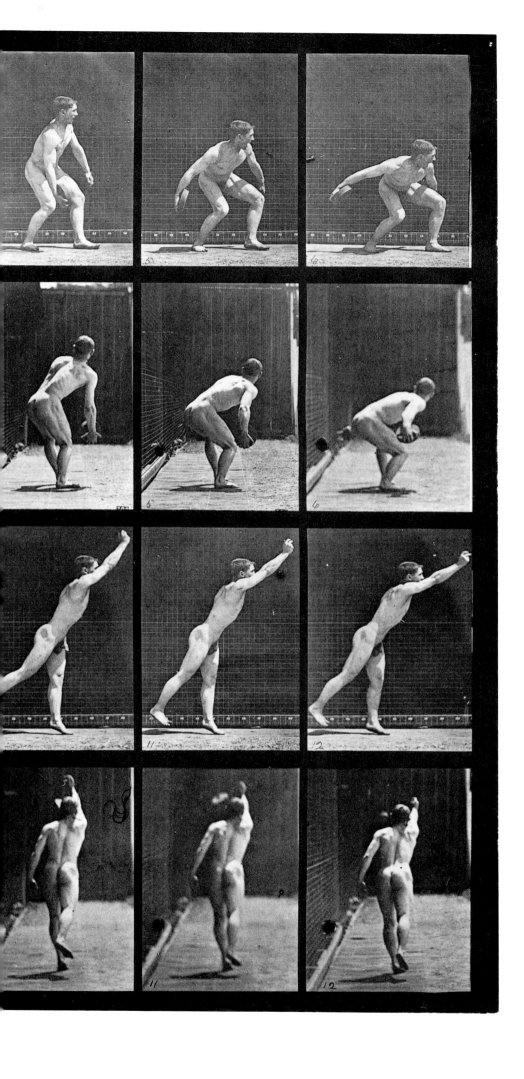

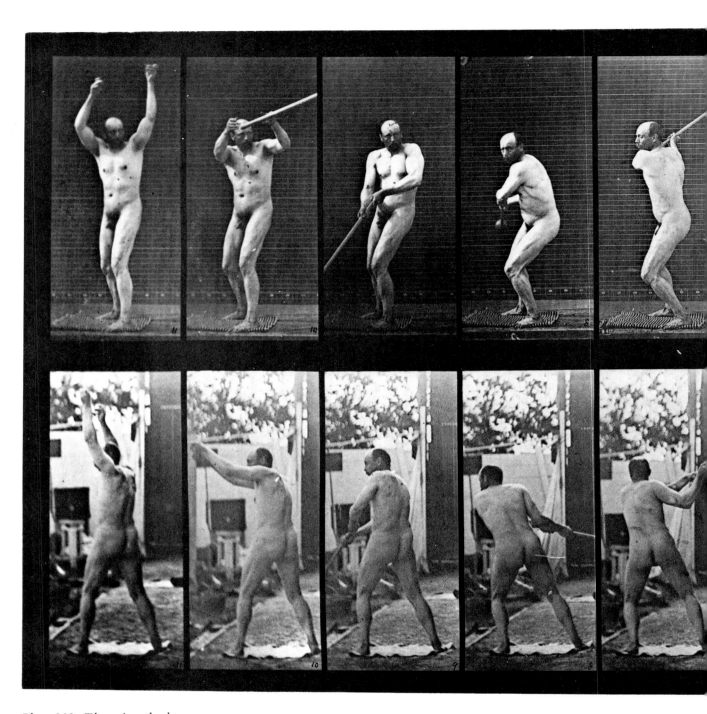

Plate 308. Throwing the hammer.

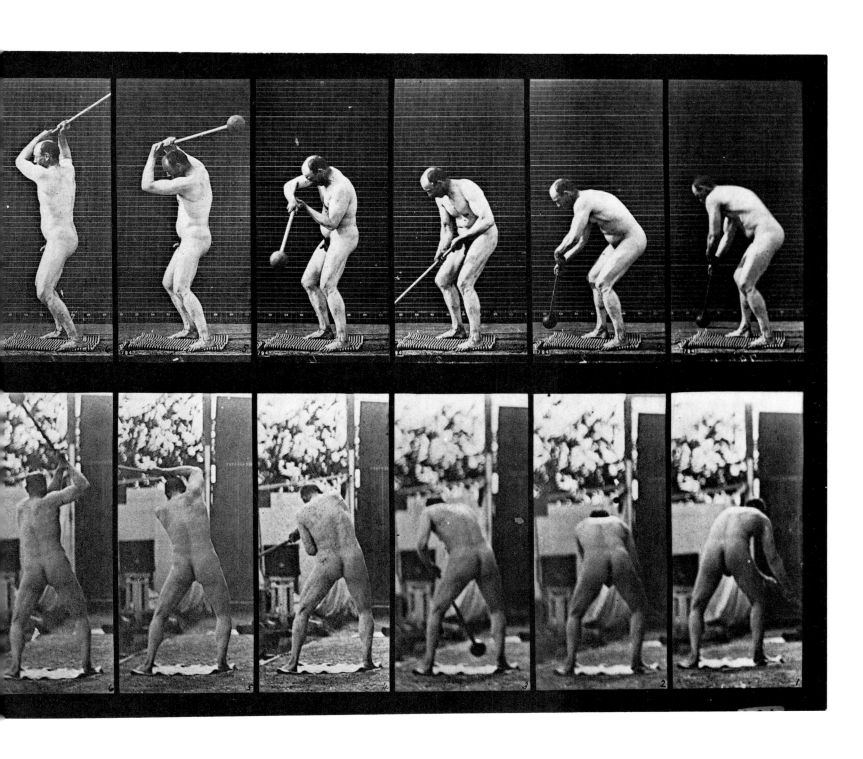

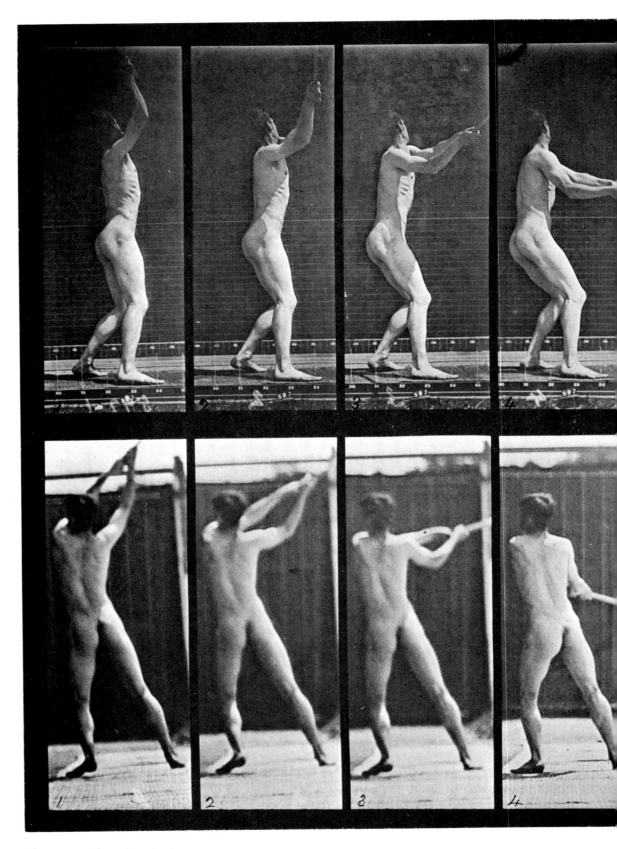

Plate 309. Throwing the hammer.

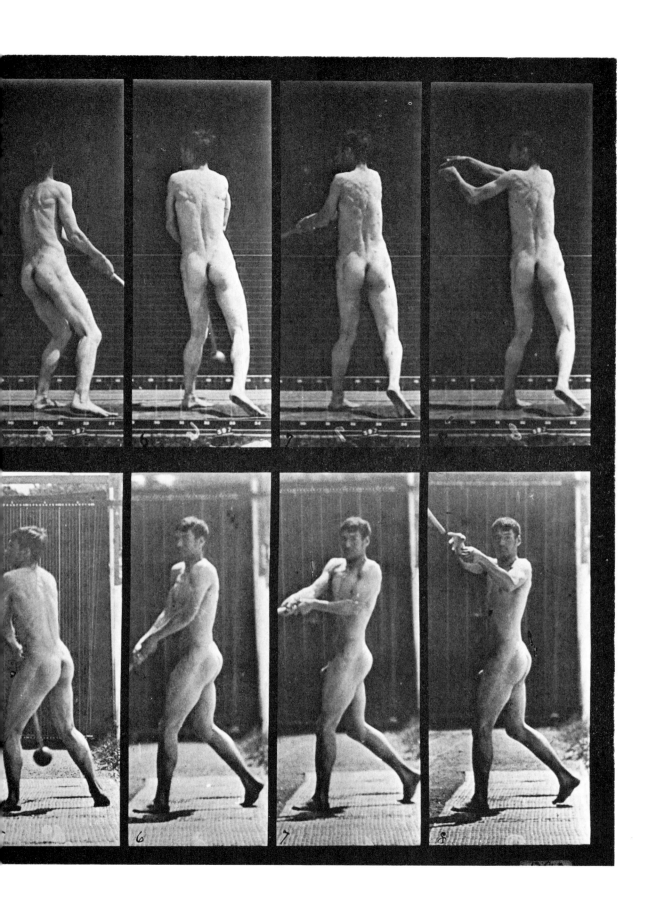

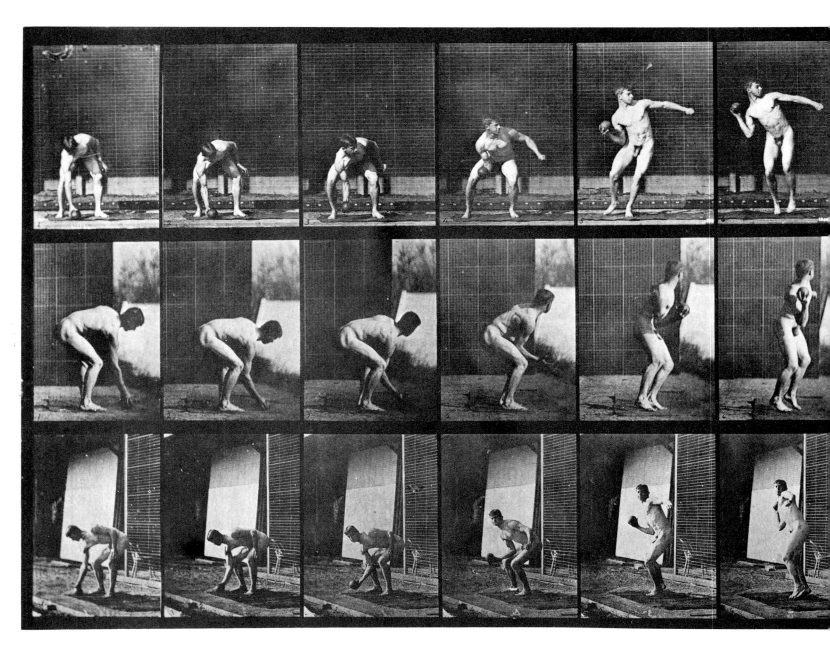

Plate 310. Putting the shot.

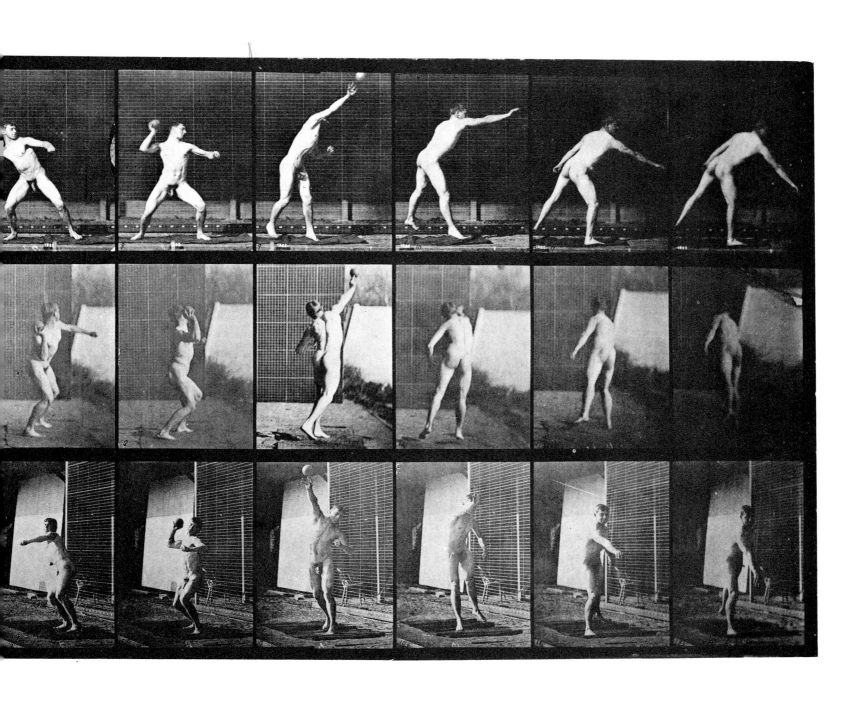

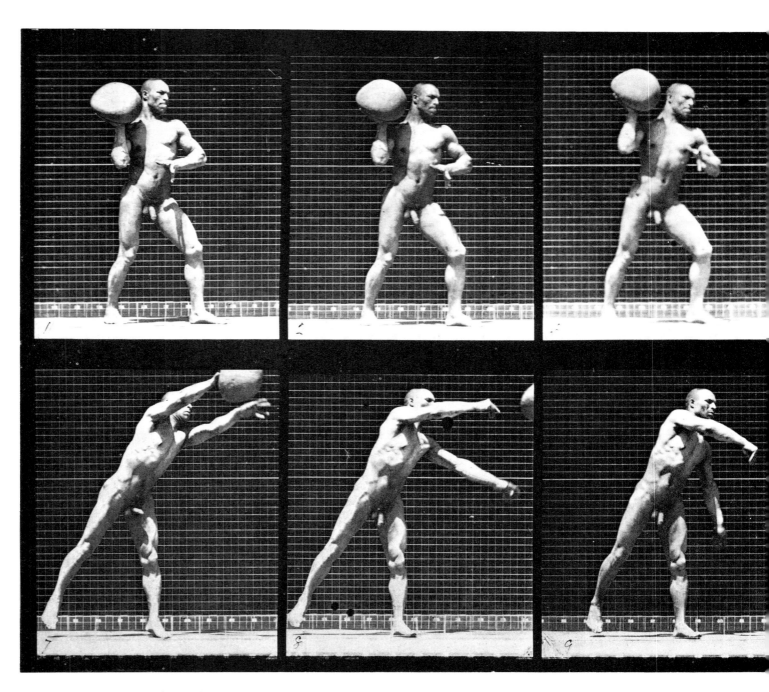

Plate 311. Heaving a 75-lb. rock.

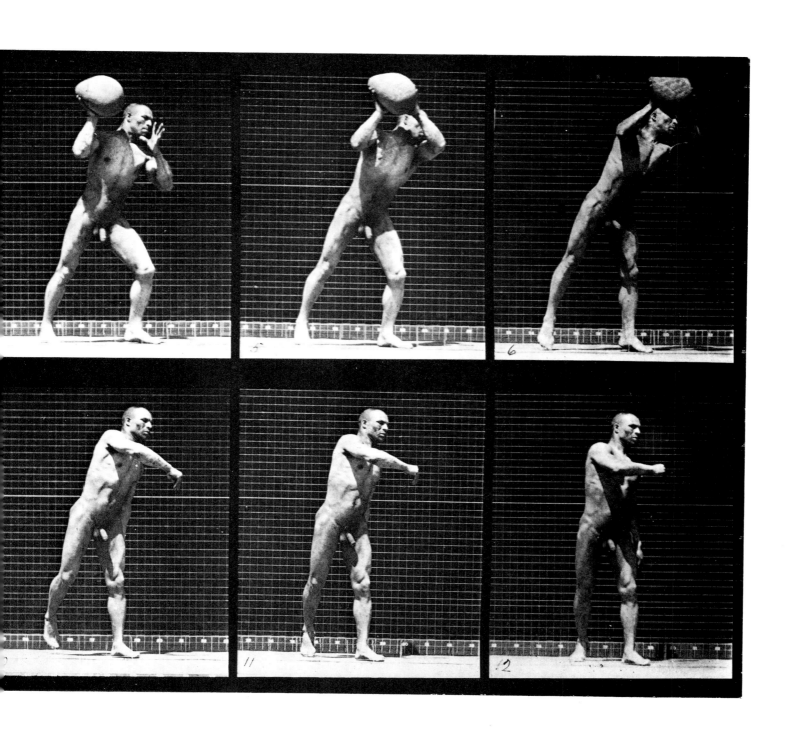

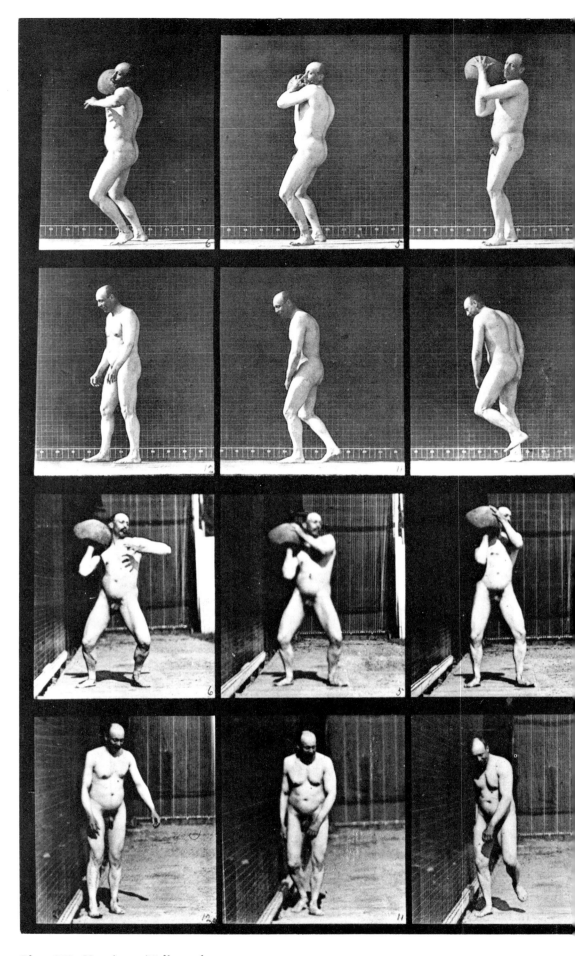

Plate 312. Heaving a 75-lb. rock.

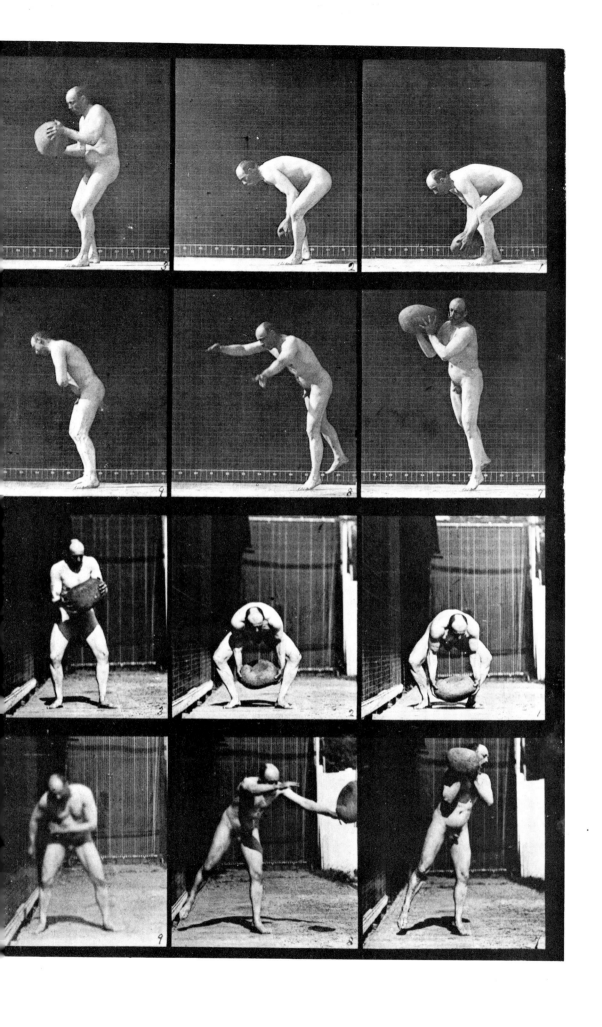

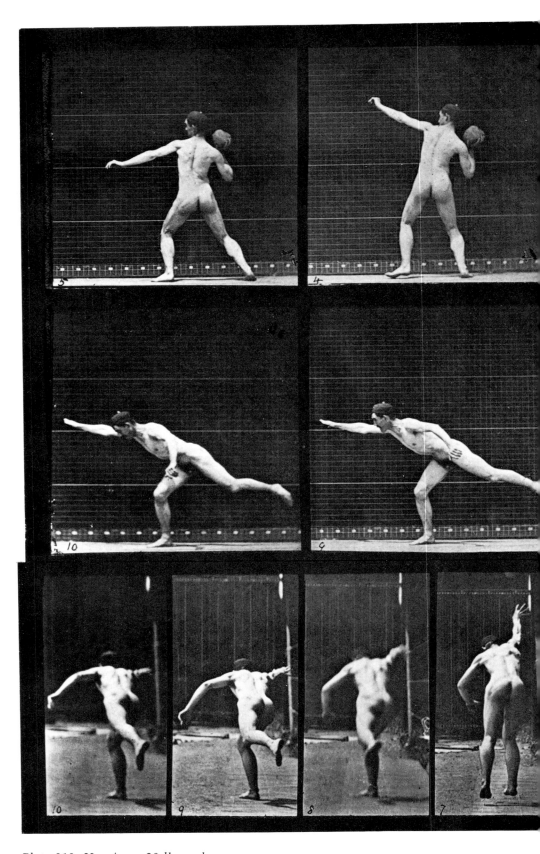

Plate 313. Heaving a 20-lb. rock.

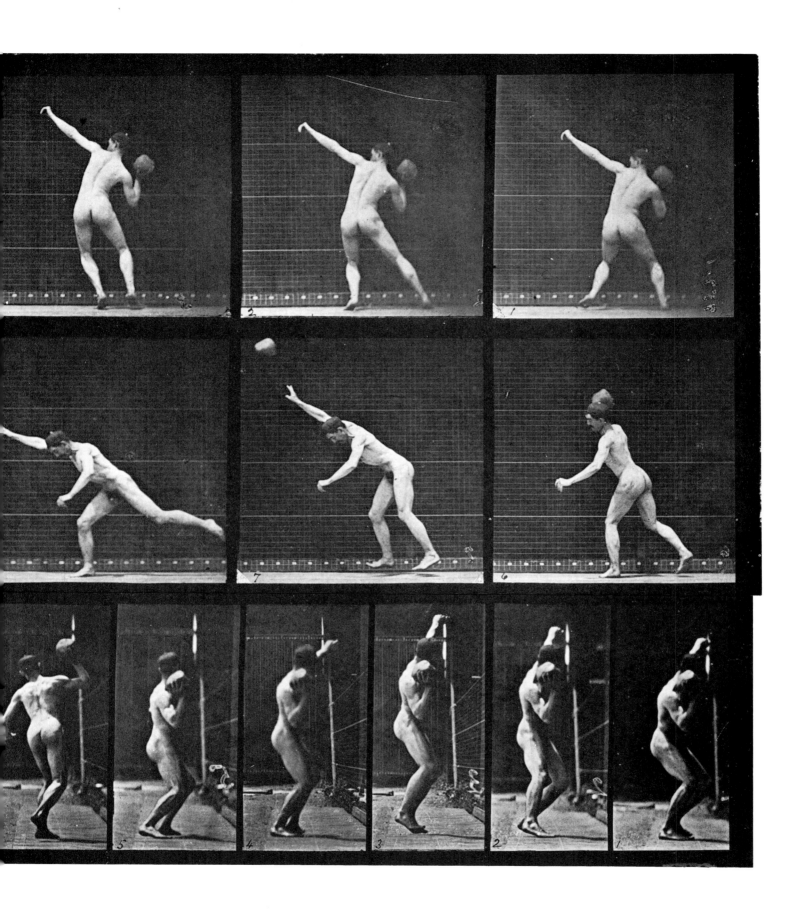

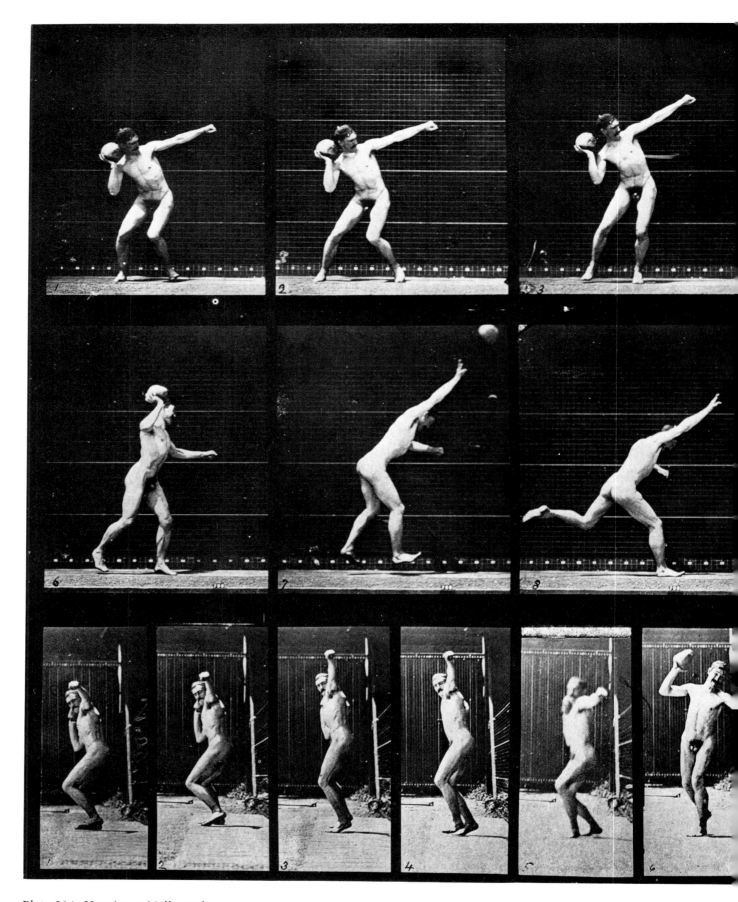

Plate 314. Heaving a 20-lb. rock.

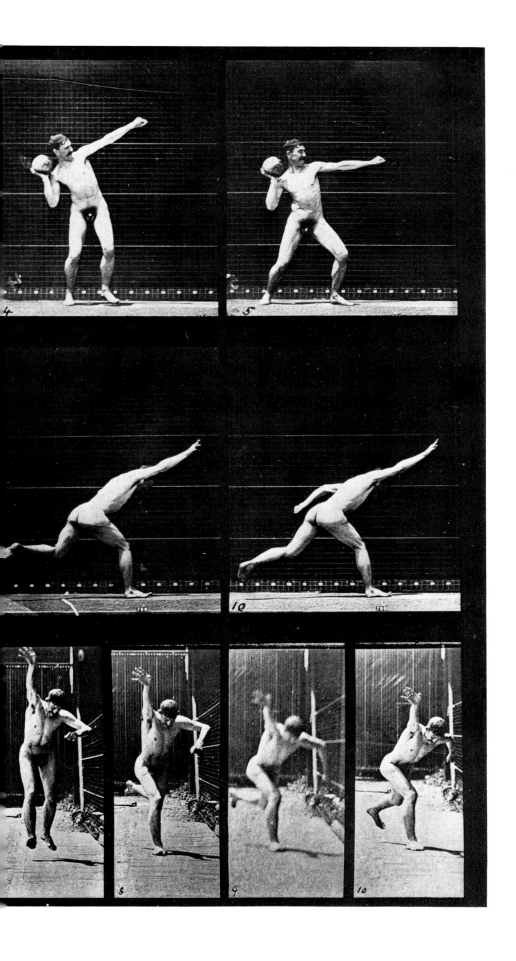

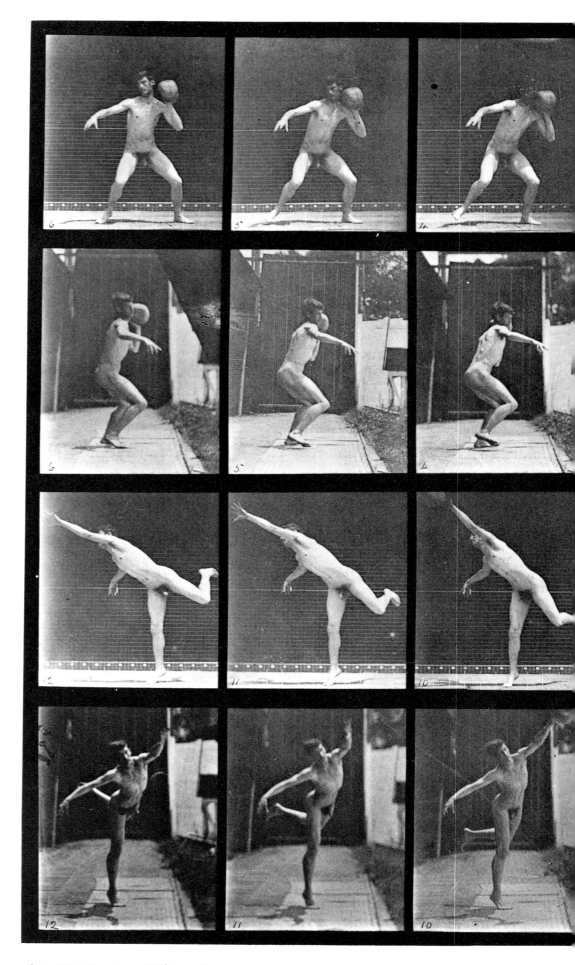

Plate 315. Heaving a 20-lb. rock.

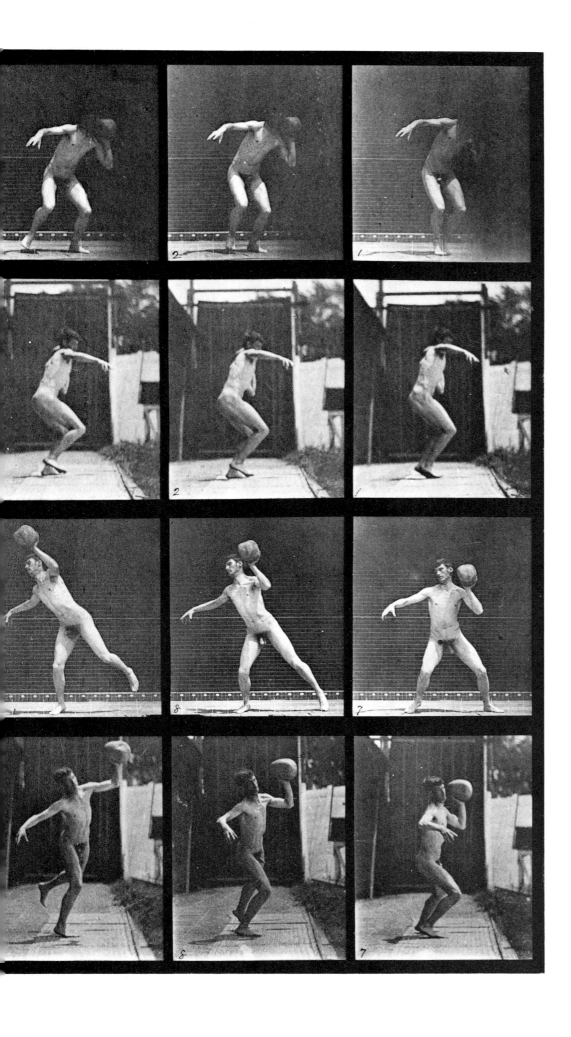

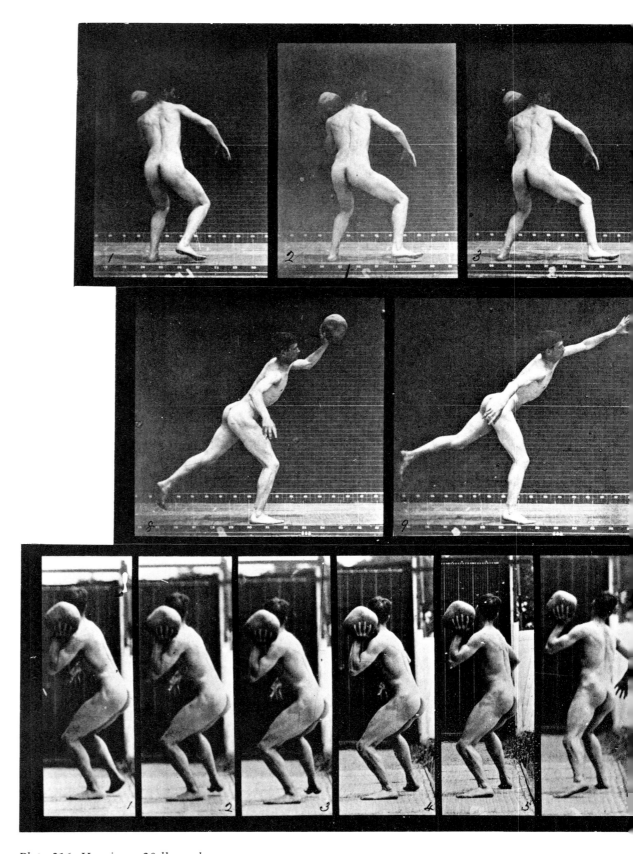

Plate 316. Heaving a 20-lb. rock.

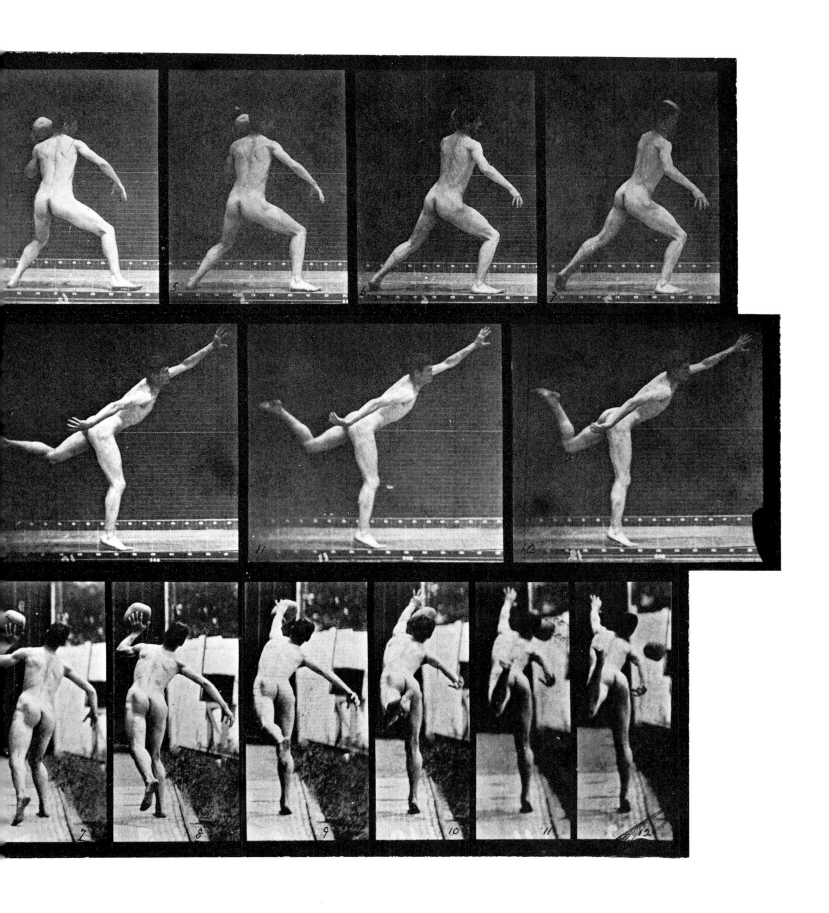

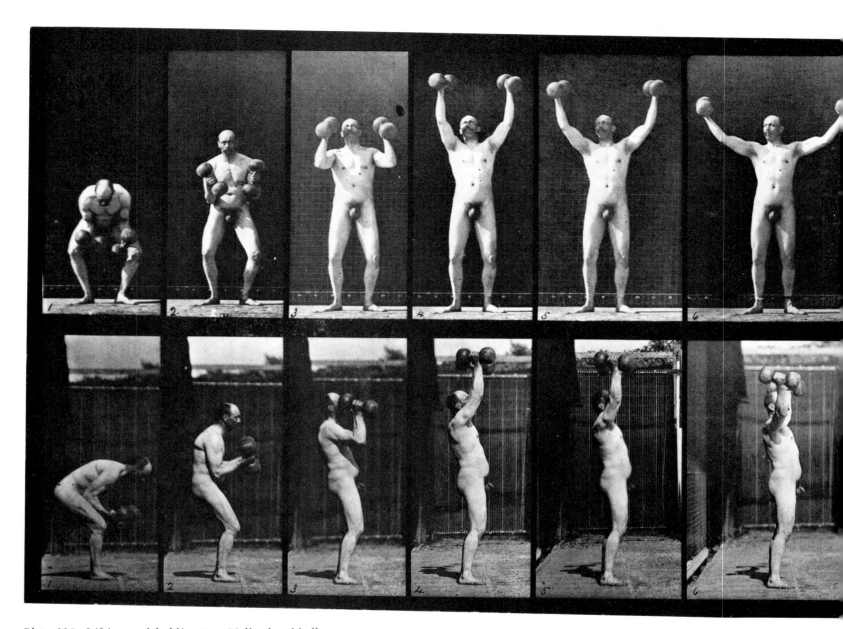

Plate 325. Lifting and holding two 50-lb. dumbbells.

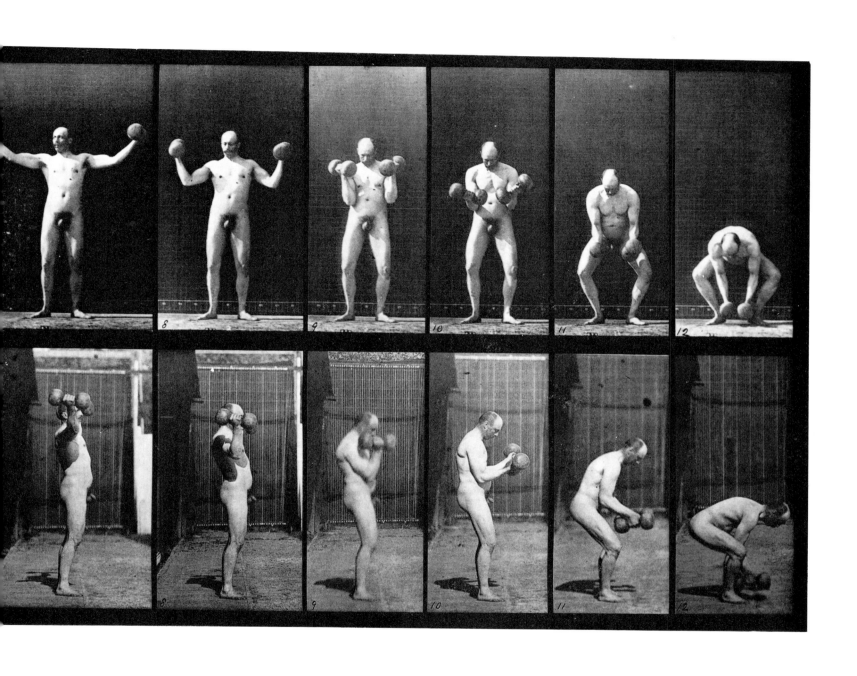

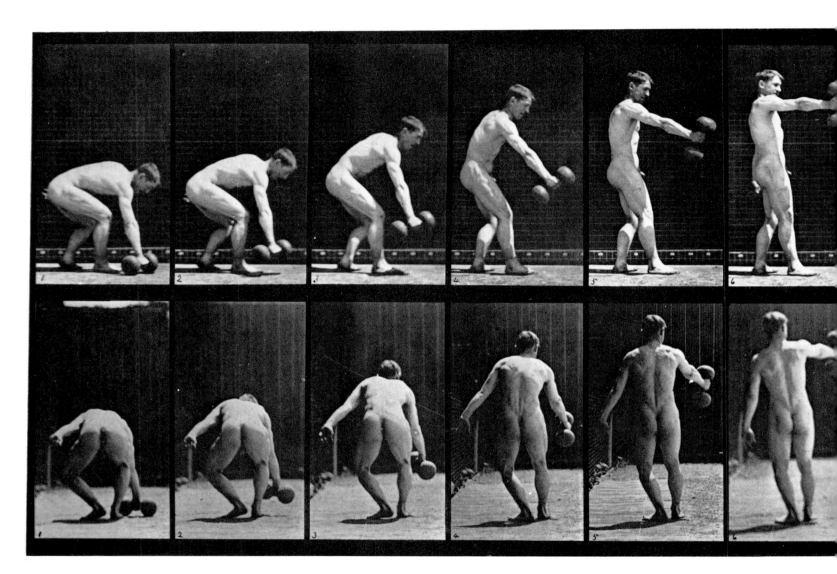

Plate 326. Lifting a 50-lb. dumbbell at arm's length.

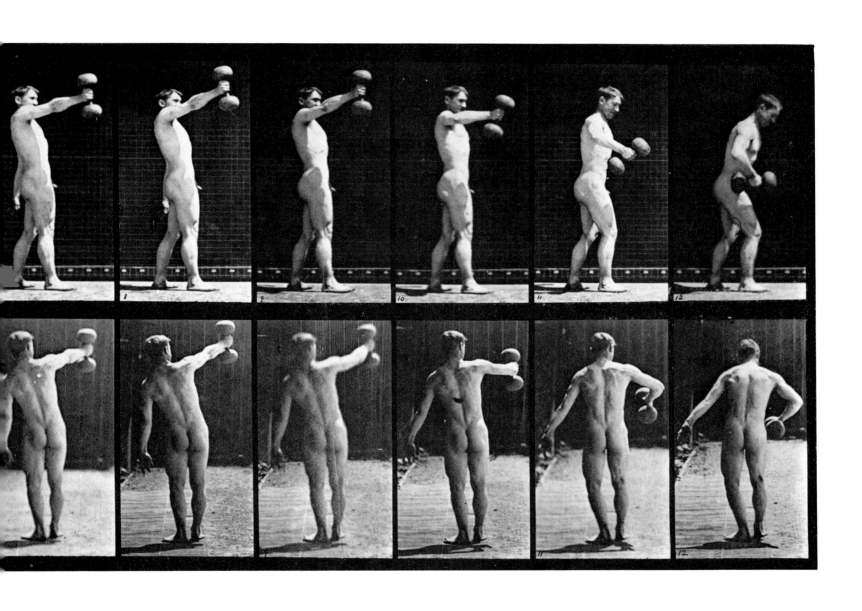

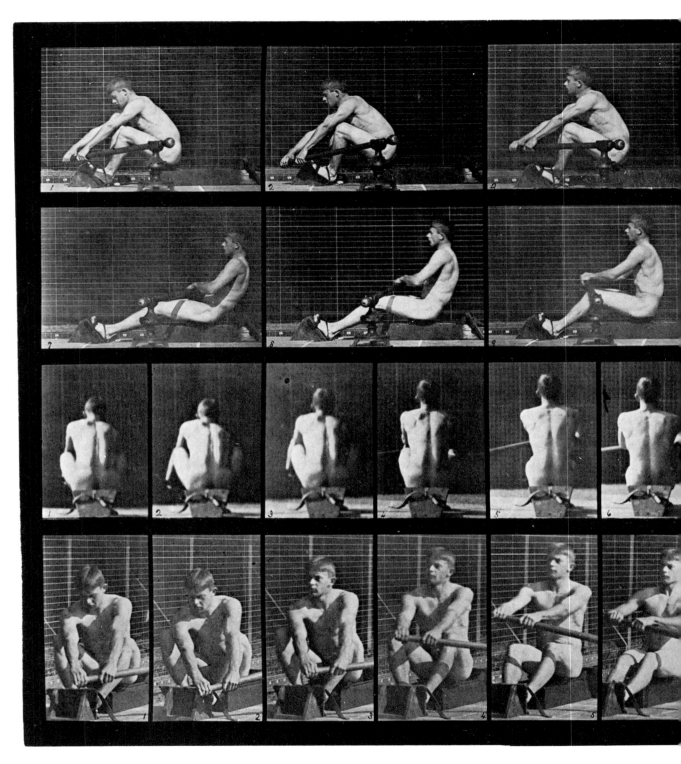

Plate 327. Rowing.

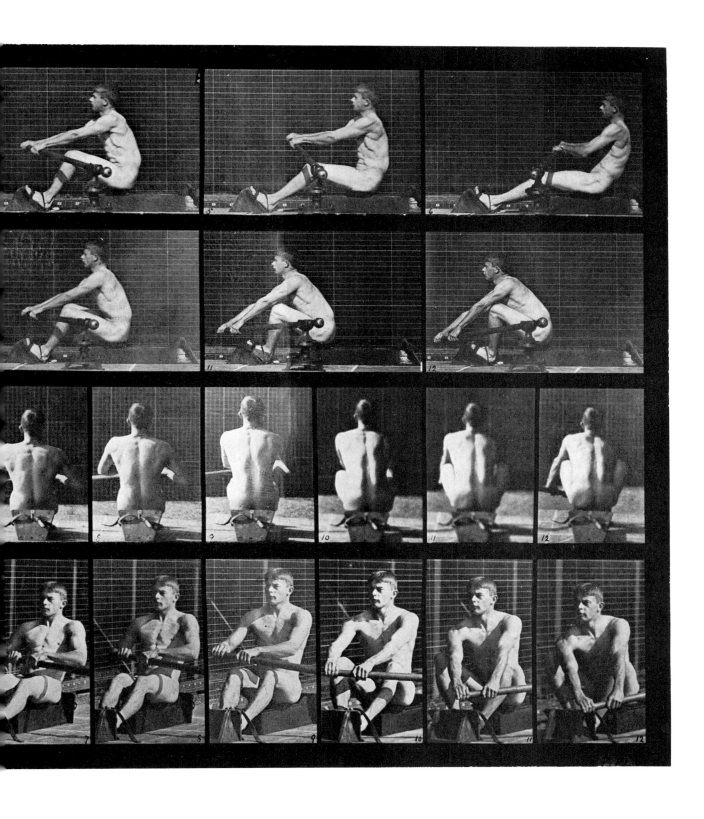

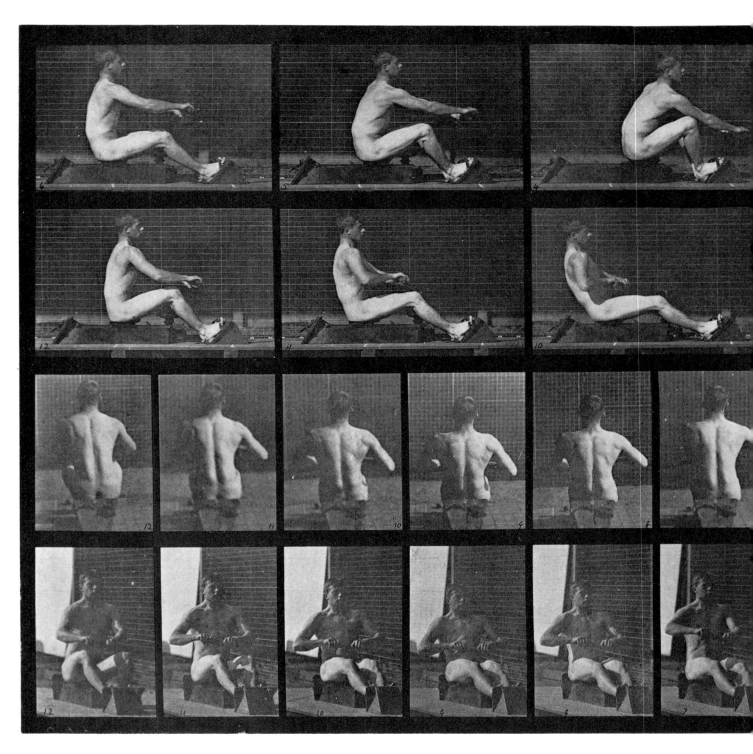

Plate 328. Rowing.

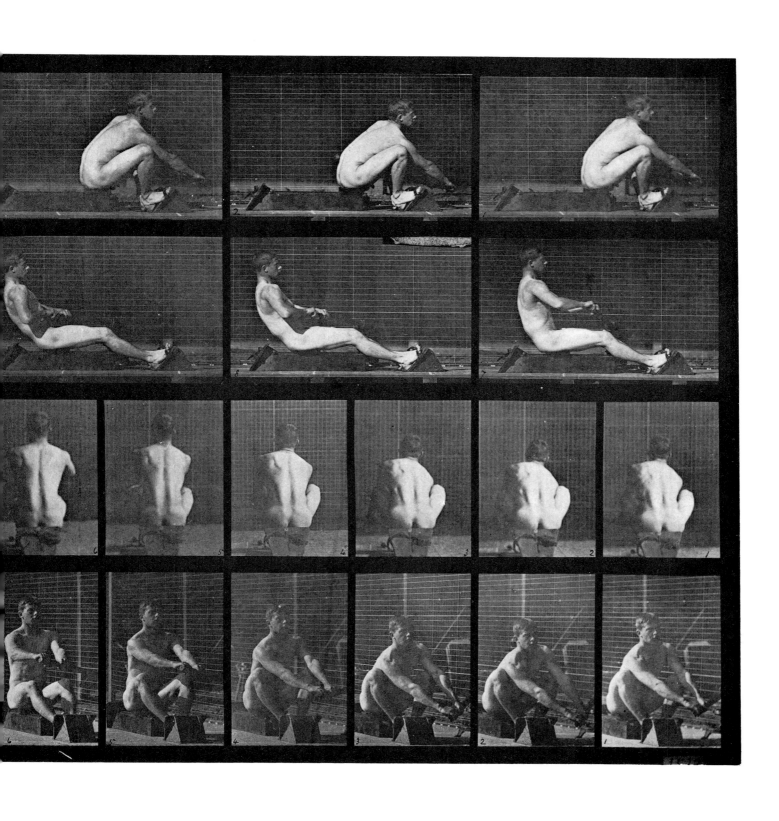

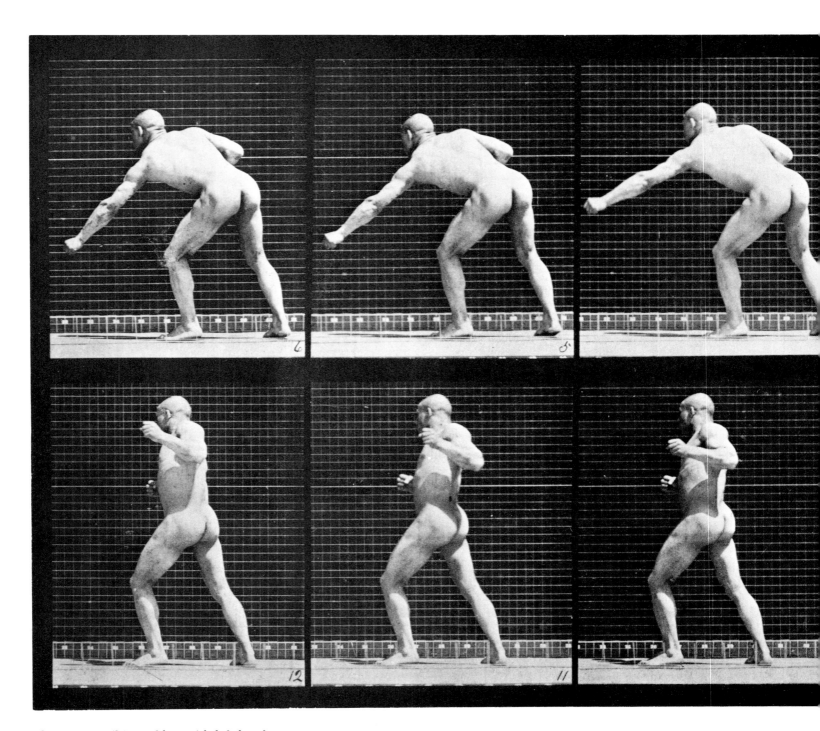

Plate 343. Striking a blow with left hand.

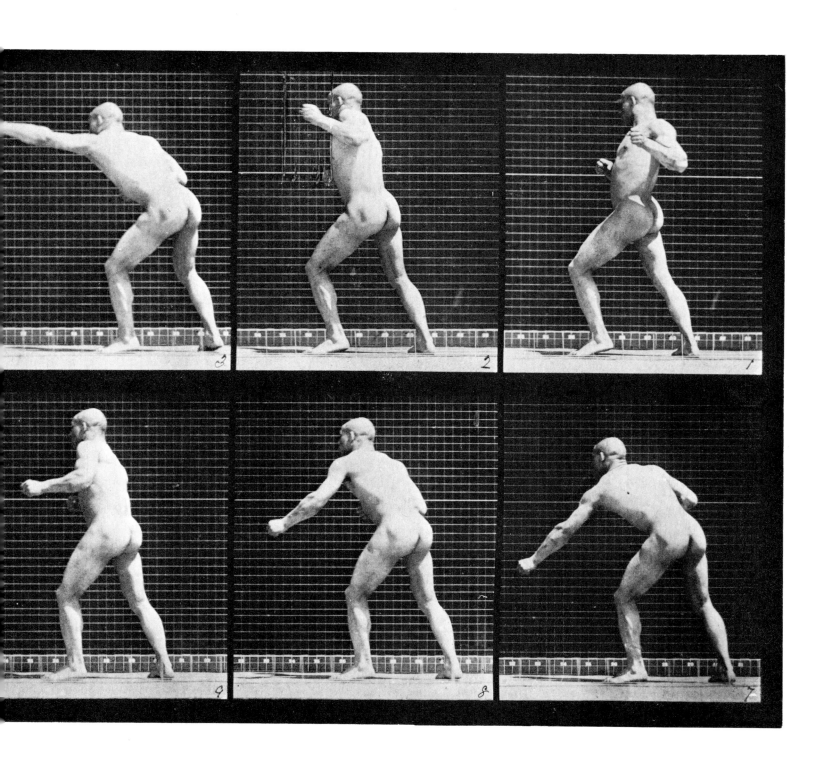

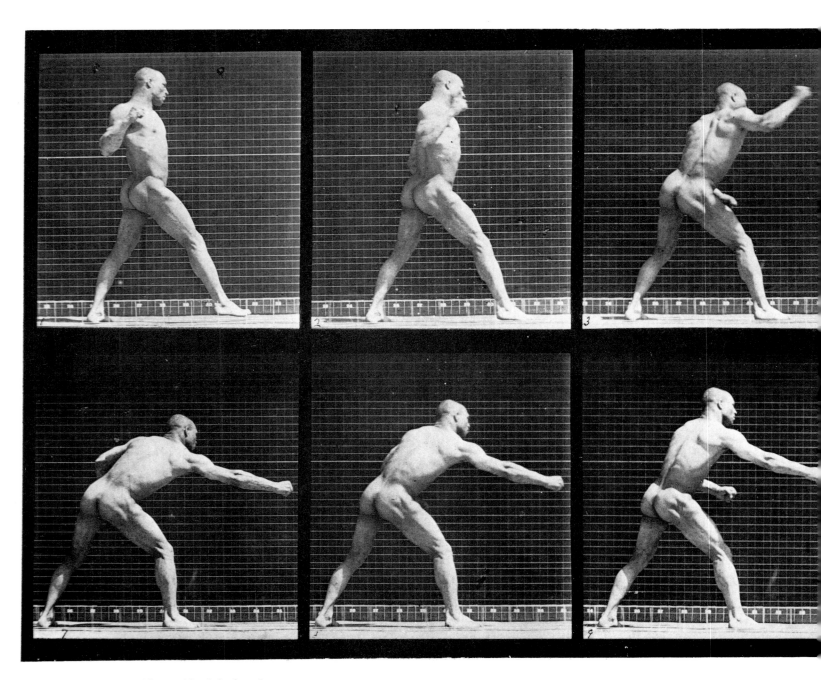

Plate 344. Striking a blow with right hand.

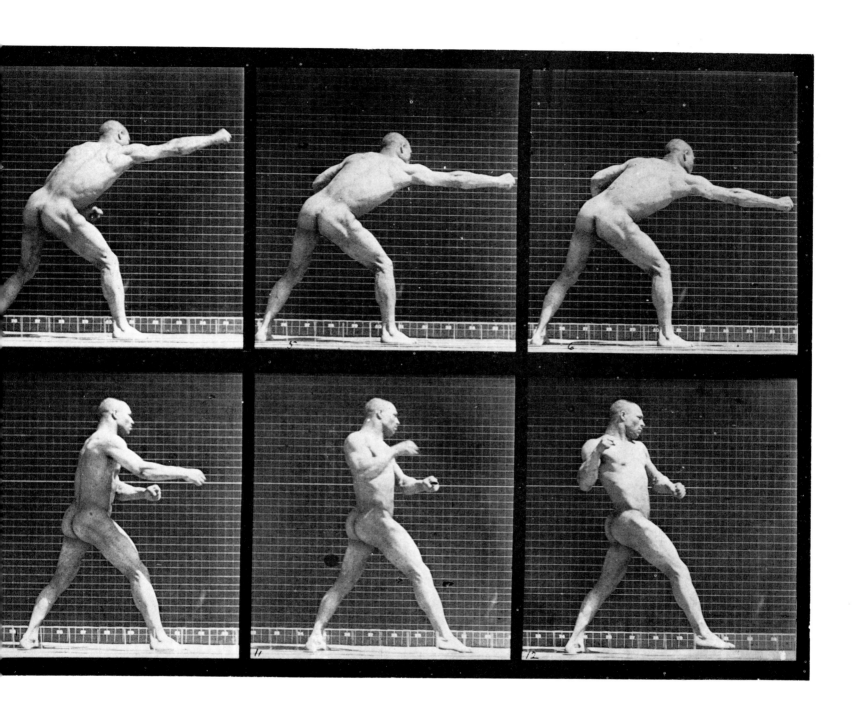

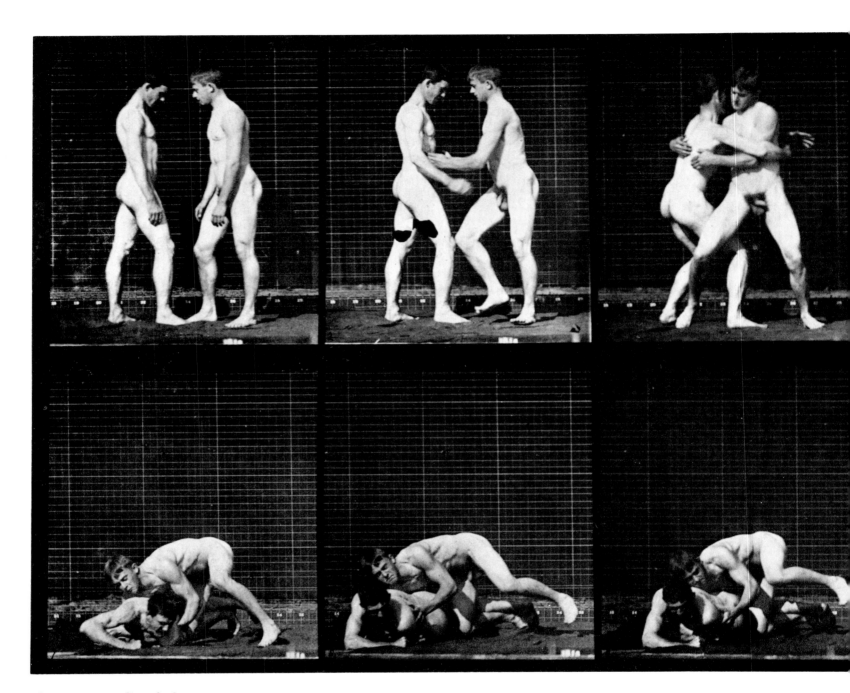

Plate 345. Wrestling, lock.

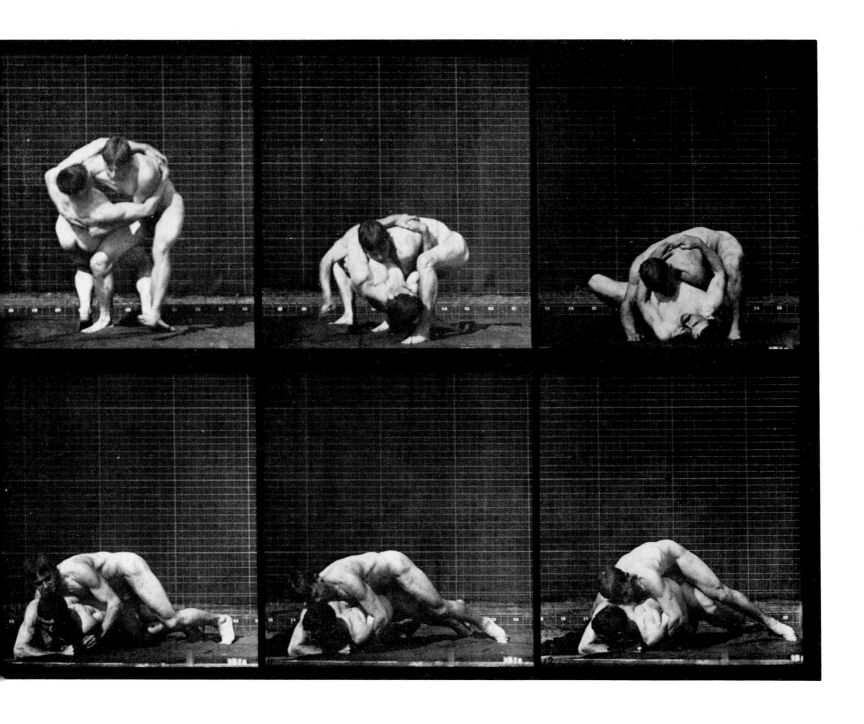

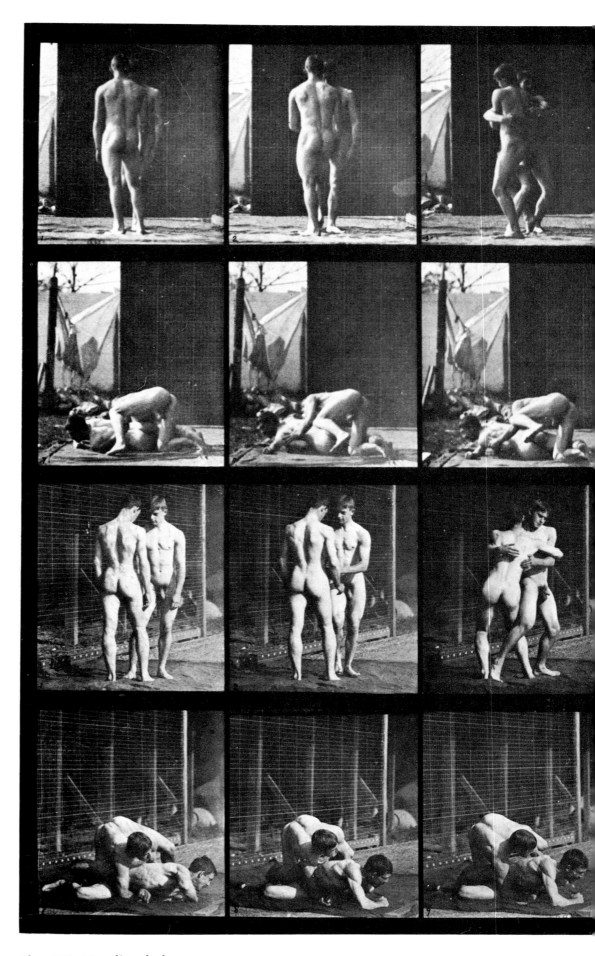

Plate 346. Wrestling, lock.

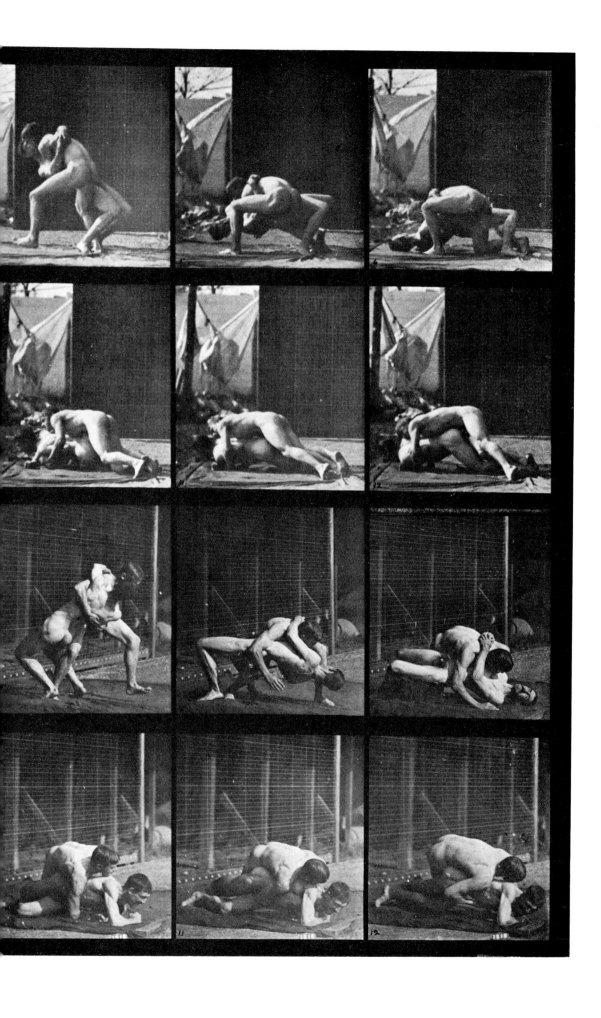

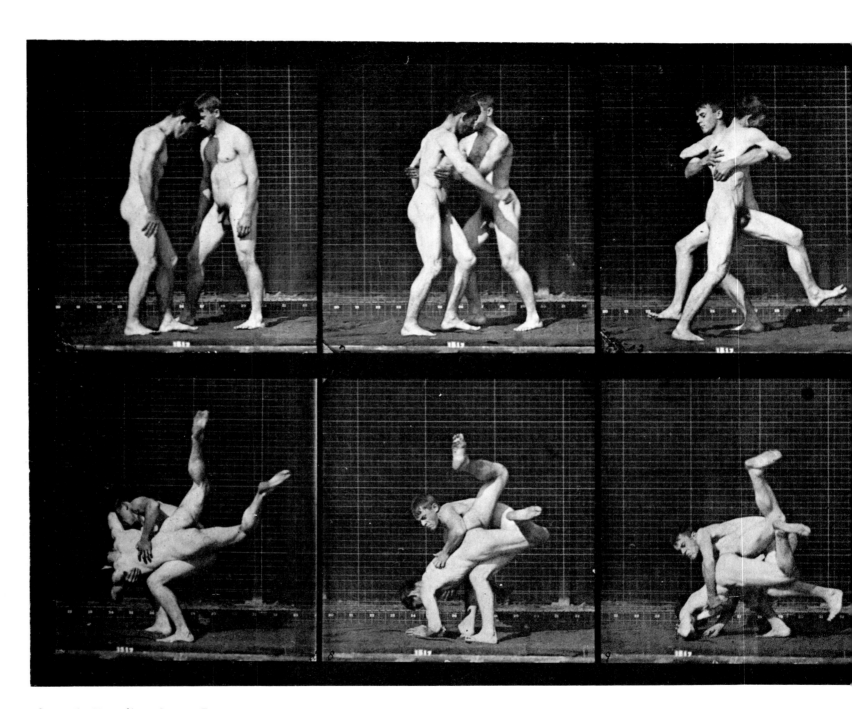

Plate 347. Wrestling, Graeco-Roman.

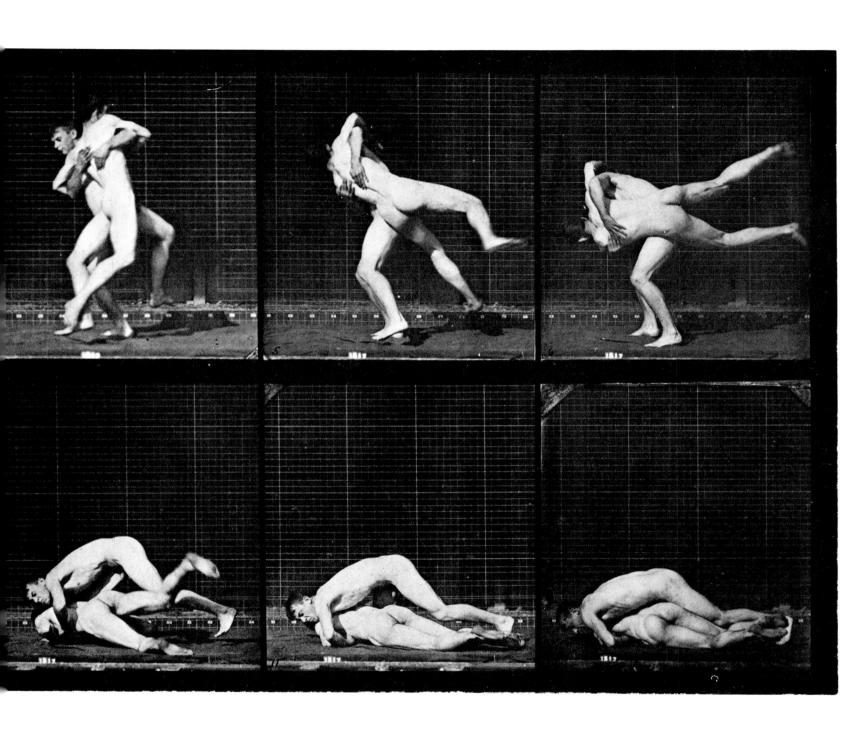

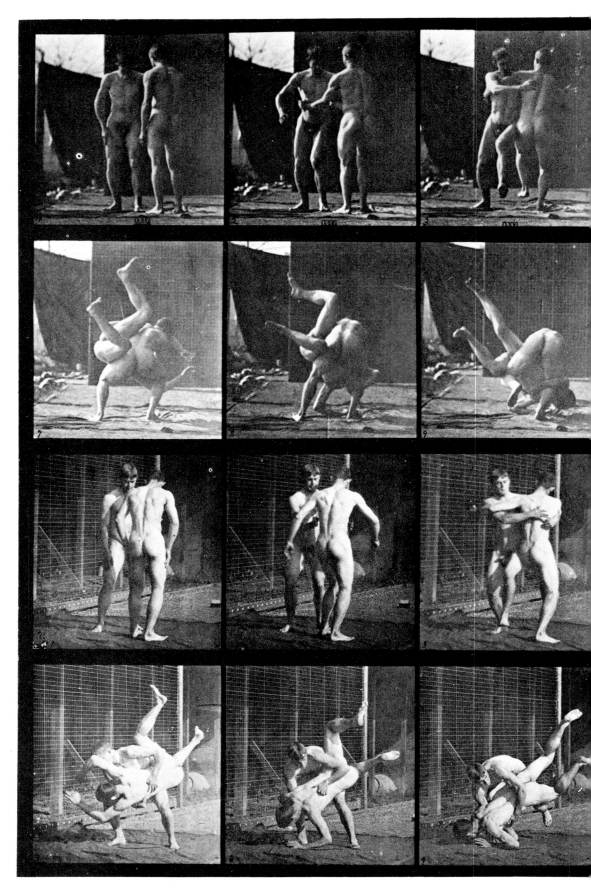

Plate 348. Wrestling, Graeco-Roman.

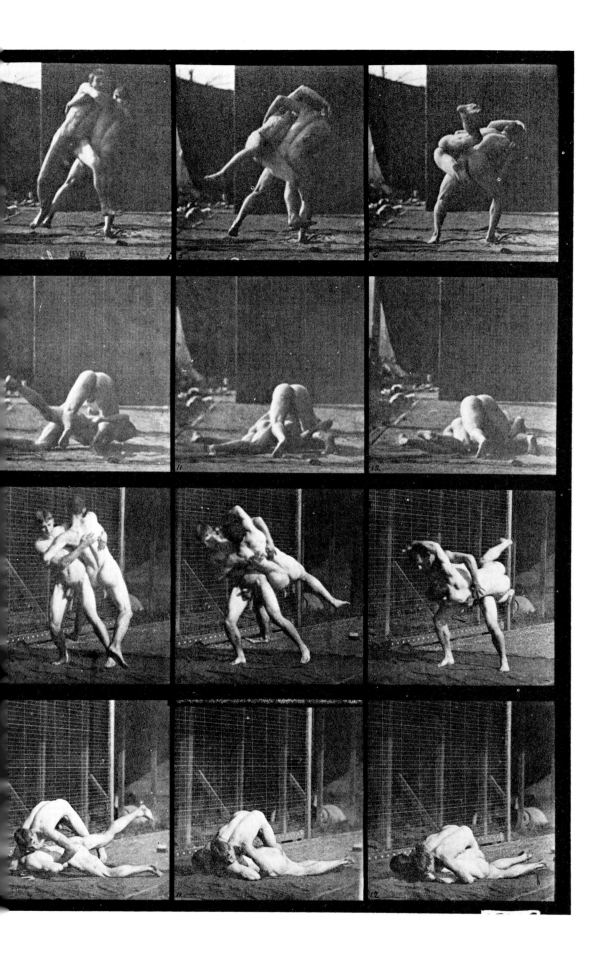

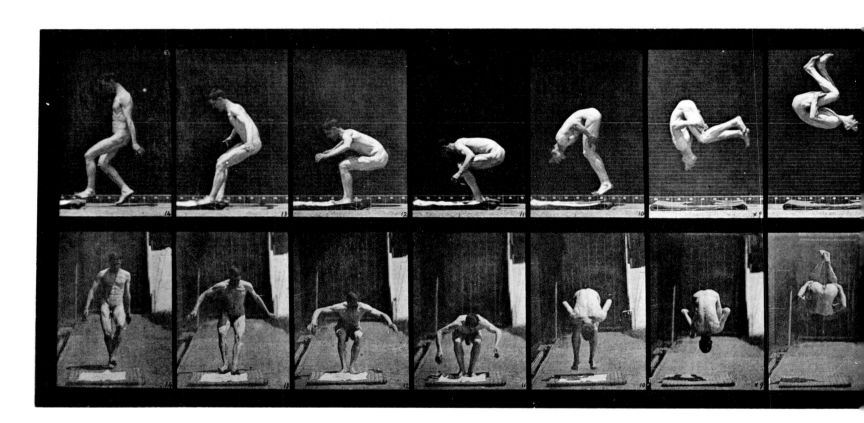

Plate 362. Back somersault.

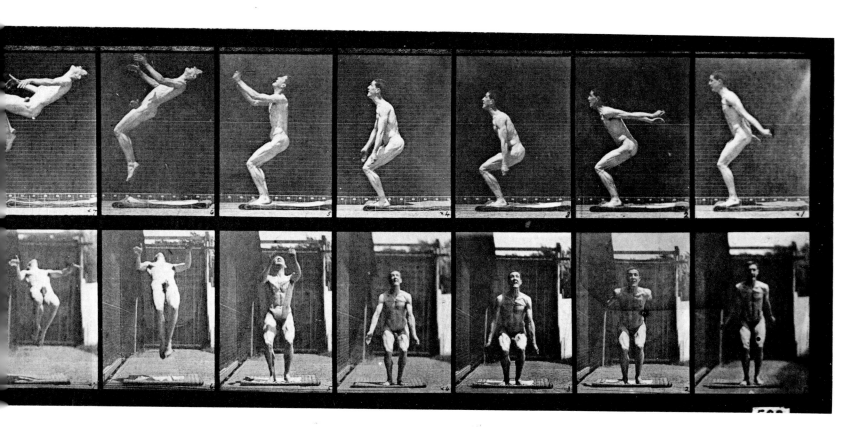

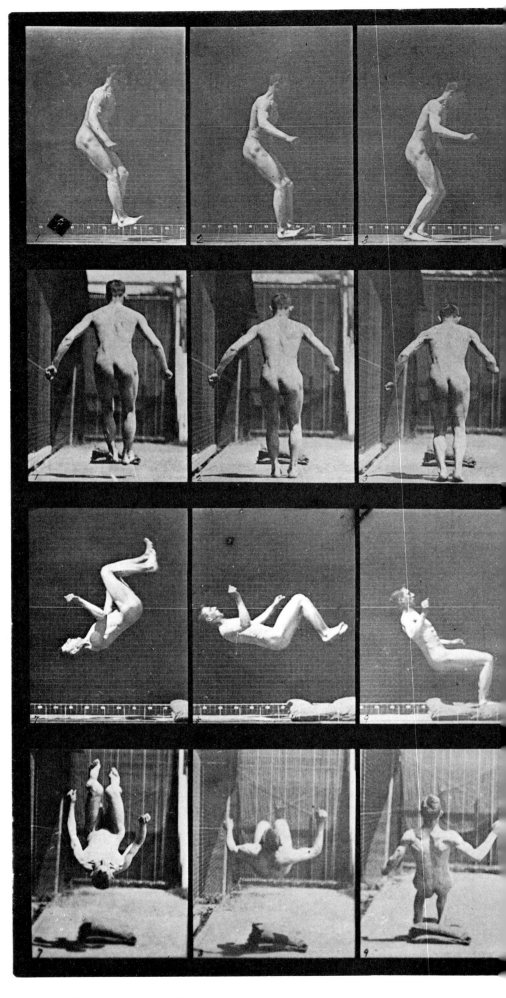

Plate 363. Running somersault.

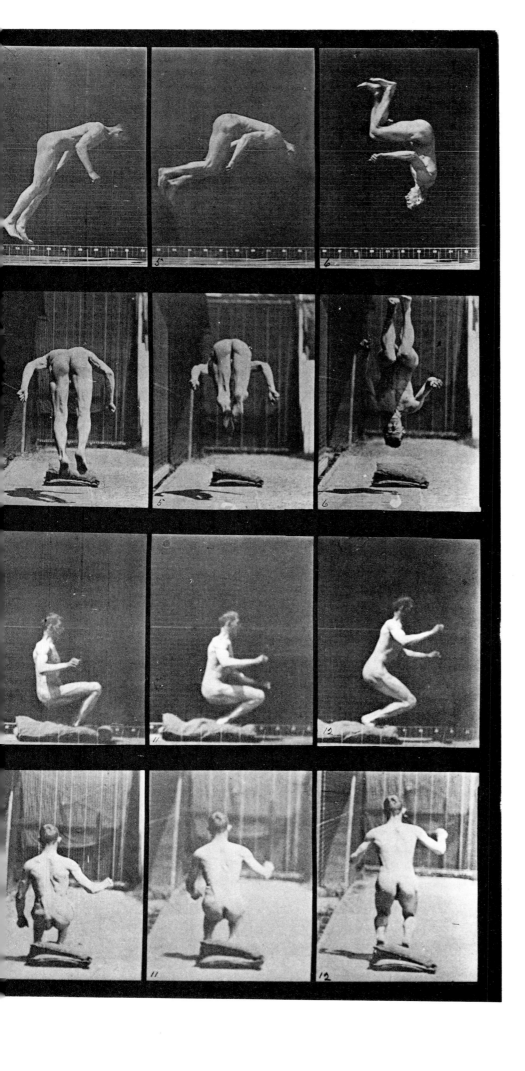

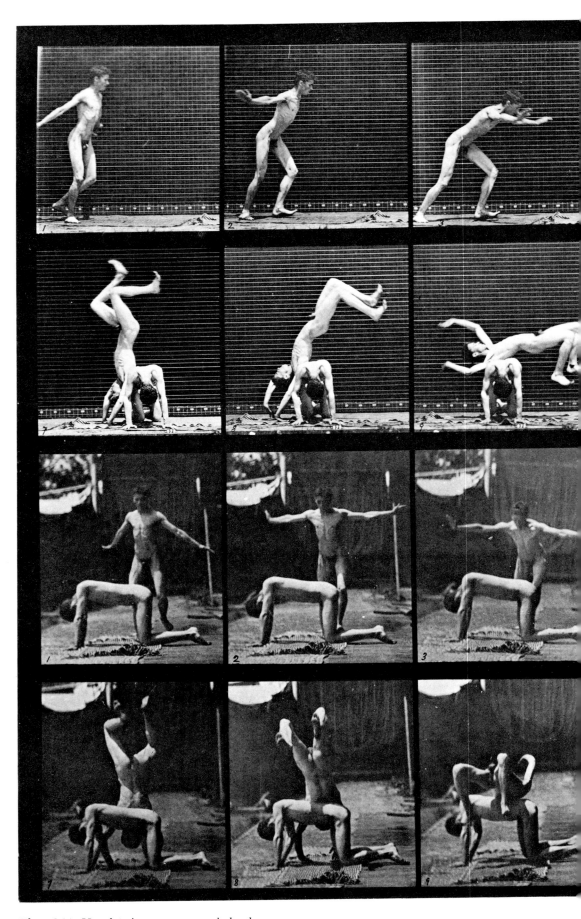

Plate 364. Handspring over a man's back.

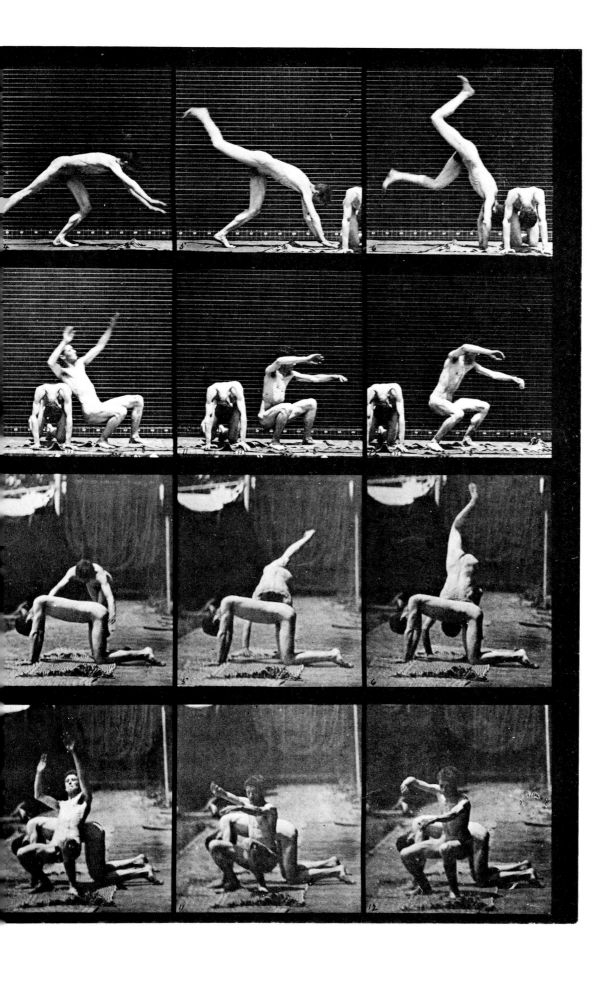

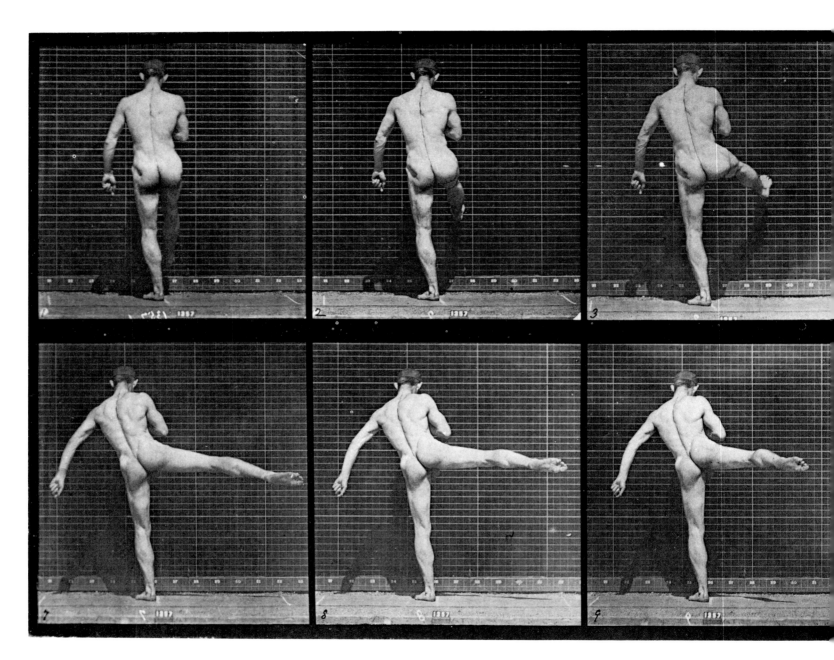

Plate 369. First ballet action.

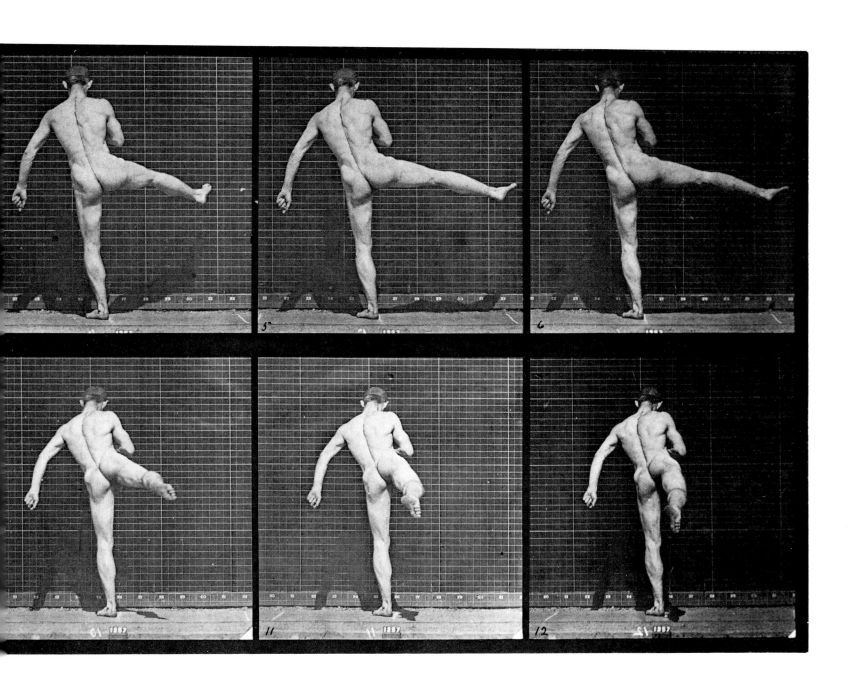

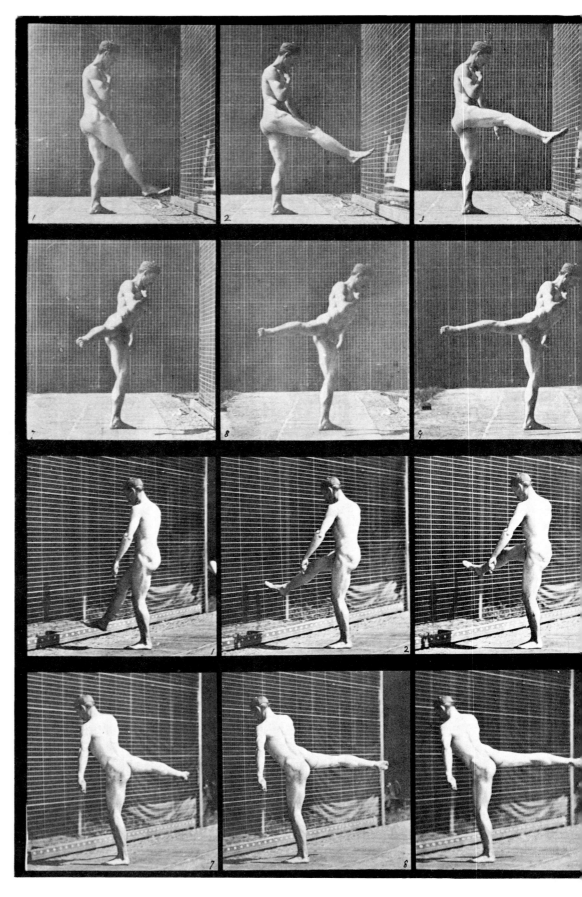

Plate 370. First ballet action.

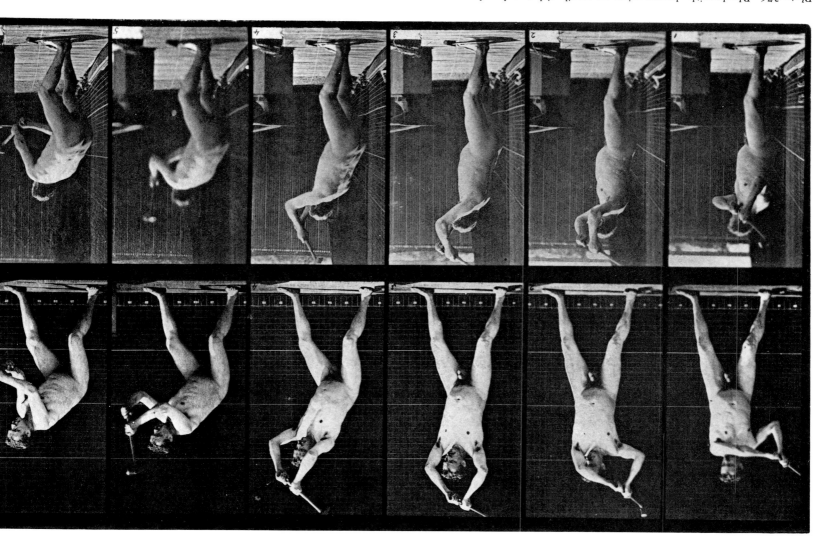

Plate 376. Blacksmith, hammering on anvil with two hands.

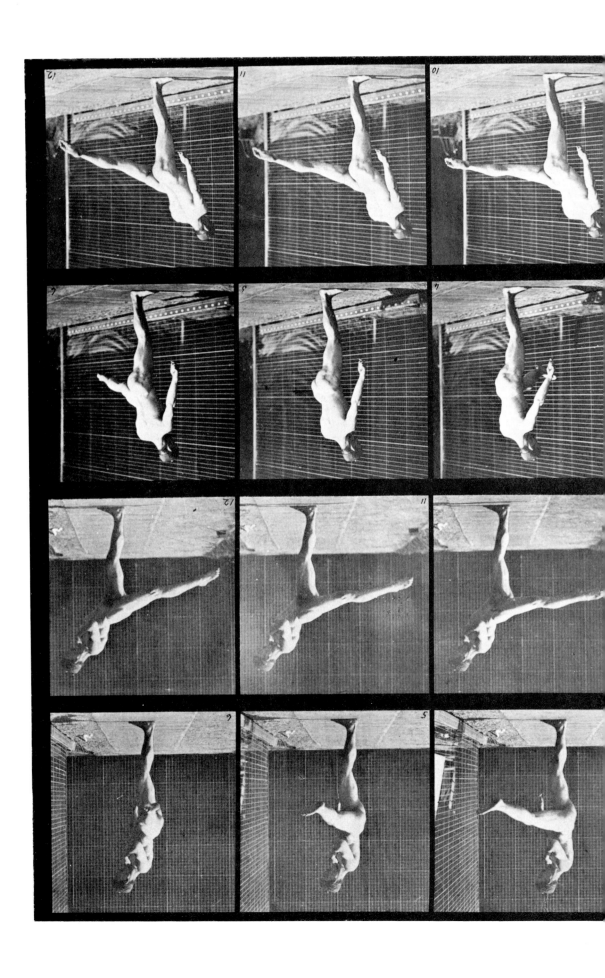

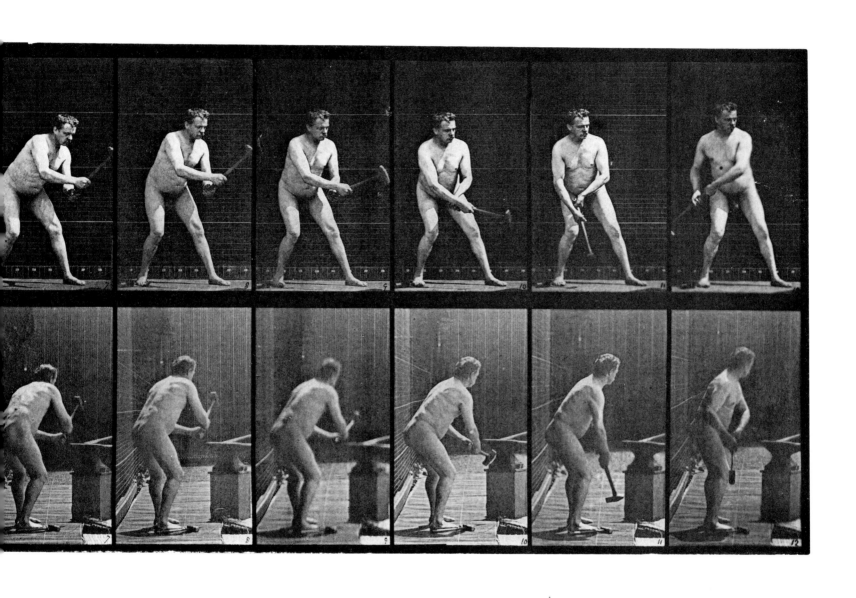

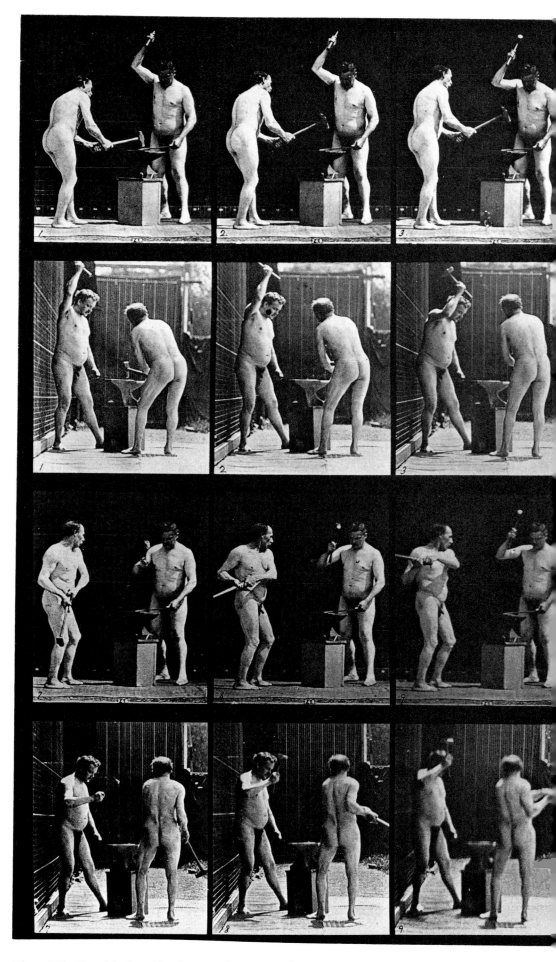

Plate 377. Two blacksmiths, hammering on anvil.

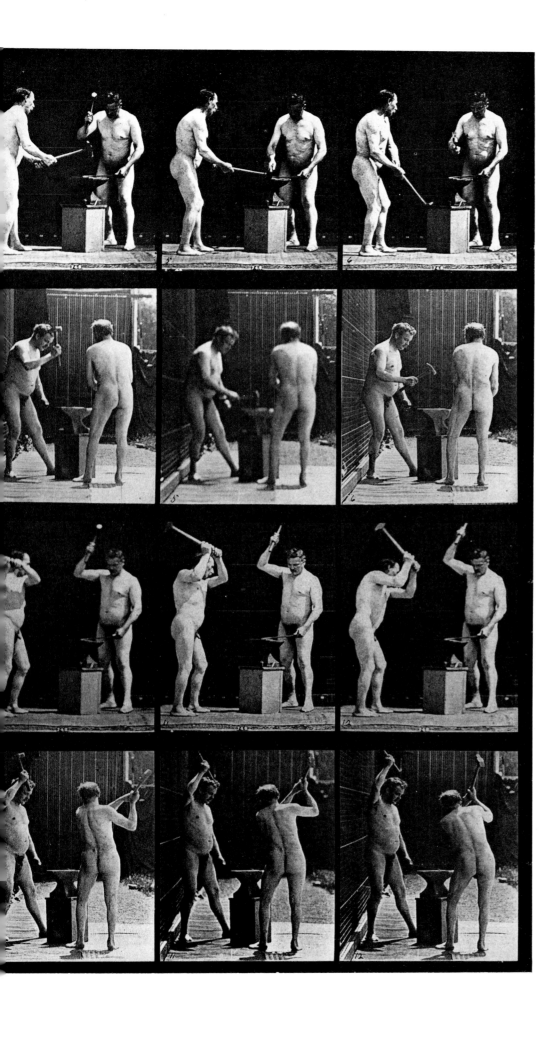

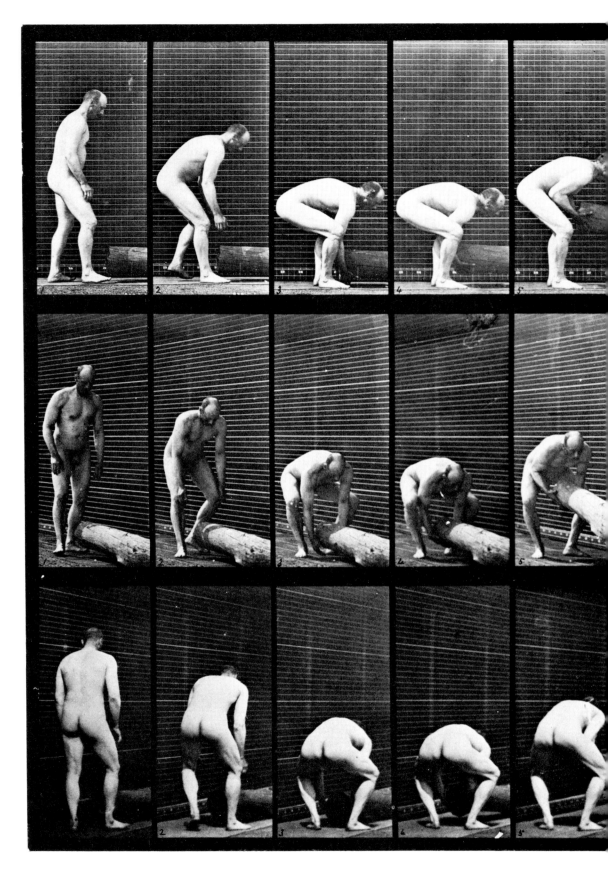

Plate 382. Lifting a log on end.

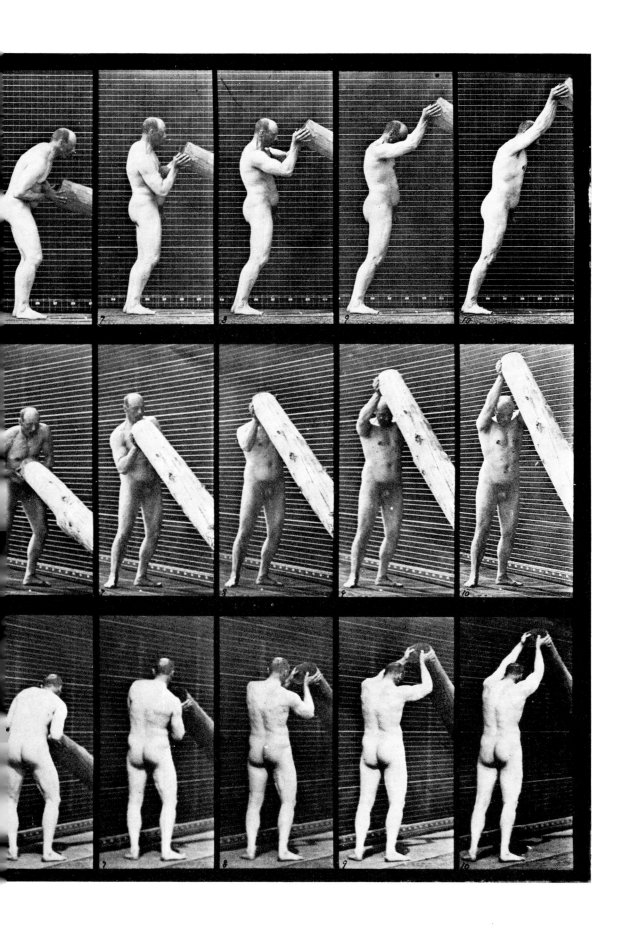

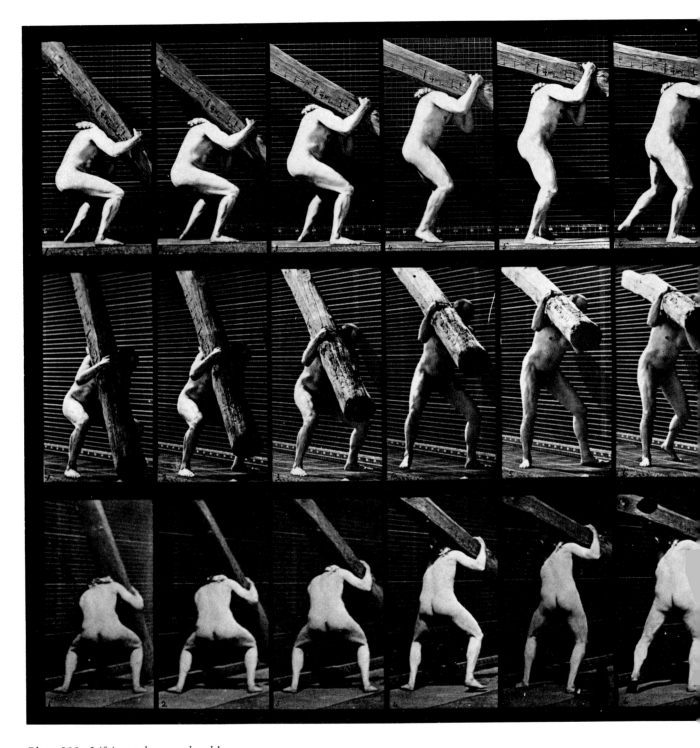

Plate 383. Lifting a log on shoulder.

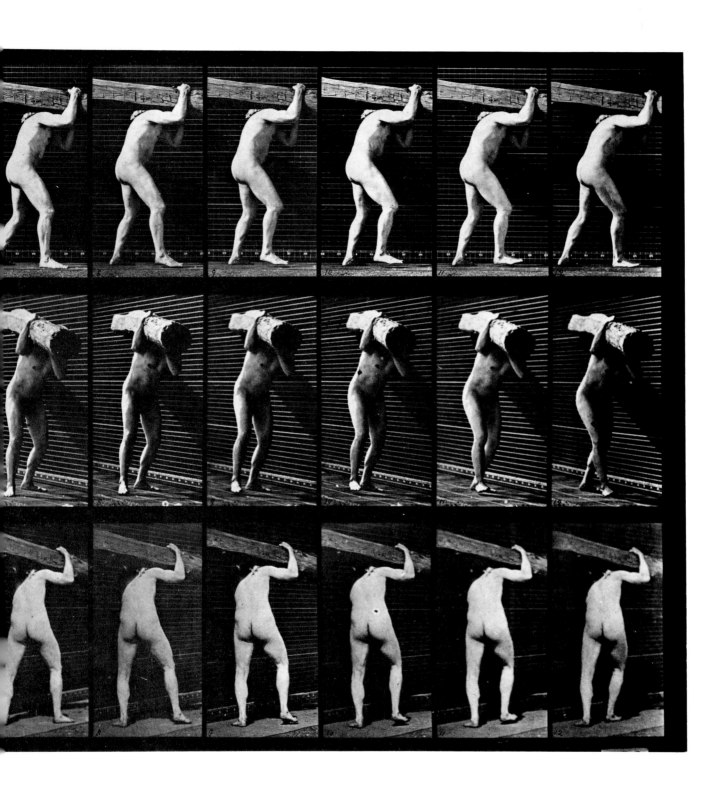

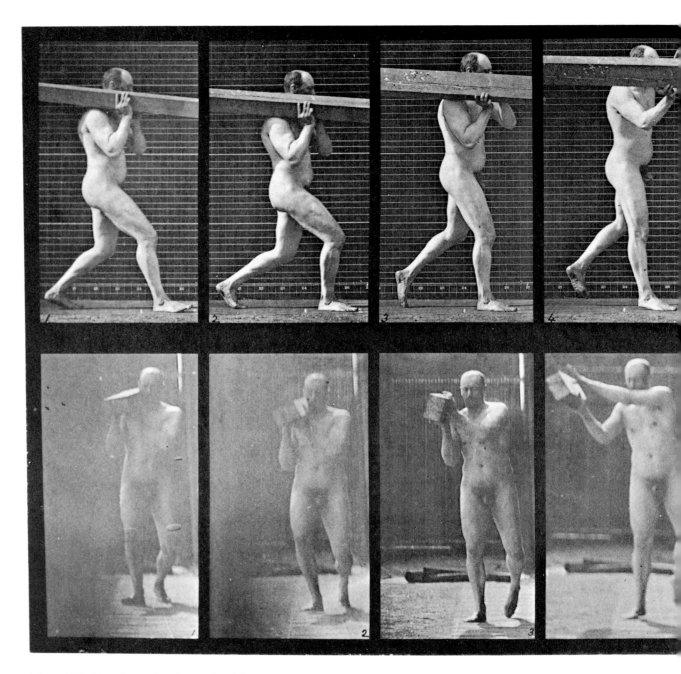

Plate 384. Heaving a log from shoulder.

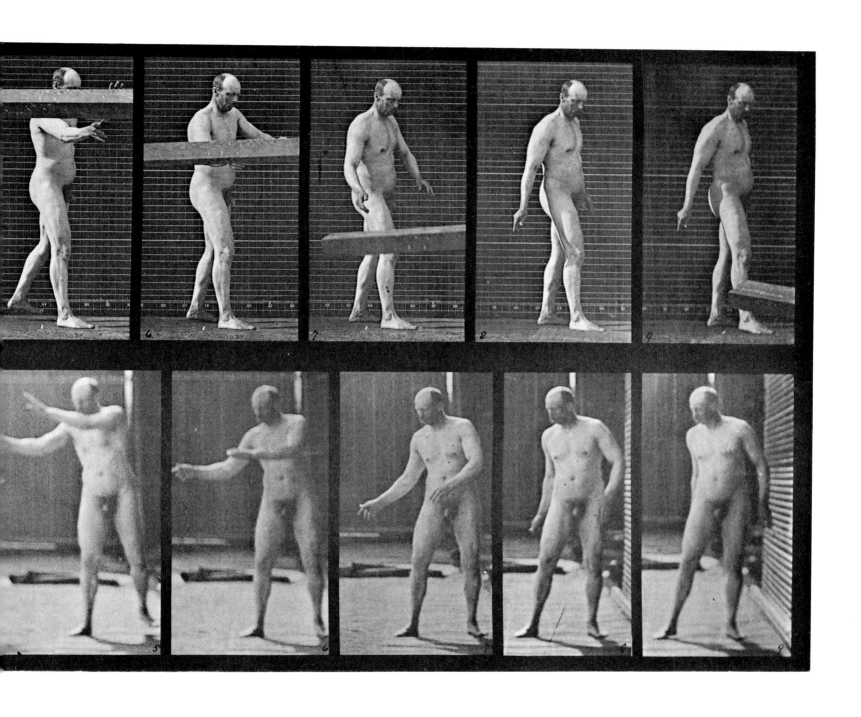

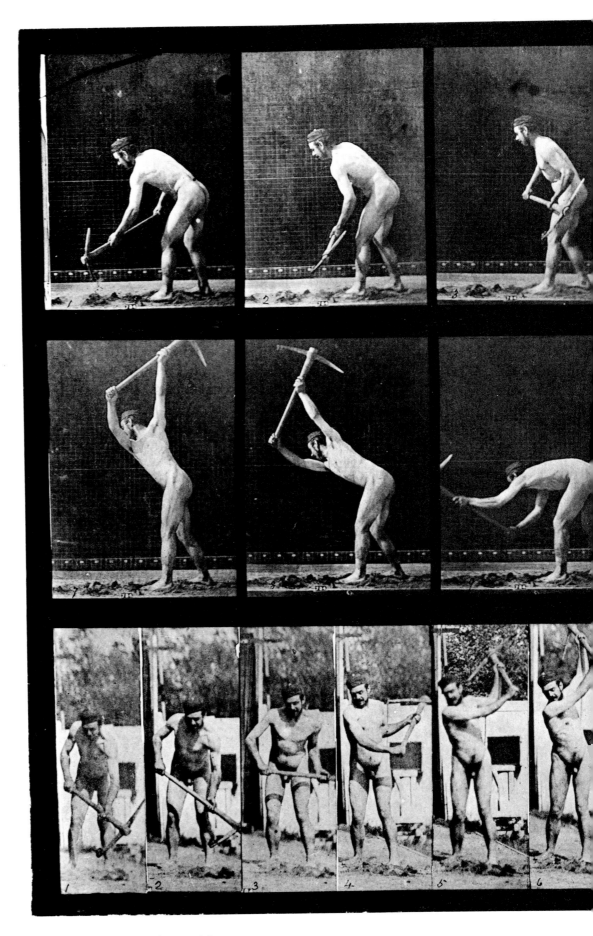

Plate 385. Farmer, using a pick.

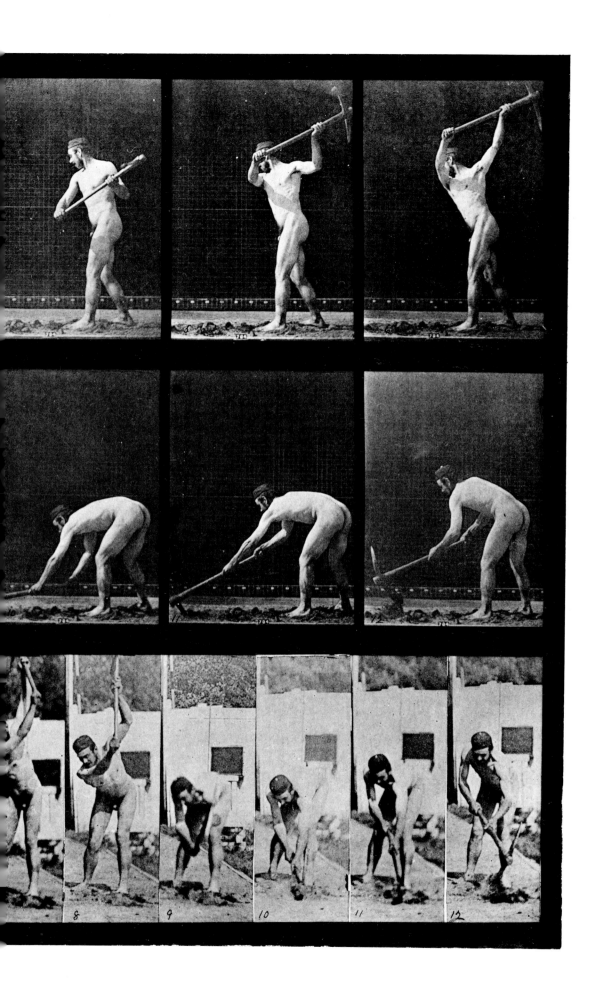

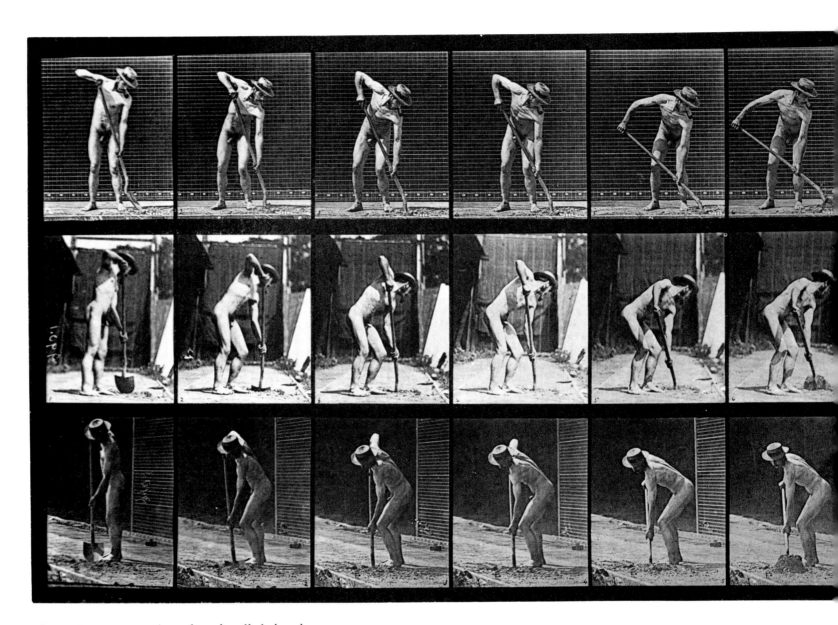

Plate 387. Farmer, using a long-handled shovel.

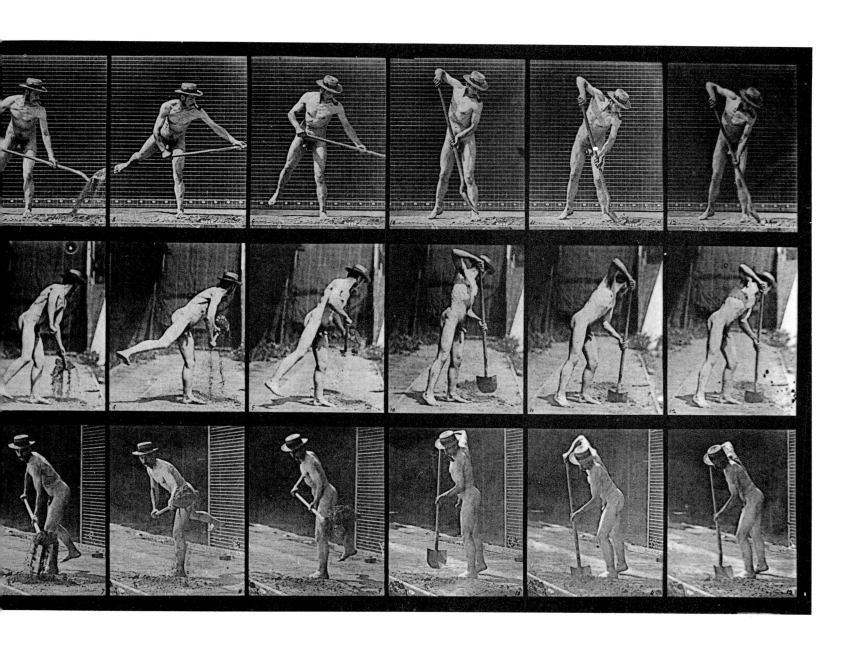

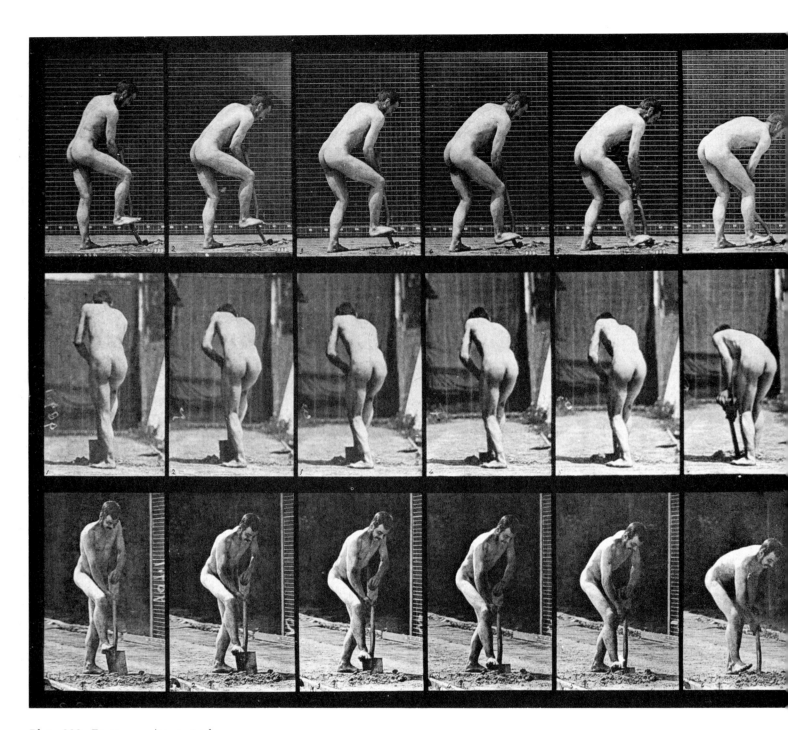

Plate 388. Farmer, using a spade.

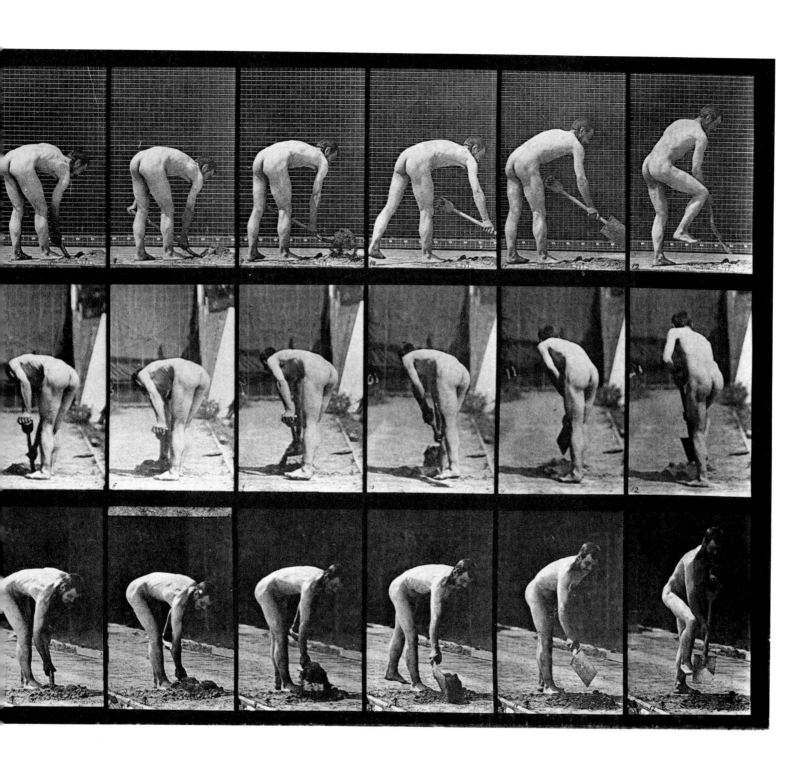

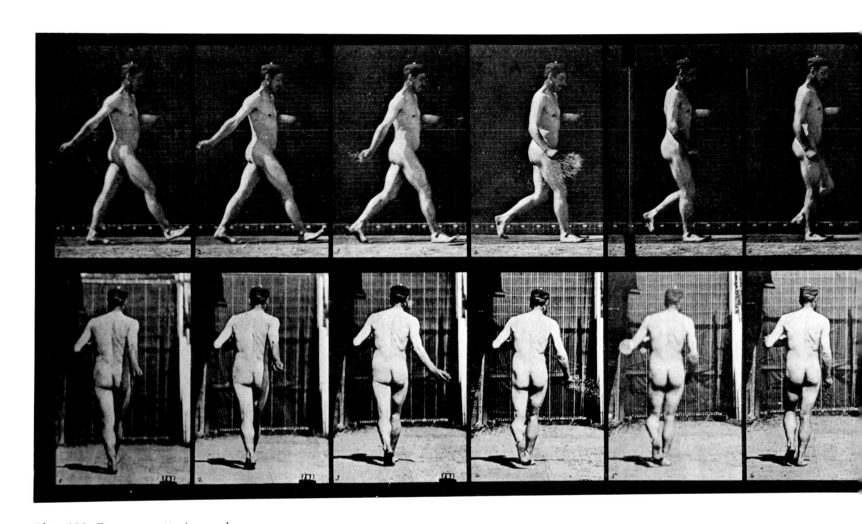

Plate 389. Farmer, scattering seed.

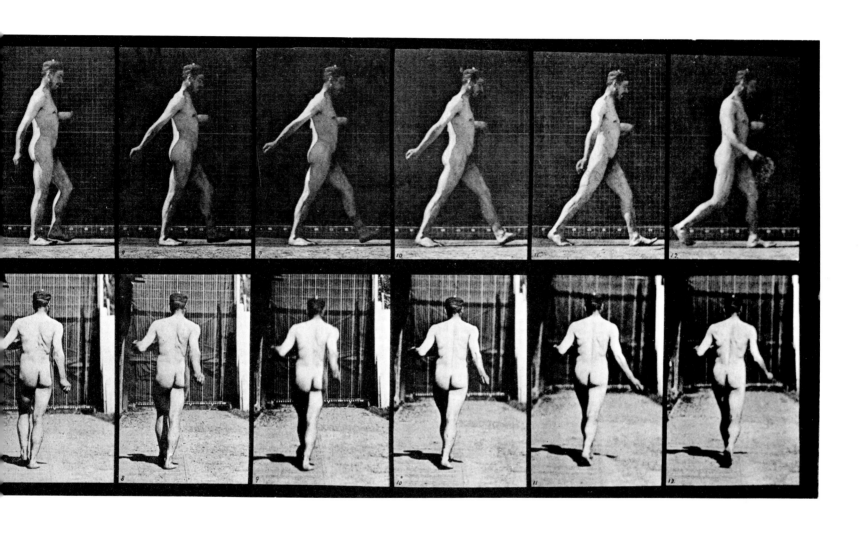

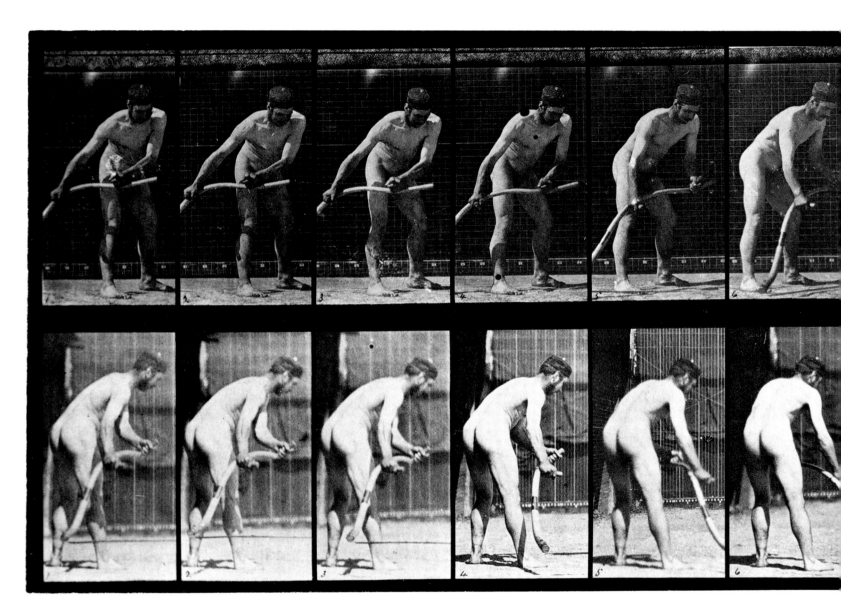

Plate 390. Farmer, mowing grass.

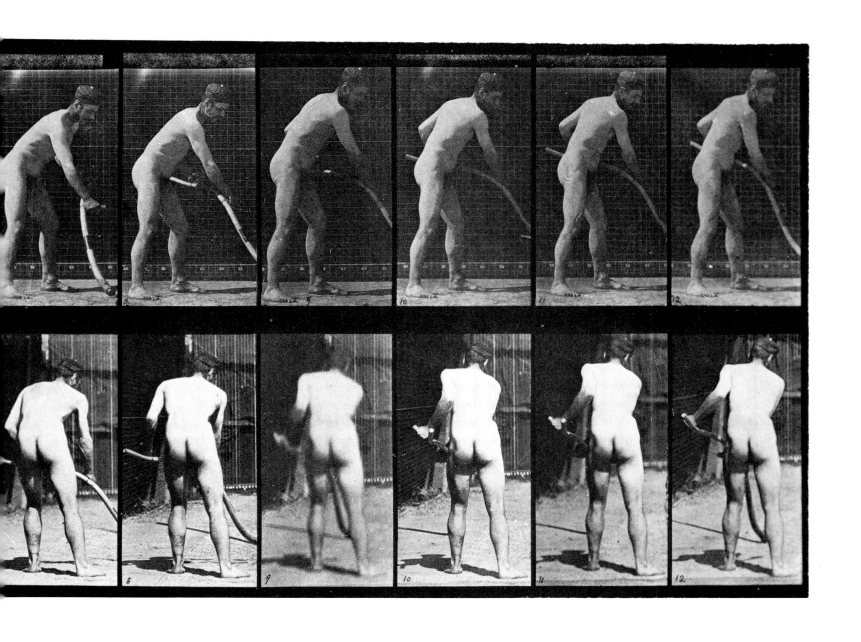

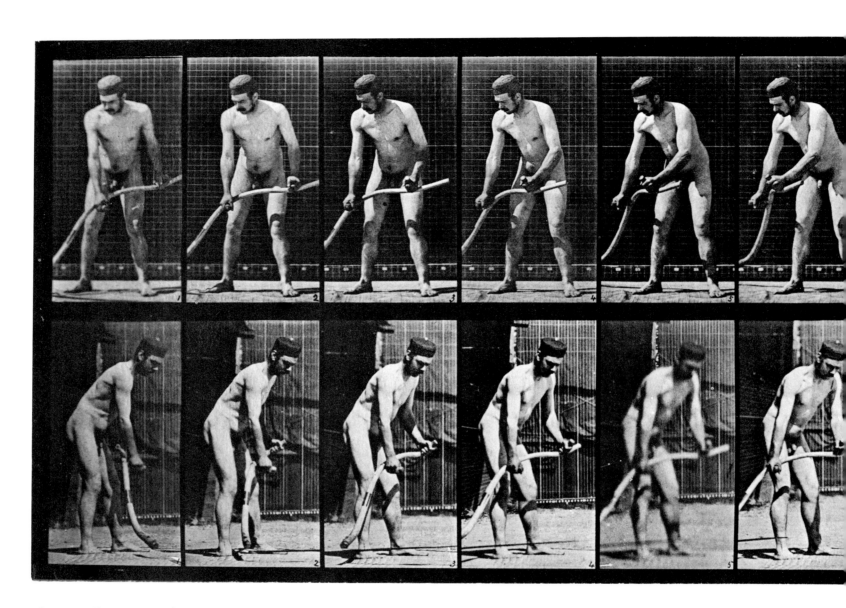

Plate 391. Farmer, mowing grass.

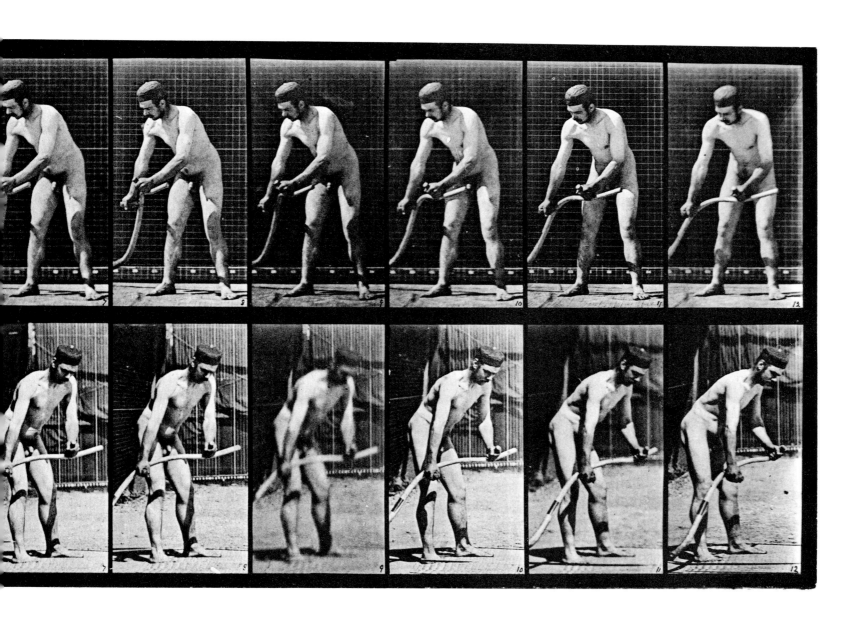

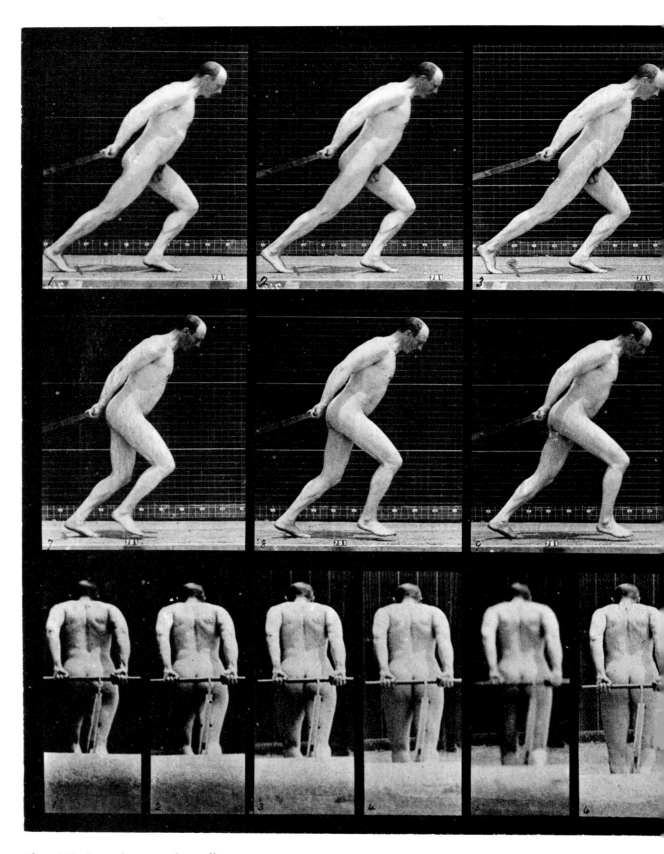

Plate 392. Dragging a garden roller.

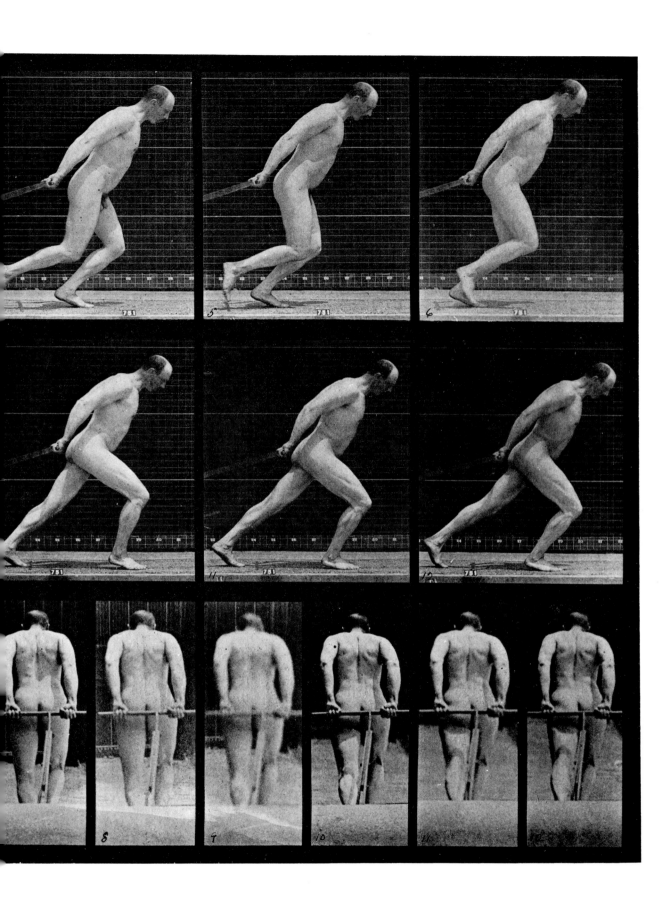

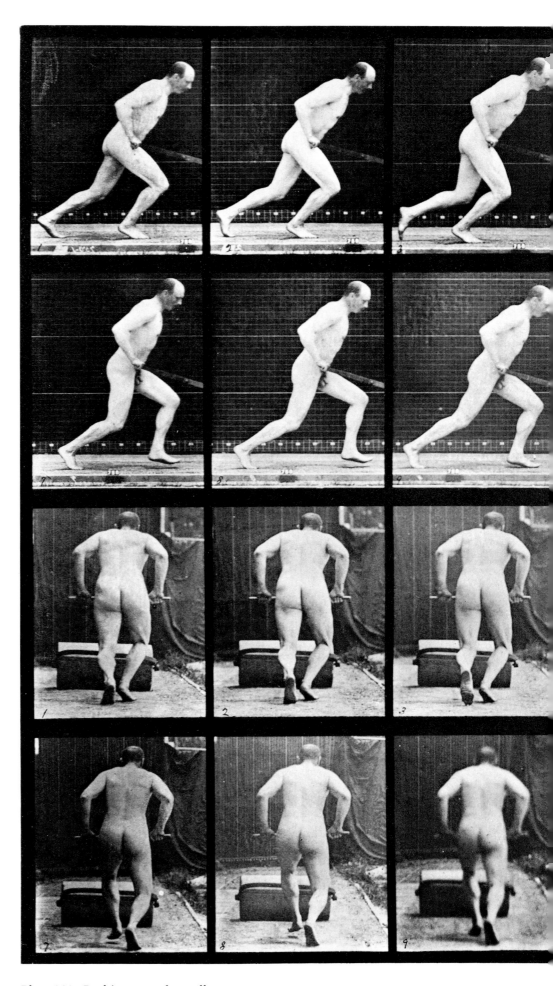

Plate 393. Pushing a garden roller.

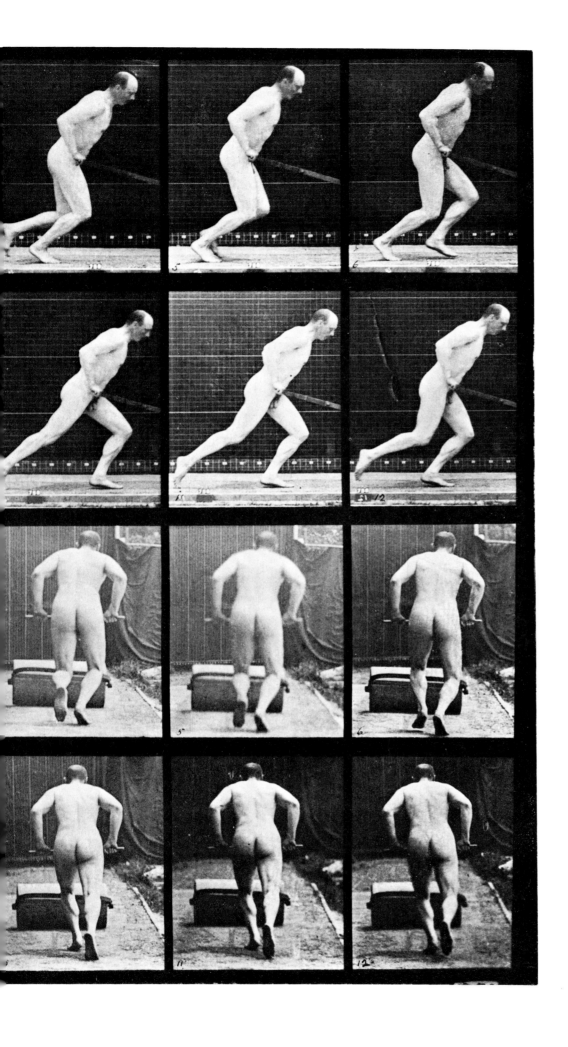

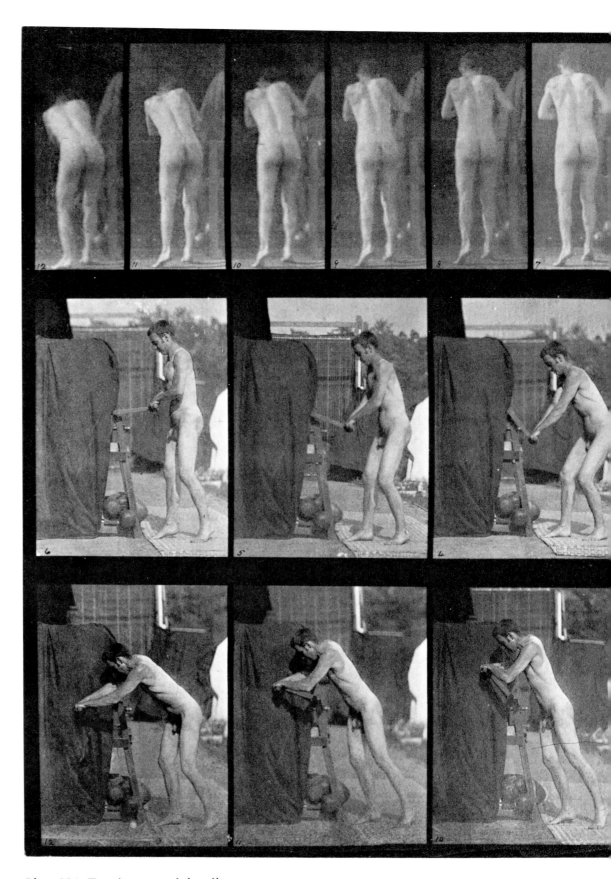

Plate 394. Turning a crank handle.

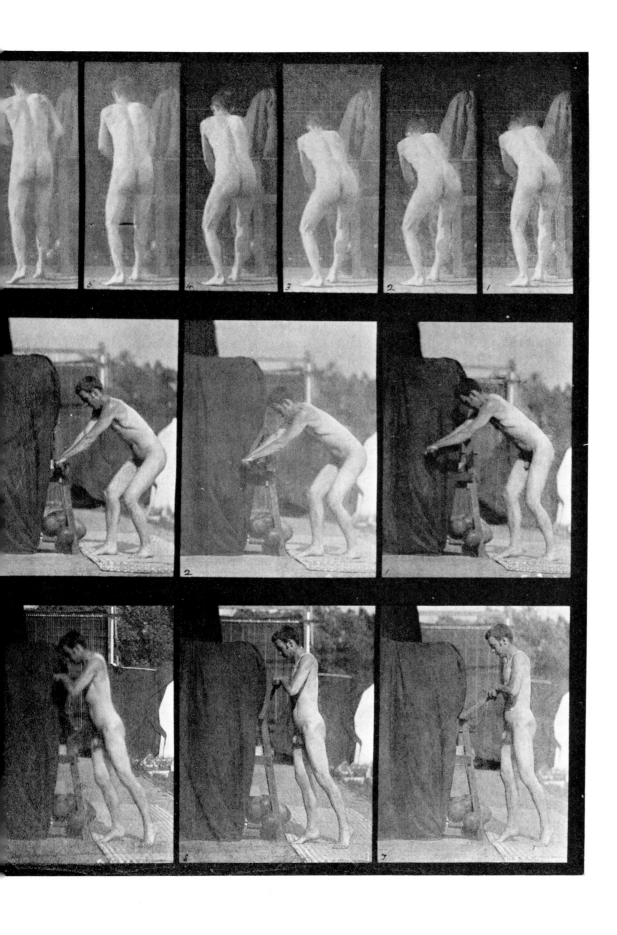

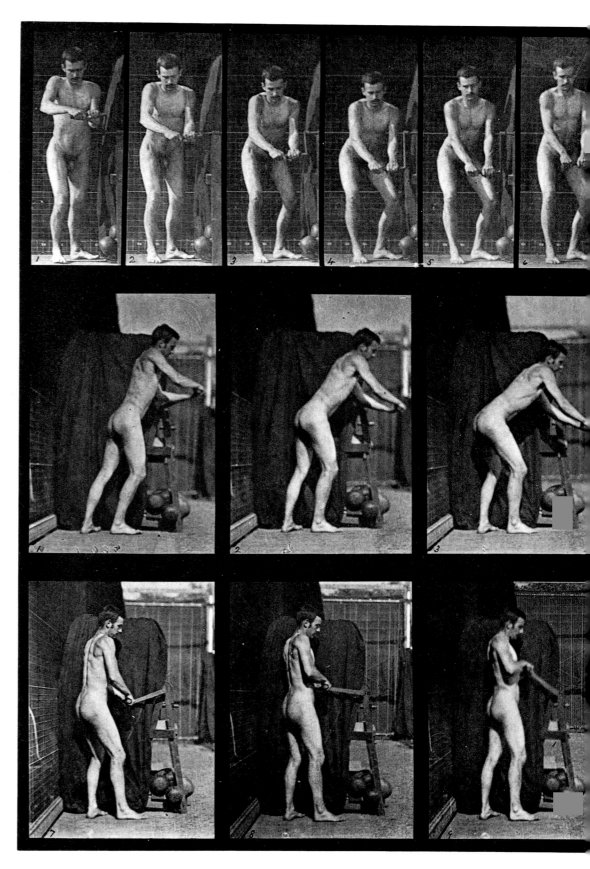

Plate 395. Turning a crank handle.

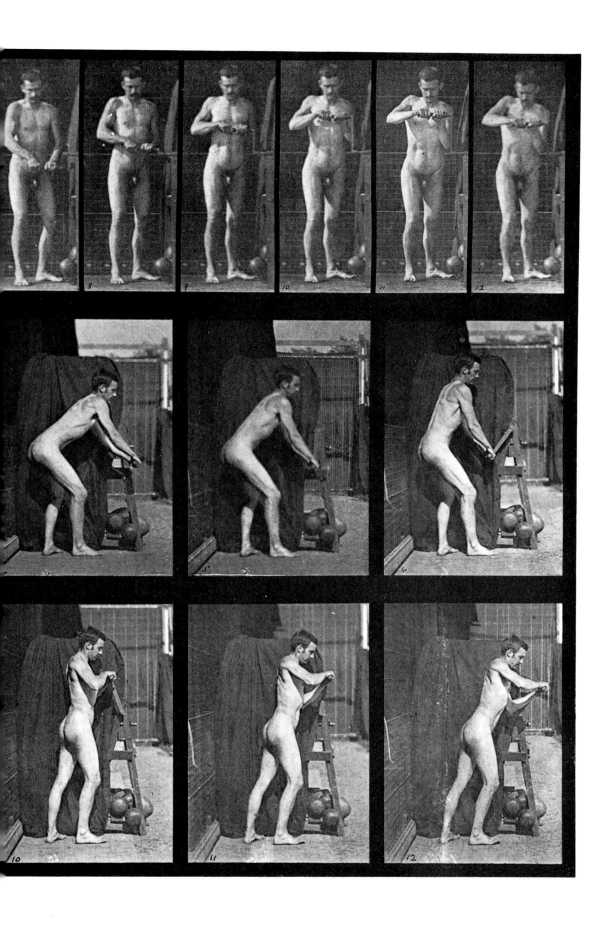

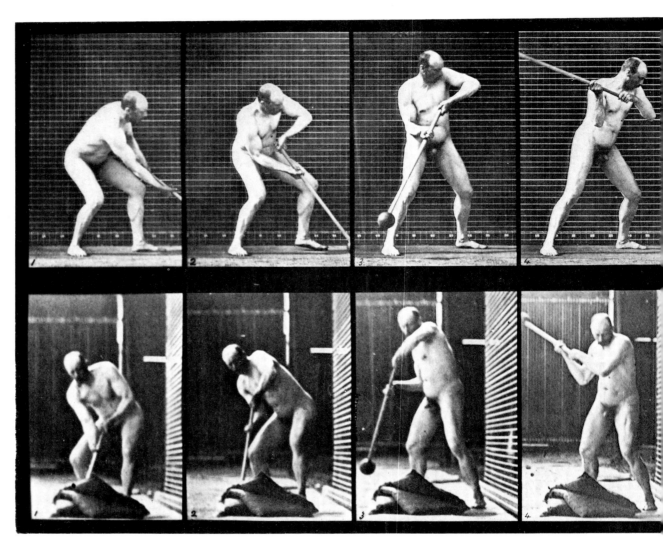

Plate 396. Pounding with a mallet.

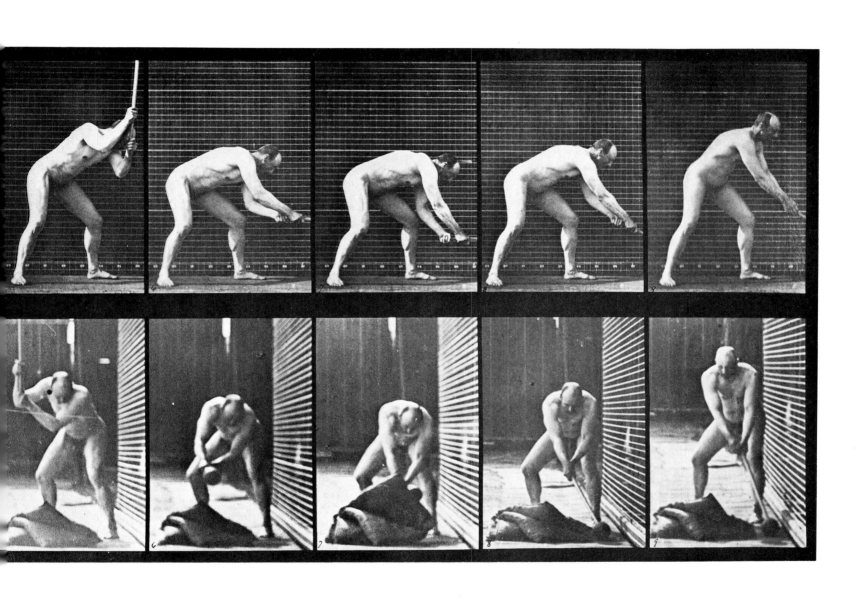

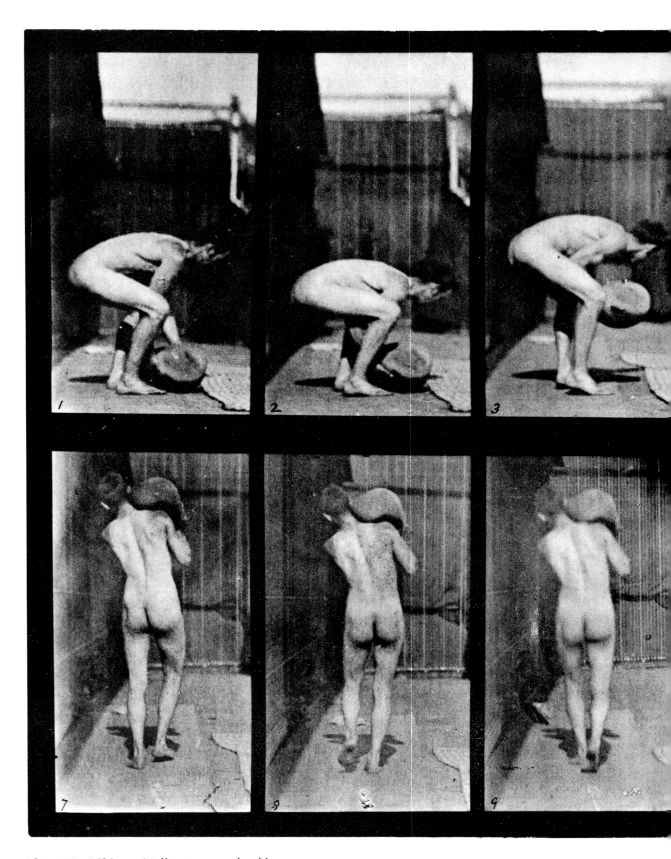

Plate 397. Lifting a 75-lb. stone on shoulder.

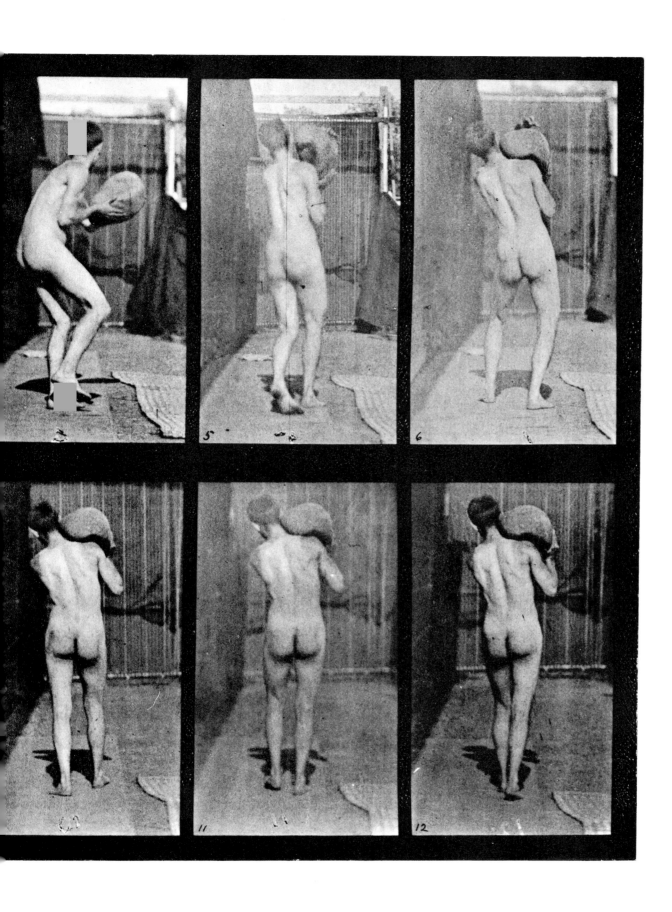

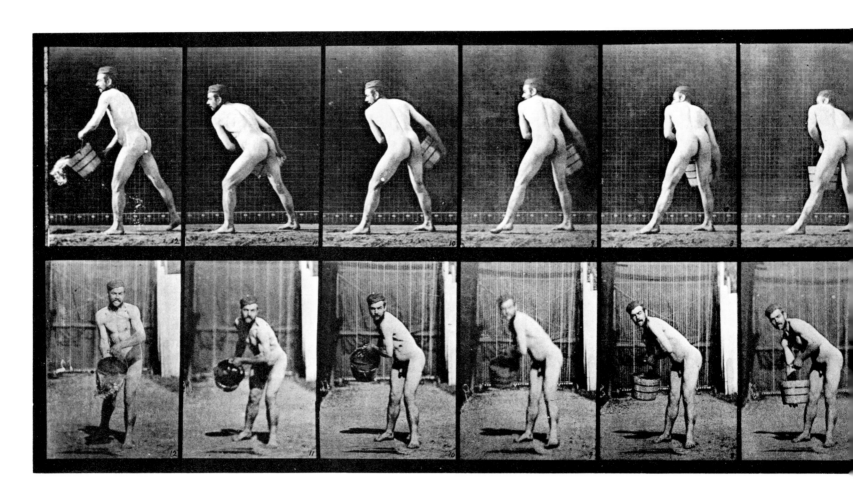

Plate 398. Lifting a bucket of water to empty it.

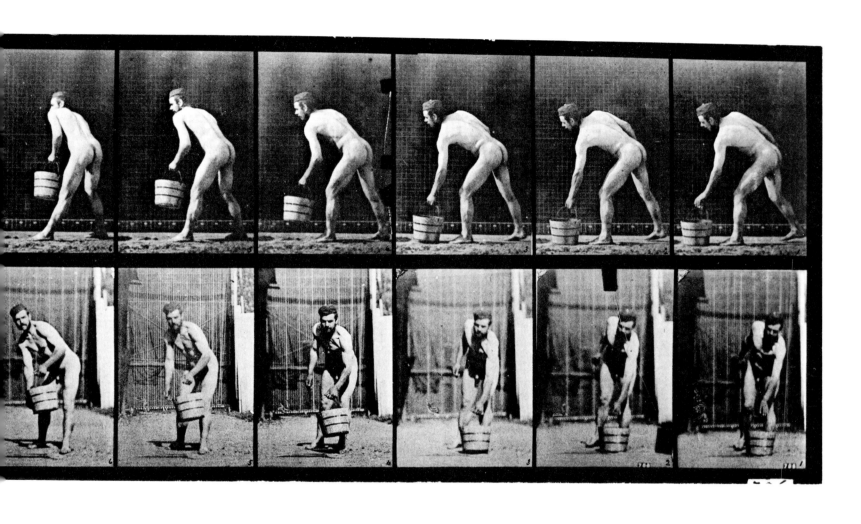

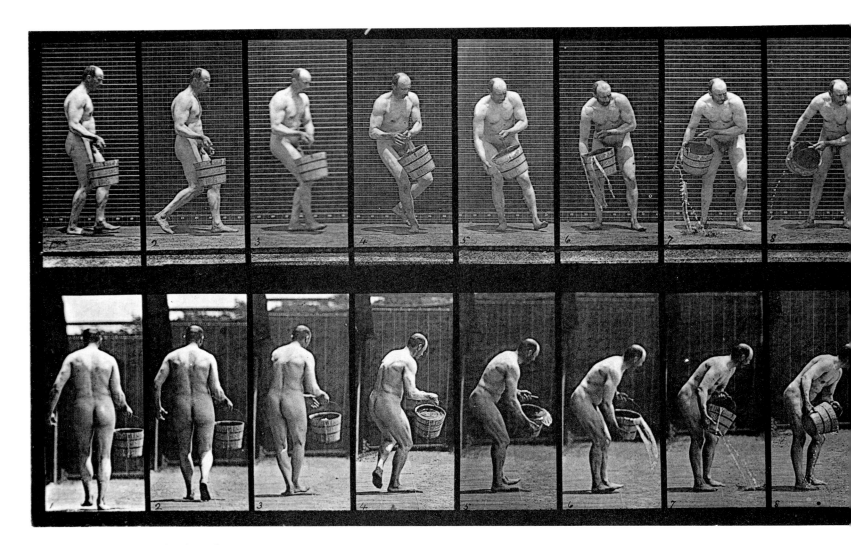

Plate 399. Emptying a bucket of water.

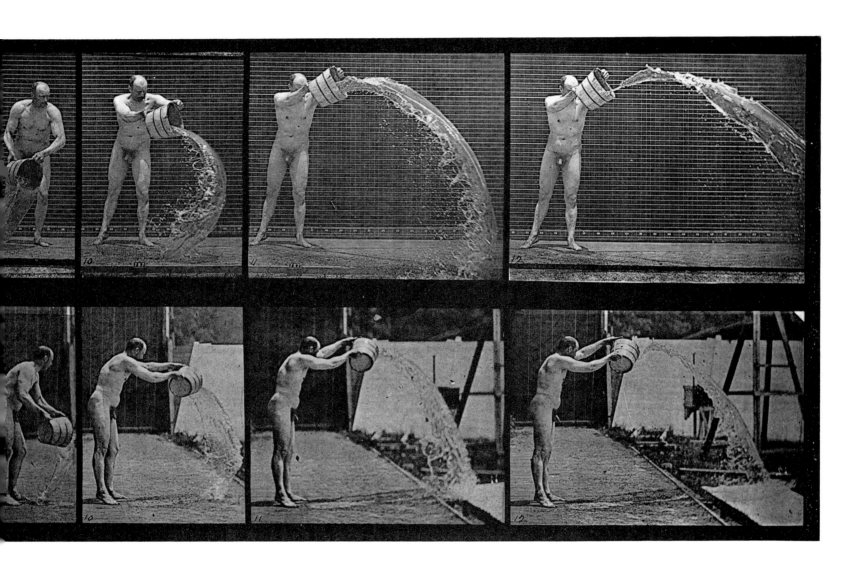

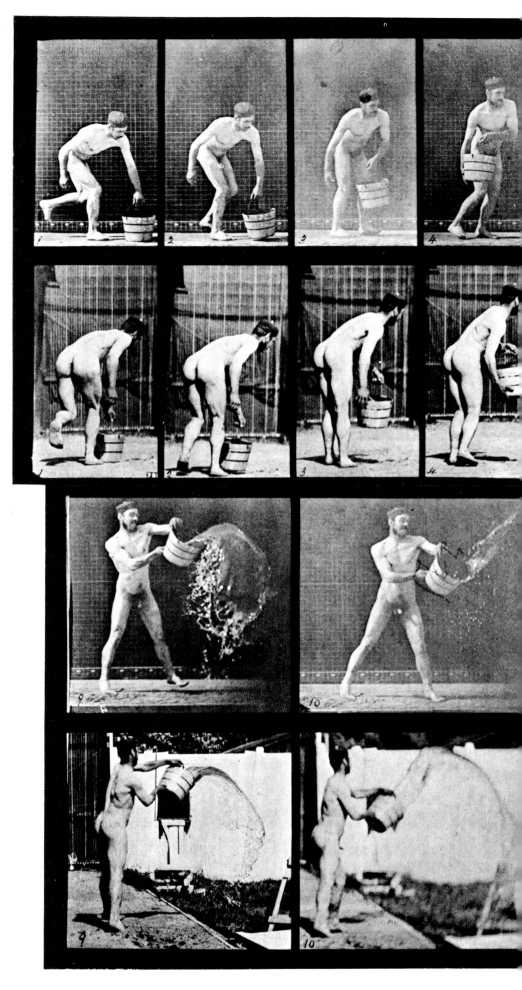

Plate 400. Emptying a bucket of water.

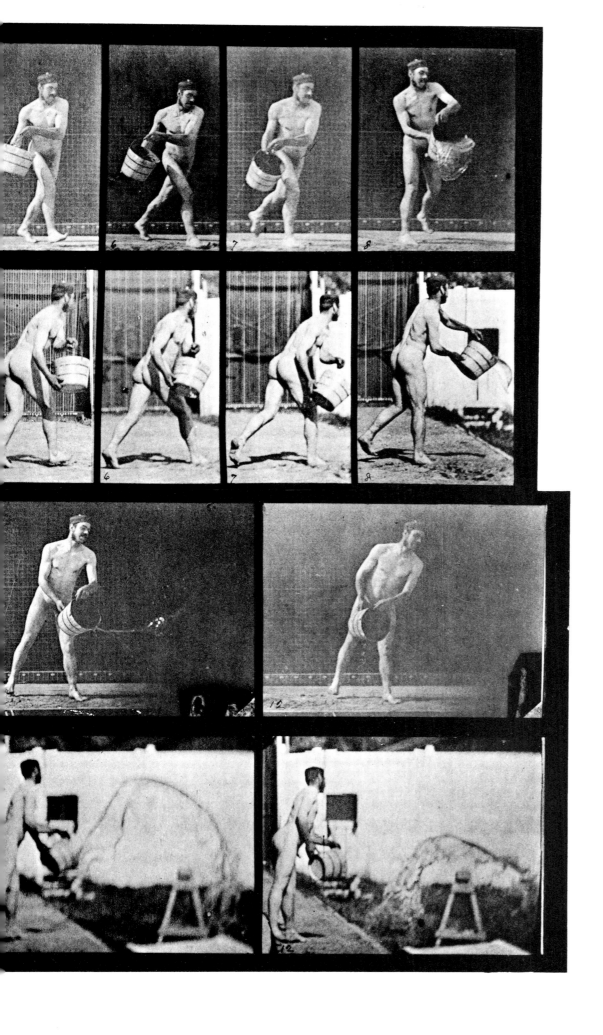

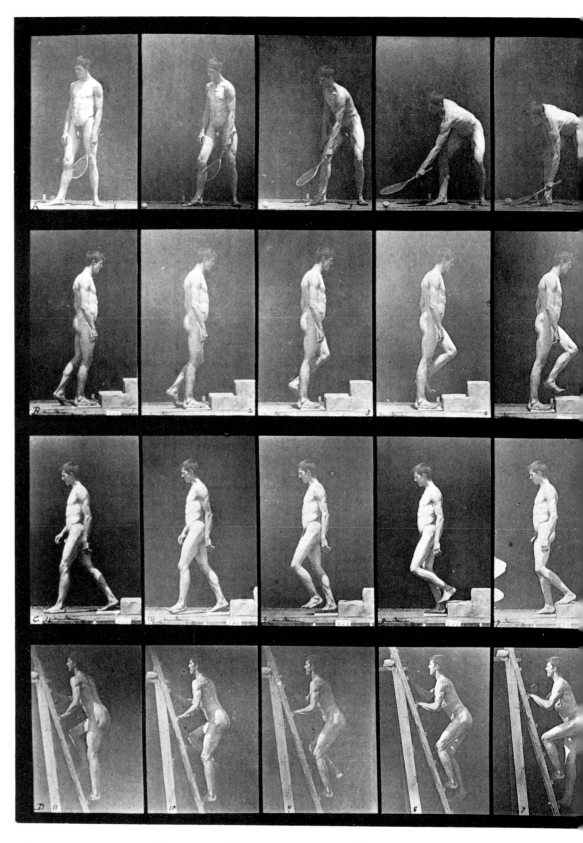

Plate 486. A: Lawn tennis. B: Ascending a step. C: Descending a step.
D: Ascending a ladder.

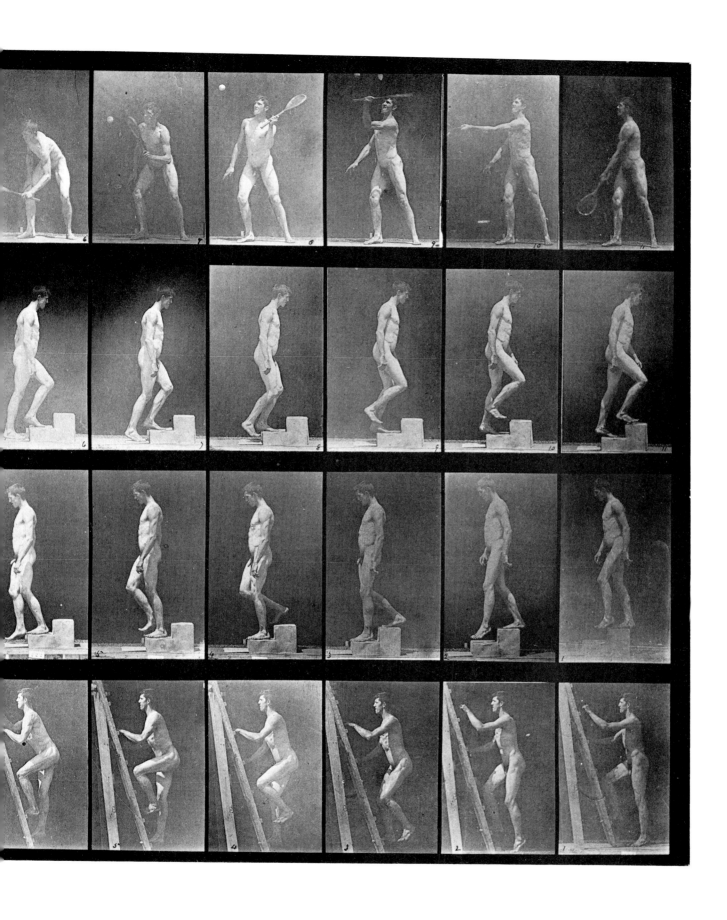

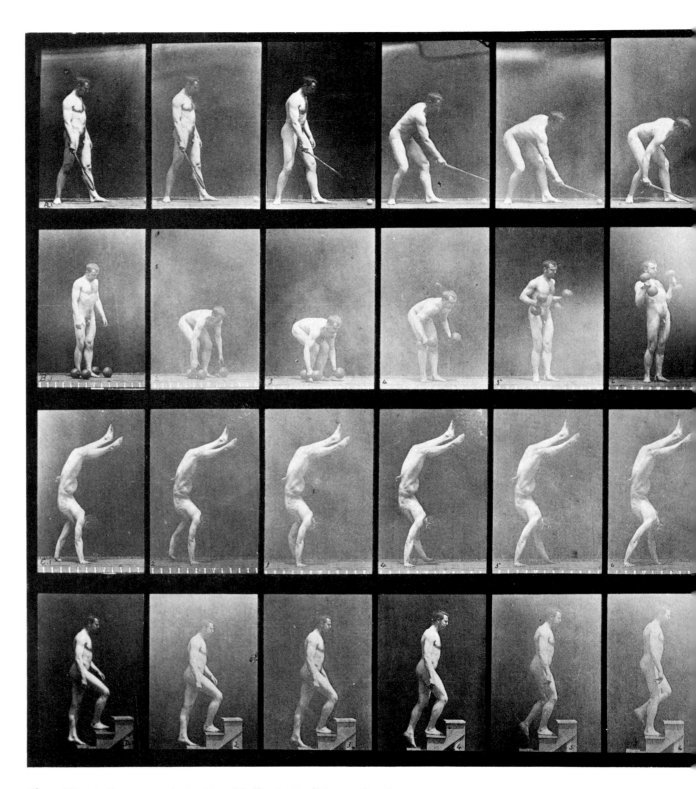

Plate 488. A: Lawn tennis. B: Dumbbells. C: Walking on hands.
D: Ascending stairs.

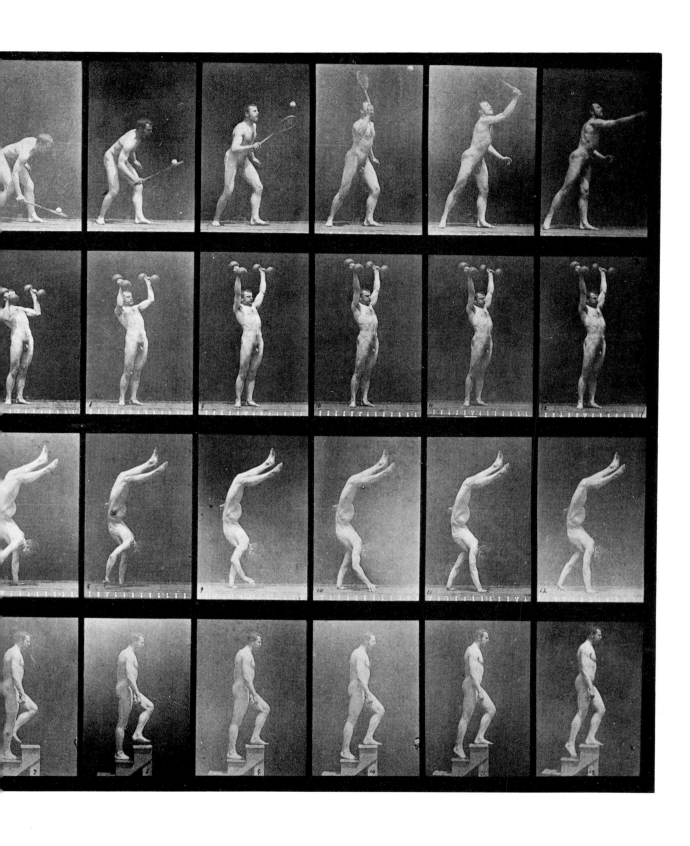

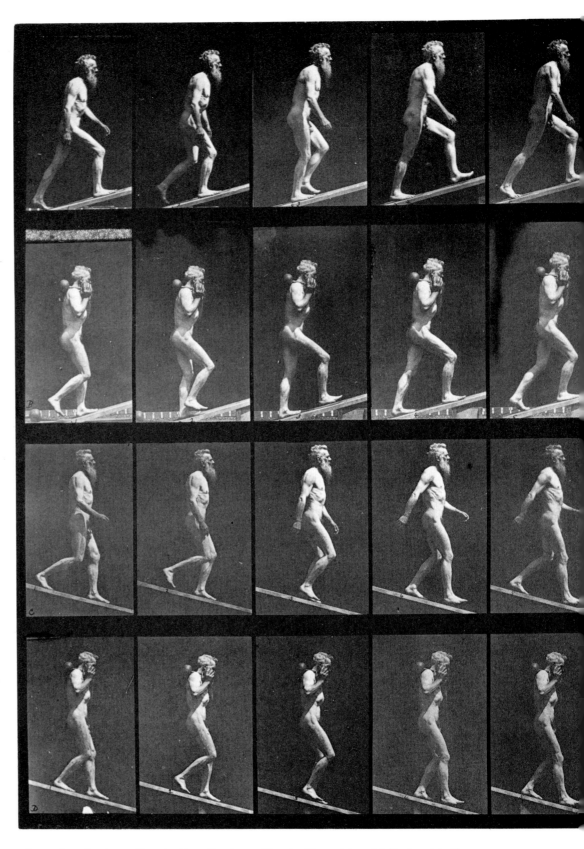

Plate 489. A: Ascending incline. B: Ascending incline with a 50-lb dumbbell.
C: Descending incline. D: Descending incline with a 50-lb. dumbbell.

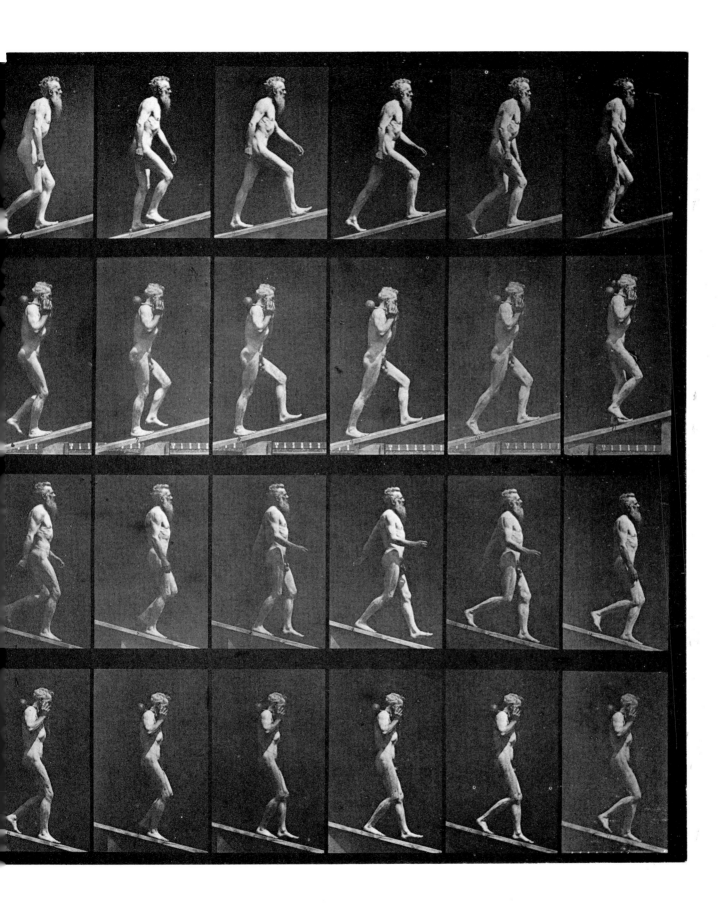

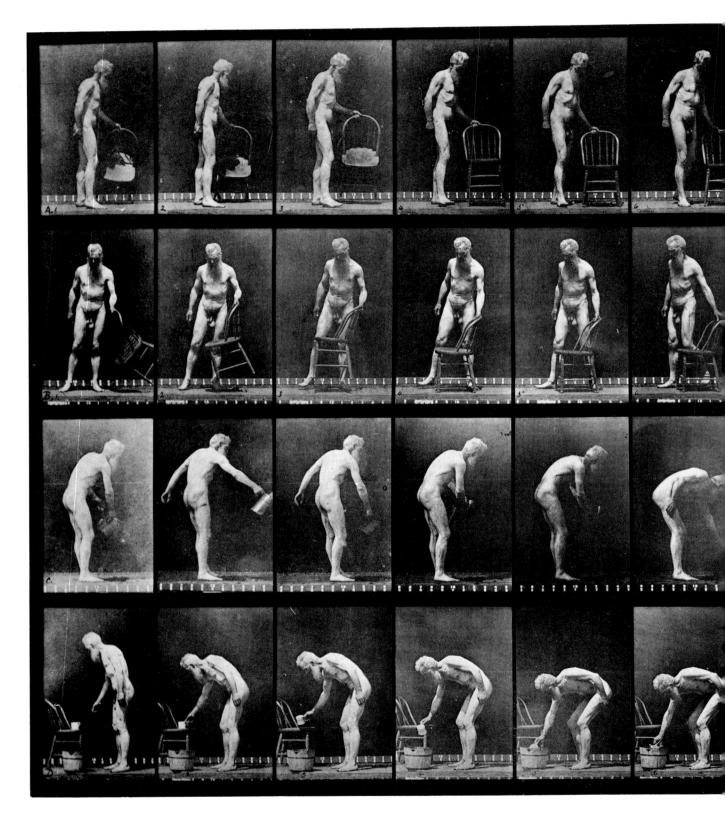

Plate 490. A, B: Sitting down. C: Sprinkling water. D: Stooping for cup and drinking.

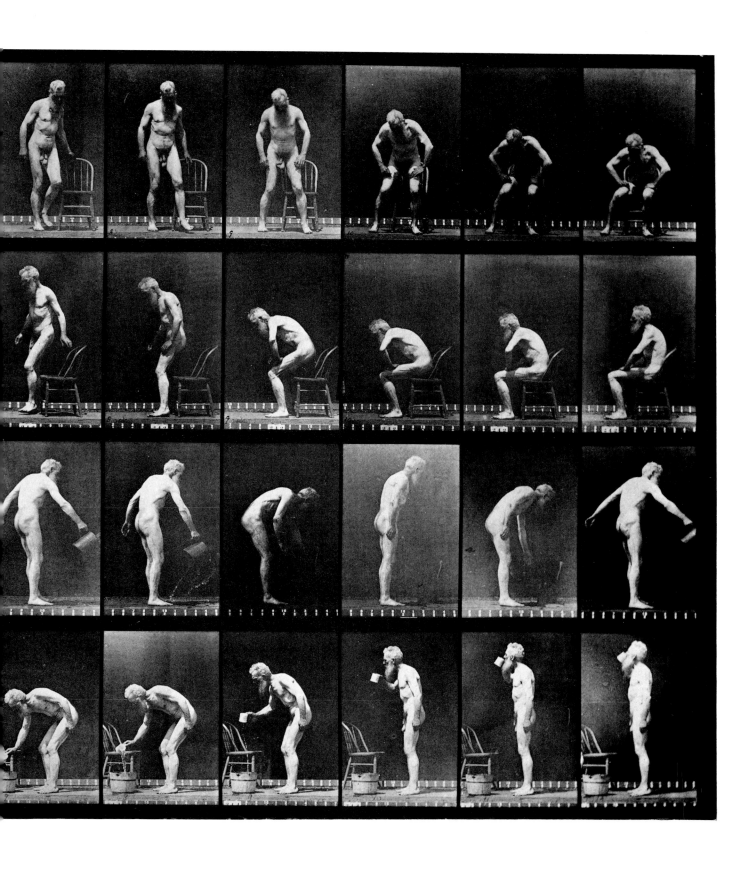

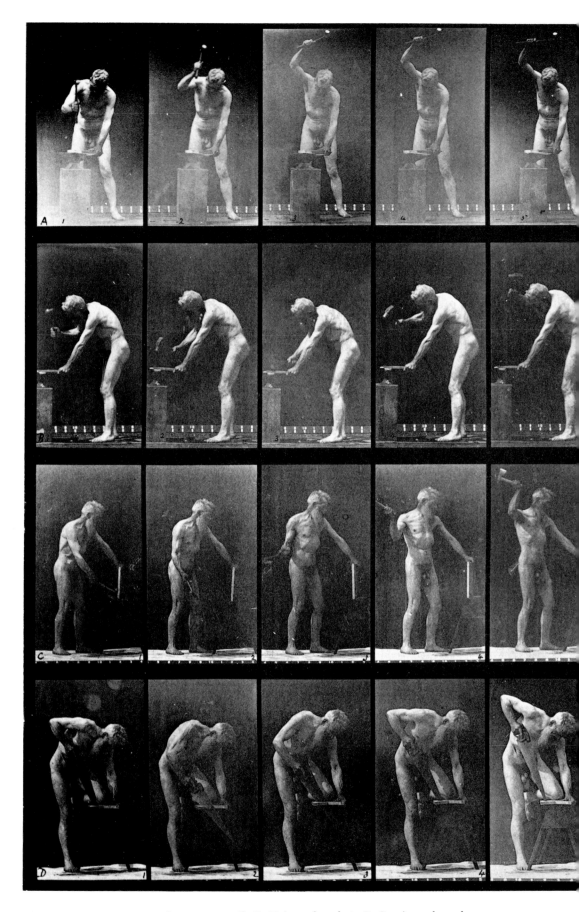

Plate 491. A, B: Hammering at an anvil. C: Using a hatchet. D: Sawing a board.

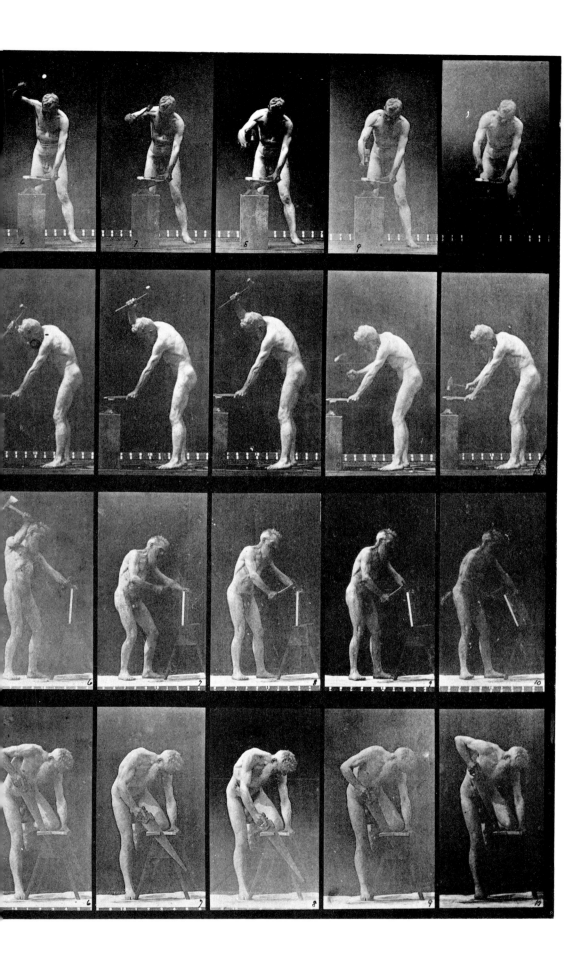

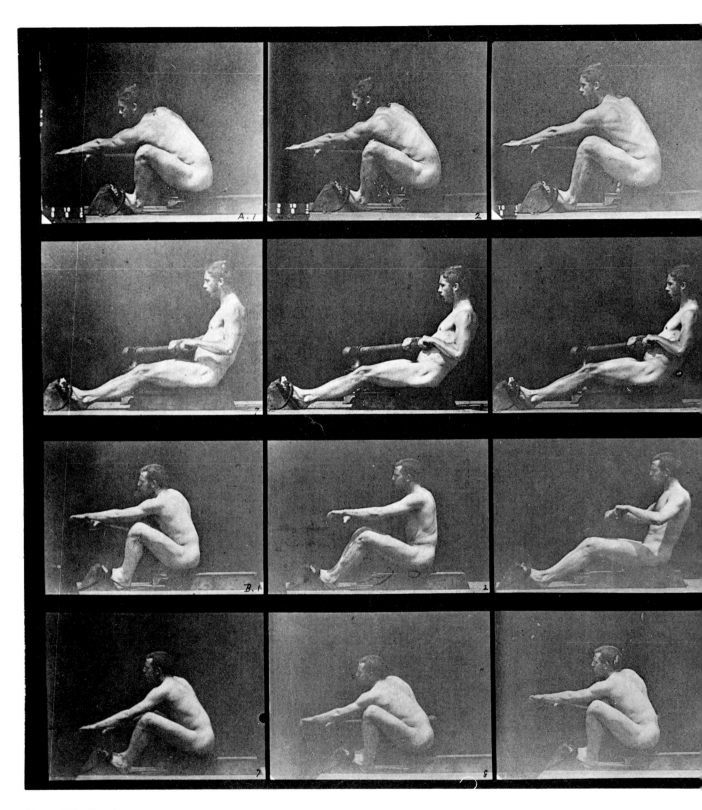

Plate 492. Rowing.

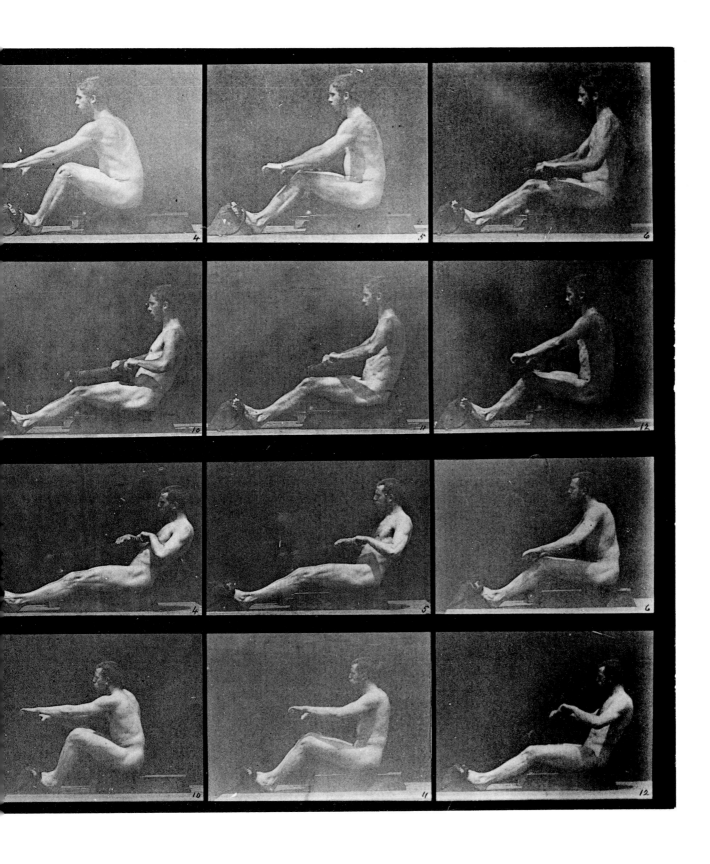

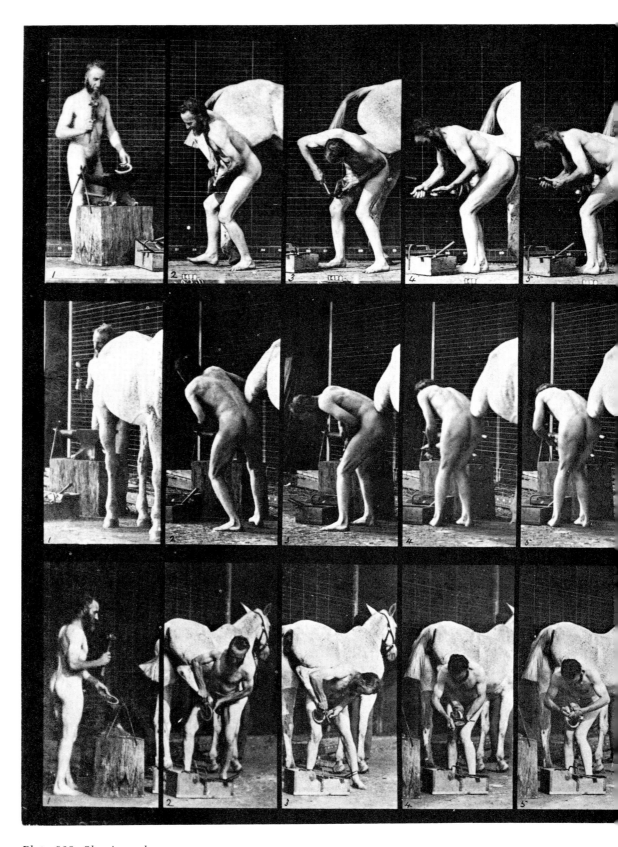

Plate 508. Shoeing a horse.

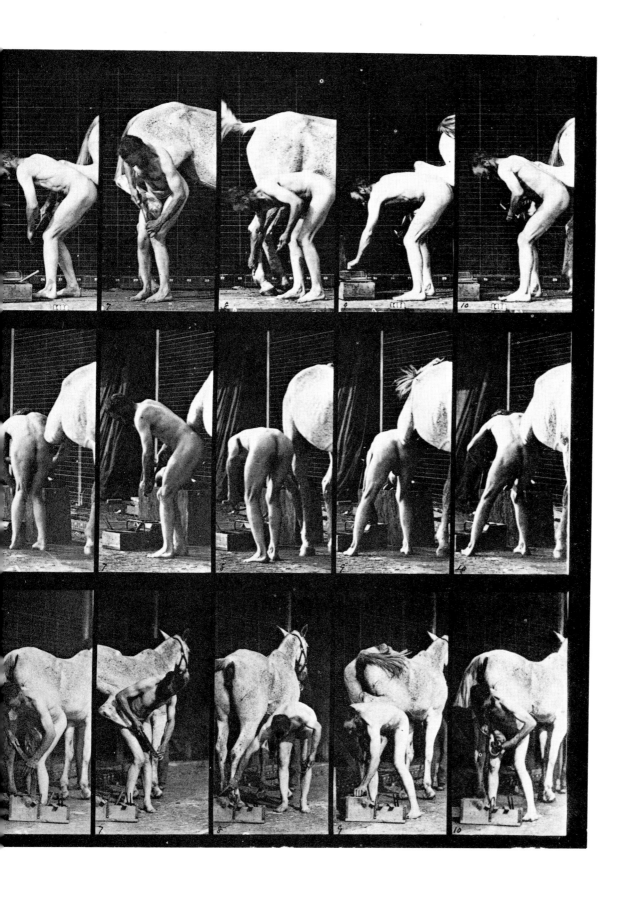

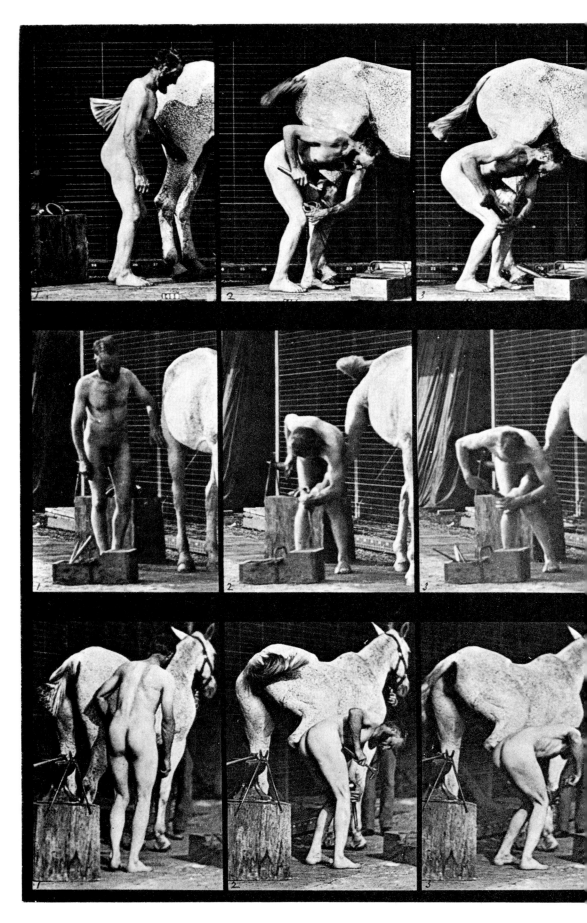

Plate 509. Shoeing a horse.

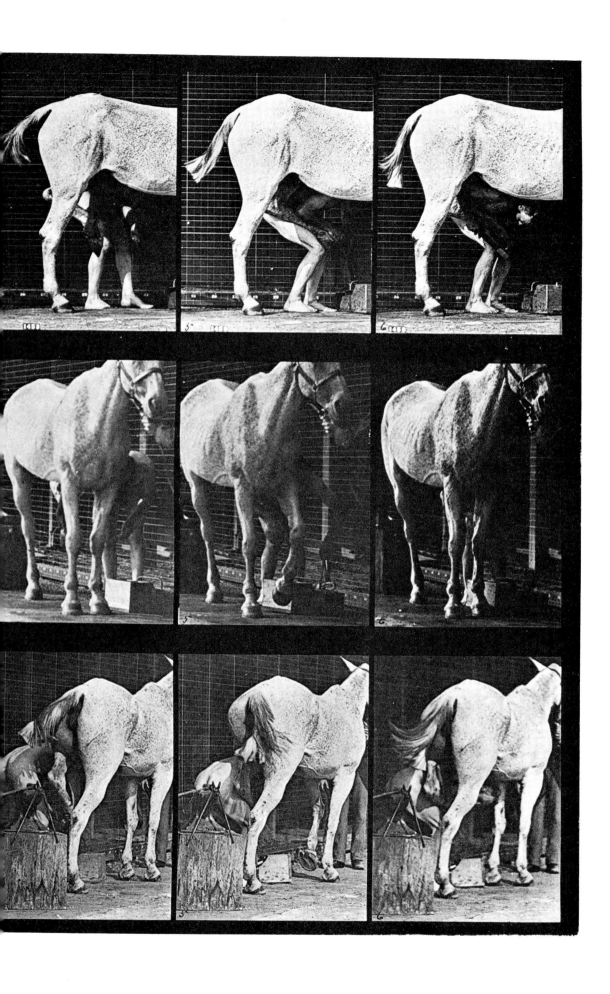

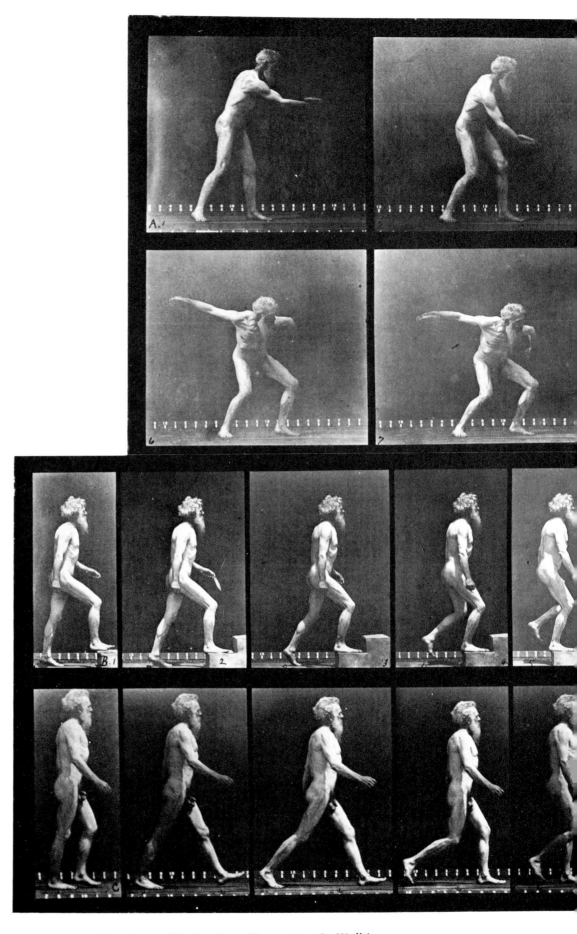

Plate 519. A: Throwing a disk. B: Ascending a step. C: Walking.

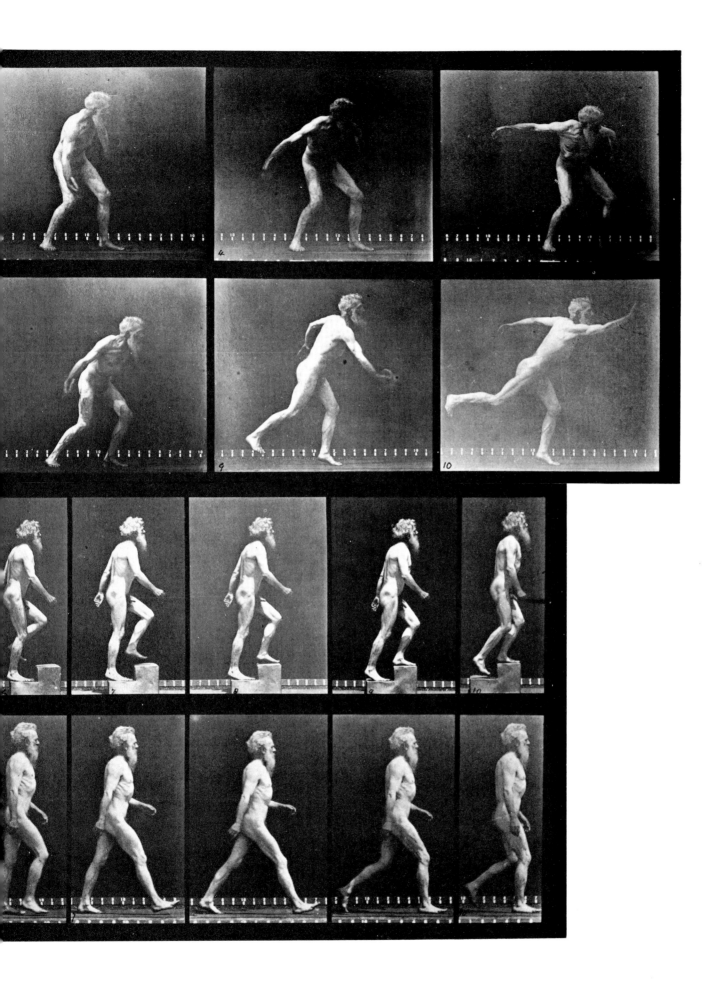

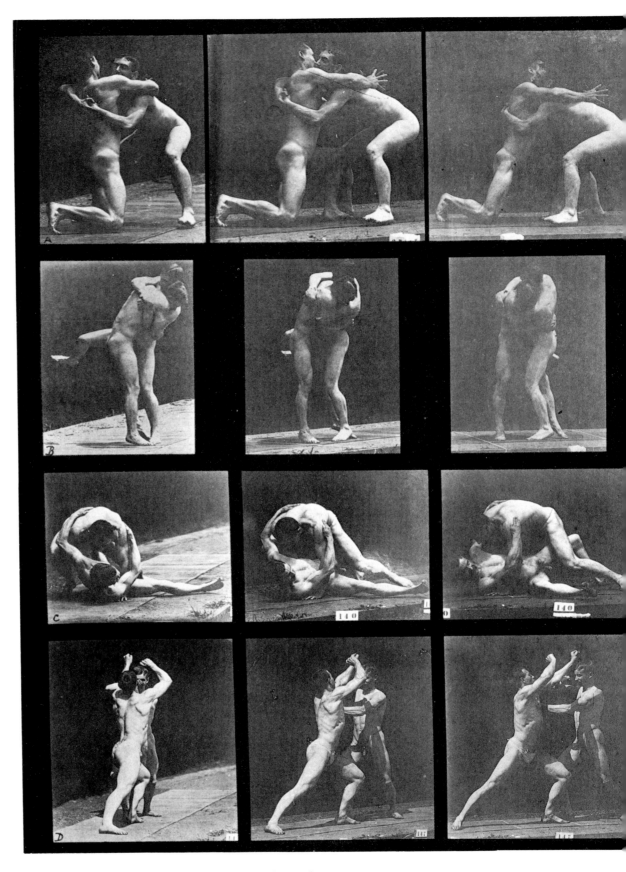

Plate 520. A–C: Wrestling. D: Sparring without gloves.

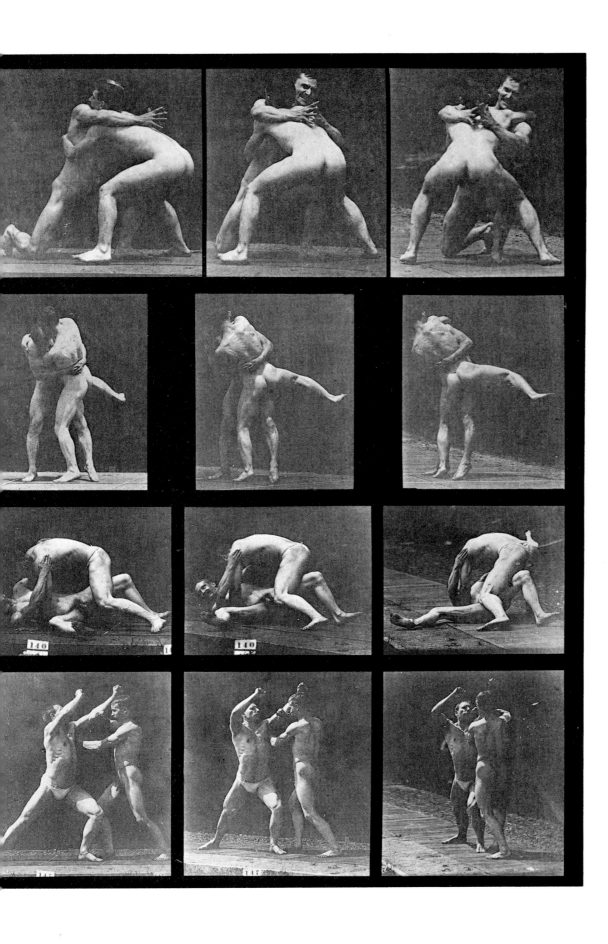

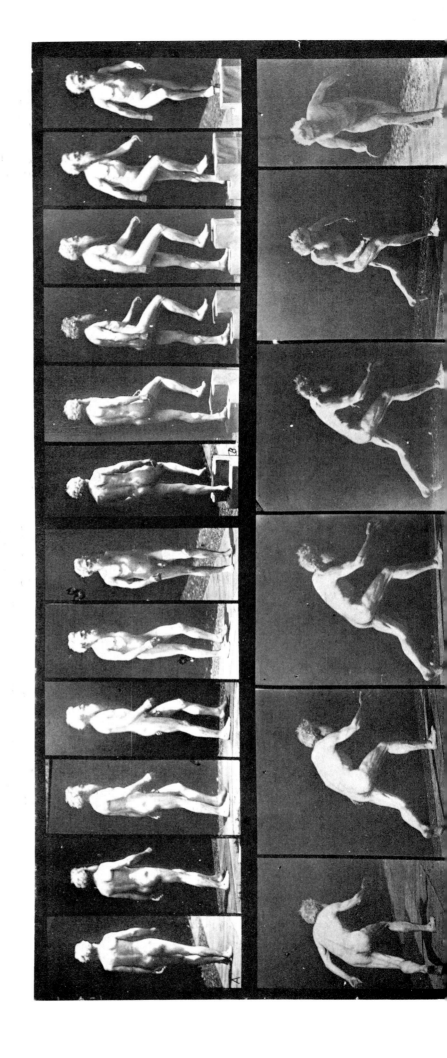

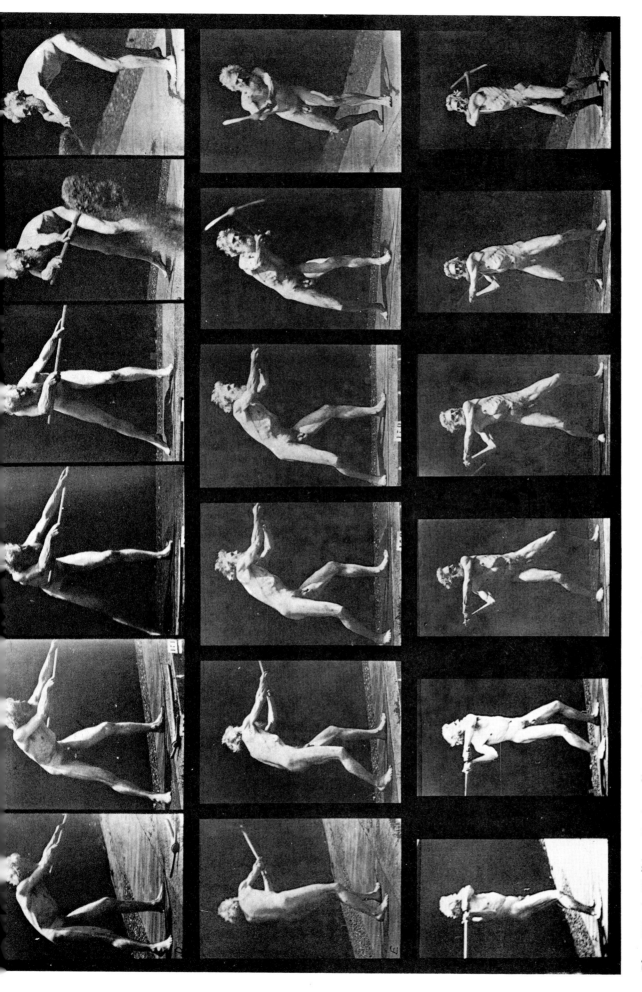

Plate 521. A: Walking. B: Ascending a step. C: Throwing the disk. D: Using a shovel. E, F: Using a pick.

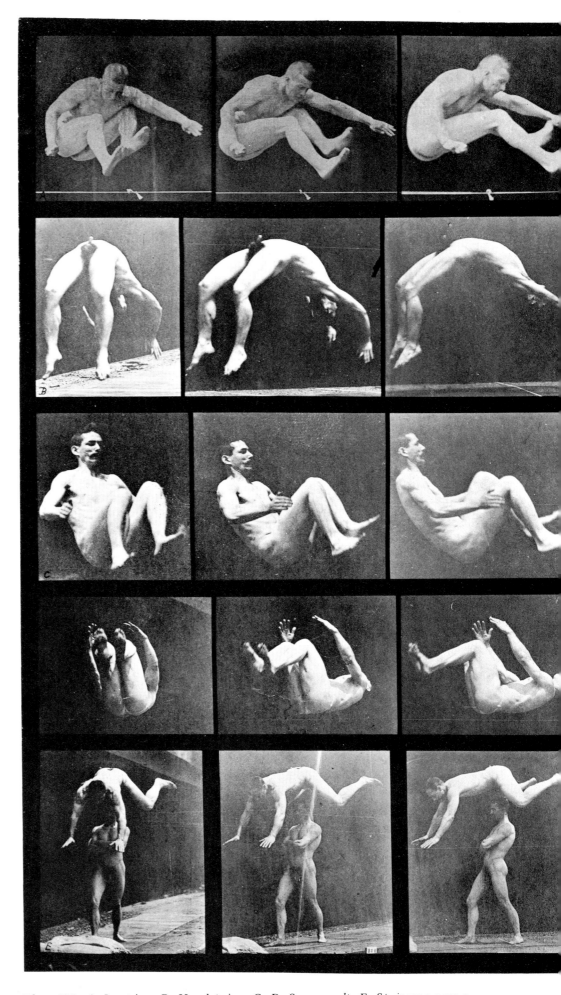

Plate 522. A: Jumping. B: Handspring. C, D: Somersault. E: Springing over a man's back.

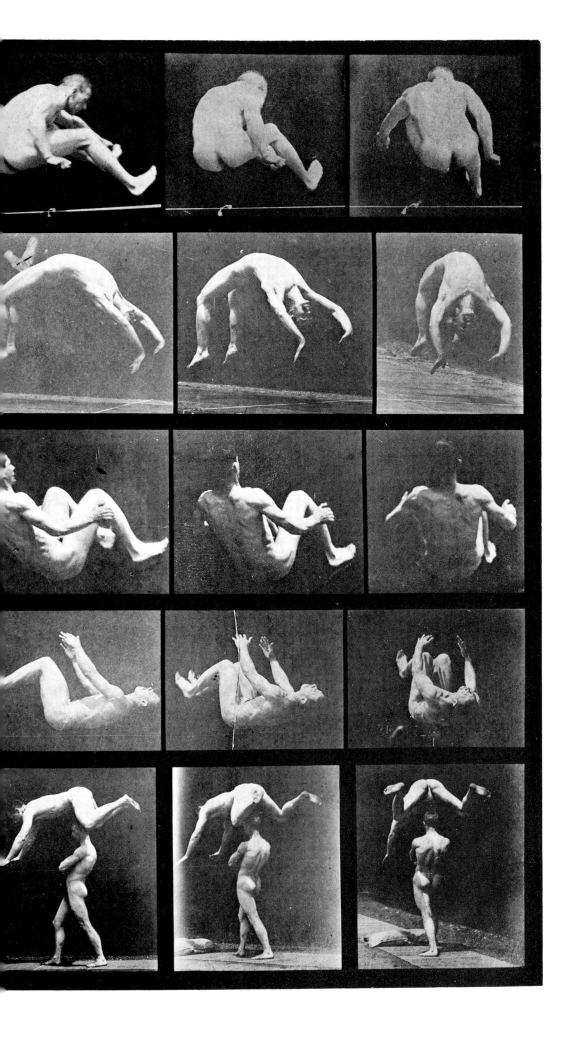

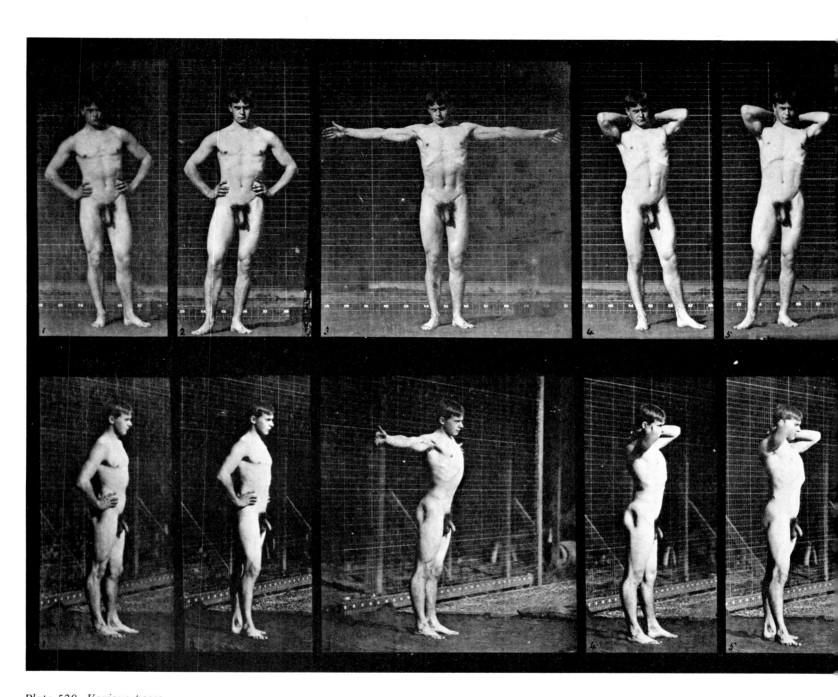

Plate 529. Various poses.

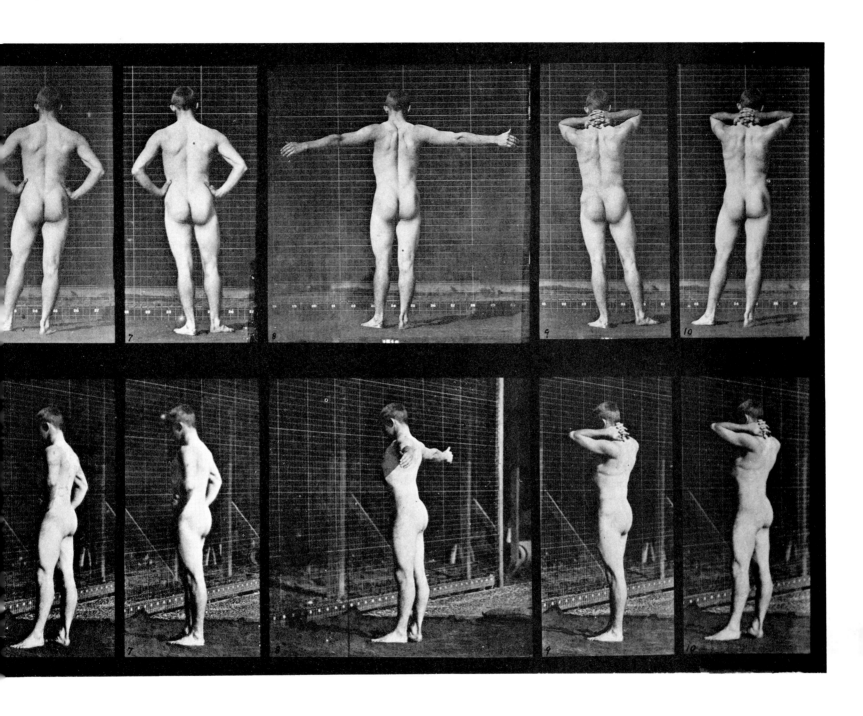

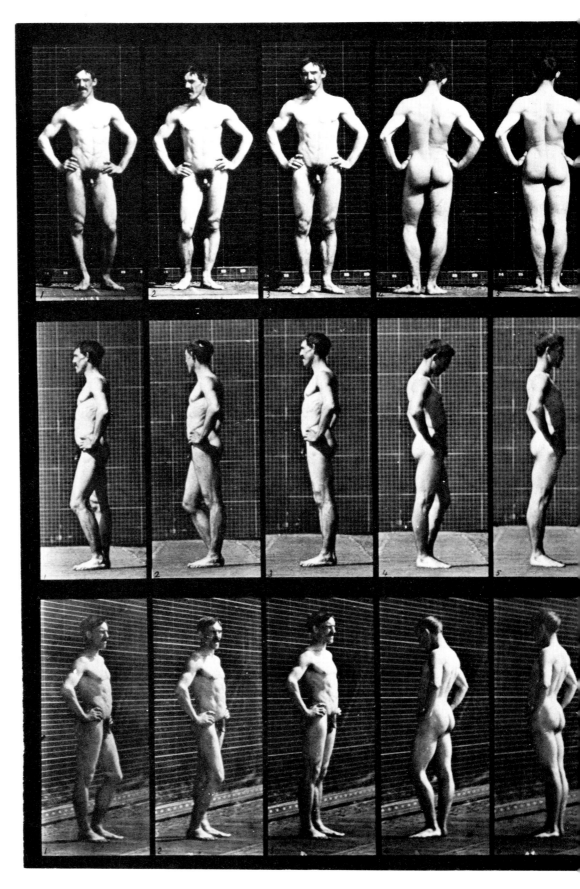

Plate 530. Various poses.

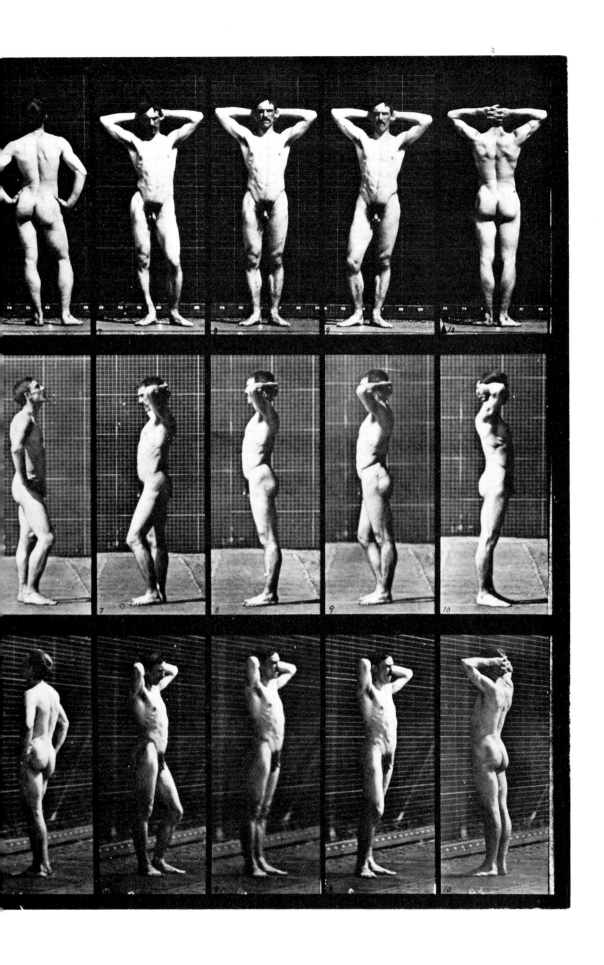

Volume 3

FEMALES
(Nude)

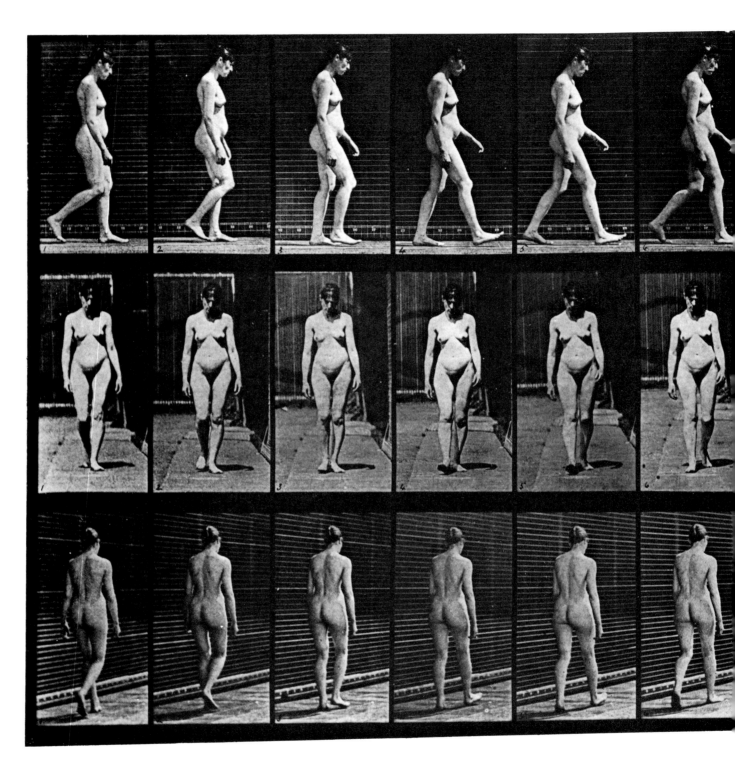

Plate 13. Walking.

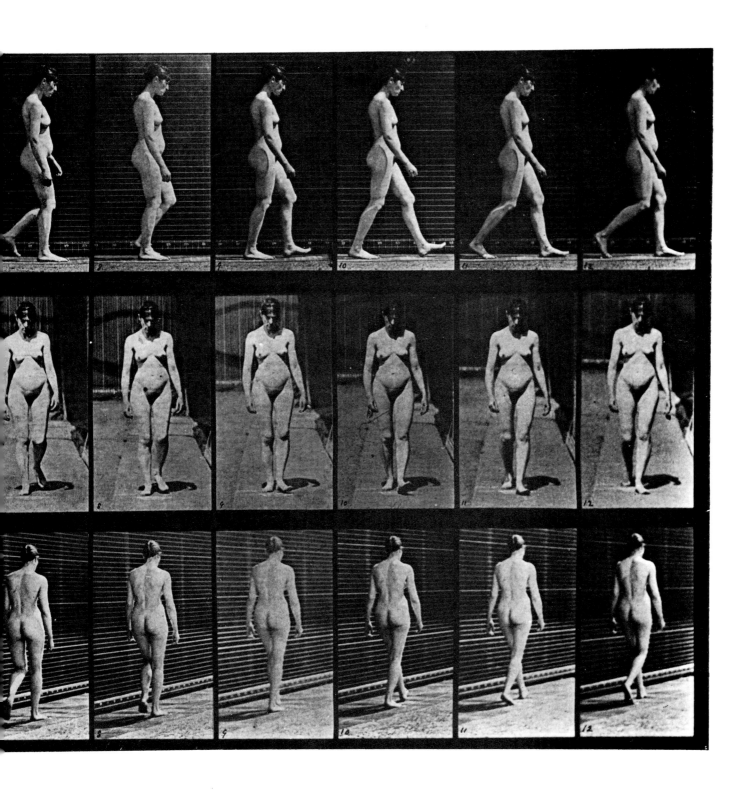

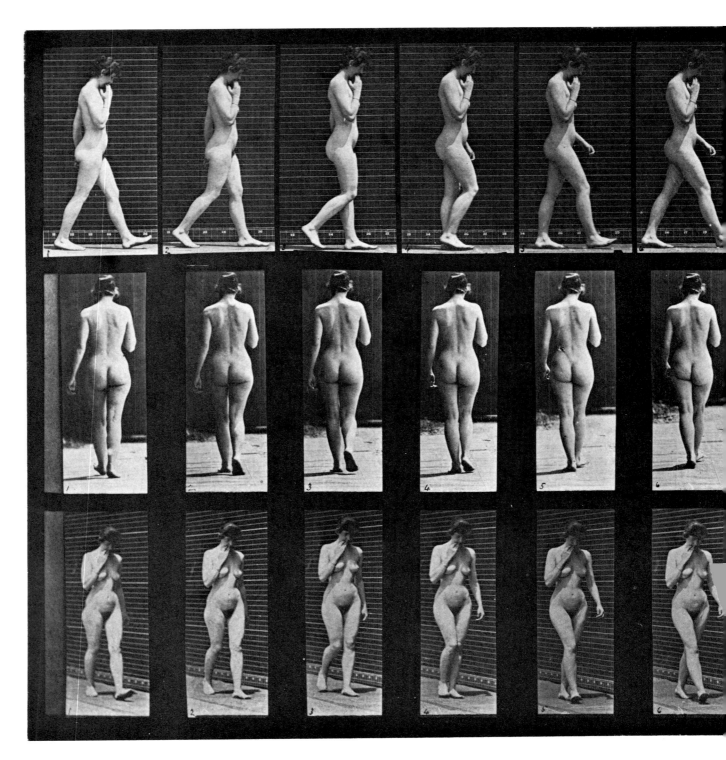

Plate 14. Walking, right hand at chin.

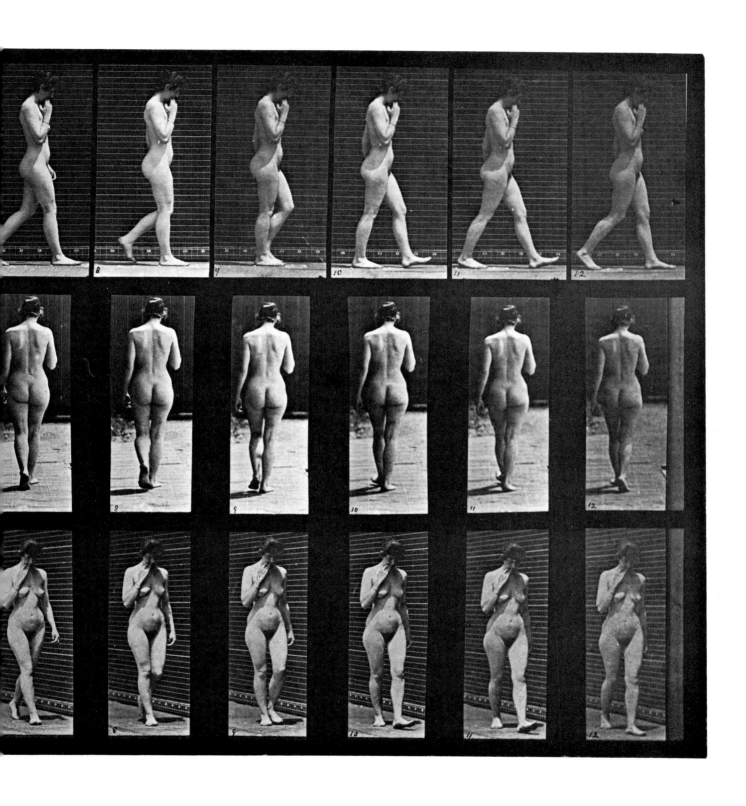

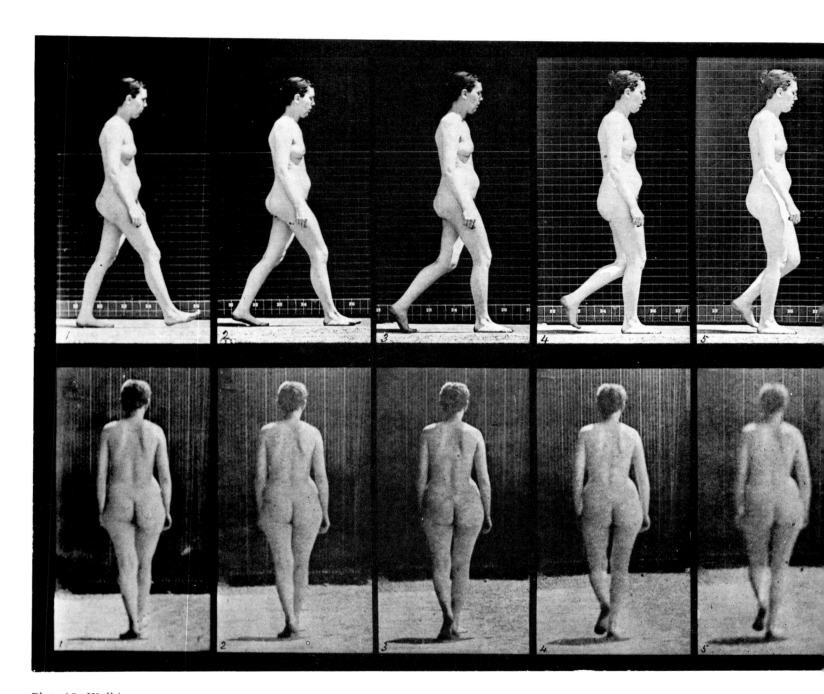

Plate 15. Walking.

276 FEMALES (NUDE)

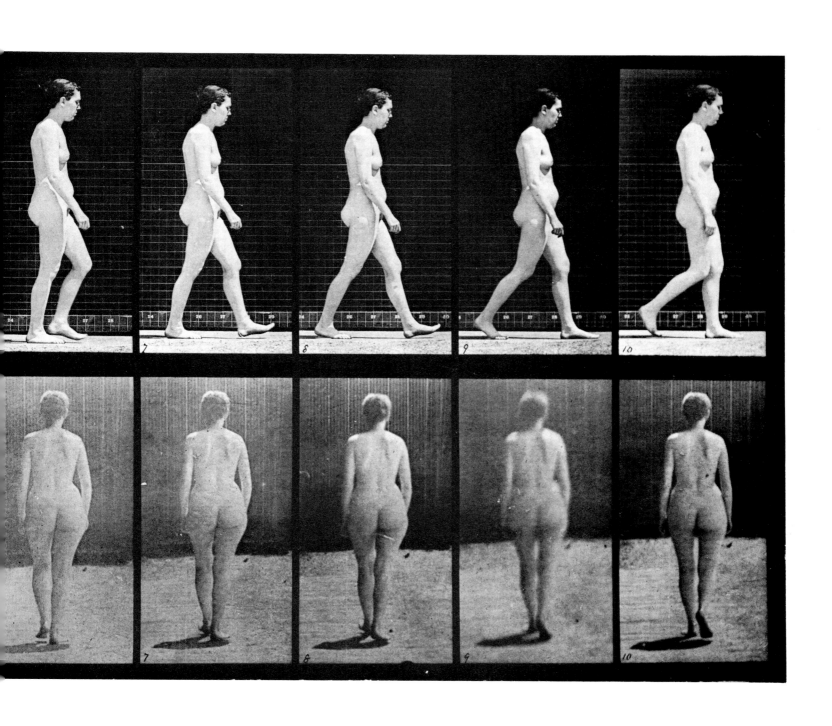

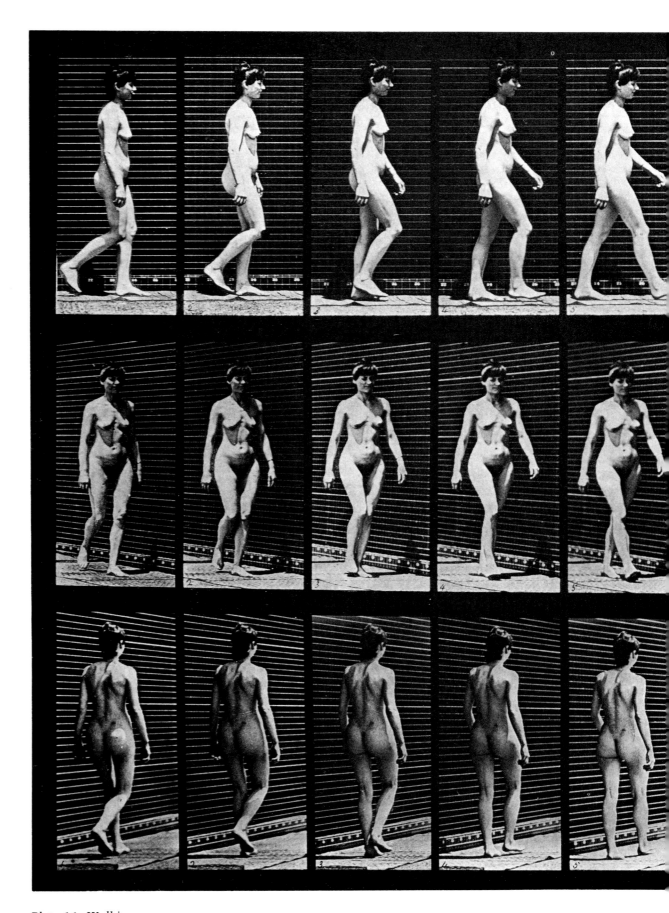

Plate 16. Walking.

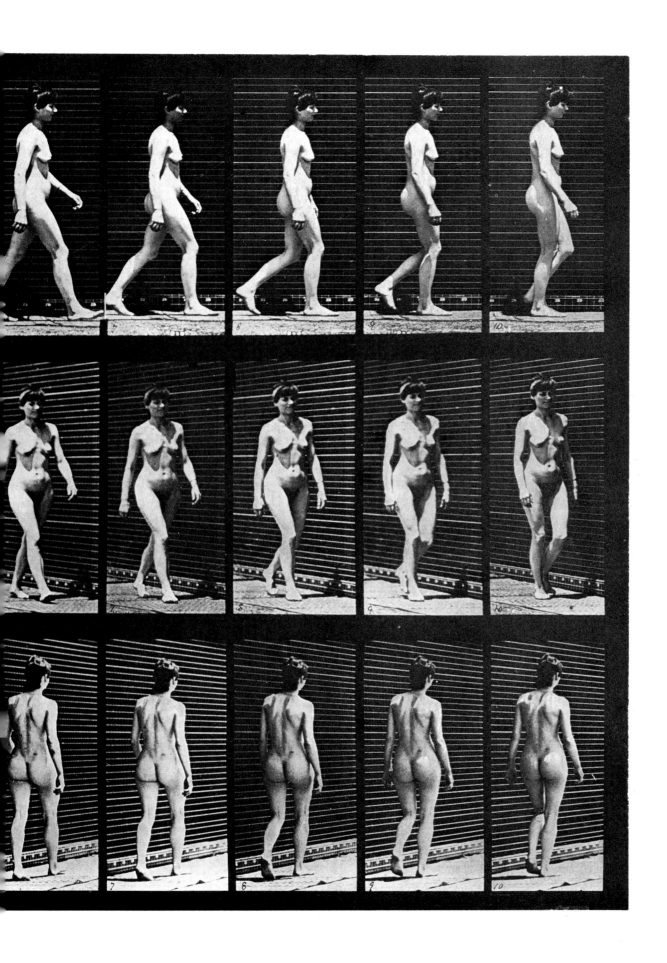

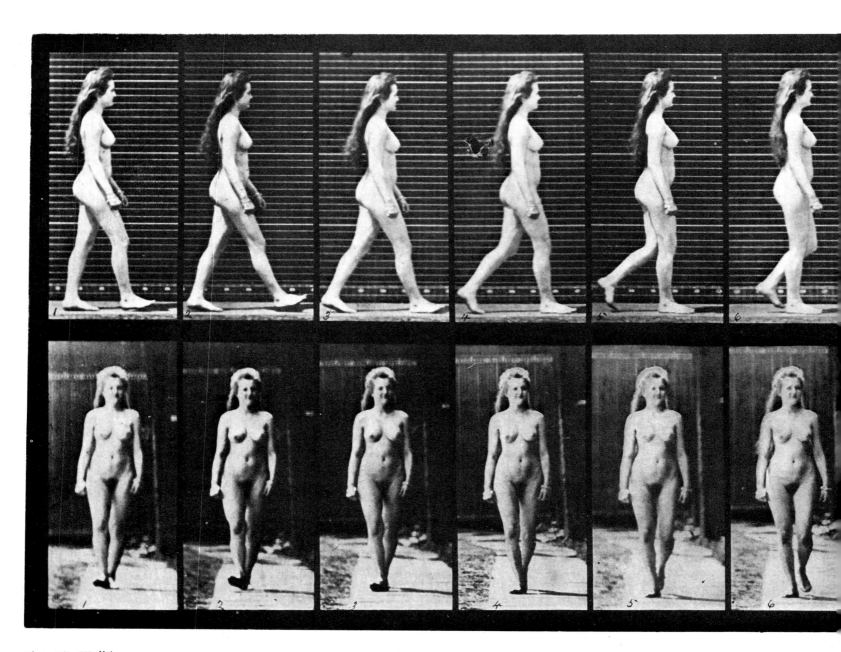

Plate 17. Walking.

280 FEMALES (NUDE)

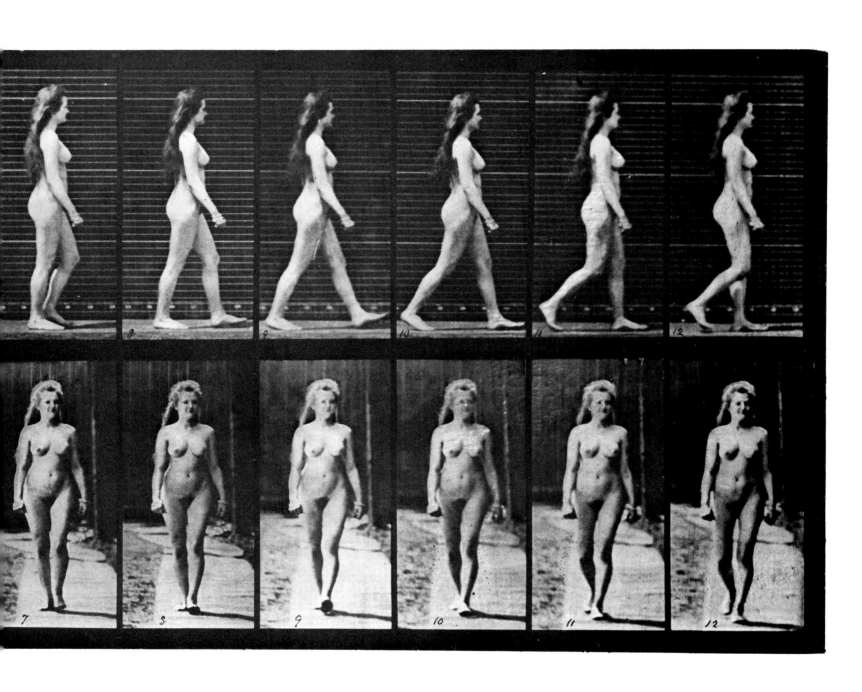

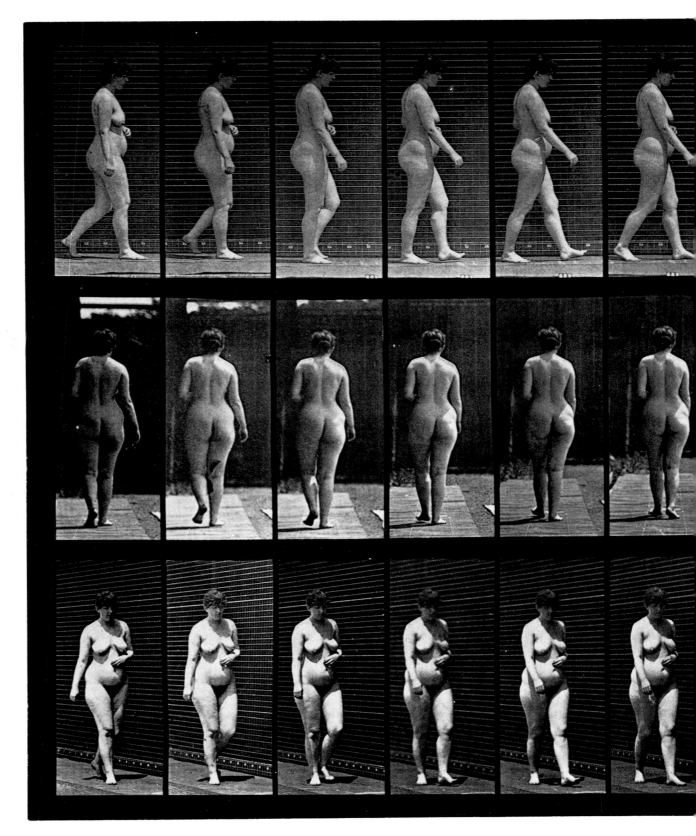

Plate 18. Walking, left hand across abdomen.

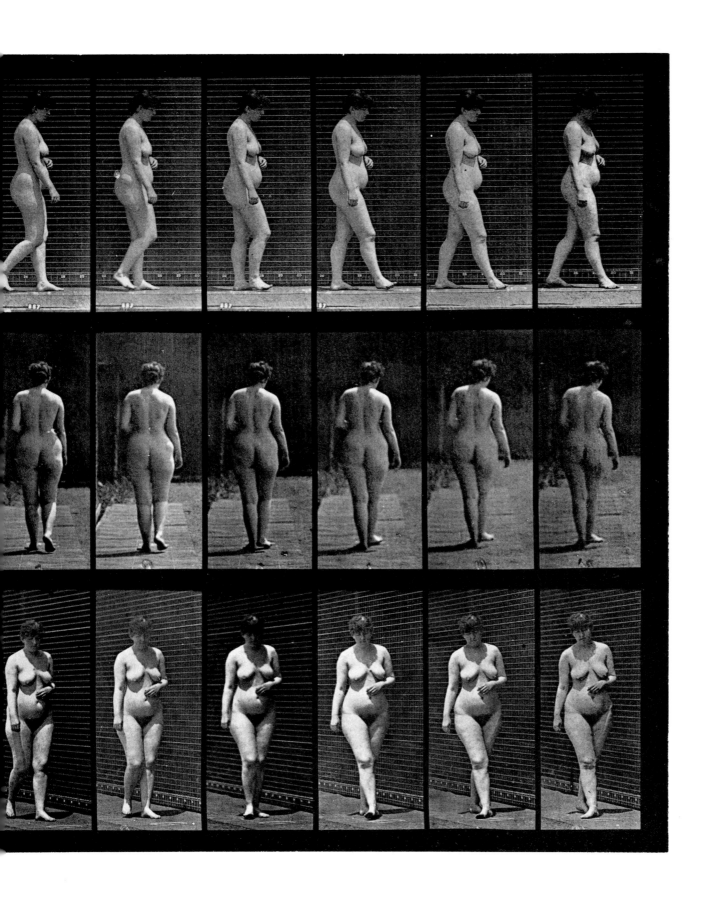

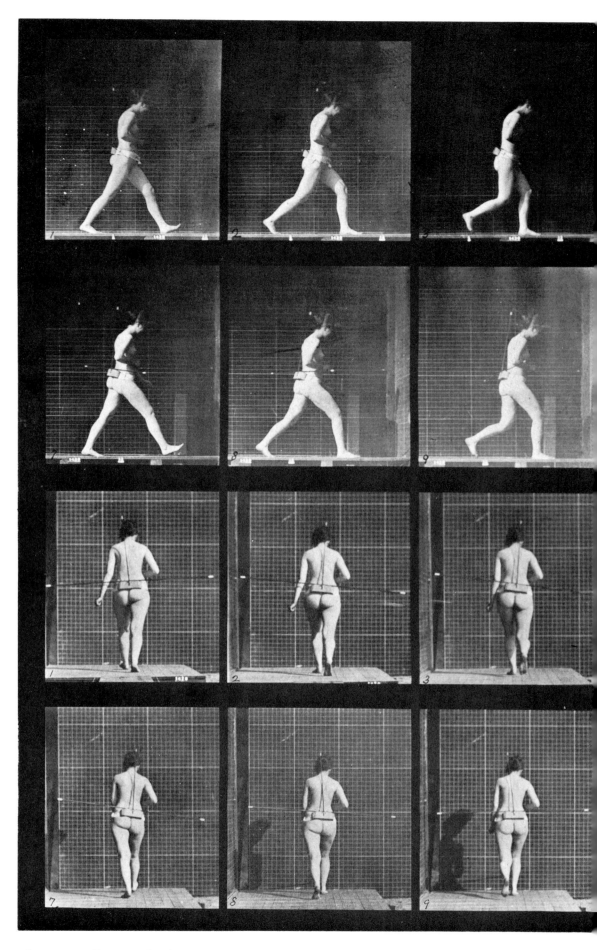

Plate 20. Walking, right elbow bent.

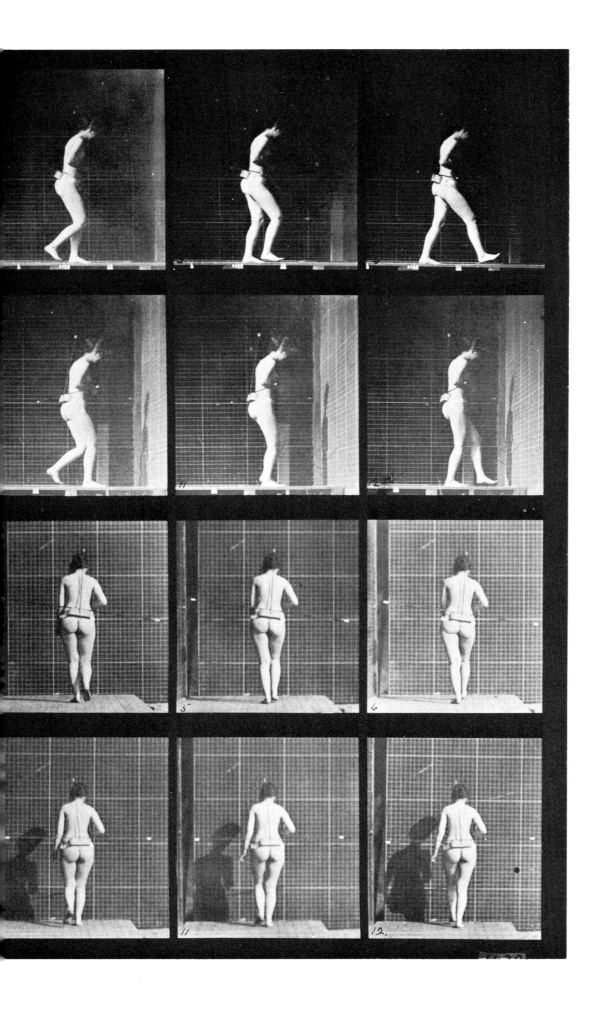

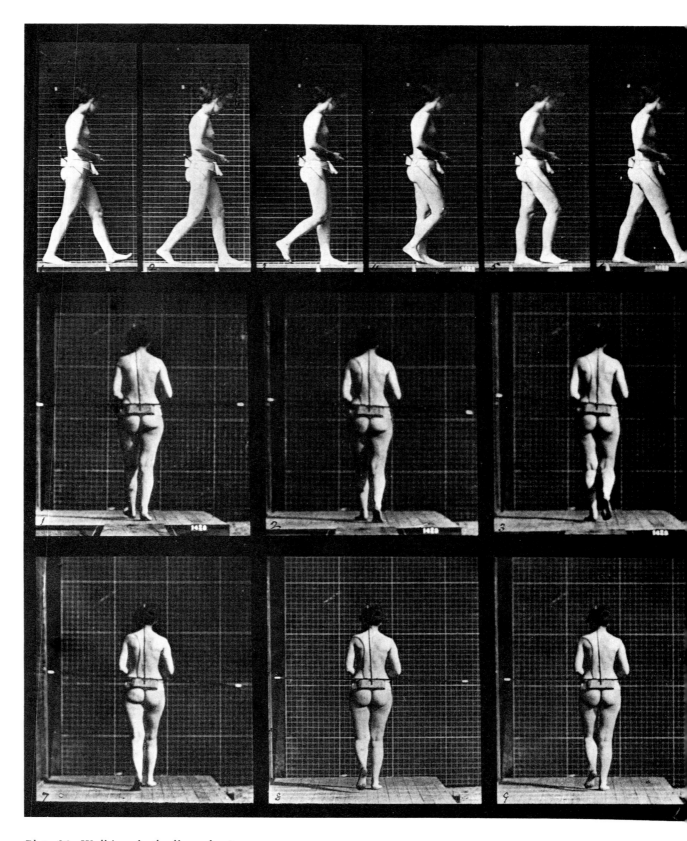

Plate 21. Walking, both elbows bent.

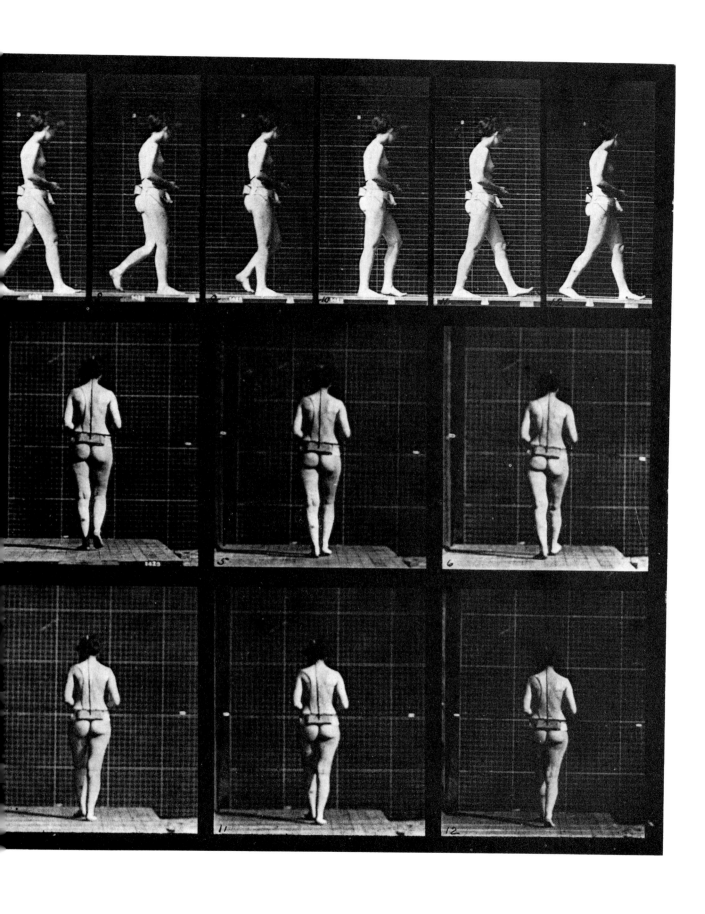

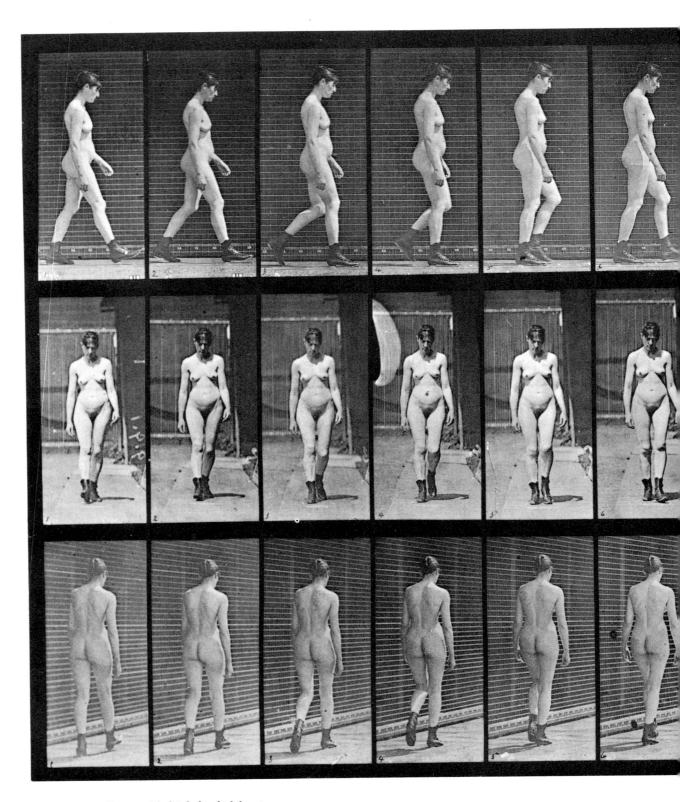

Plate 22. Walking with high-heeled boots on.

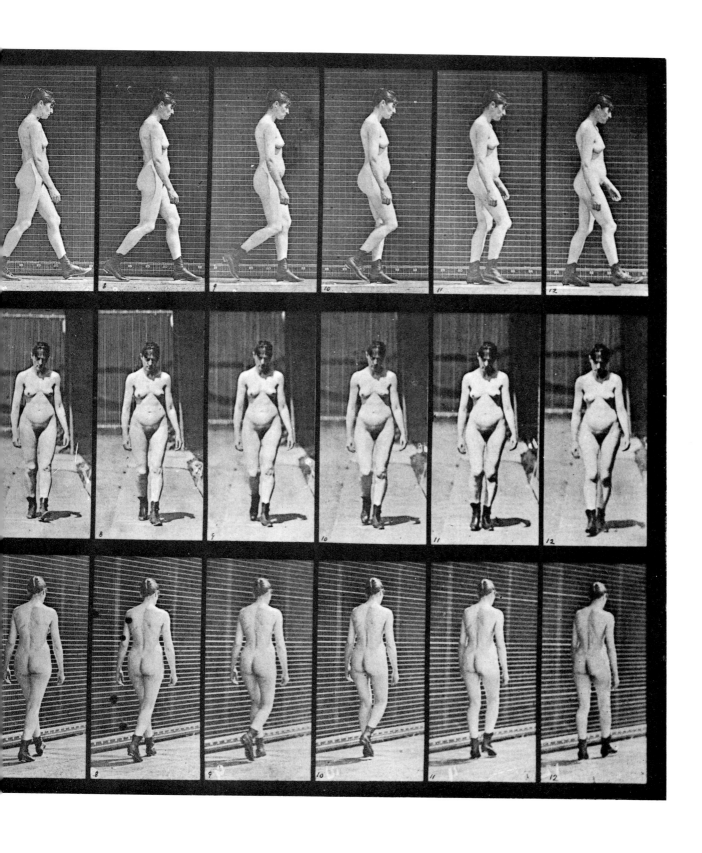

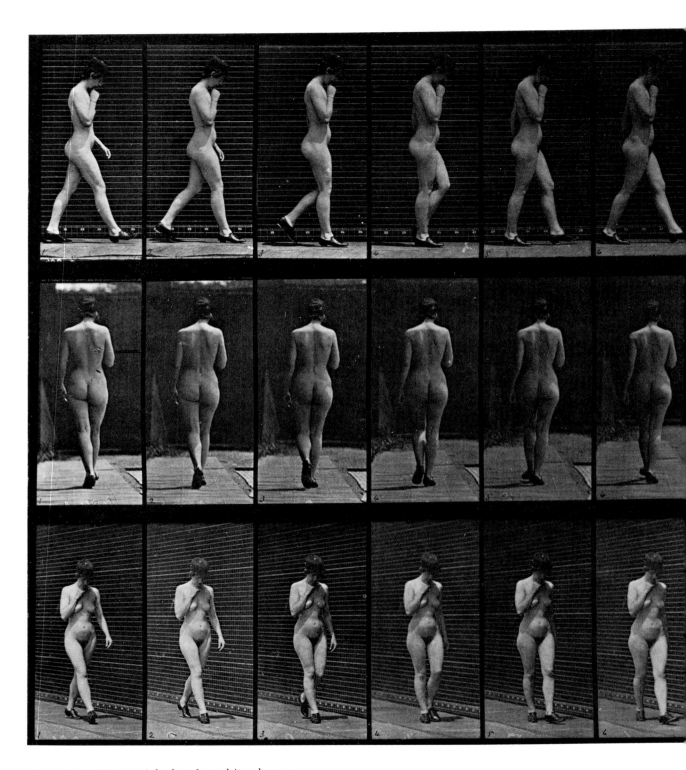

Plate 23. Walking, right hand at chin, shoes on.

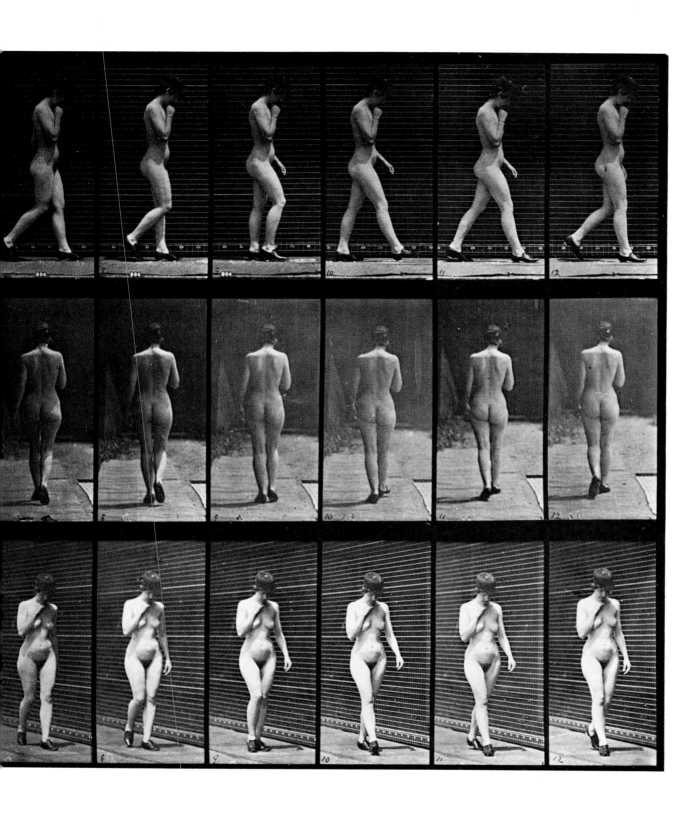

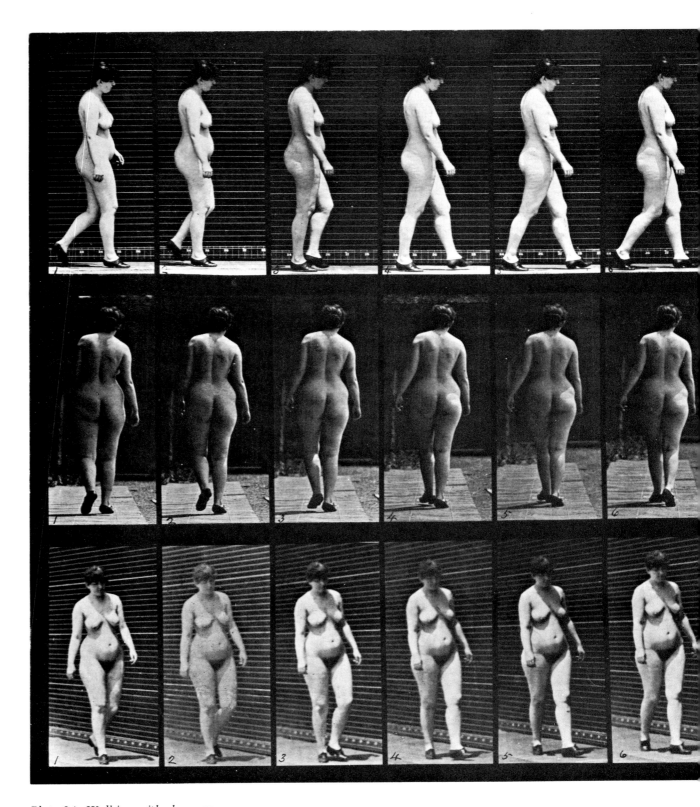

Plate 24. Walking with shoes on.

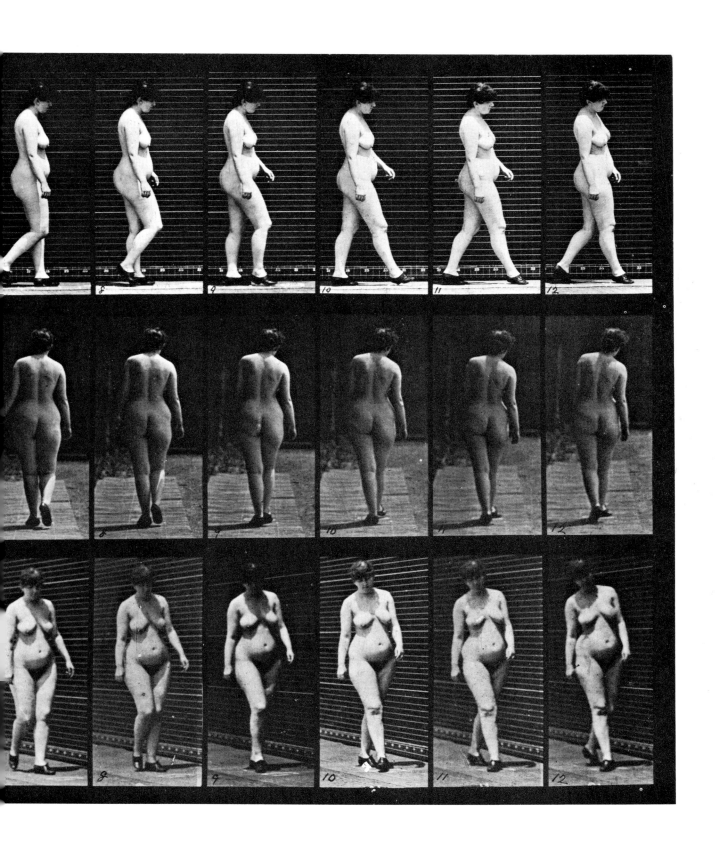

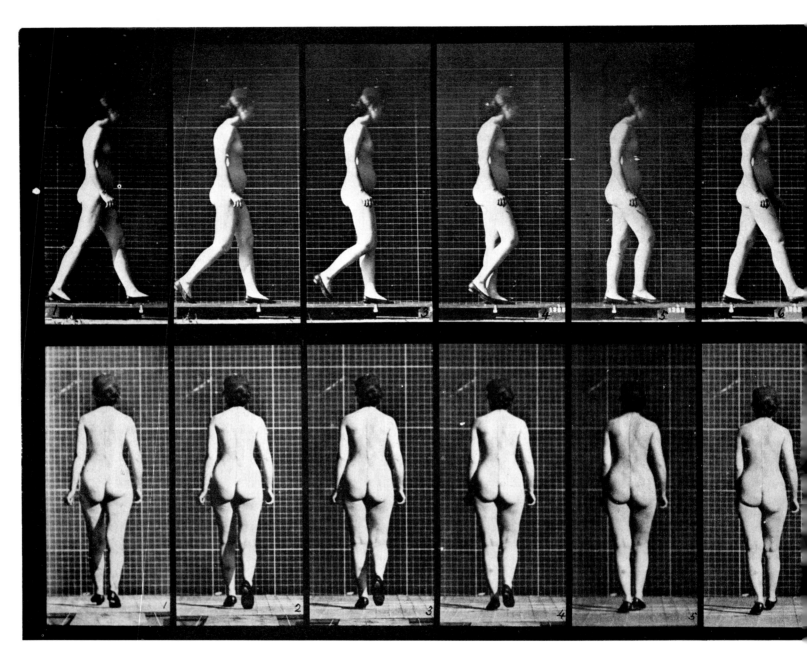

Plate 25. Walking with shoes on.

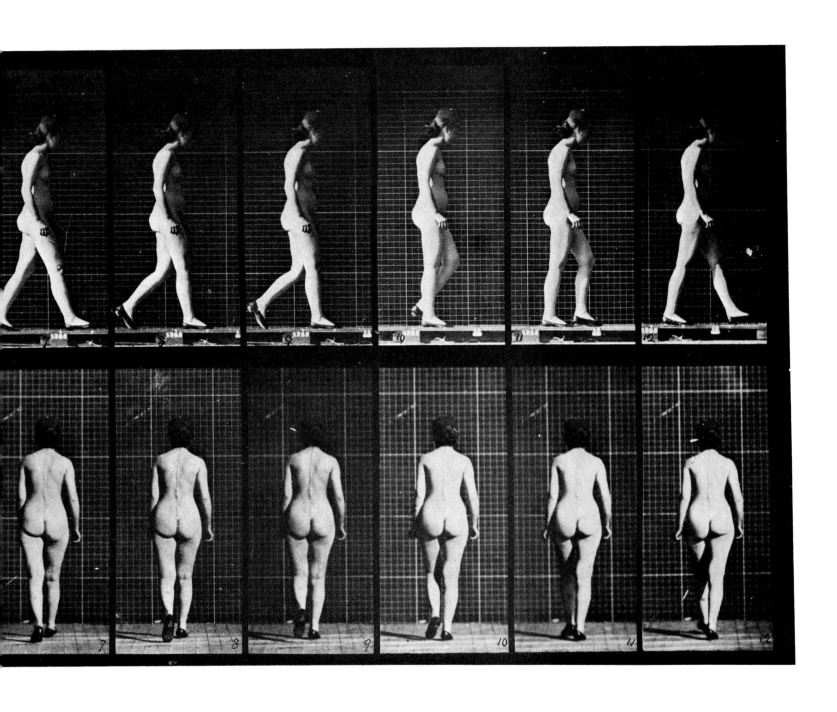

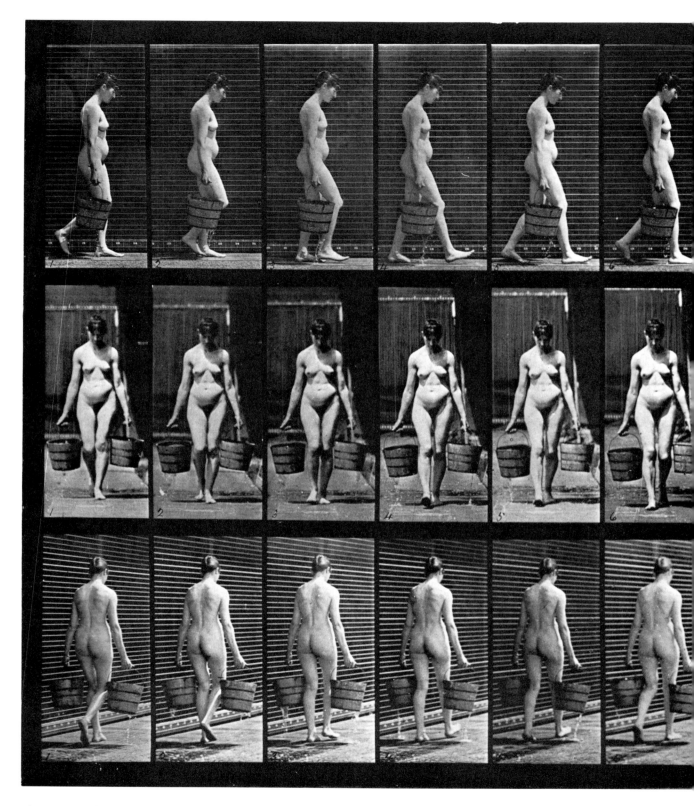

Plate 32. Walking and carrying a bucket of water in each hand.

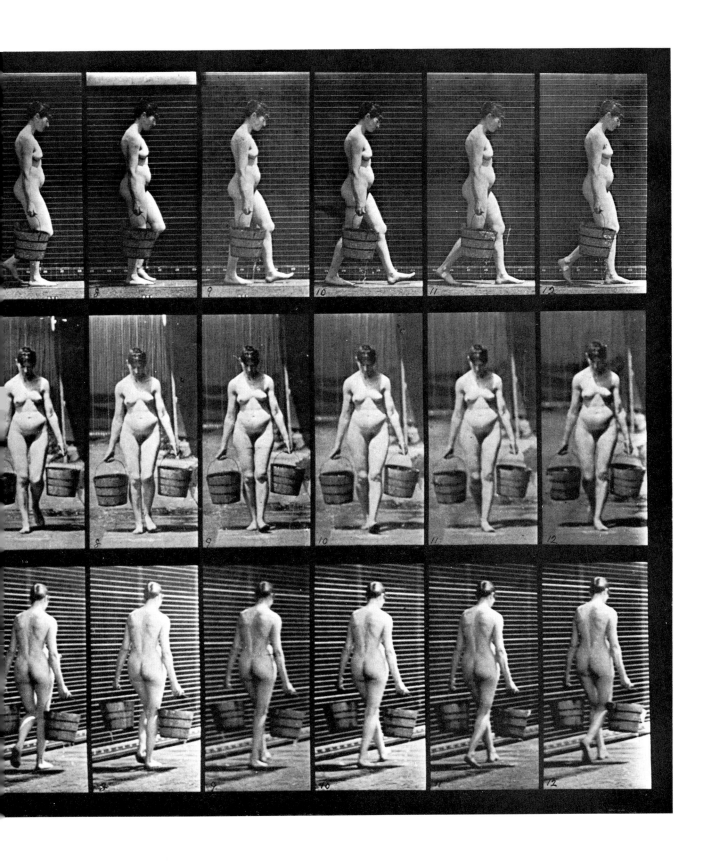

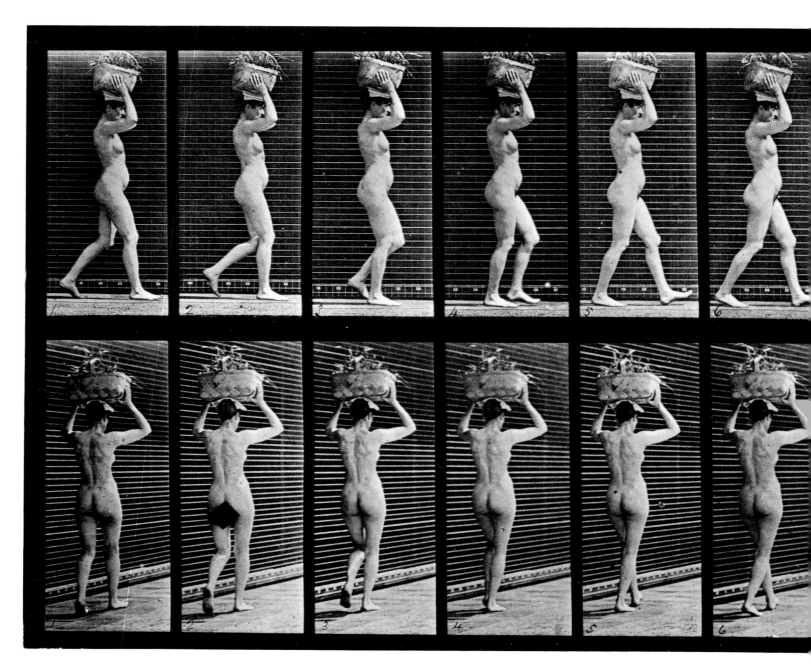

Plate 33. Walking and carrying a 14-lb. basket on head, hands raised.

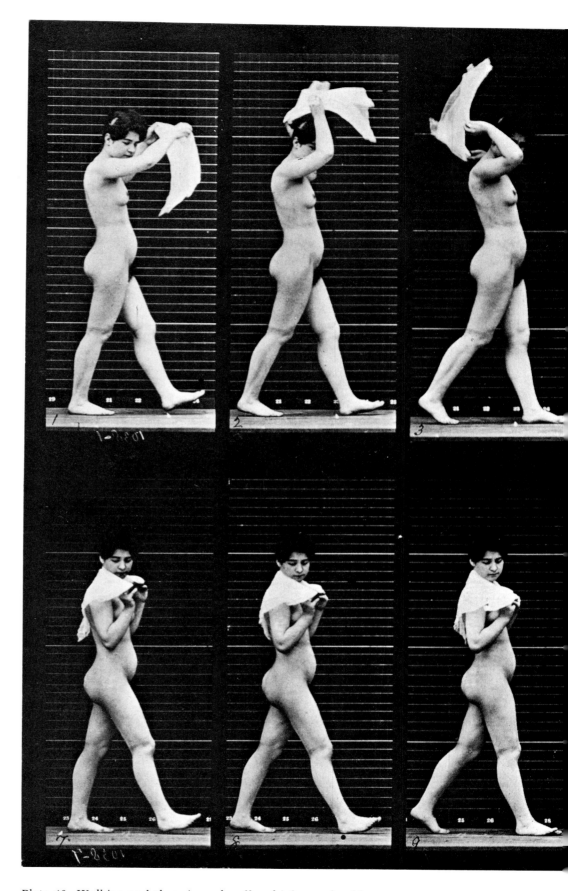

Plate 40. Walking and throwing a handkerchief over shoulders.

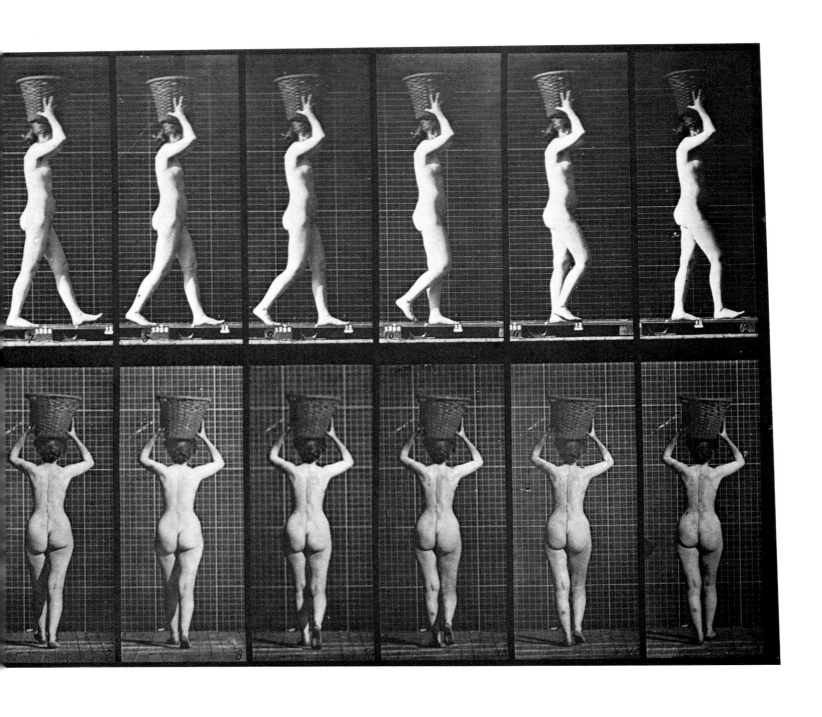

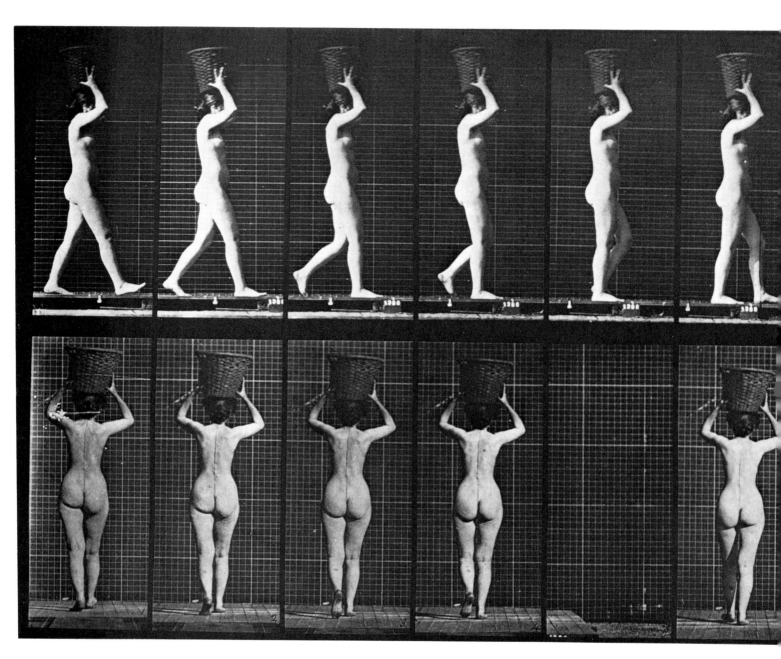

Plate 34. Walking and carrying a 15-lb. basket on head, hands raised.

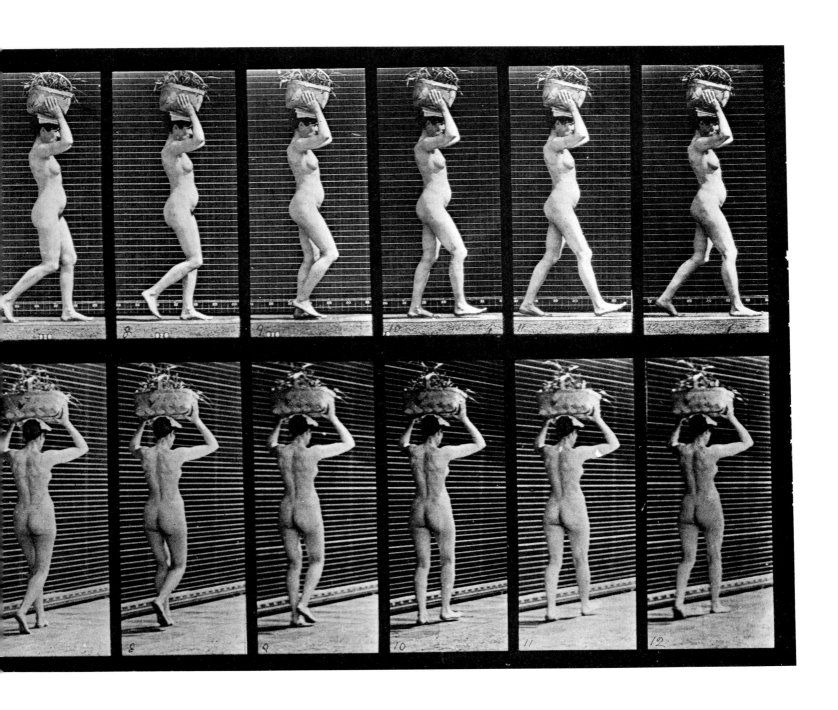

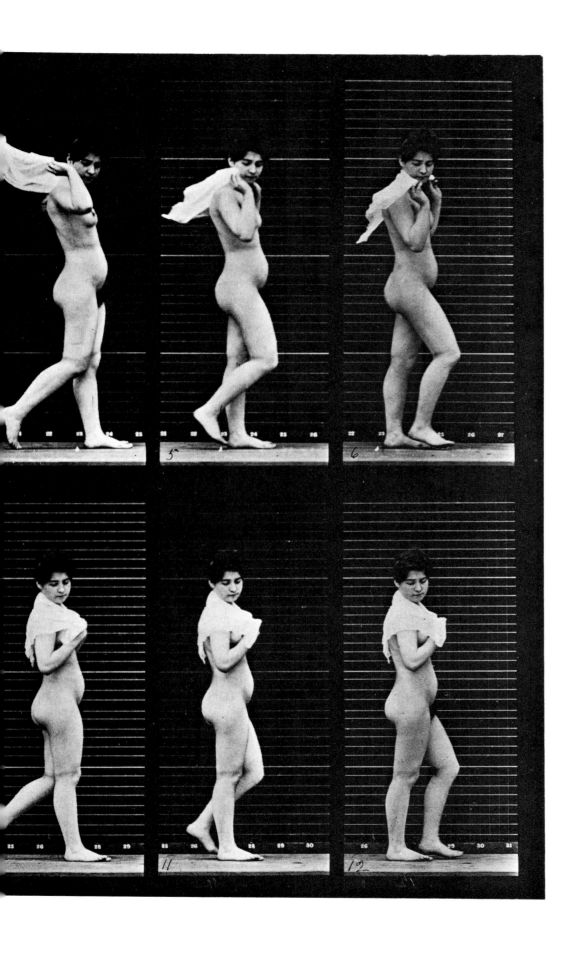

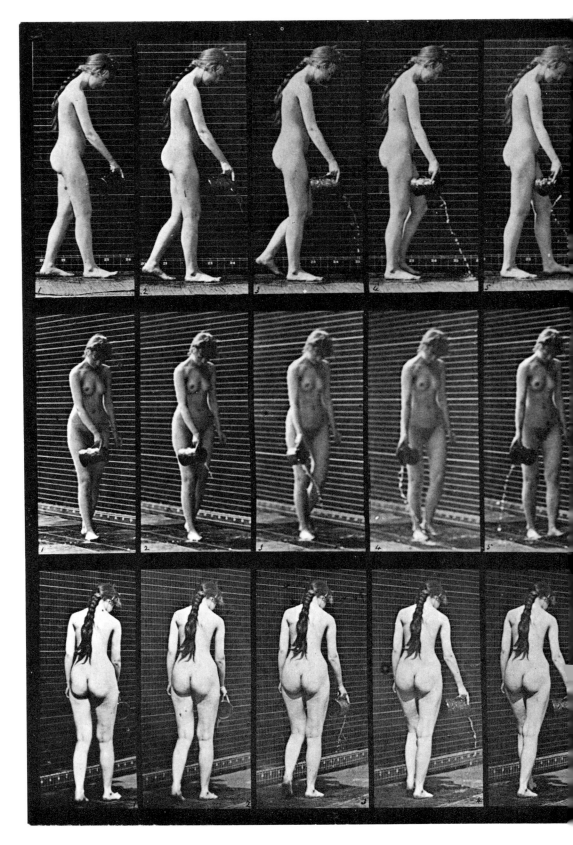

Plate 42. Walking and pouring water from a pitcher.

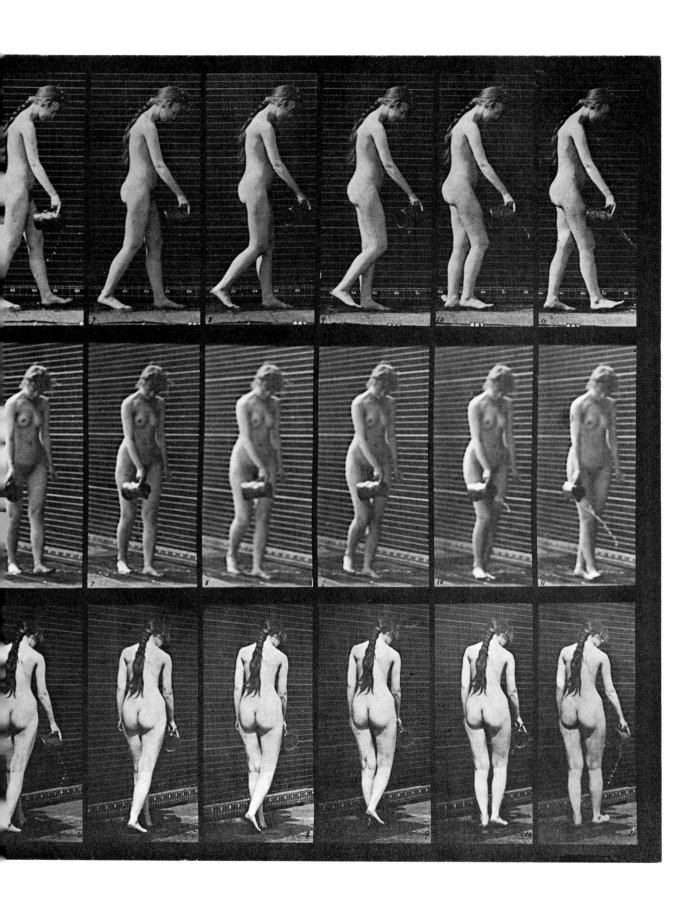

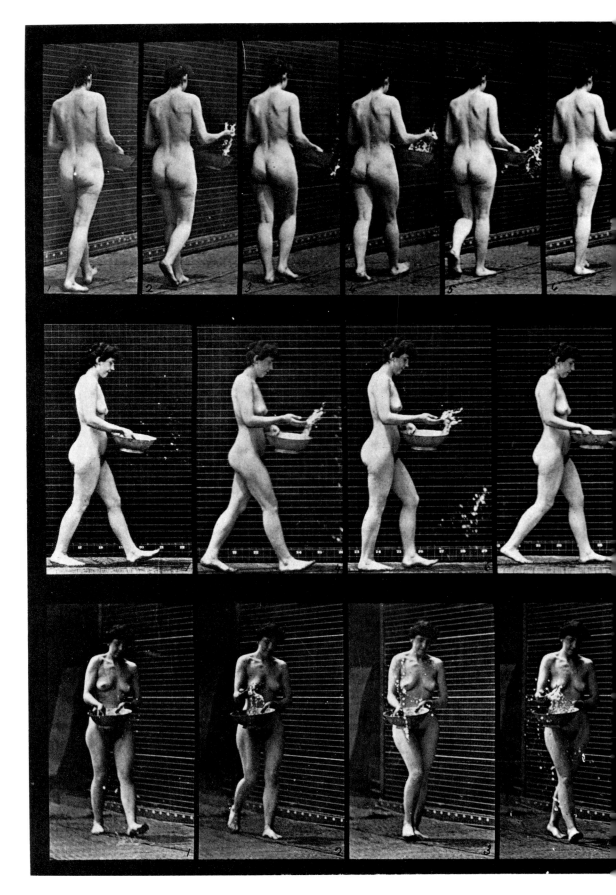

Plate 43. Walking, sprinkling water from a basin and turning around.

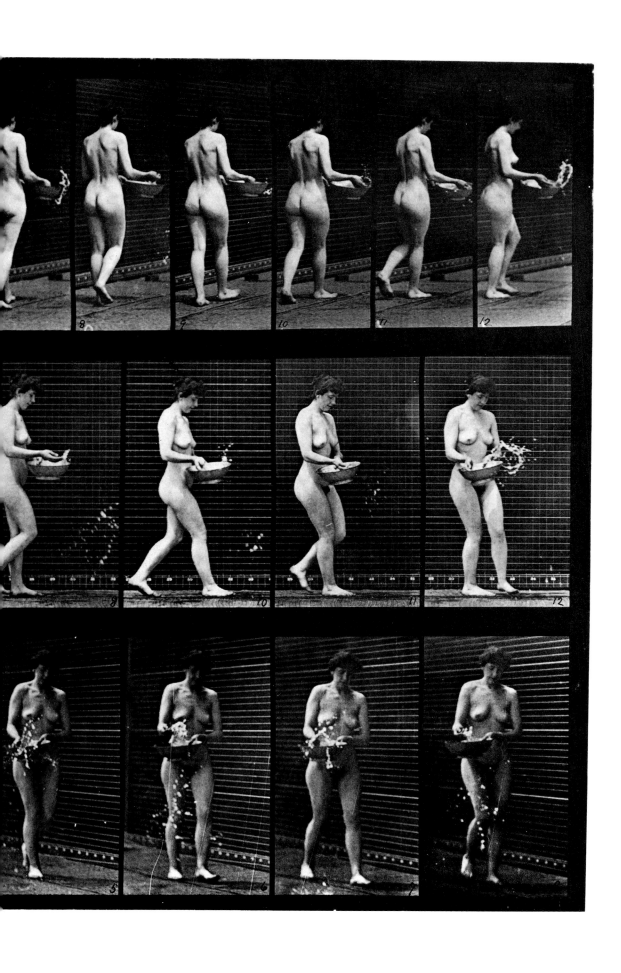

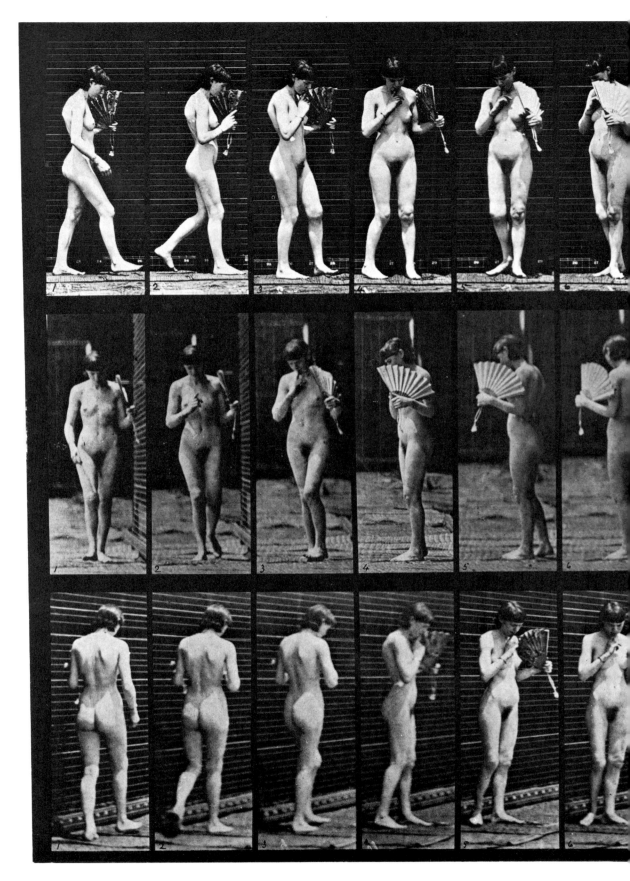

Plate 46. Walking, flirting a fan and turning around.

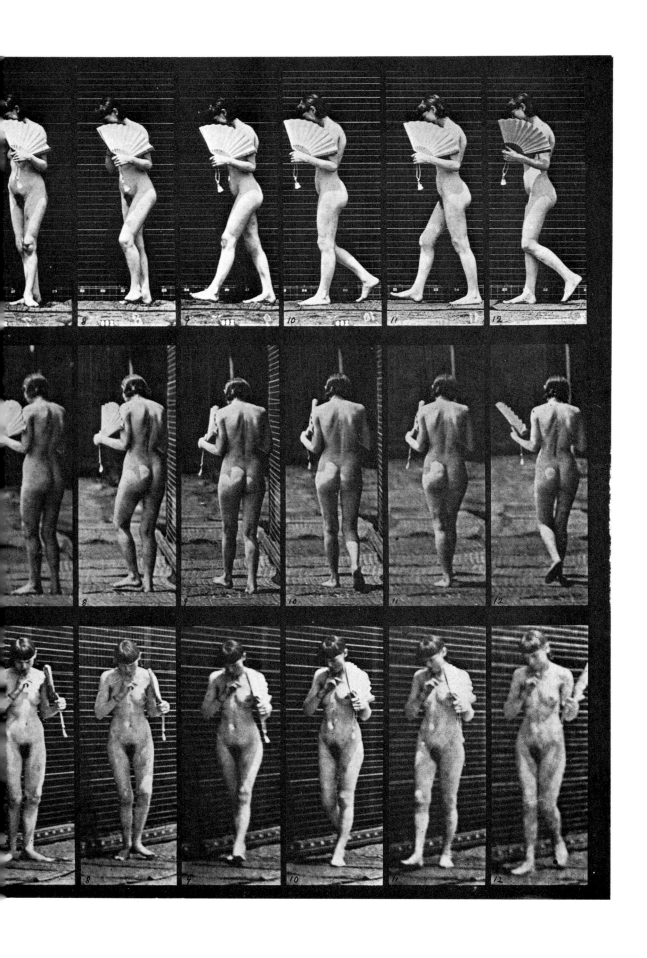

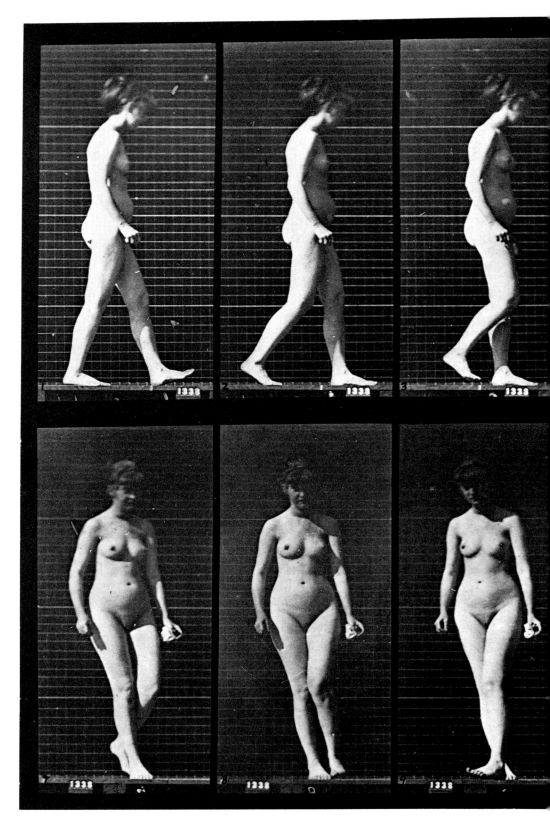

Plate 47. Walking and turning around.

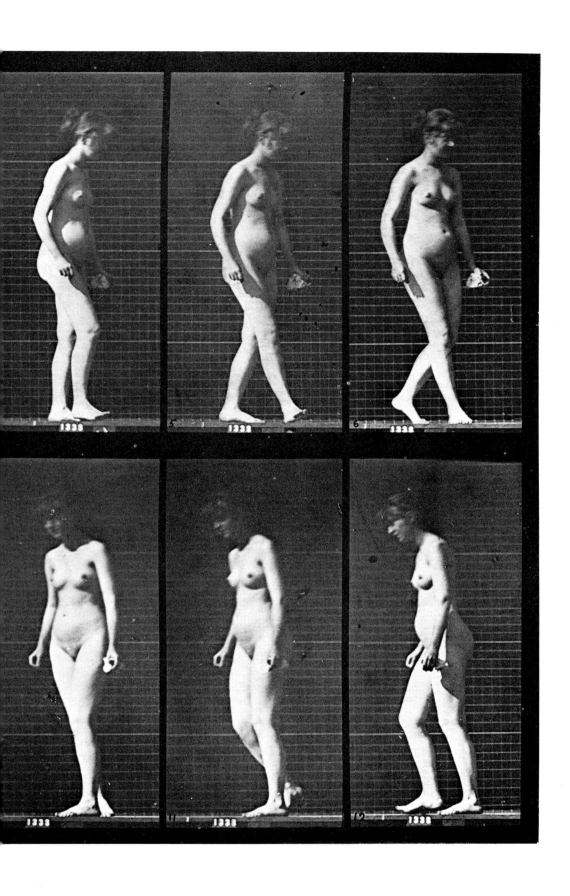

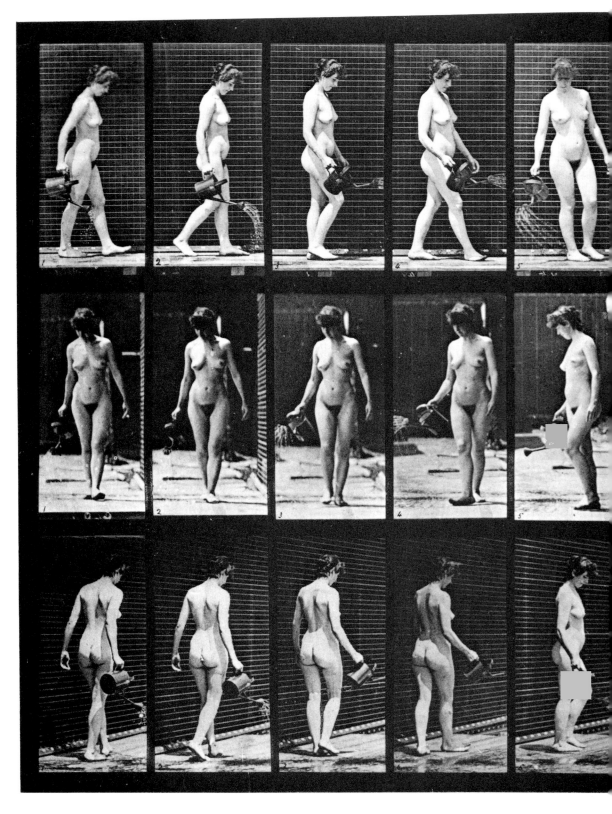

Plate 51. Walking, turning around and using a sprinkling pot.

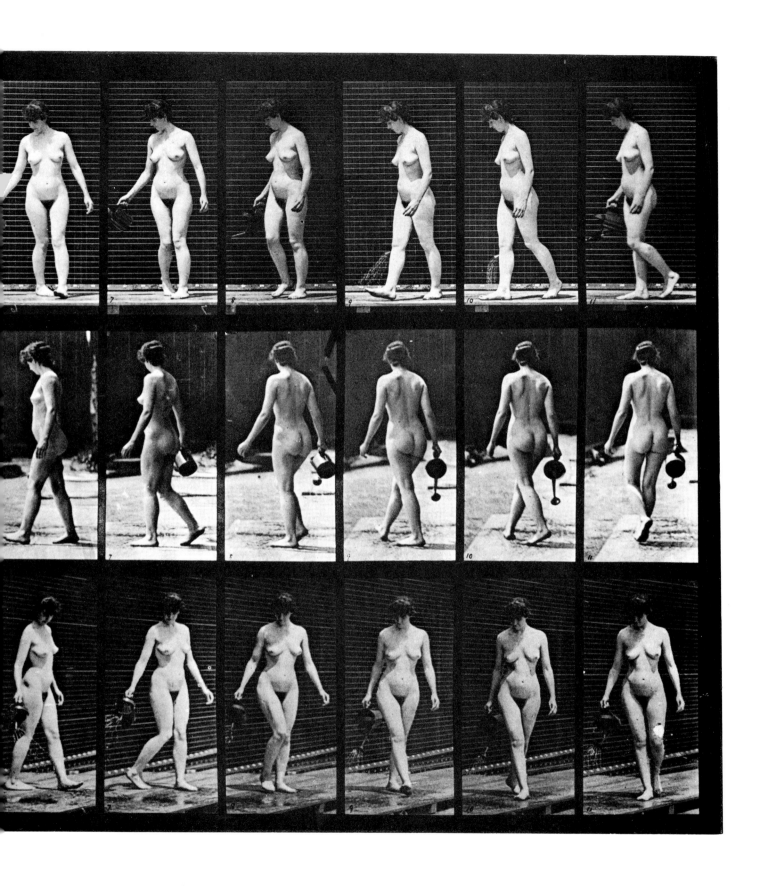

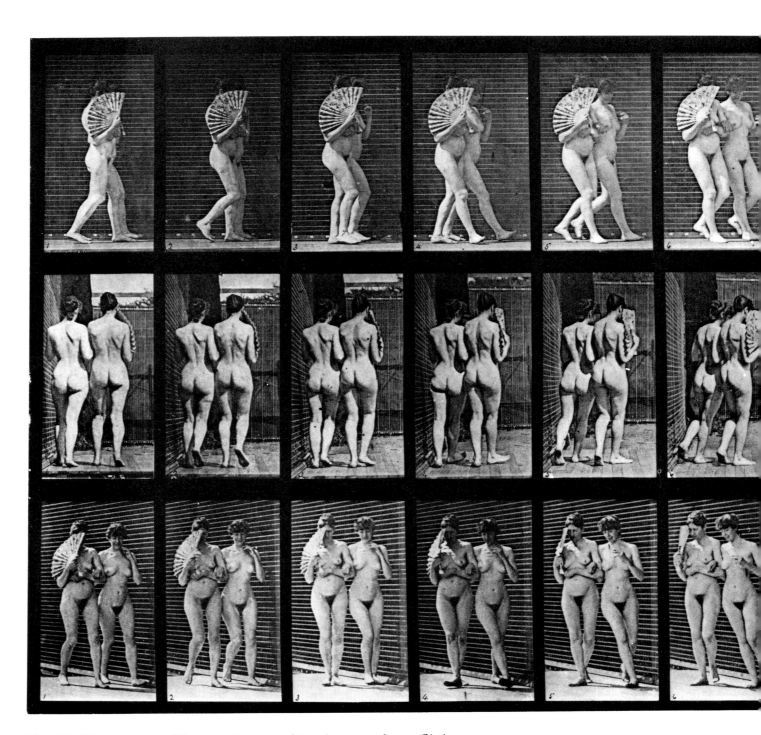

Plate 54. Two women walking arm in arm and turning around; one flirting a fan.

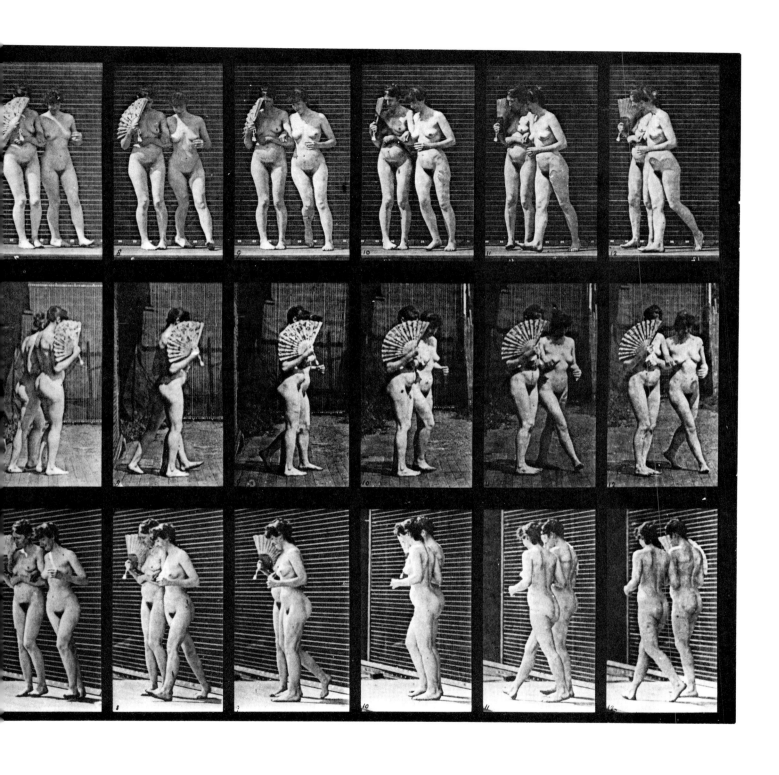

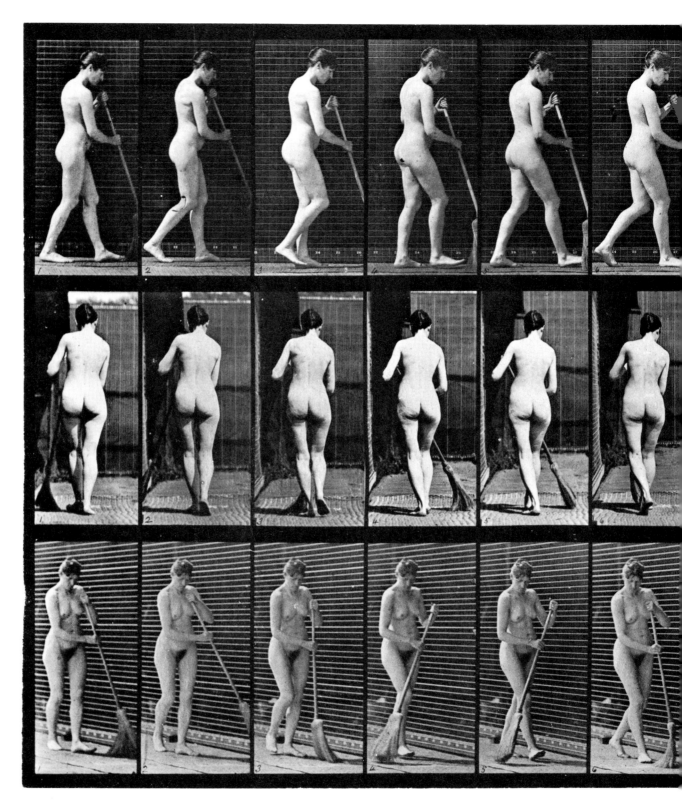

Plate 58. Walking, turning around and sweeping the floor.

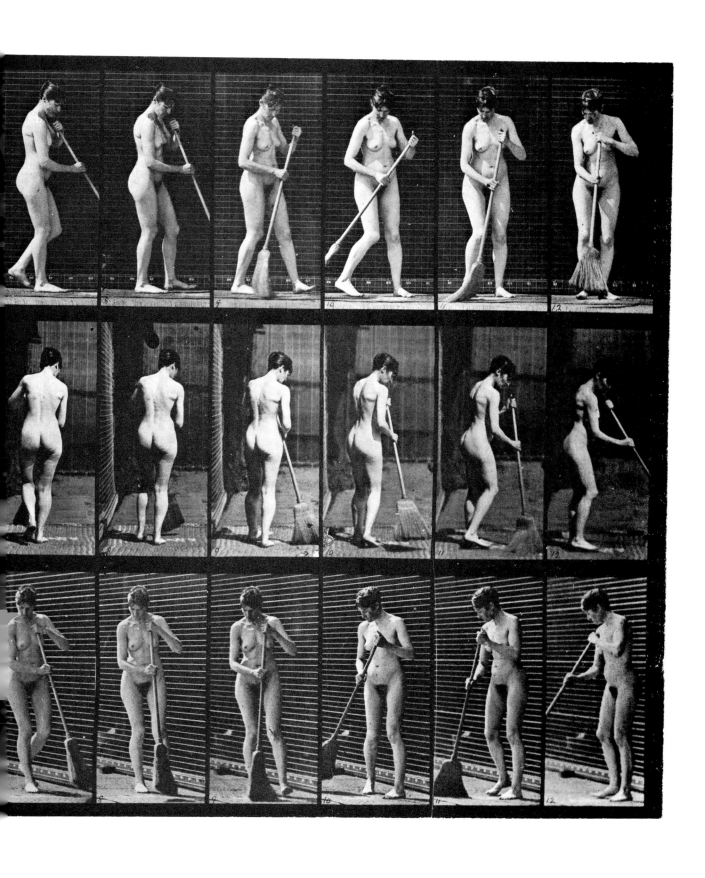

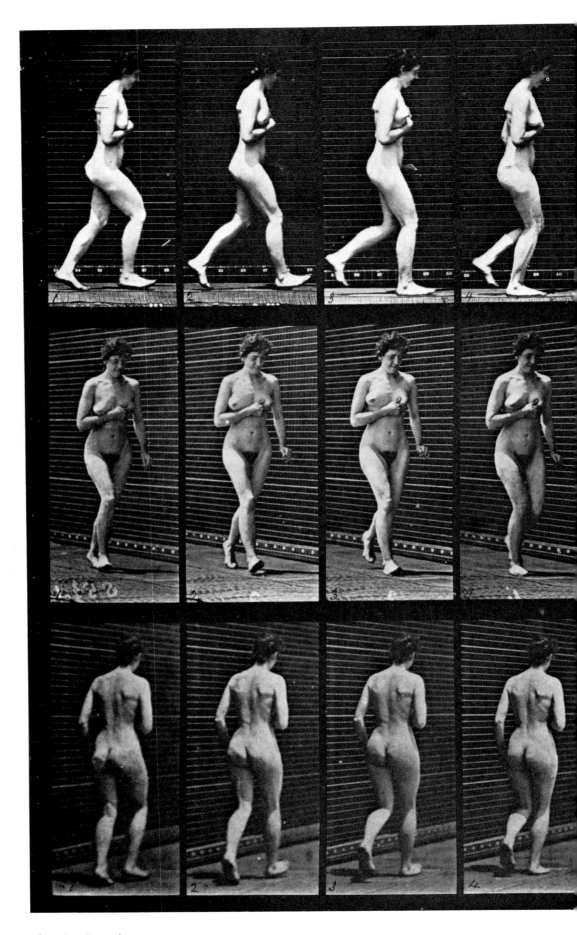

Plate 70. Running.

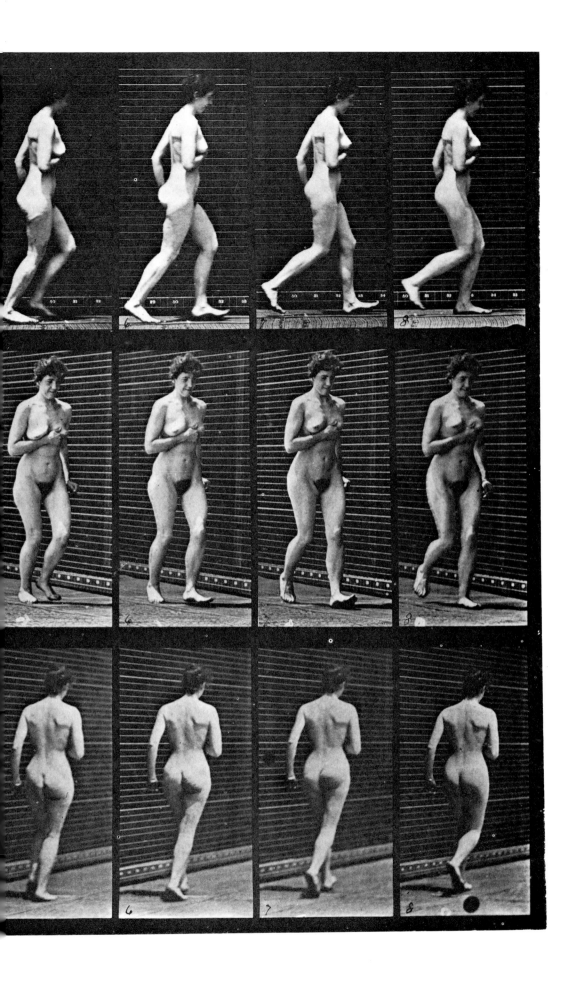

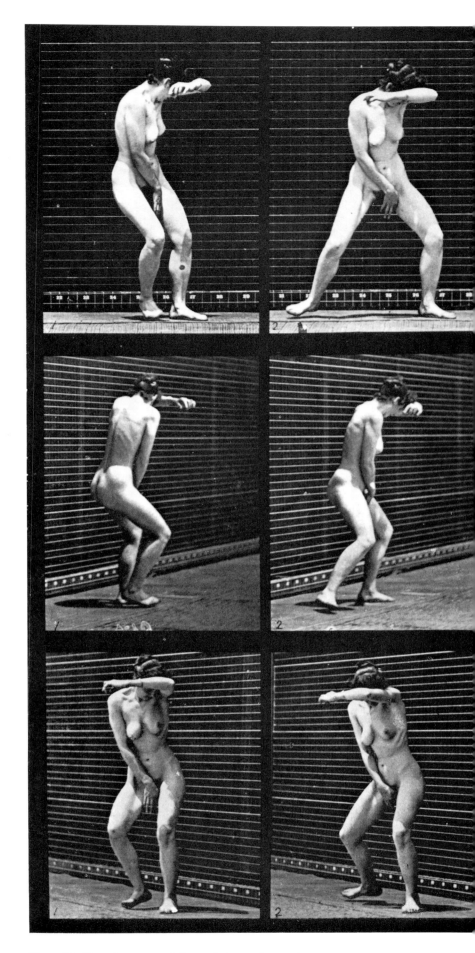

Plate 73. Turning around in surprise and running away.

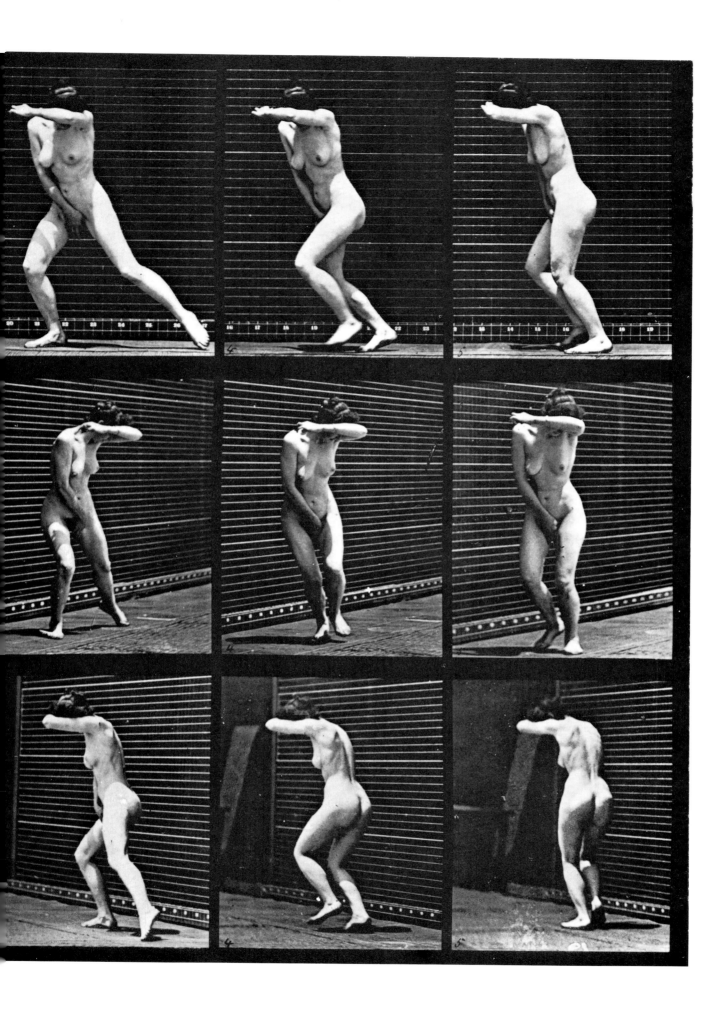

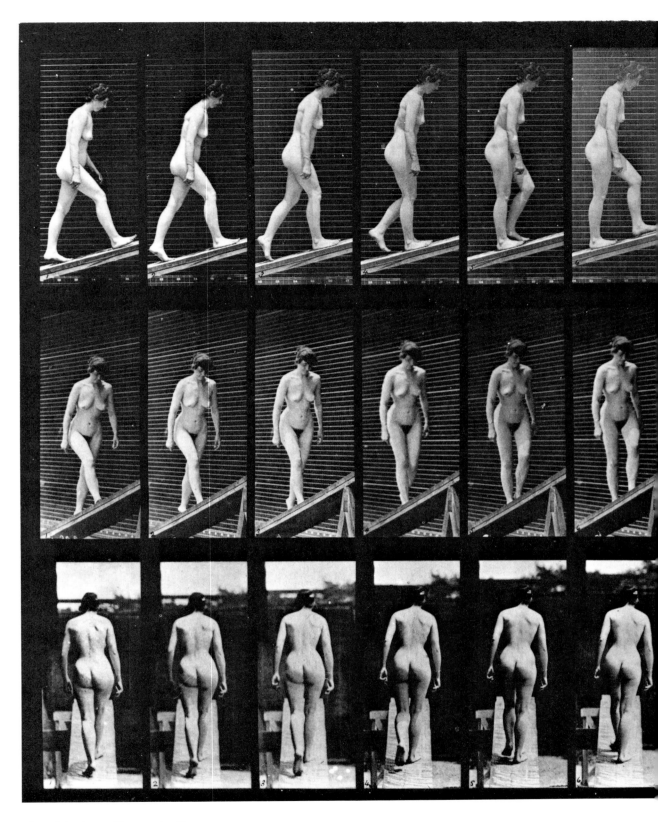

Plate 76. Ascending an incline.

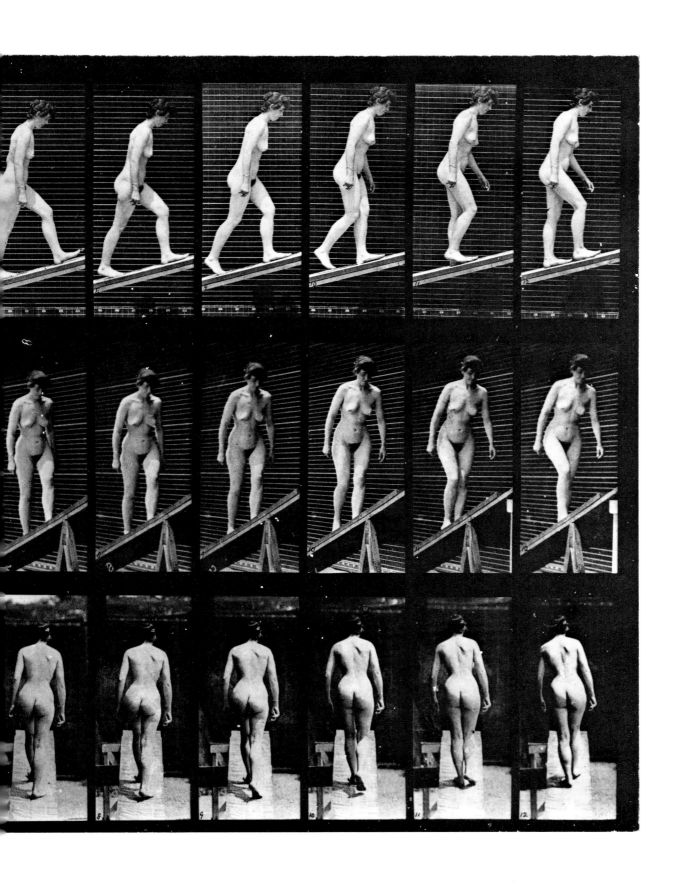

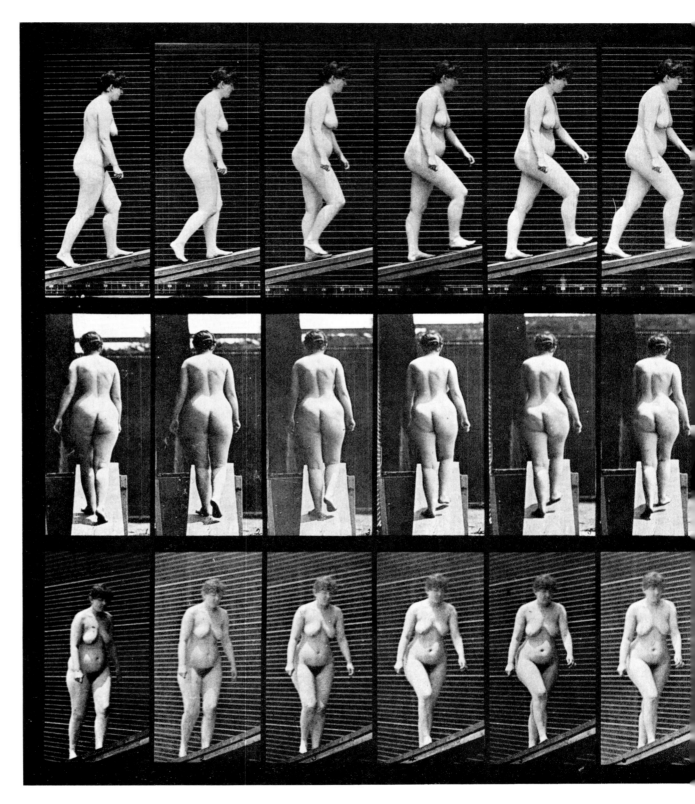

Plate 77. Ascending an incline.

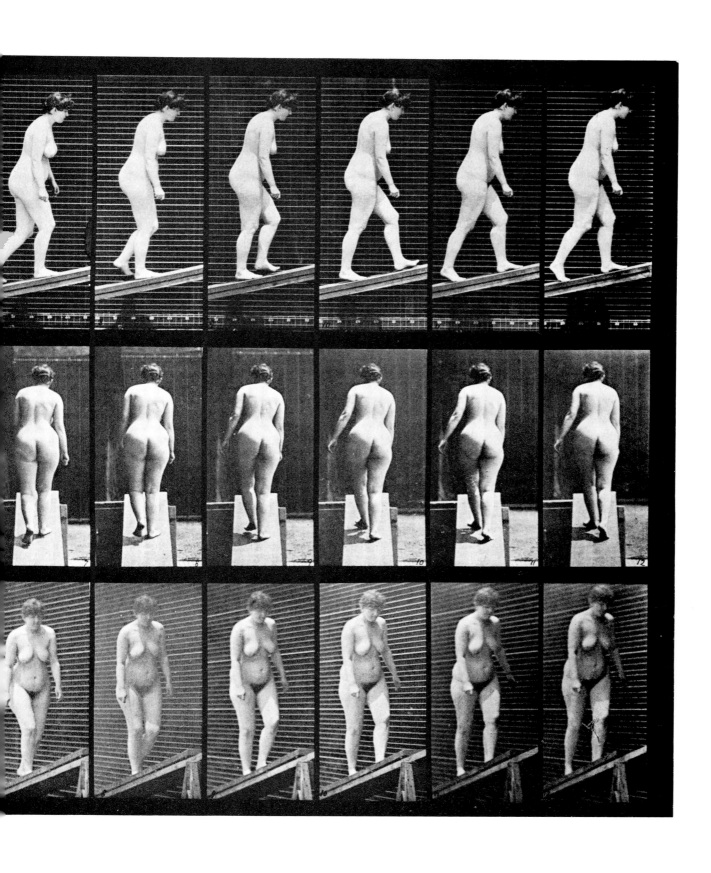

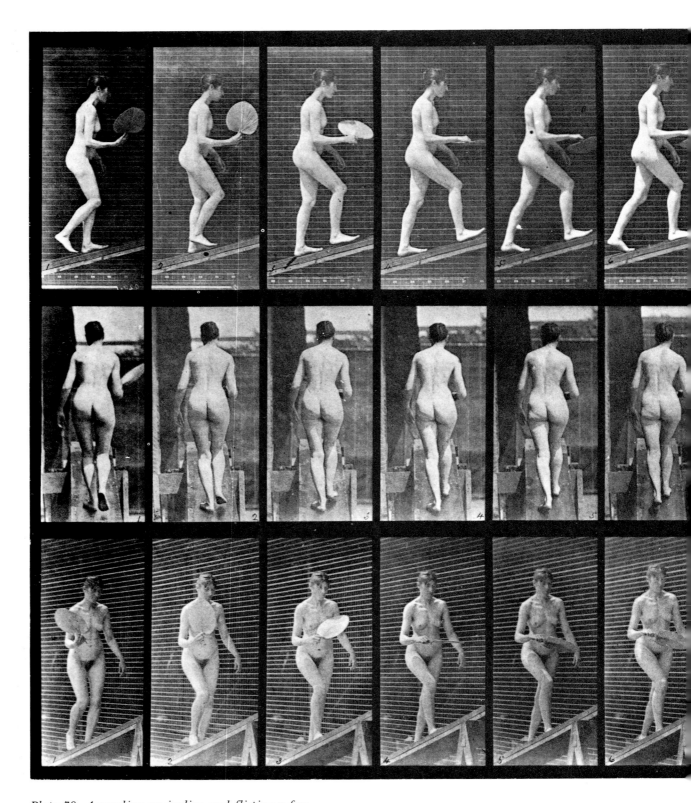

Plate 78. Ascending an incline and flirting a fan.

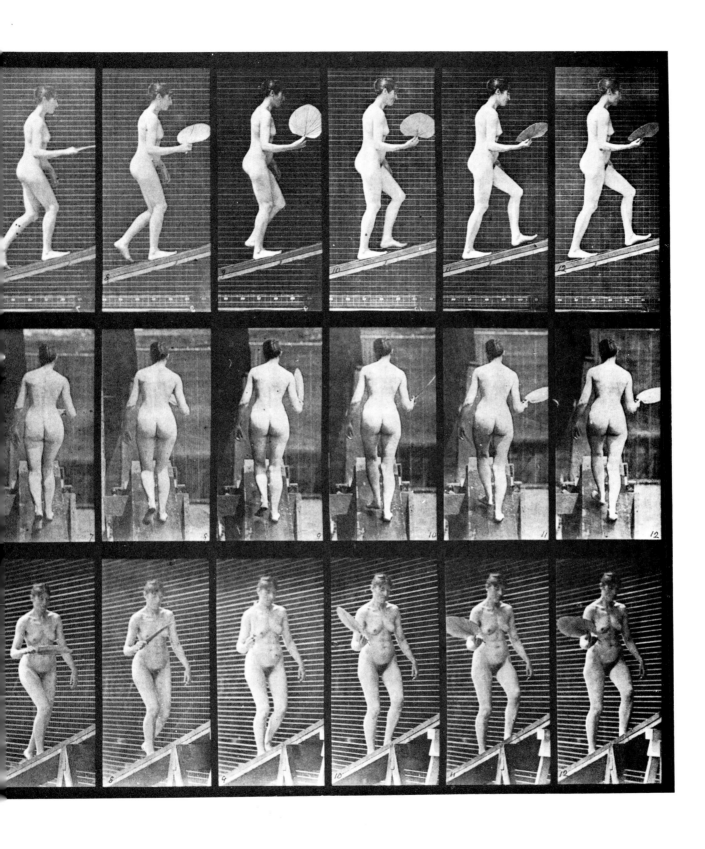

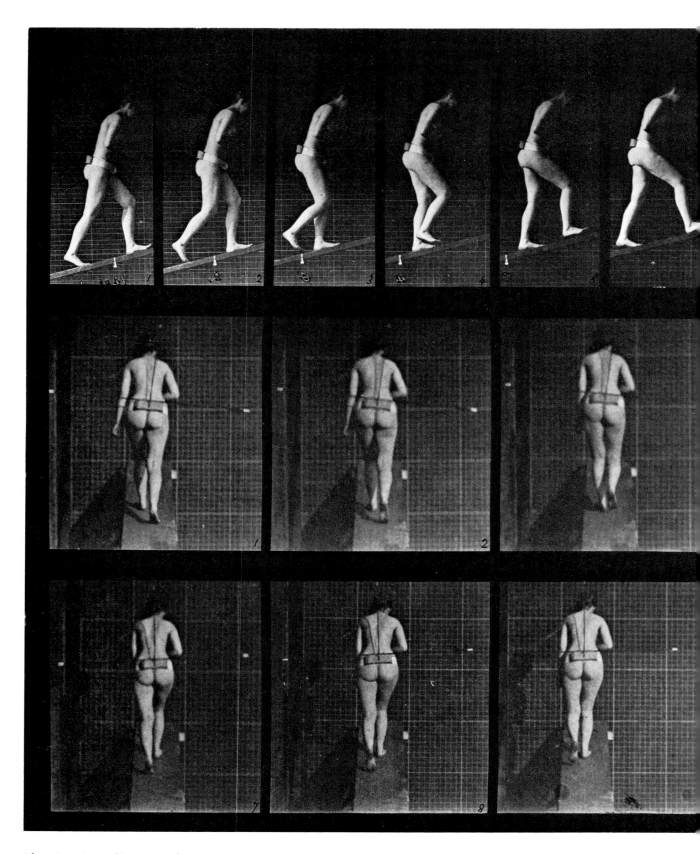

Plate 79. Ascending an incline.

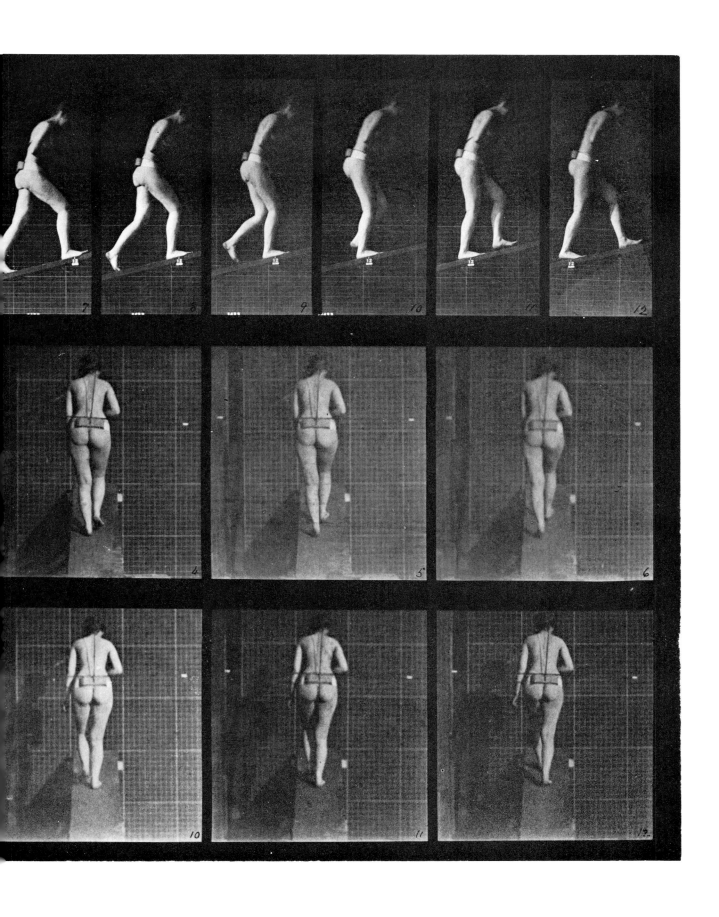

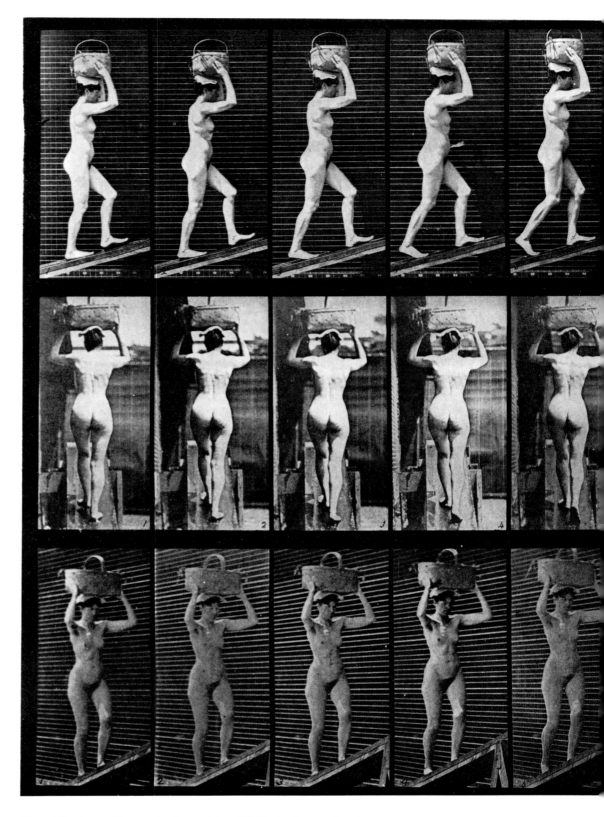

Plate 80. Ascending an incline with a 20-lb. basket on head.

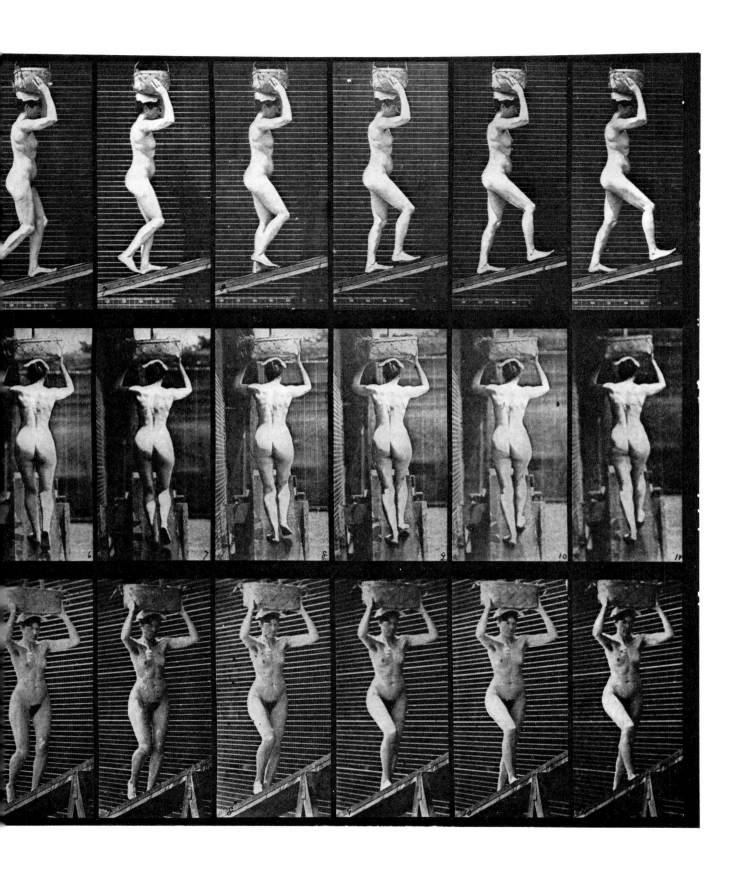

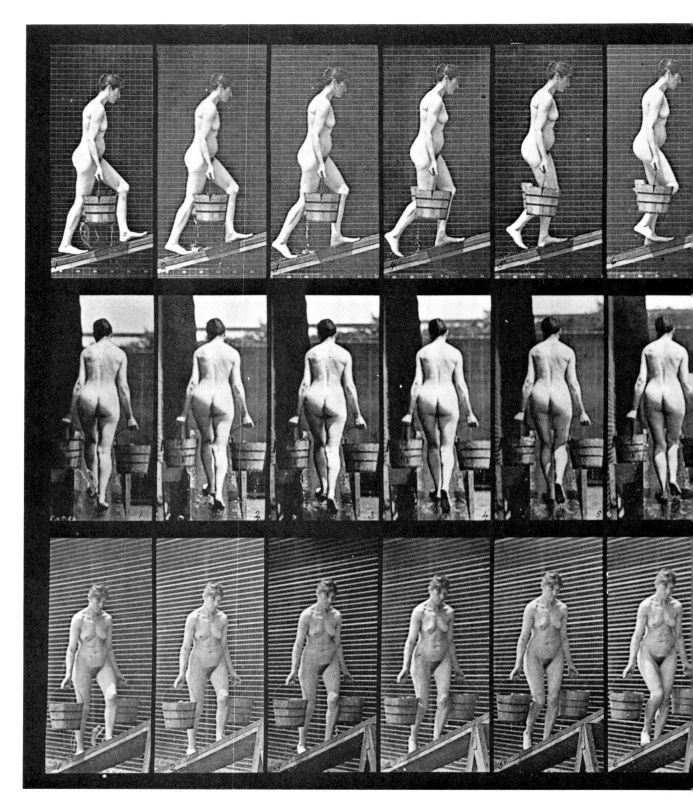

Plate 81. Ascending an incline with a bucket of water in each hand.

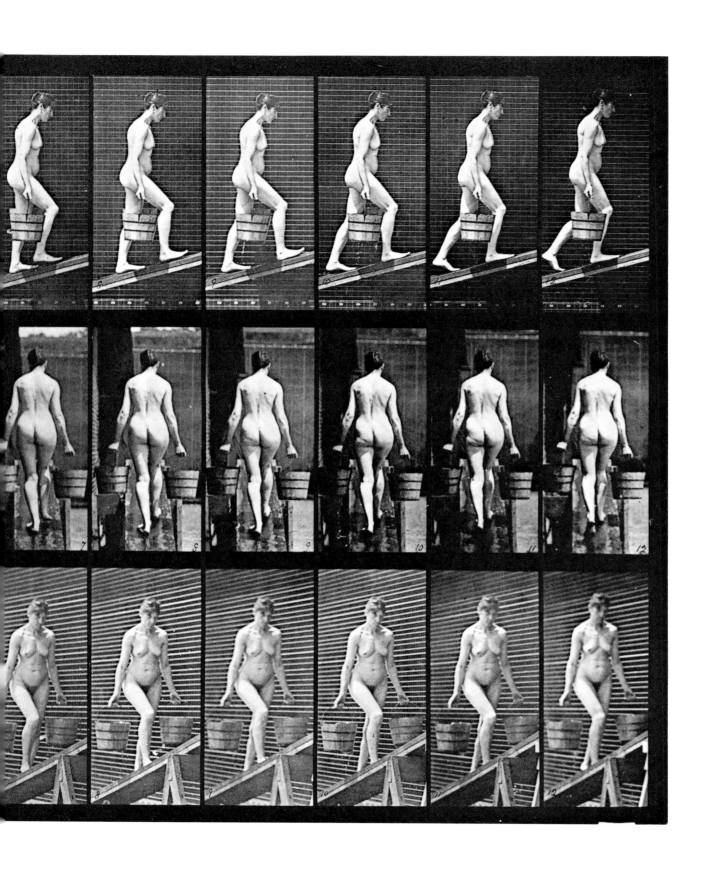

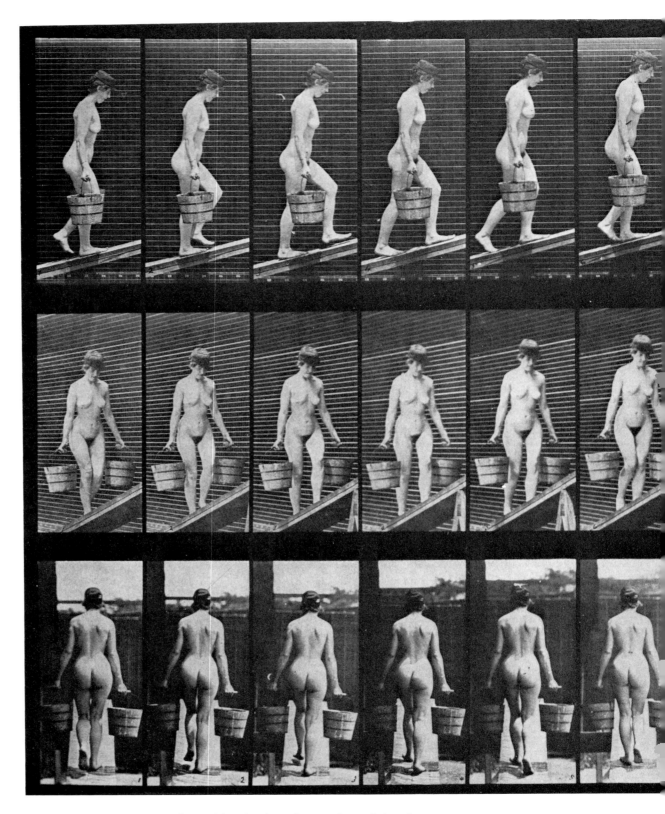

Plate 82. Ascending an incline with a bucket of water in each hand.

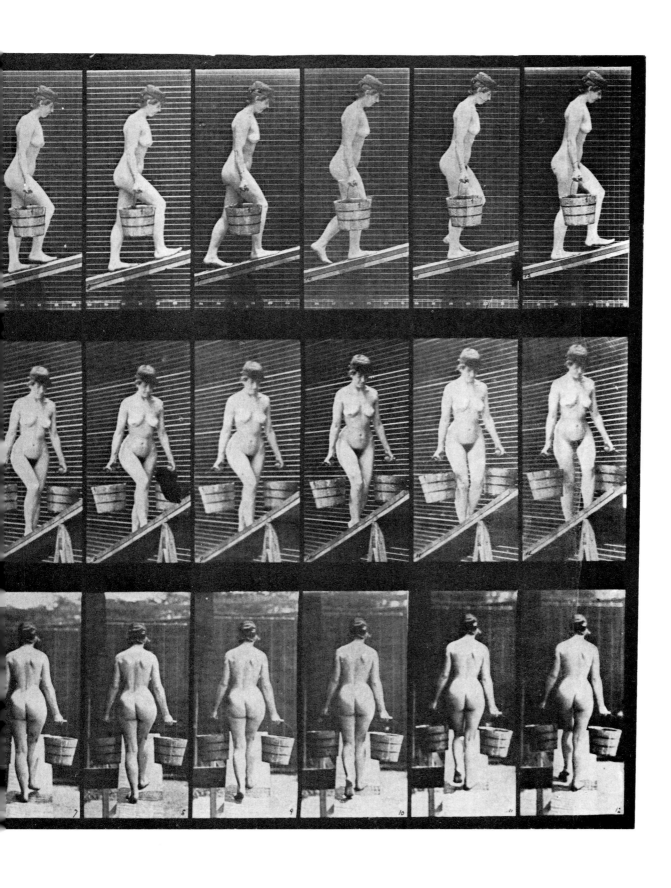

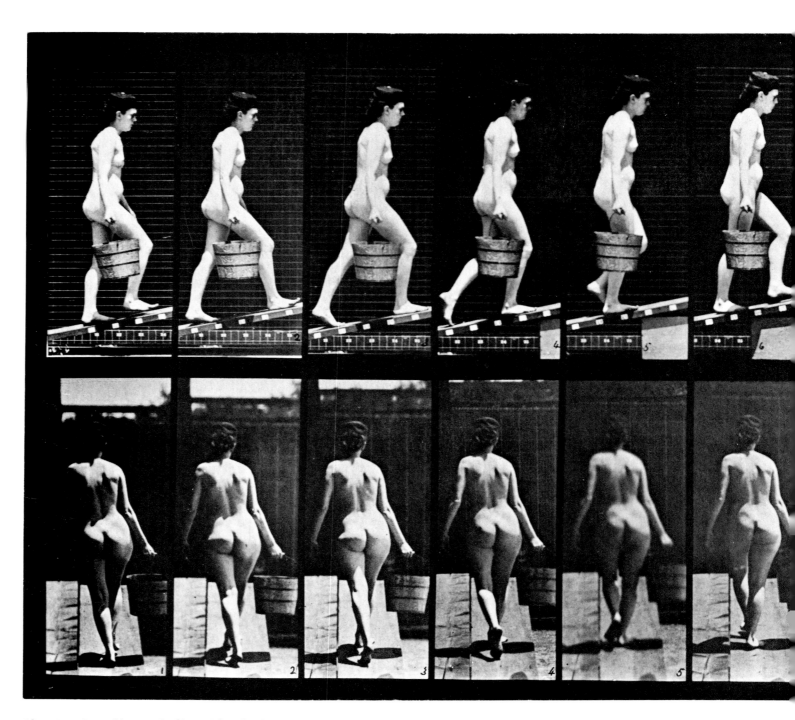

Plate 83. Ascending an incline with a bucket of water in right hand.

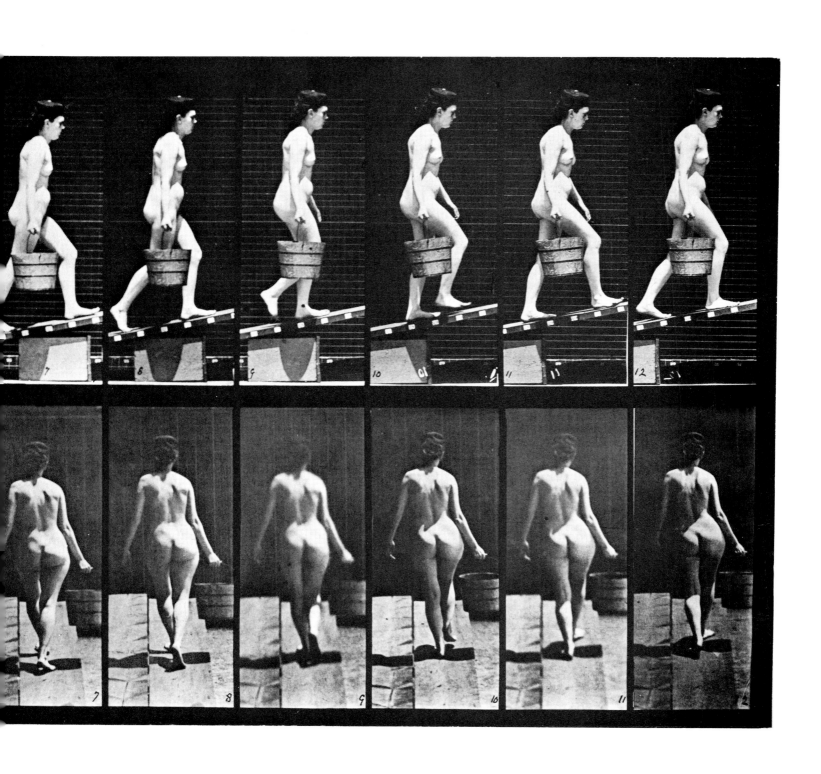

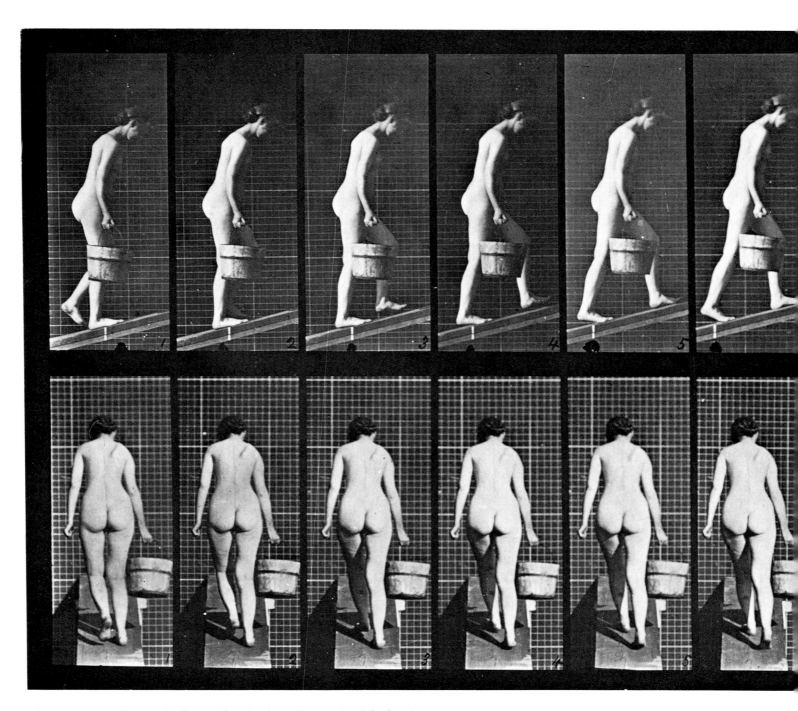

Plate 84. Ascending an incline with a bucket of water in right hand.

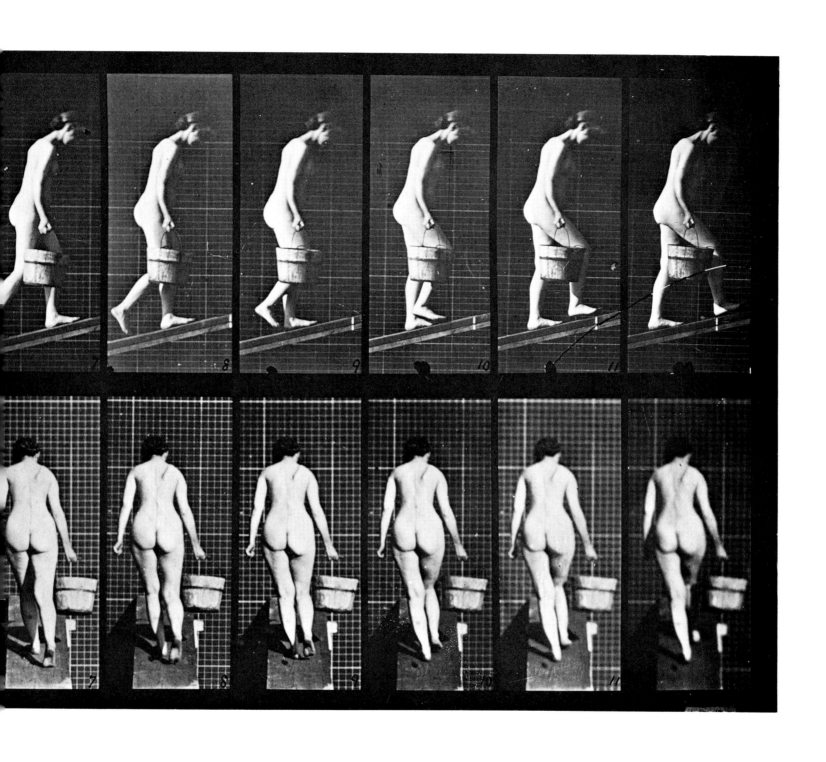

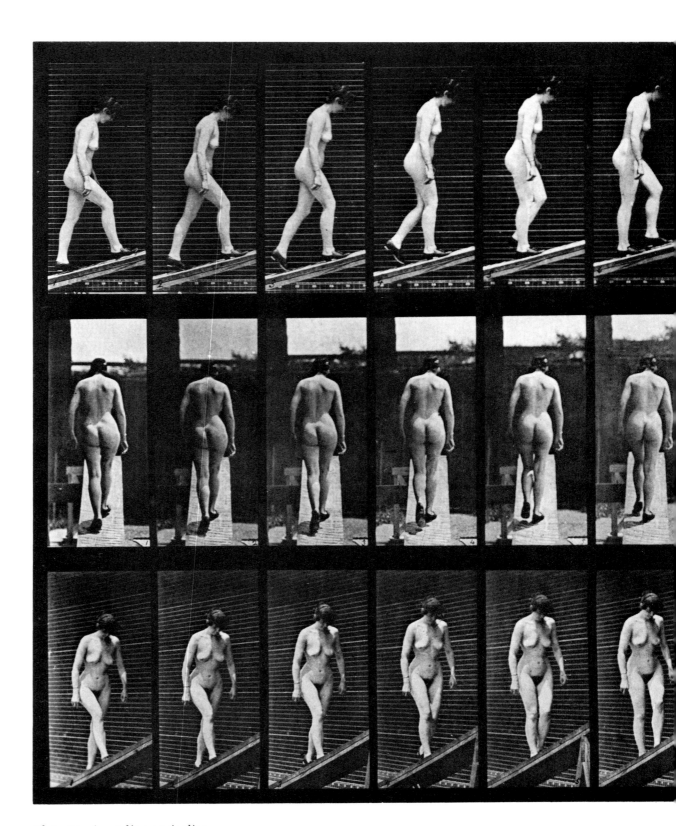

Plate 85. Ascending an incline.

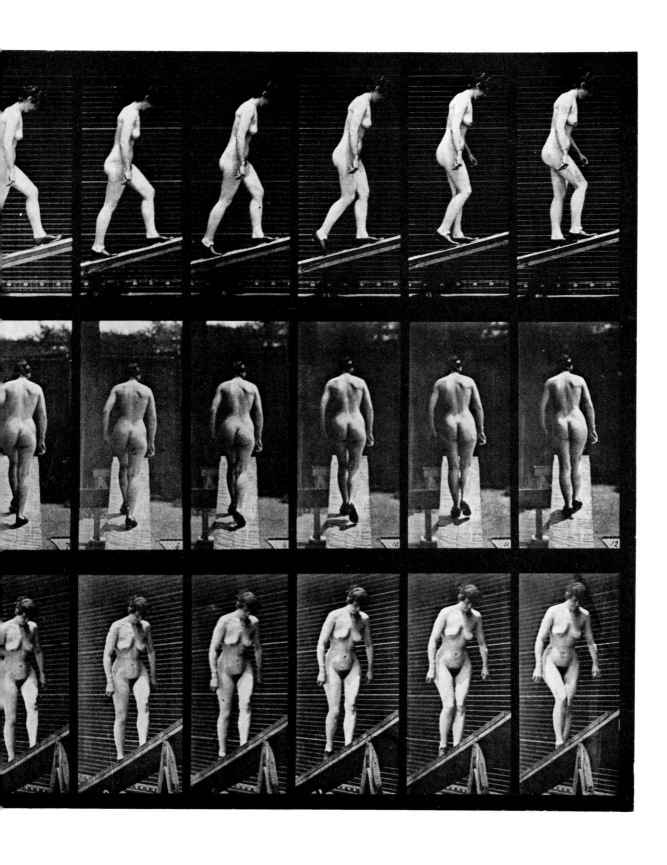

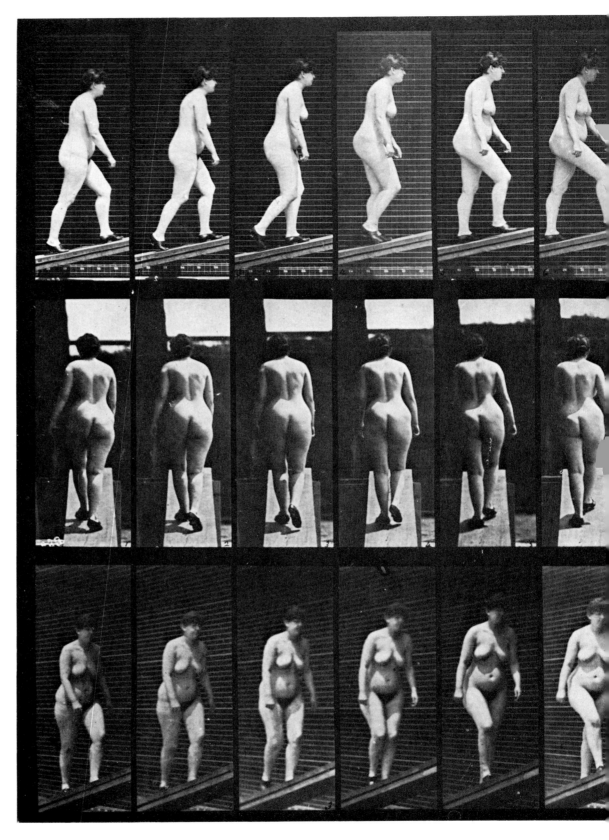

Plate 86. Ascending an incline.

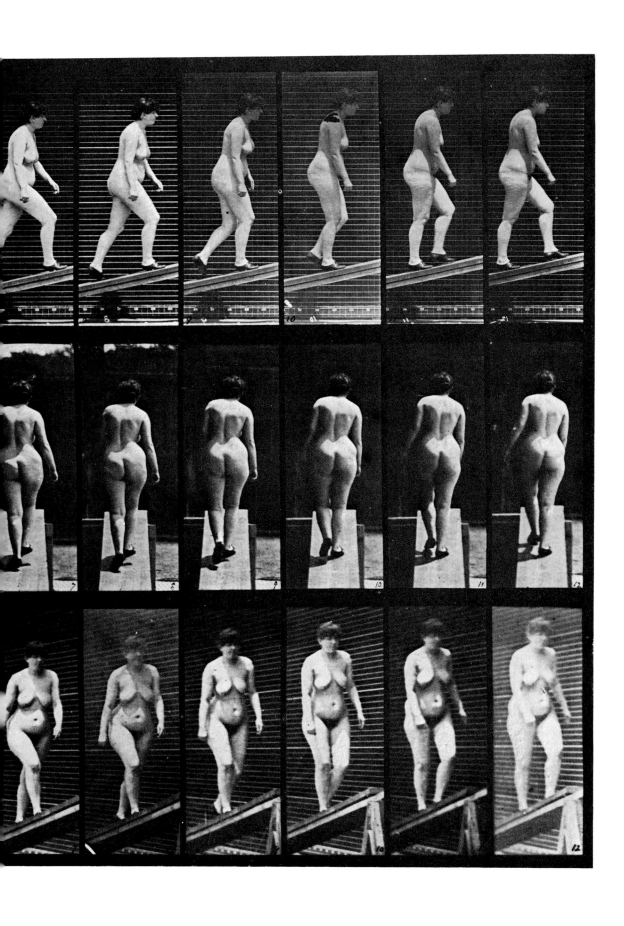

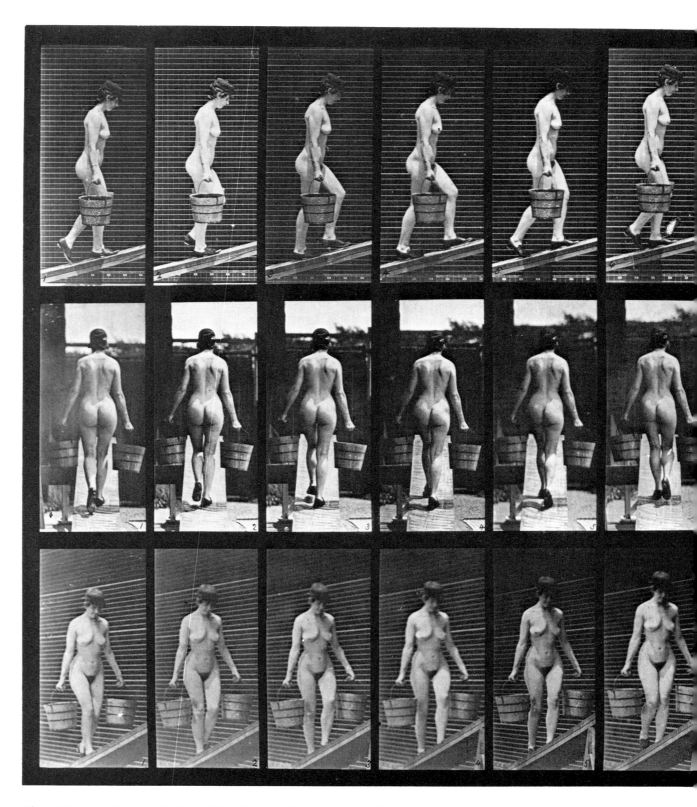

Plate 87. Ascending an incline with a bucket of water in each hand.

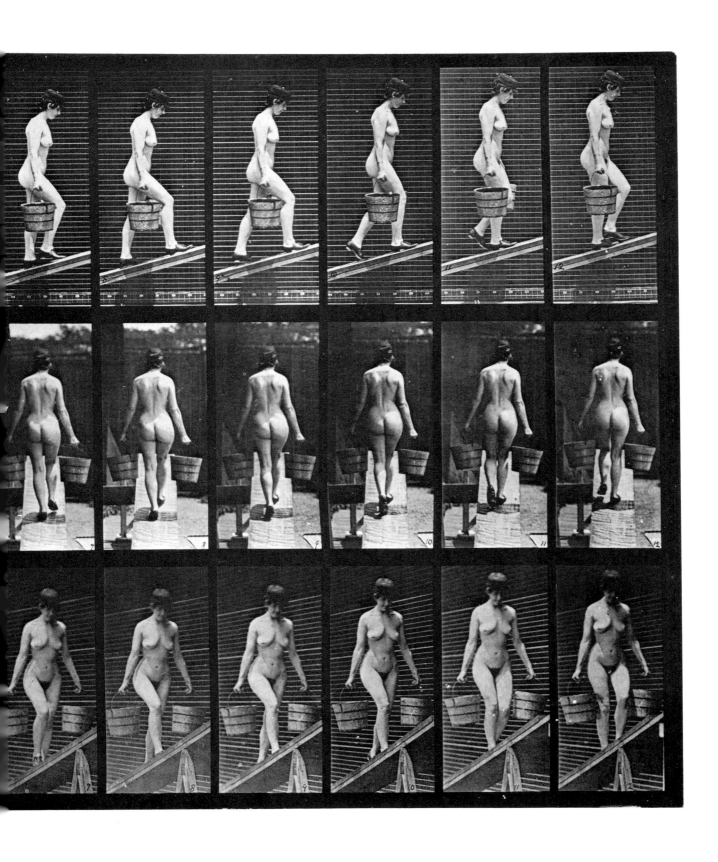

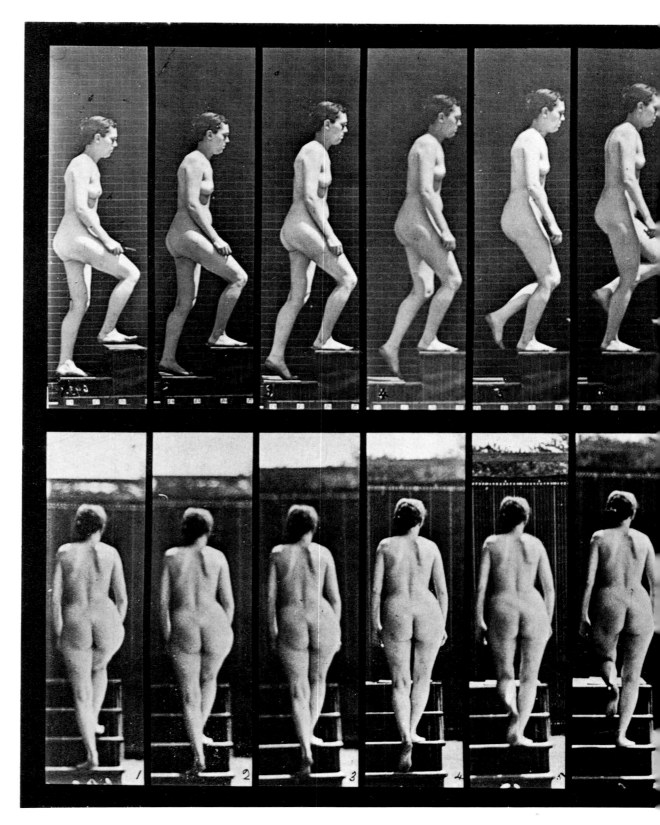

Plate 92. *Ascending stairs.*

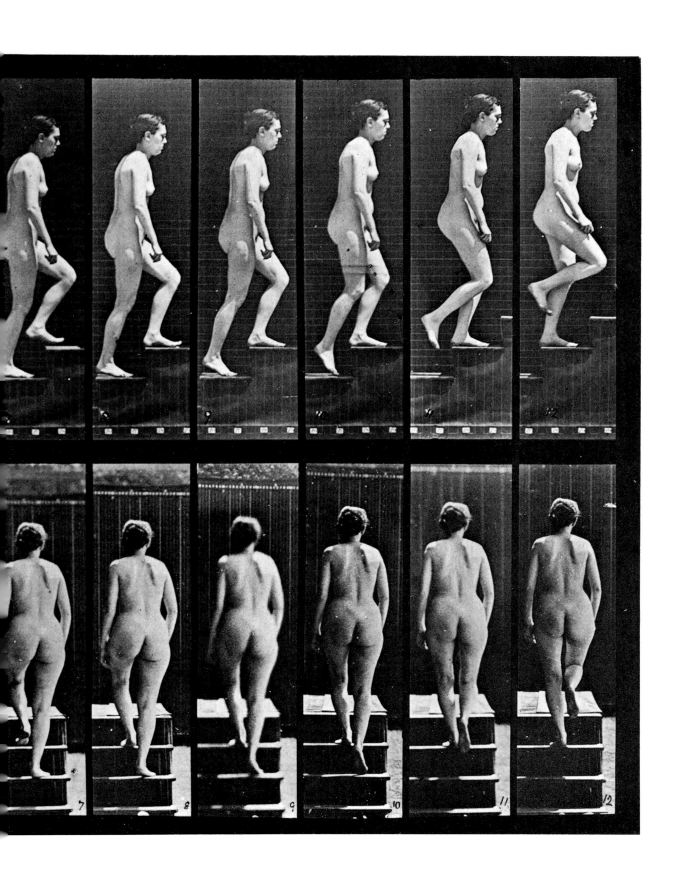

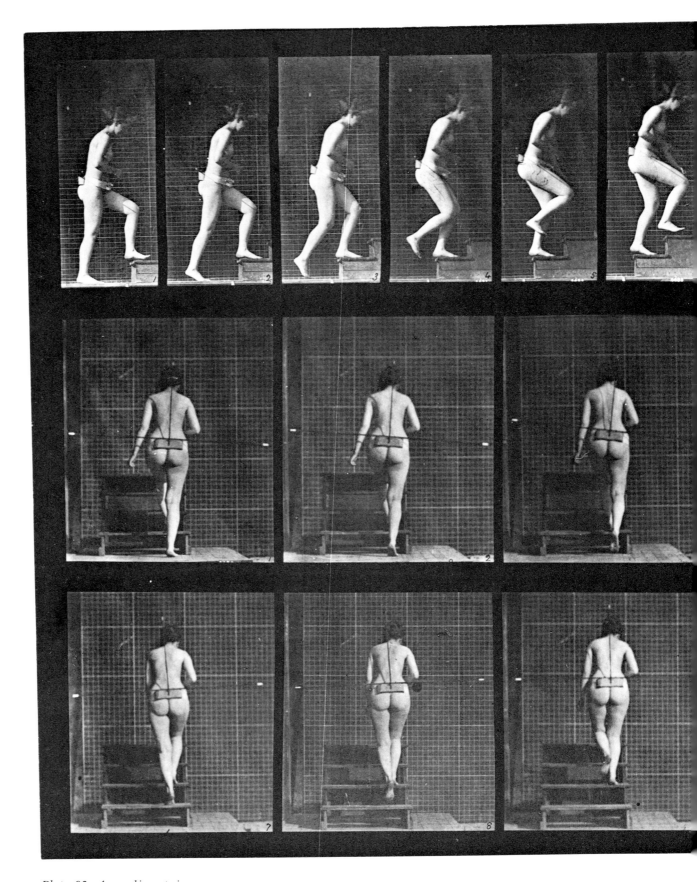

Plate 93. Ascending stairs.

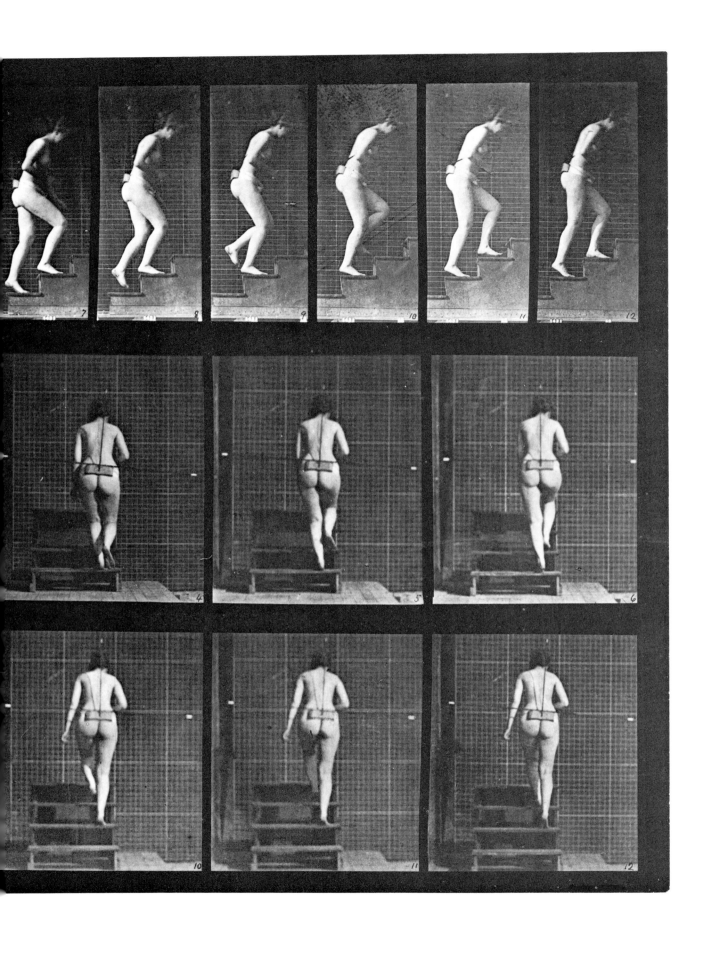

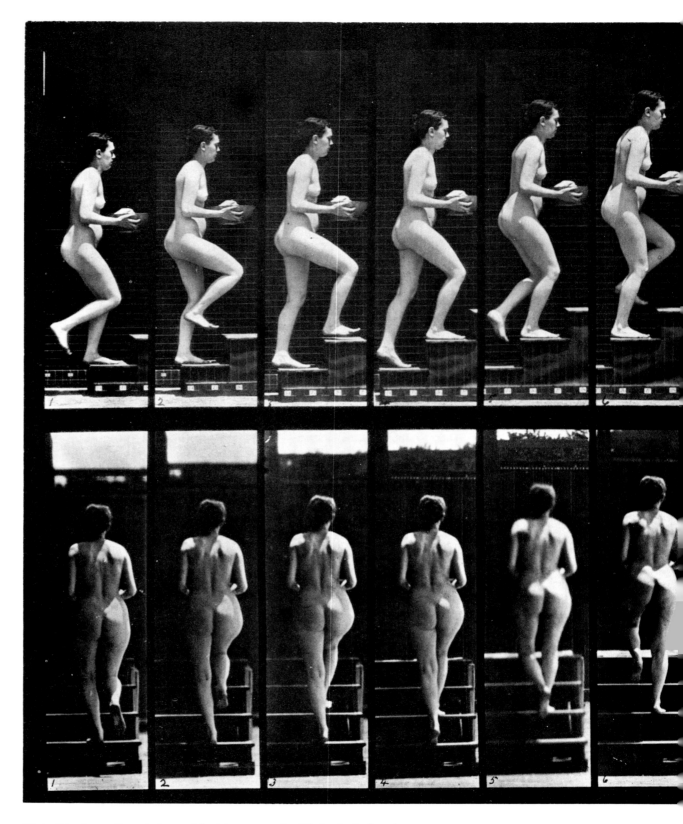

Plate 94. Ascending stairs and looking around with basin in hands.

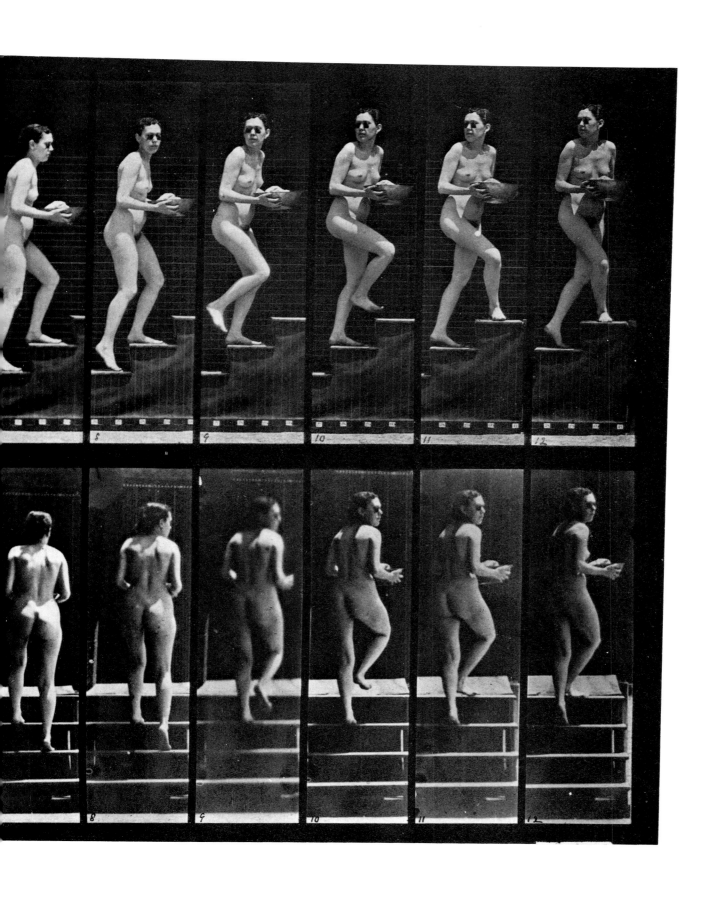

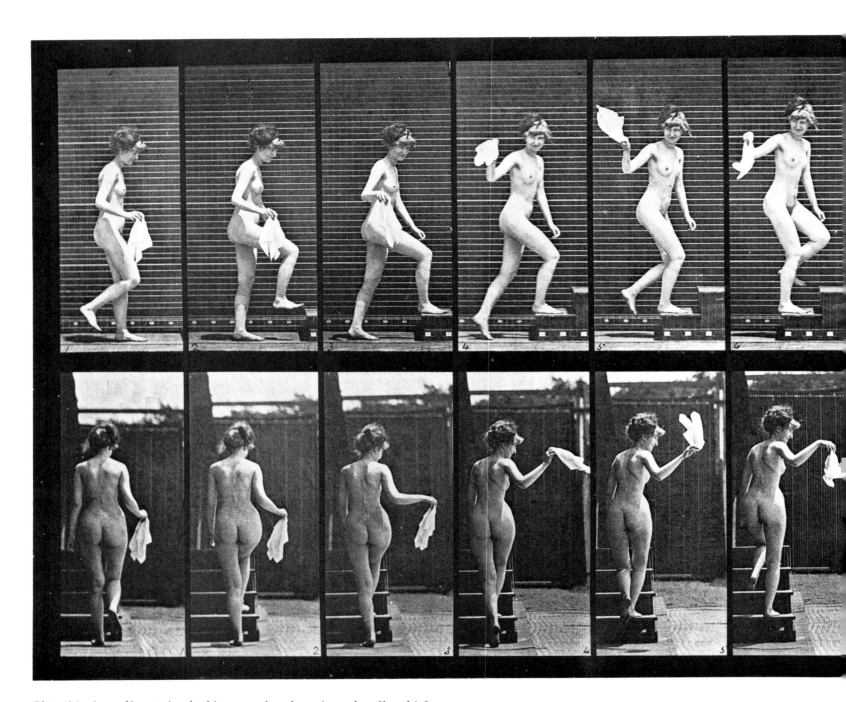

Plate 96. Ascending stairs, looking round and waving a handkerchief.

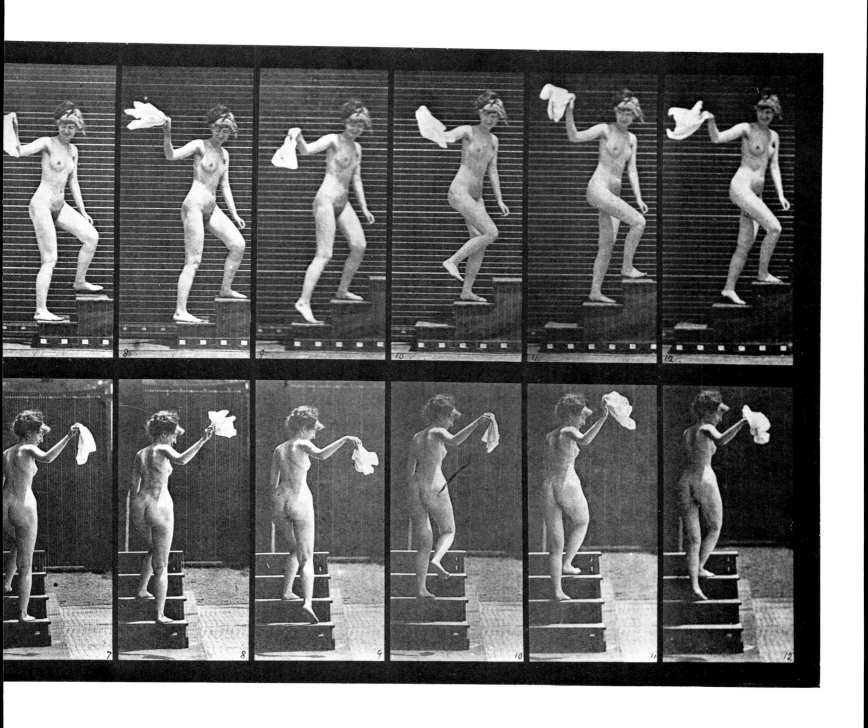

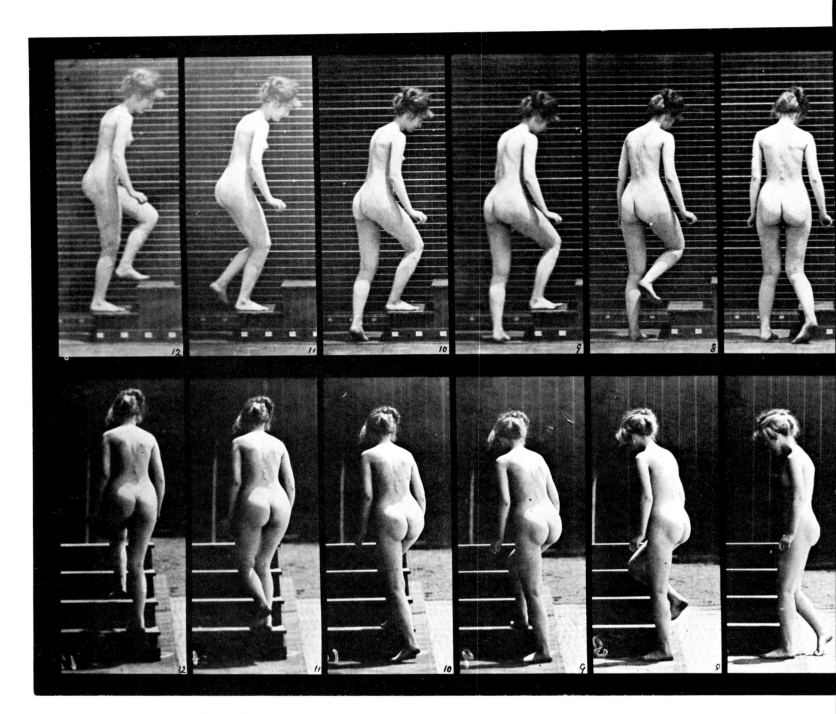

Plate 98. Turning and ascending stairs.

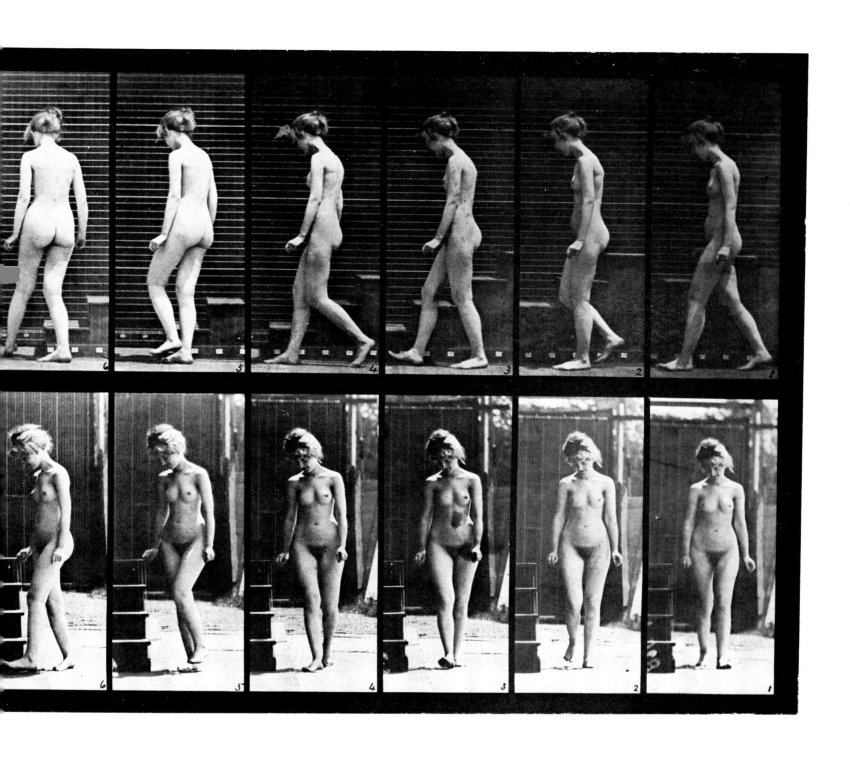

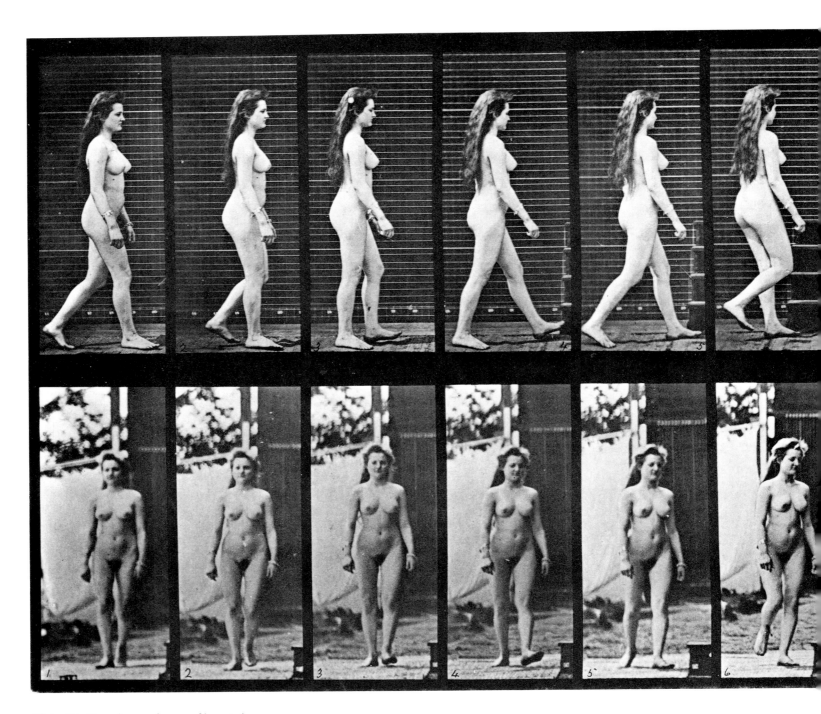

Plate 99. Turning and ascending stairs.

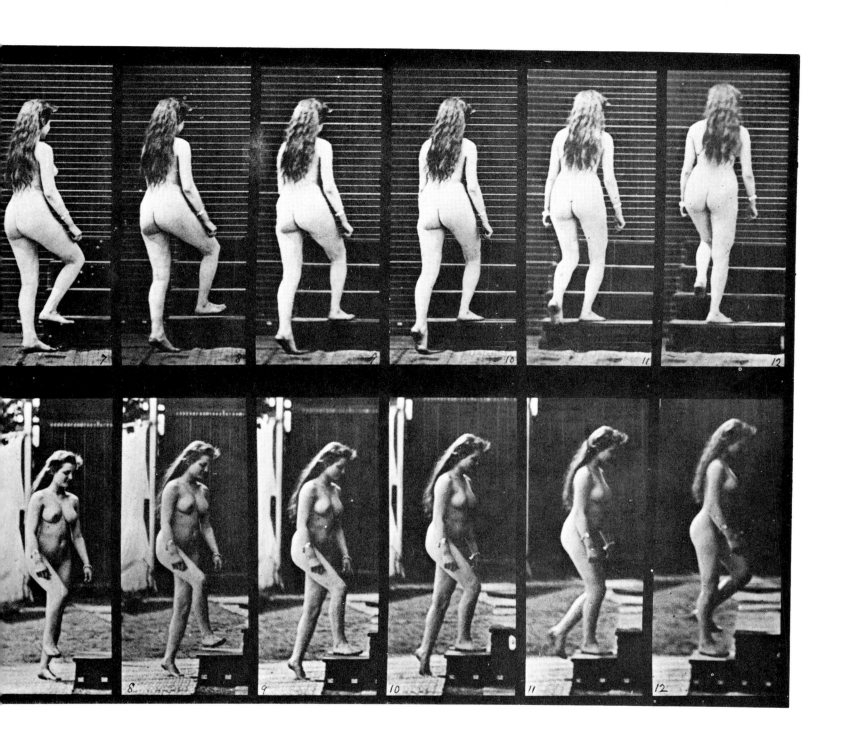

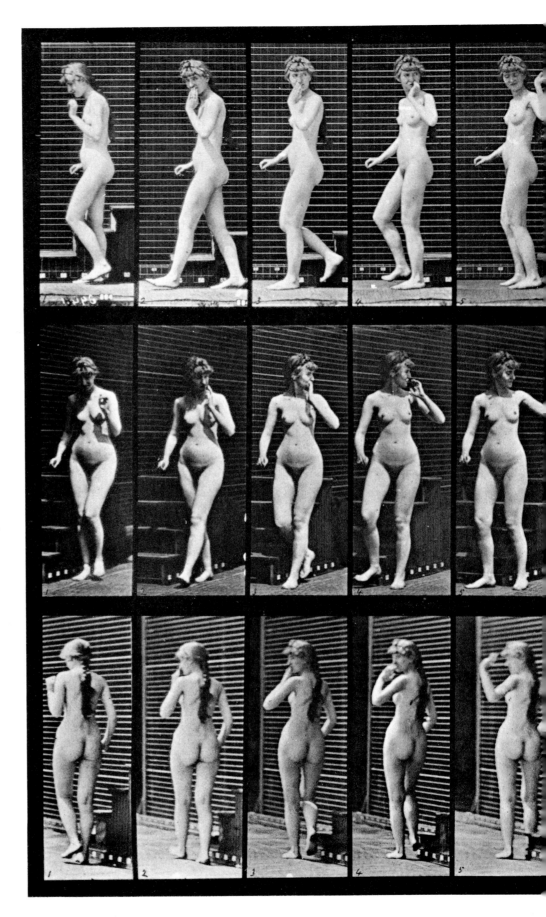

Plate 101. Turning, ascending stairs and waving hand.

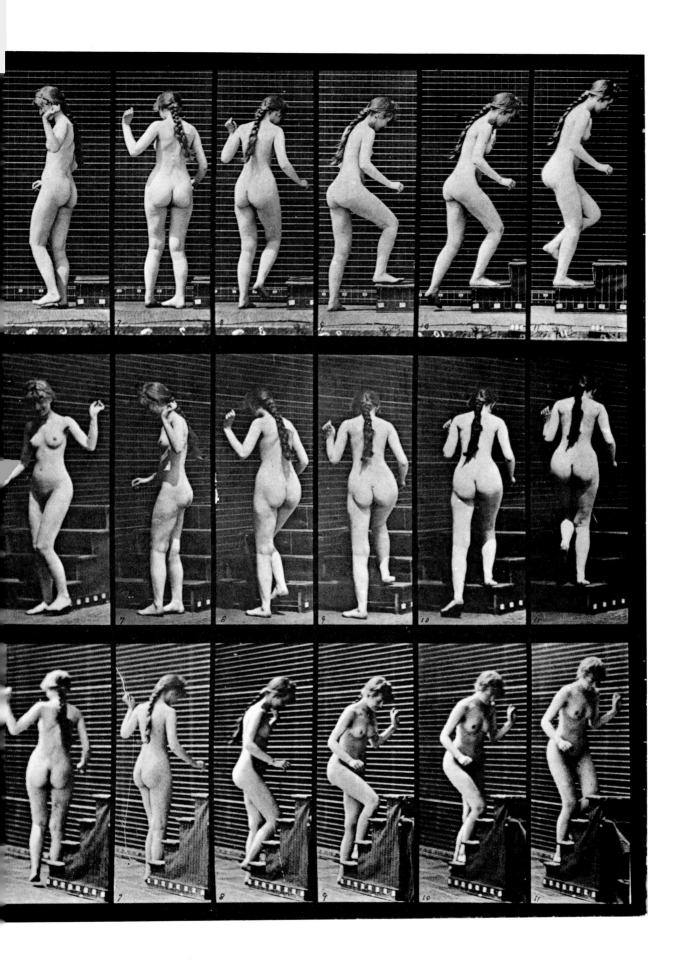

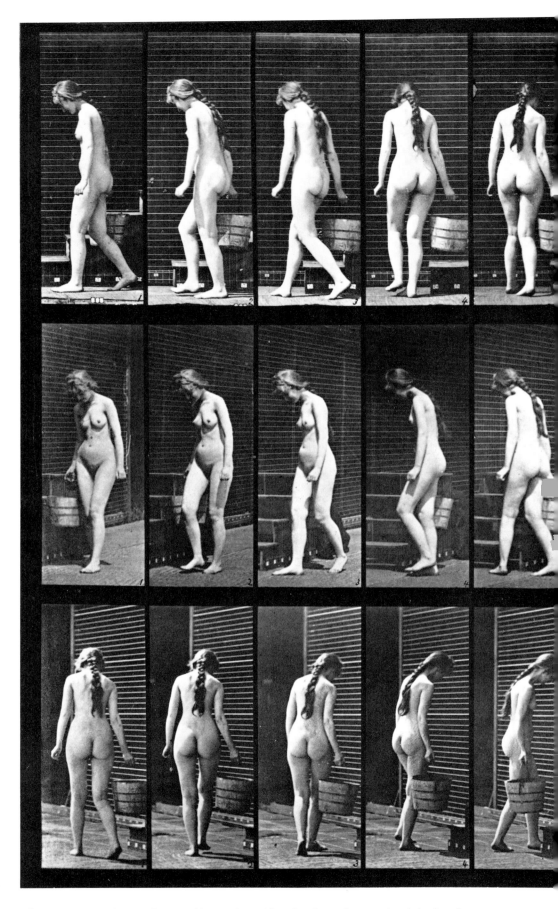

Plate 102. Turning and ascending stairs with a bucket of water in right hand.

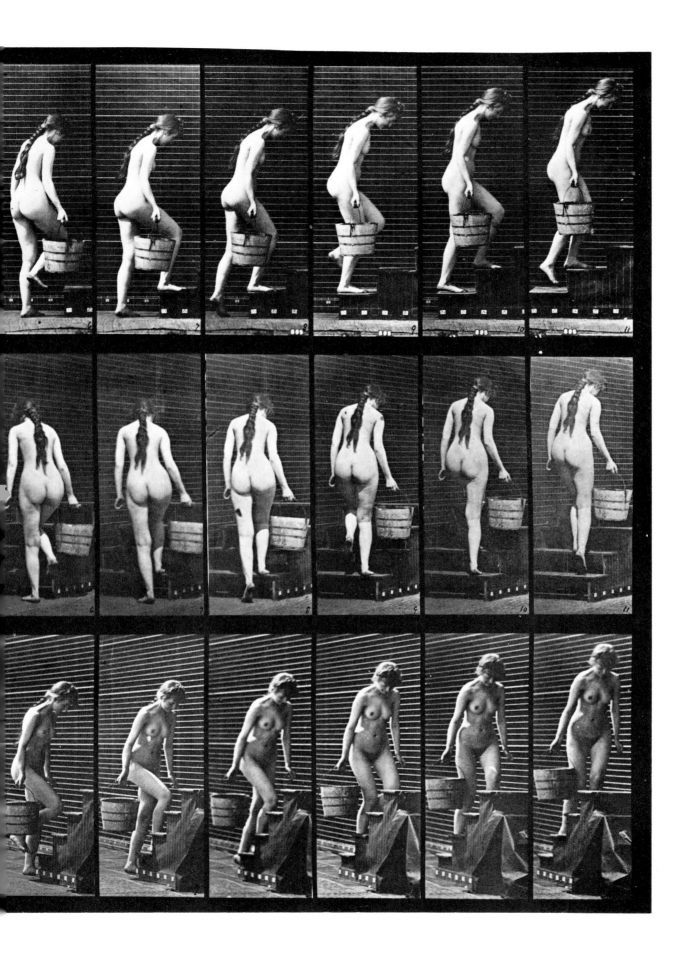

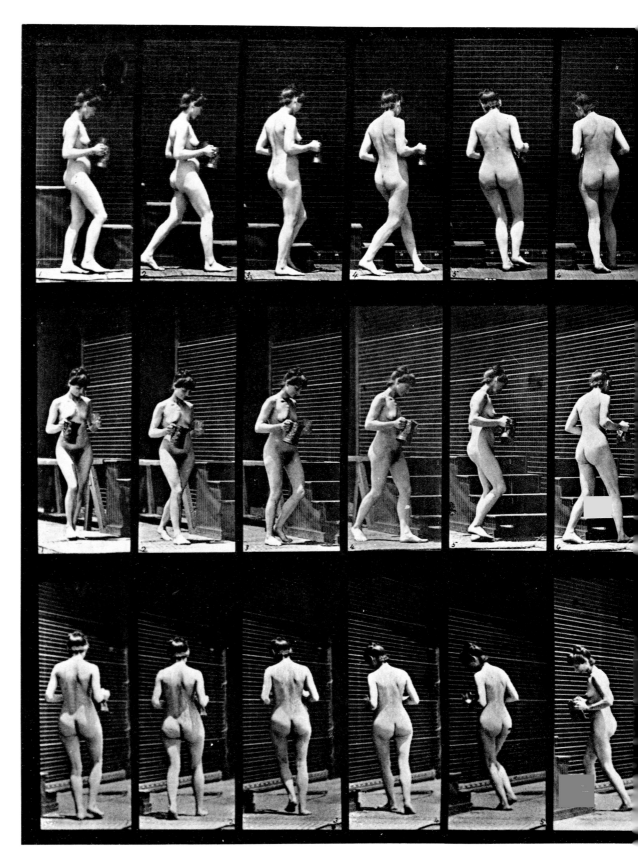

Plate 103. Turning and ascending stairs with a pitcher and goblet in hands.

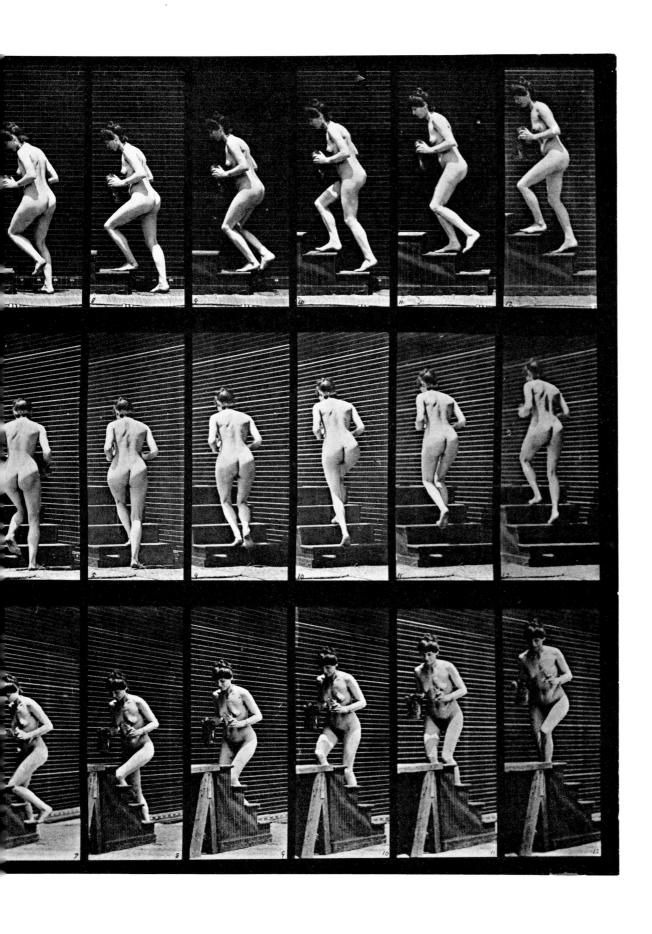

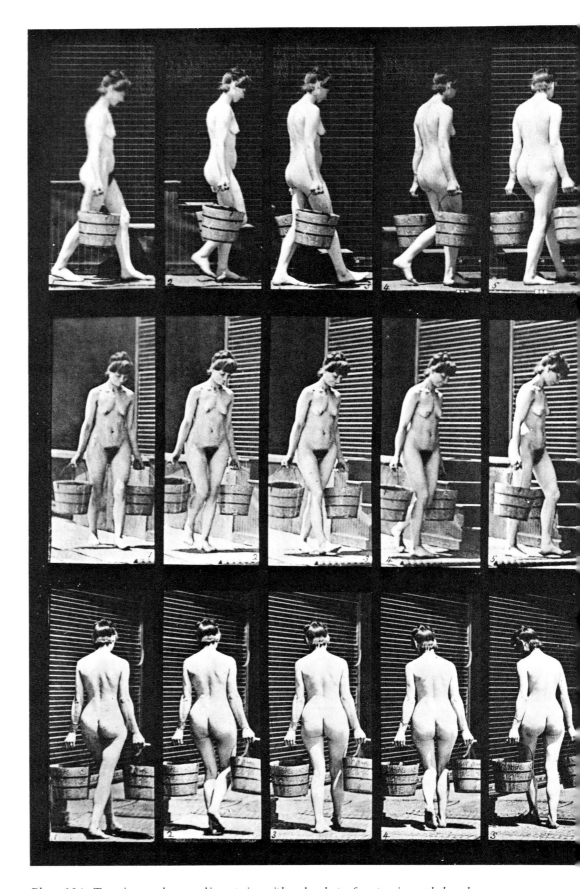

Plate 104. Turning and ascending stairs with a bucket of water in each hand.

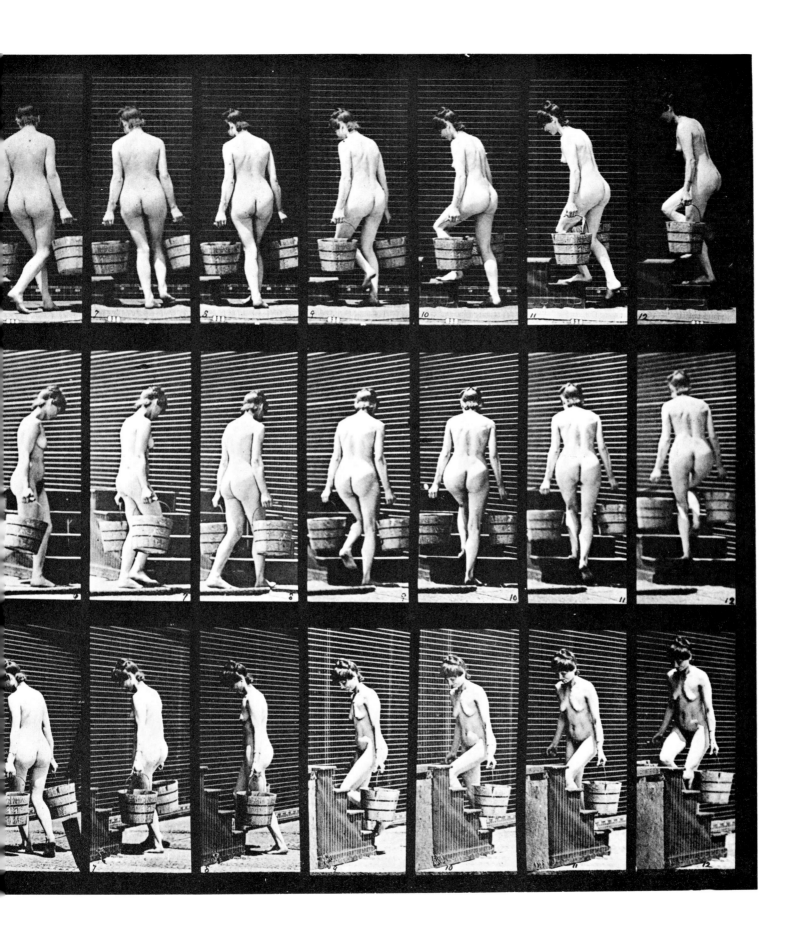

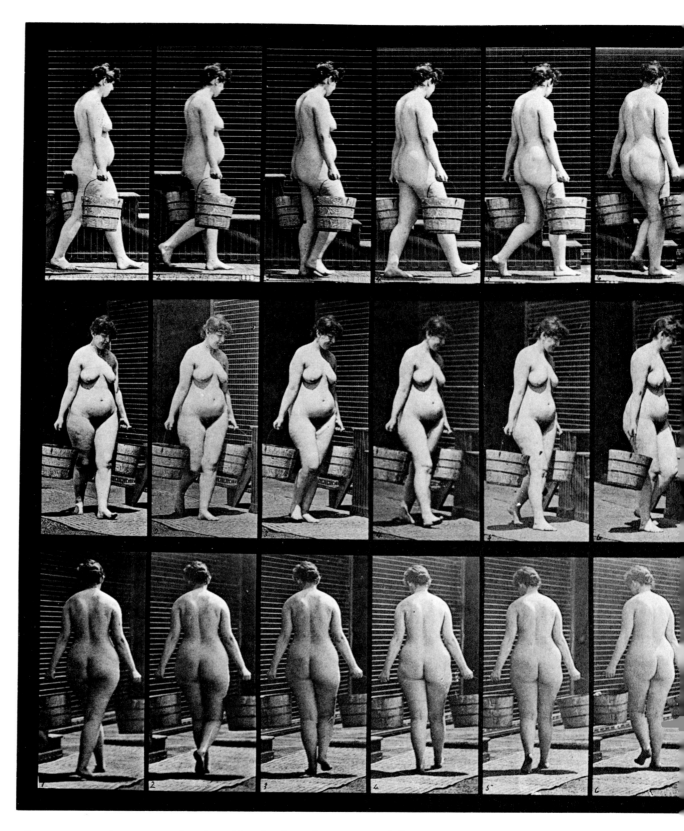

Plate 106. Turning to ascend stairs with a bucket of water in each hand.

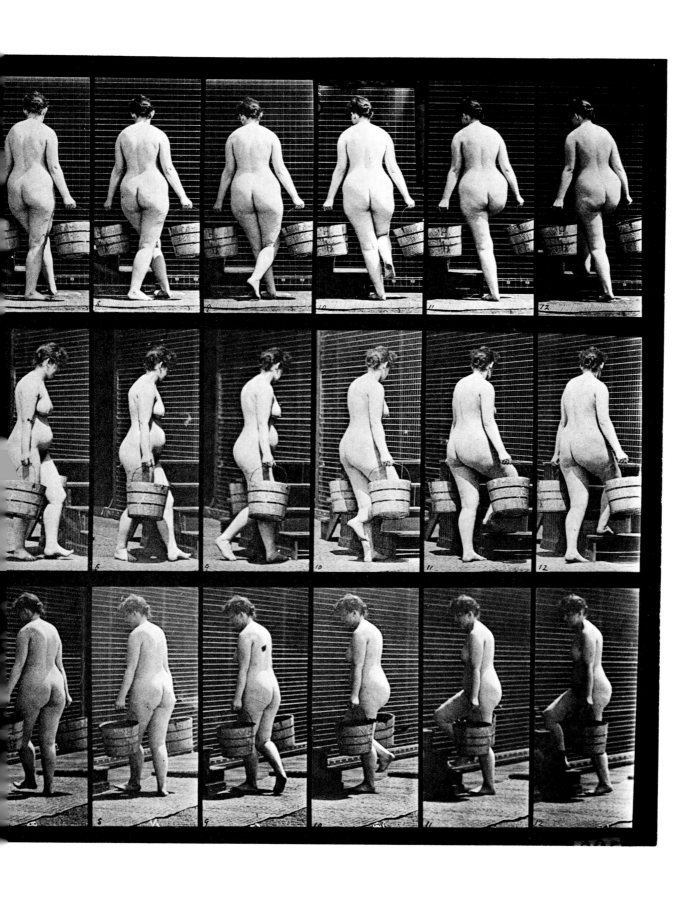

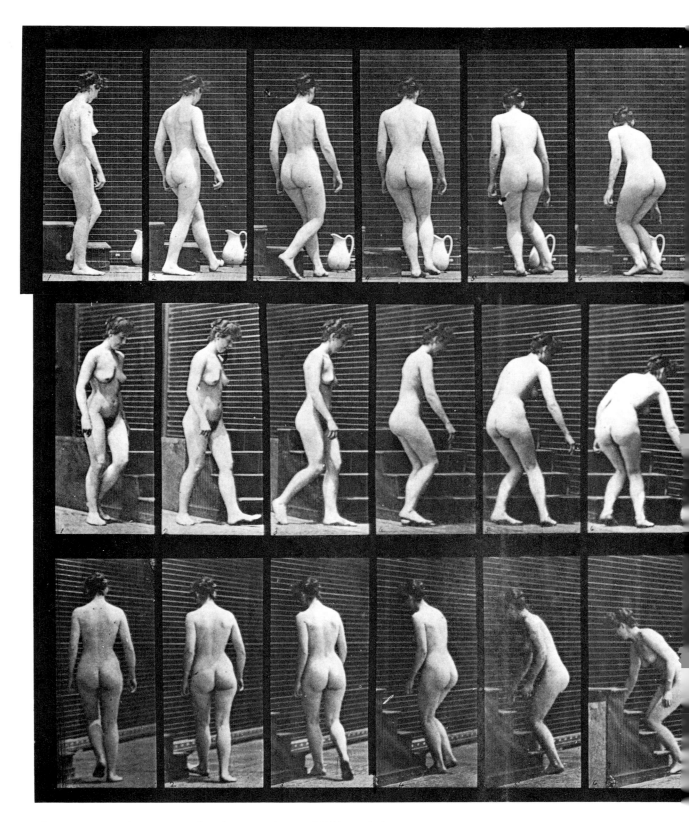

Plate 108. Turning to ascend stairs, stooping and lifting pitcher.

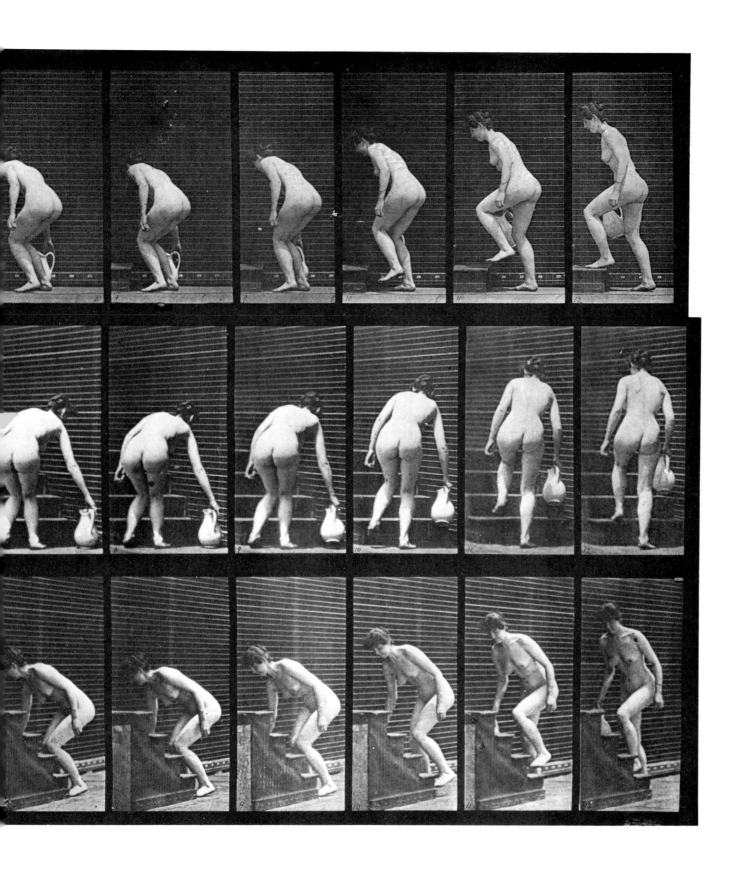

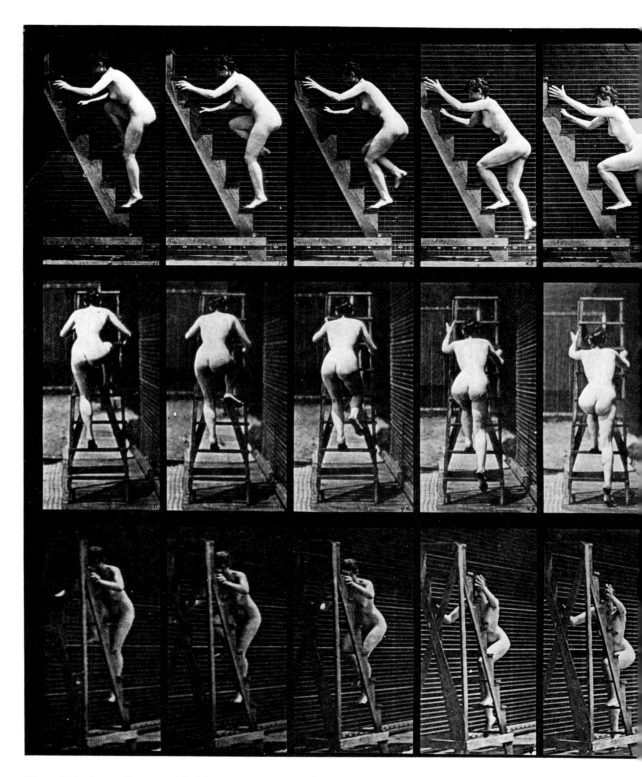

Plate 110. Ascending a stepladder two steps at a time.

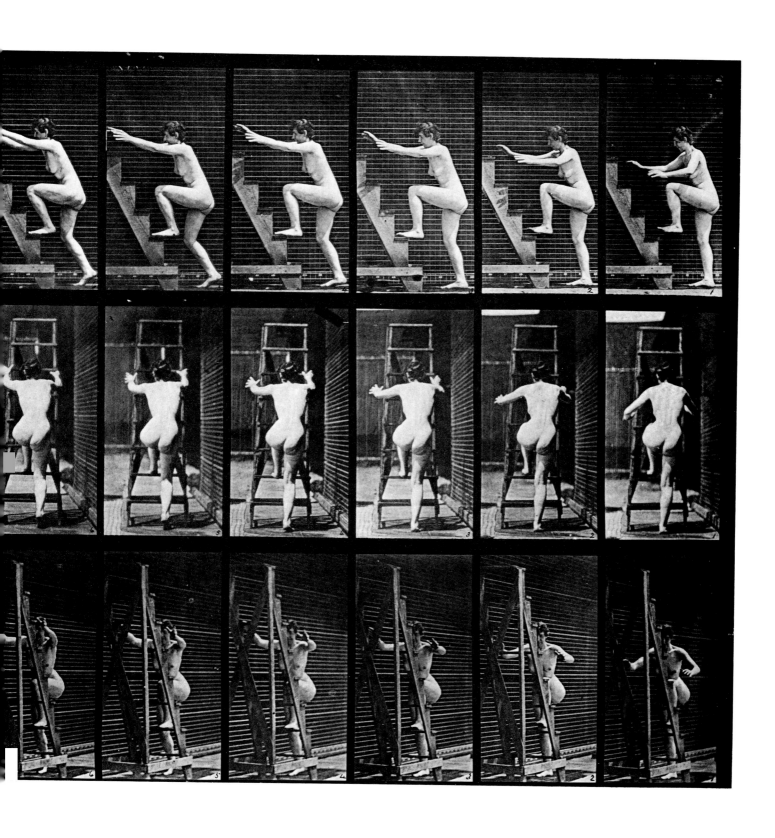

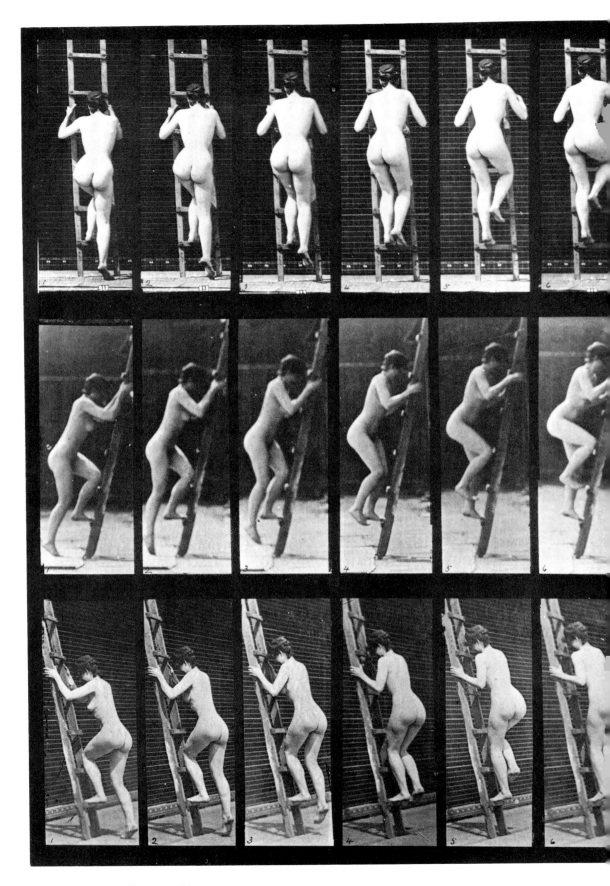

Plate 112. Ascending a ladder.

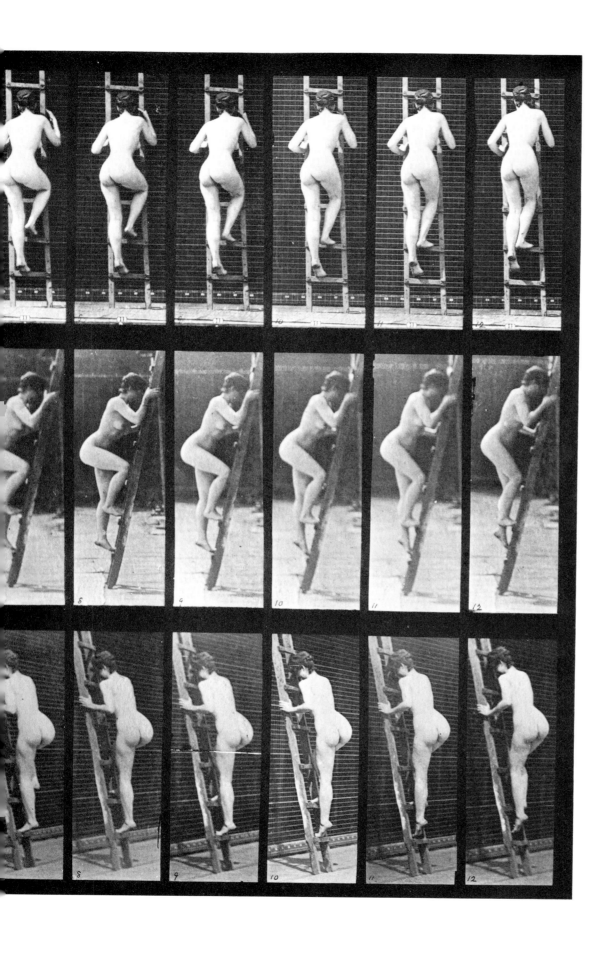

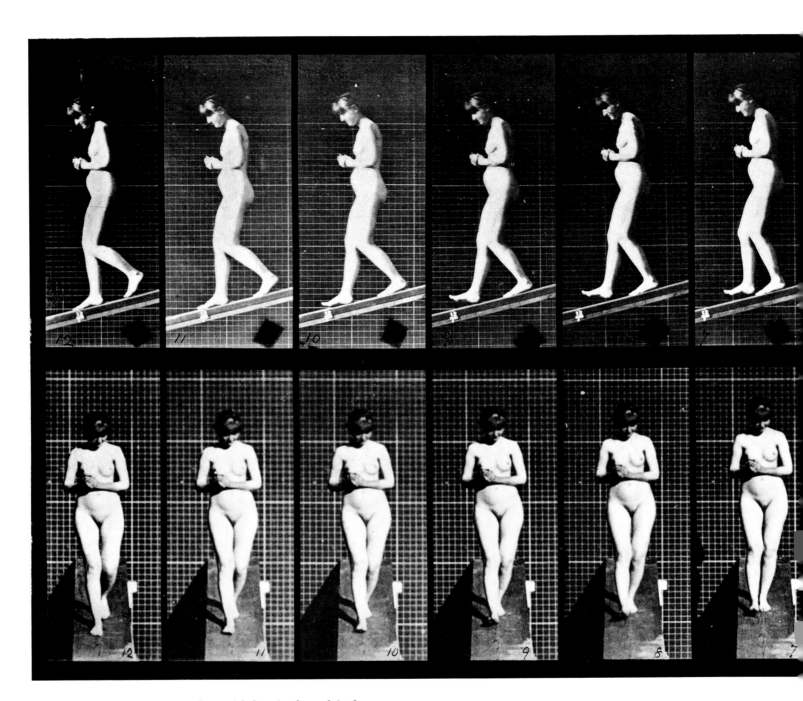

Plate 115. Descending an incline with hands clasped in front.

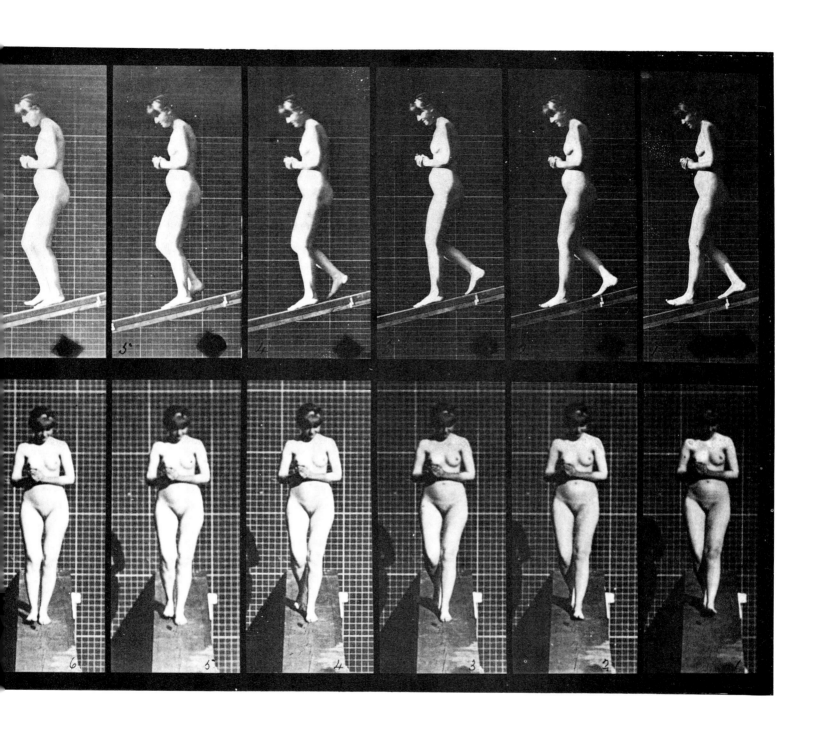

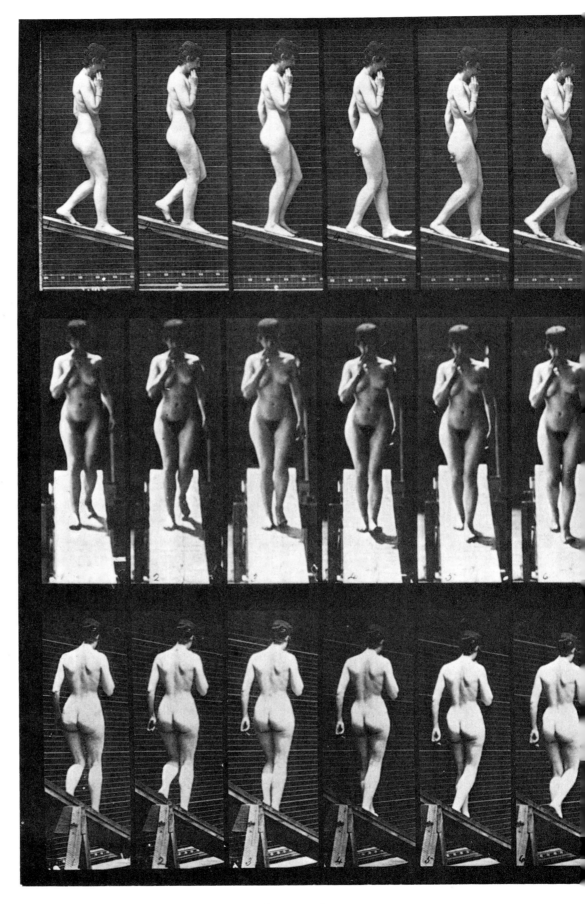

Plate 116. Descending an incline with one hand on chin.

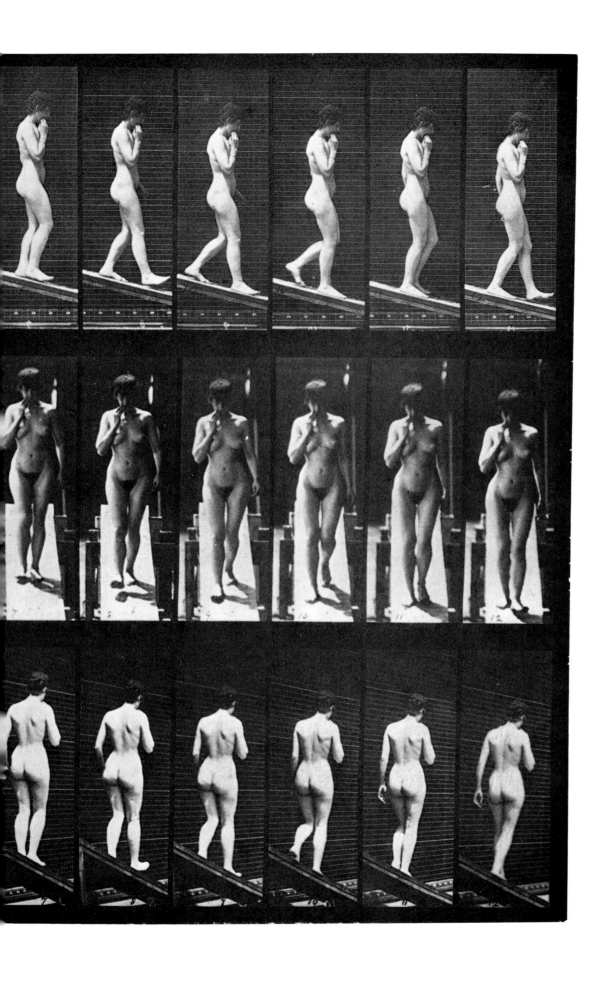

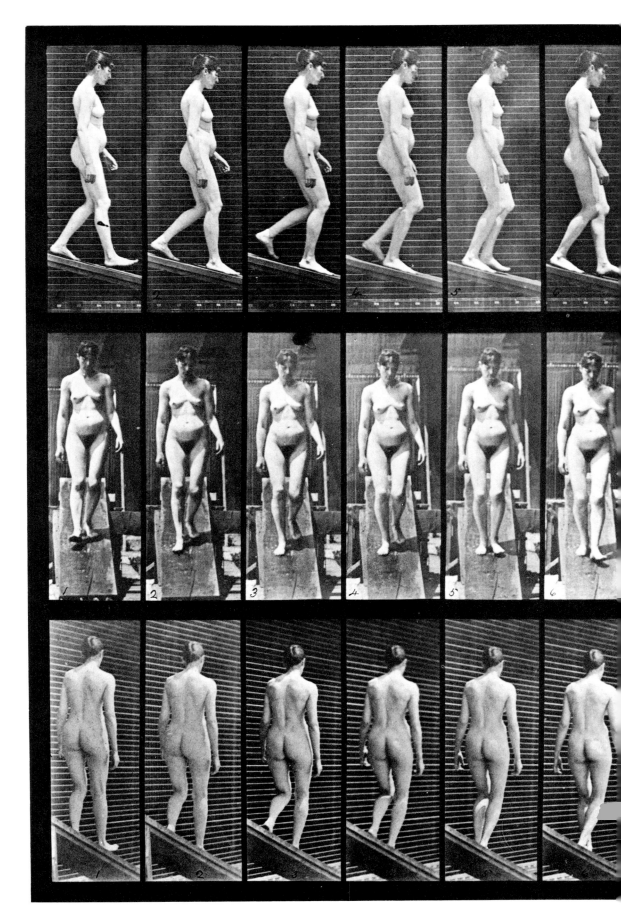

Plate 117. Descending an incline.

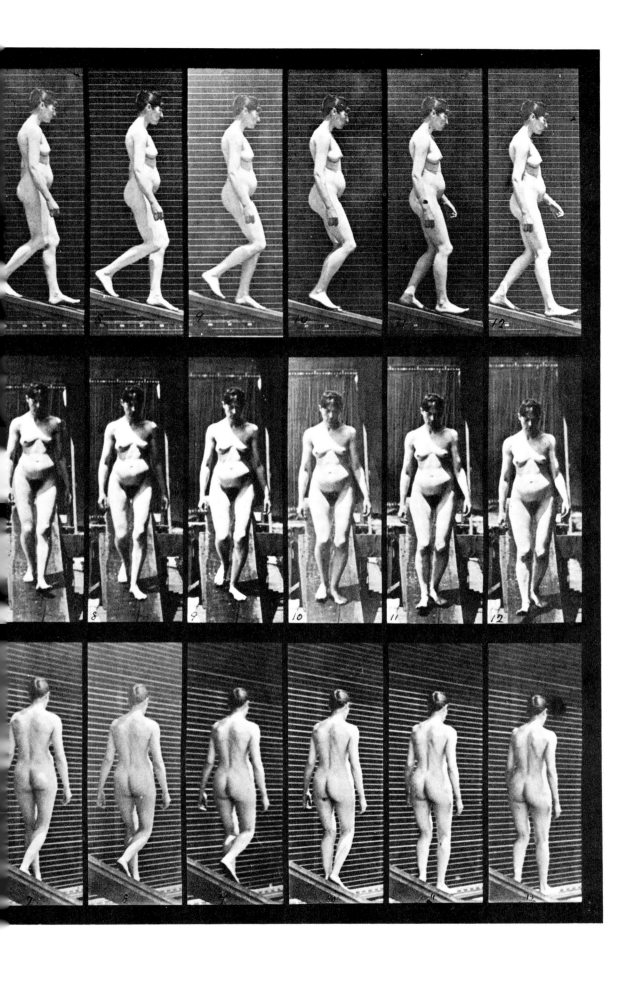

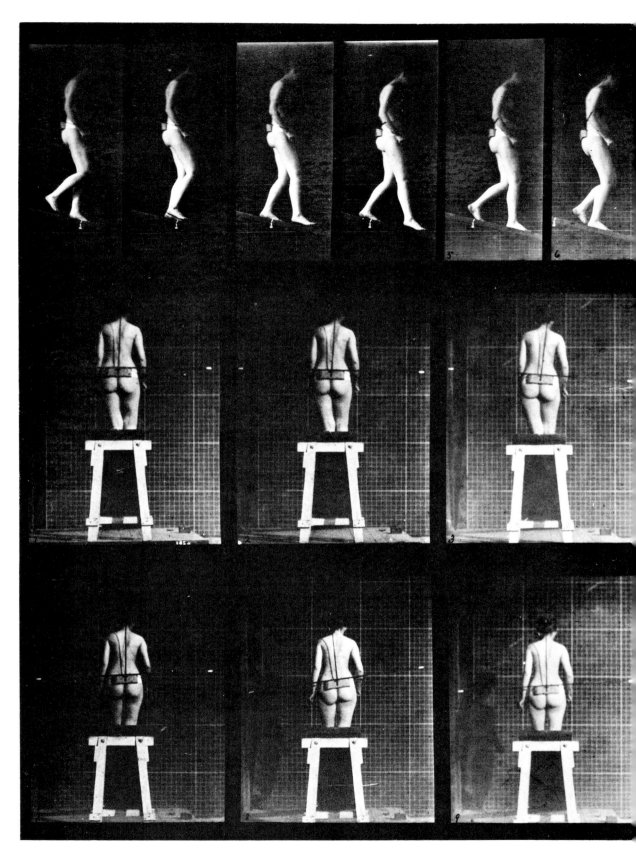

Plate 118. Descending an incline.

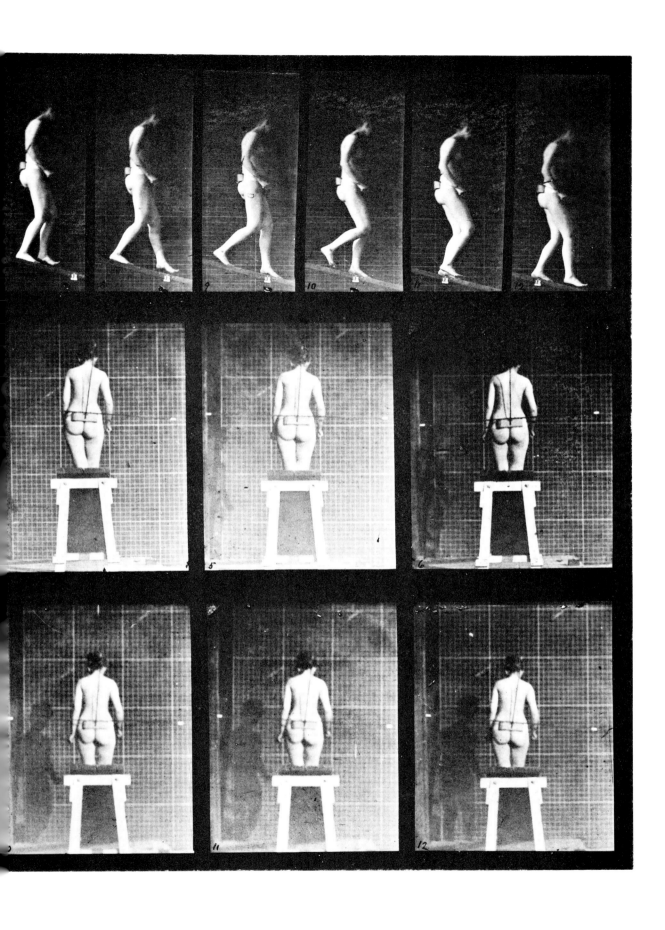

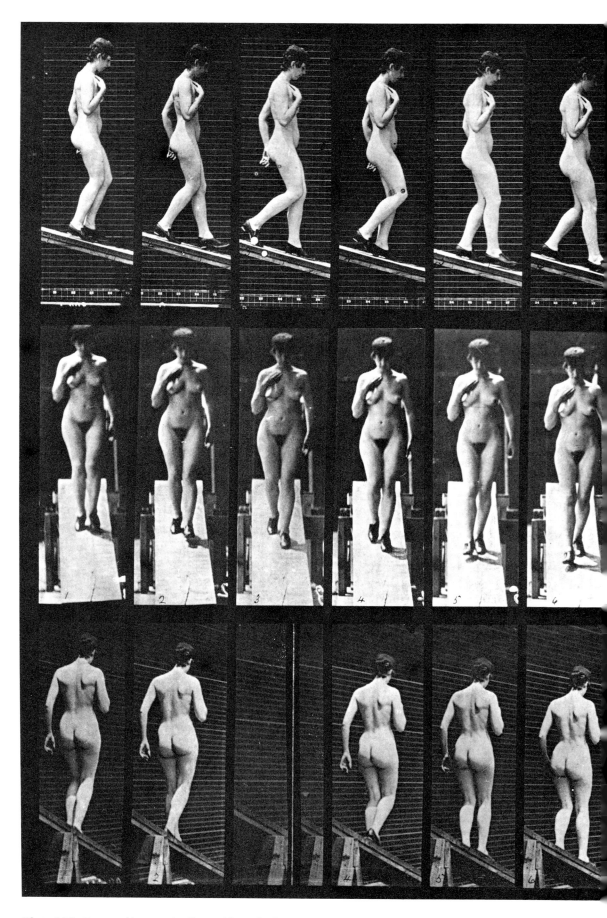

Plate 119. Descending an incline with right hand on breast.

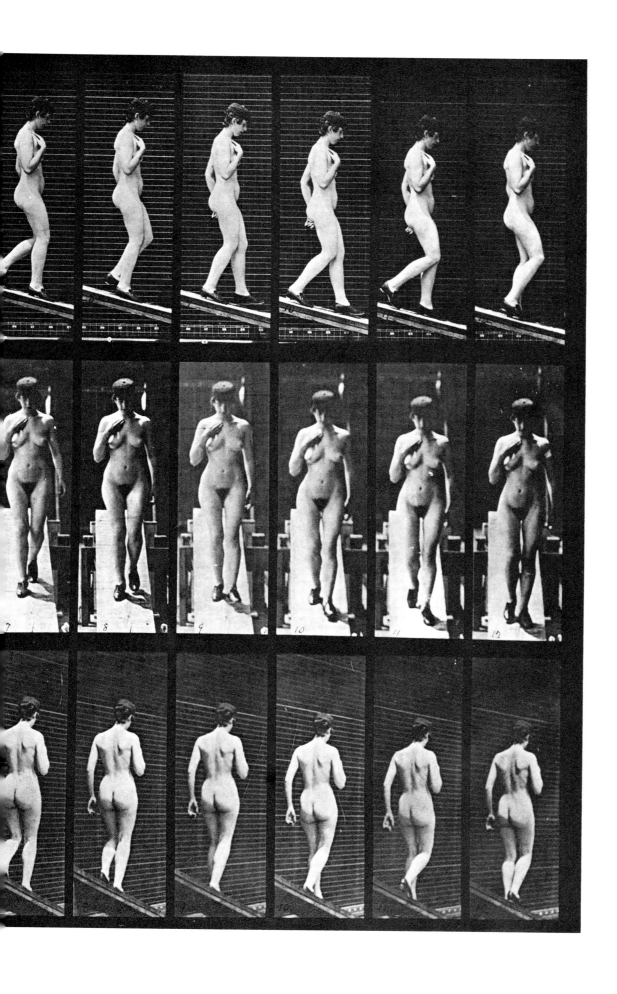

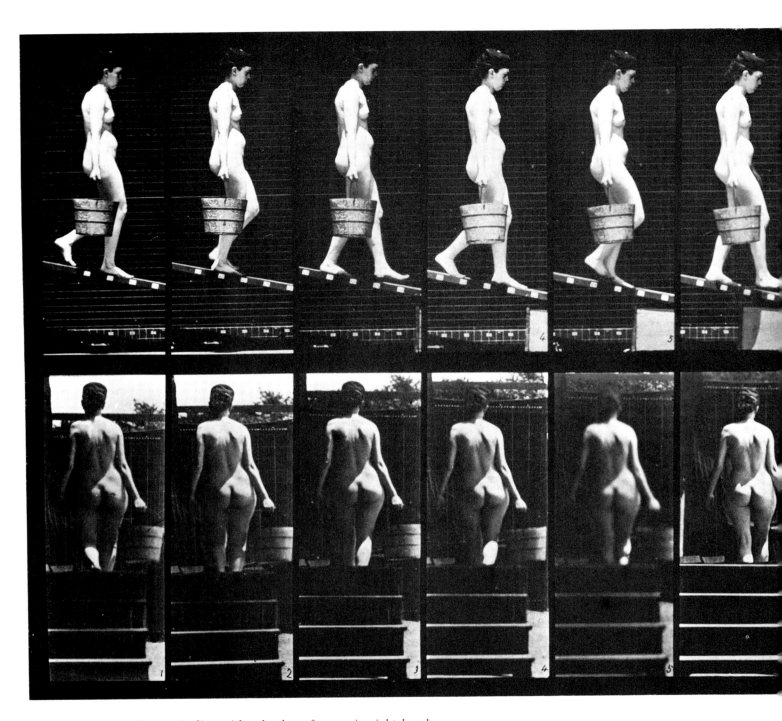

Plate 120. Descending an incline with a bucket of water in right hand.

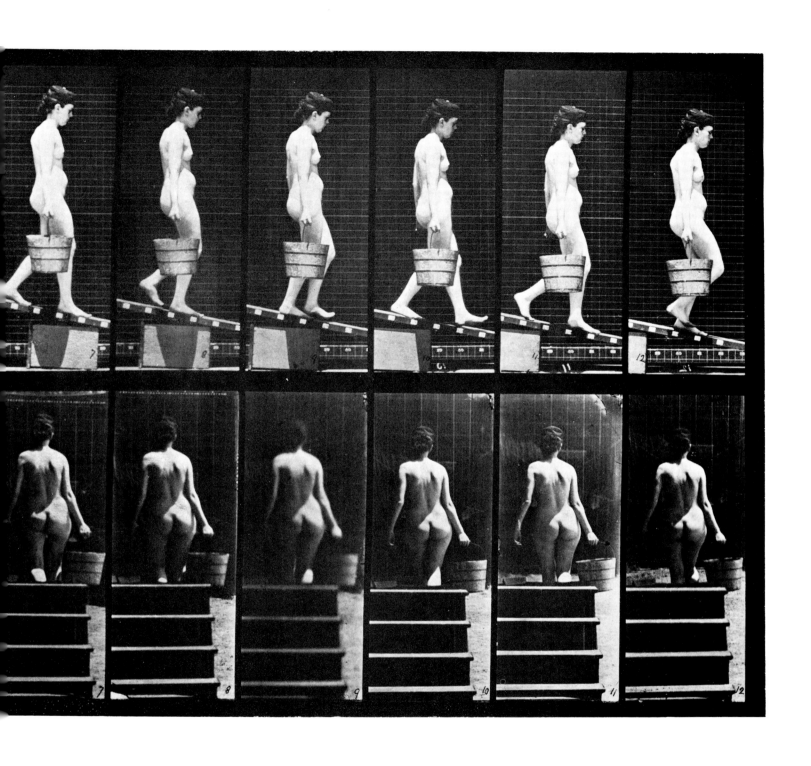

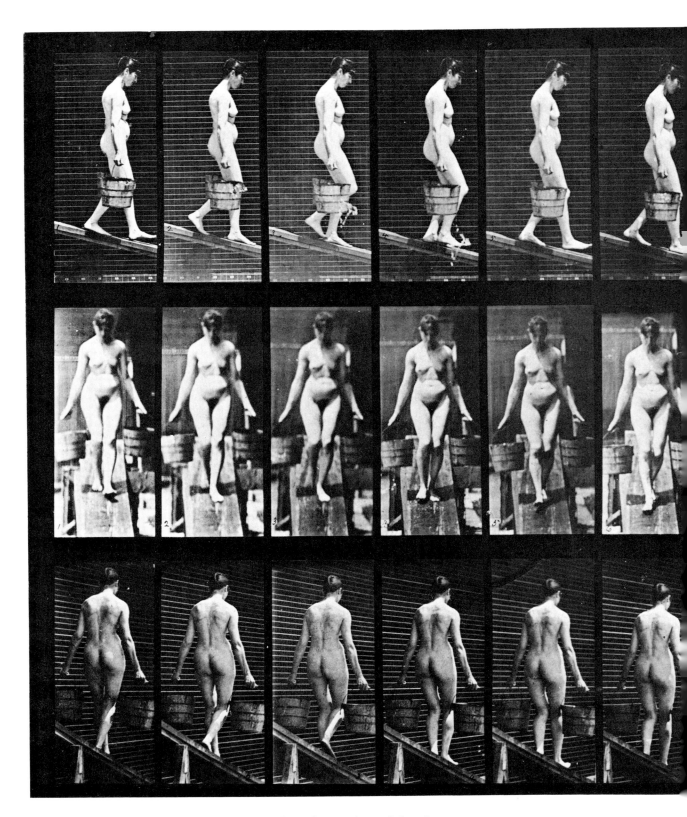

Plate 121. Descending an incline with a bucket of water in each hand.

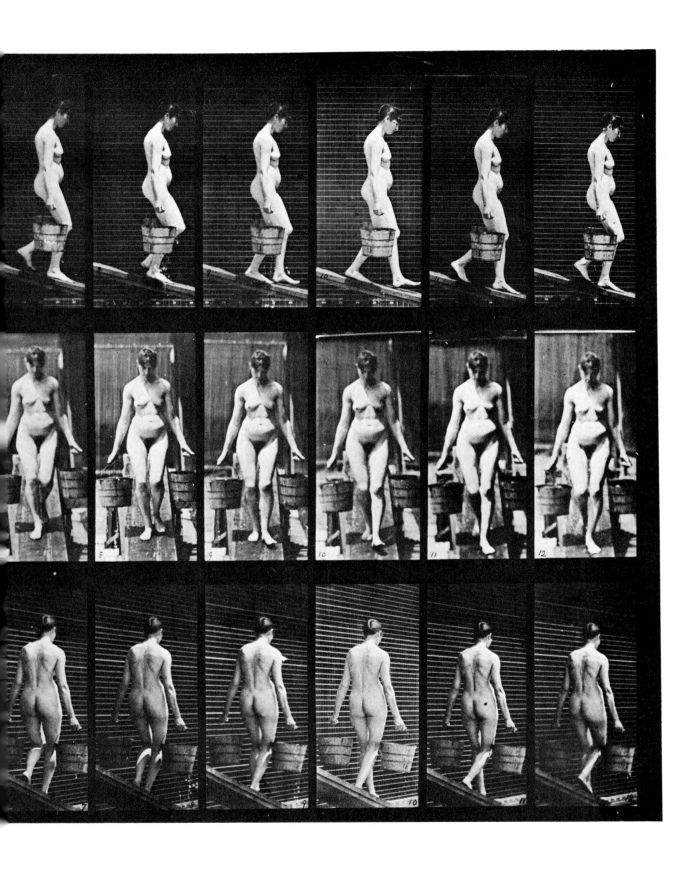

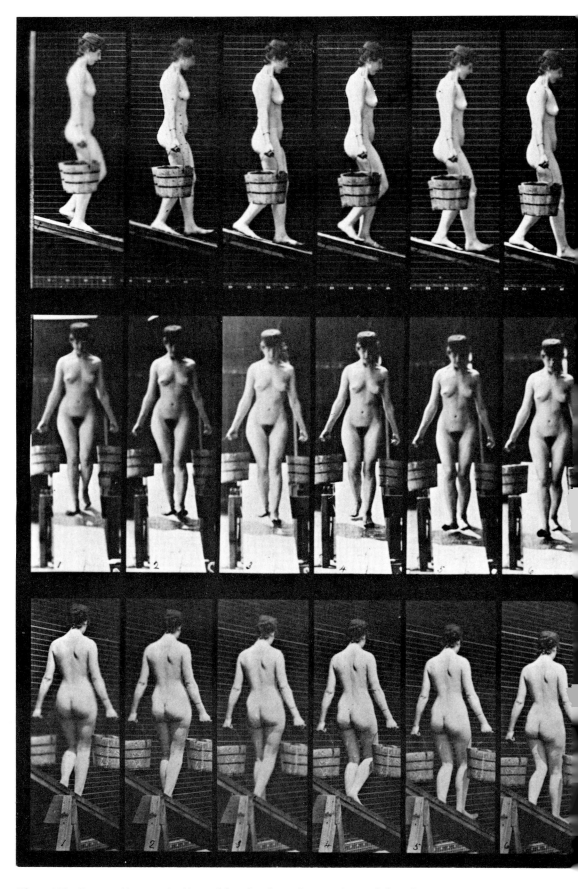

Plate 122. Descending an incline with a bucket of water in each hand.

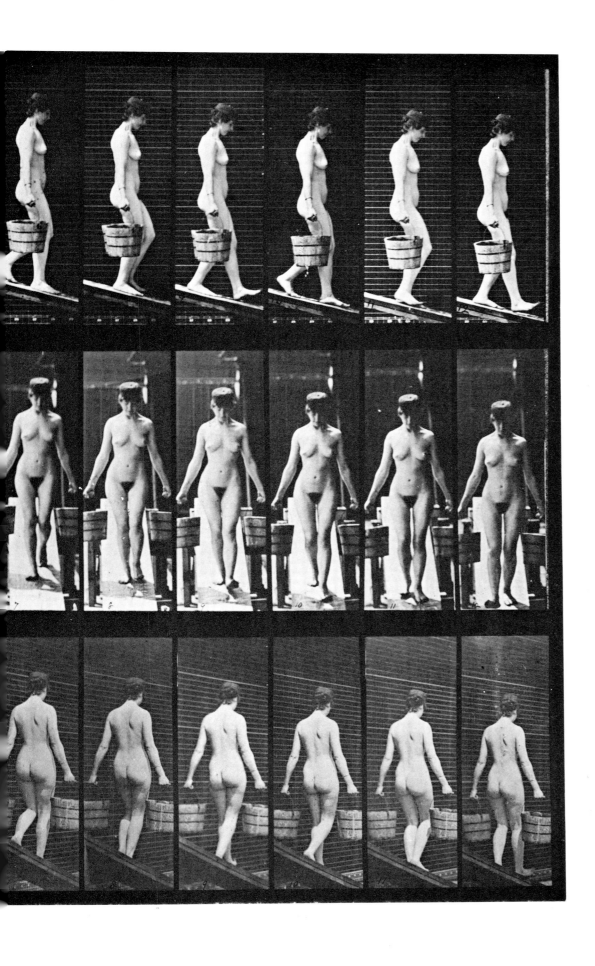

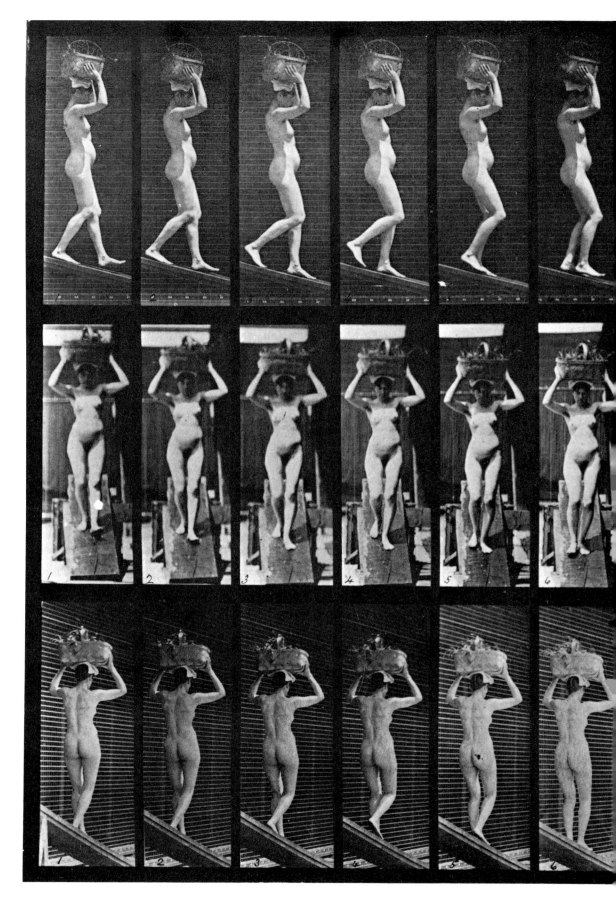

Plate 123. Descending an incline with a 20-lb. basket on head, hands raised.

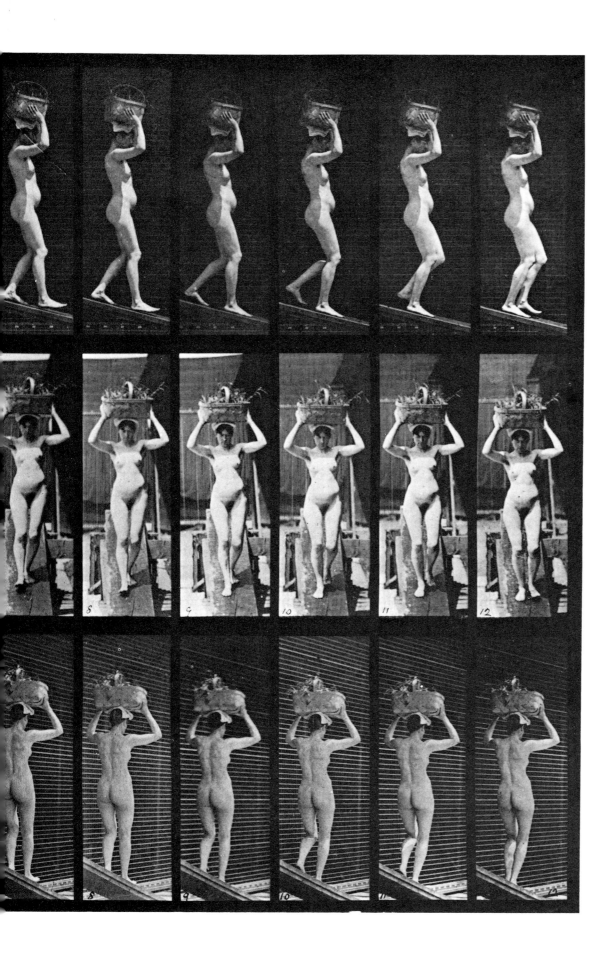

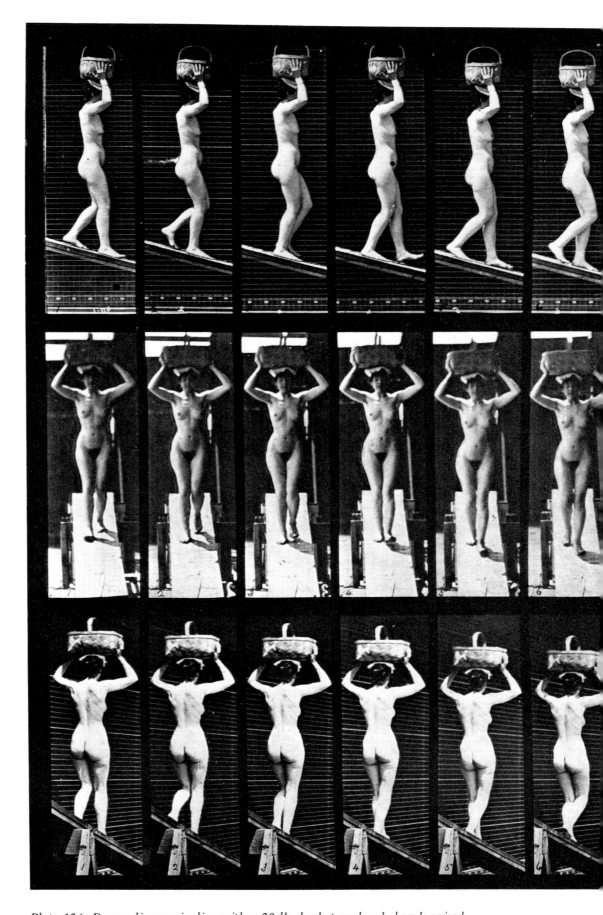

Plate 124. Descending an incline with a 20-lb. basket on head, hands raised.

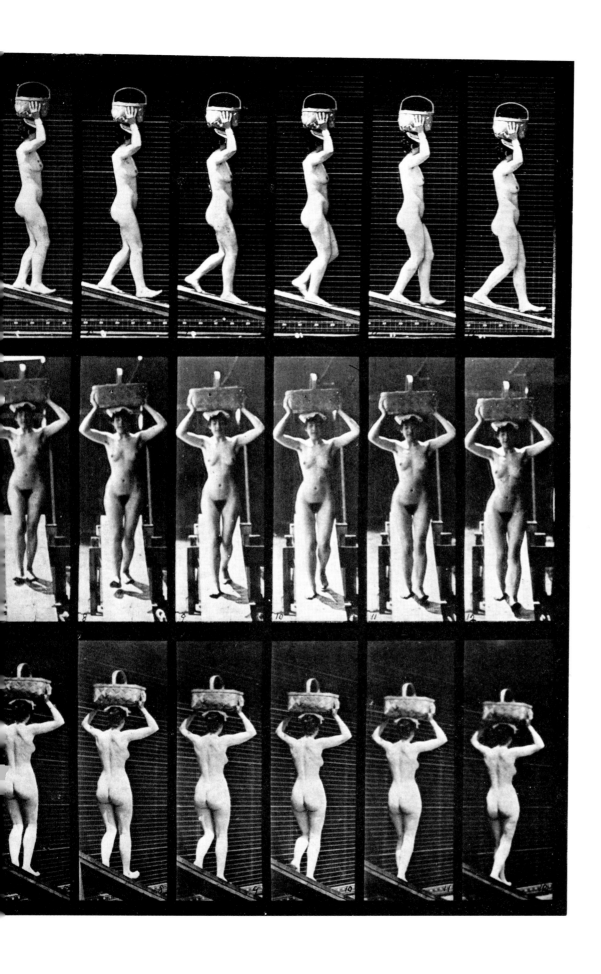

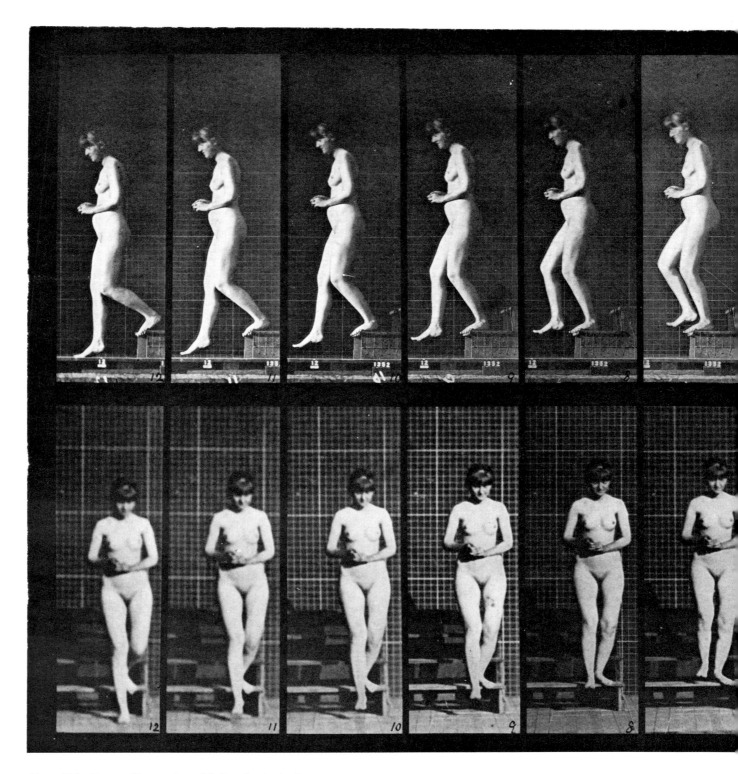

Plate 128. Descending stairs with hands clasped.

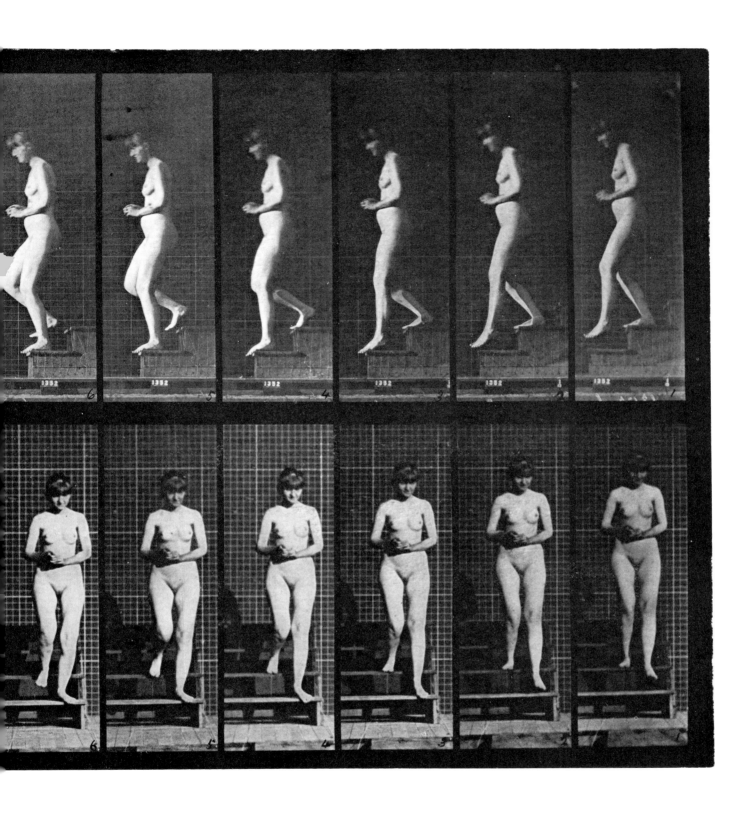

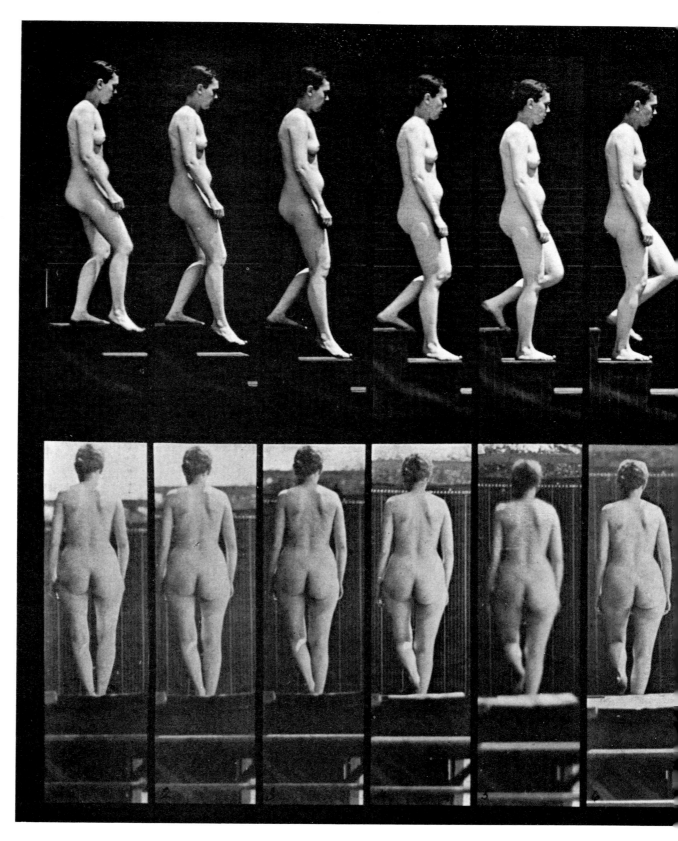

Plate 129. Descending stairs.

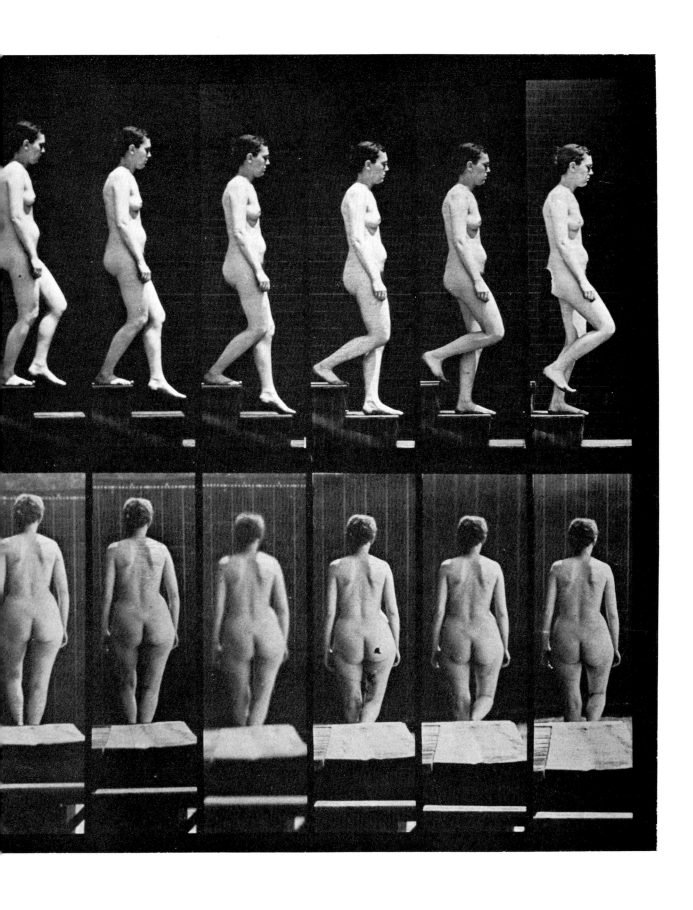

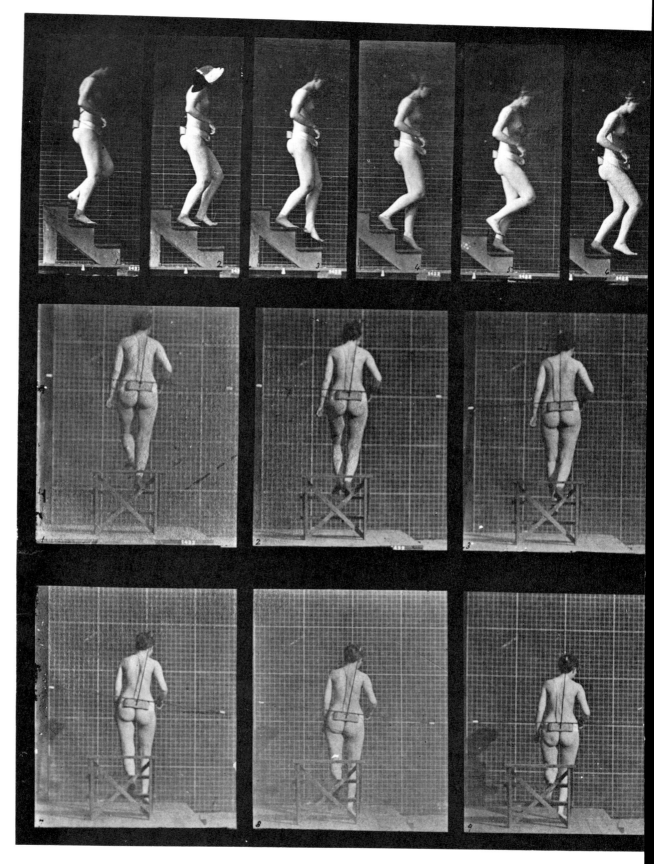

Plate 130. Descending stairs.

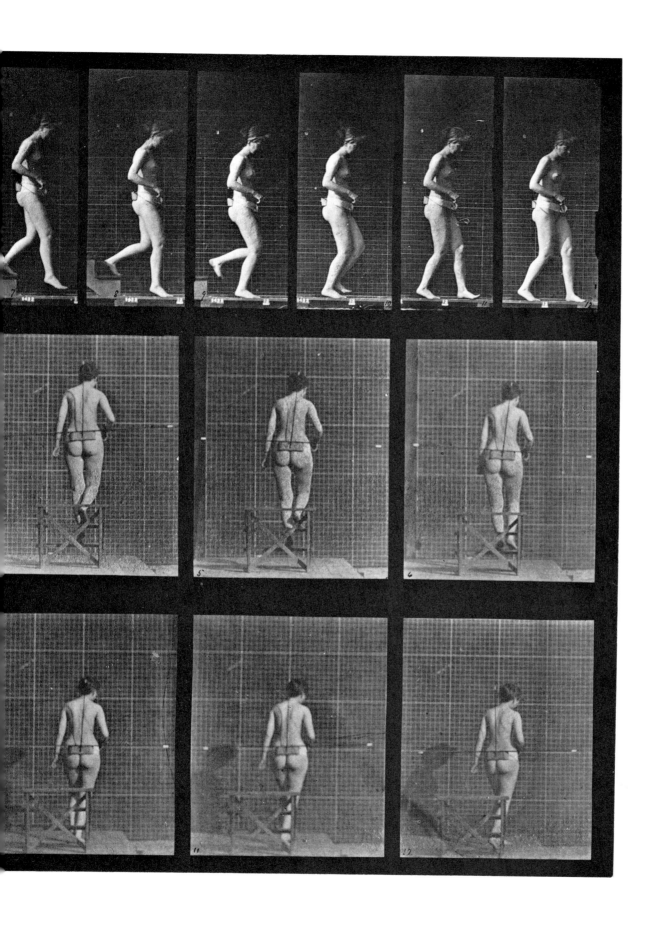

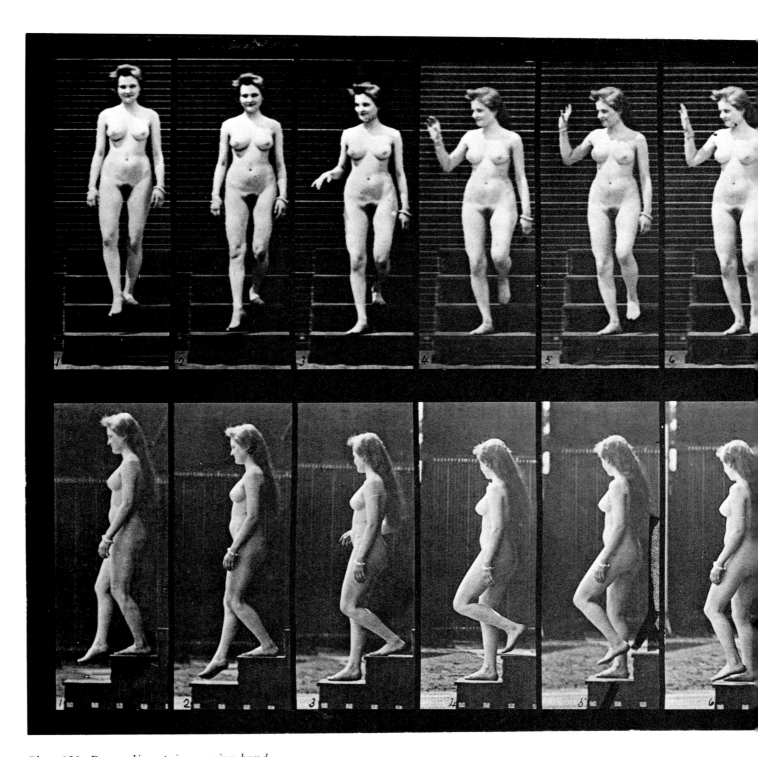

Plate 131. Descending stairs, waving hand.

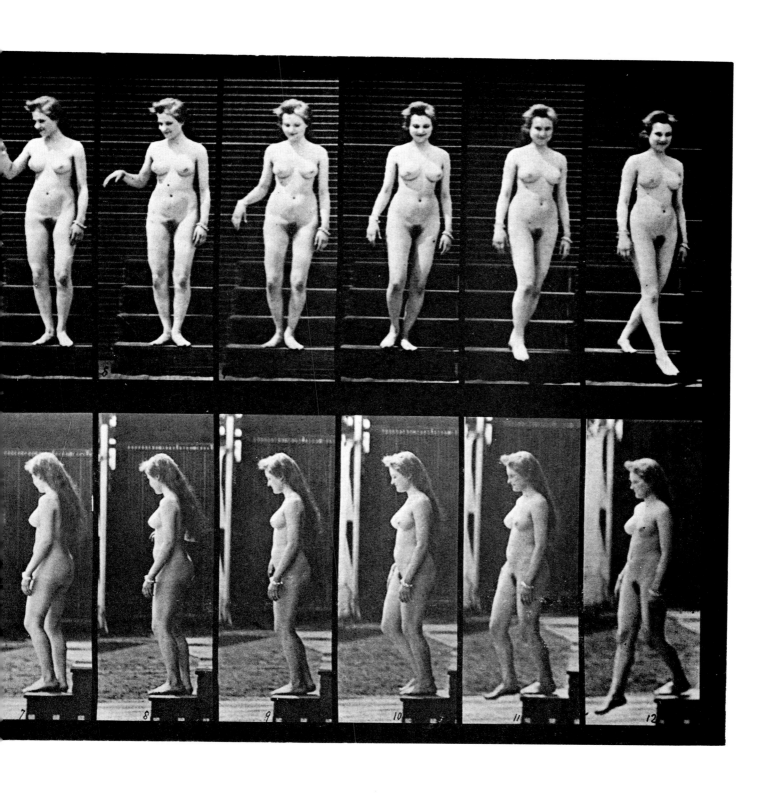

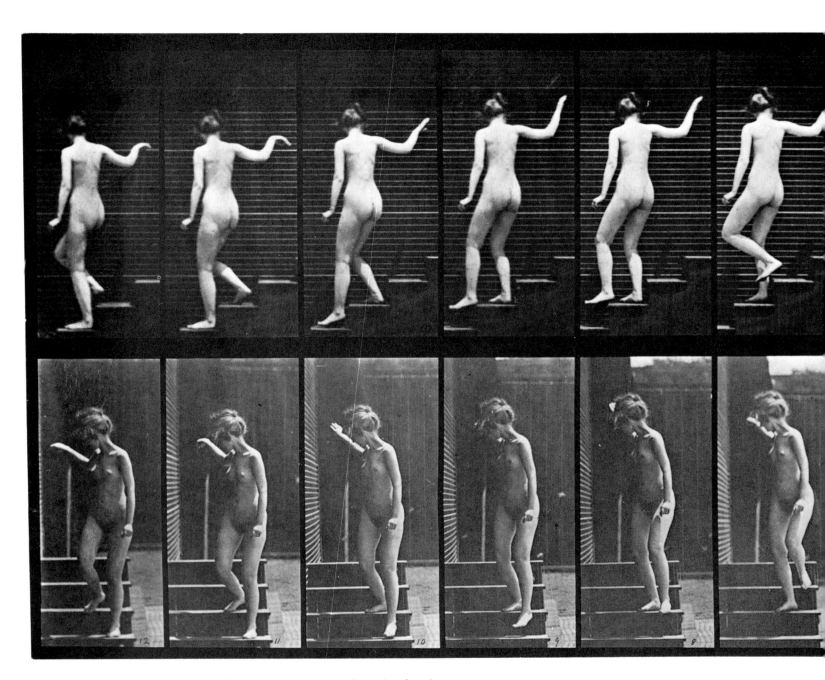

Plate 132. Descending stairs, turning to look around and waving hand.

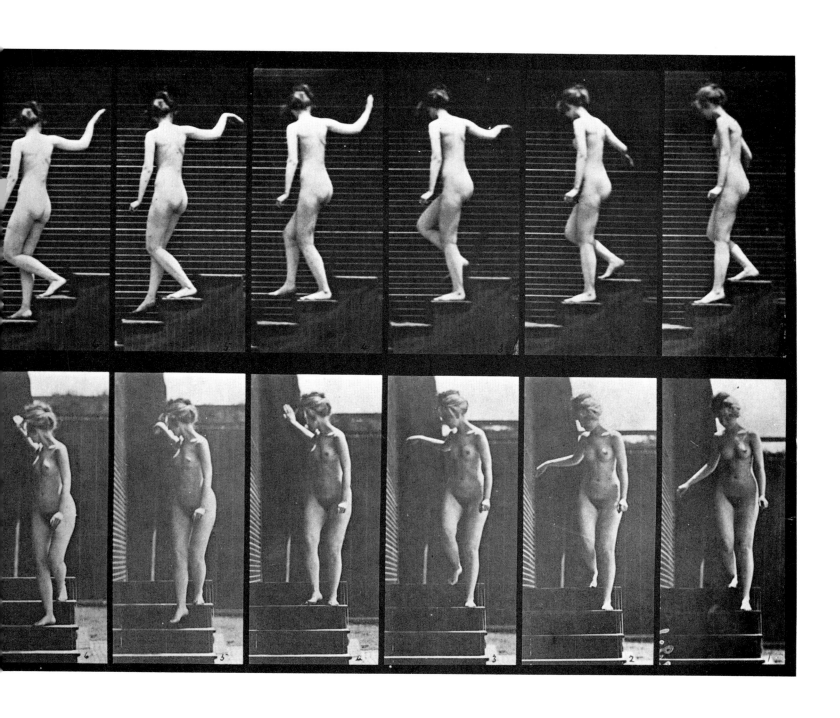

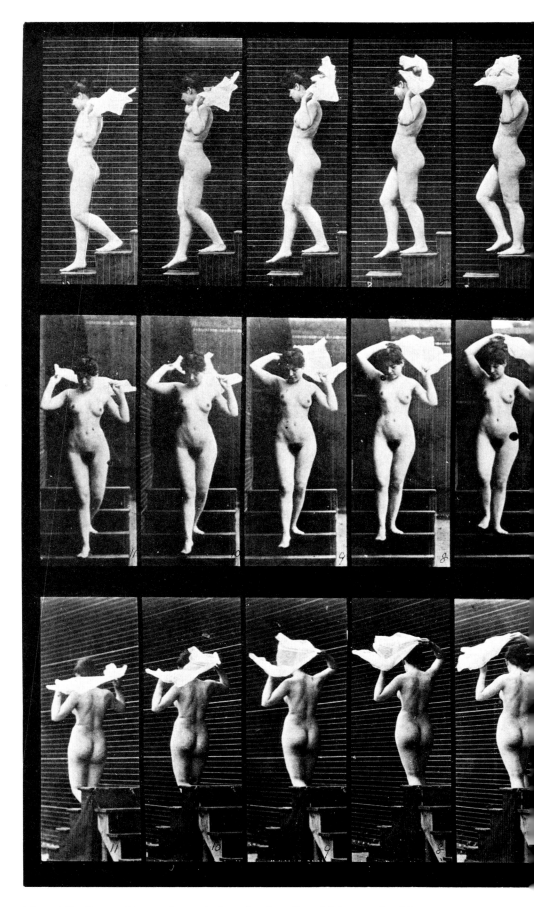

Plate 133. Descending stairs and throwing handkerchief over shoulders.

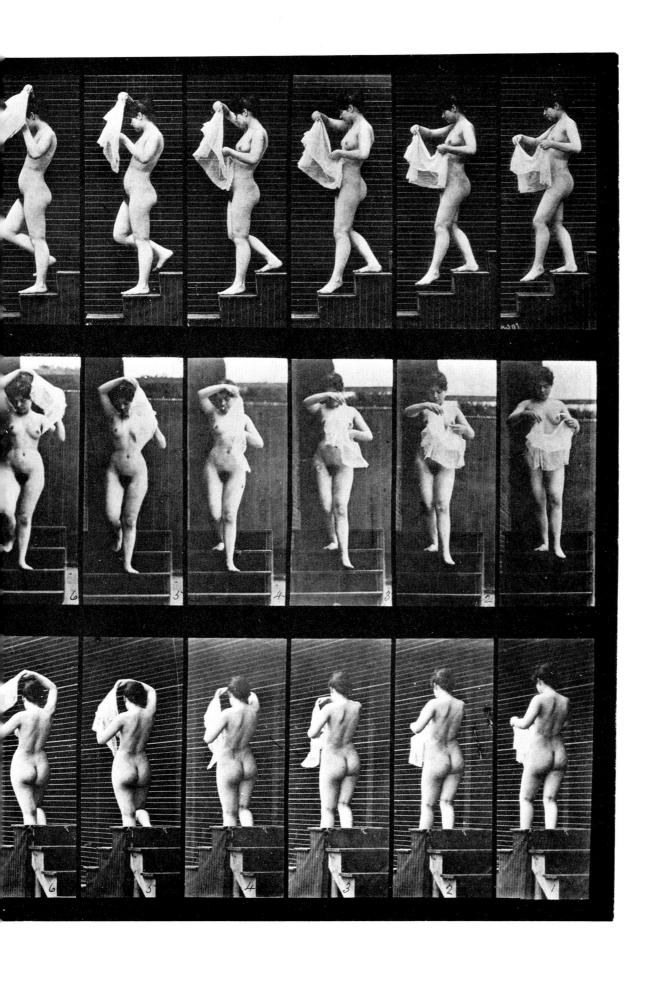

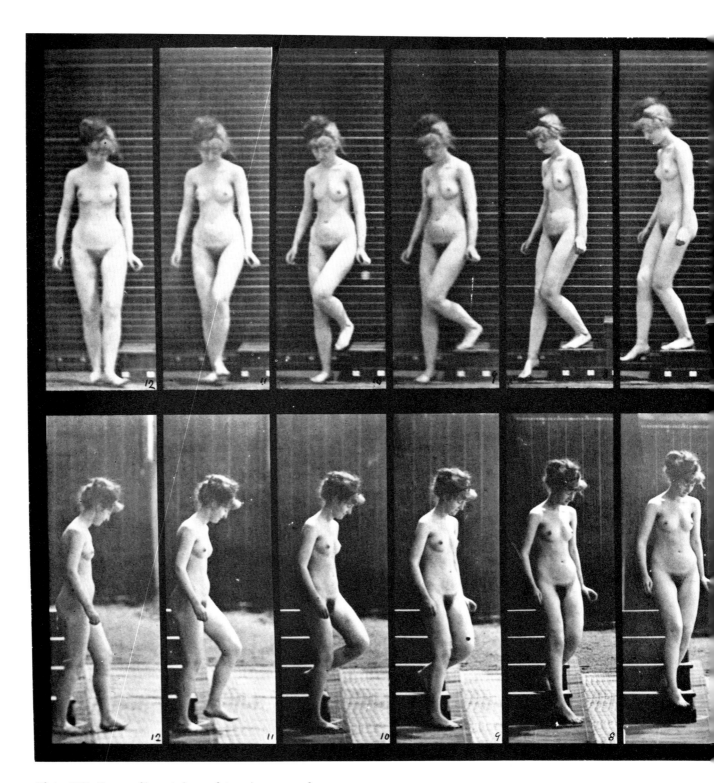

Plate 137. Descending stairs and turning around.

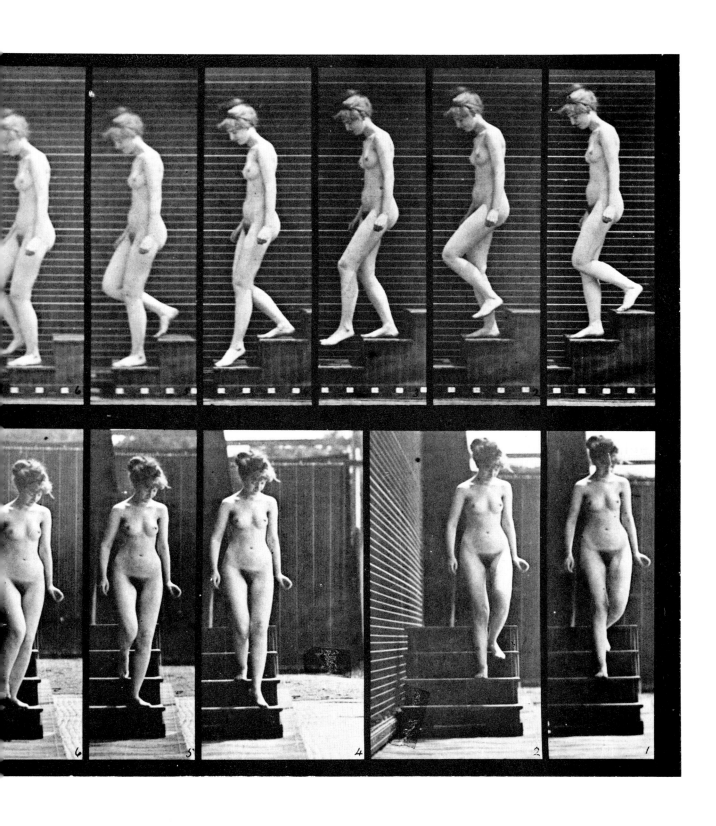

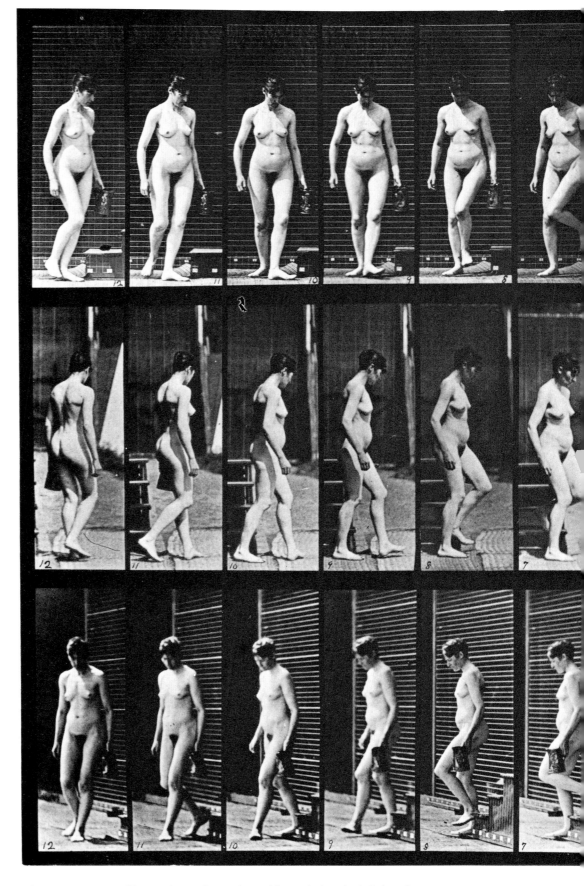

Plate 138. Descending stairs and turning with a pitcher in left hand.

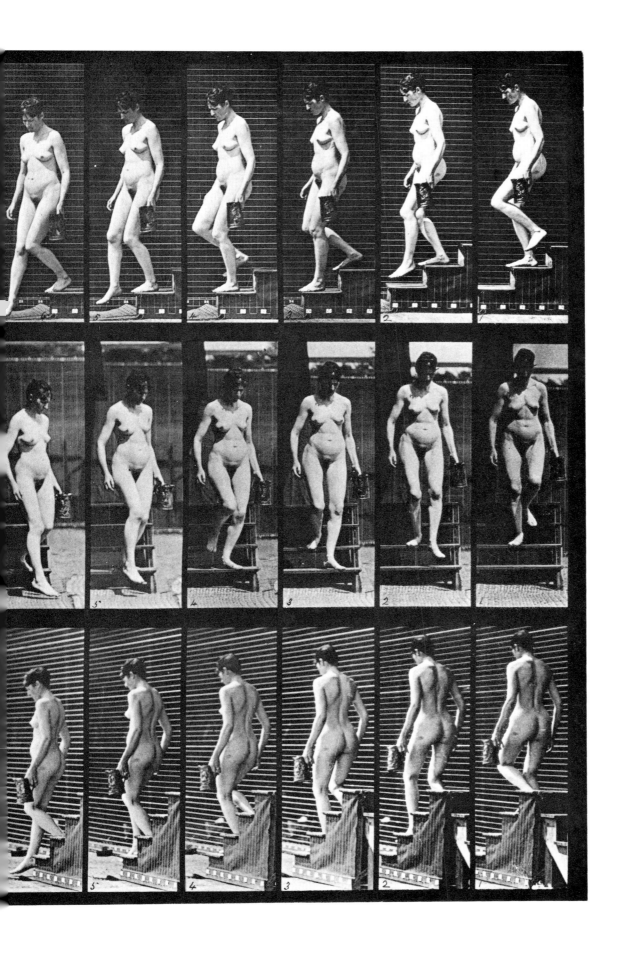

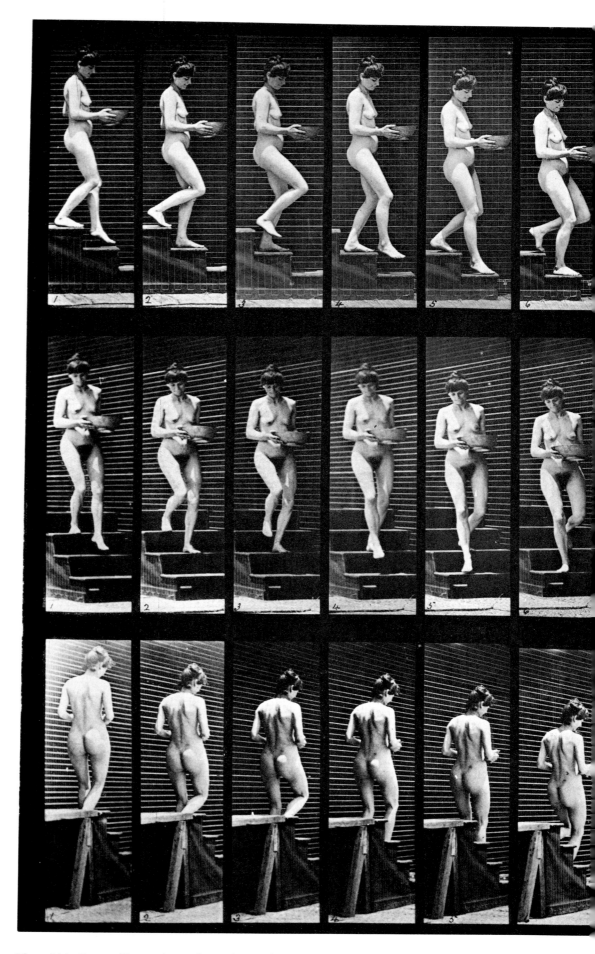

Plate 144. Descending stairs and turning with a basin in hands.

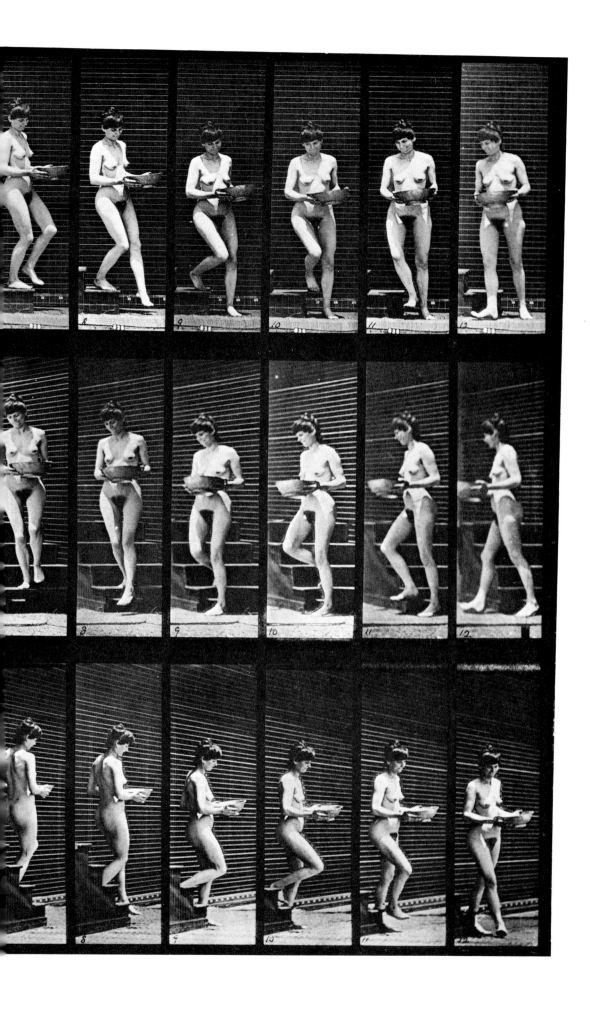

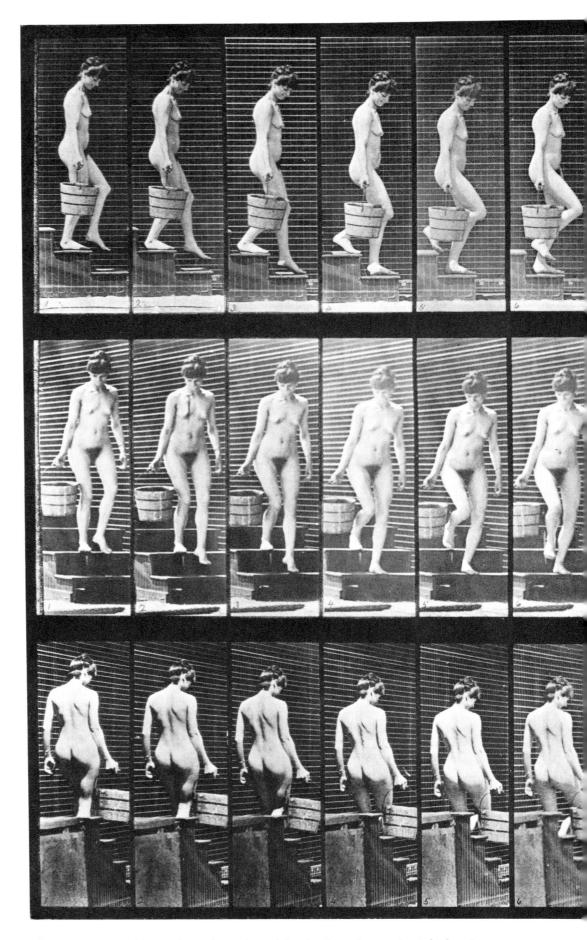

Plate 145. Descending stairs and turning with a bucket of water in right hand.

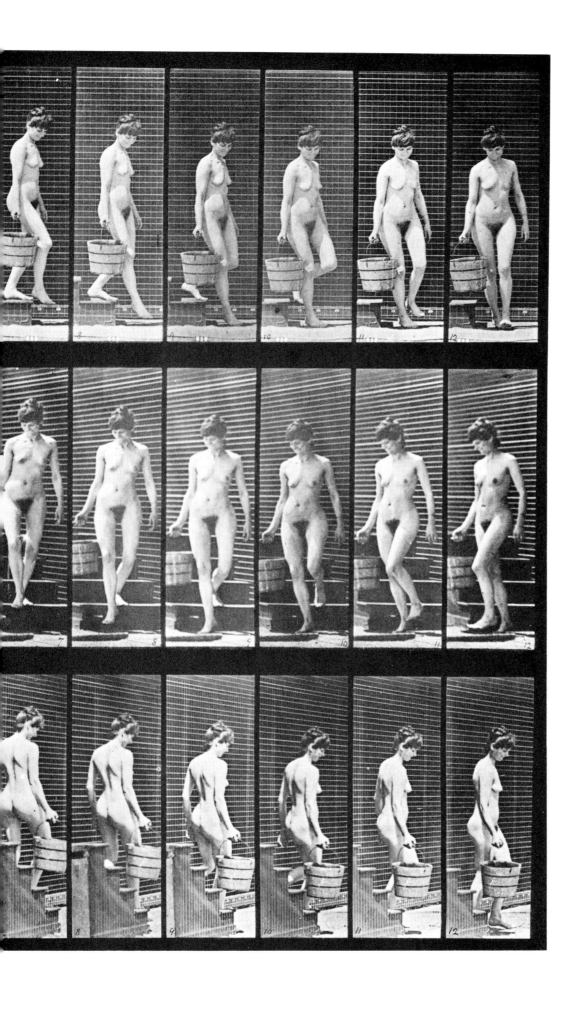

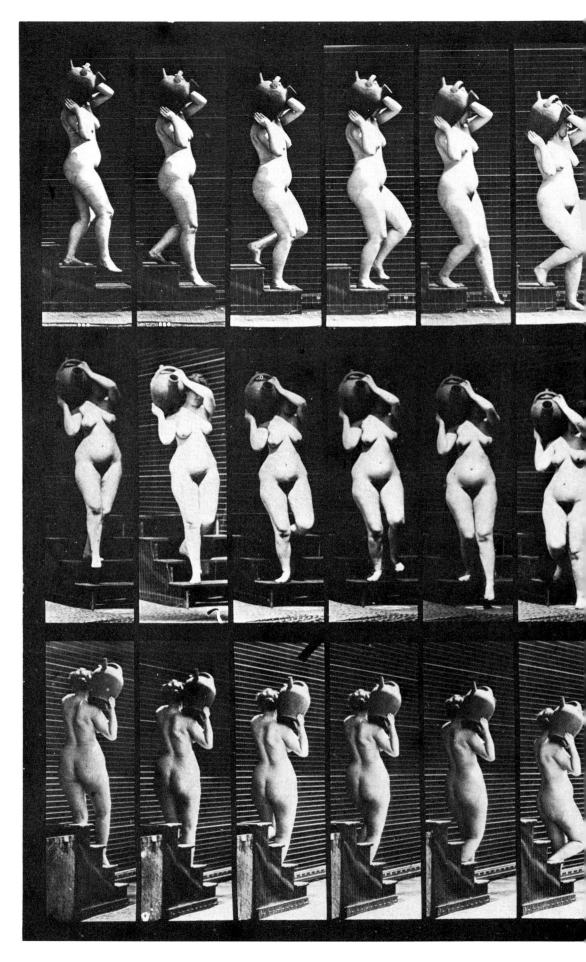

Plate 147. Descending stairs and turning with a water jar on right shoulder.

414 FEMALES (NUDE)

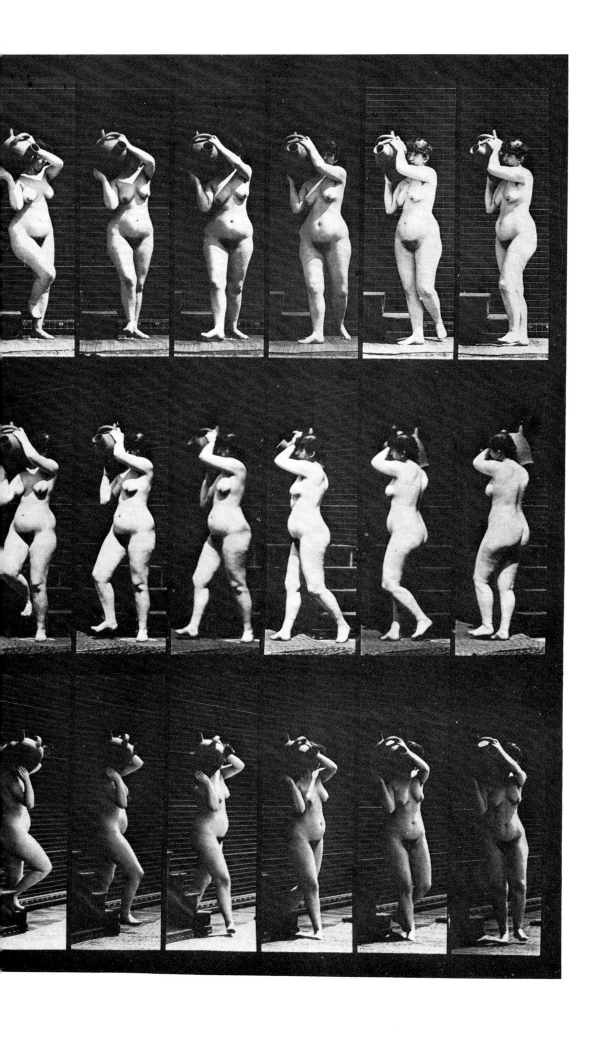

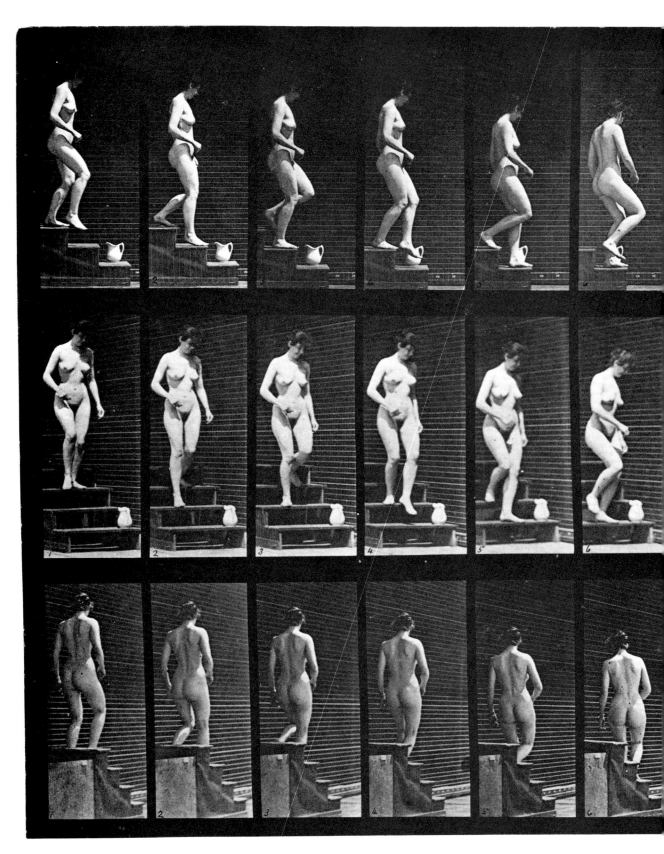

Plate 149. Descending stairs and stooping to lift a pitcher.

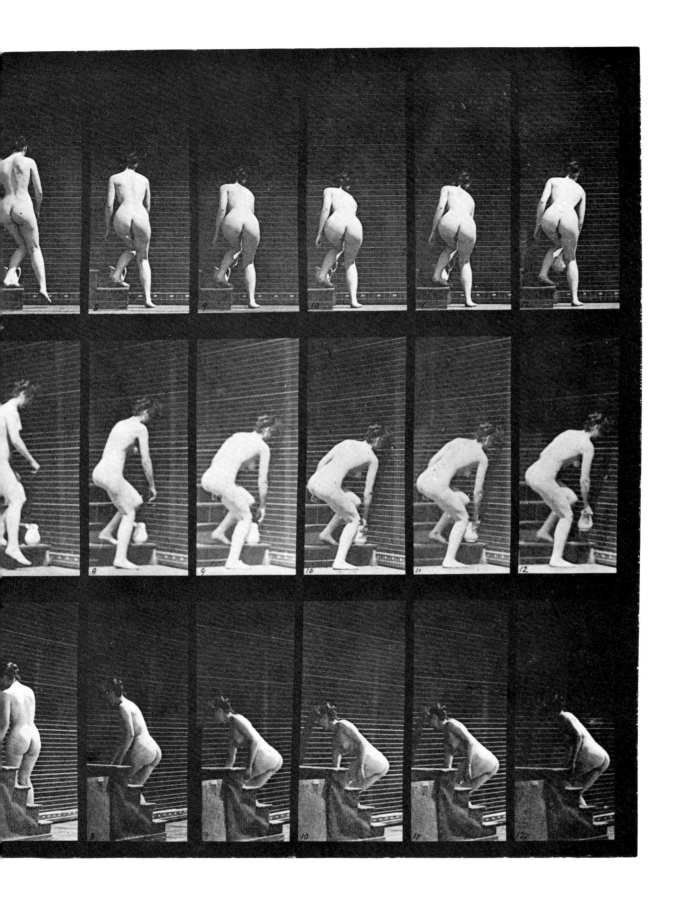

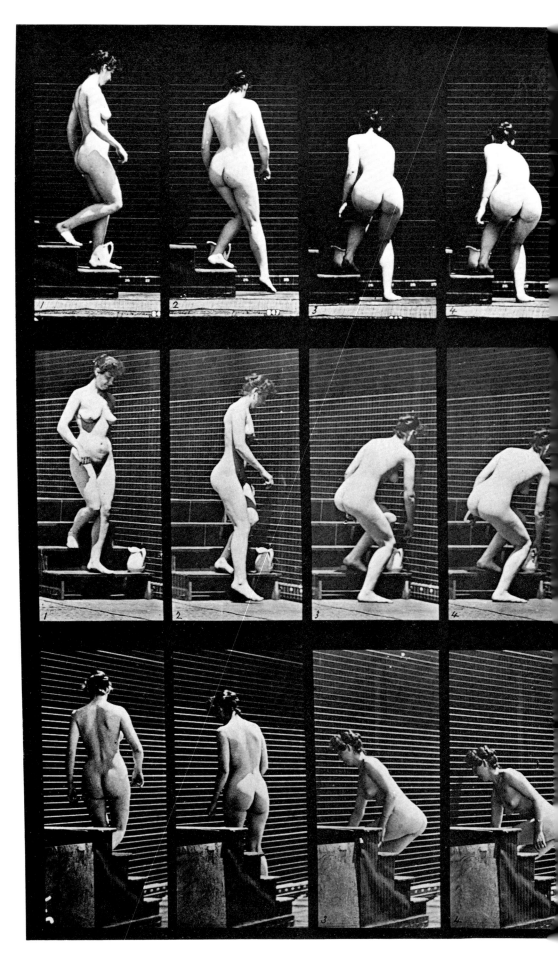

Plate 150. Descending stairs, stooping, lifting a pitcher and turning.

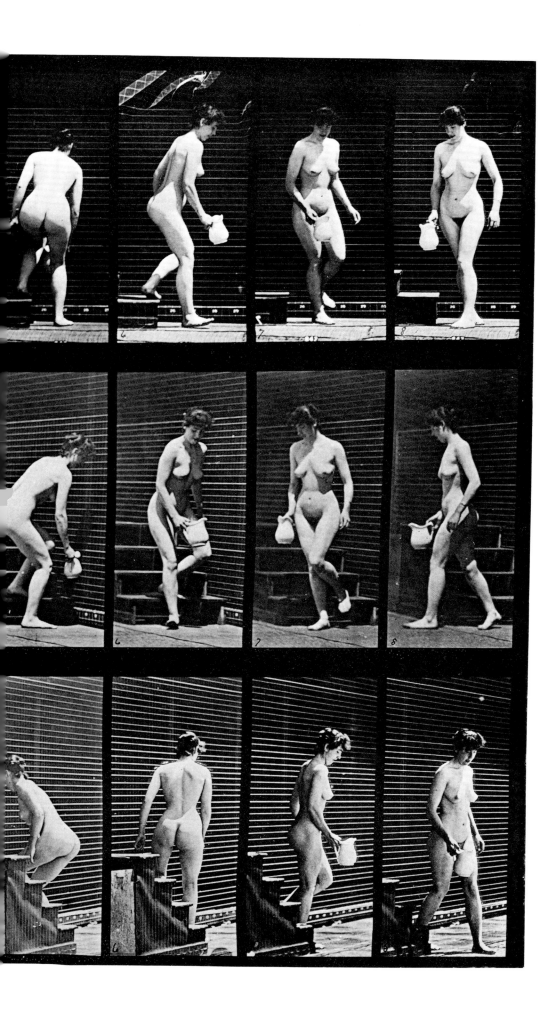

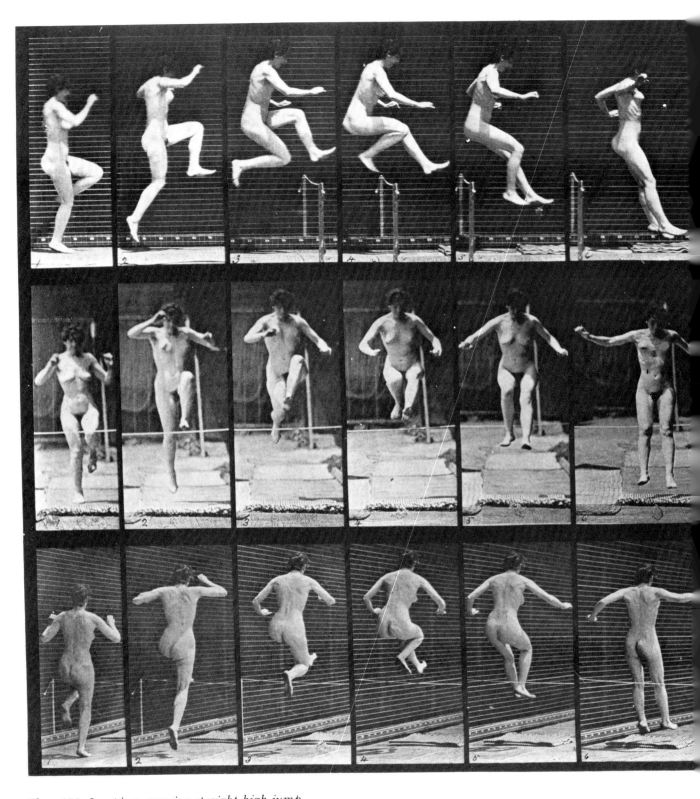

Plate 155. Jumping, running straight high jump.

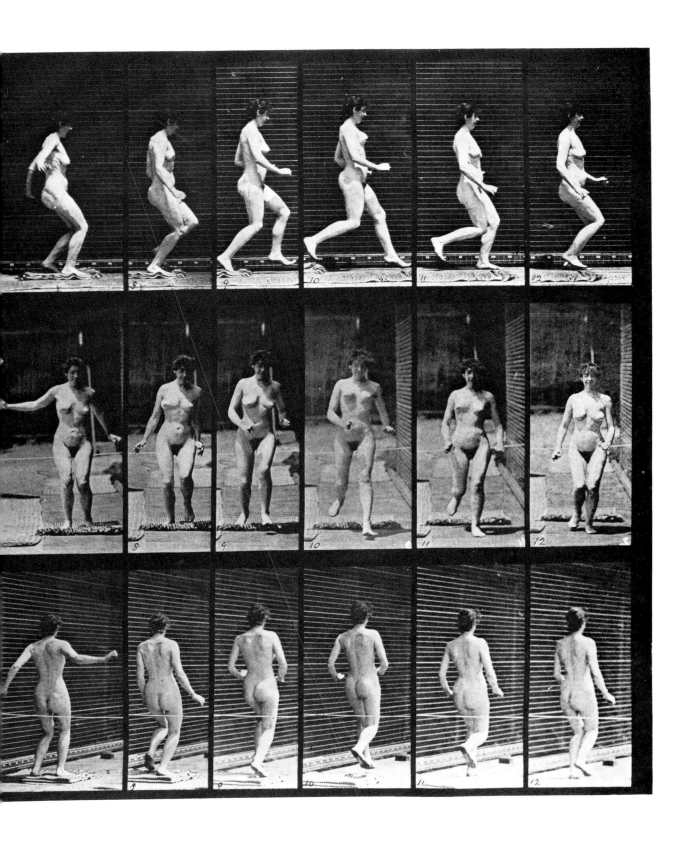

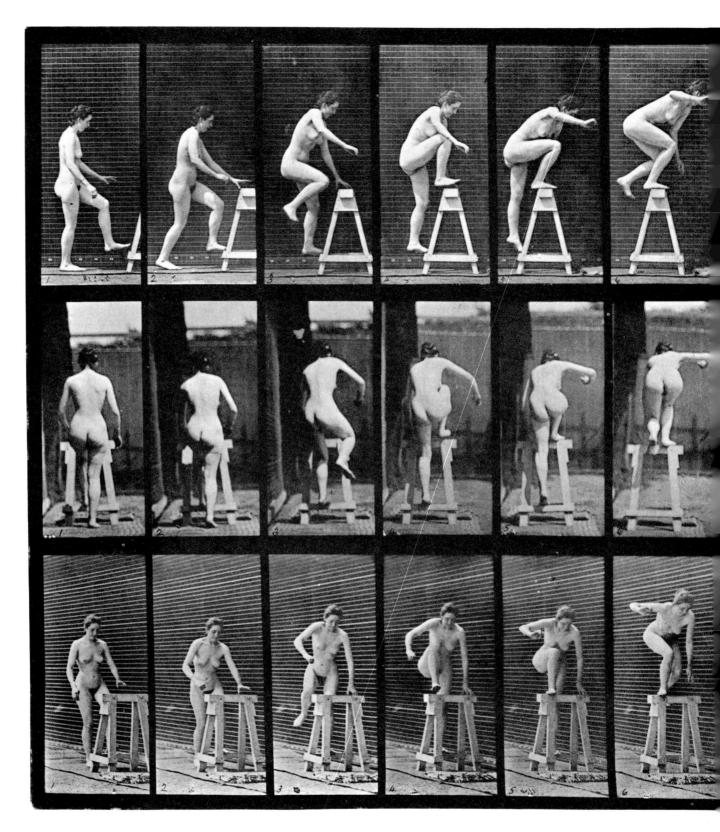

Plate 171. Stepping up on a trestle, jumping down and turning.

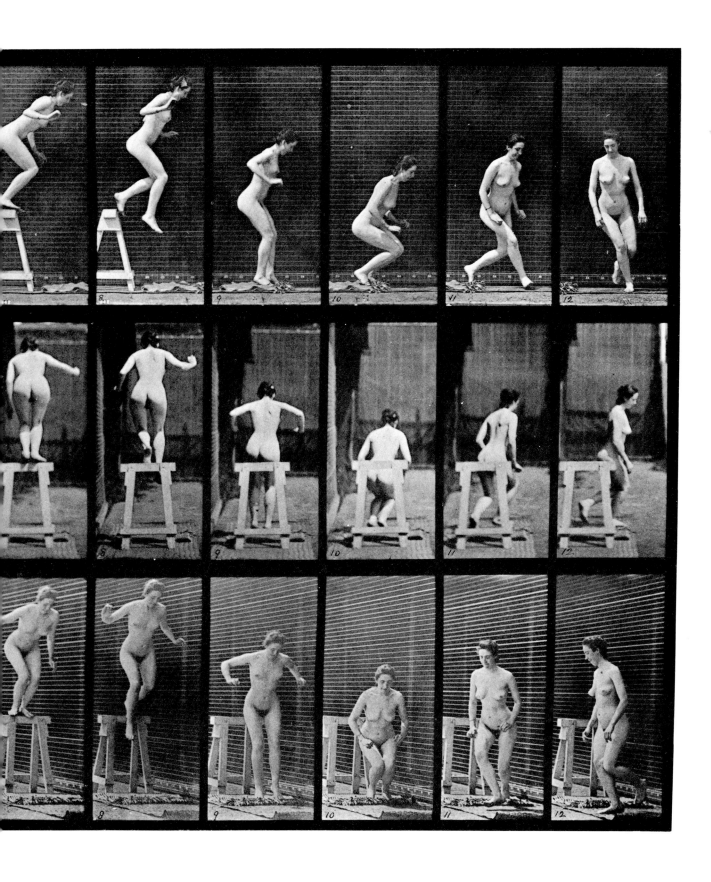

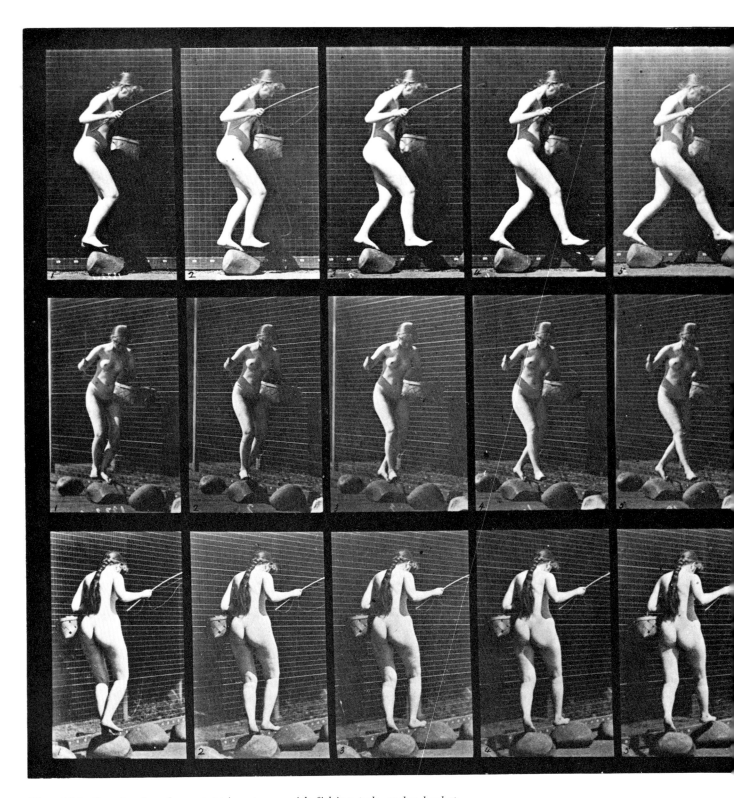

Plate 176. Crossing brook on stepping-stones with fishing pole and a basket.

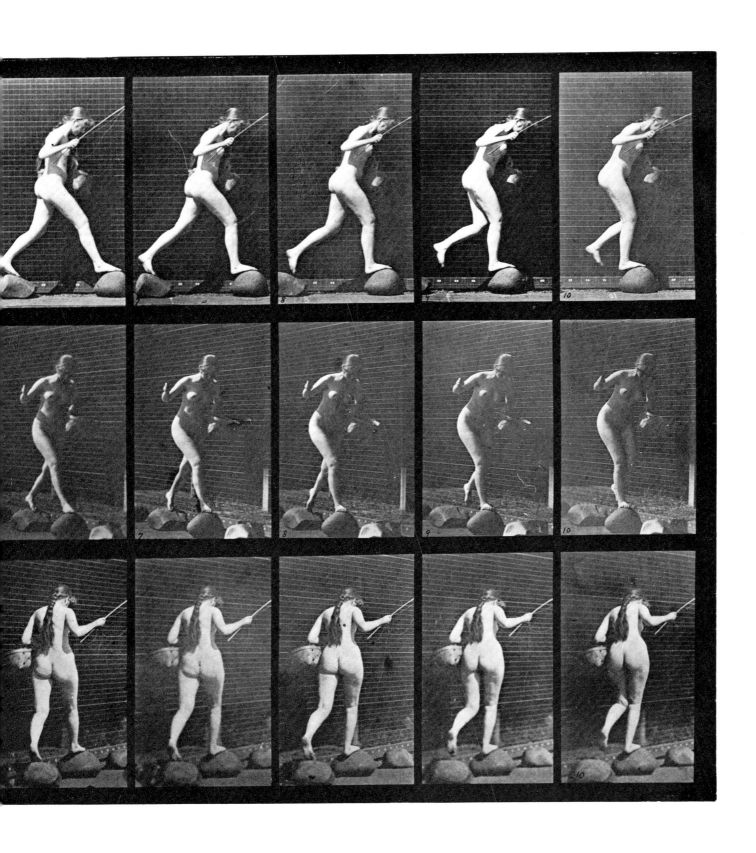

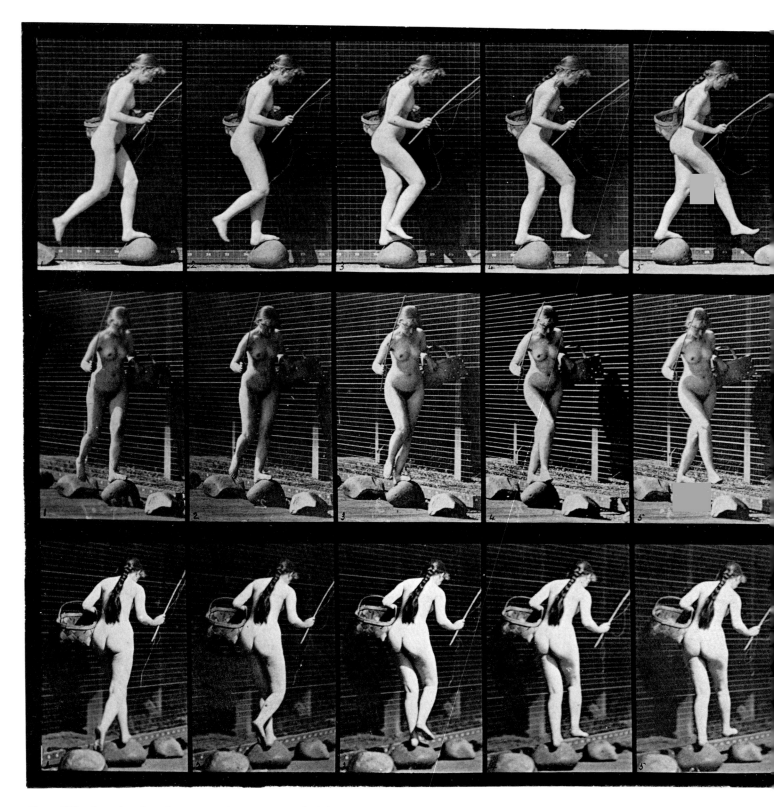

Plate 177. Crossing brook on stepping-stones with fishing pole and a basket.

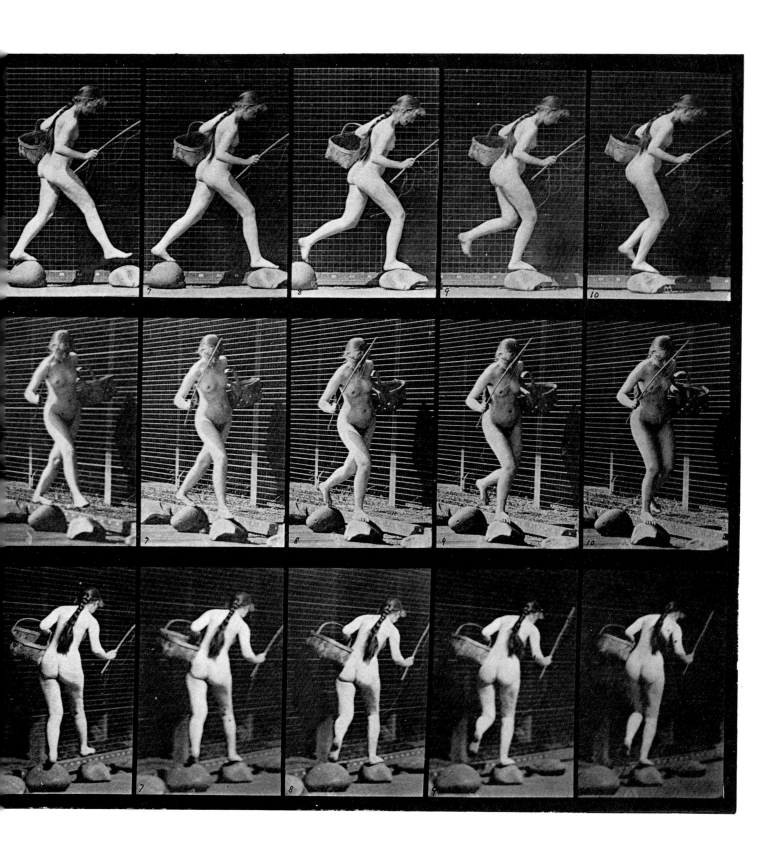

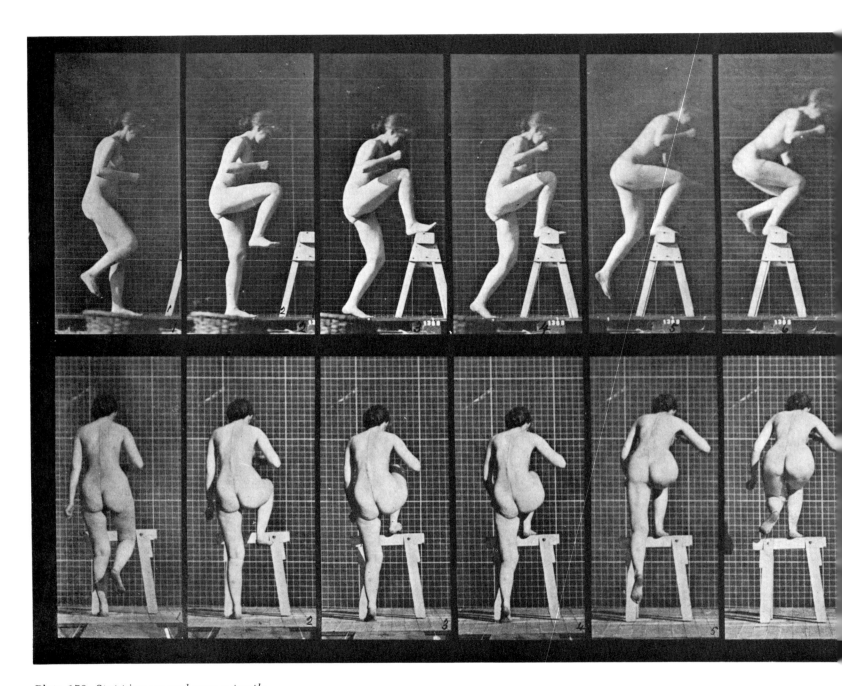

Plate 178. Stepping on and over a trestle.

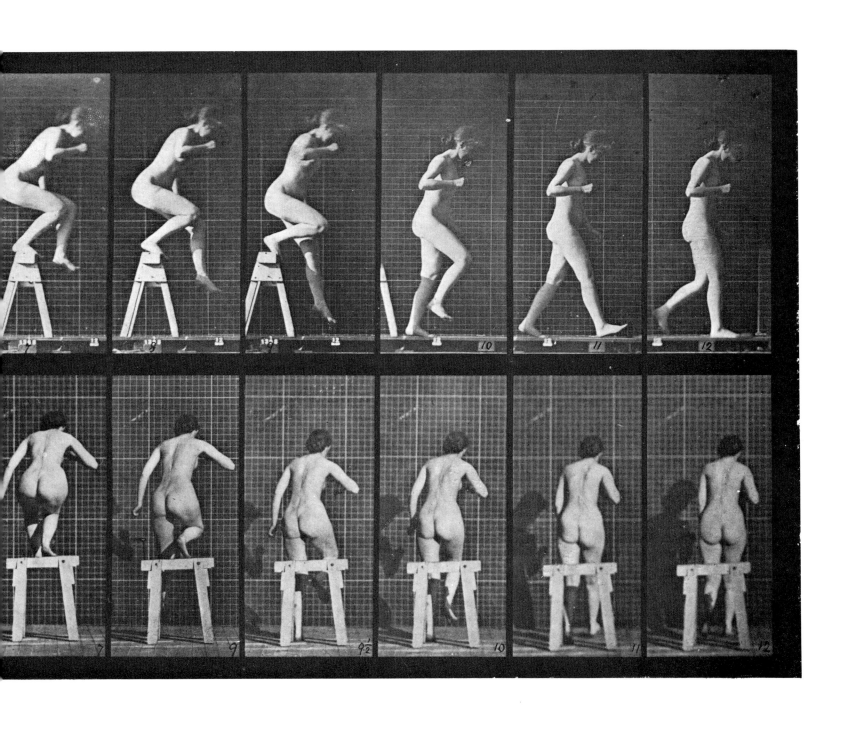

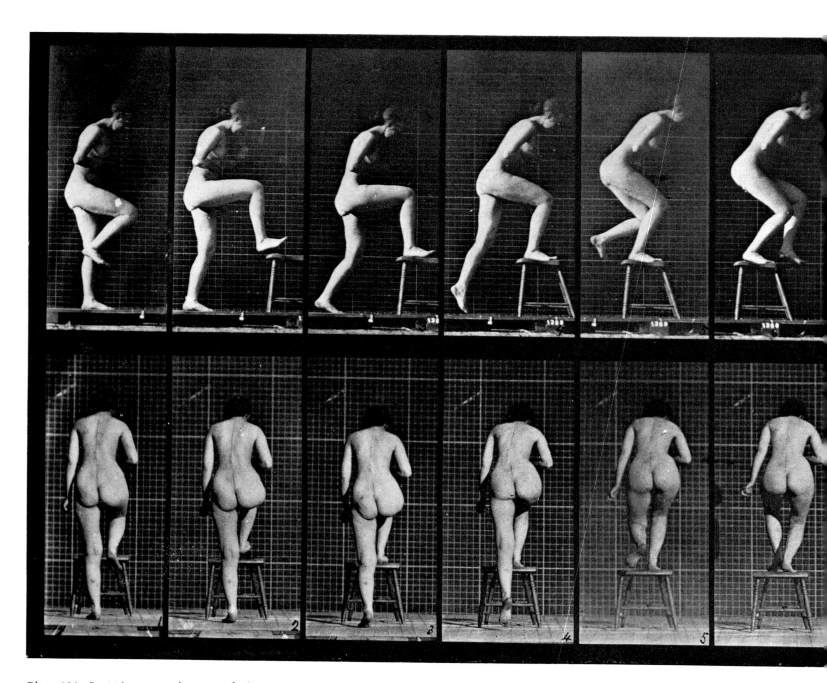

Plate 180. Stepping on and over a chair.

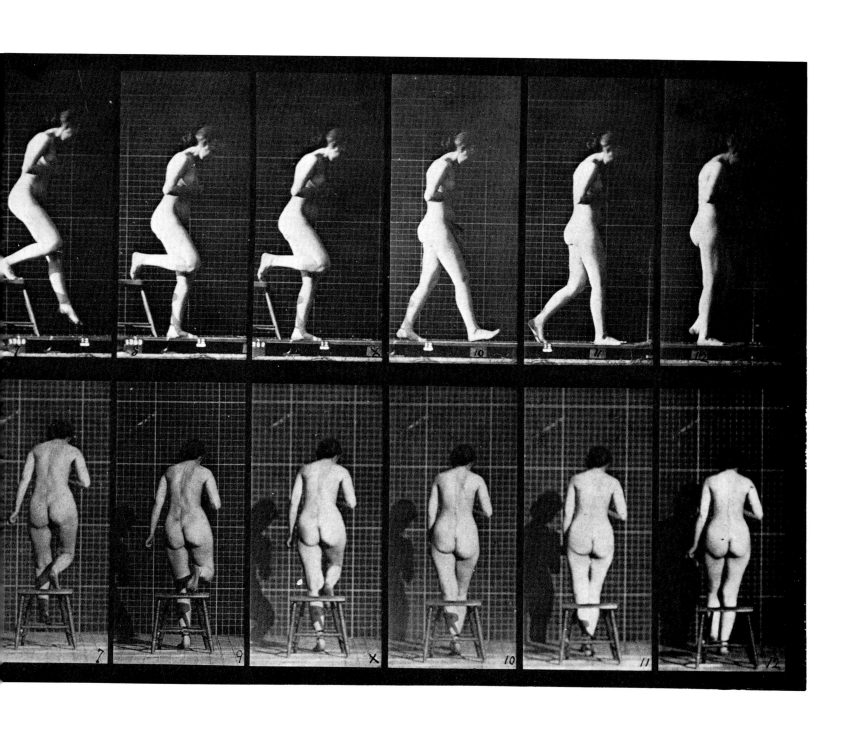

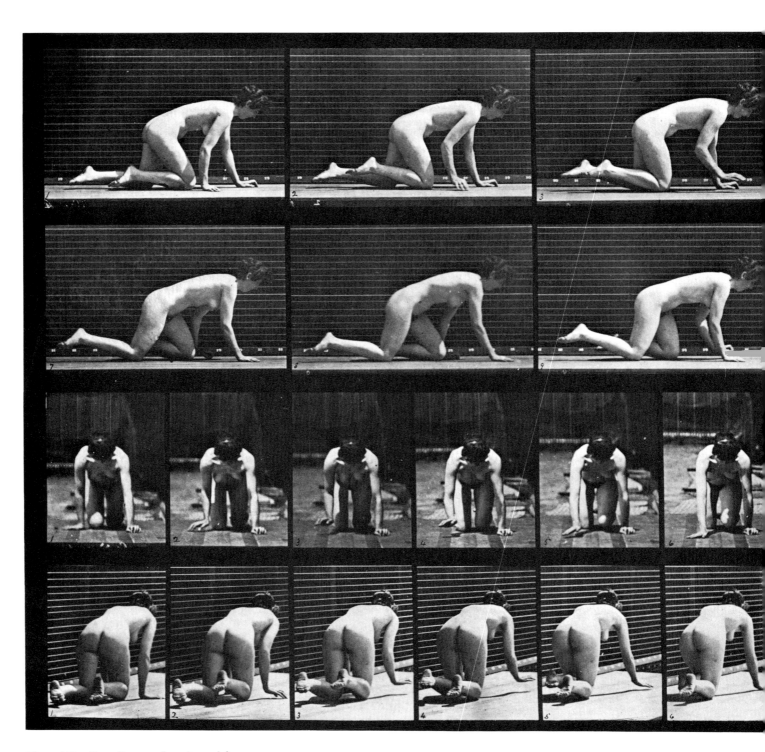

Plate 182. Crawling on hands and knees.

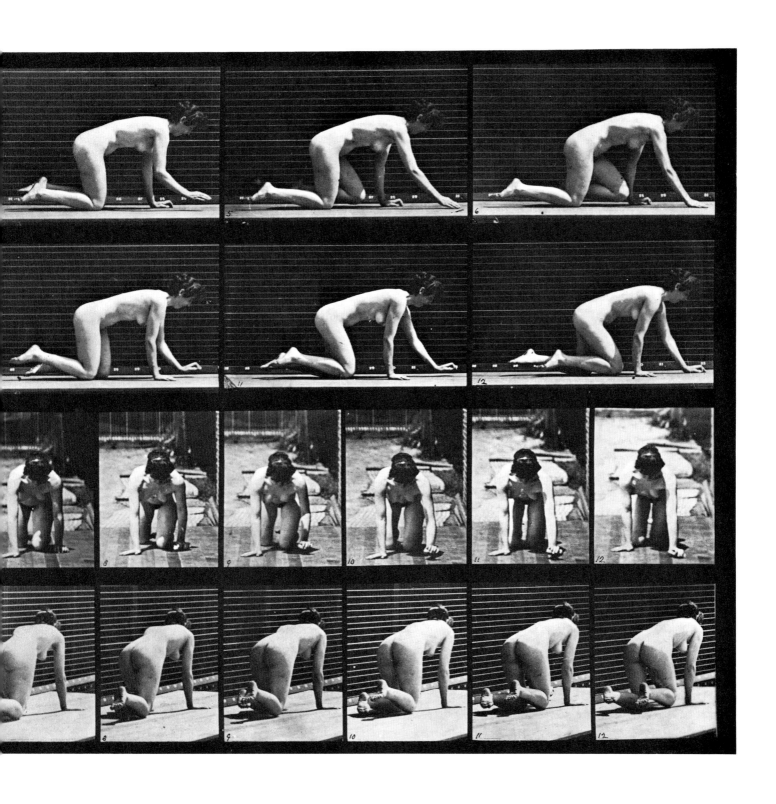

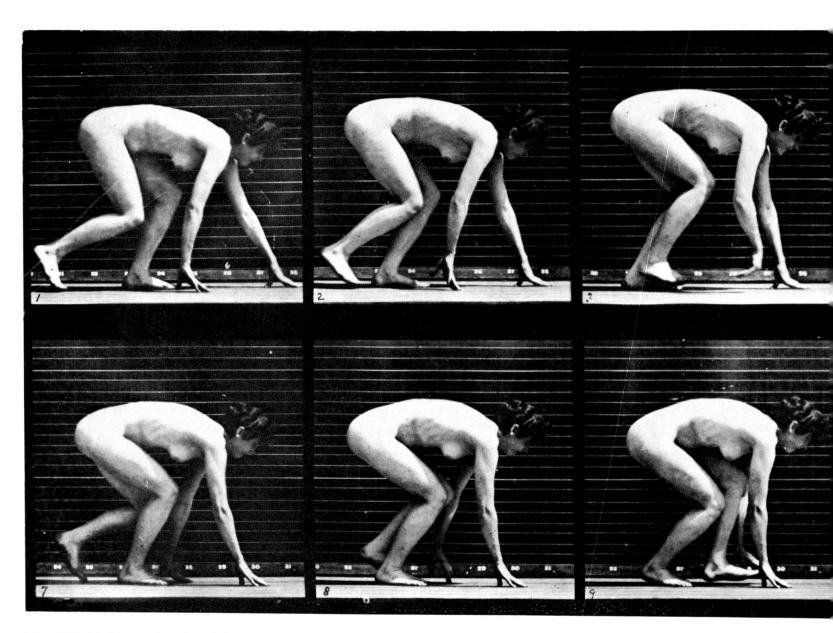

Plate 183. Walking on hands and feet.

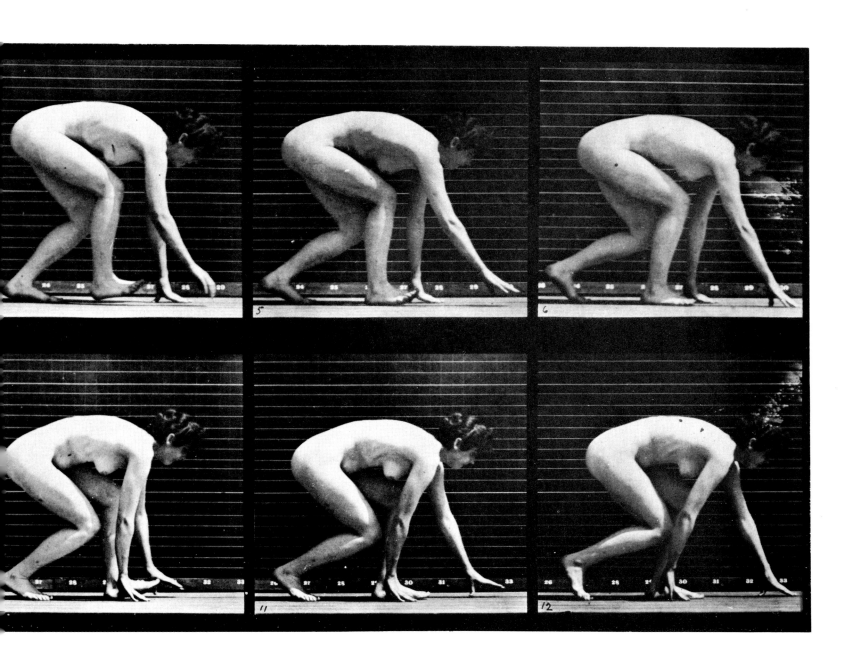

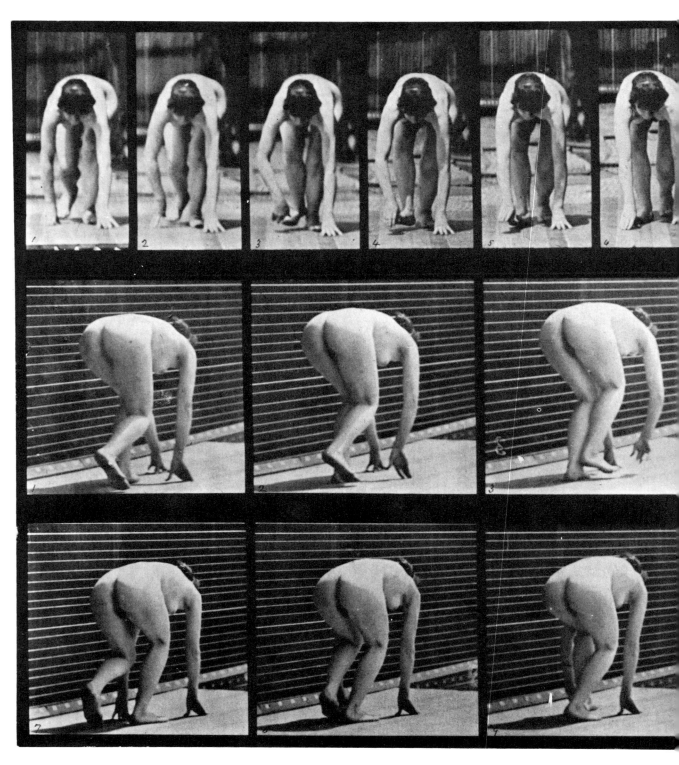

Plate 184. Walking on hands and feet.

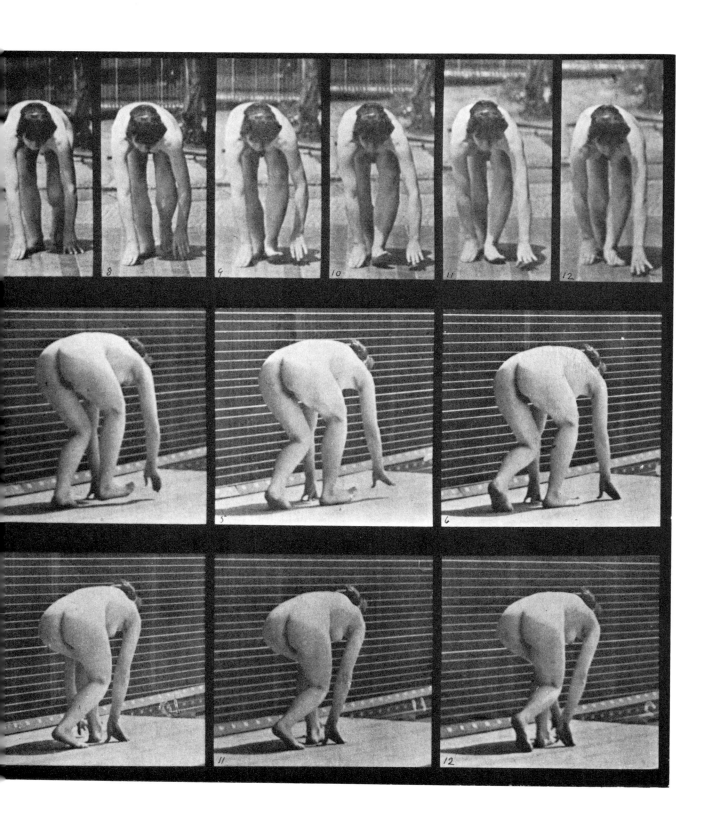

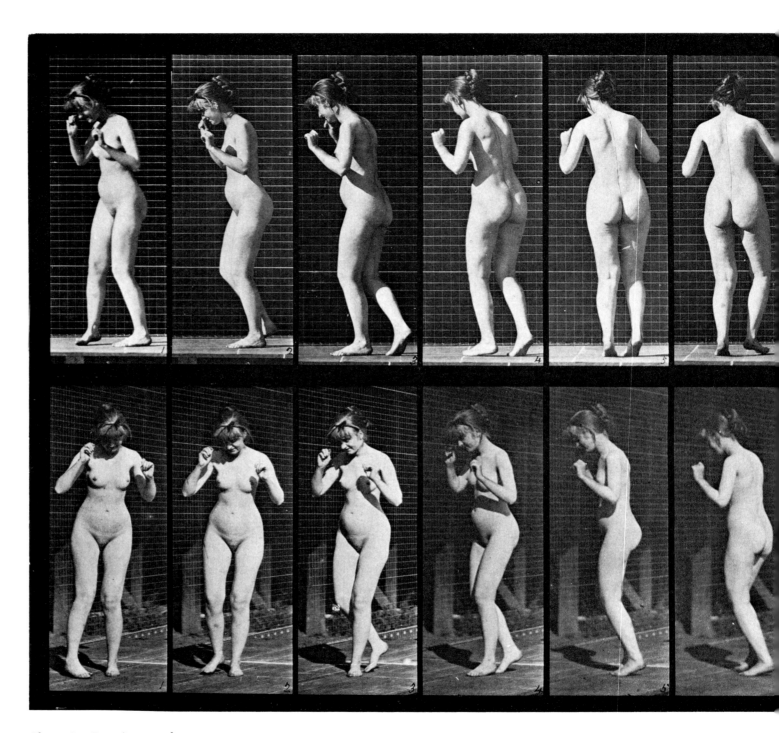

Plate 195. Dancing a waltz.

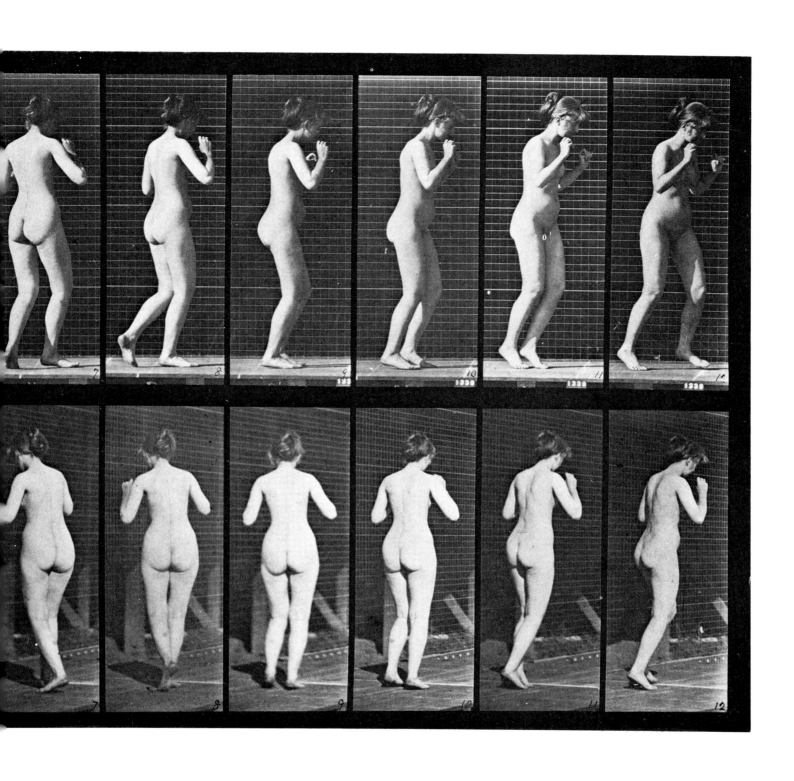

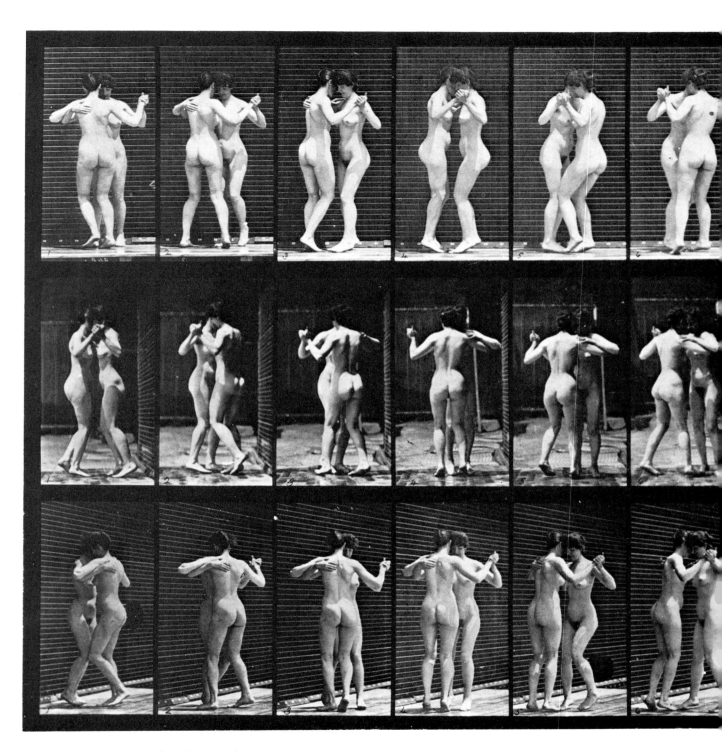

Plate 196. Two women dancing a waltz.

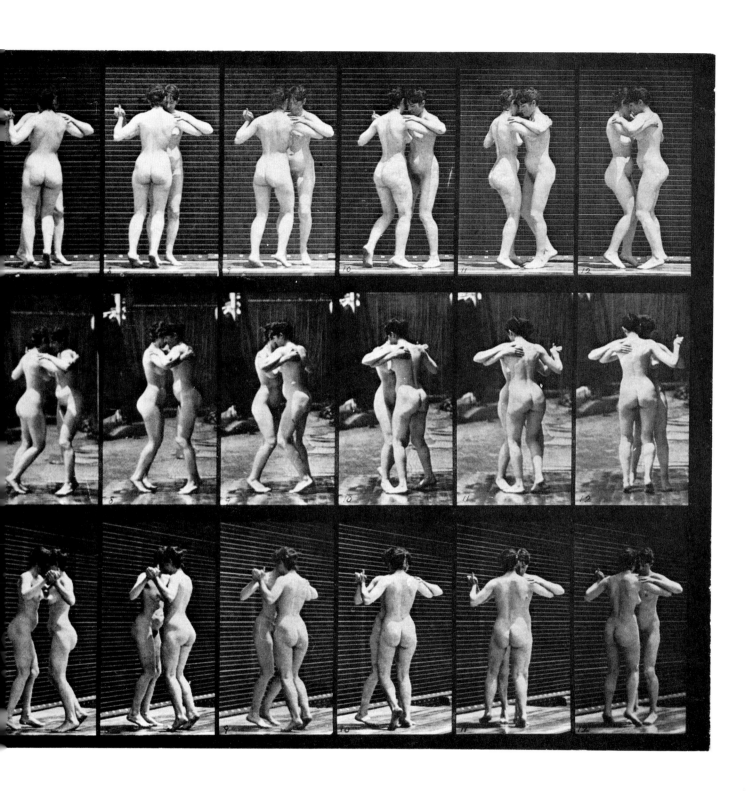

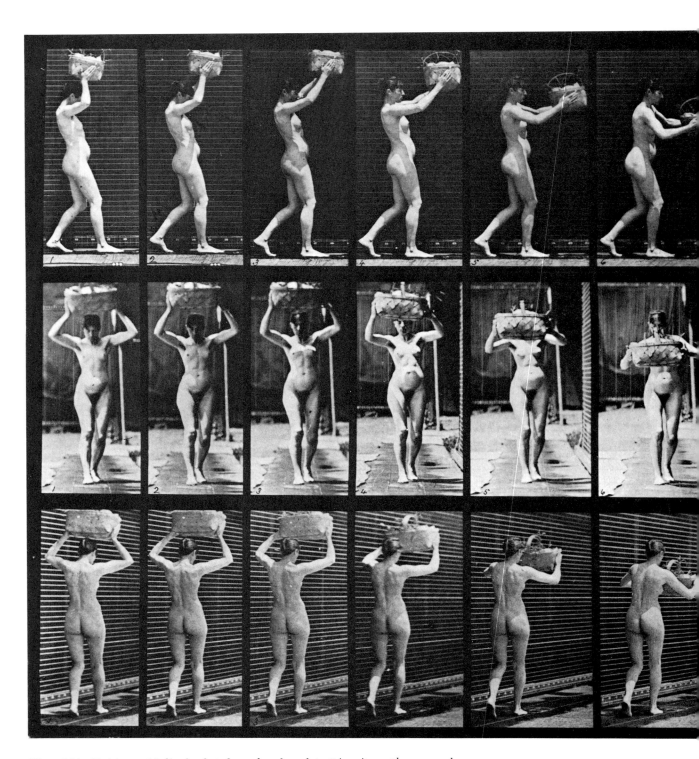

Plate 201. Taking a 12-lb. basket from head and putting it on the ground.

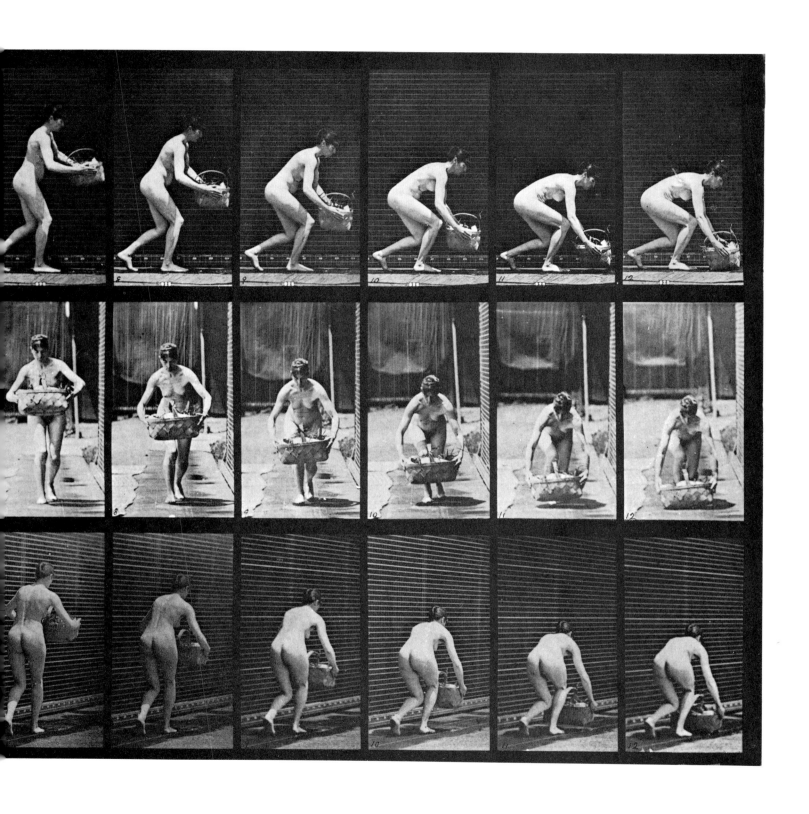

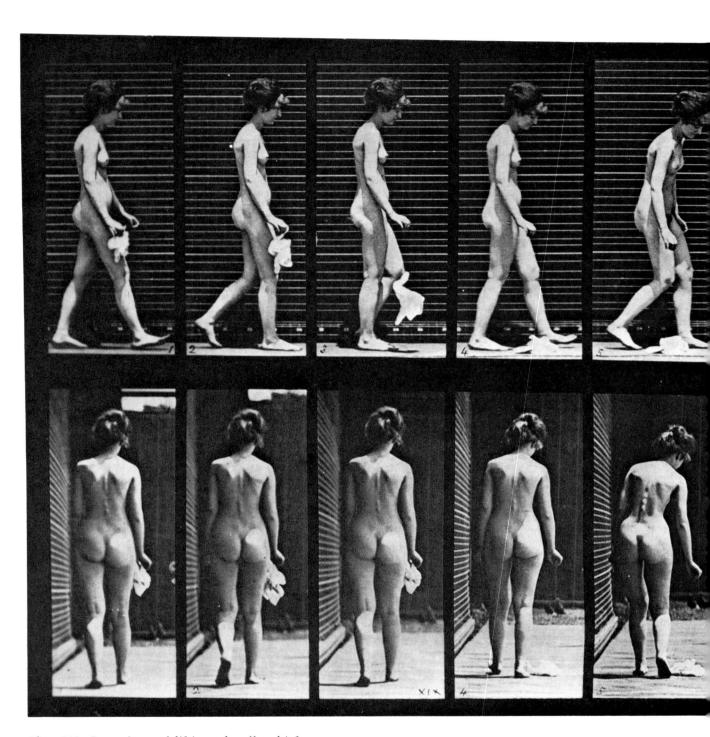

Plate 202. Dropping and lifting a handkerchief.

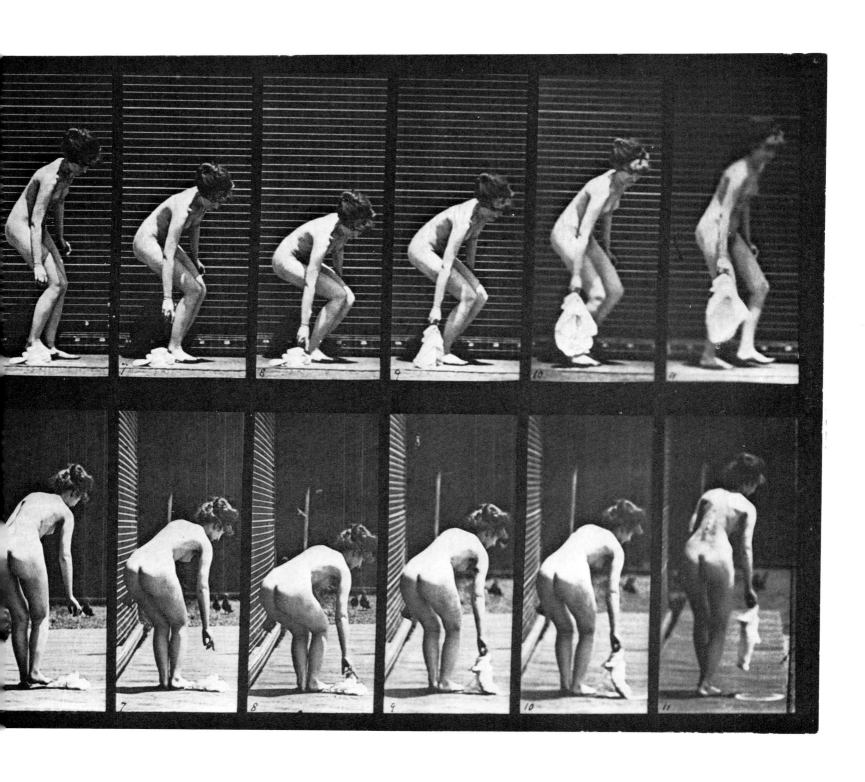

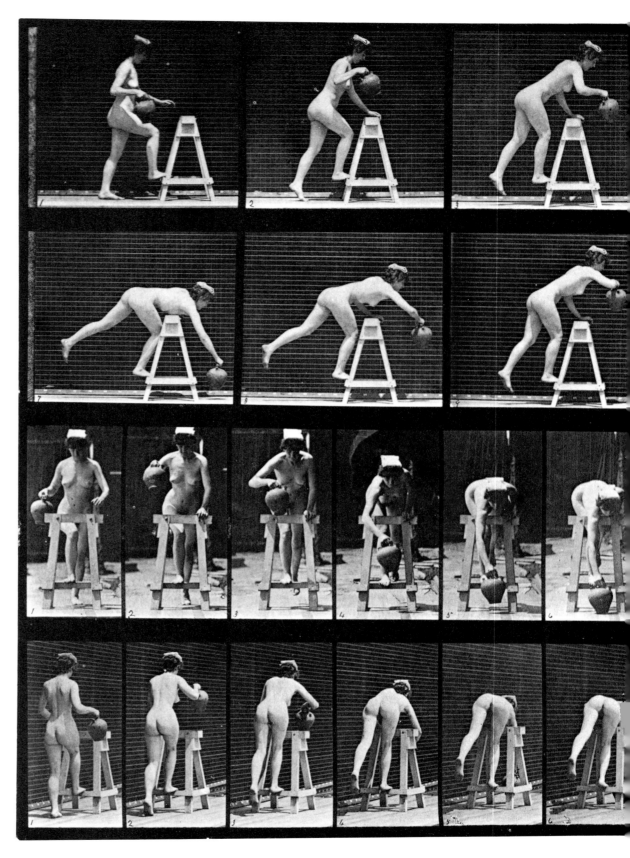

Plate 203. Bending over a trestle with a water jar.

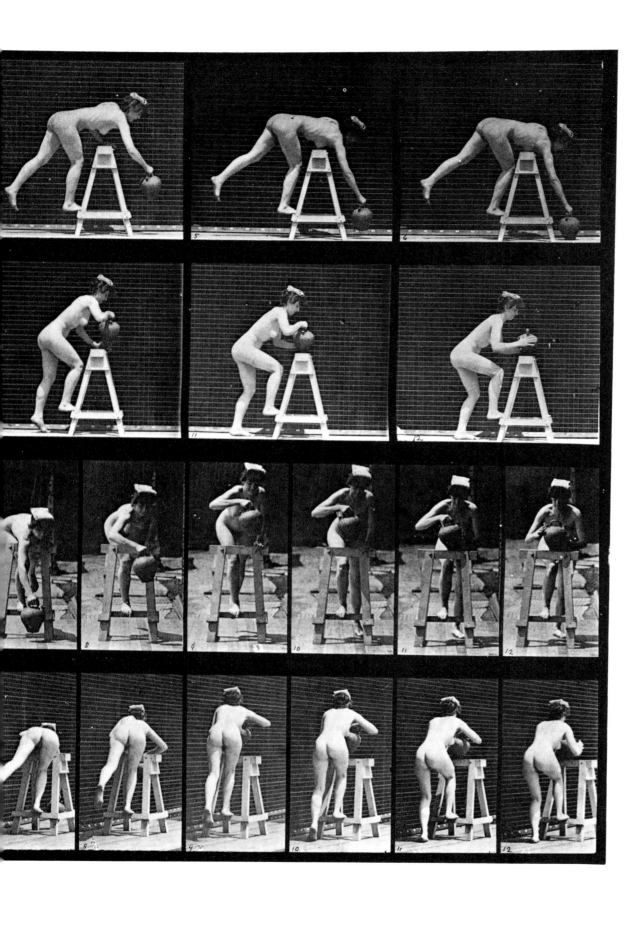

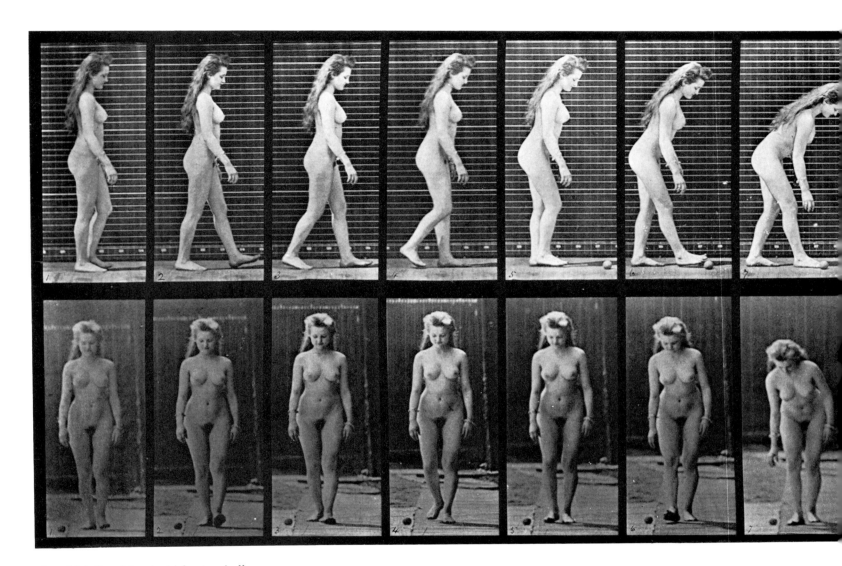

Plate 204. Stooping to pick up a ball.

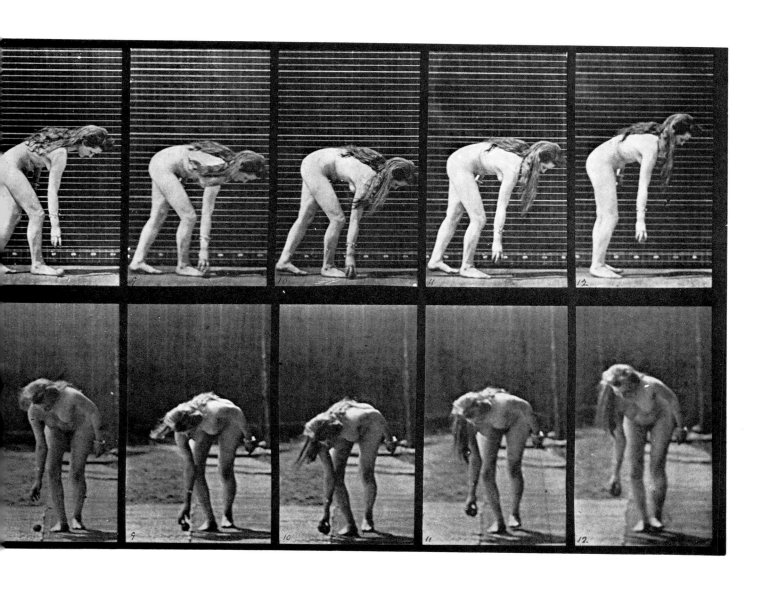

Volume 4

FEMALES
(Nude); continued

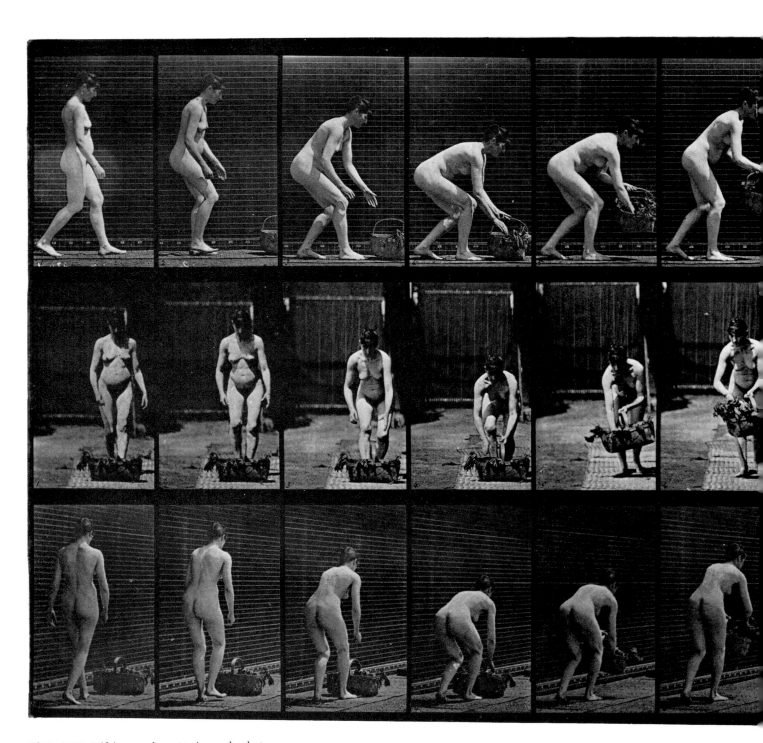

Plate 213. Lifting and emptying a basket.

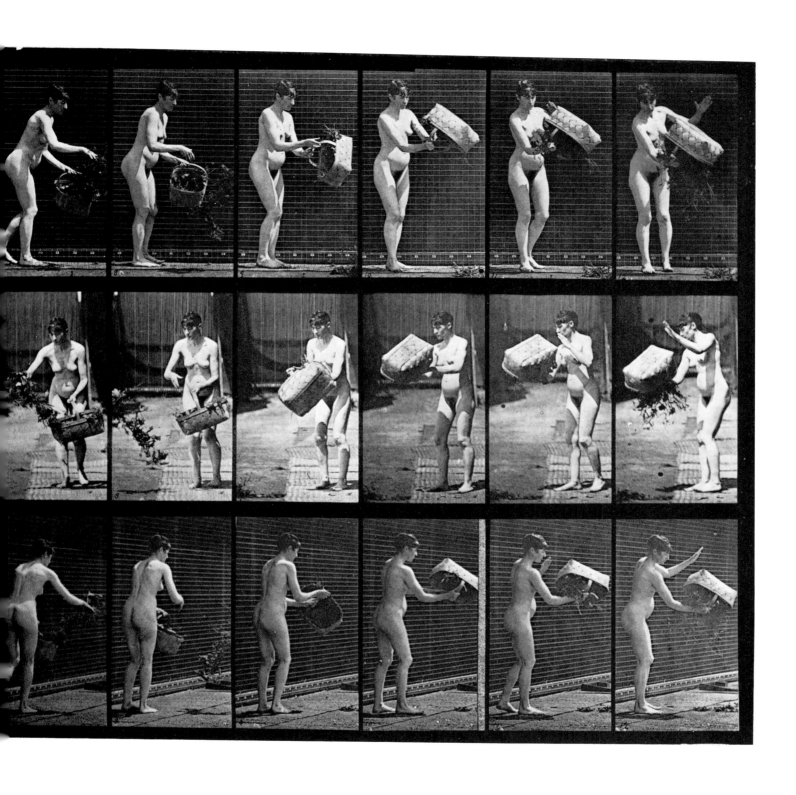

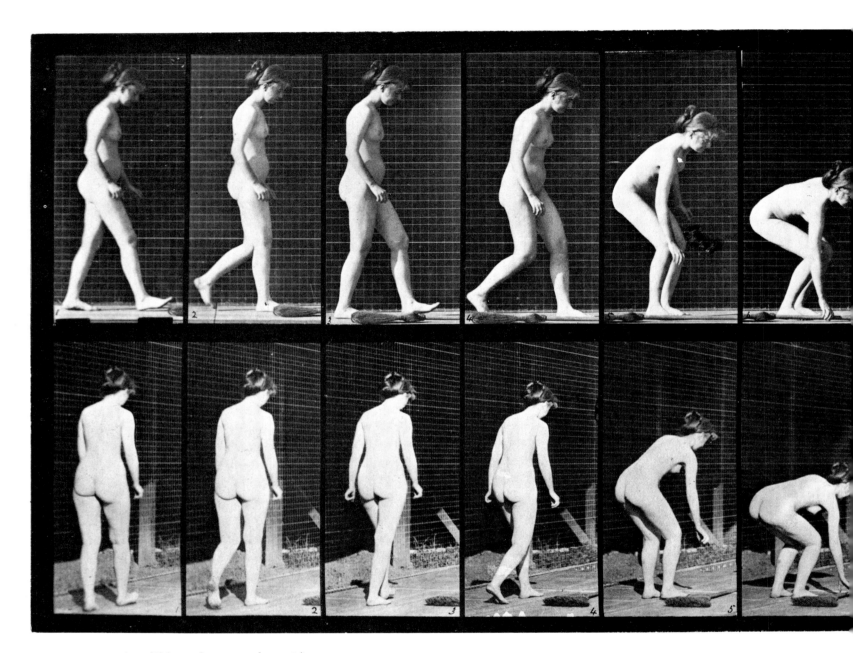

Plate 219. Stooping, lifting a broom and sweeping.

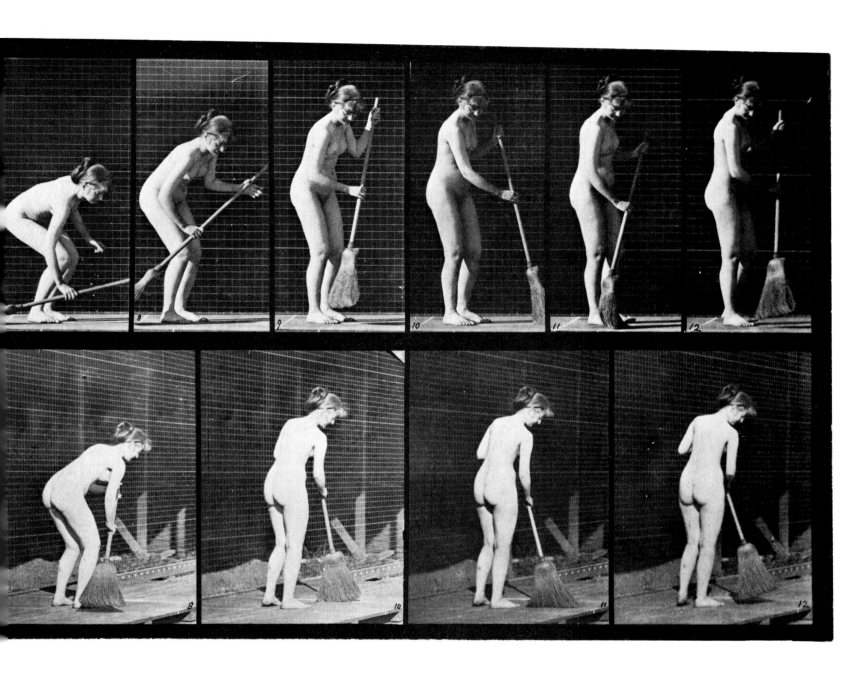

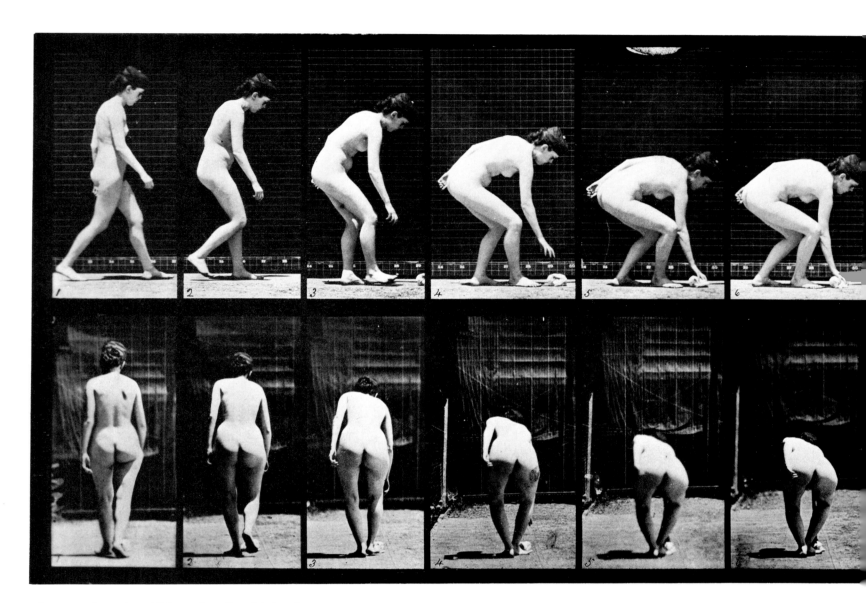

Plate 220. Stooping, lifting a handkerchief and turning.

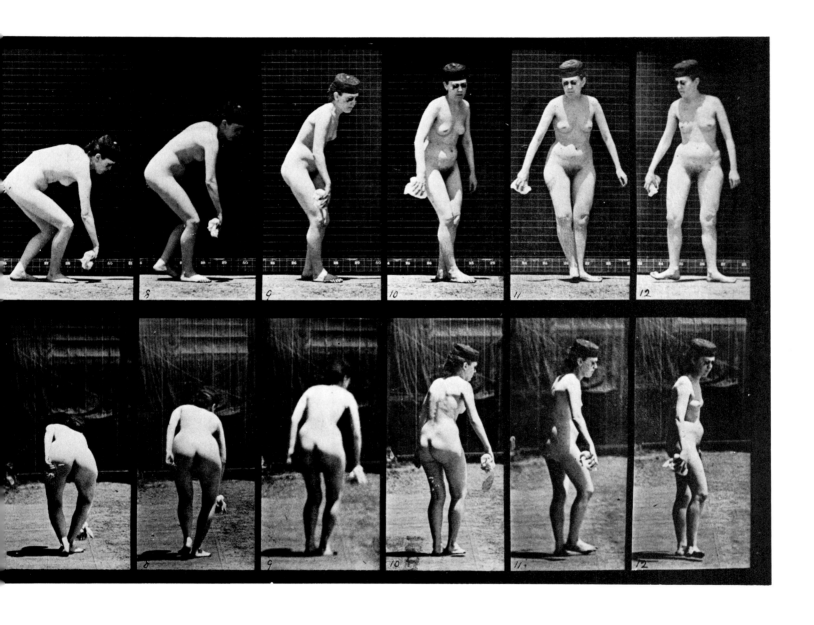

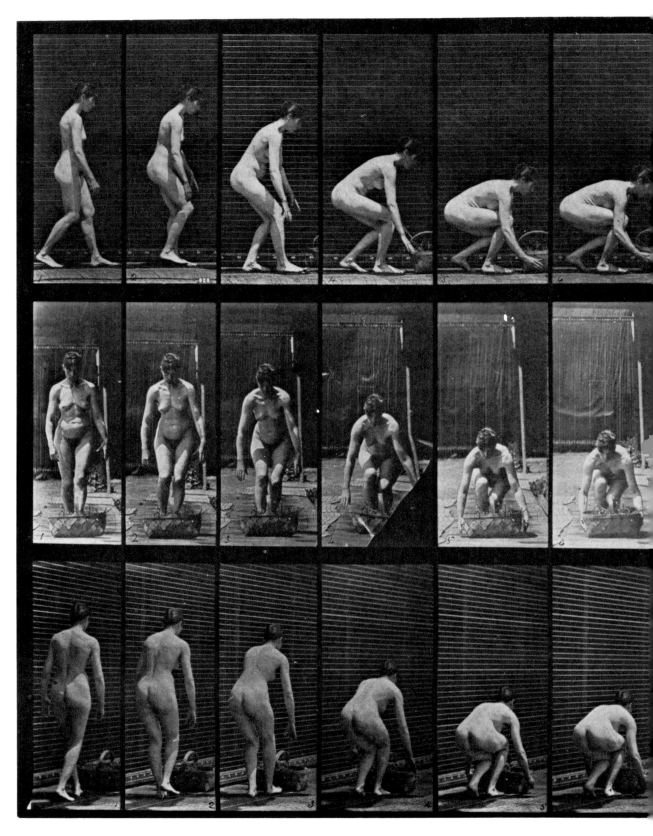

Plate 221. Stooping and lifting a 12-lb. basket to head.

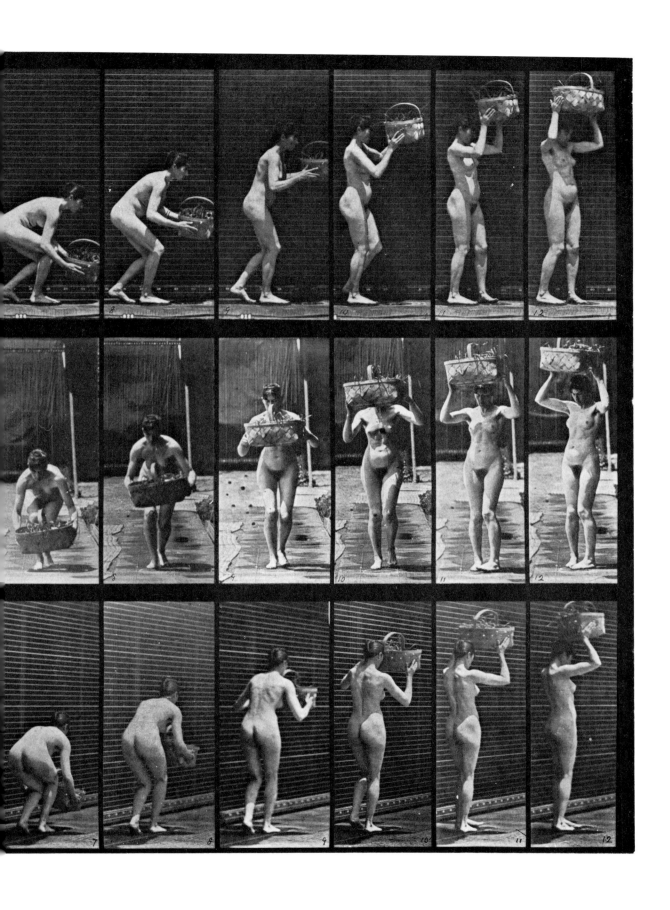

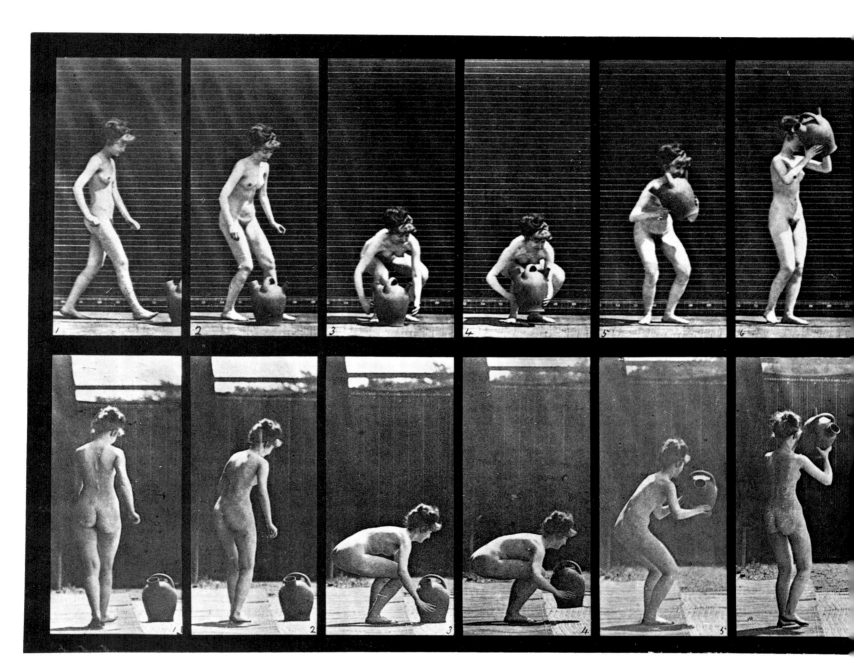

Plate 222. Stooping, lifting a water jar to head and turning.

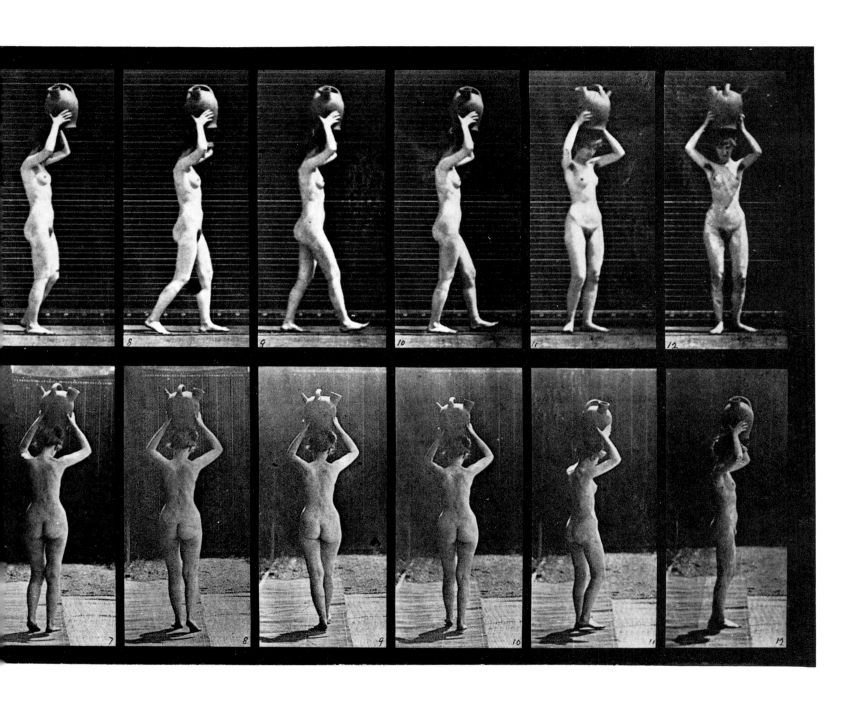

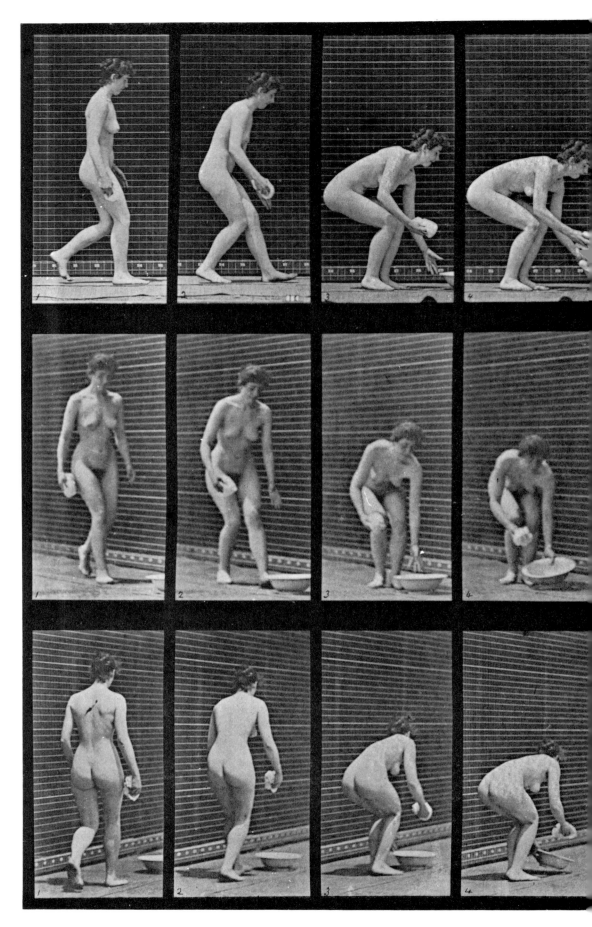

Plate 223. Stooping, lifting a basin, wiping it and turning.

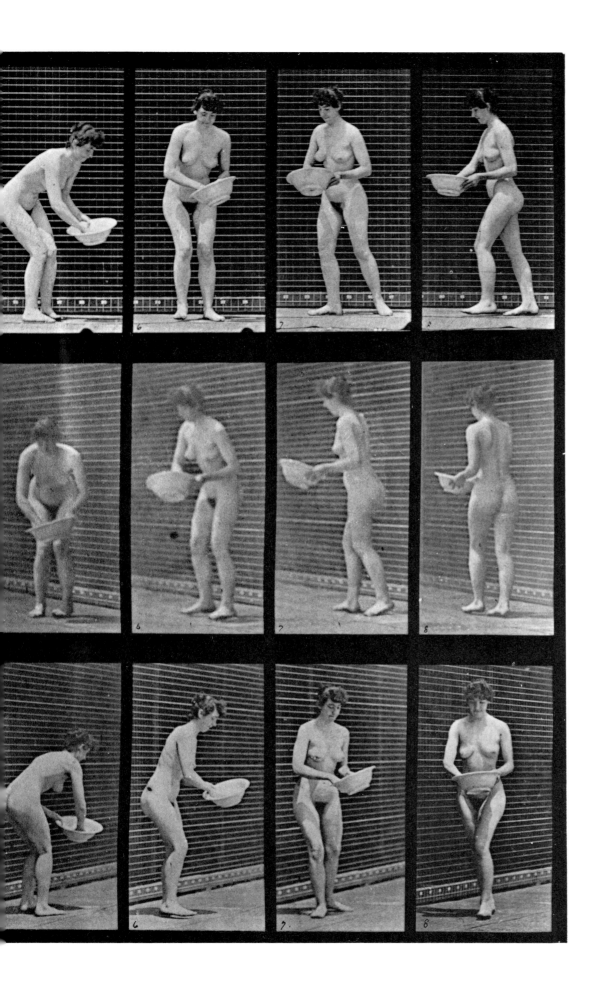

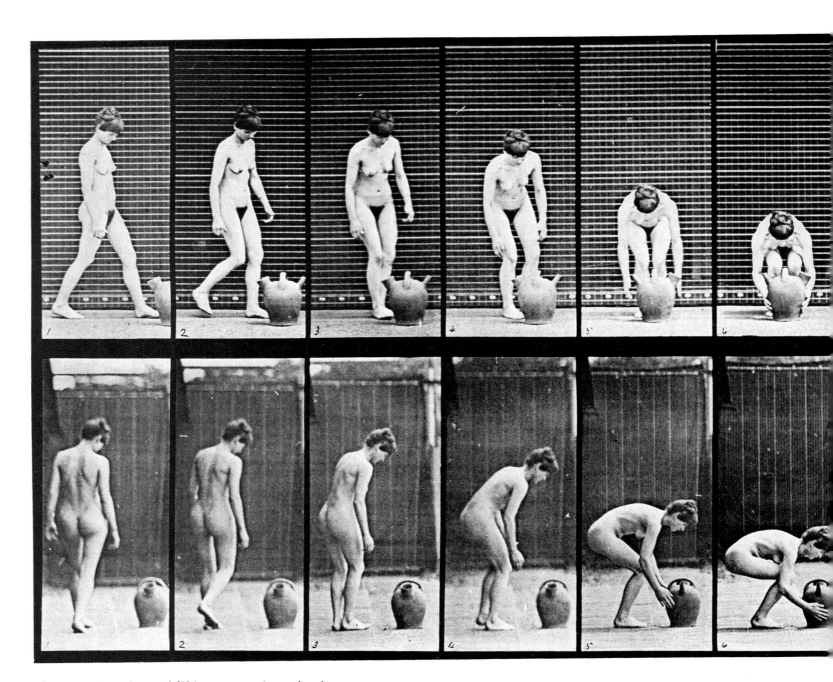

Plate 224. Stooping and lifting a water jar to head.

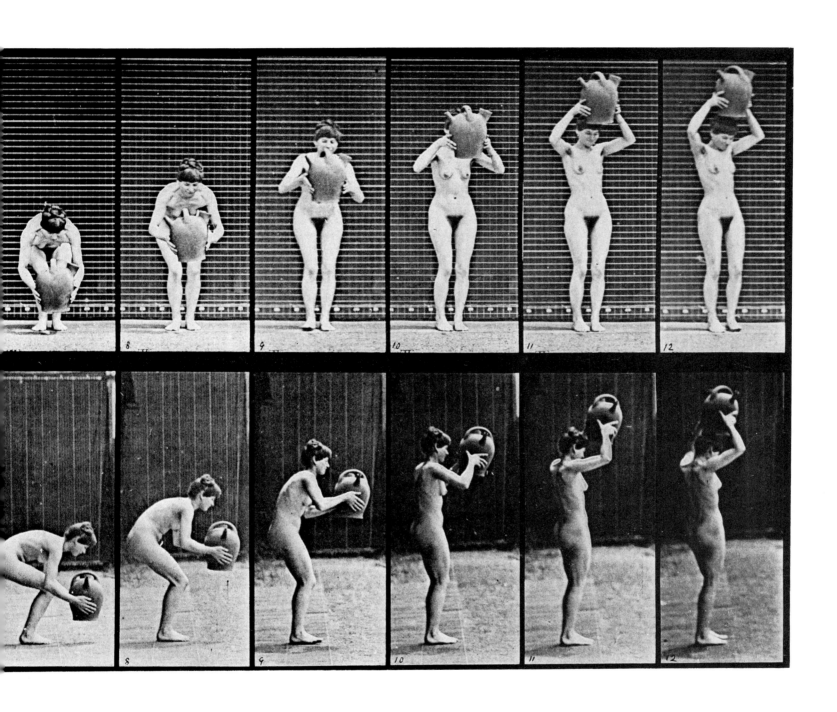

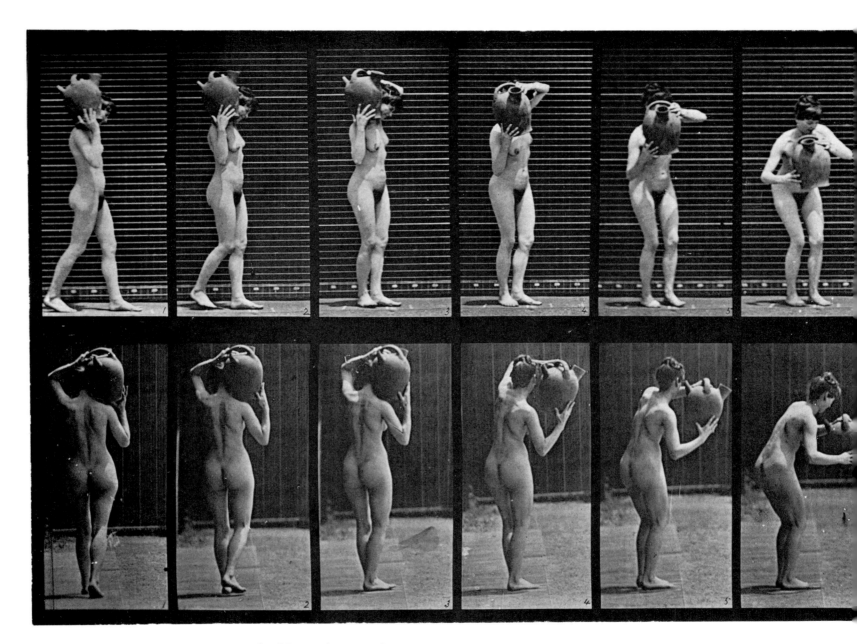

Plate 225. Removing a water jar from shoulder to the ground.

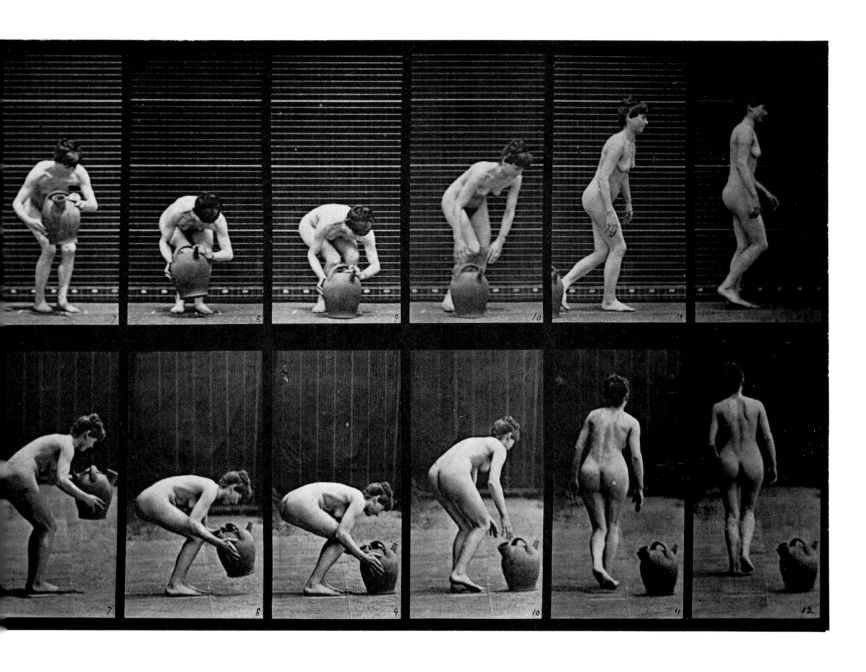

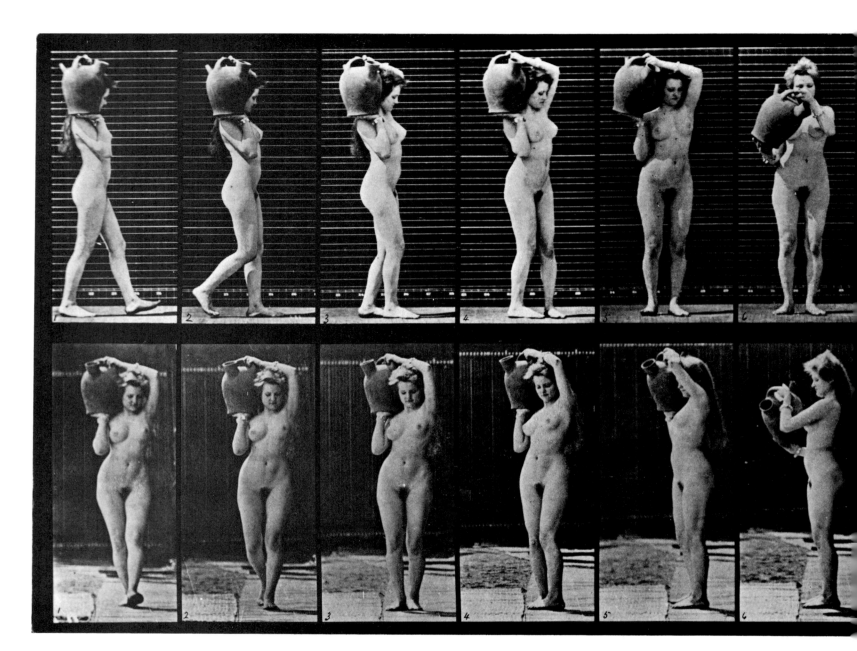

Plate 226. Removing a water jar from shoulder to the ground and turning.

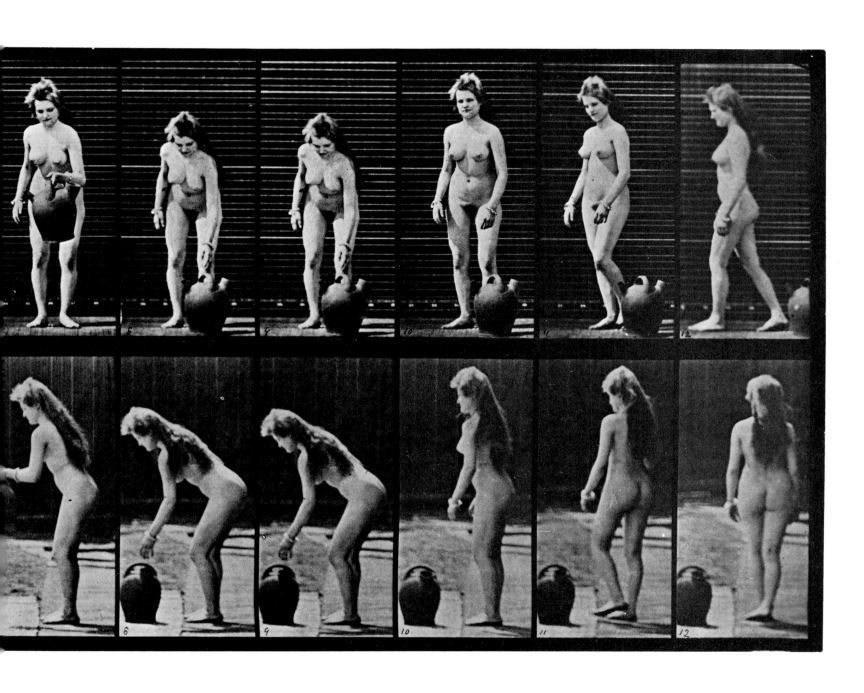

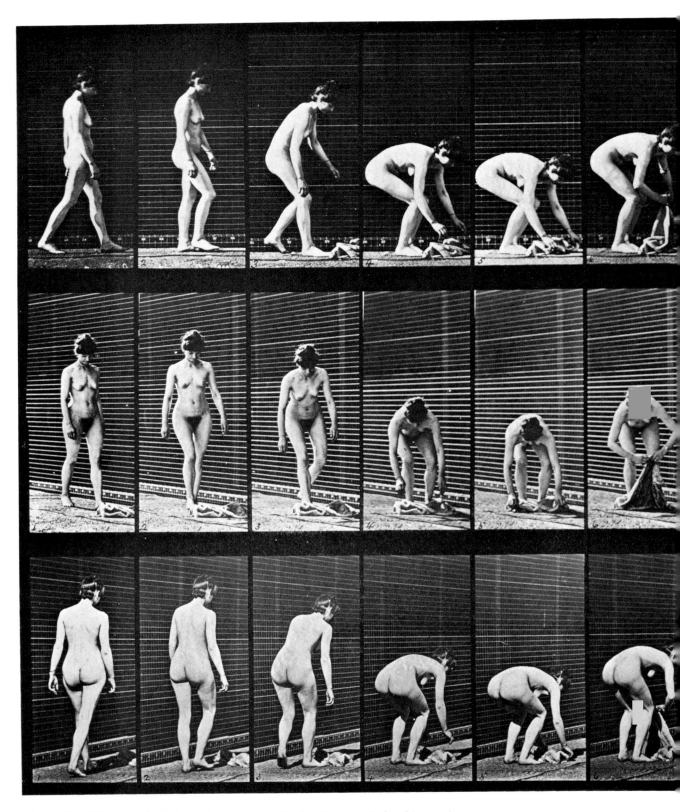

Plate 227. Lifting a cloth from the ground, placing it around shoulder and turning.

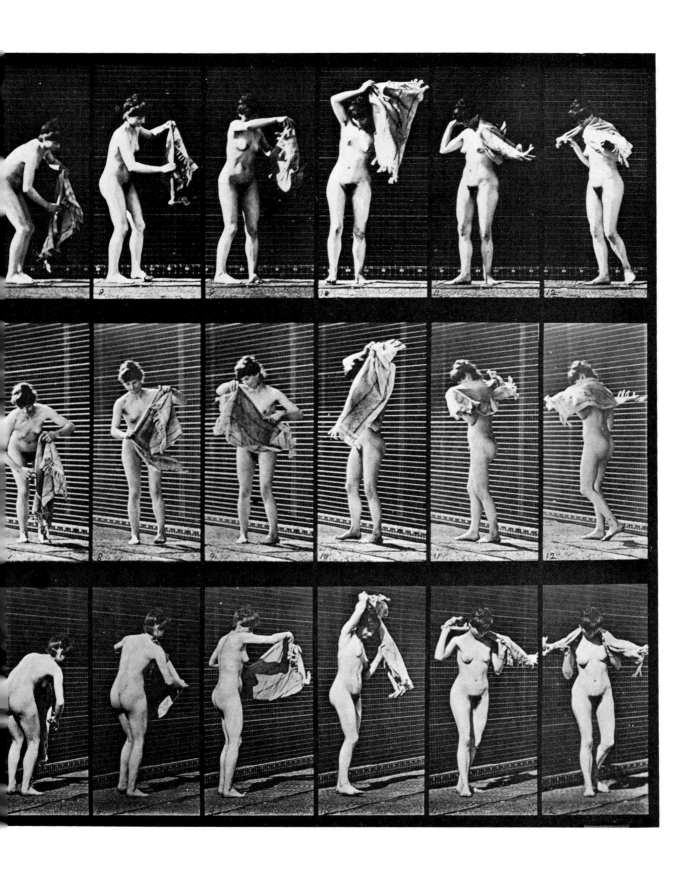

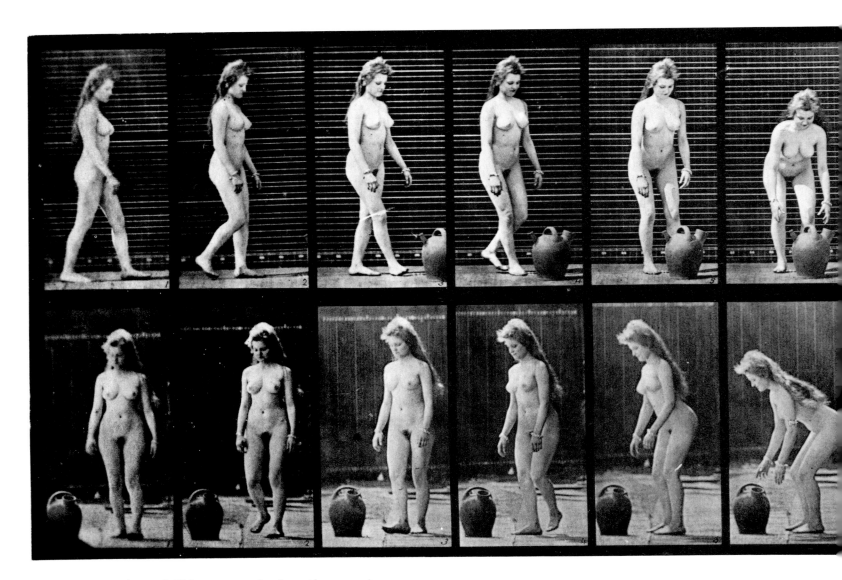

Plate 228. Turning and lifting a water jar from the ground.

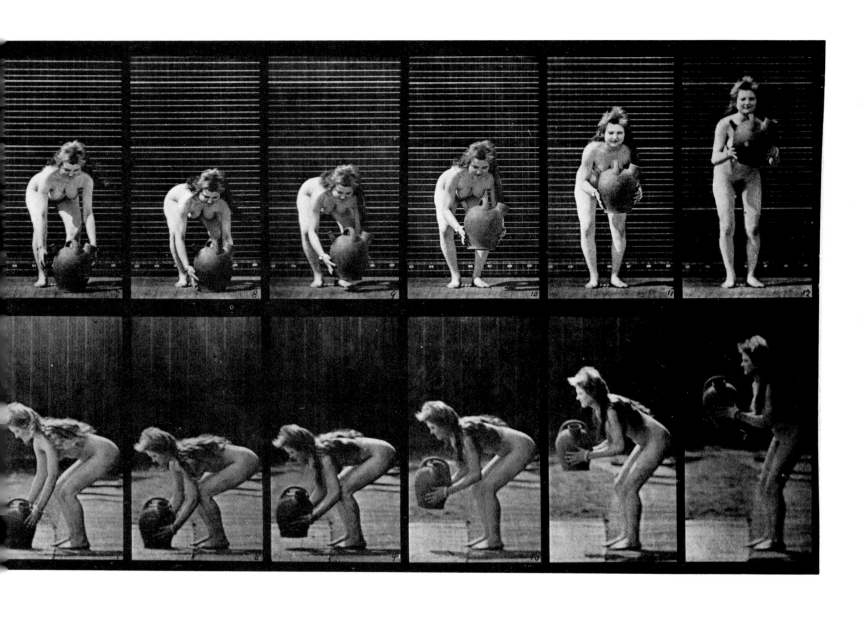

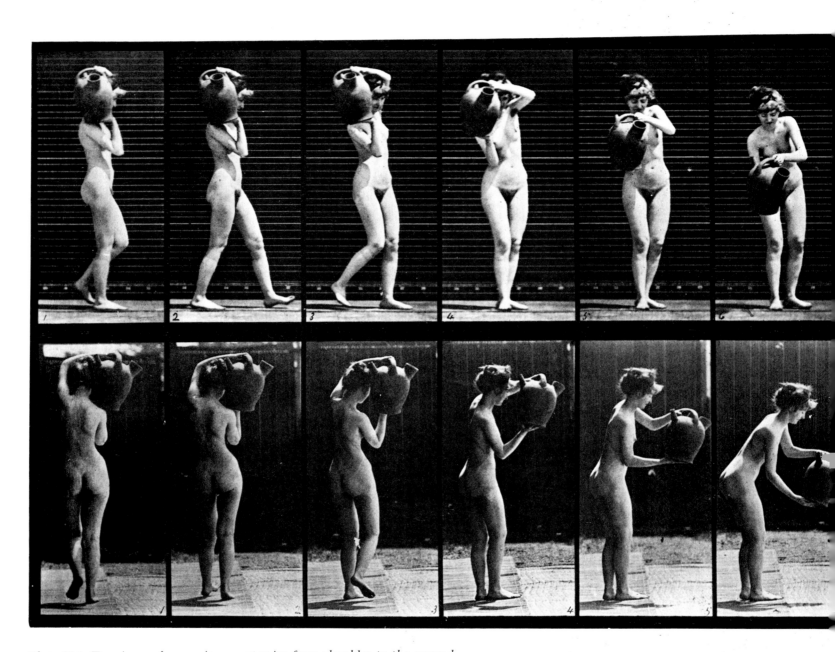

Plate 235. Turning and removing a water jar from shoulder to the ground.

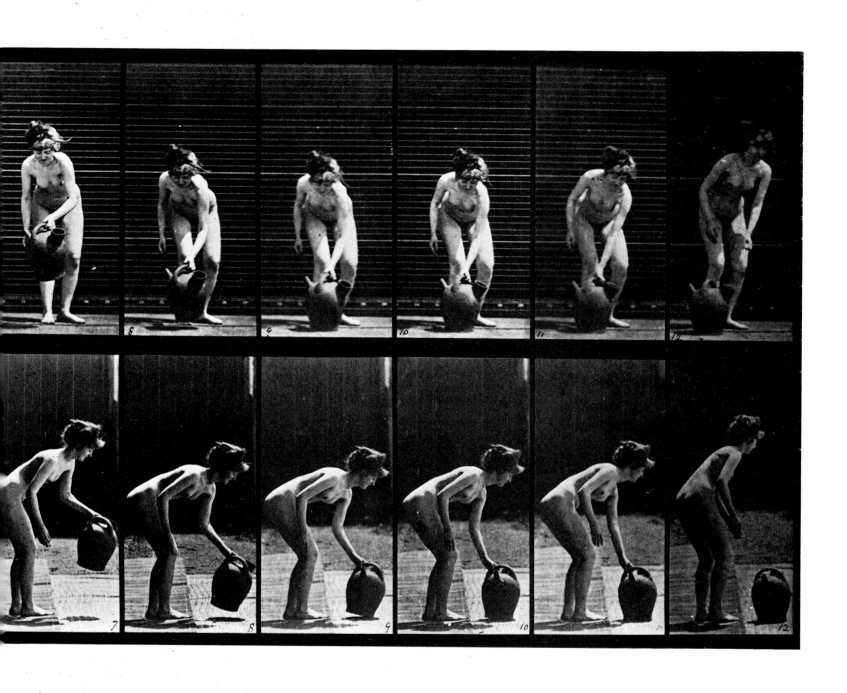

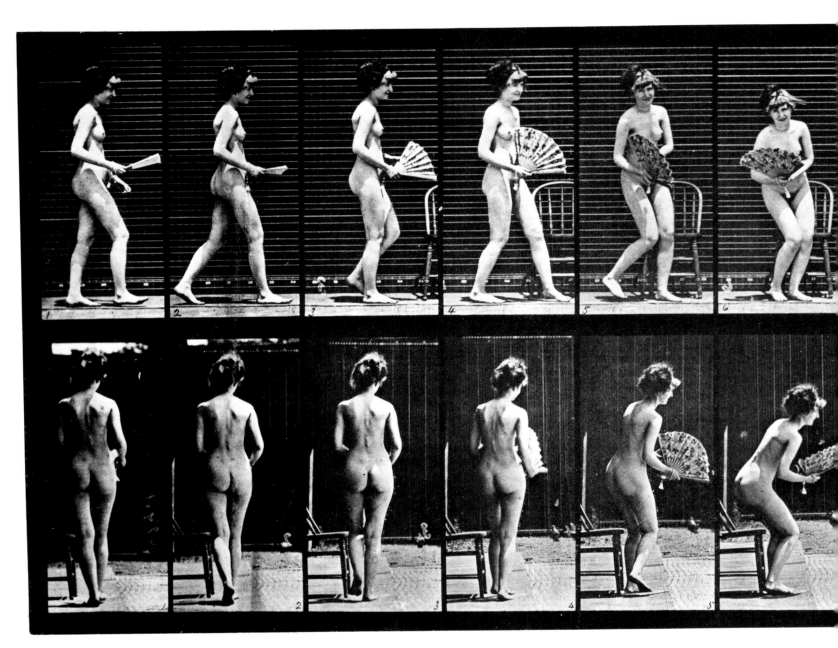

Plate 237. Sitting down on a chair and opening a fan.

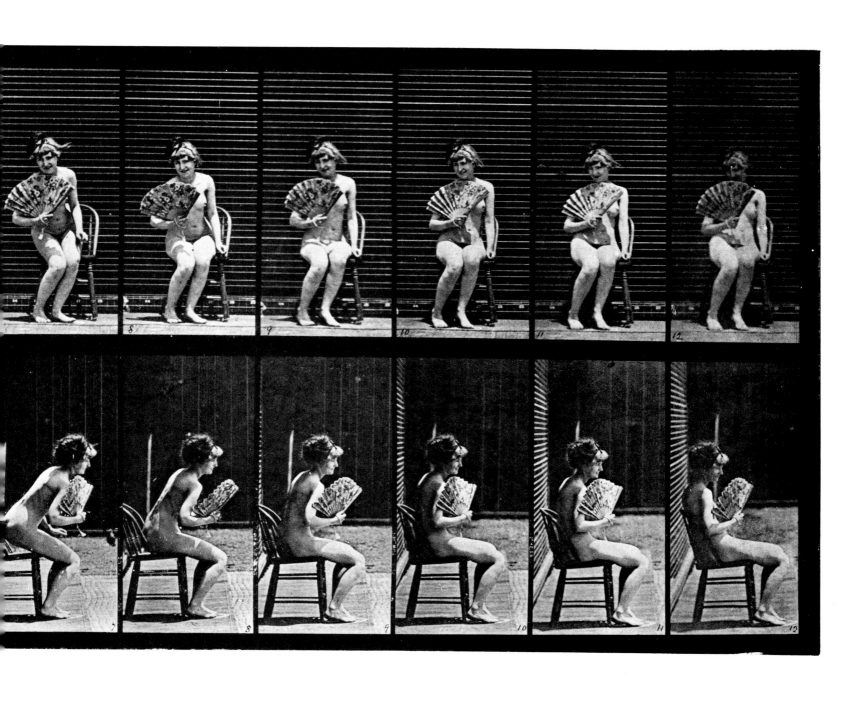

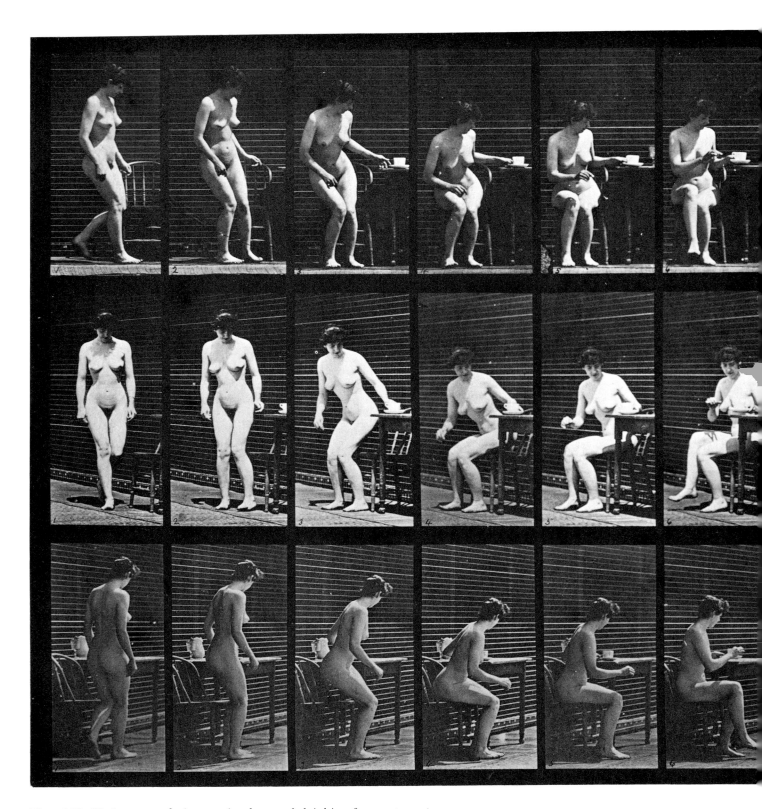

Plate 238. Sitting on a chair, crossing legs and drinking from a teacup.

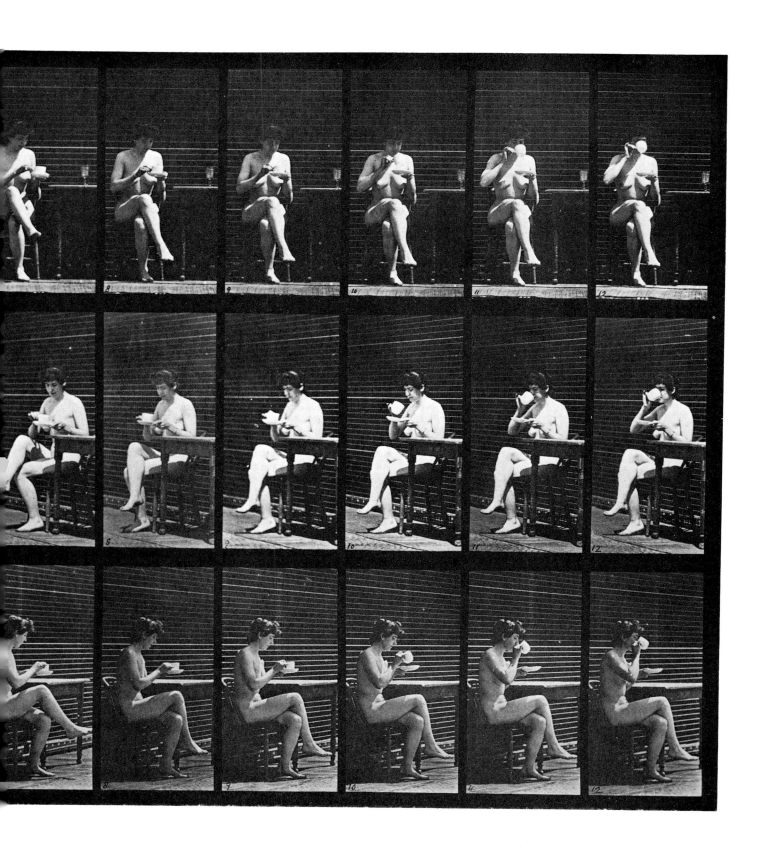

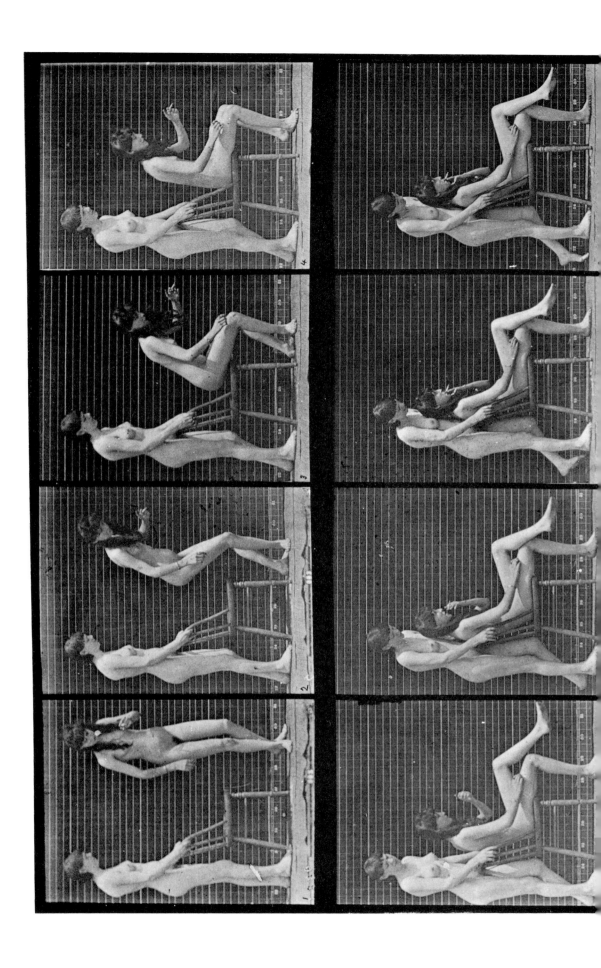

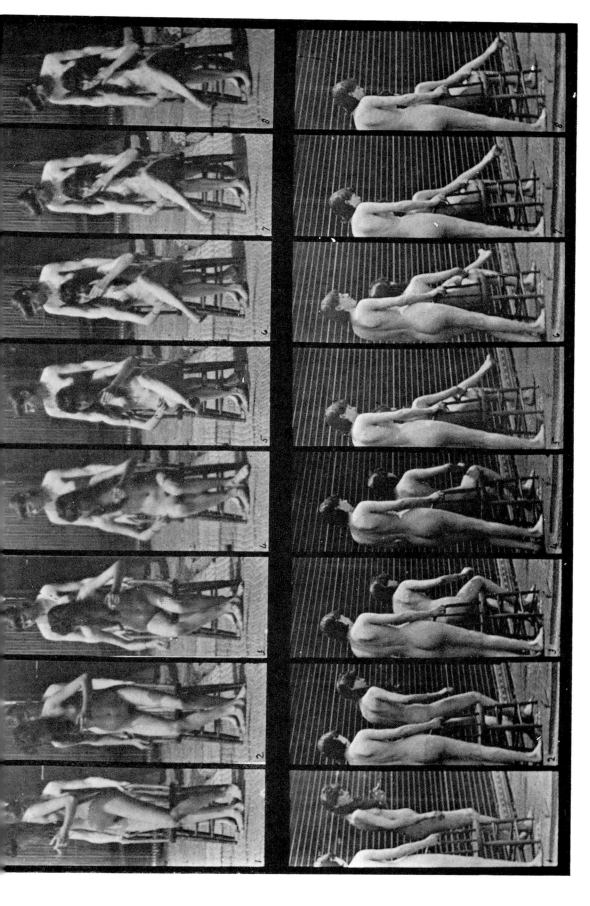

Plate 239. One woman standing, another sitting and crossing legs.

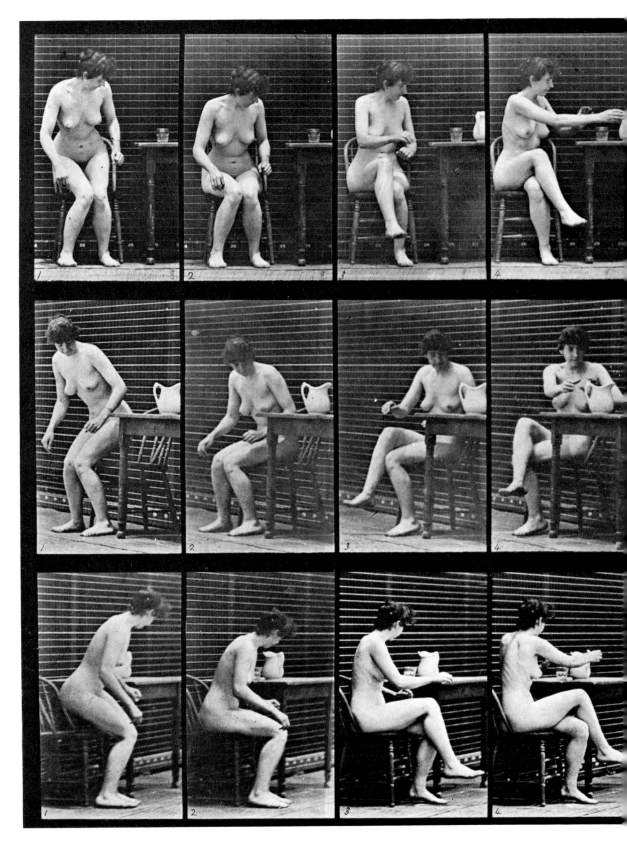

Plate 244. Sitting, crossing legs and filling a goblet from a pitcher.

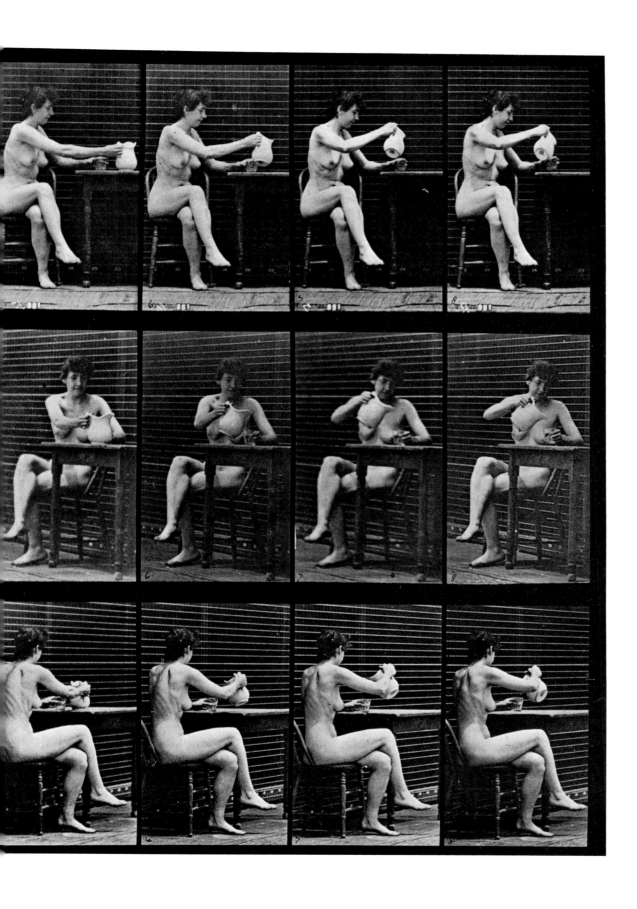

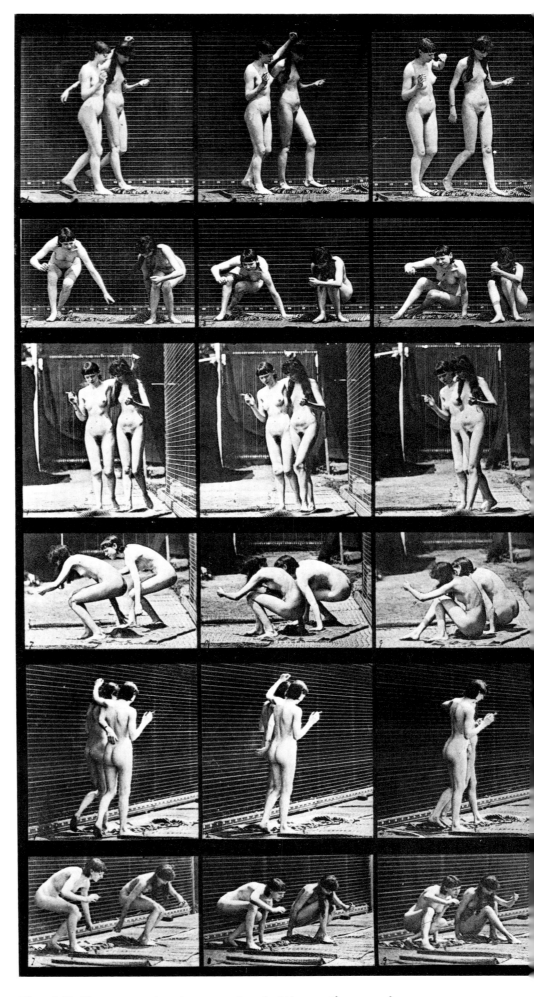

Plate 245. Two women turning around and sitting on the ground.

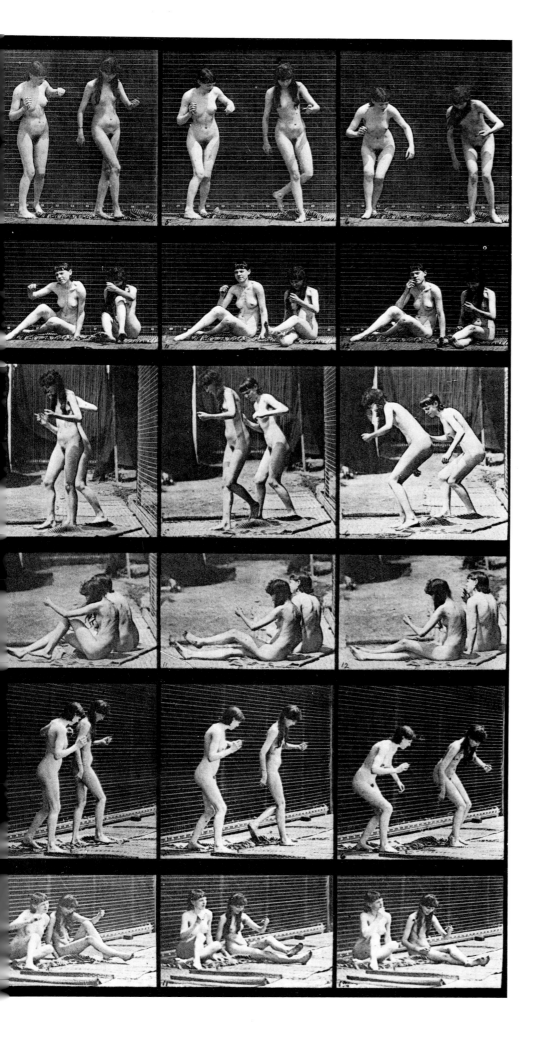

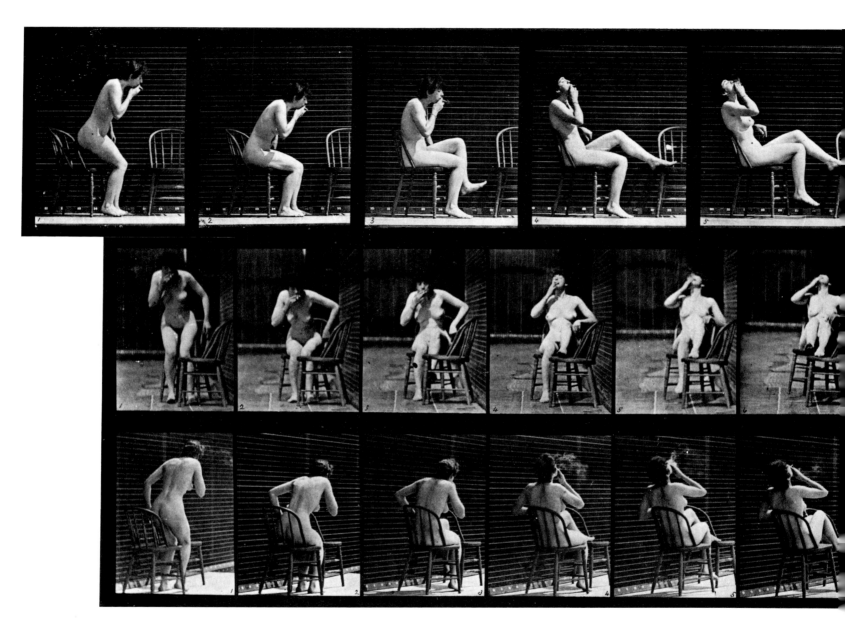

Plate 247. Sitting down and placing feet on chair.

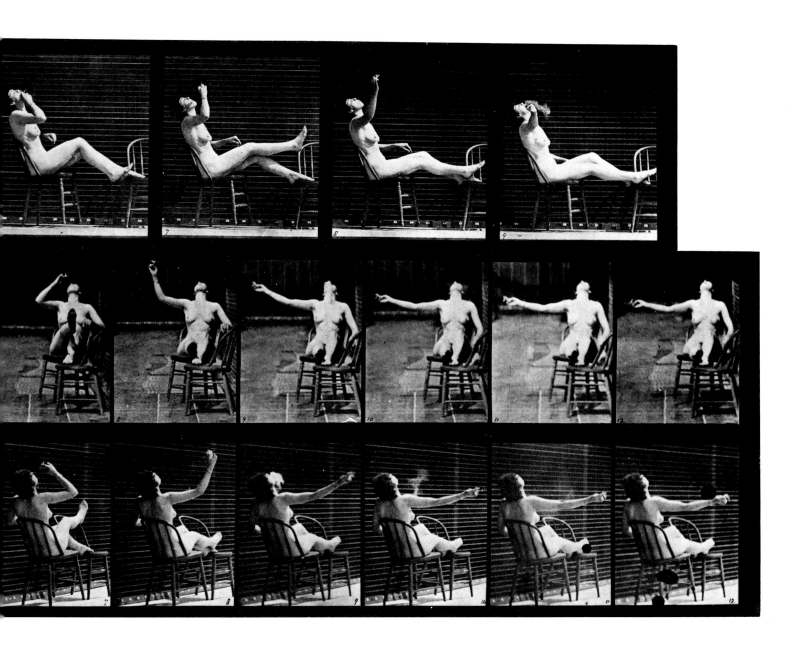

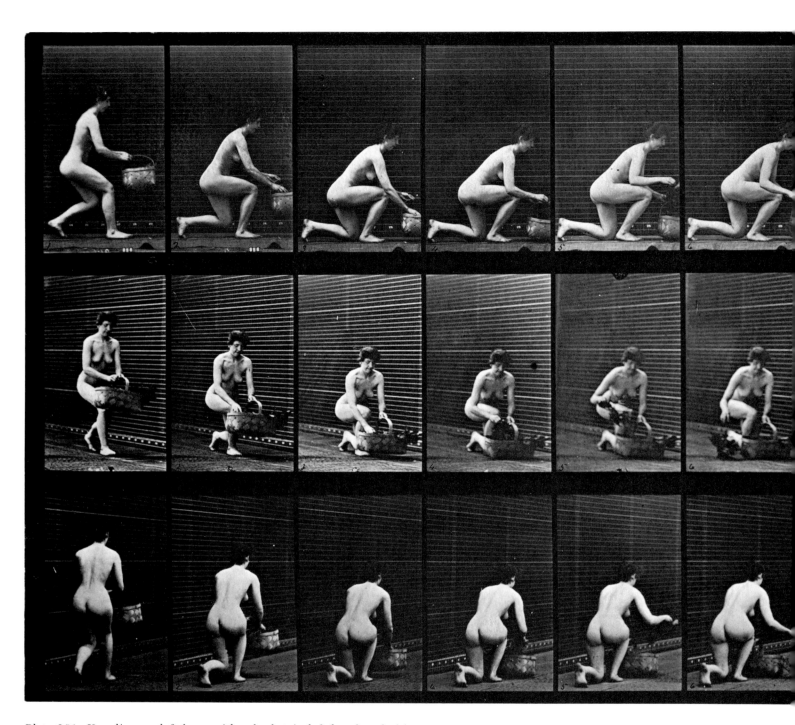

Plate 251. Kneeling on left knee with a basket in left hand and rising.

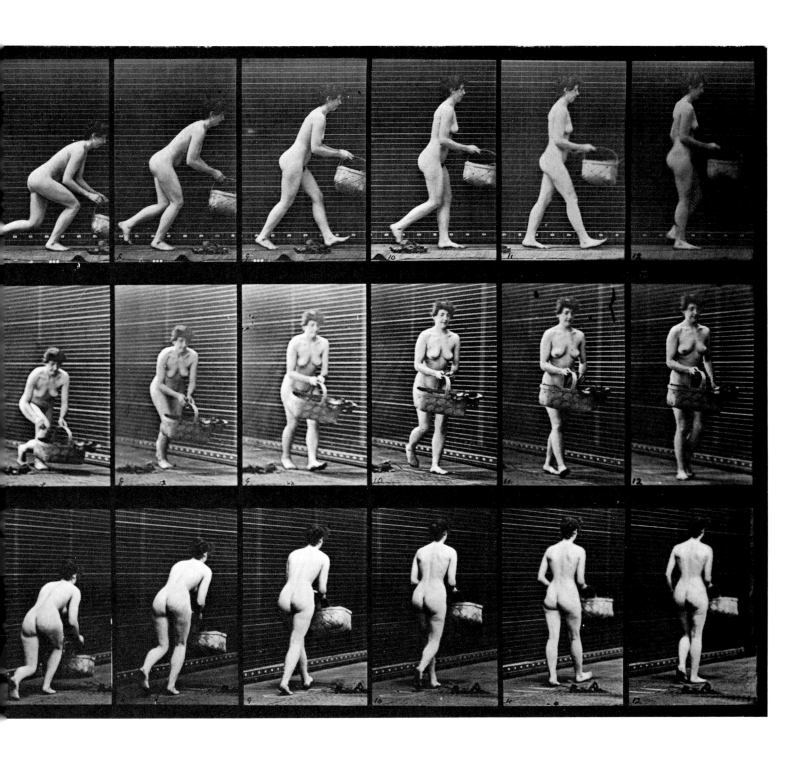

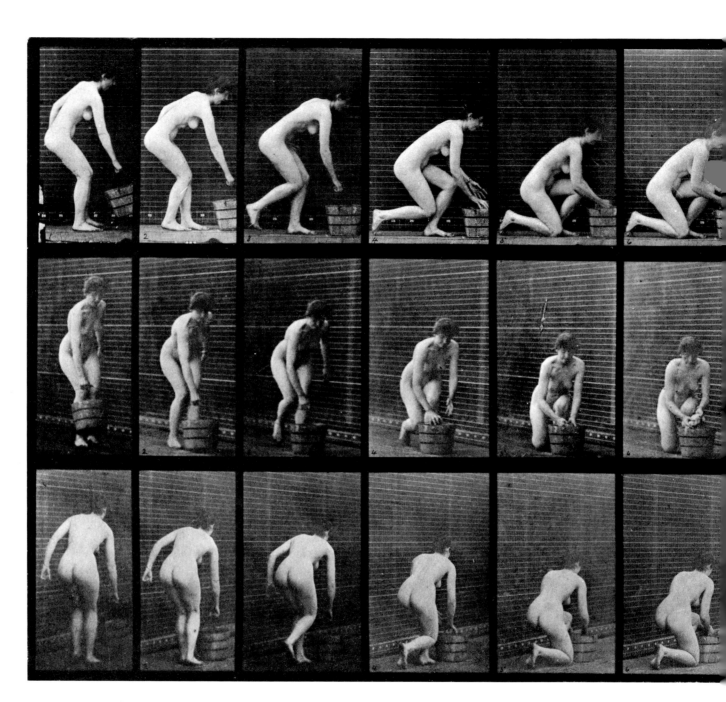

Plate 252. Kneeling on right knee and scrubbing the floor.

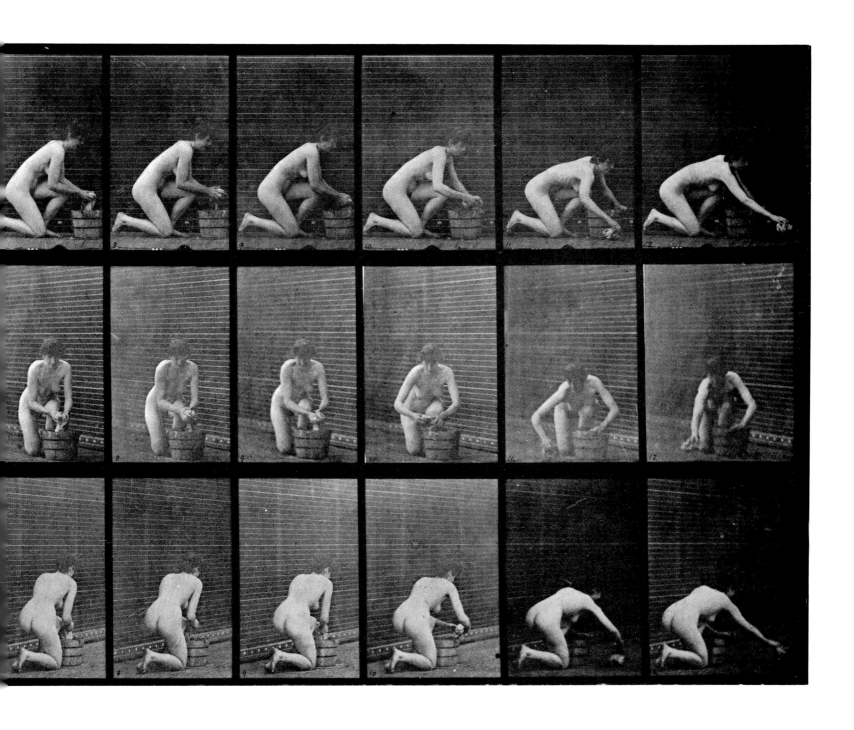

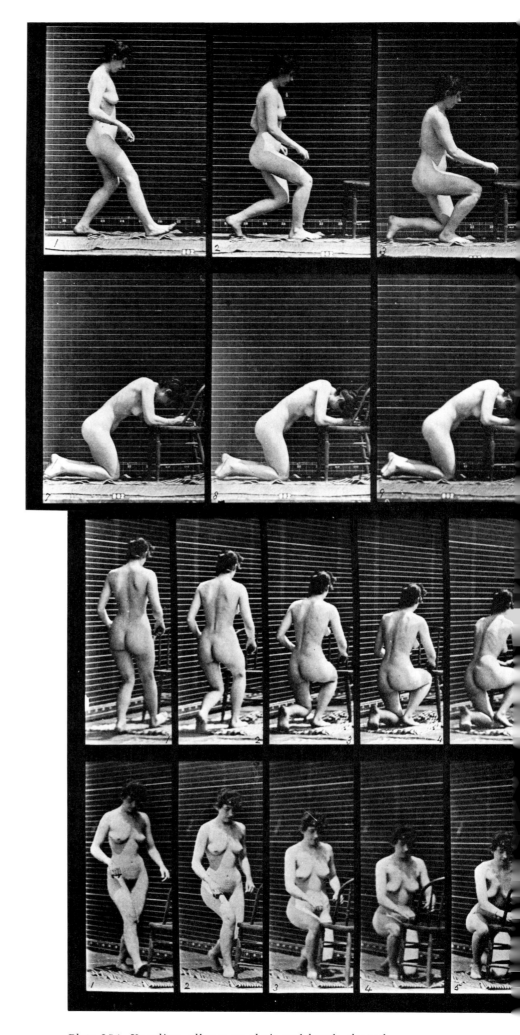

Plate 254. Kneeling, elbows on chair and hands clasped.

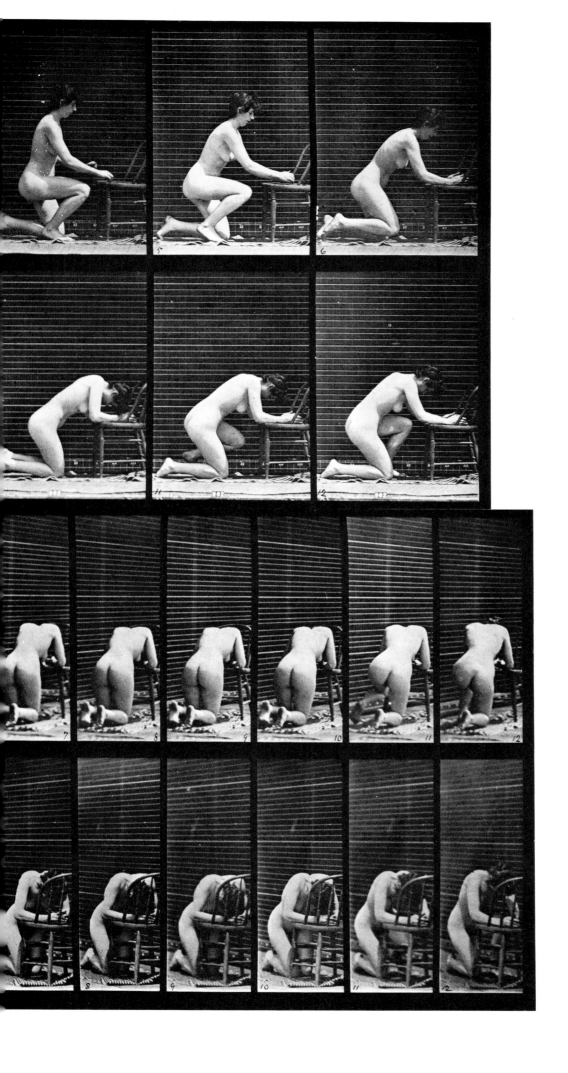

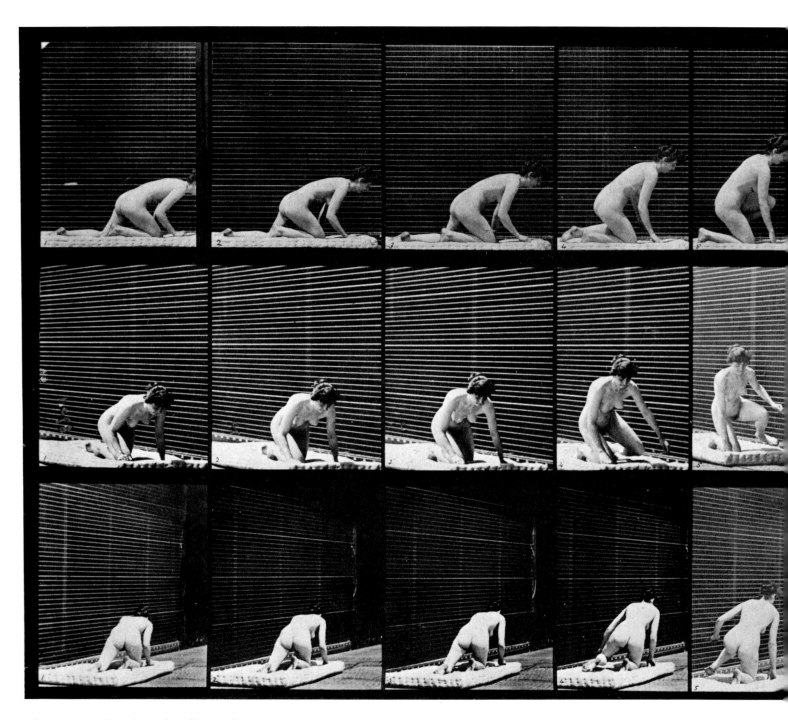

Plate 255. Arising from kneeling and turning.

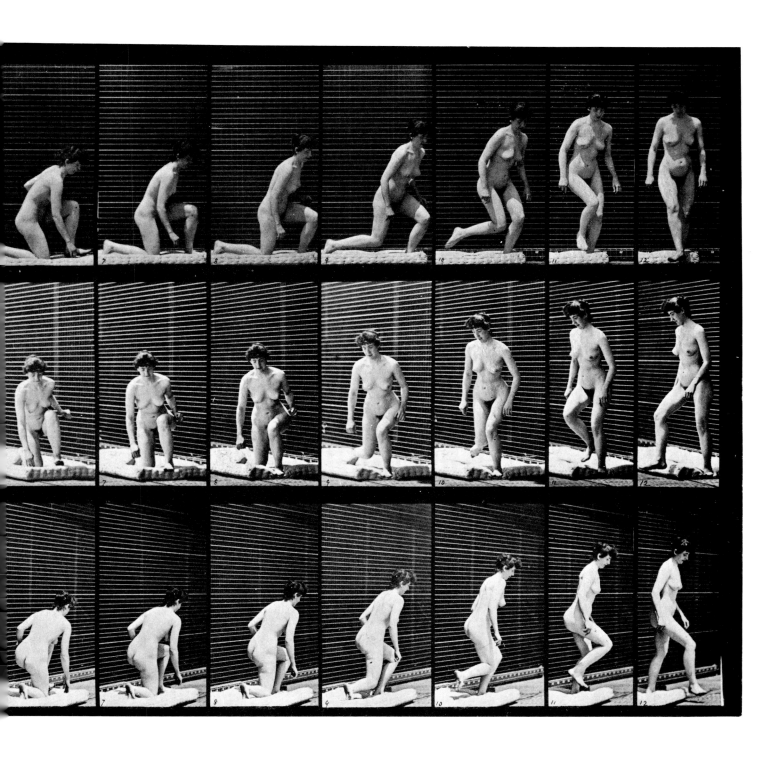

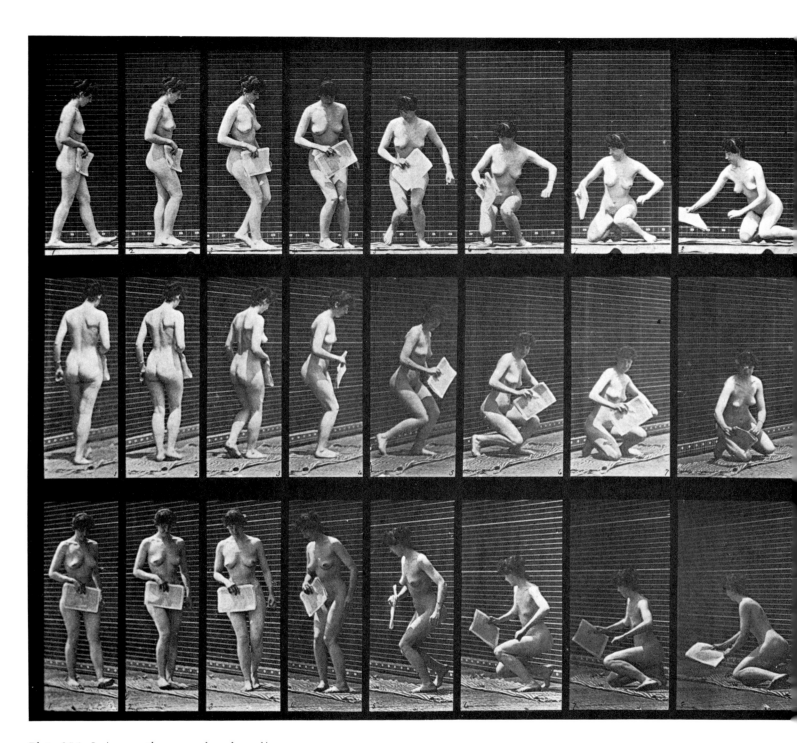

Plate 256. Lying on the ground and reading.

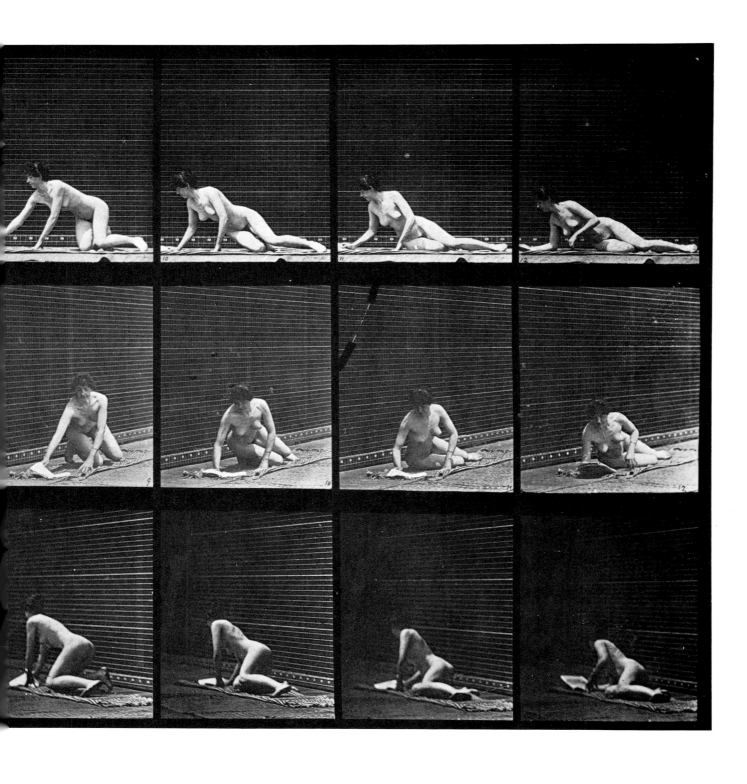

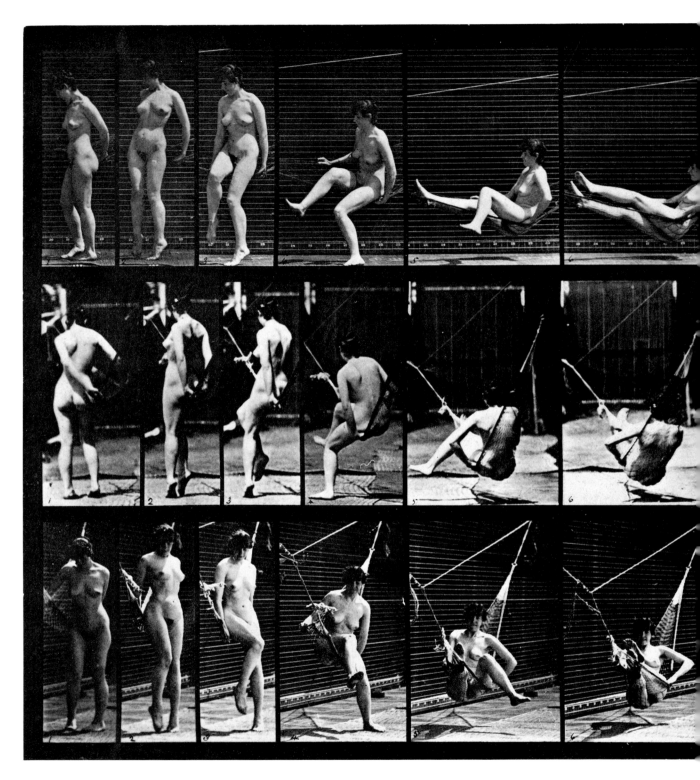

Plate 261. Getting into hammock.

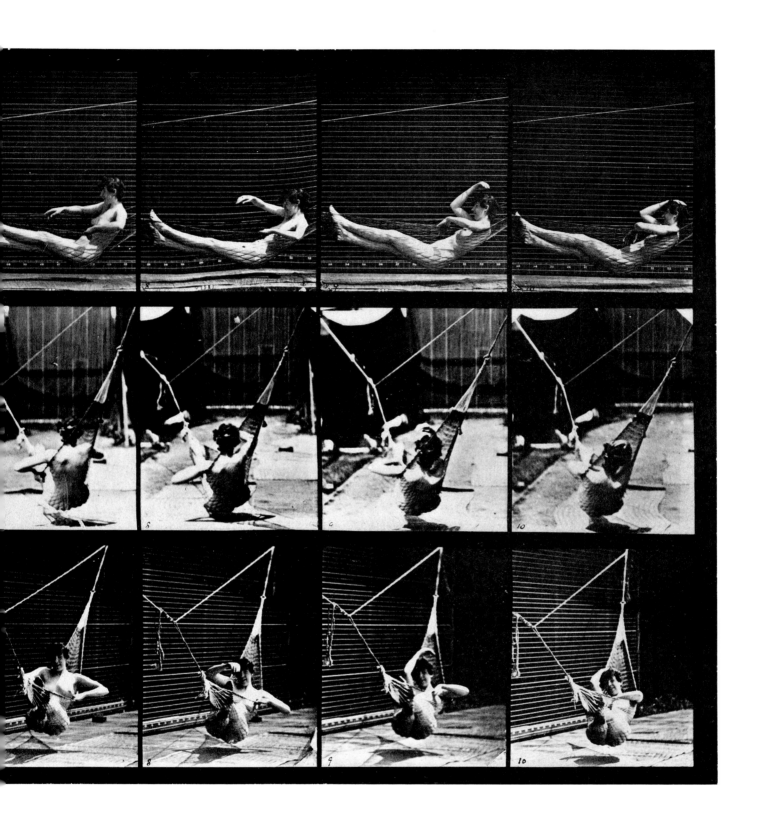

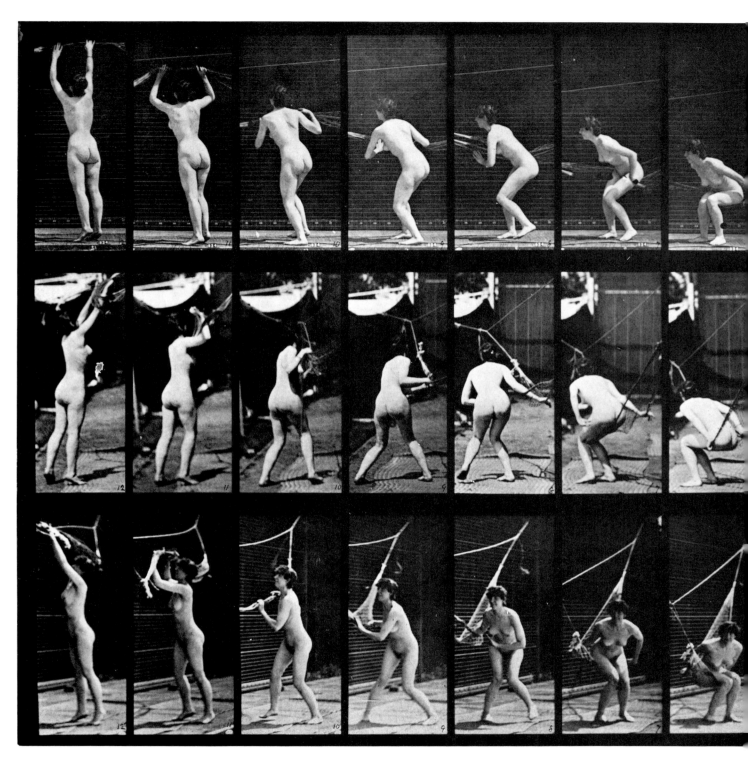

Plate 262. Getting out of hammock.

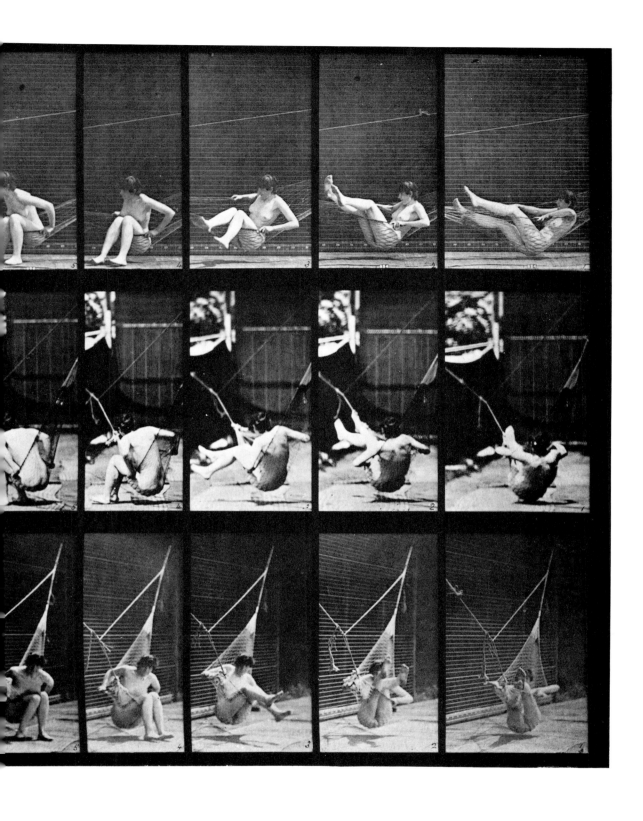

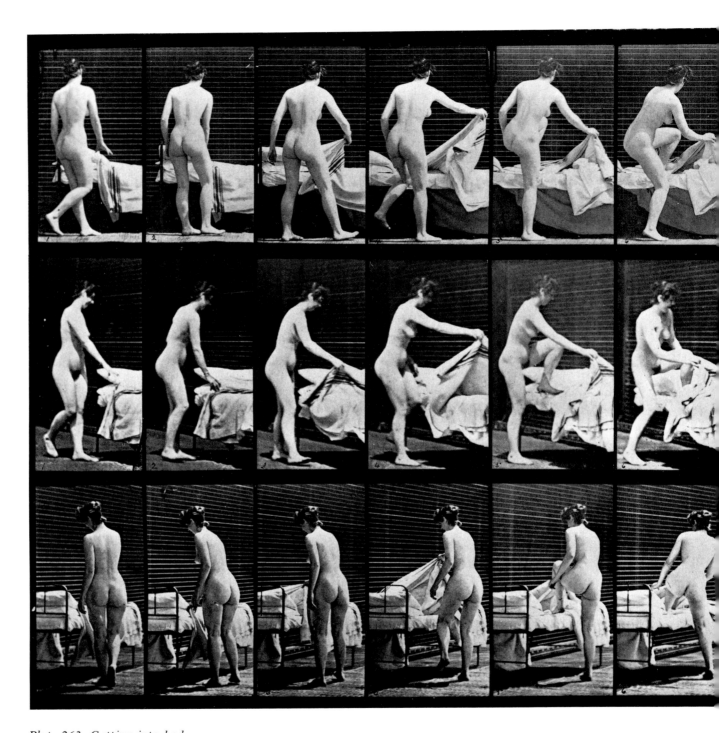

Plate 263. Getting into bed.

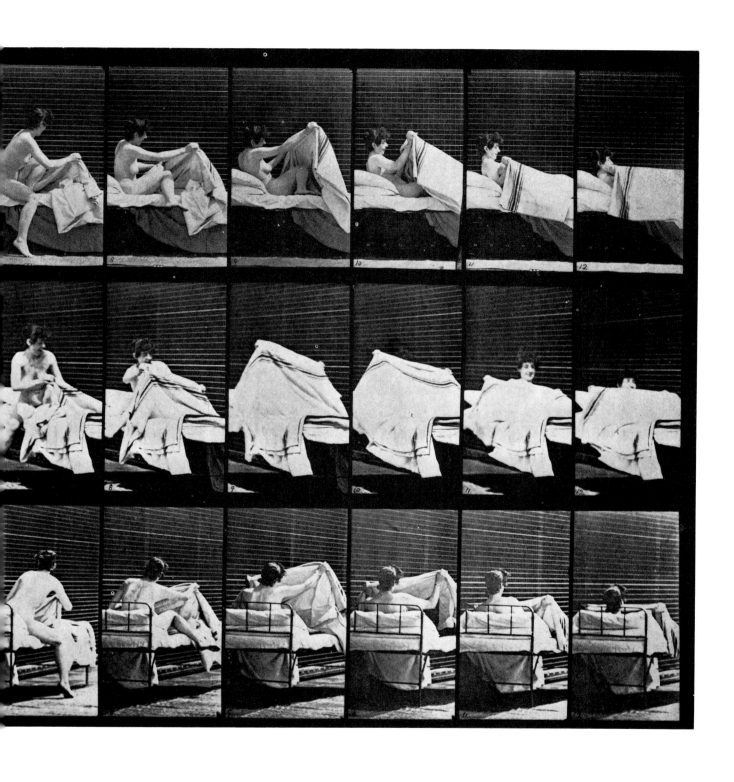

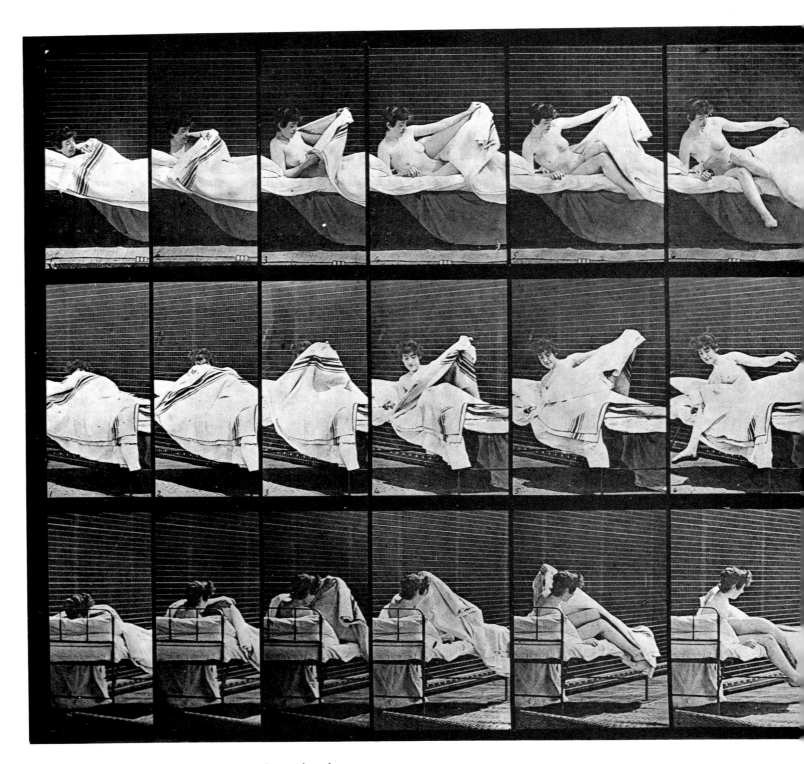

Plate 264. Getting out of bed and preparing to kneel.

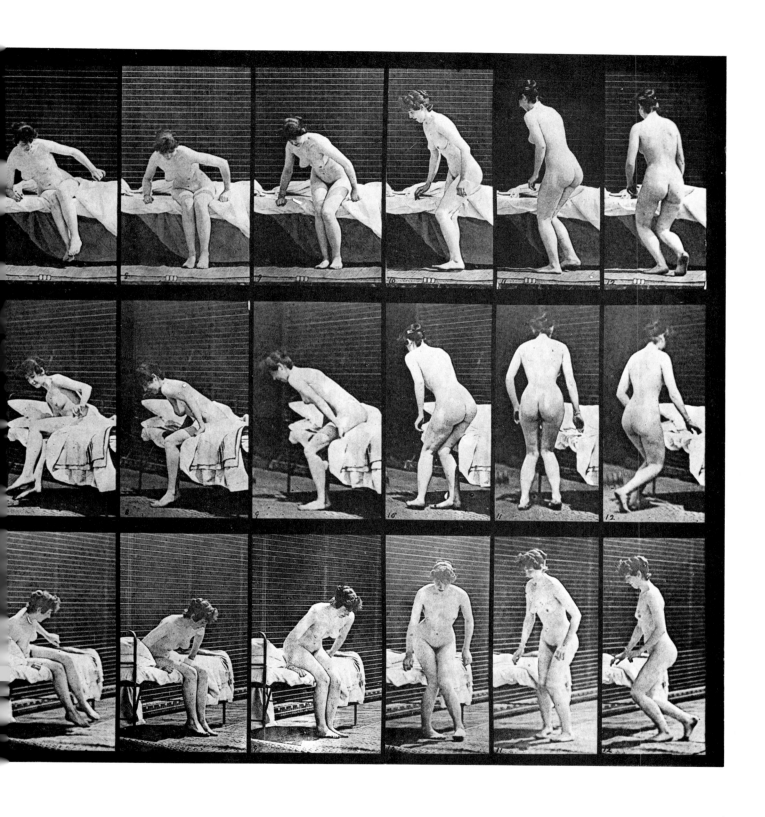

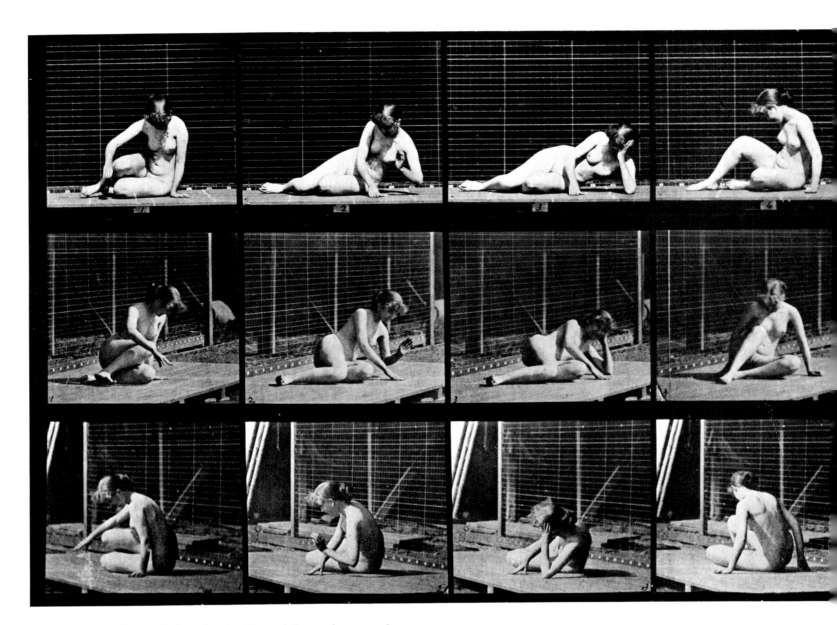

Plate 266. Turning and changing position while on the ground.

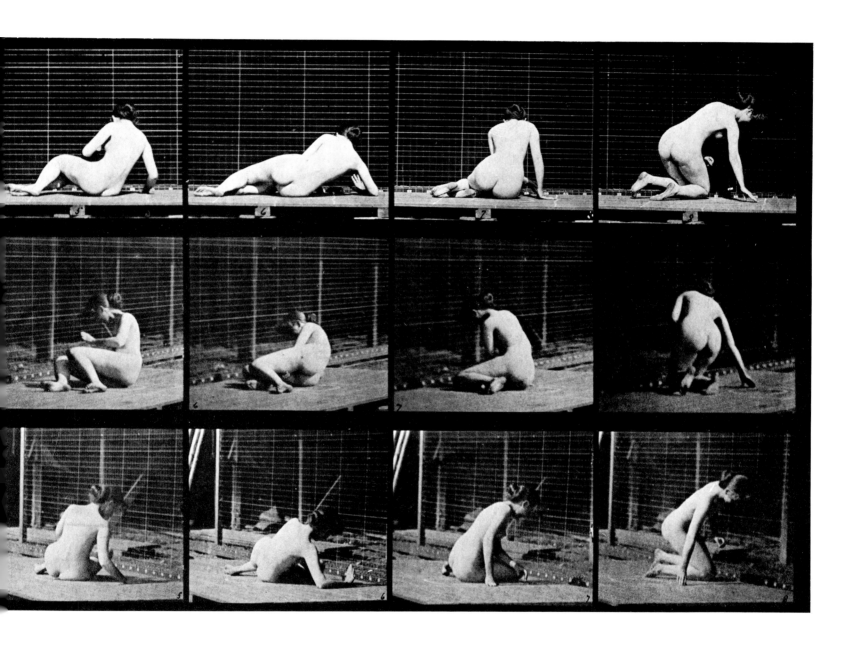

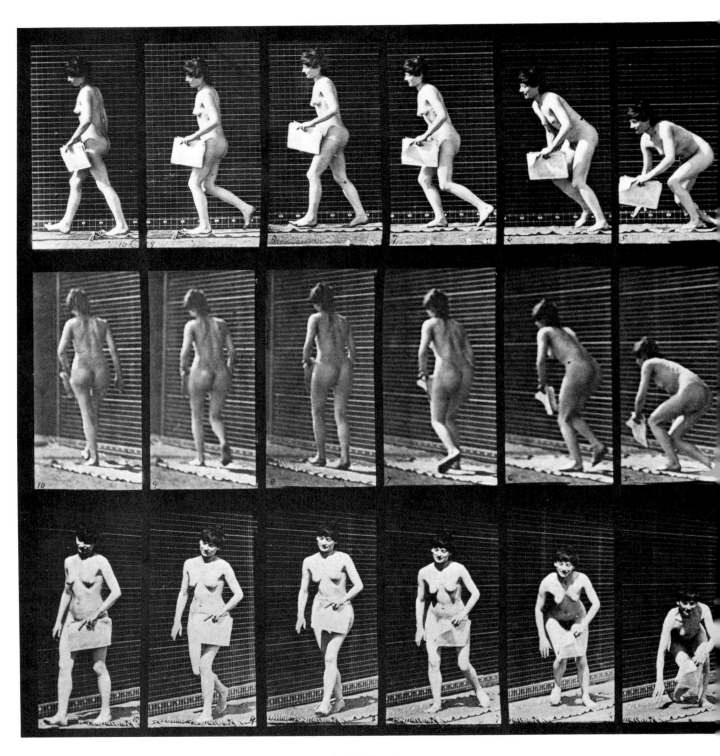

Plate 269. Arising from the ground with a newspaper in left hand.

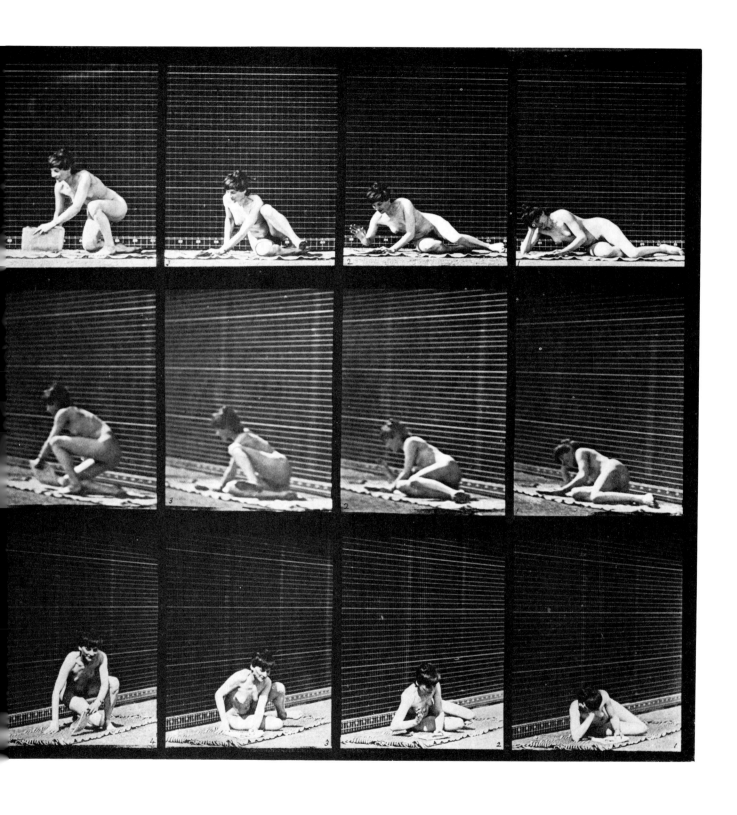

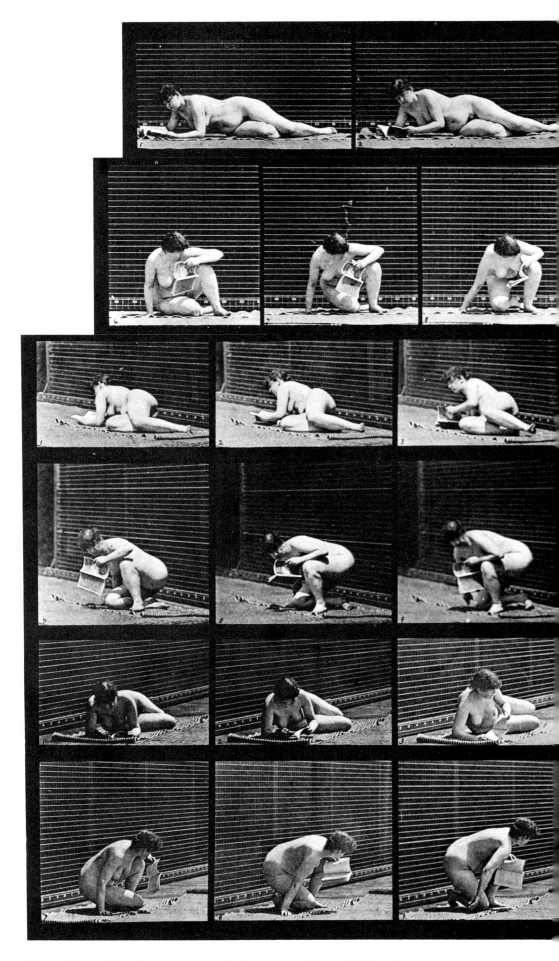

Plate 270. Arising from the ground with a pamphlet in left hand.

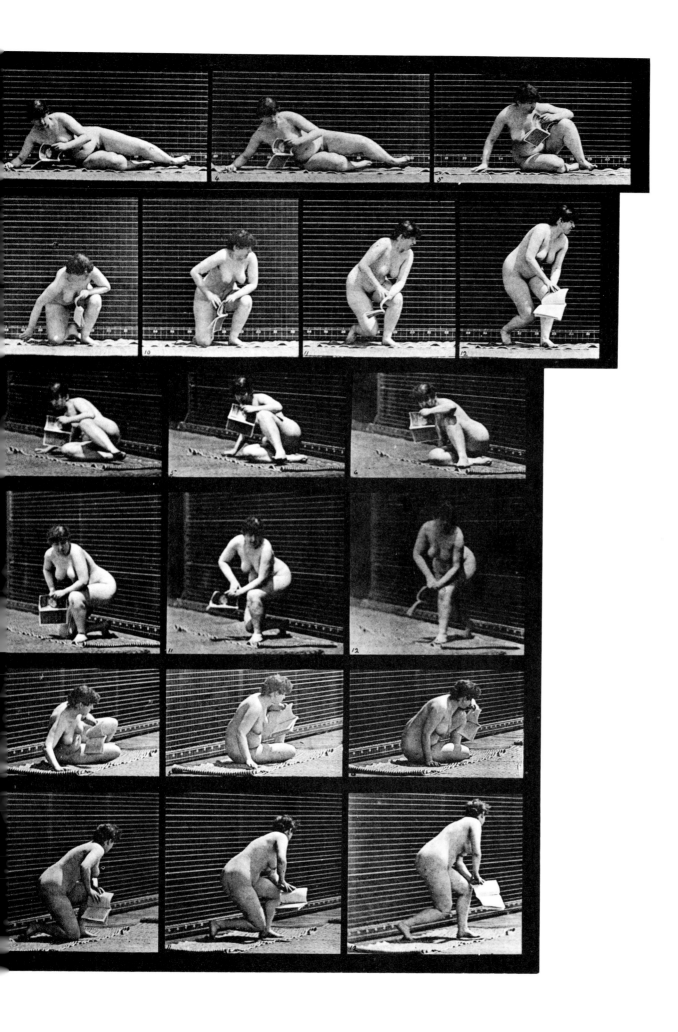

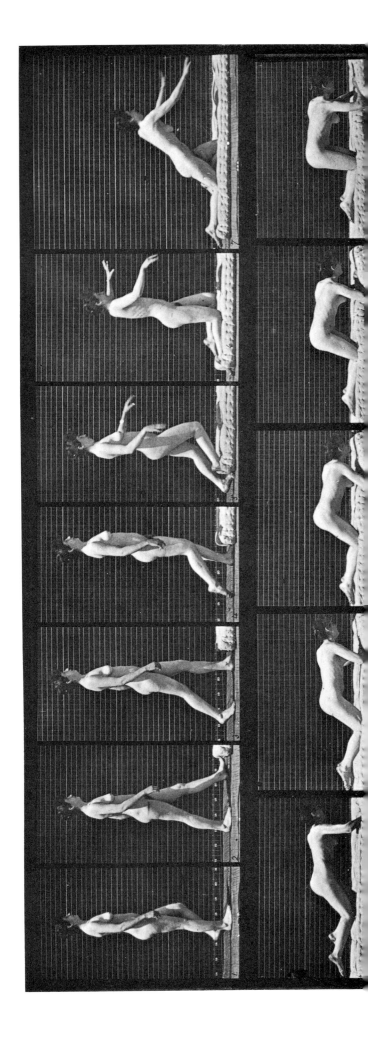

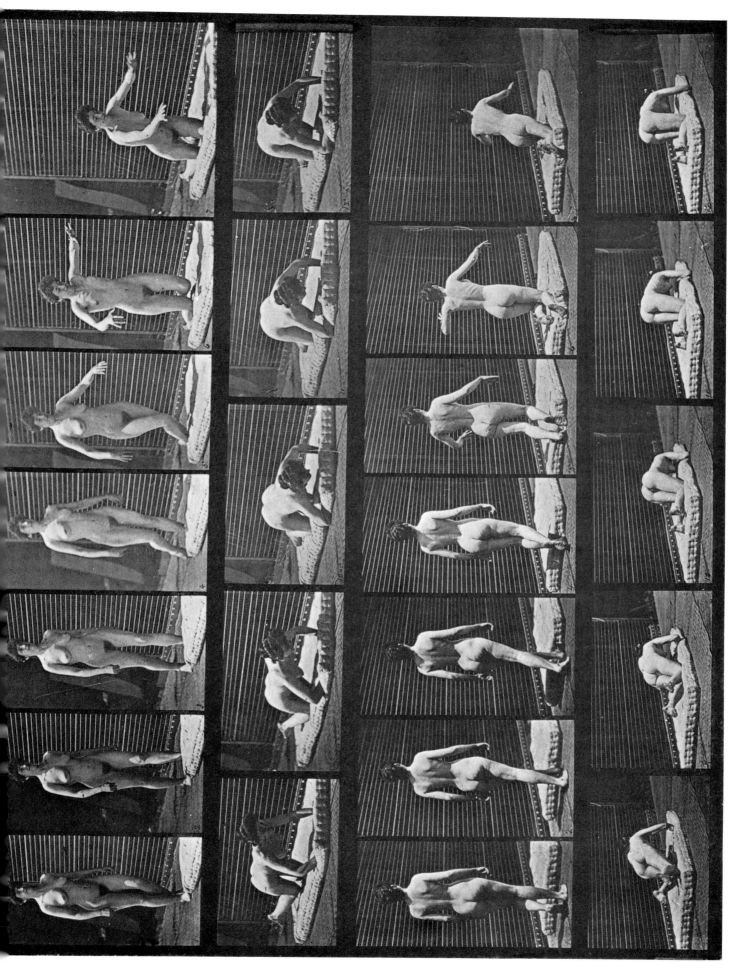

Plate 272. Stumbling and falling on the ground.

FEMALES (NUDE) 513

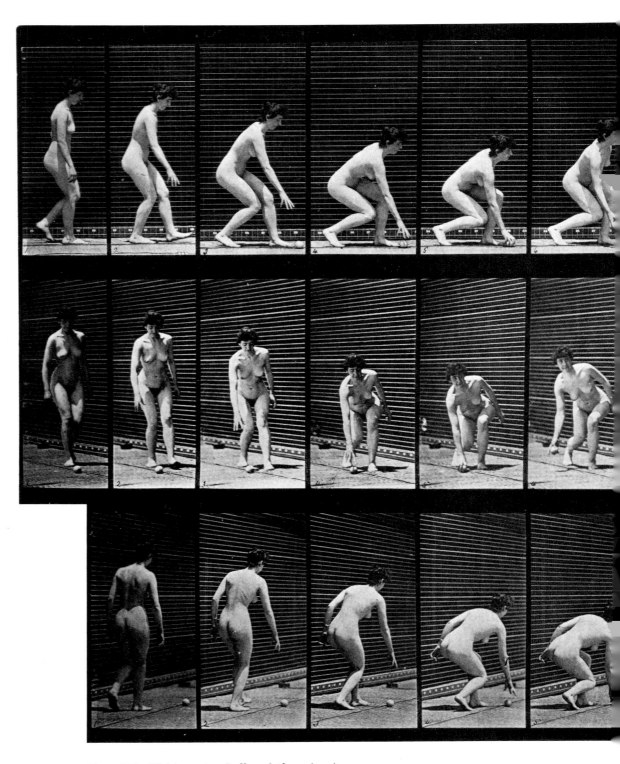

Plate 303. Picking up a ball and throwing it.

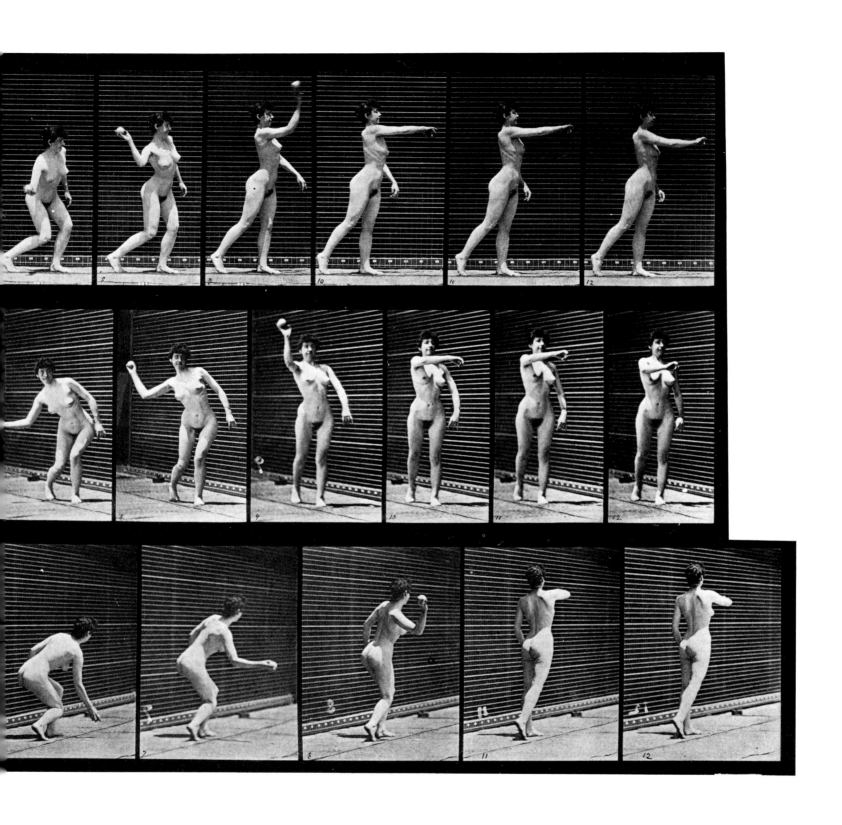

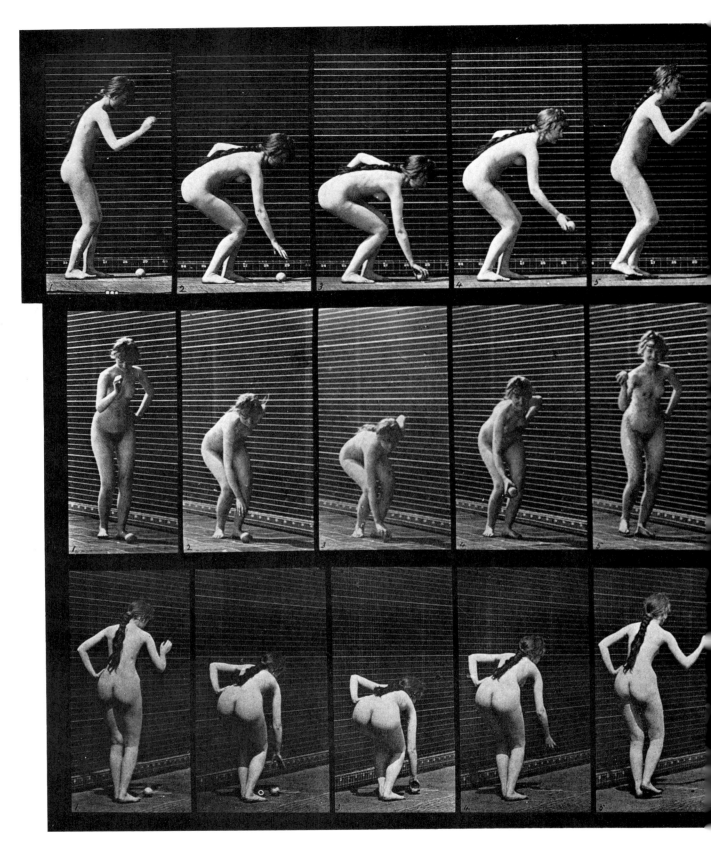

Plate 304. Picking up a ball and throwing it.

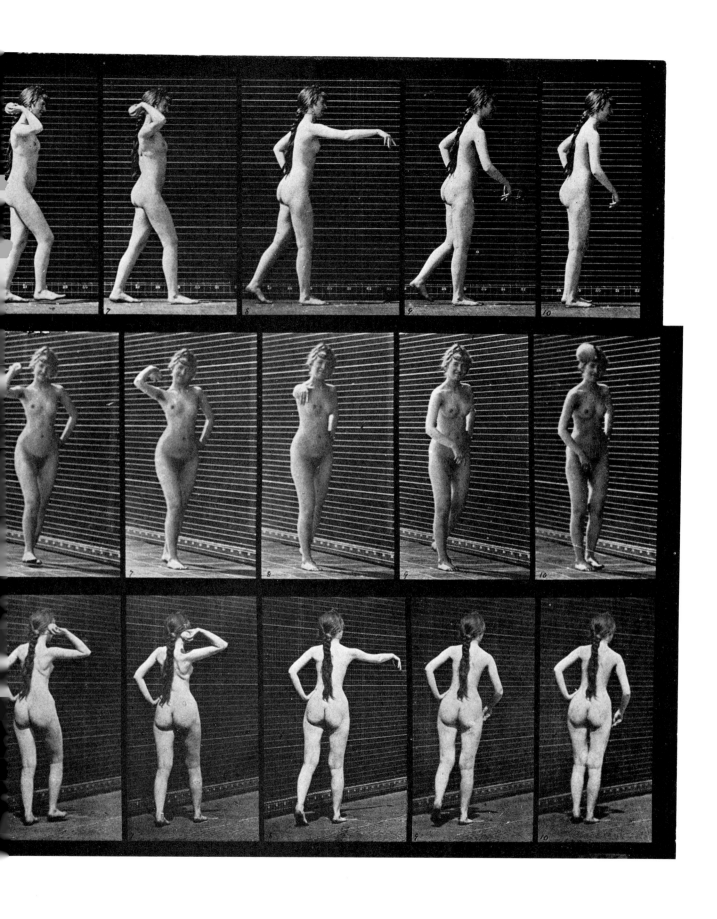

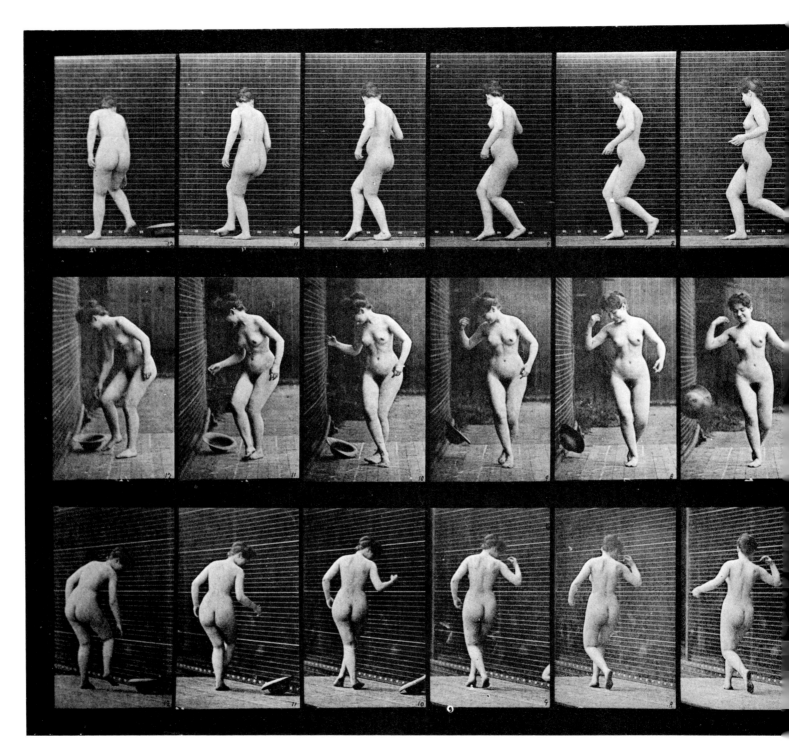

Plate 367. Kicking a hat.

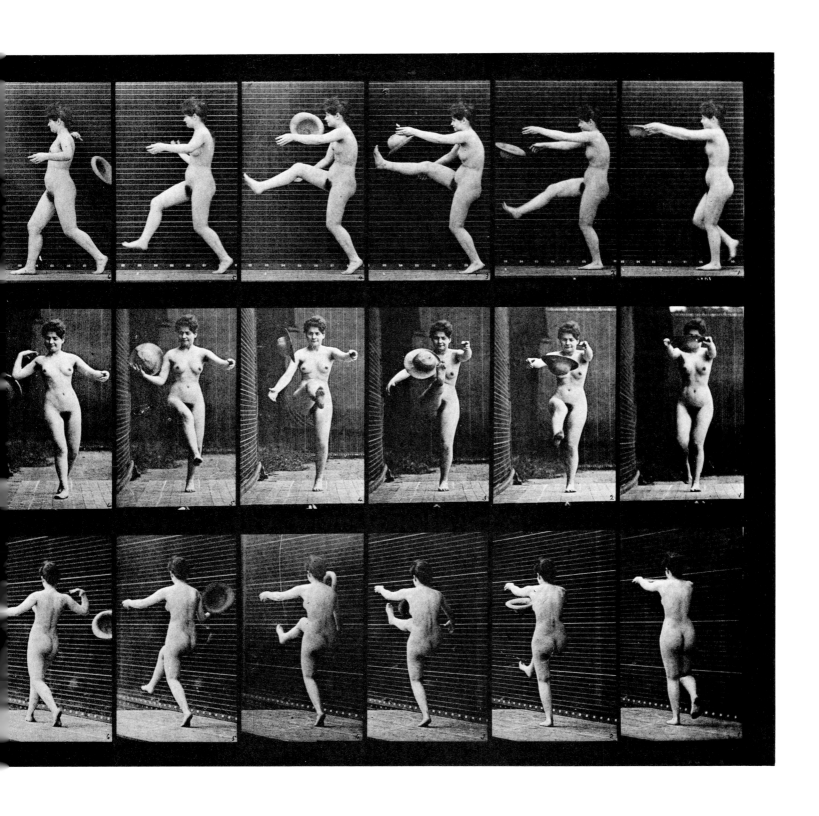

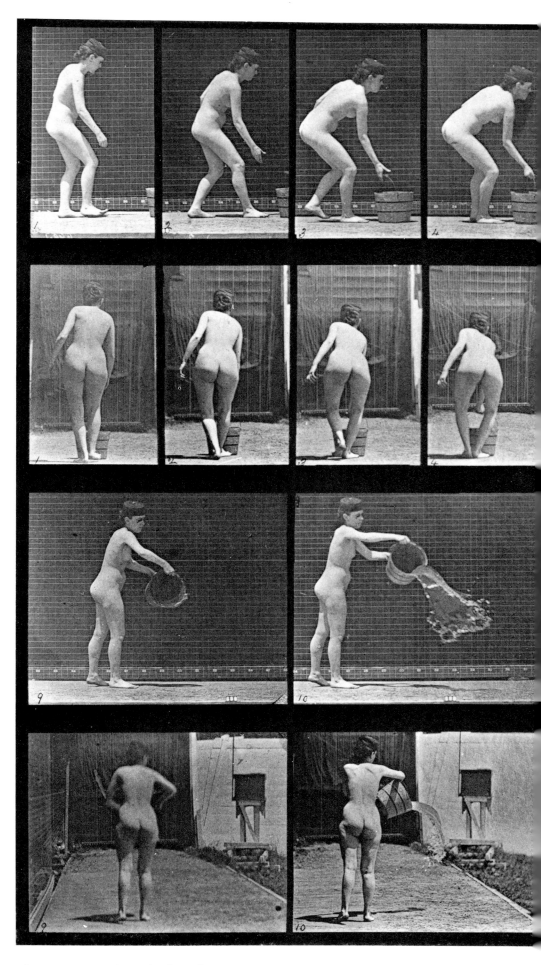

Plate 401. Emptying a bucket of water.

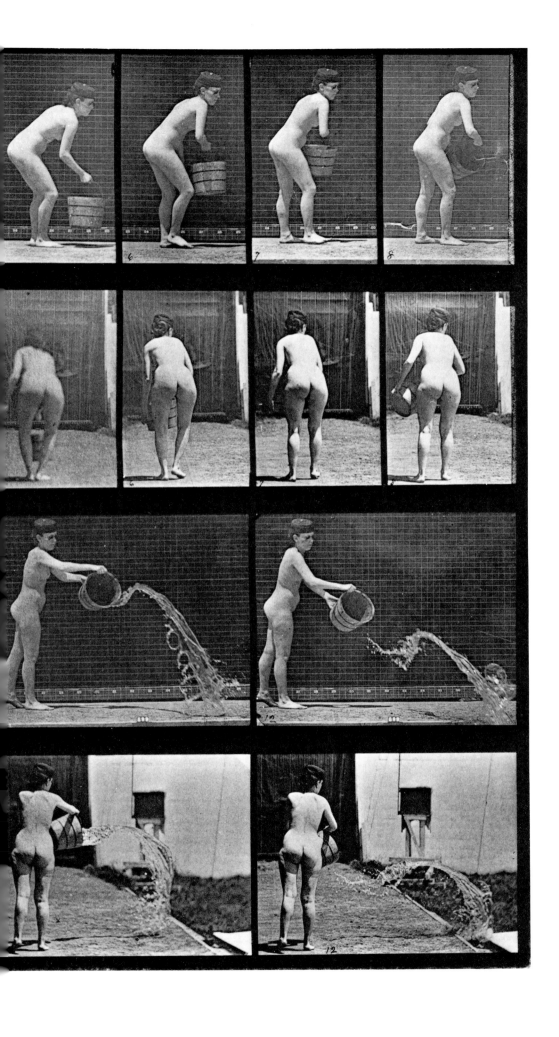

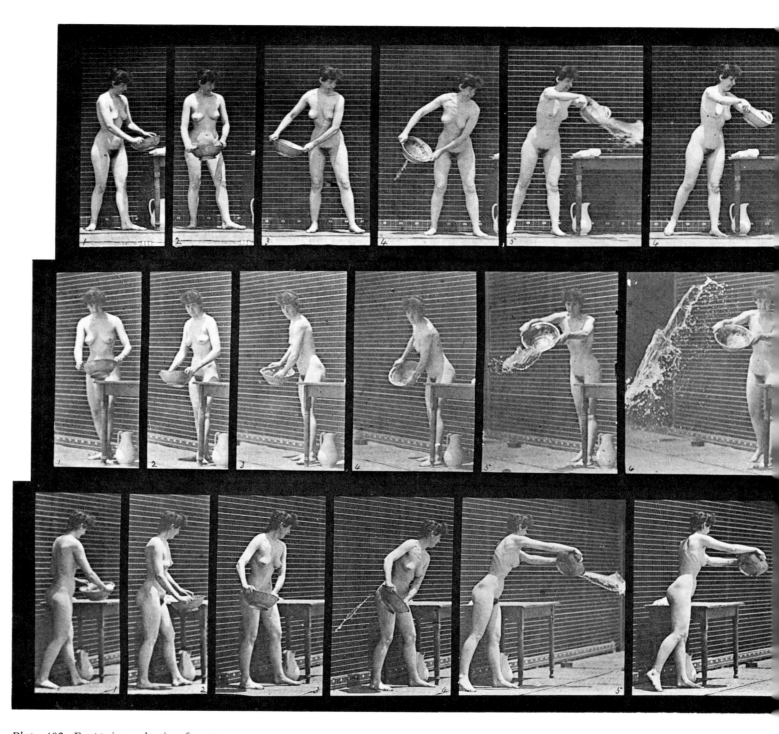

Plate 402. Emptying a basin of water.

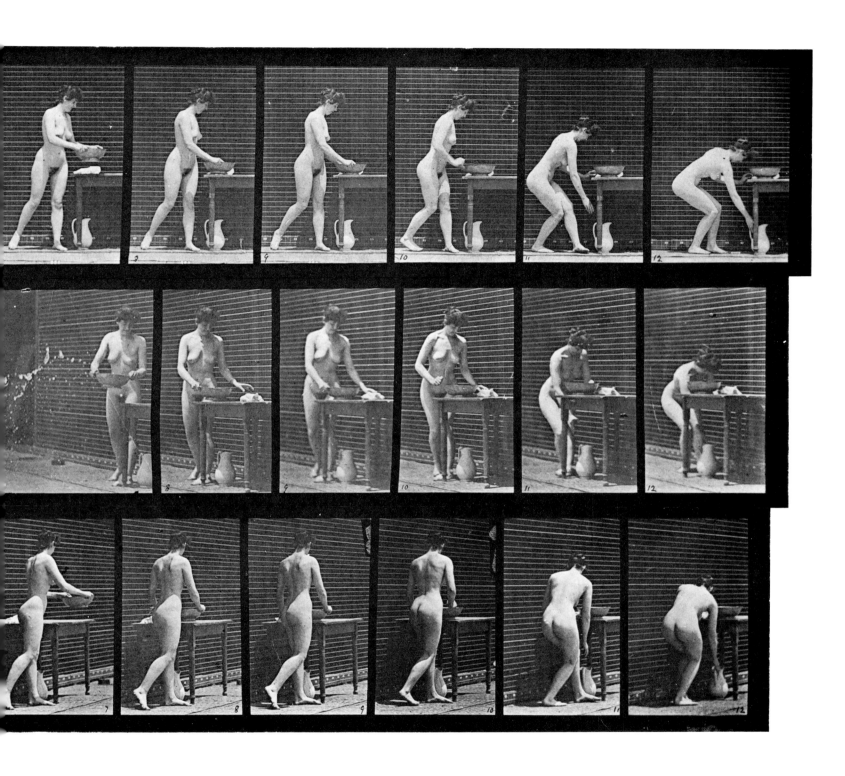

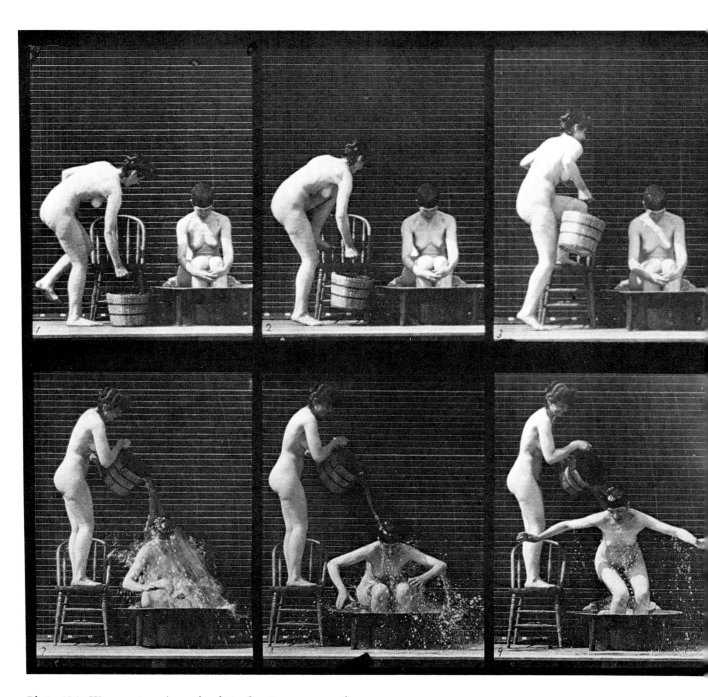

Plate 406. Woman pouring a bucket of water over another woman.

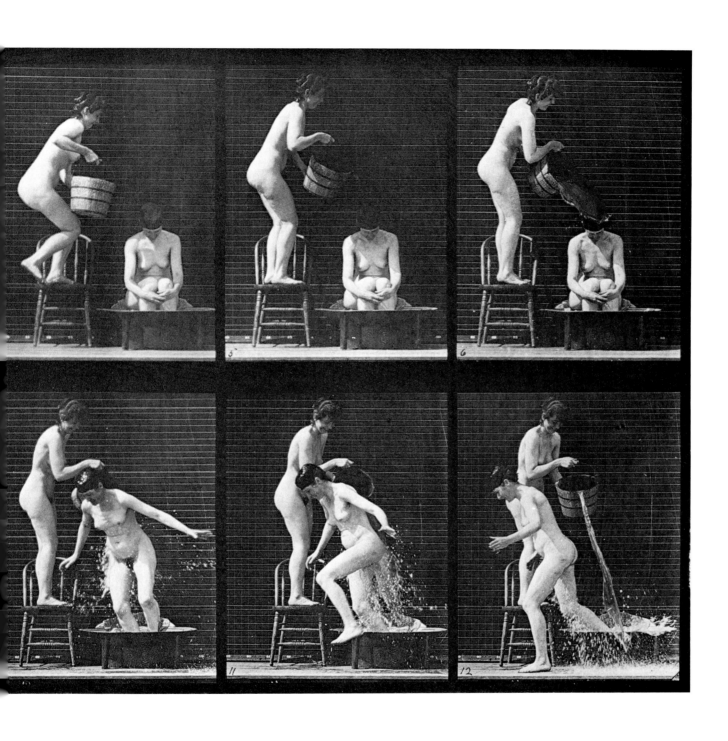

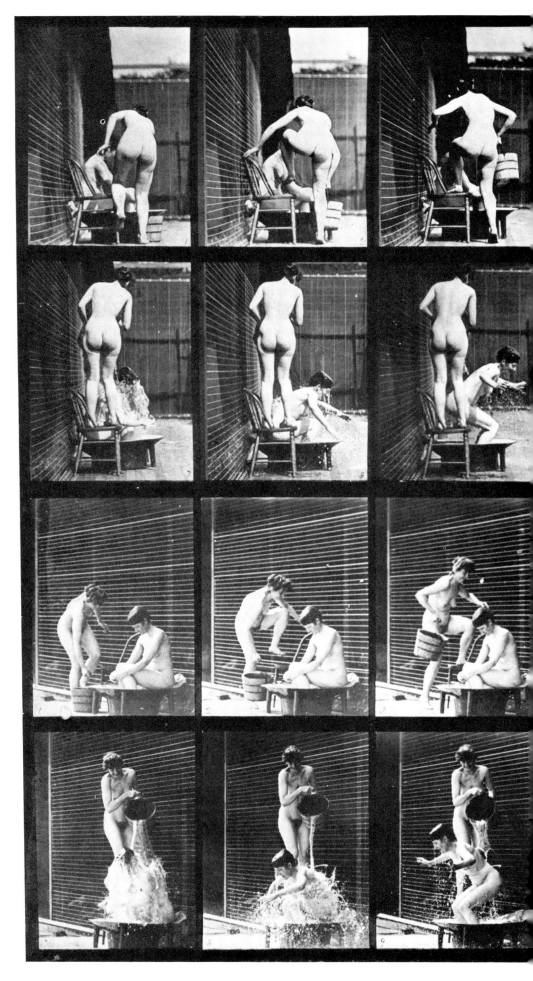

Plate 407. Woman pouring a bucket of water over another woman.

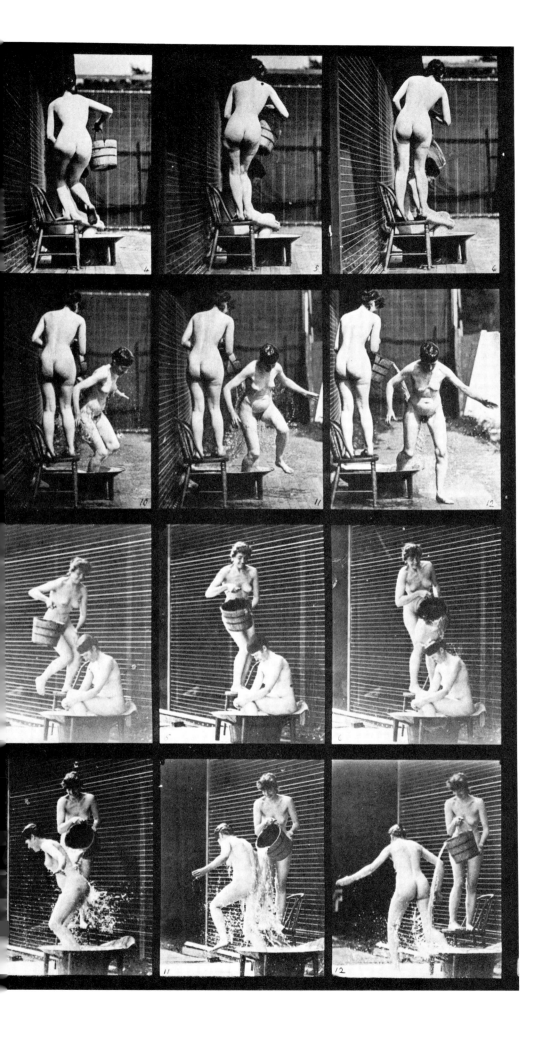

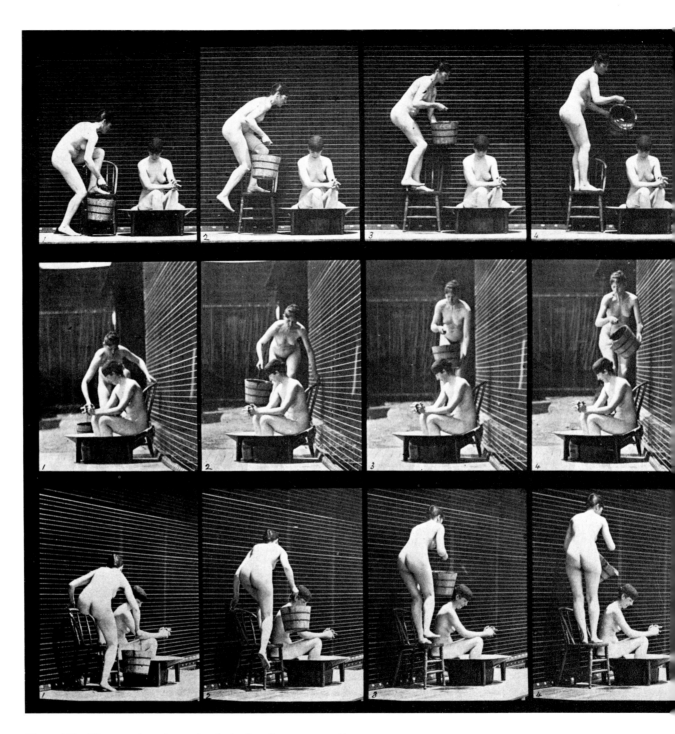

Plate 408. Woman pouring a bucket of water over another woman.

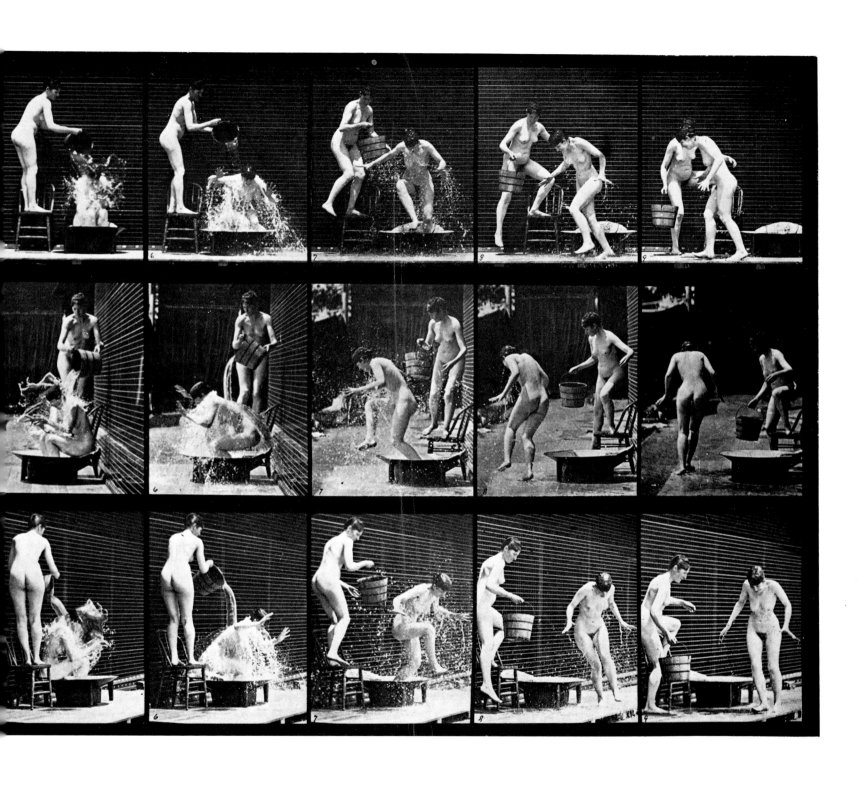

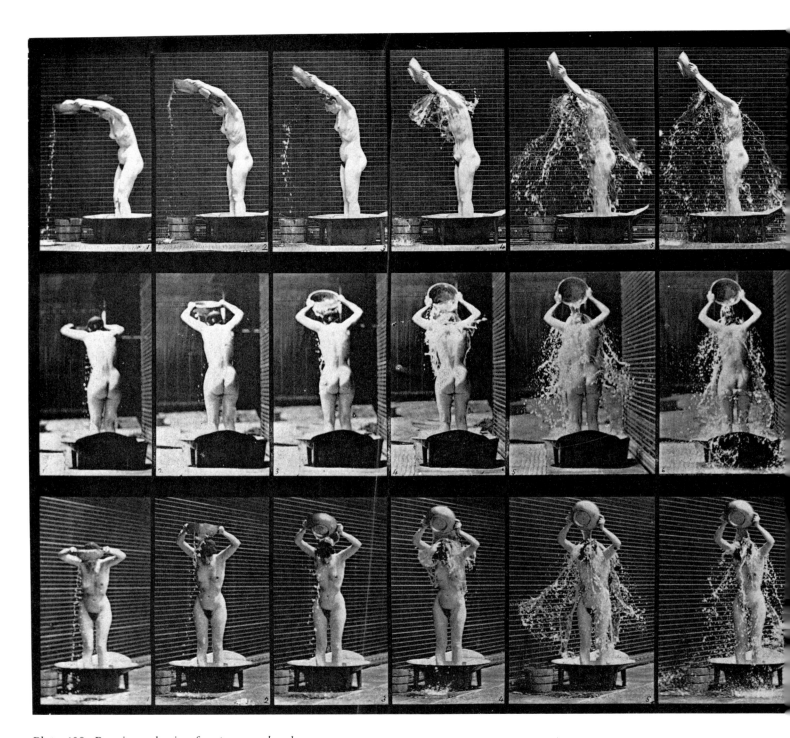

Plate 409. Pouring a basin of water over head.

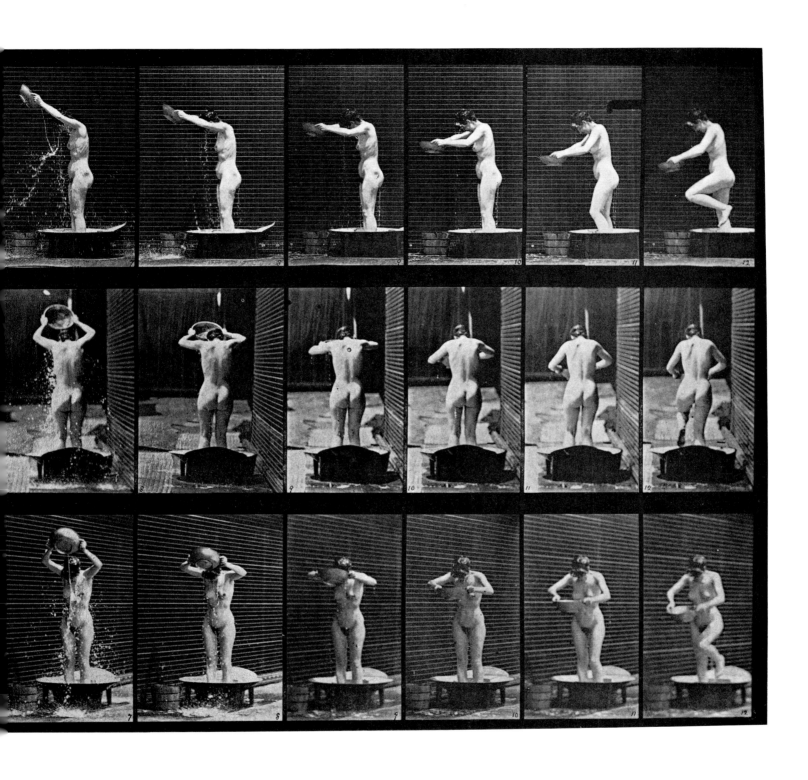

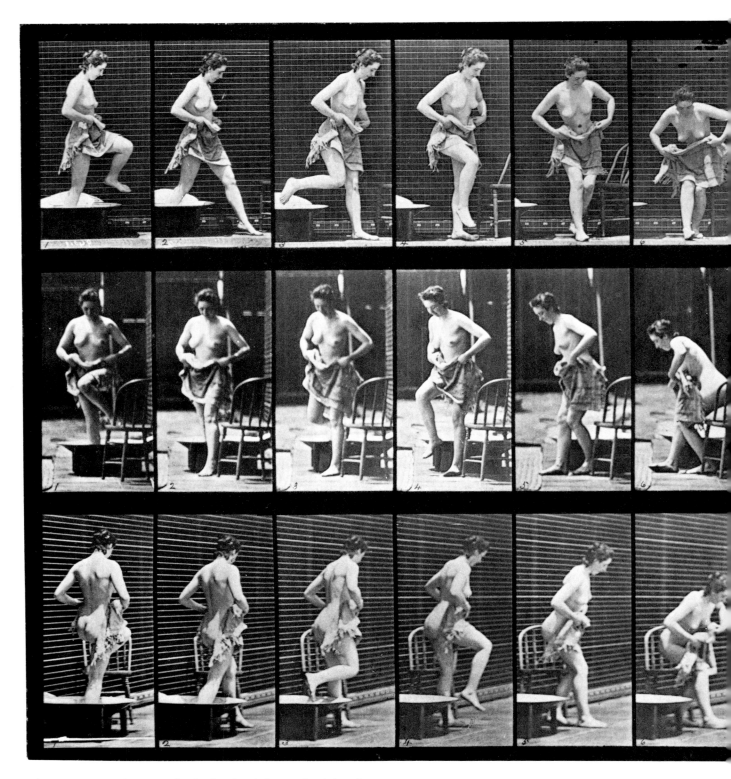

Plate 410. Stepping out of a bathtub, sitting and wiping feet.

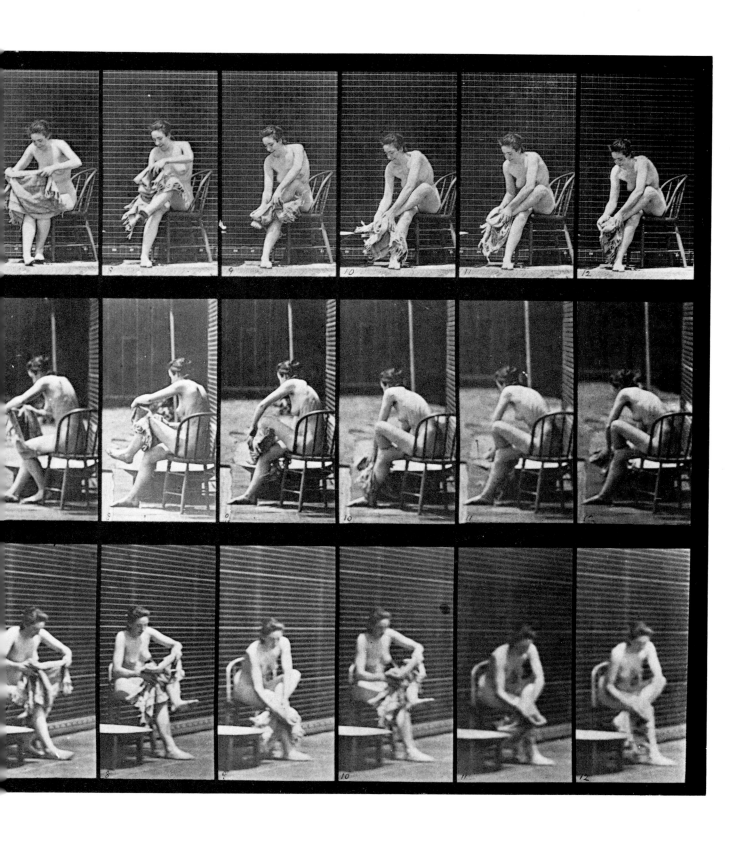

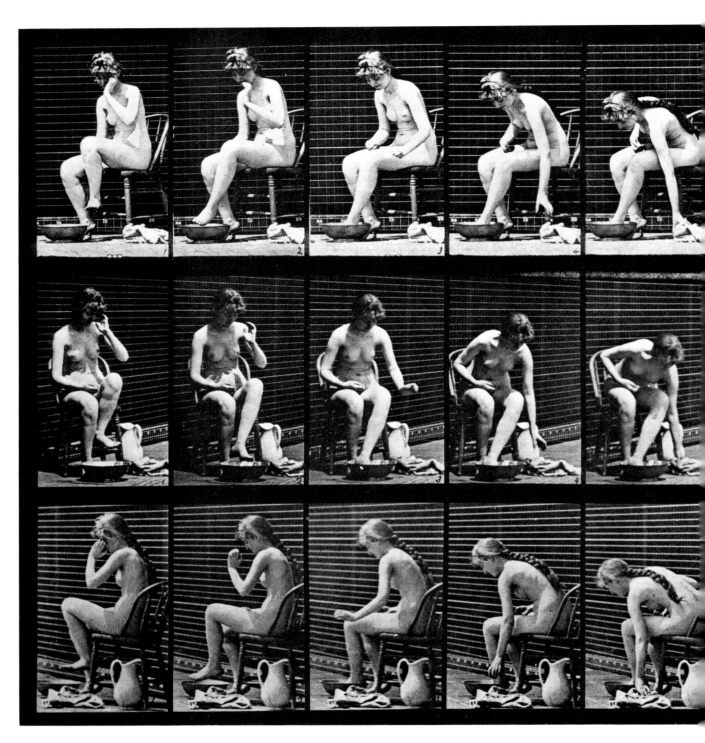

Plate 411. Lifting a towel while sitting and wiping feet.

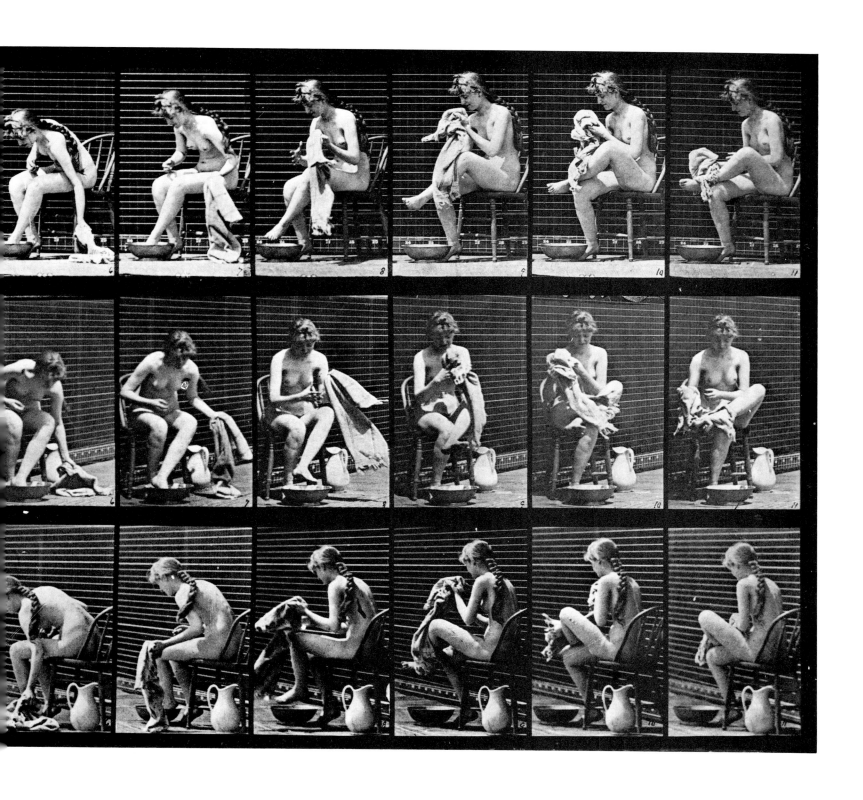

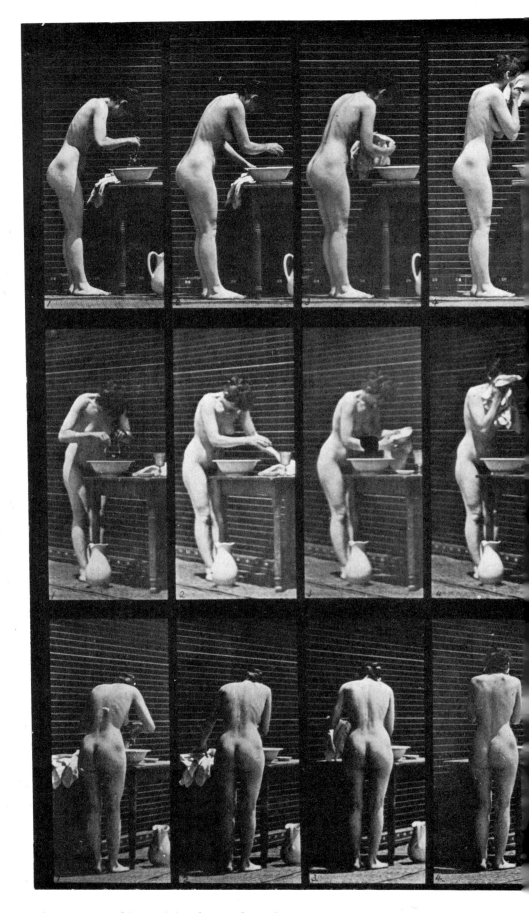

Plate 412. Washing, wiping face and turning.

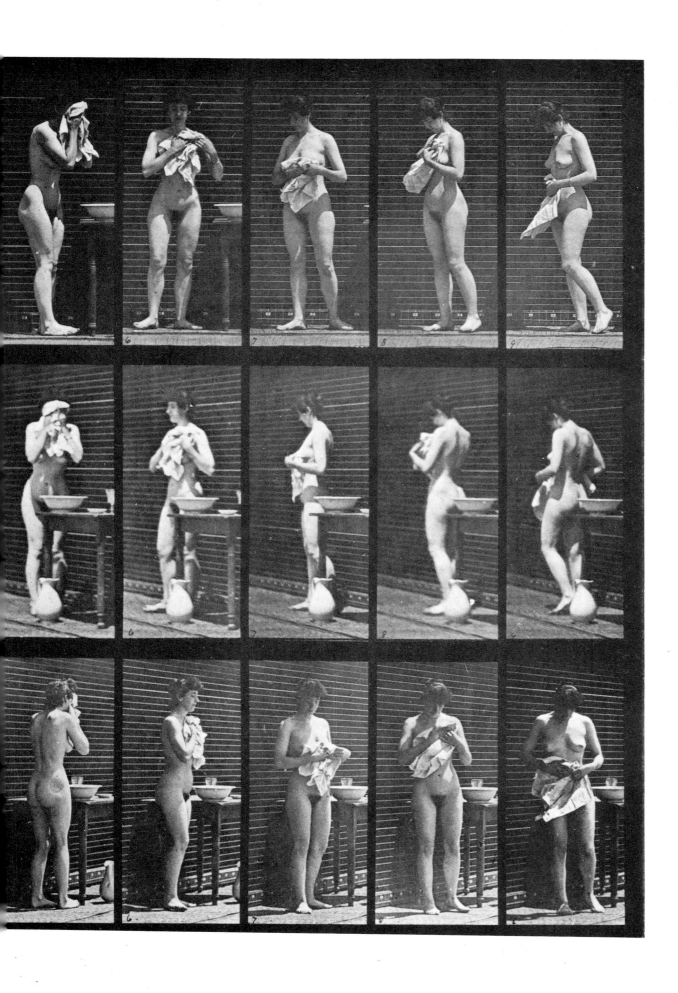

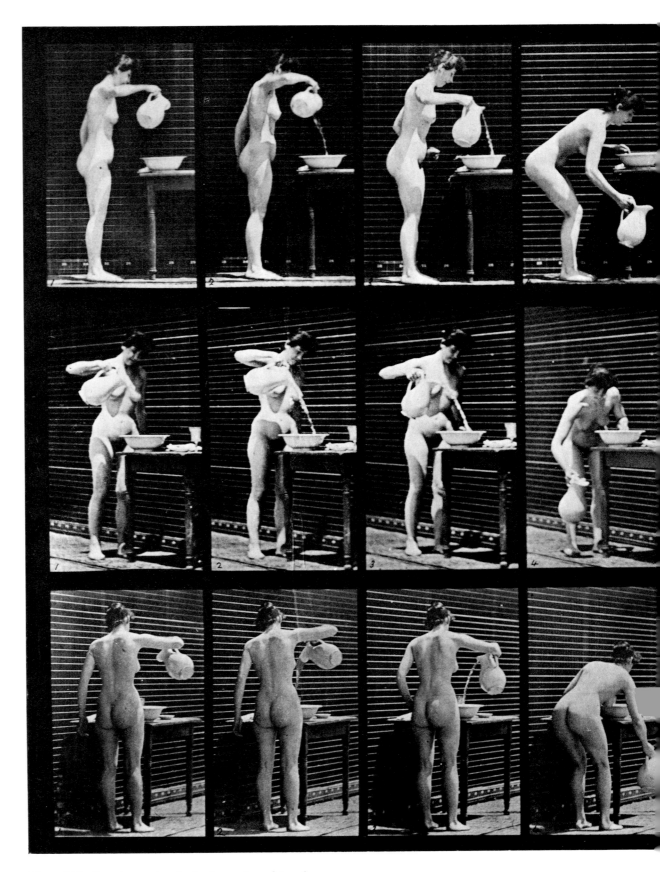

Plate 413. Pouring water in basin and washing face.

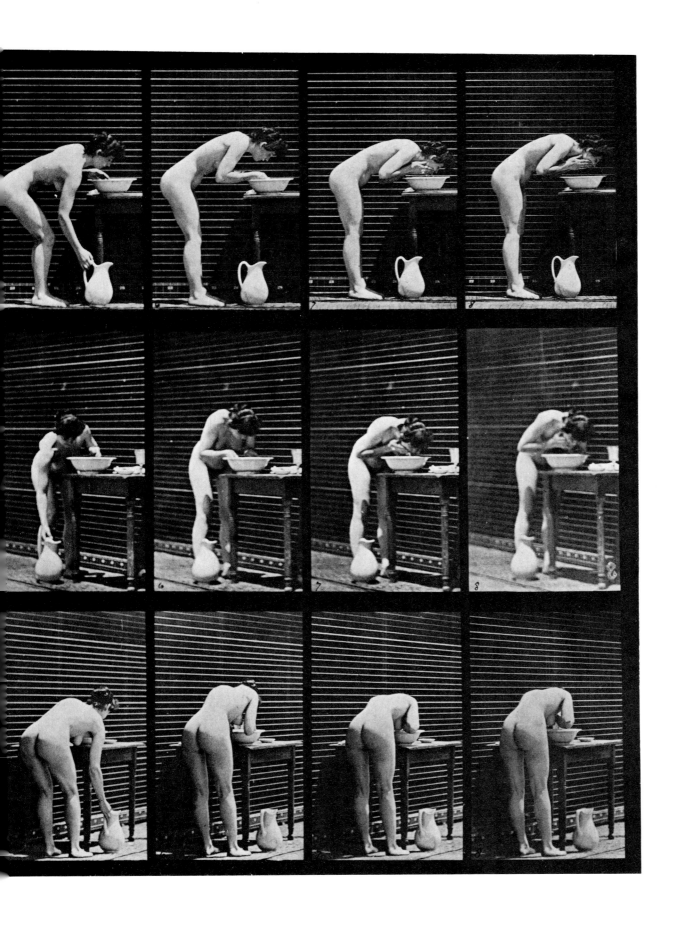

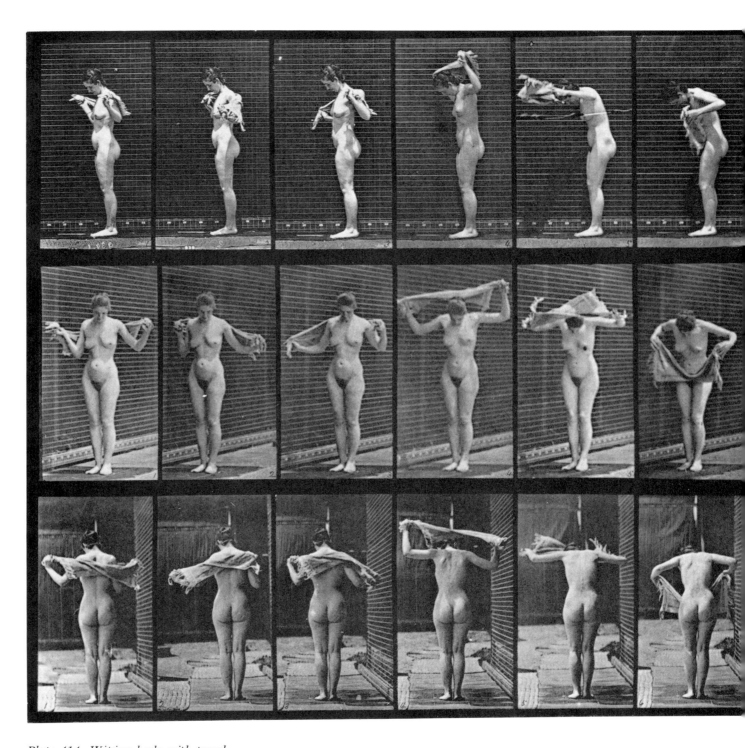

Plate 414. Wiping body with towel.

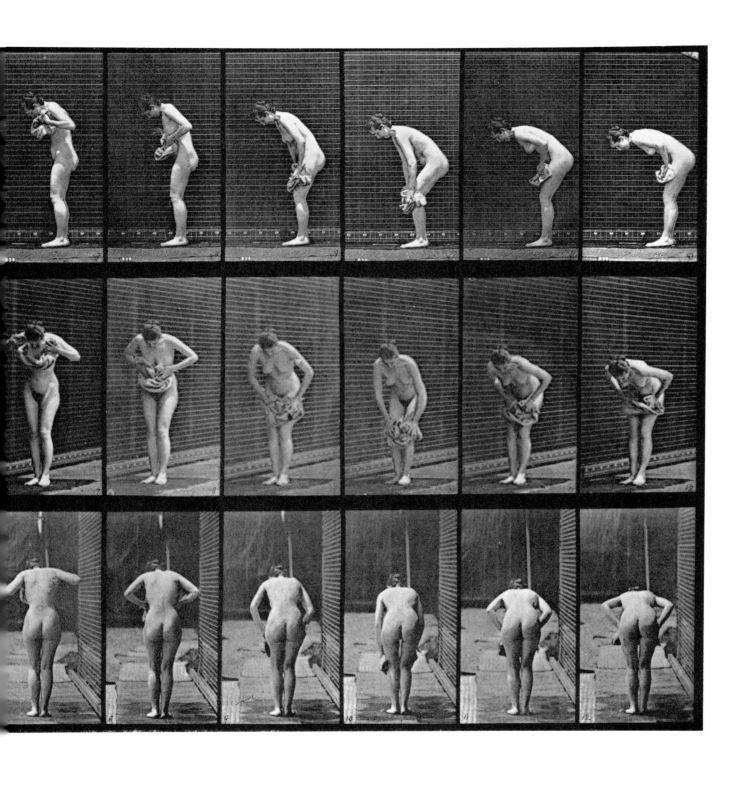

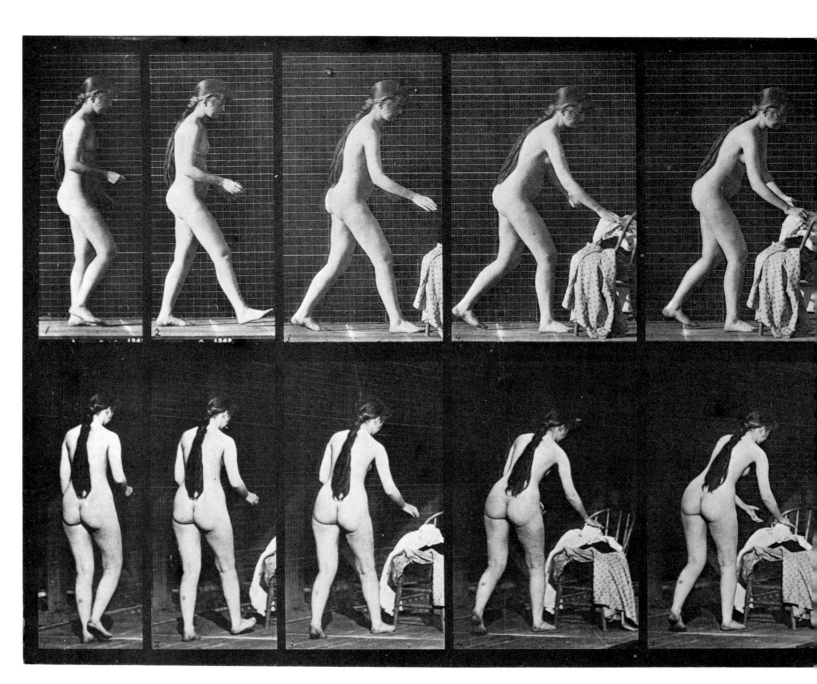

Plate 415. Toilet, preparing to put on clothing.

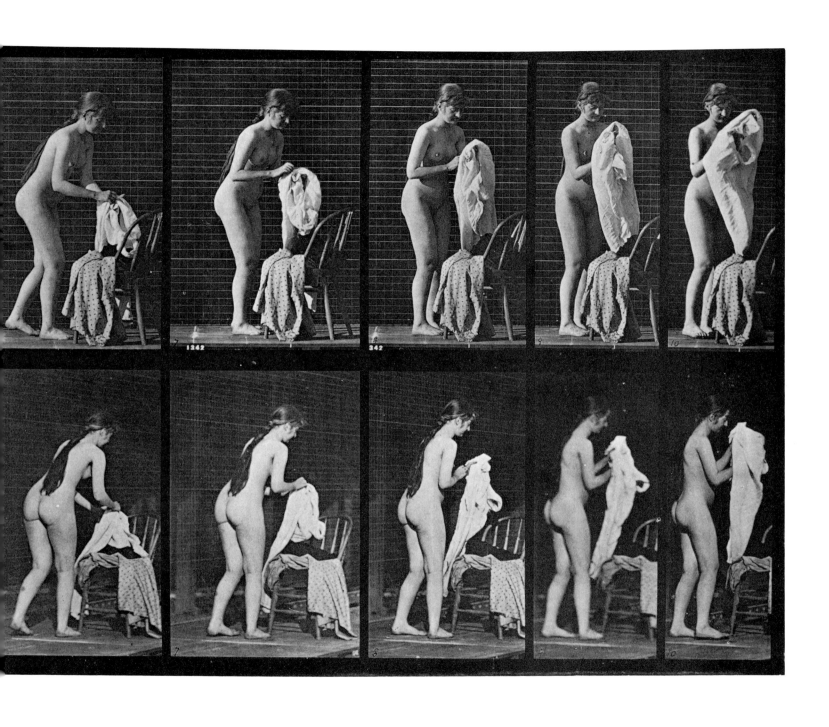

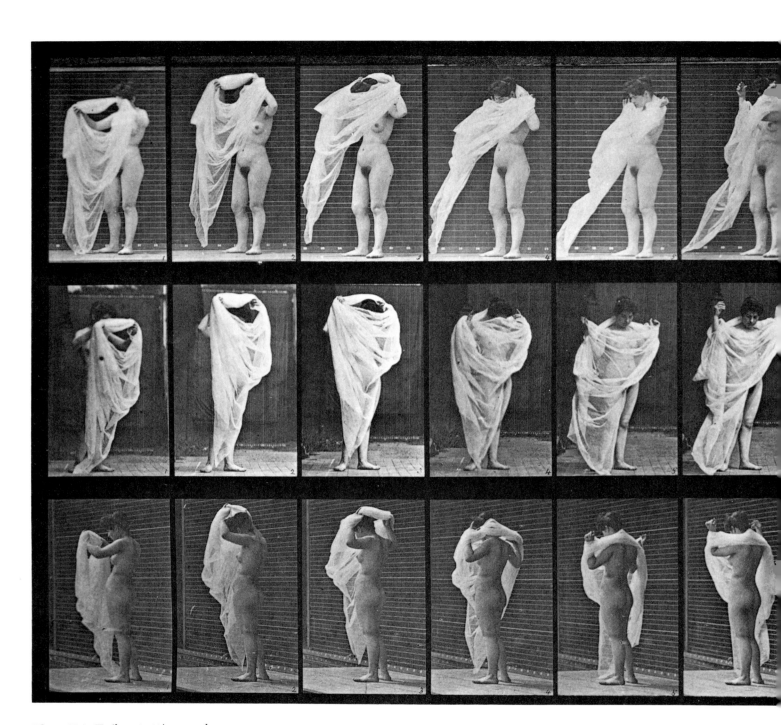

Plate 416. Toilet, putting on dress.

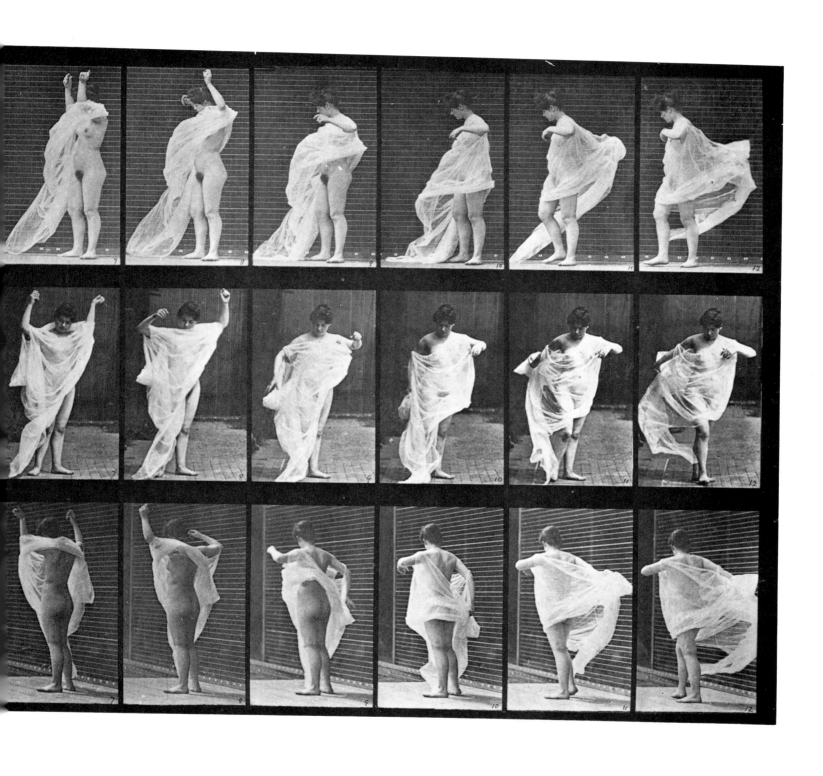

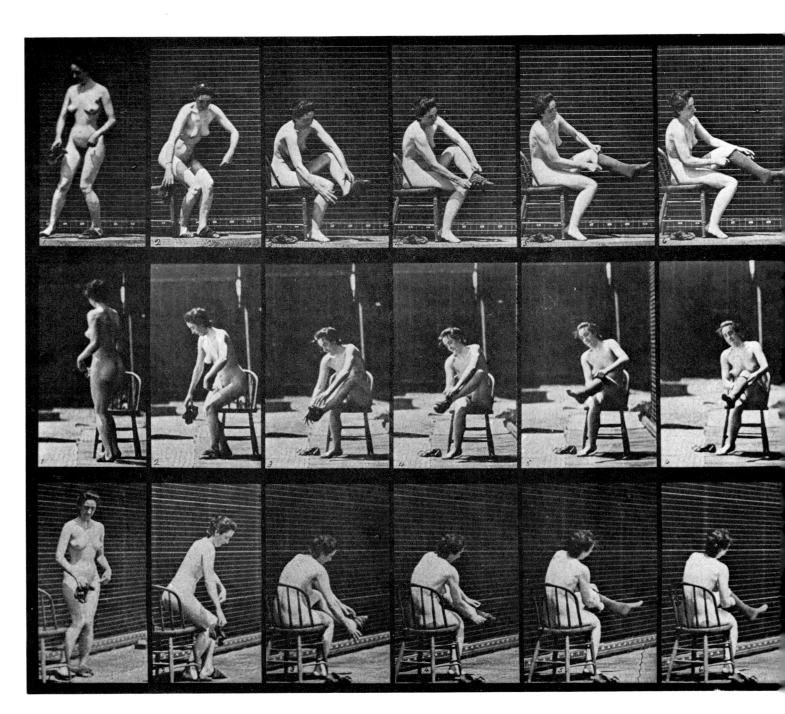

Plate 418. Toilet, sitting and putting on stockings.

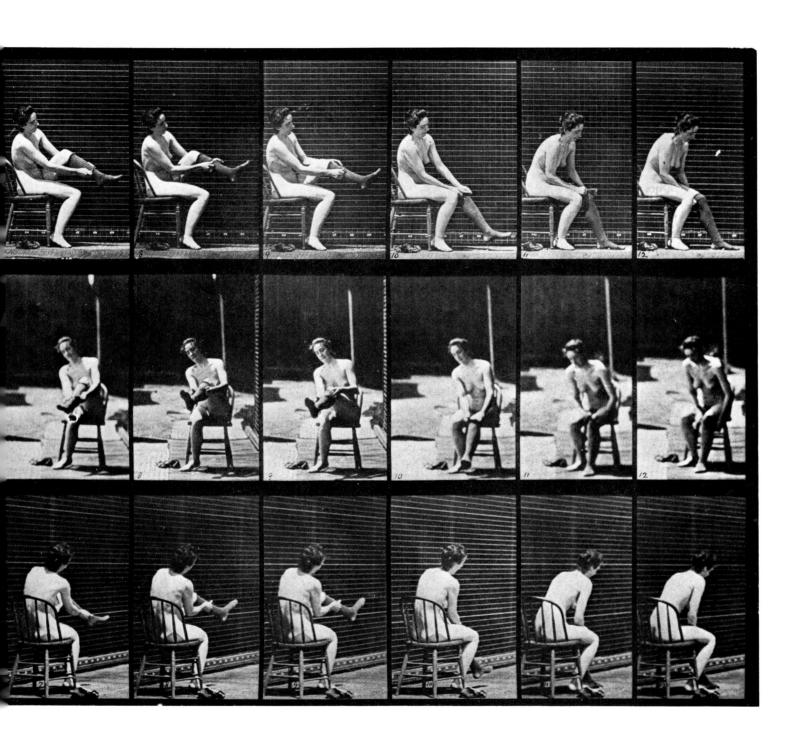

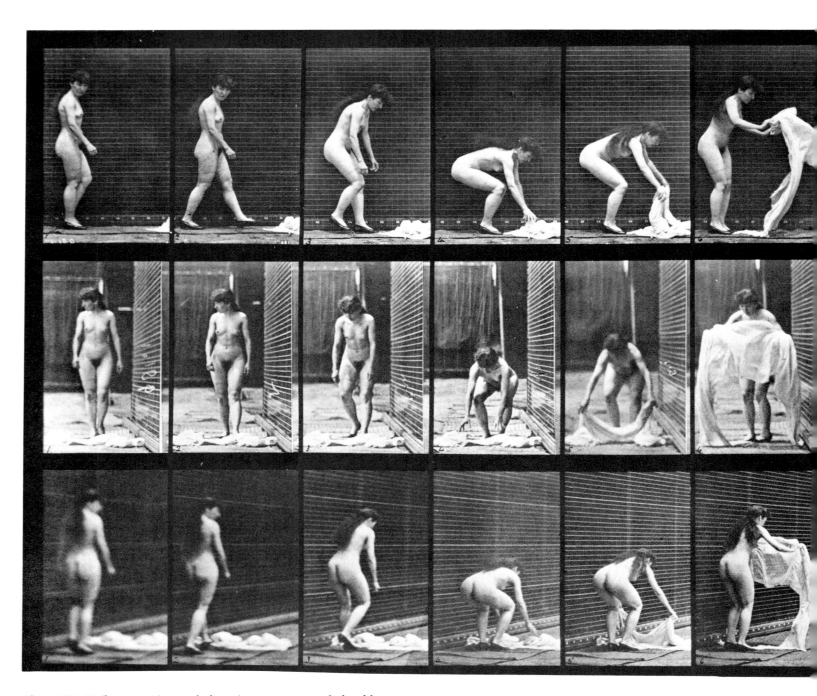

Plate 419. Toilet, stooping and throwing wrap around shoulders.

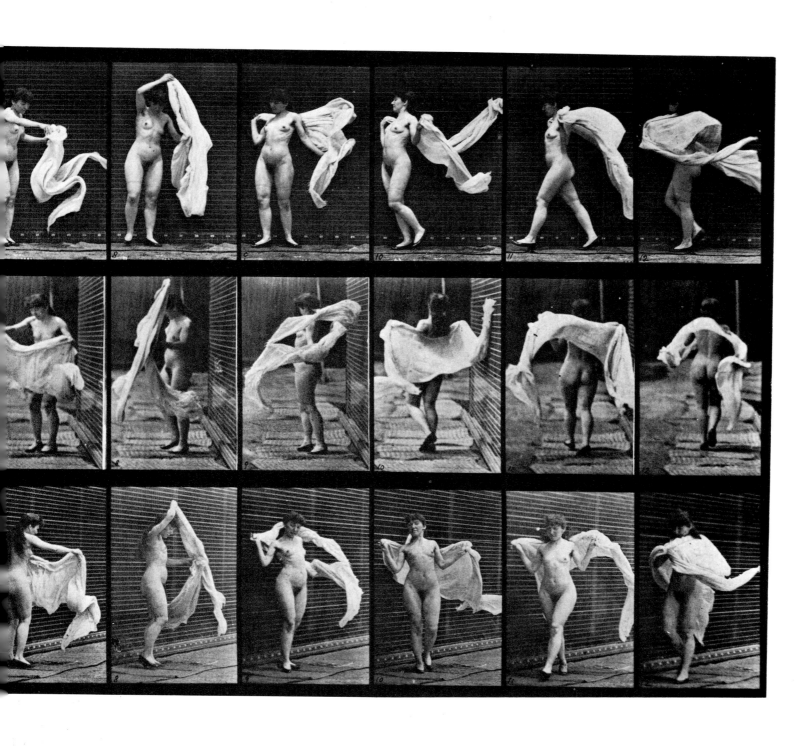

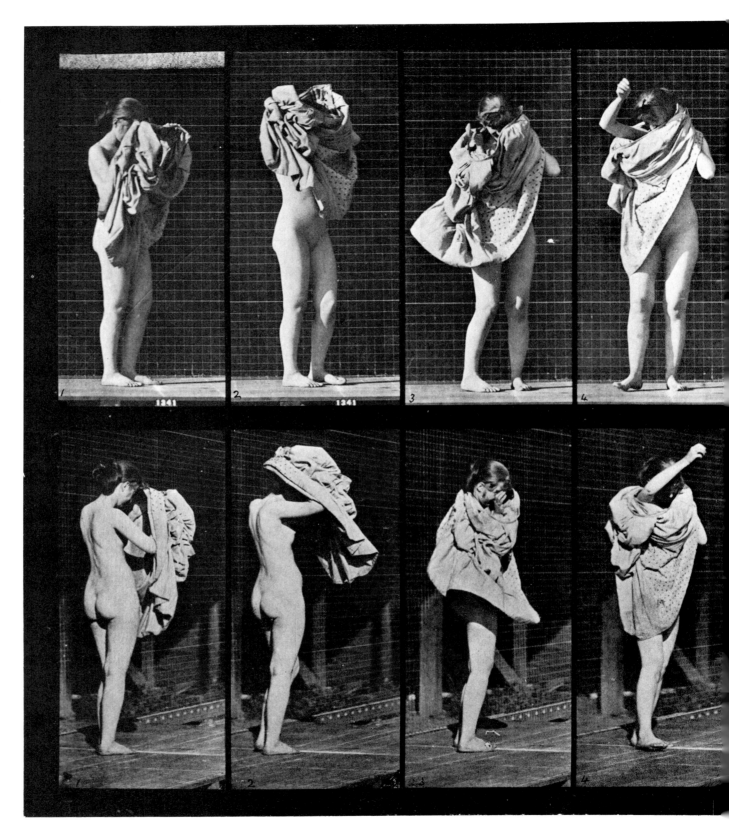

Plate 425. Toilet, putting on a dress and turning around.

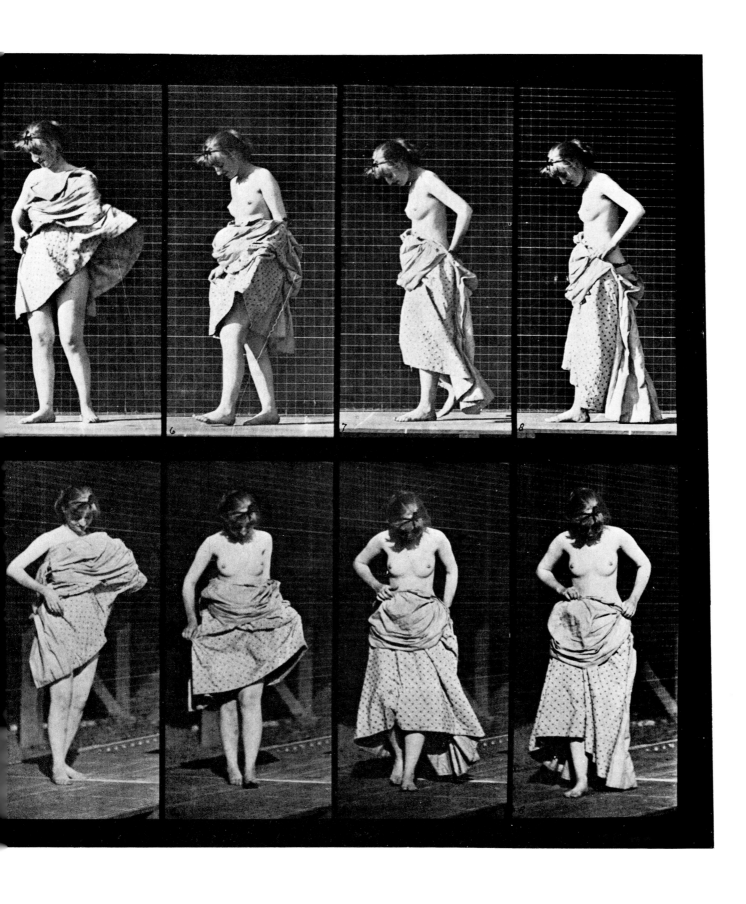

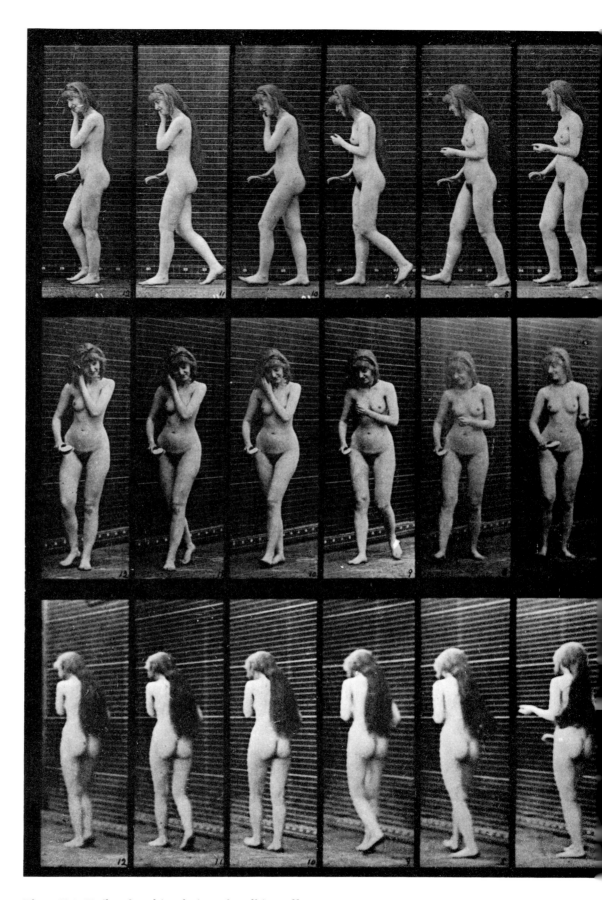

Plate 426. Toilet, brushing hair and walking off.

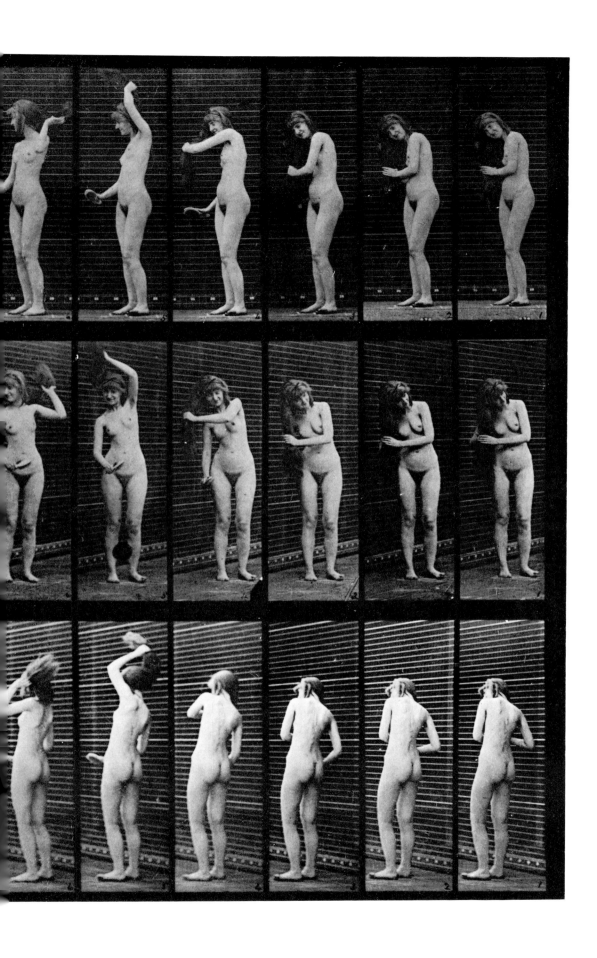

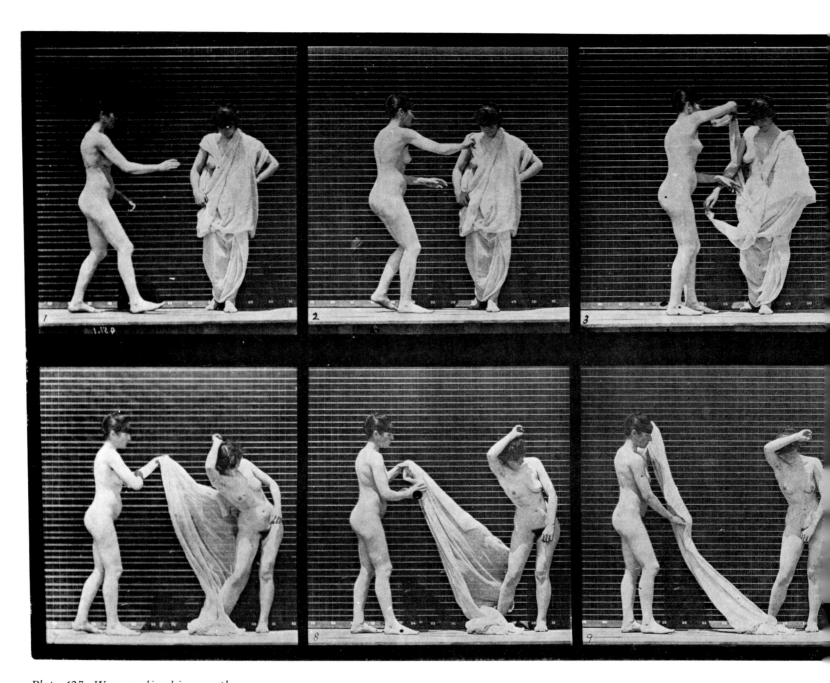

Plate 427. Woman disrobing another.

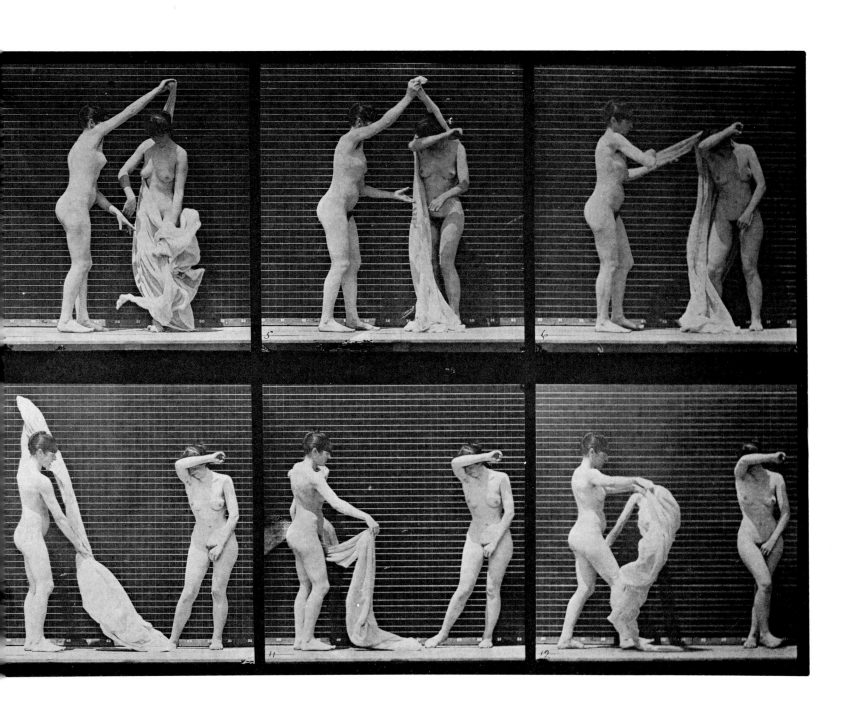

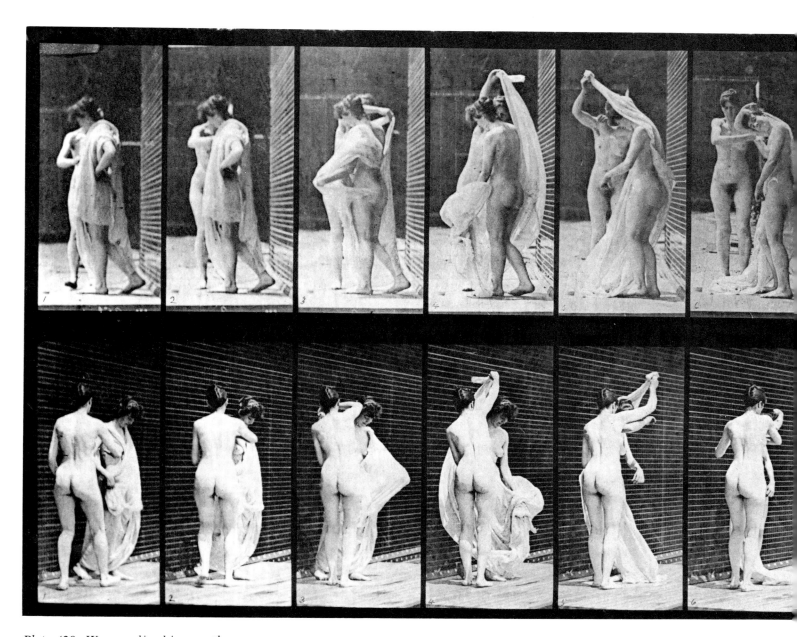

Plate 428. Woman disrobing another.

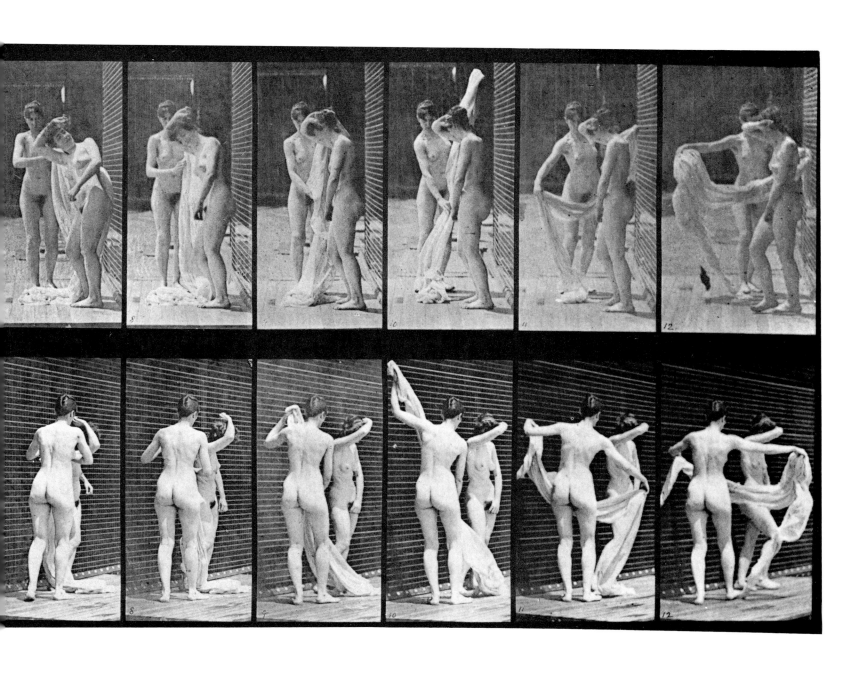

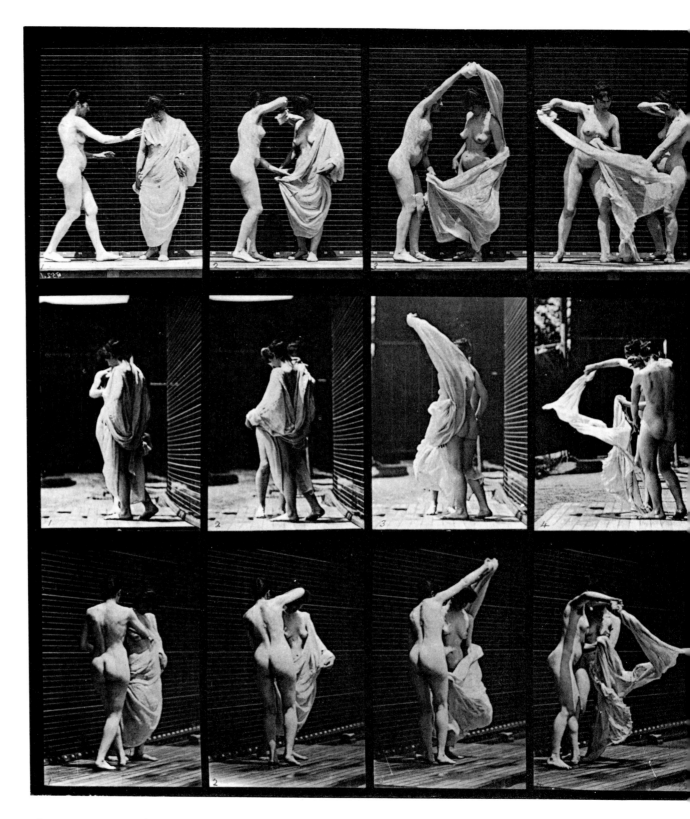

Plate 429. Woman disrobing another.

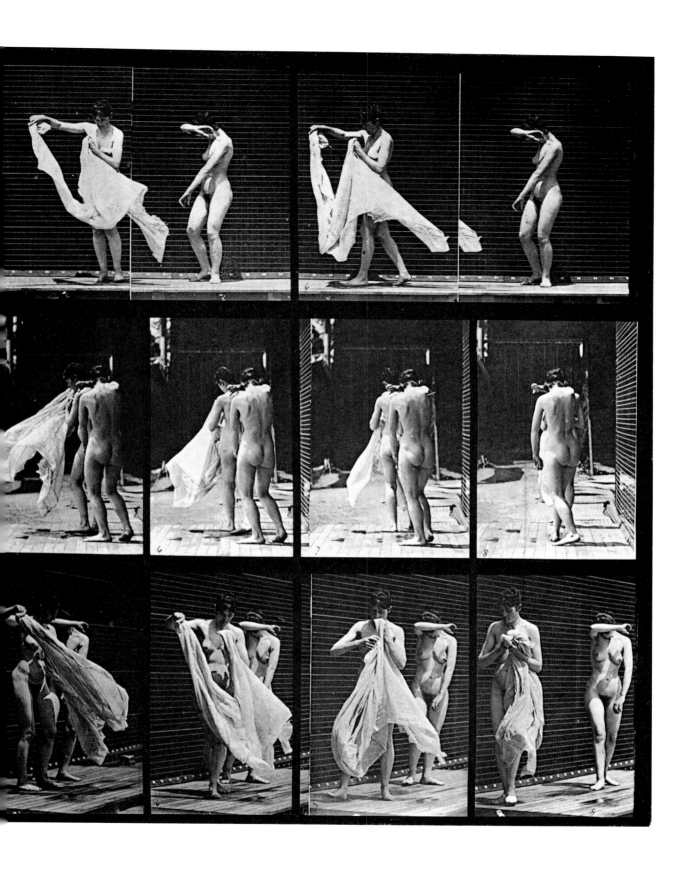

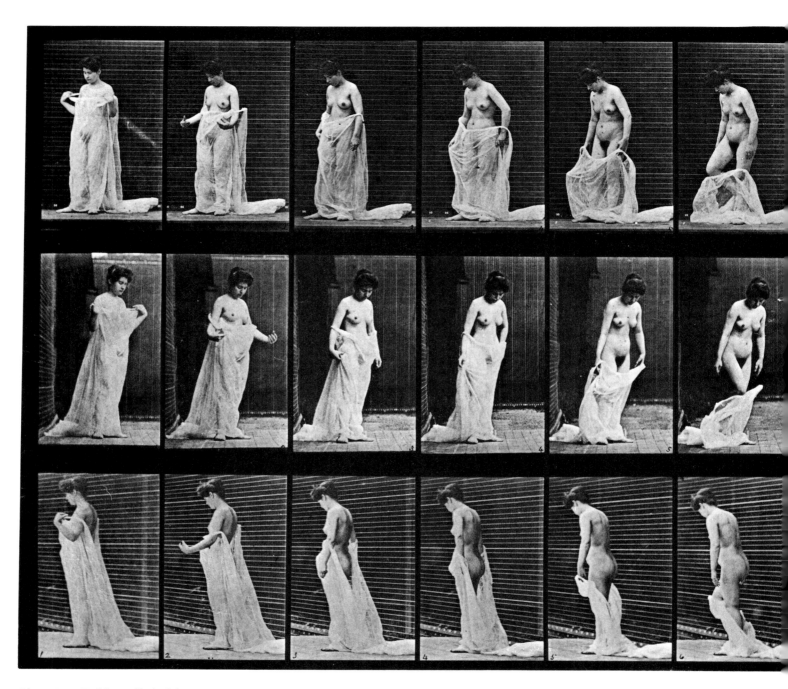

Plate 430. Taking off clothing.

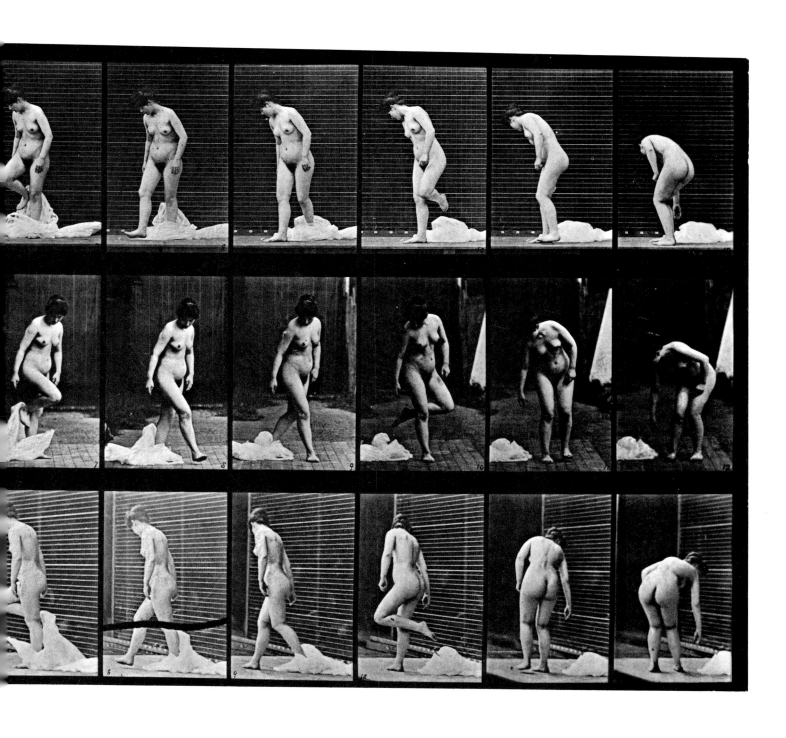

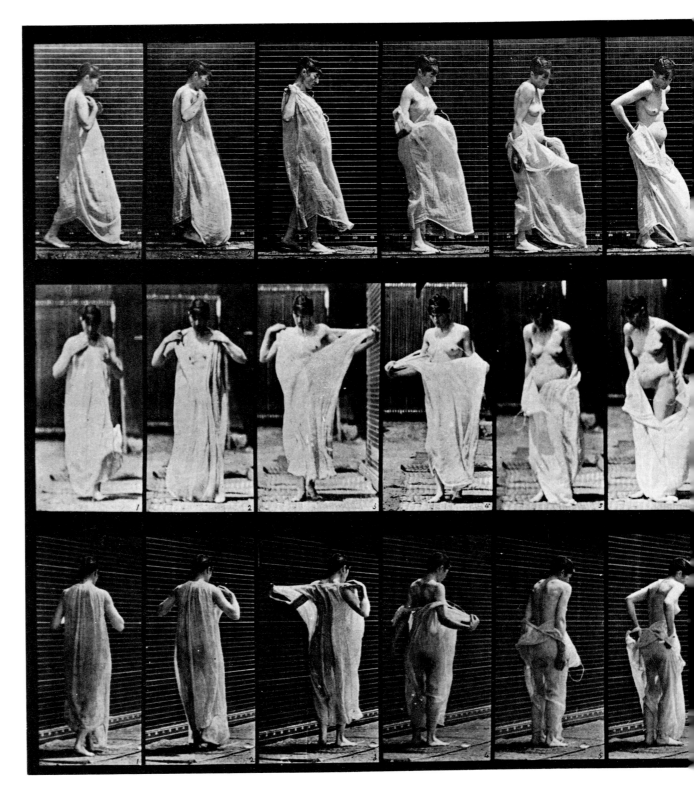

Plate 431. Taking off clothing.

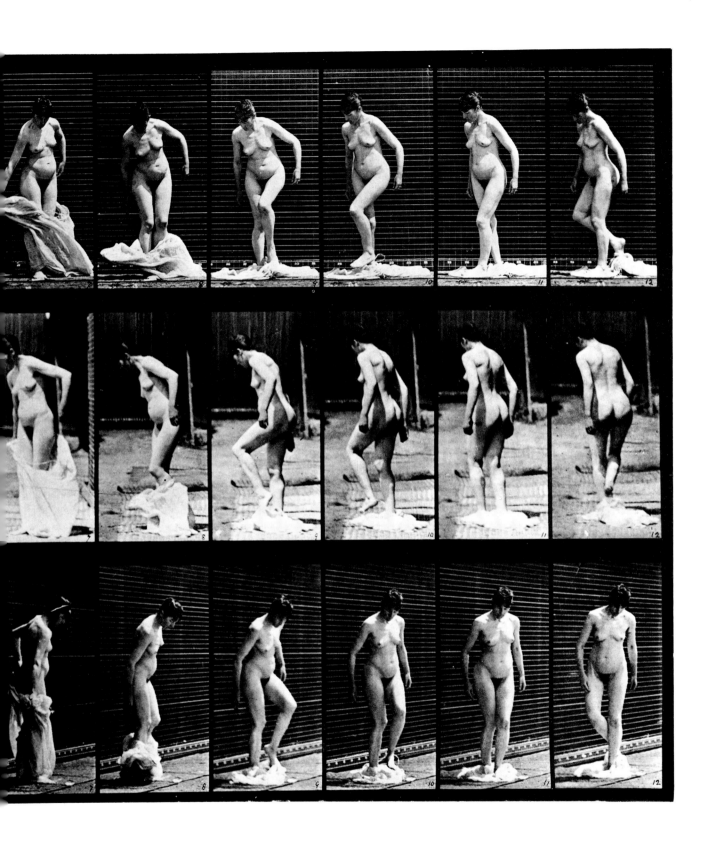

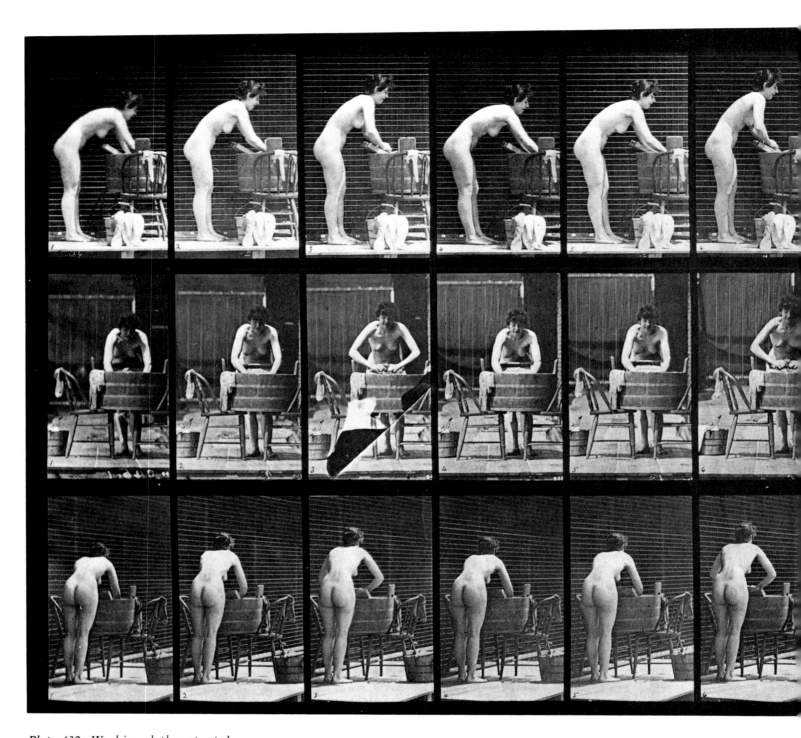

Plate 432. Washing clothes at a tub.

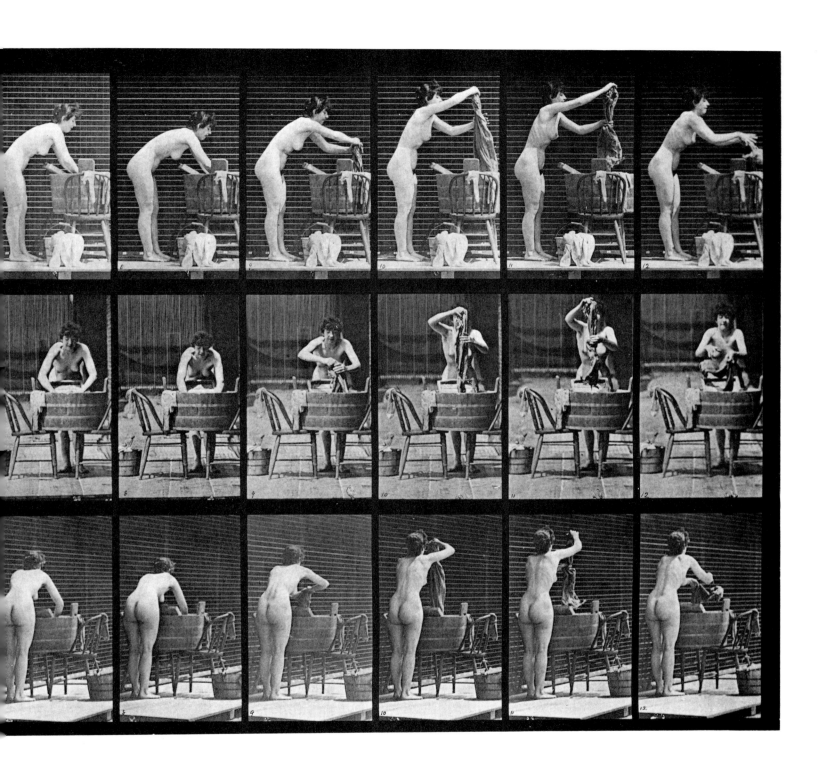

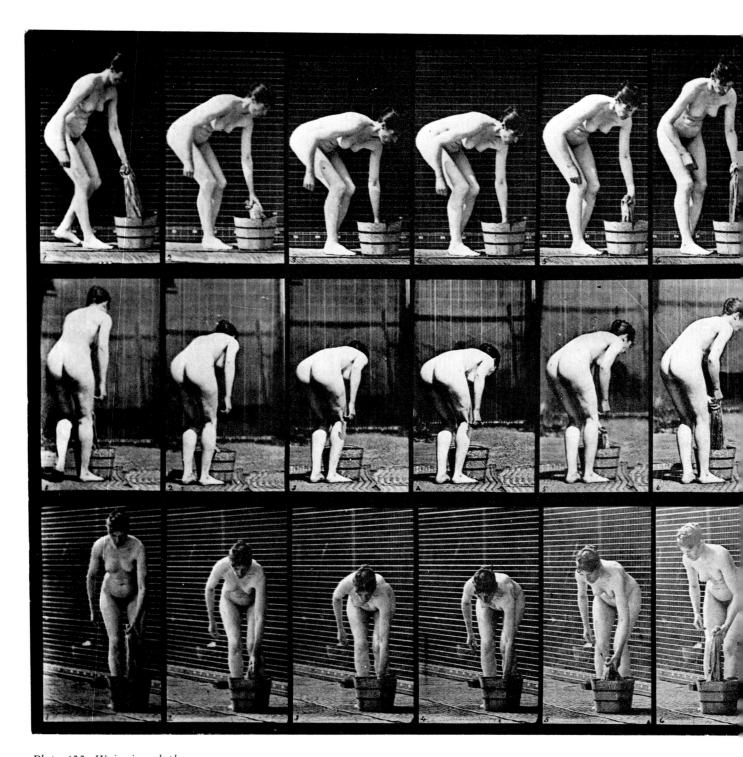

Plate 433. Wringing clothes.

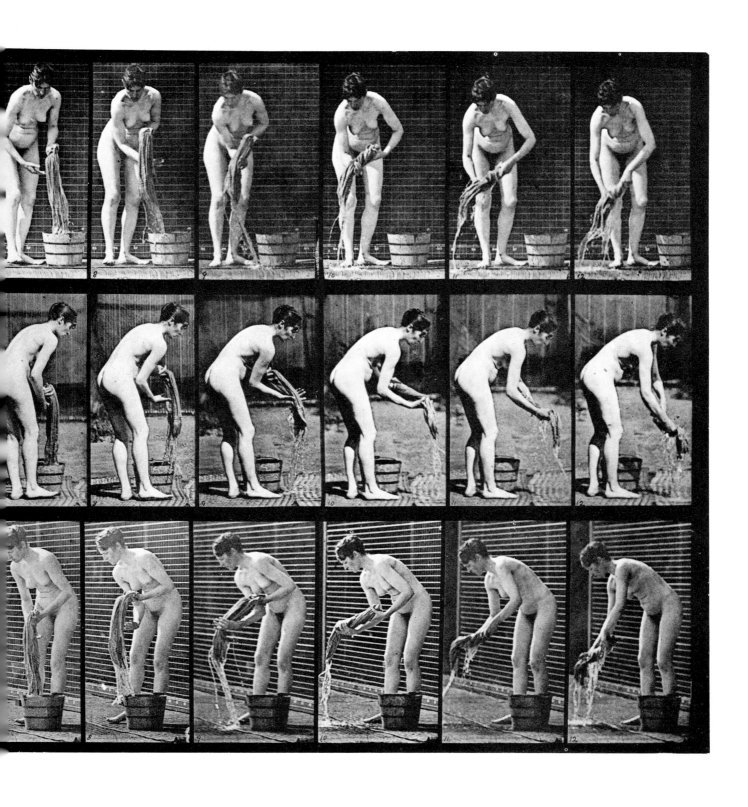

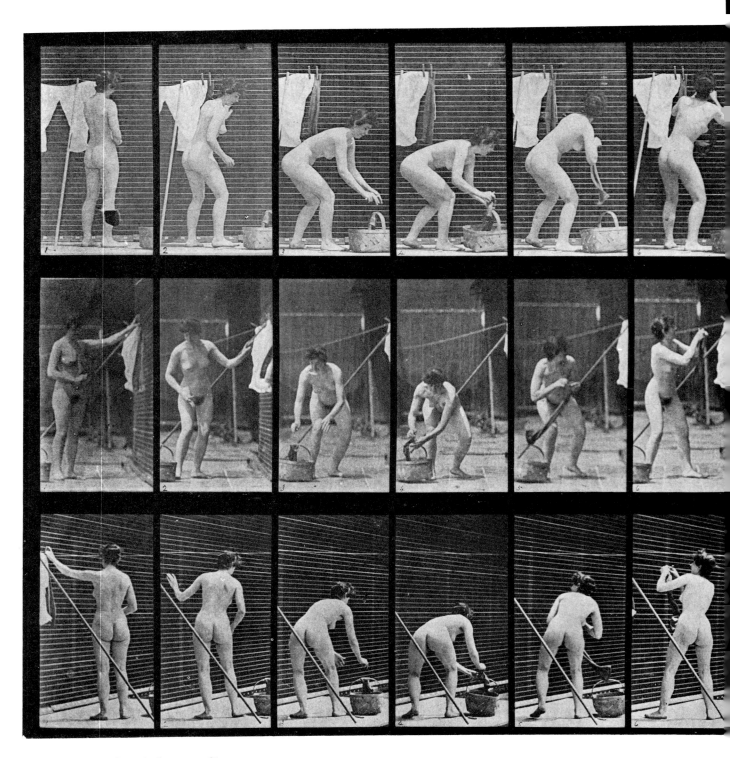

Plate 434. Hanging clothes on a line.

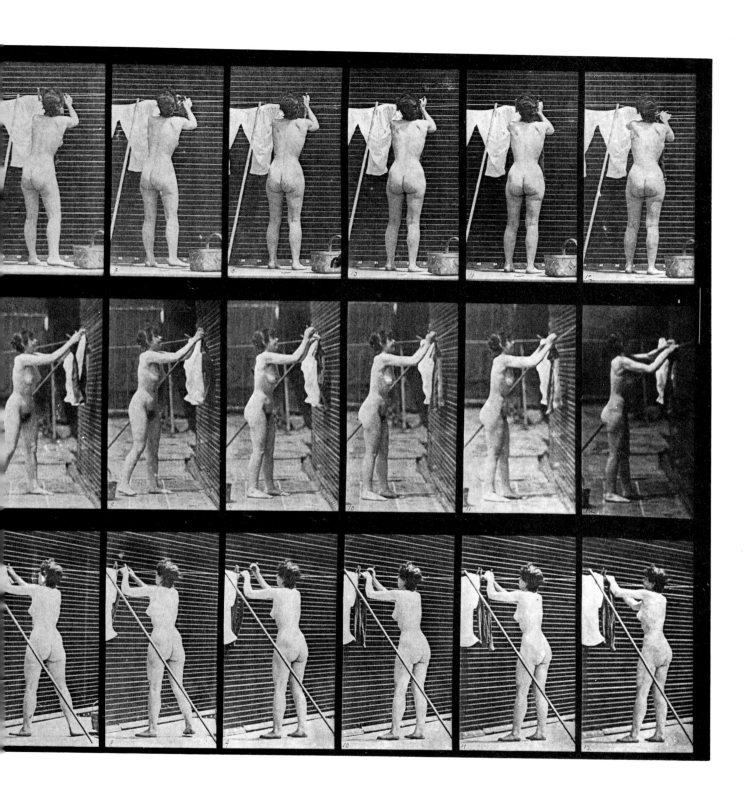

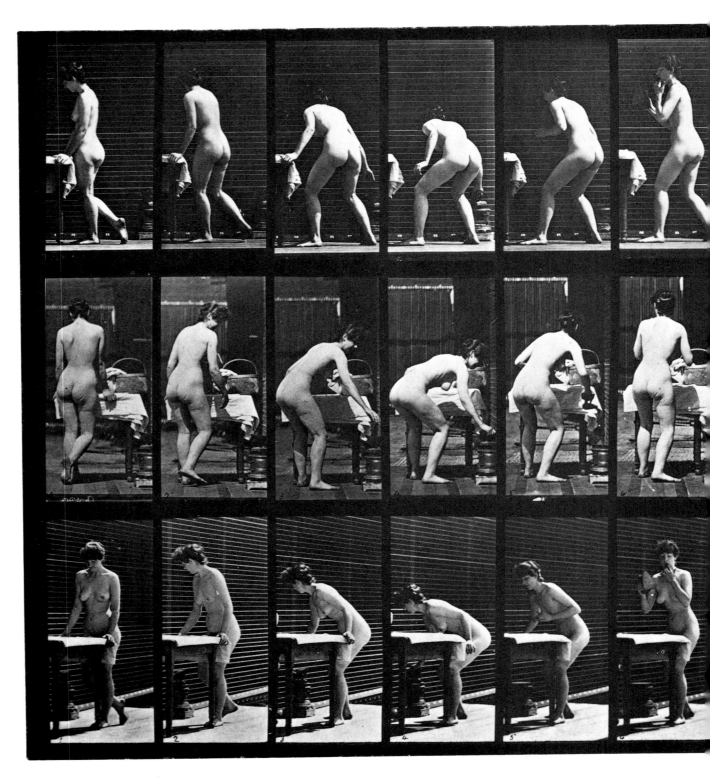

Plate 435. Ironing clothes.

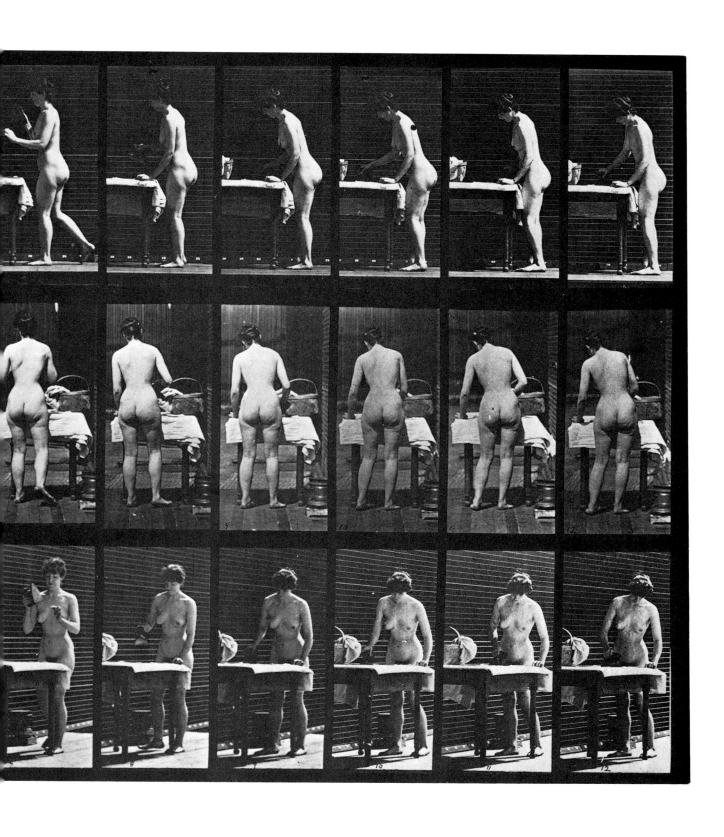

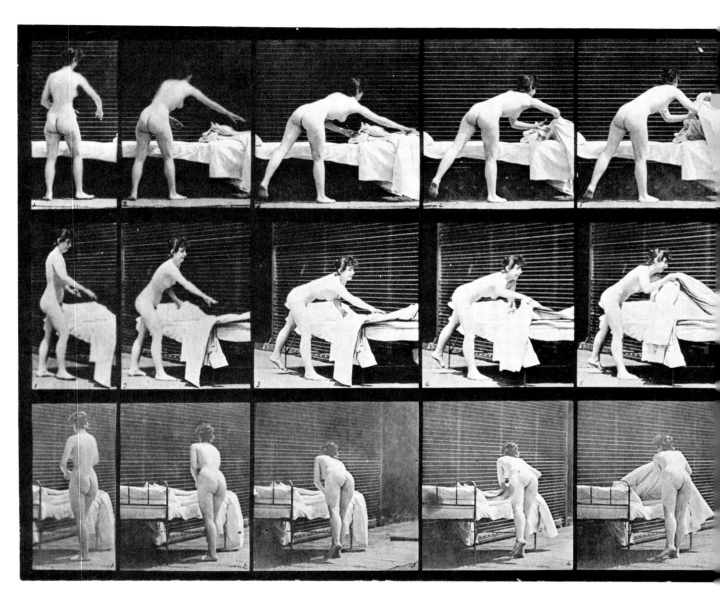

Plate 436. Making up a bed.

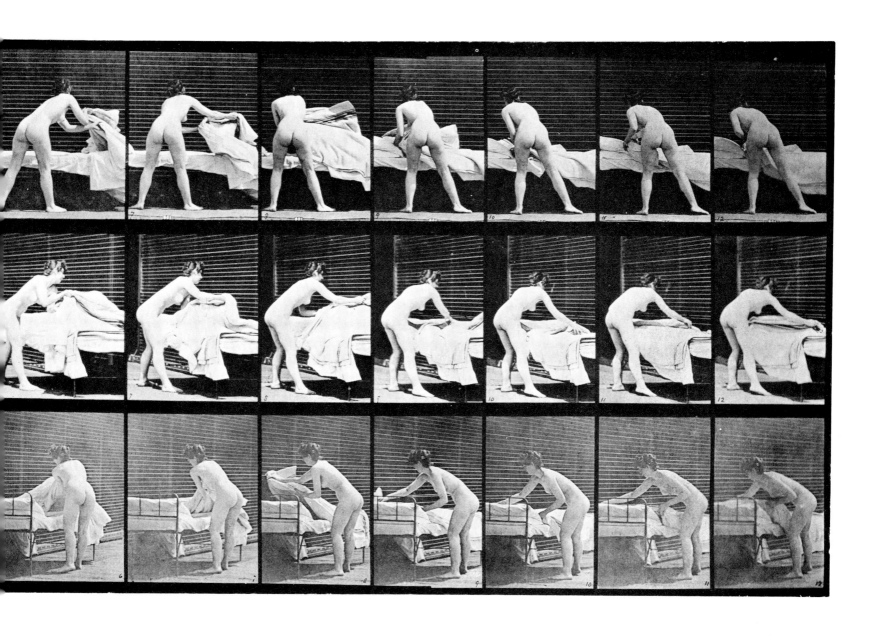

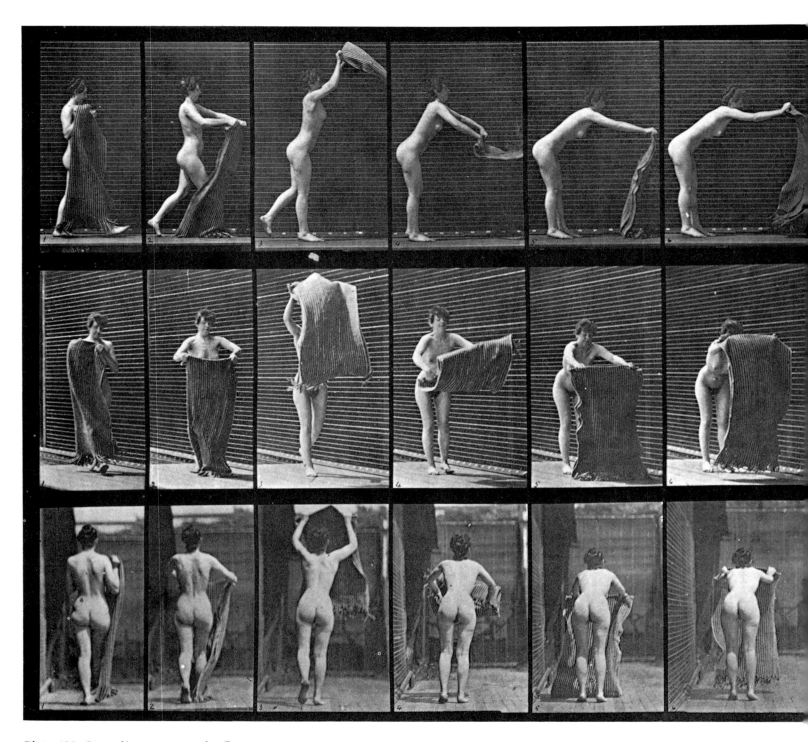

Plate 439. Spreading a rug on the floor.

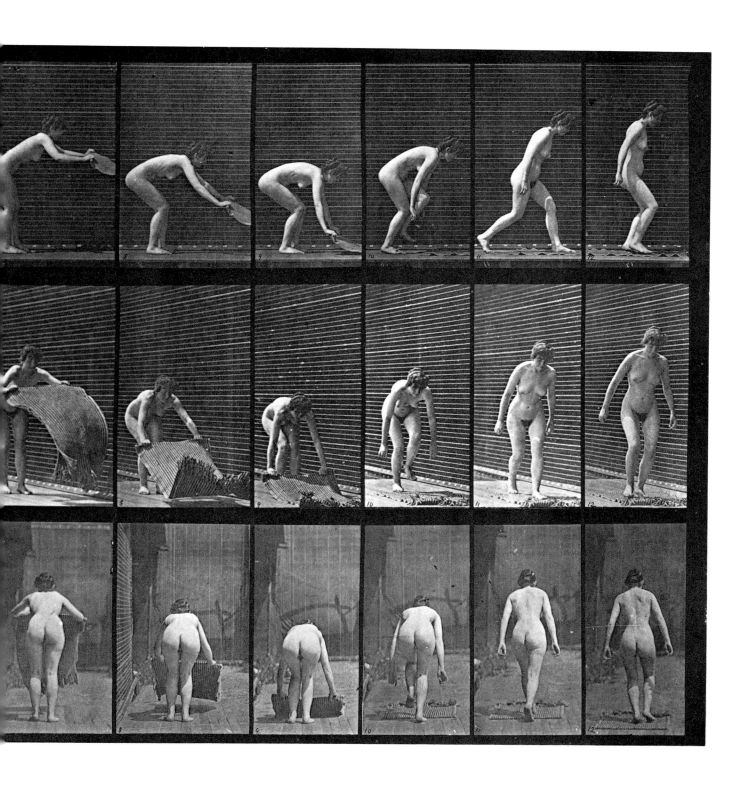

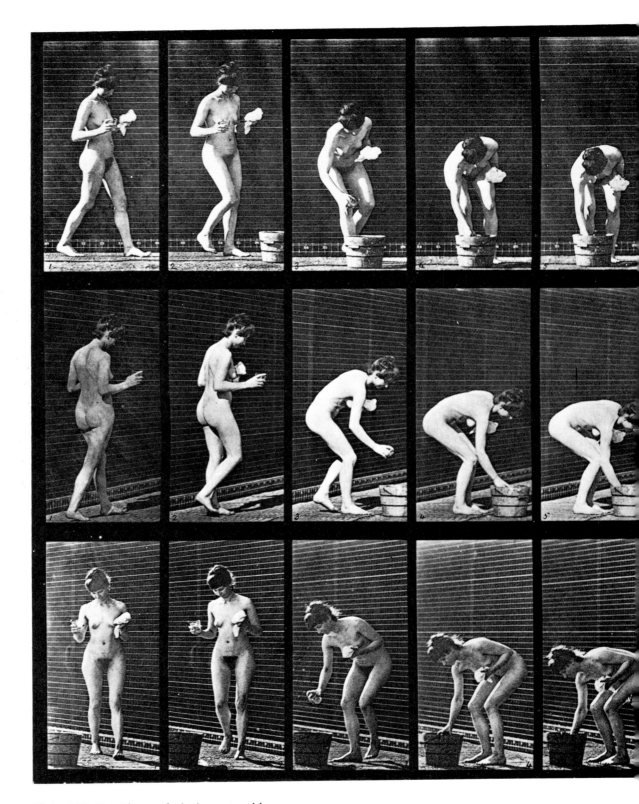

Plate 440. Stooping and rinsing a tumbler.

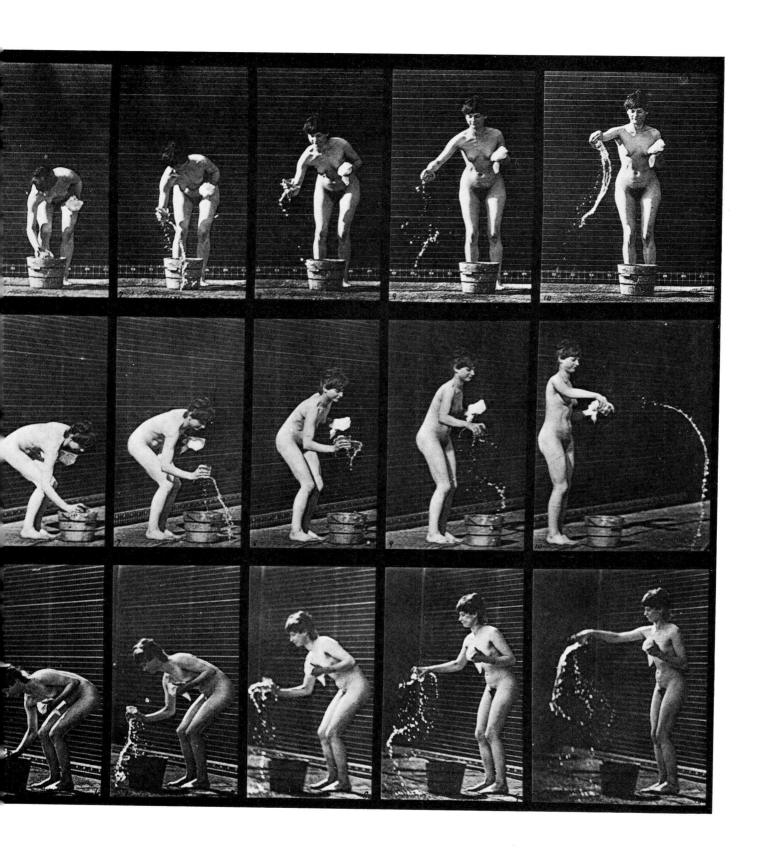

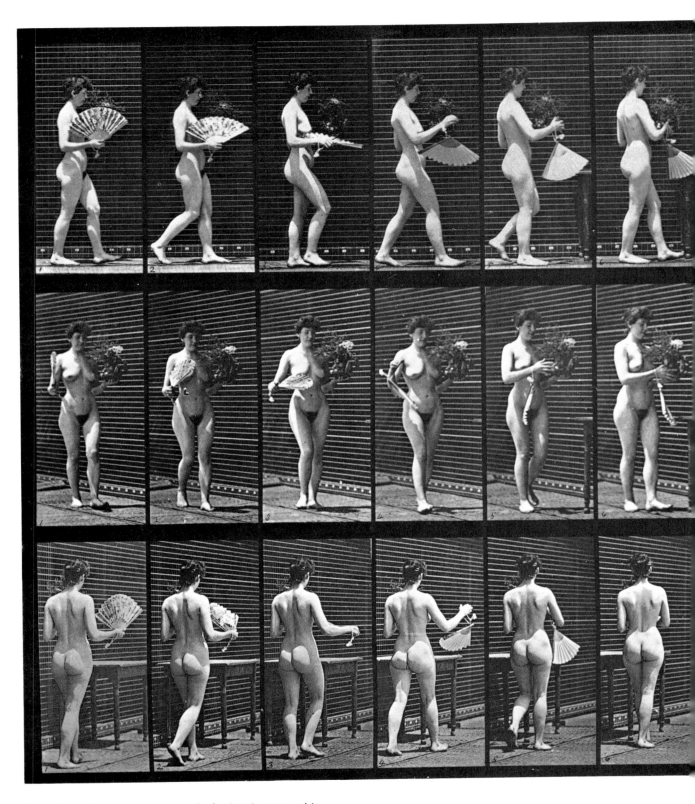

Plate 441. Carrying a vase and placing it on a table.

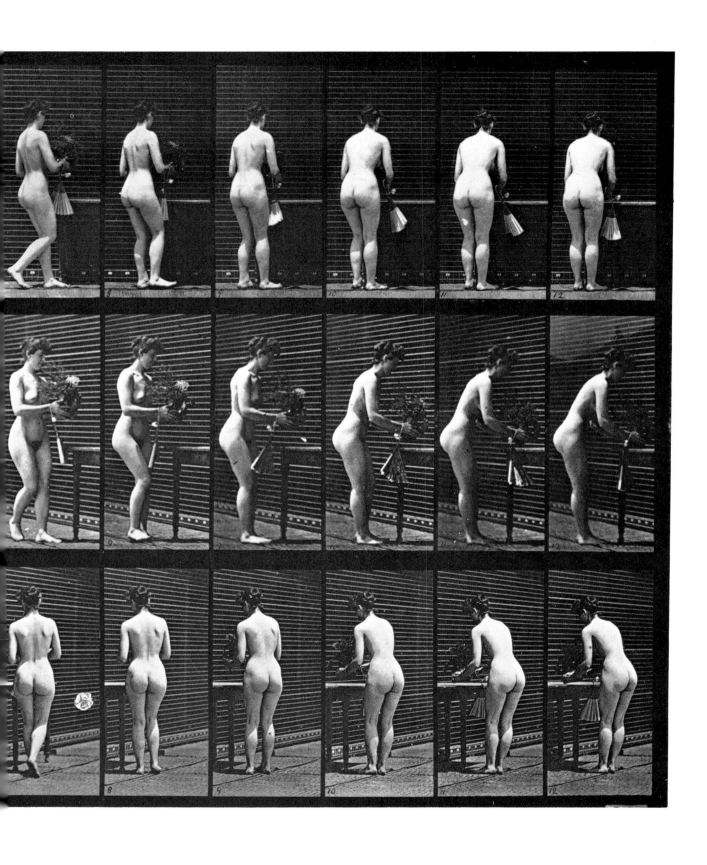

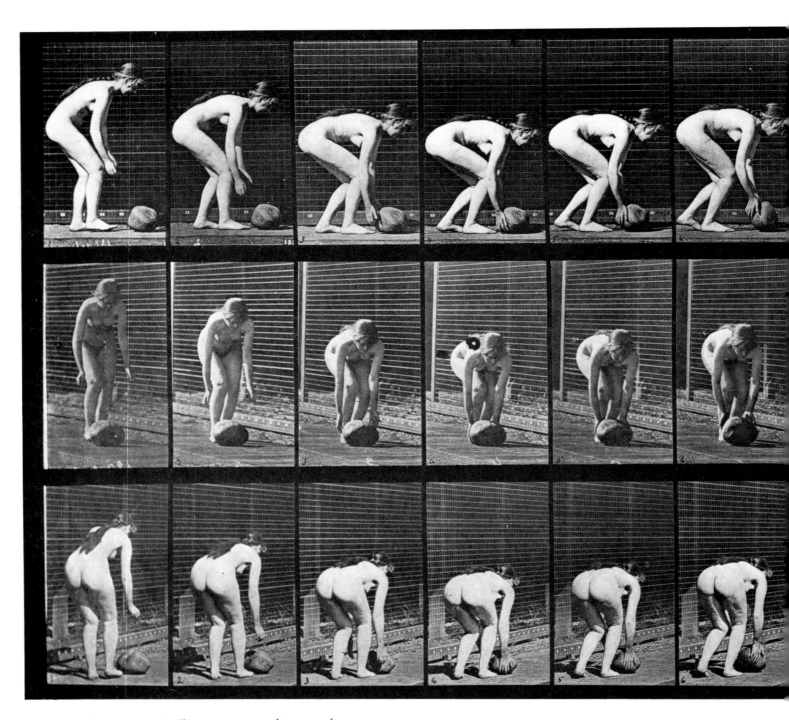

Plate 442. Stooping and rolling a stone on the ground.

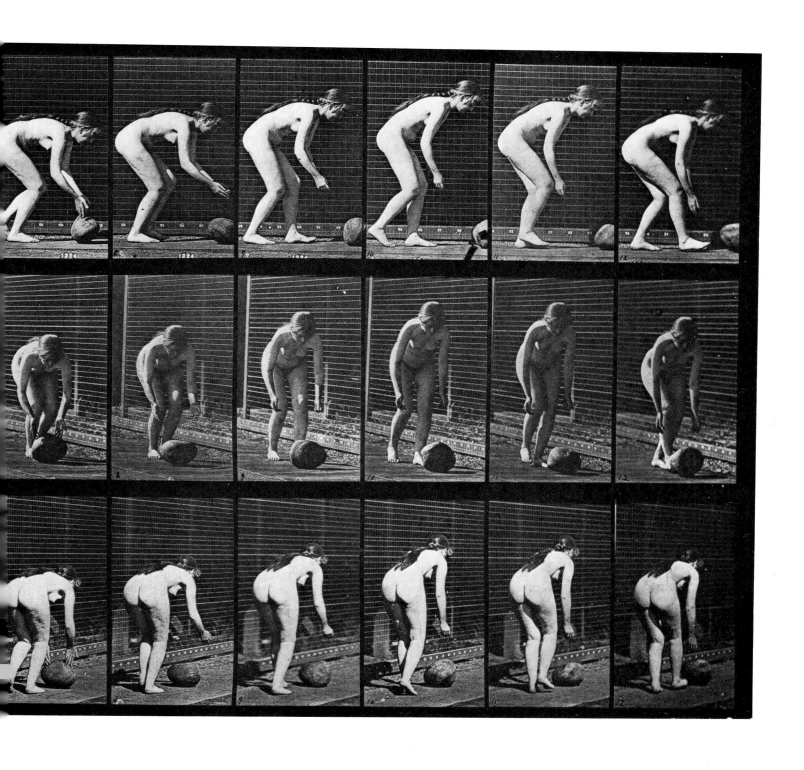

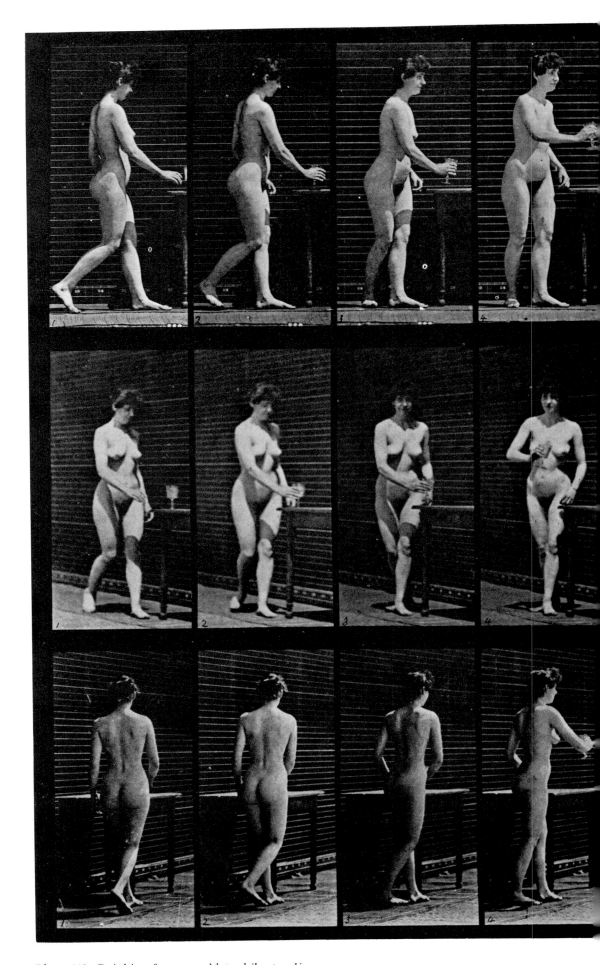

Plate 443. Drinking from a goblet while standing.

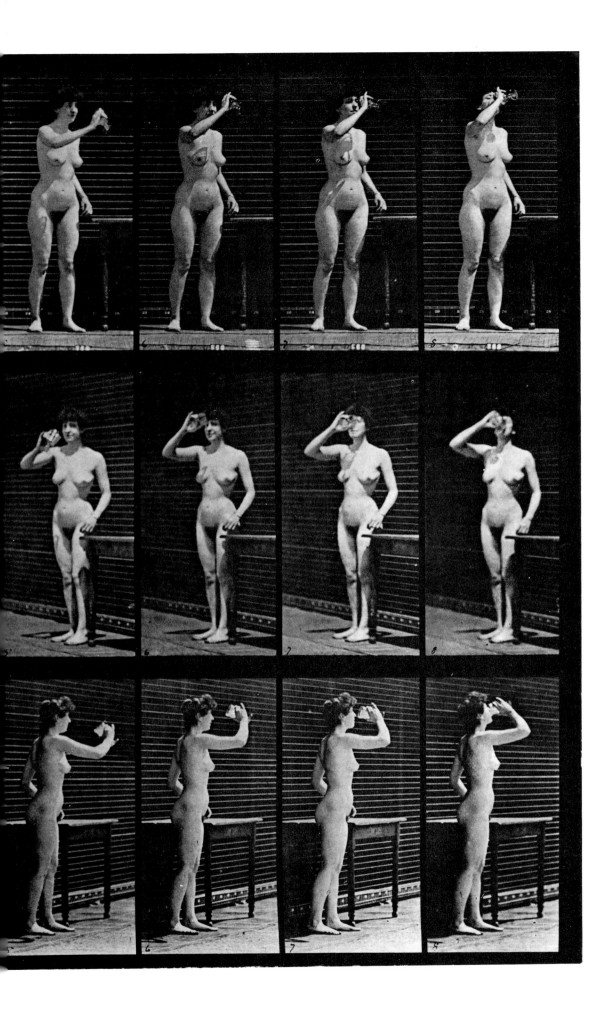

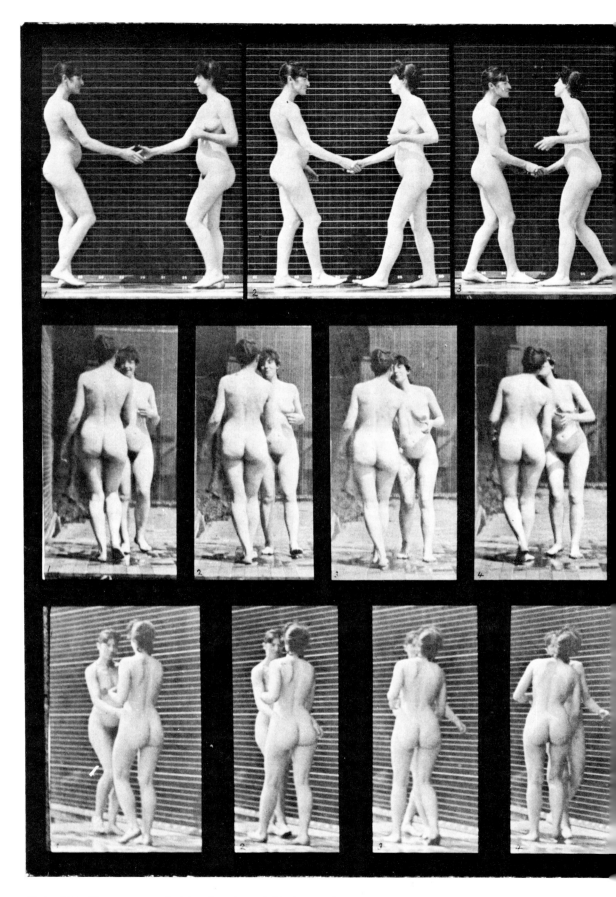

Plate 444. Two women shaking hands and kissing each other.

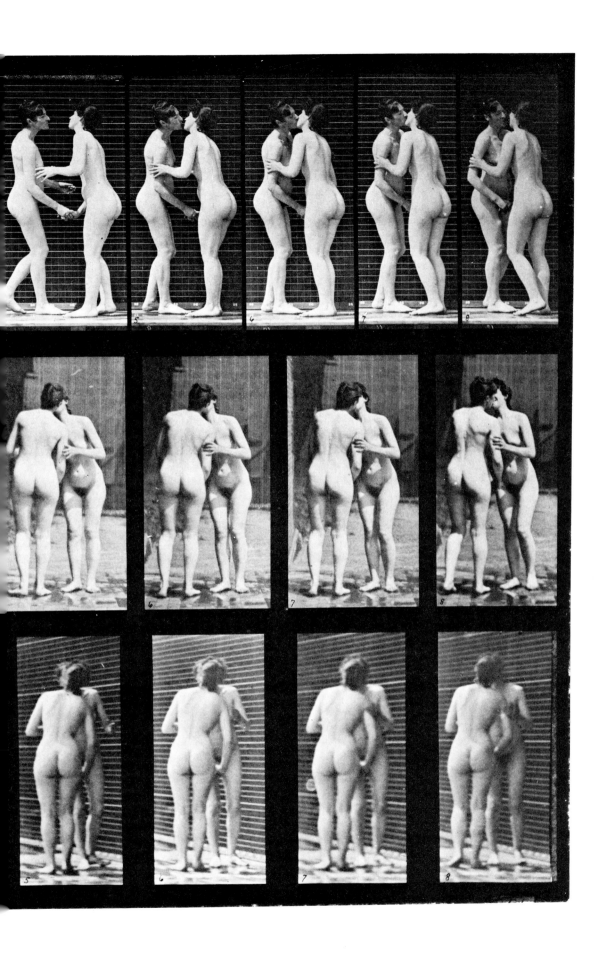

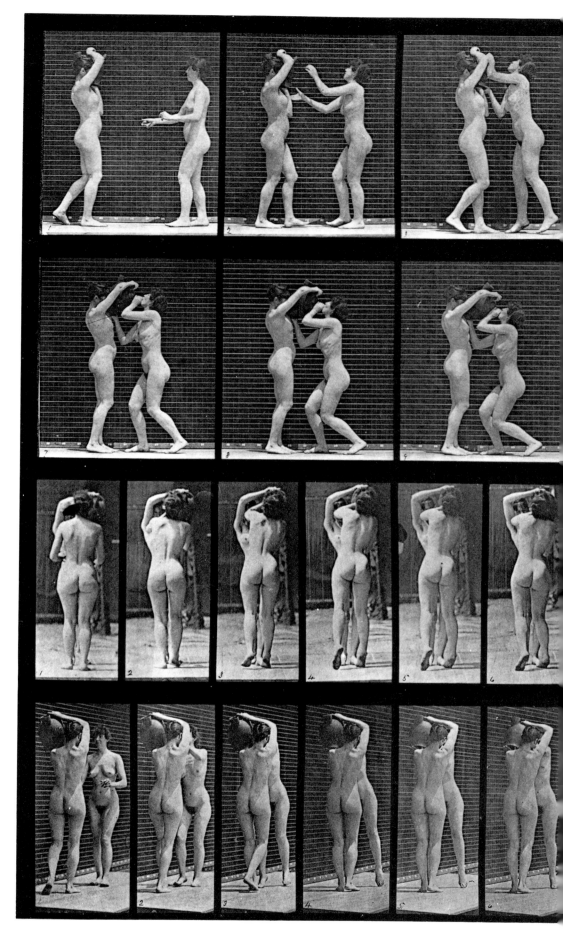

Plate 445. Woman drinking from the water jar on the shoulder of another woman.

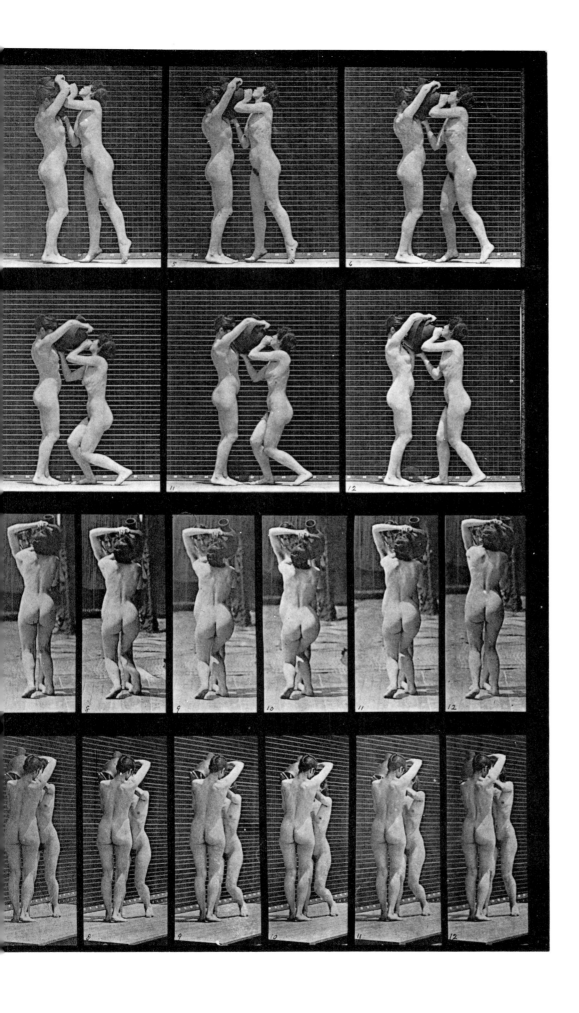

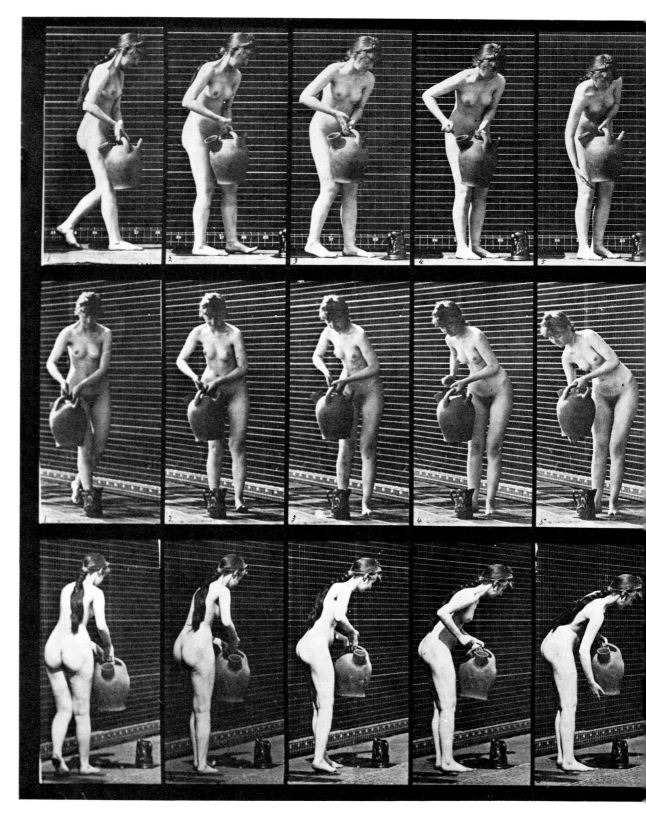

Plate 446. Filling a pitcher on the ground from a water jar.

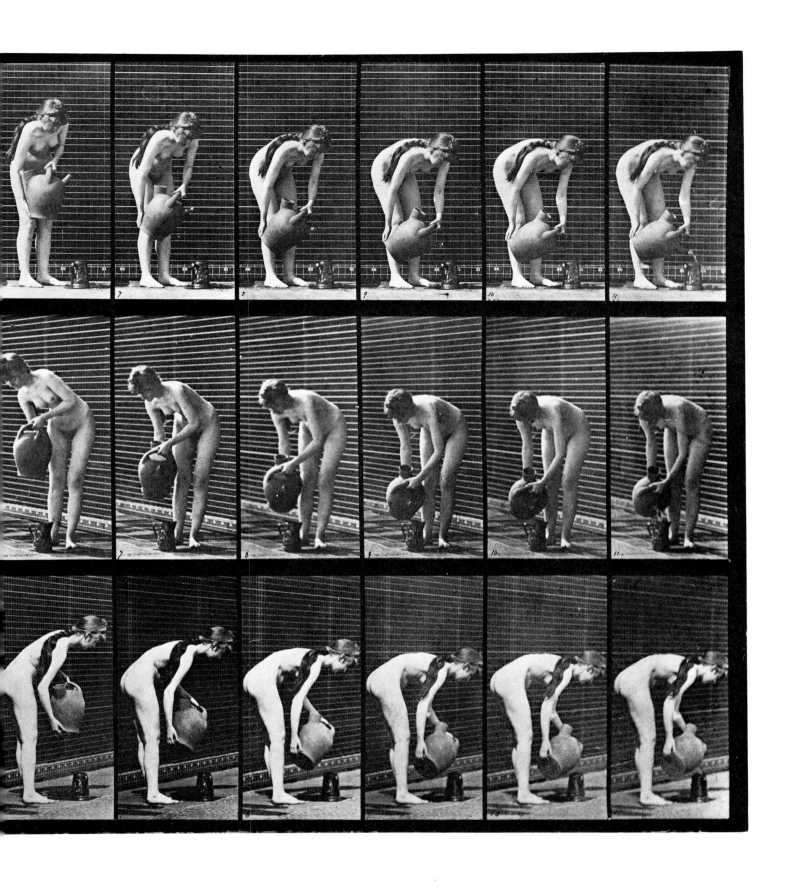

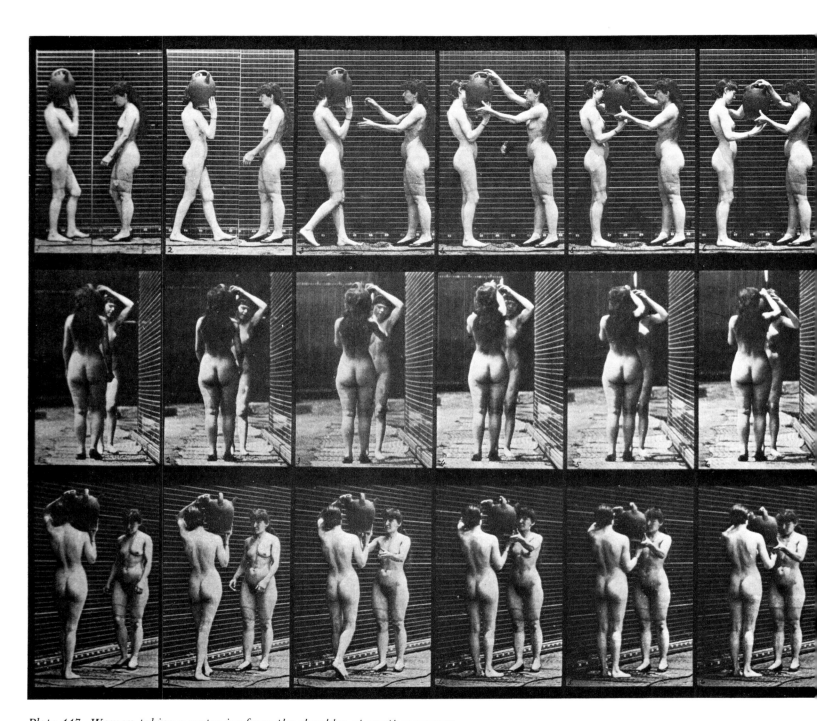

Plate 447. Woman taking a water jar from the shoulder of another woman.

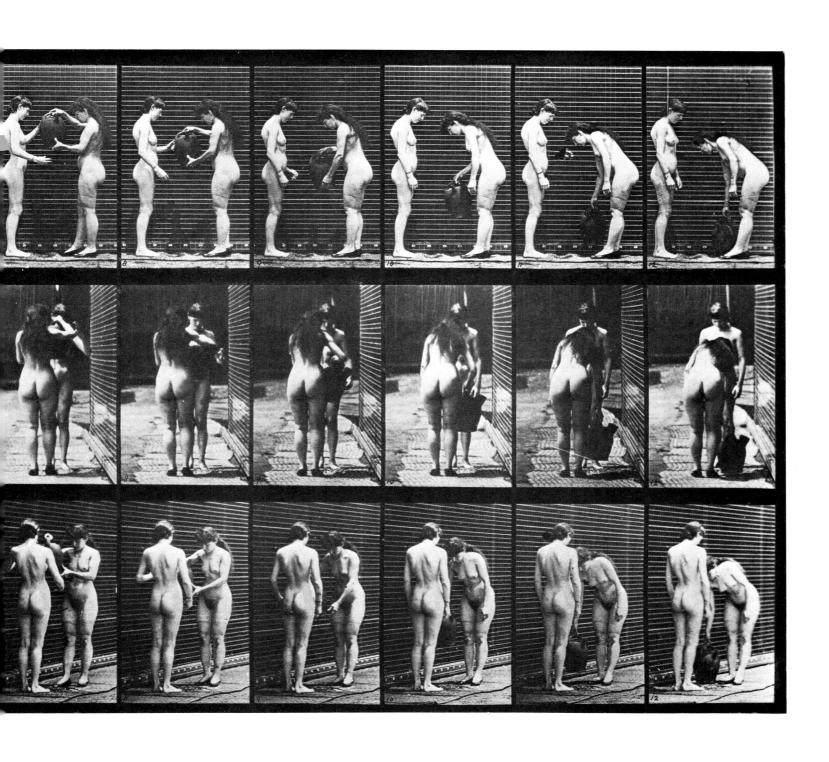

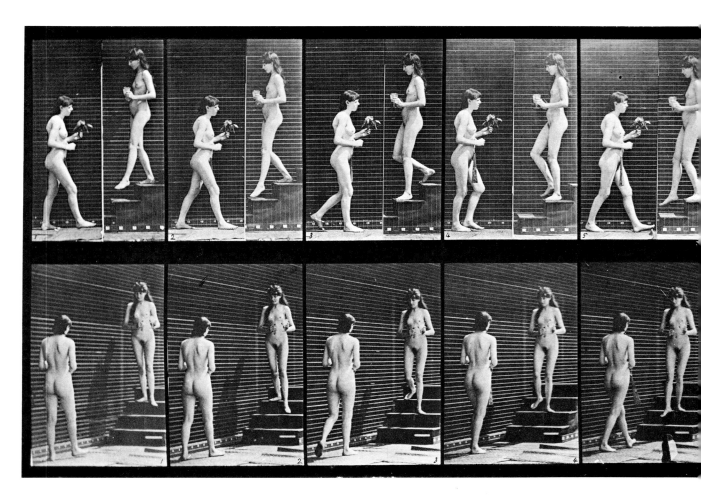

Plate 448. Woman descending stairs with a goblet meets another woman with a bouquet.

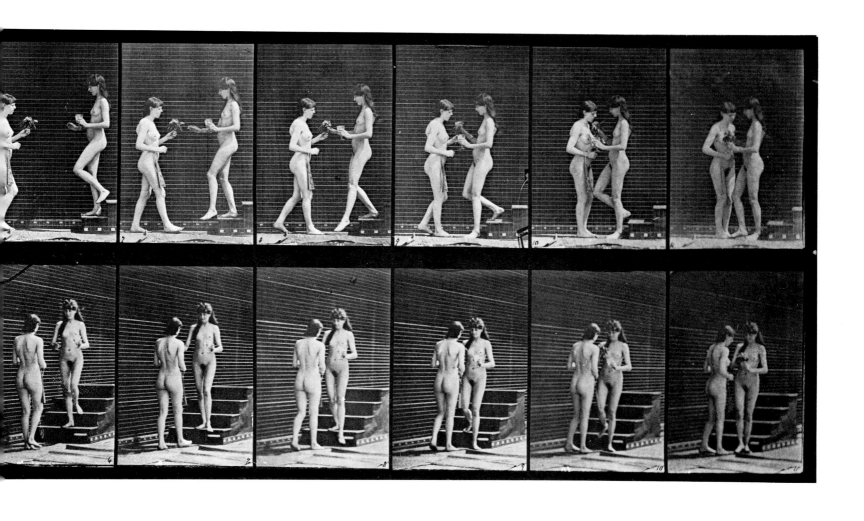

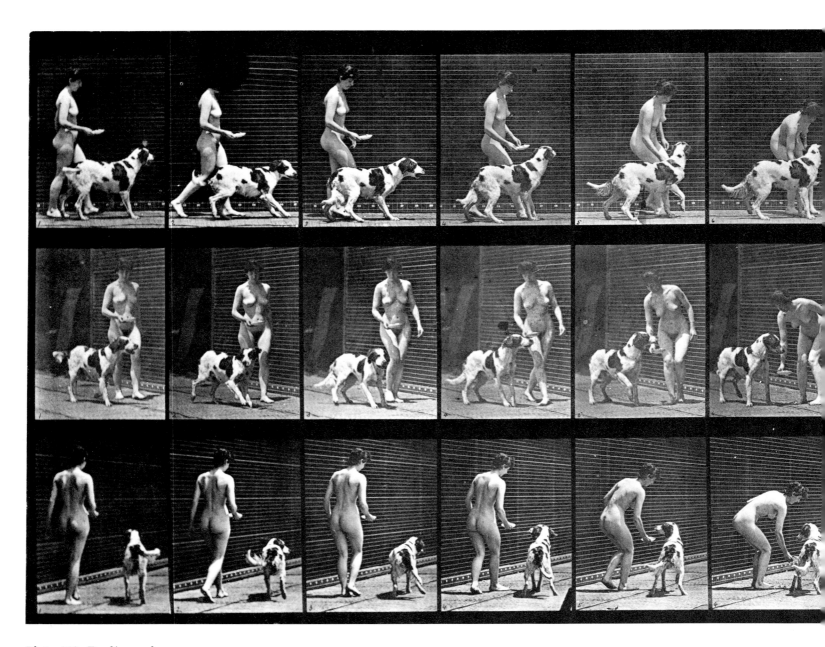

Plate 449. Feeding a dog.

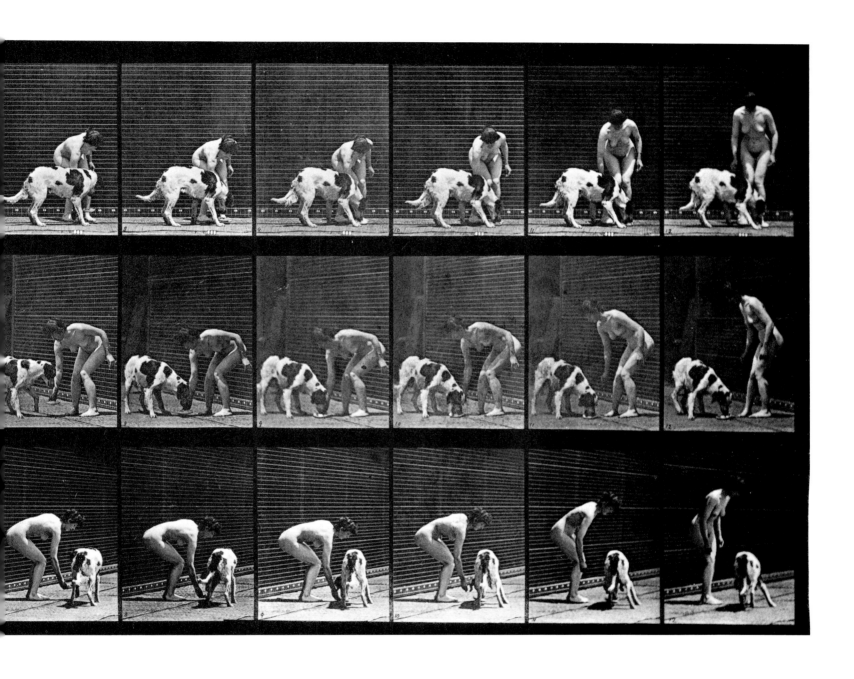

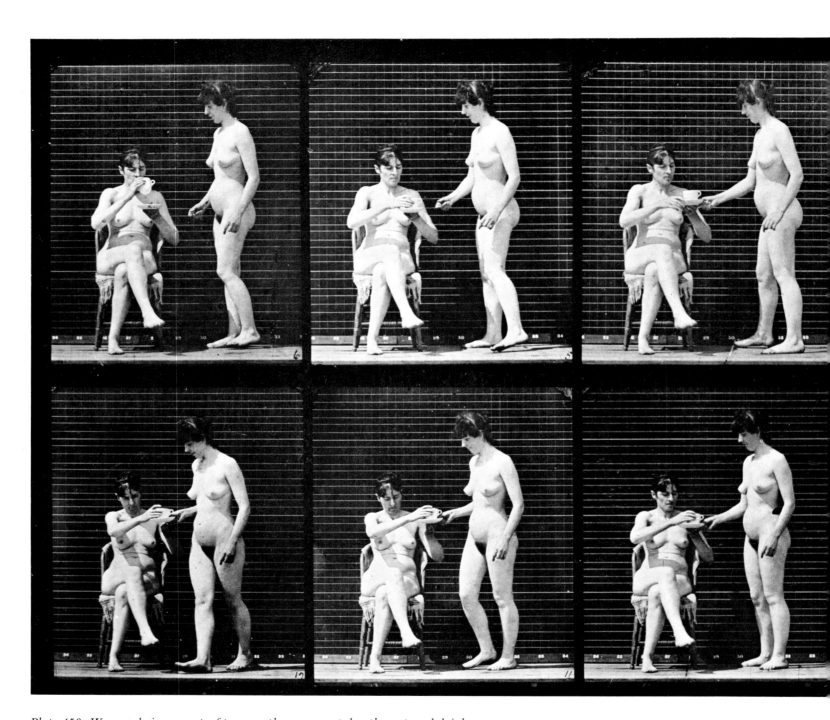

Plate 450. Woman brings a cup of tea; another woman takes the cup and drinks.

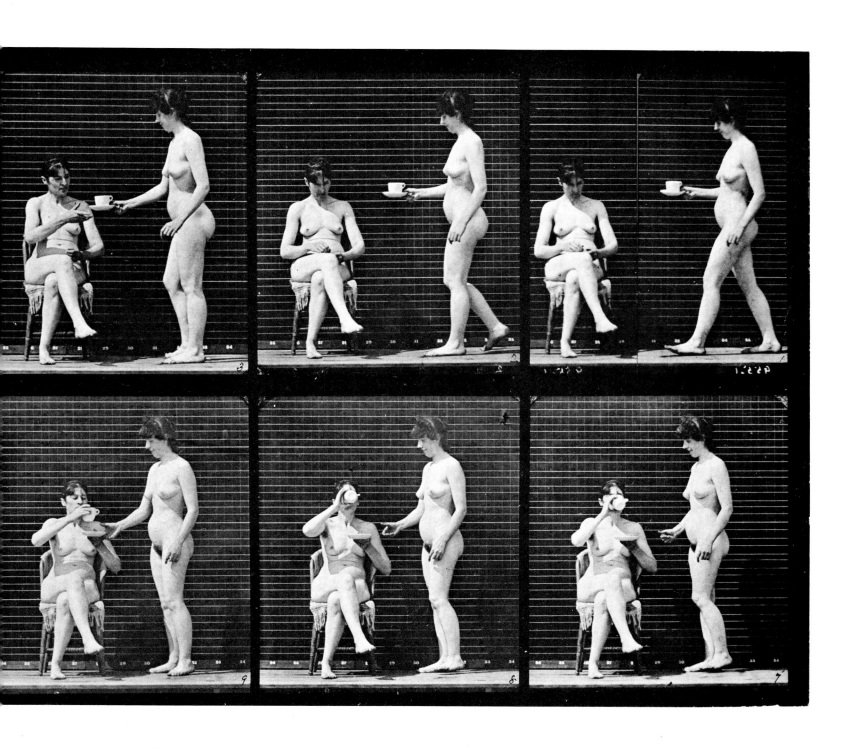

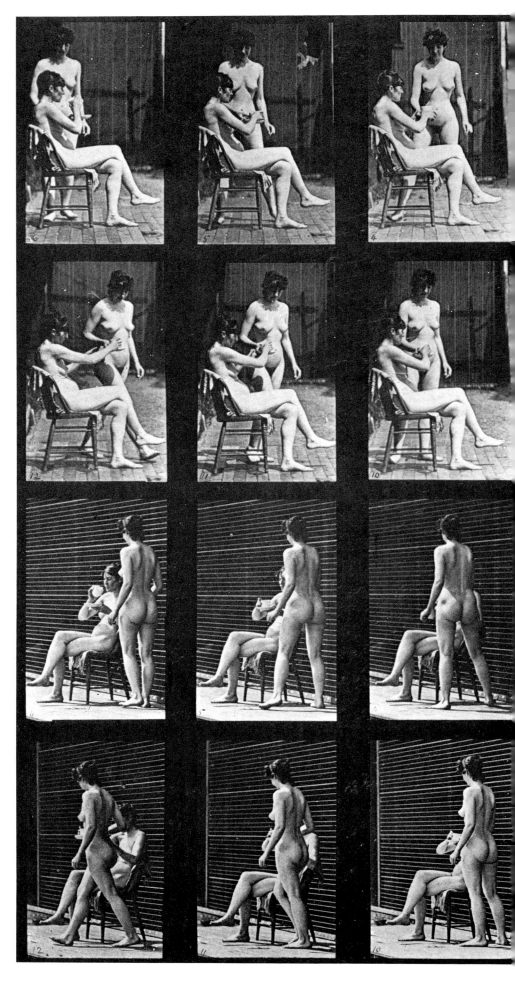

Plate 451. Woman brings a cup of tea; another takes the cup and drinks.

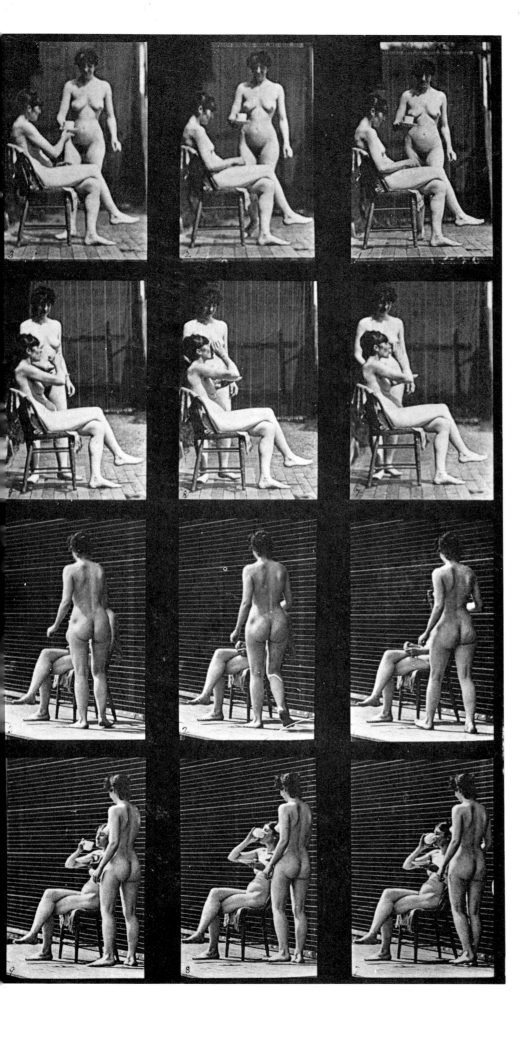

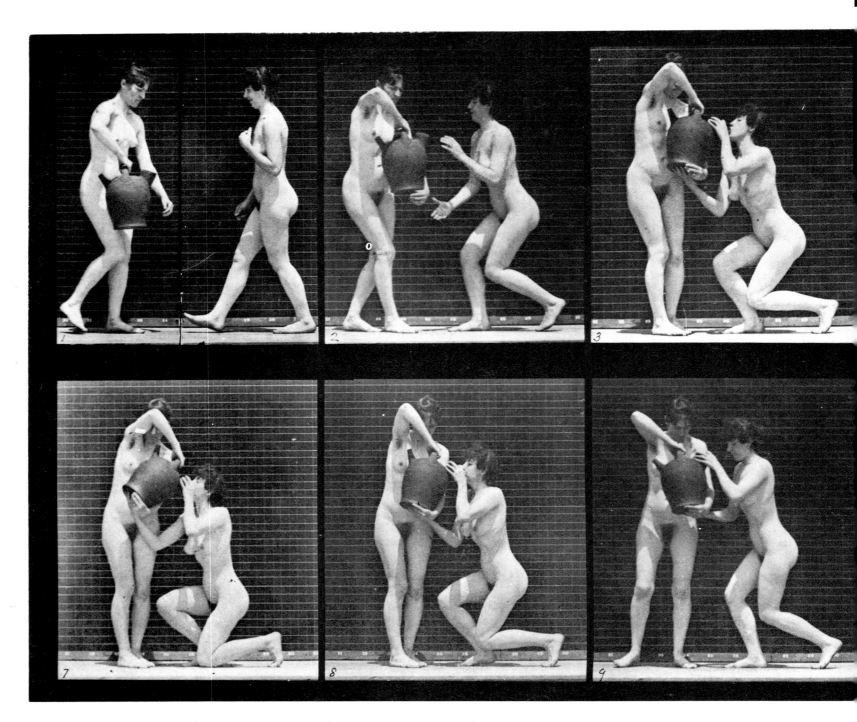

Plate 452. Woman kneels and drinks from the water jar of another woman and both walk off.

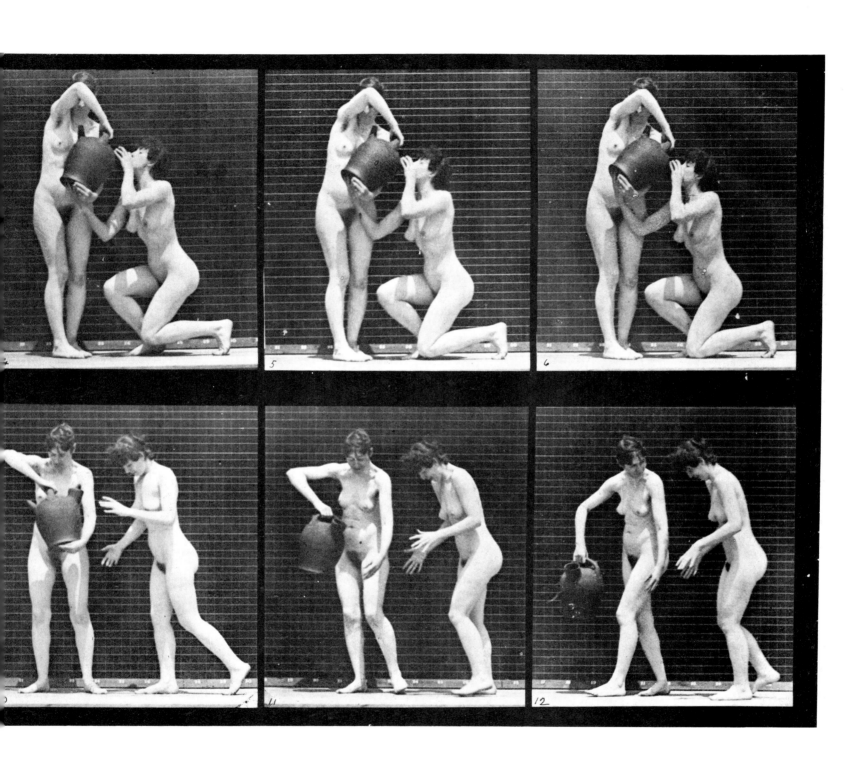

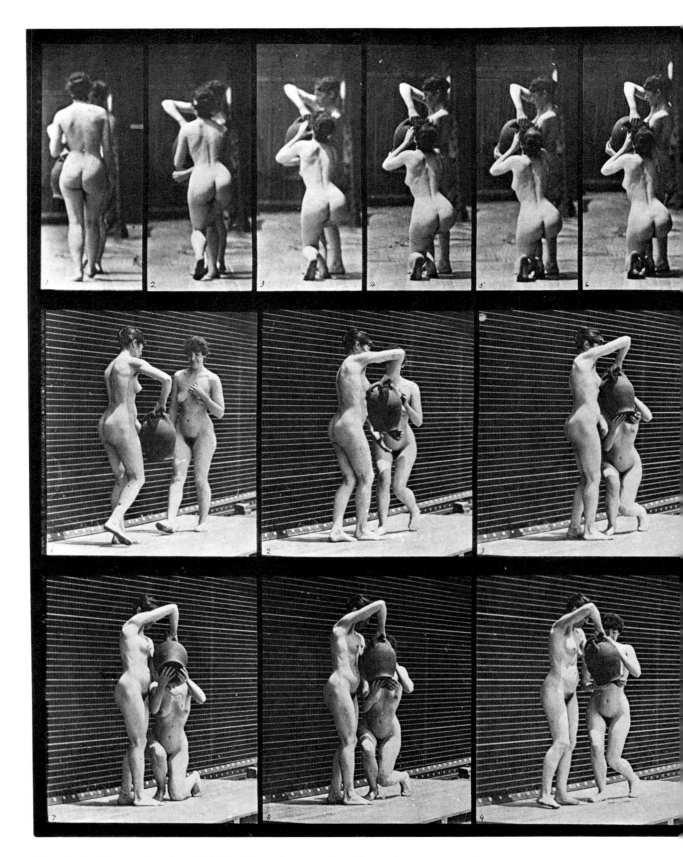

Plate 453. Woman kneels and drinks from the water jar of another woman and both walk off.

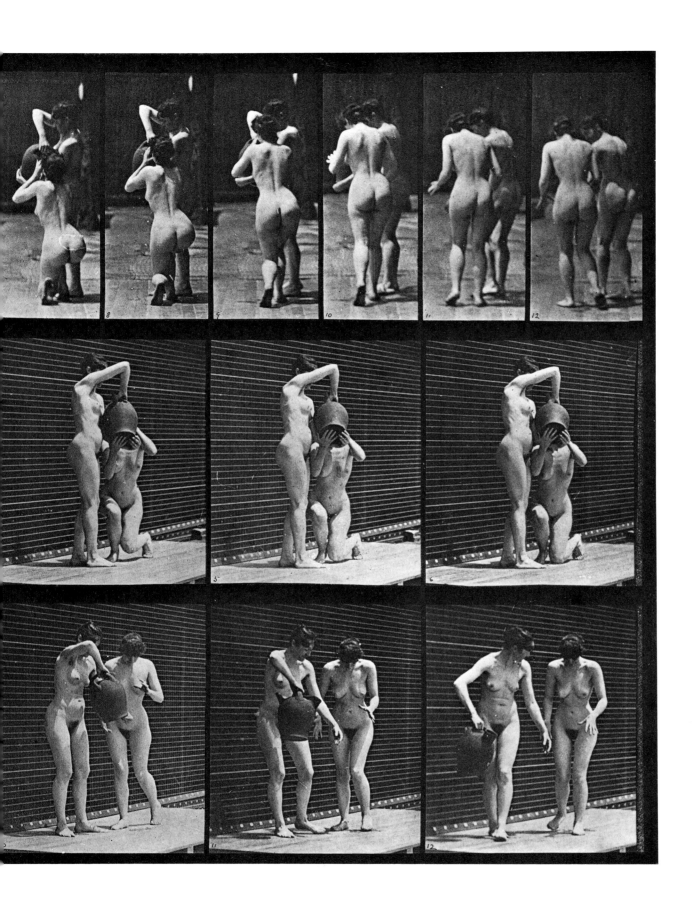

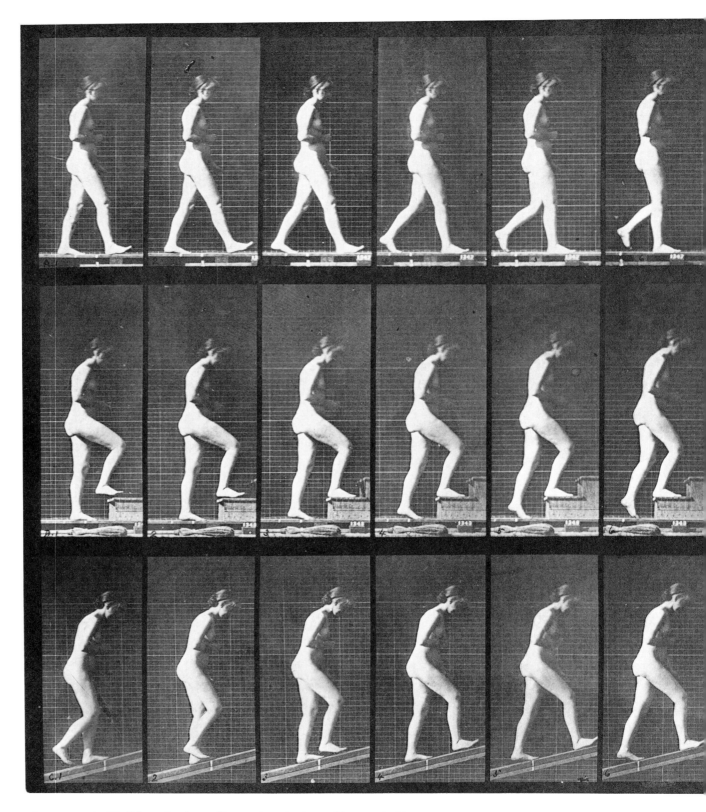

Plate 482. A: Walking. B: Ascending stairs. C: Ascending an incline.

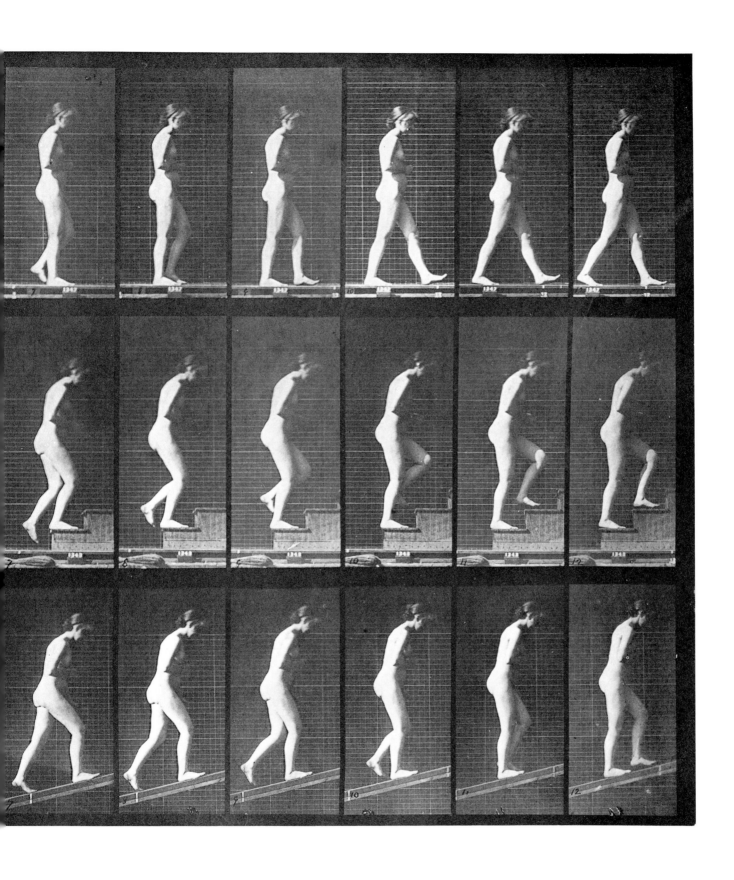

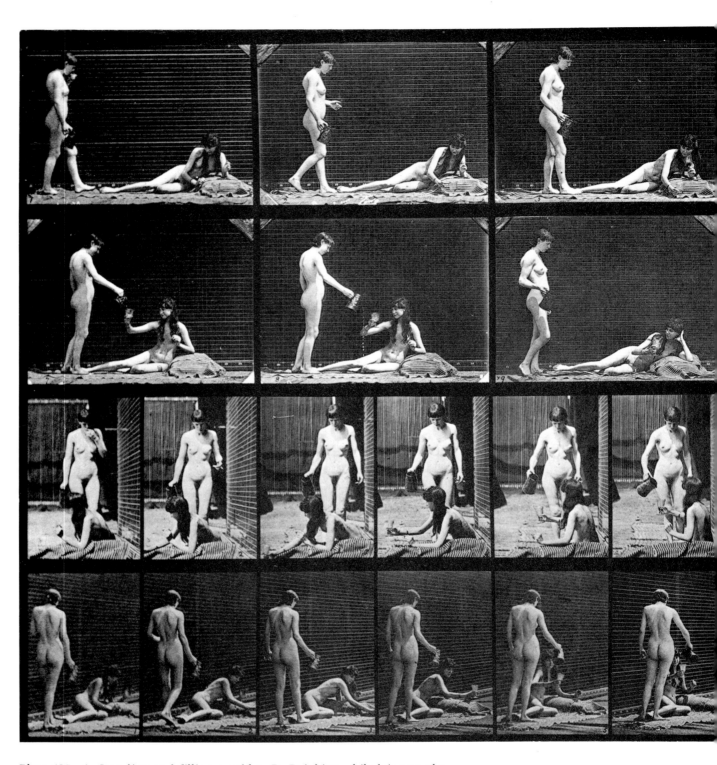

Plate 485. A: Standing and filling a goblet. B: Drinking while lying on the ground.

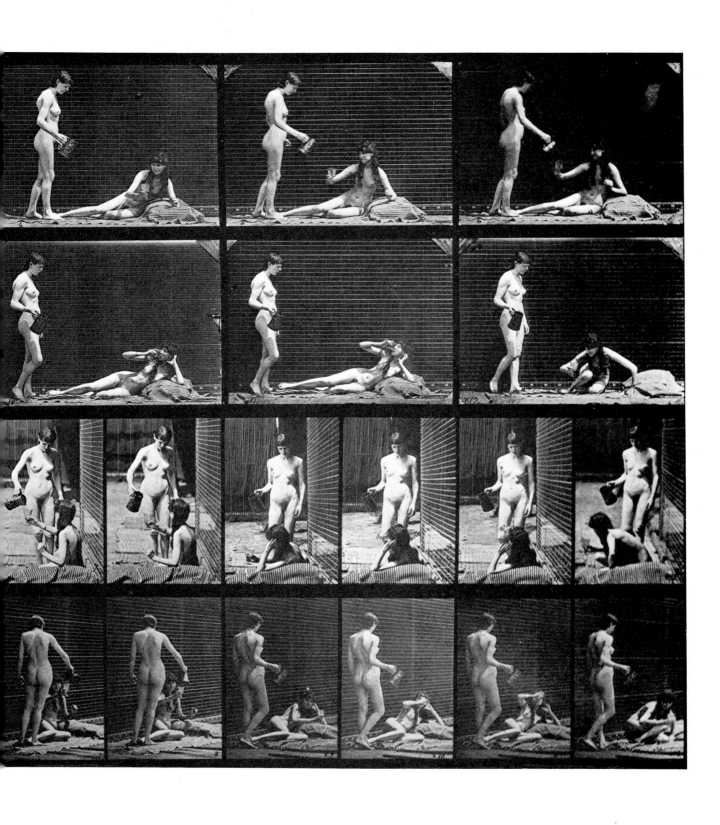

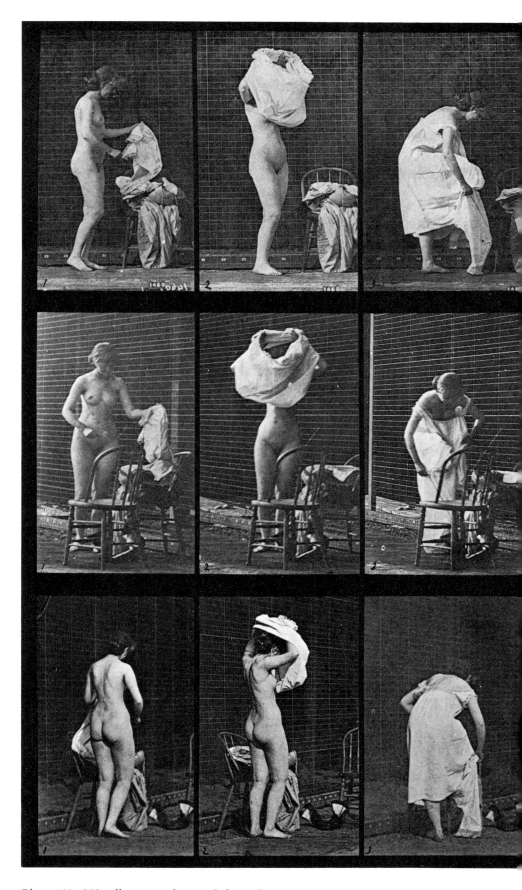

Plate 493. Miscellaneous phases of the toilet.

608 FEMALES (NUDE)

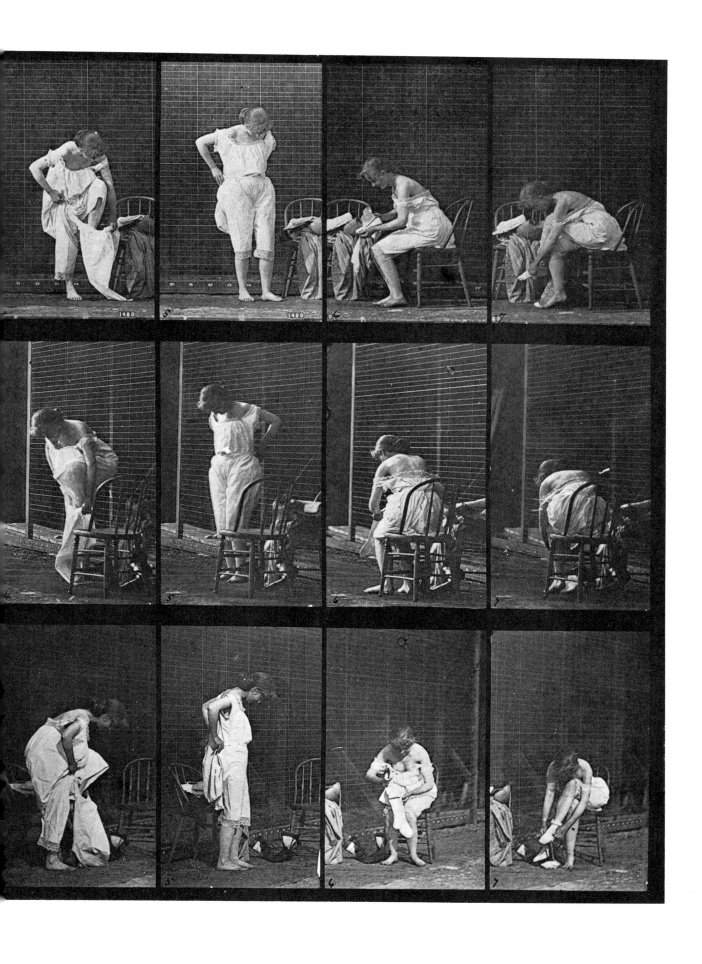

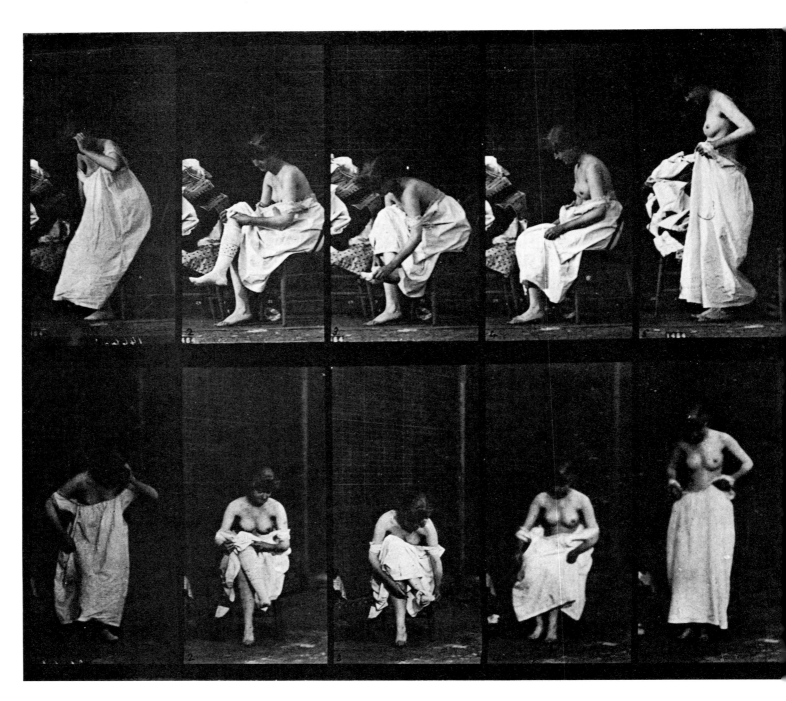

Plate 498. Miscellaneous phases of the toilet.

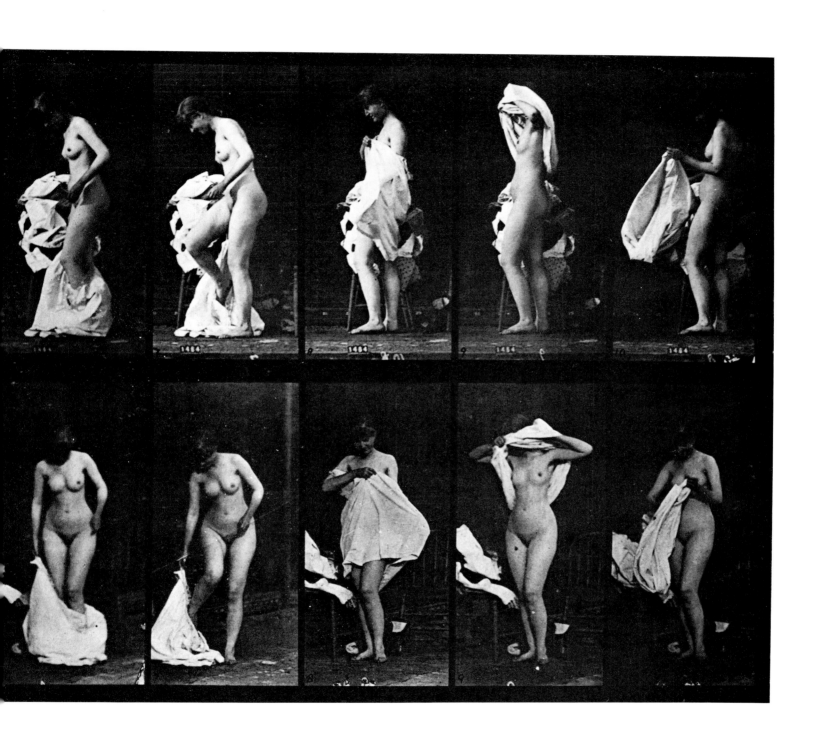

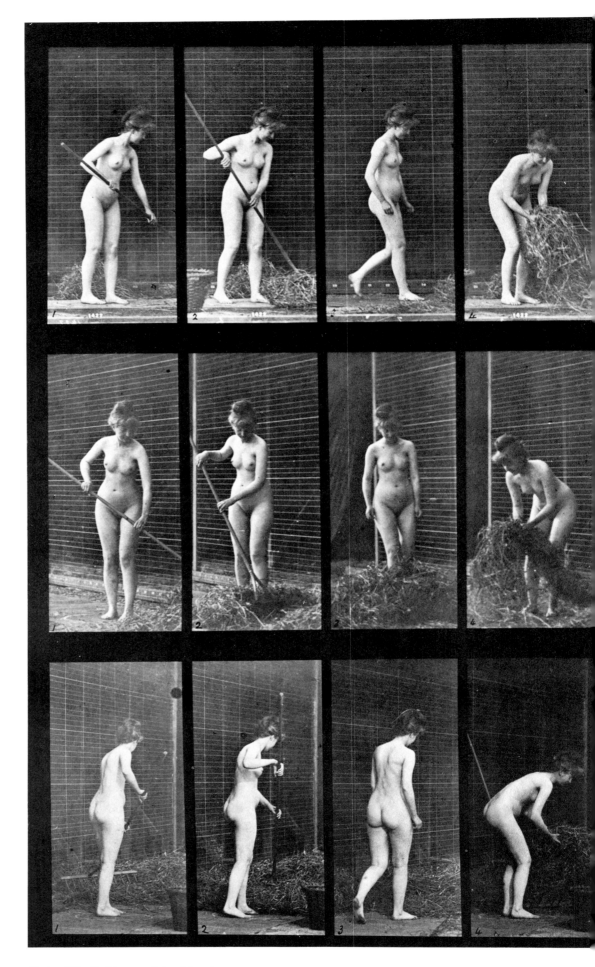

Plate 499. Raking and packing hay.

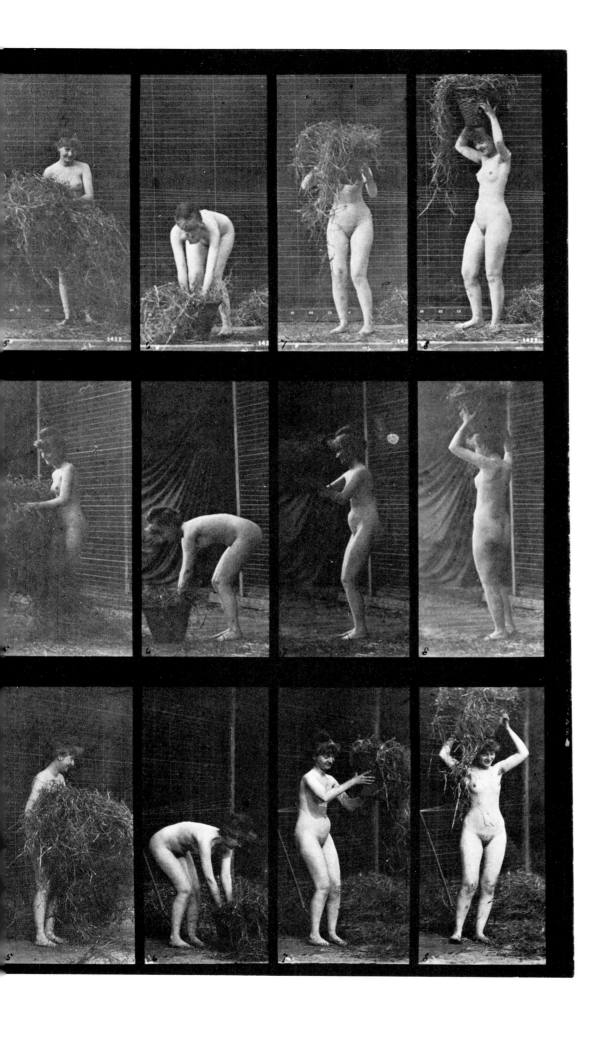

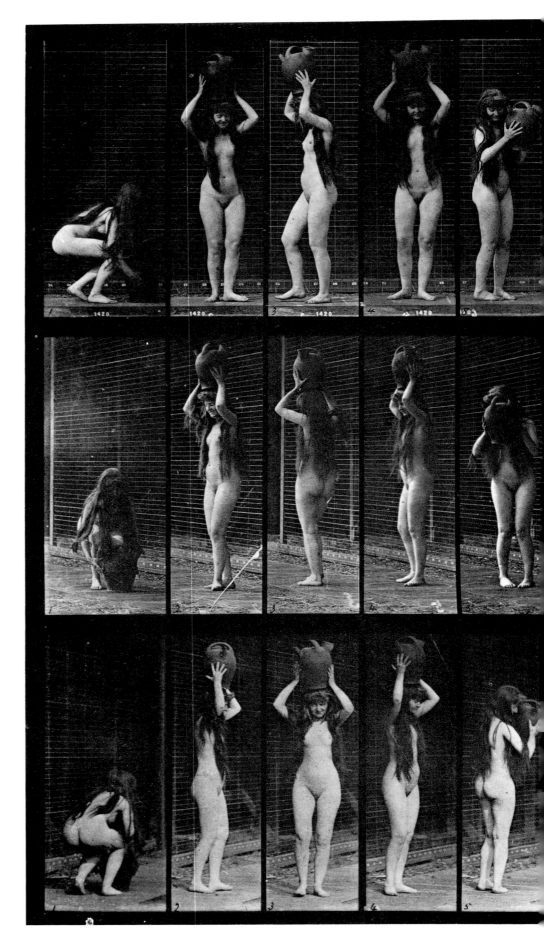

Plate 500. Various movements with a water jar.

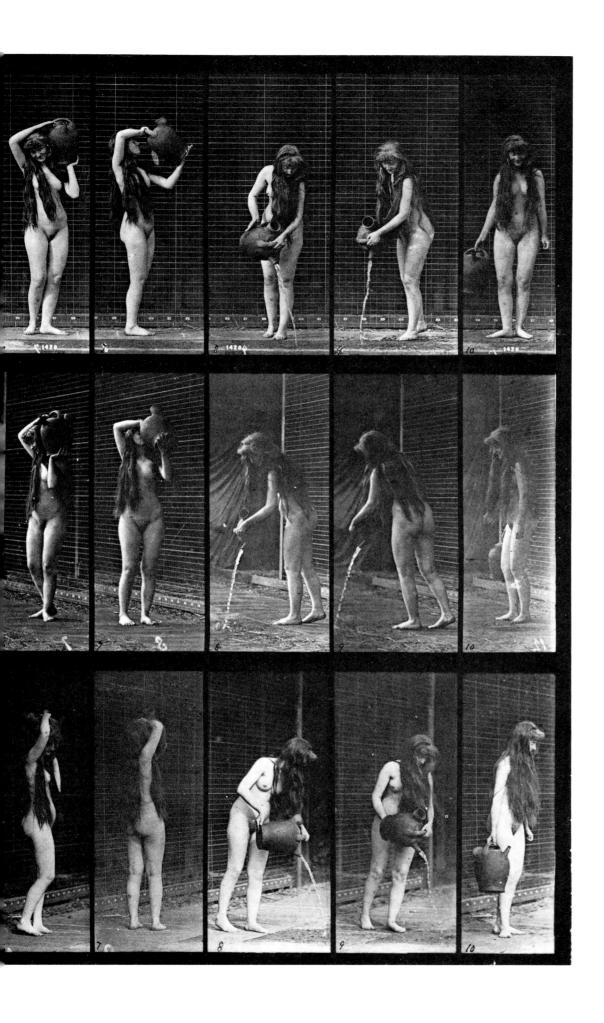

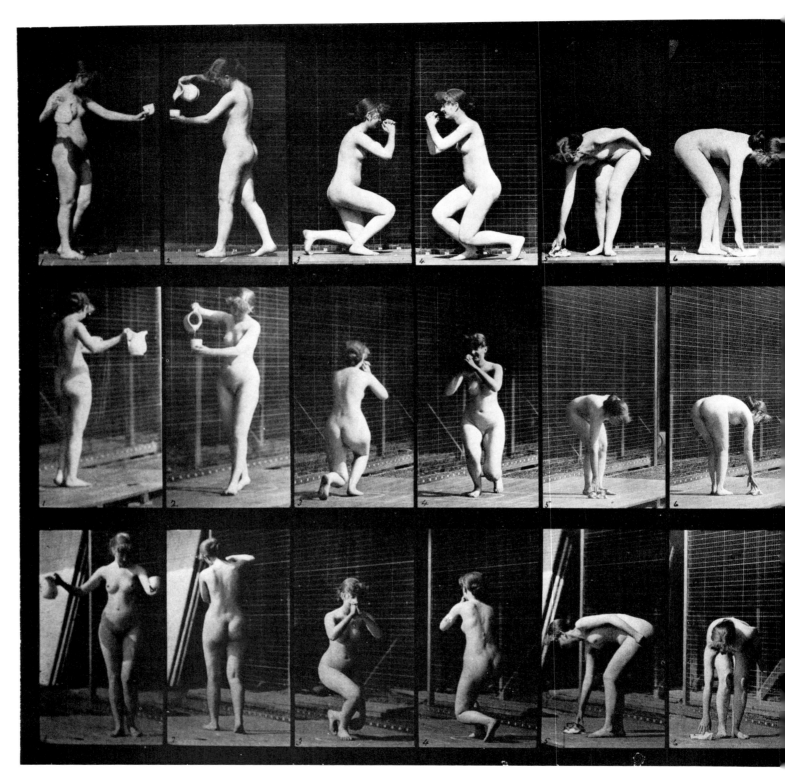

Plate 501. Miscellaneous, stooping, kneeling, etc.

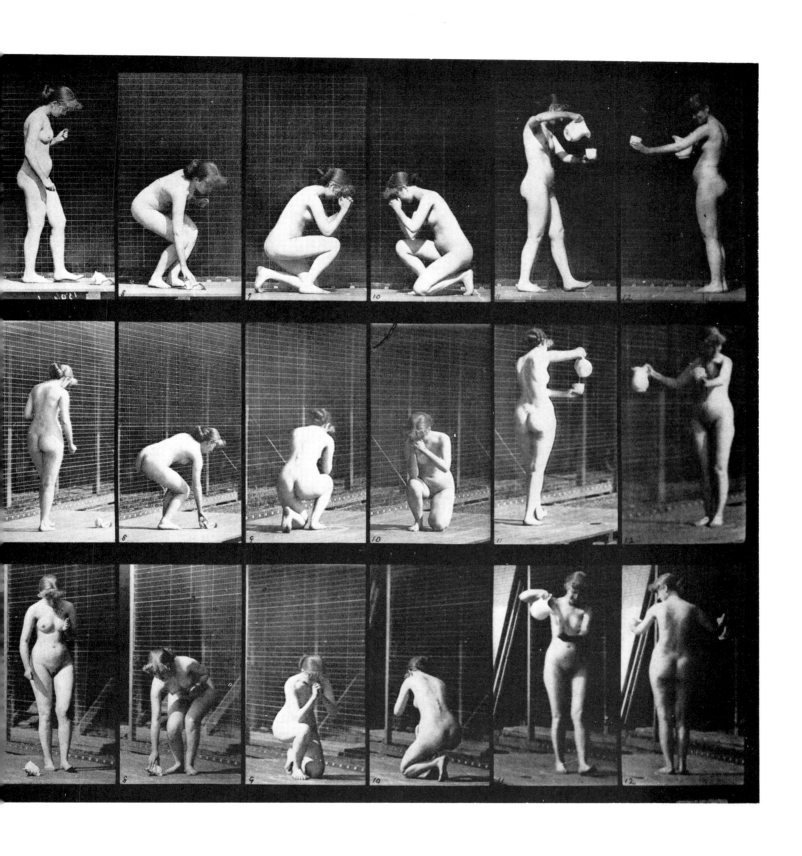

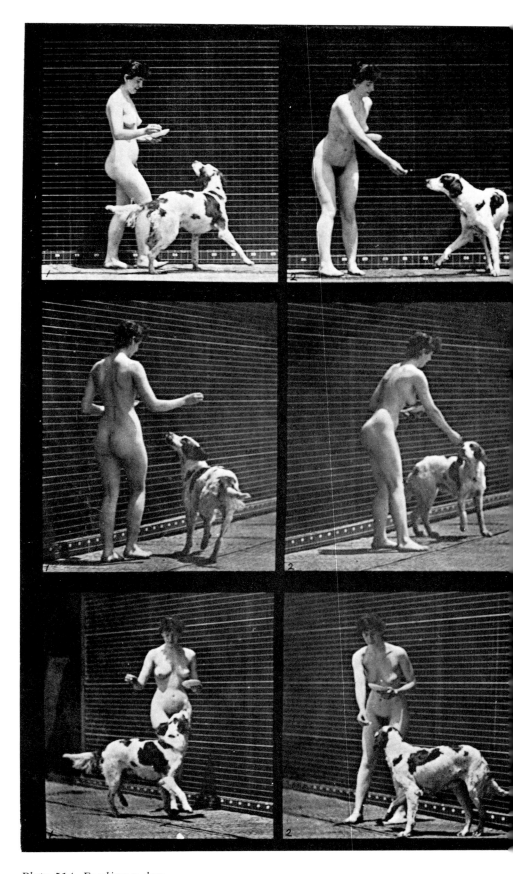

Plate 514. Feeding a dog.

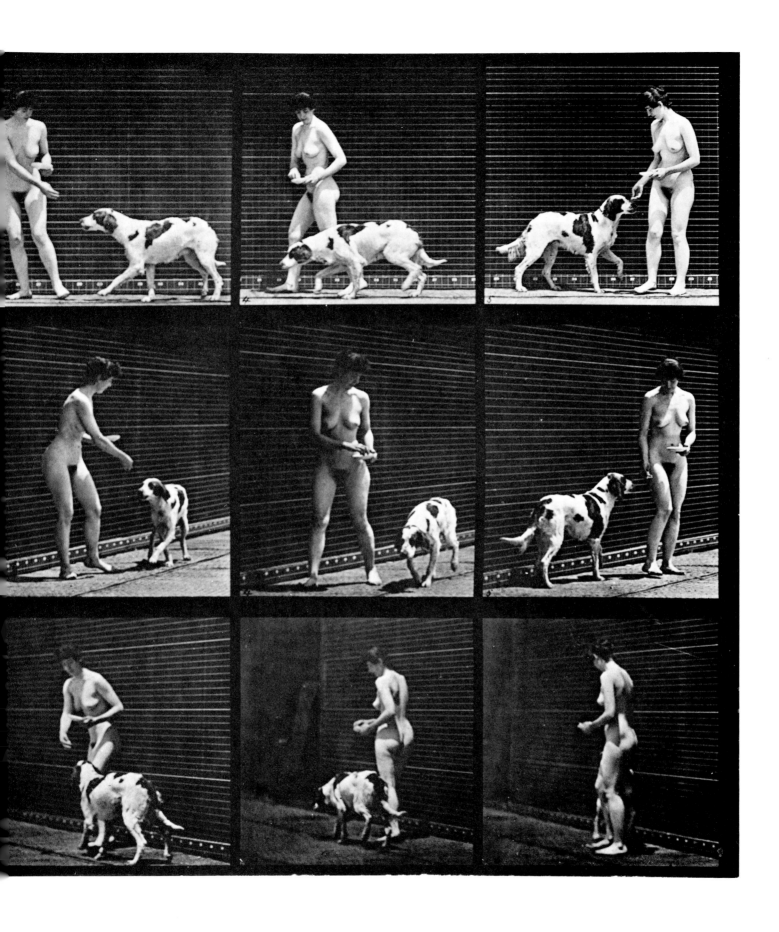

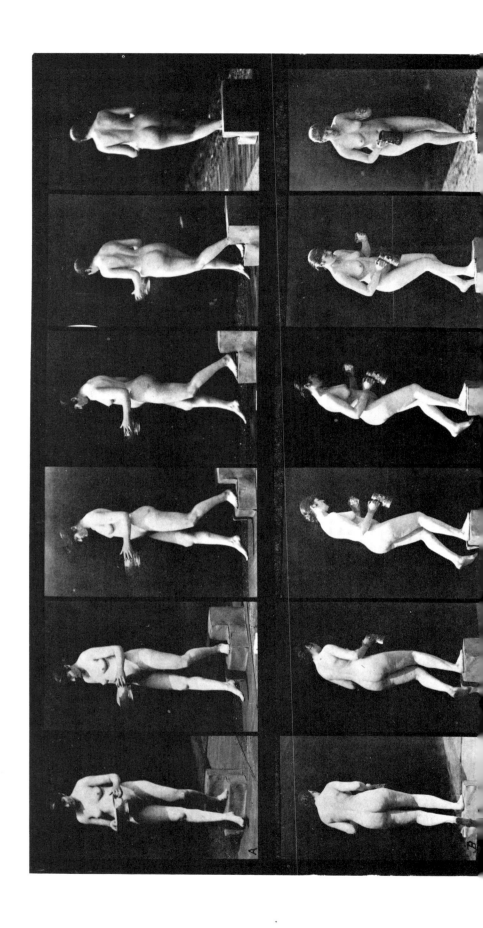

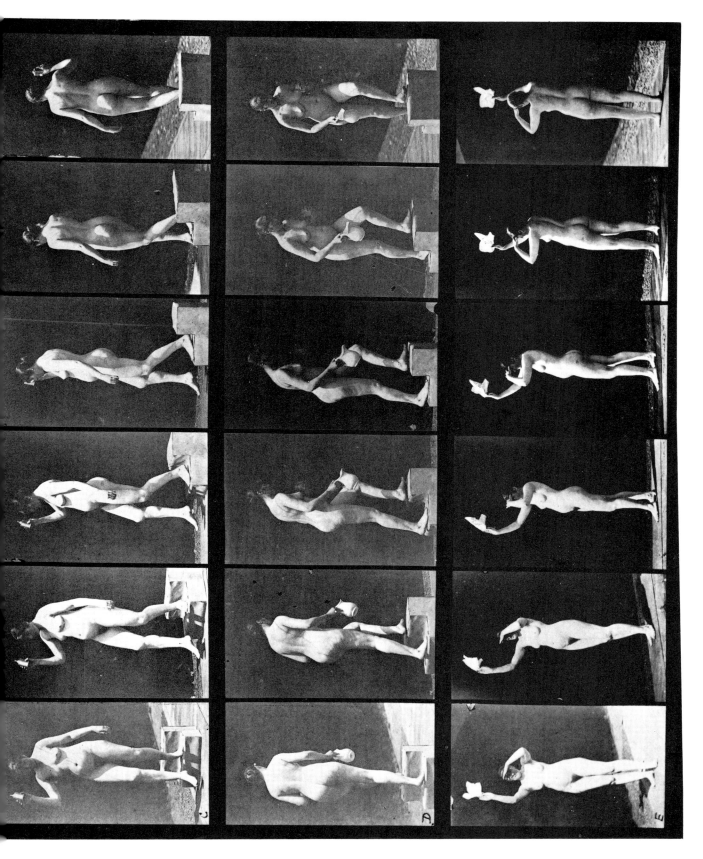

Plate 525. A, C: Descending a step. B, D: Ascending a step. E: Waving a handkerchief.

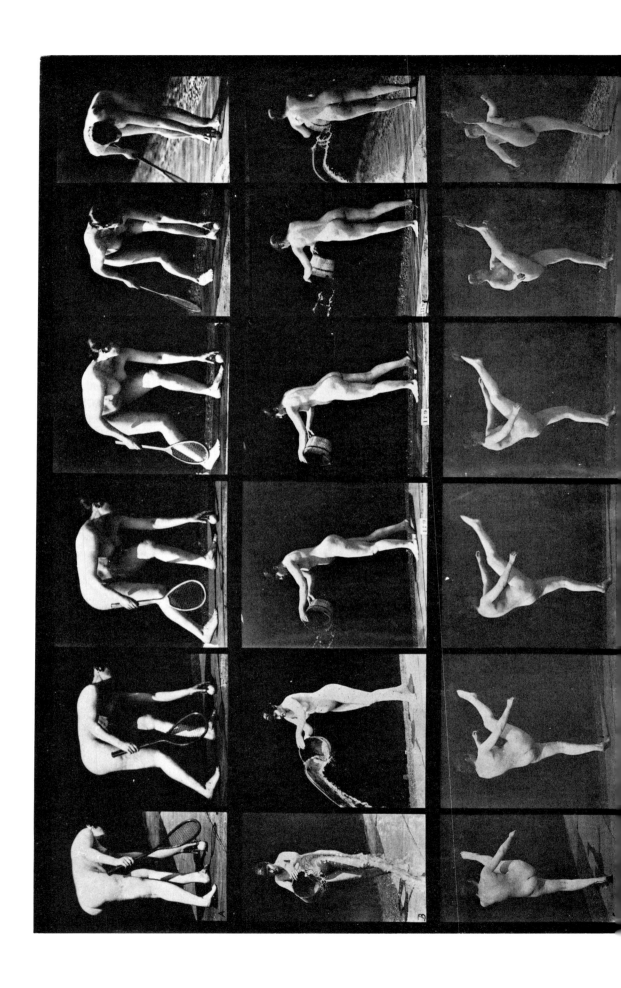

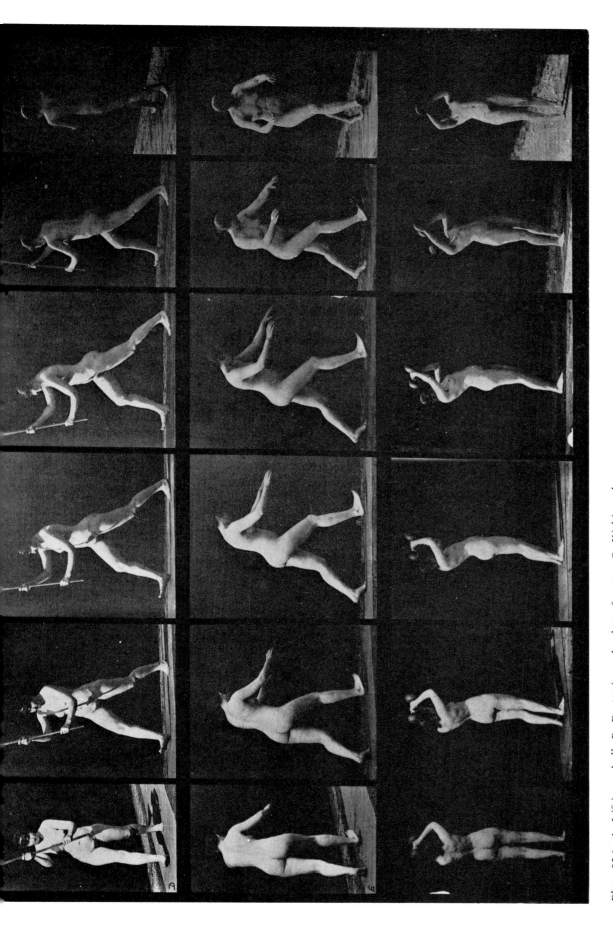

Plate 526. A: Lifting a ball. B: Emptying a bucket of water. C: Kicking above her head. D: Striking with a stick. E: Stumbling. F: Lifting a 50-lb. dumbbell.

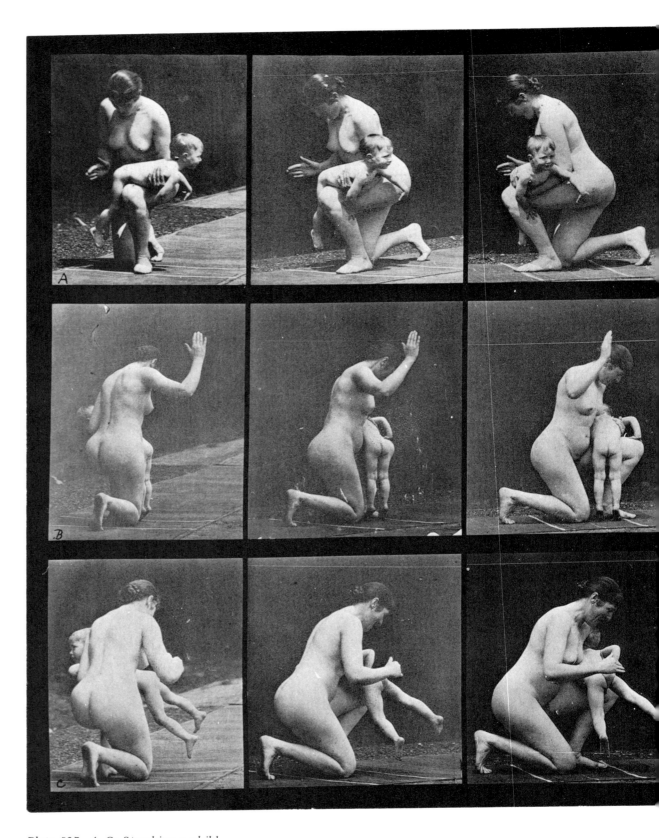

Plate 527. A–C: Spanking a child.

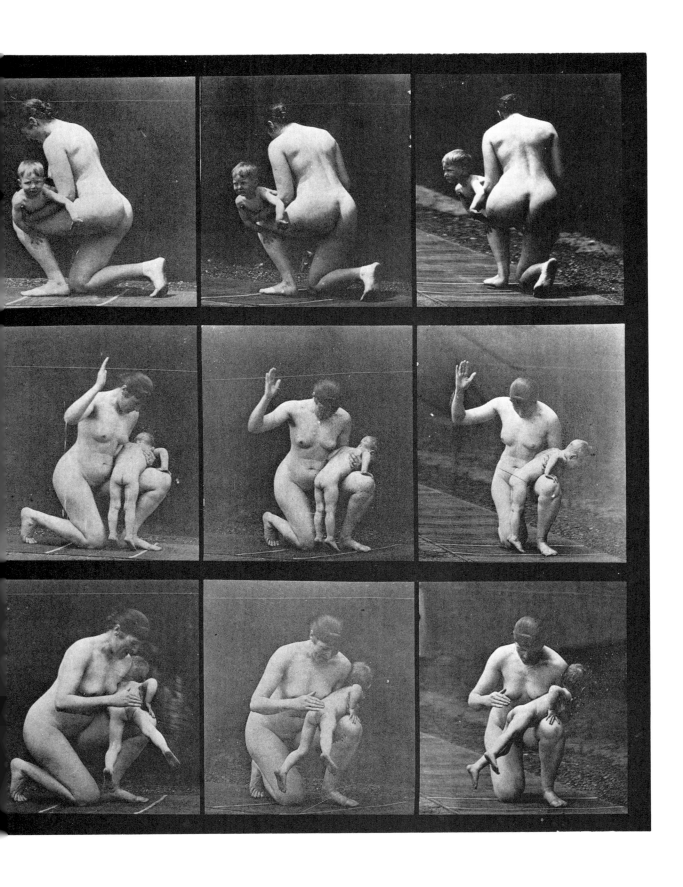

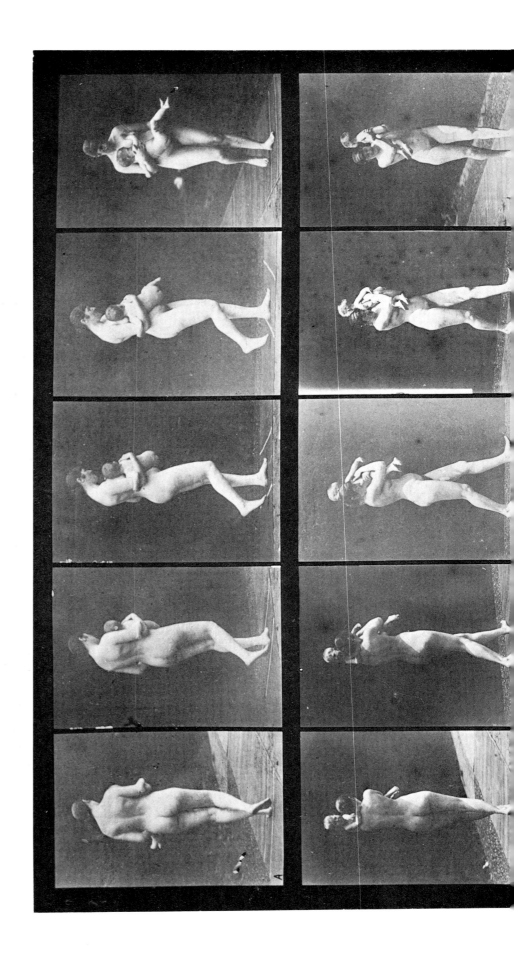

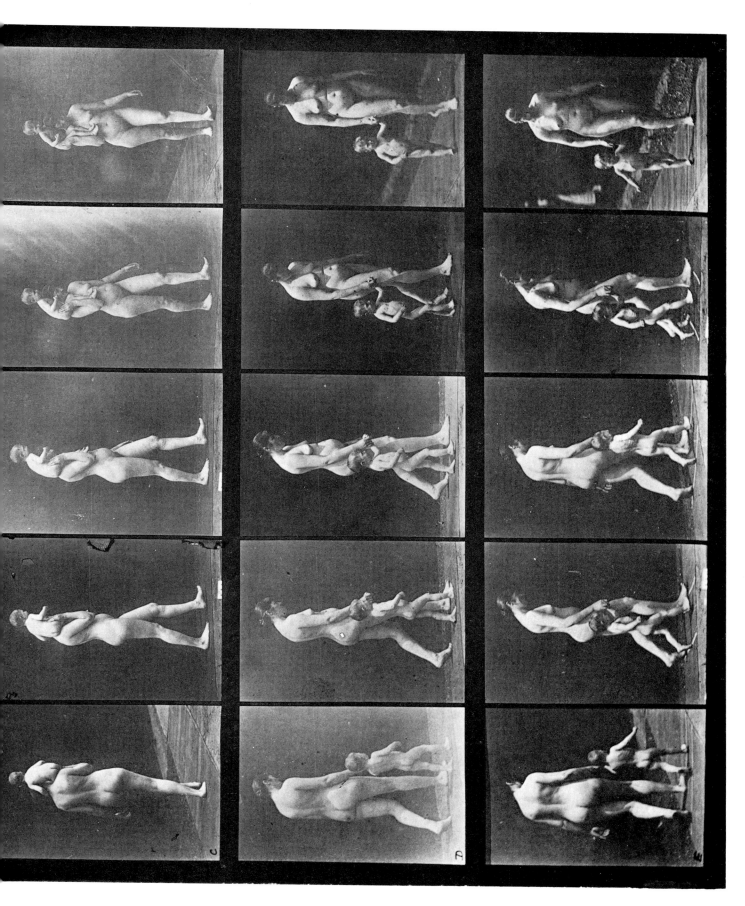

Plate 528. A–C: Carrying a child. D: Walking with a child hand in hand.
E: Running with a child hand in hand.

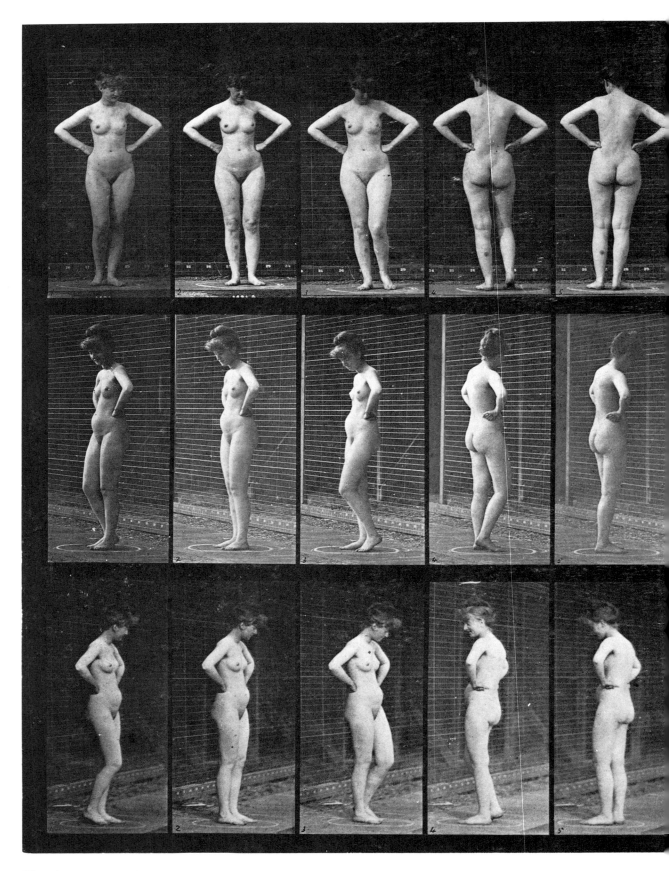

Plate 531. Various poses.

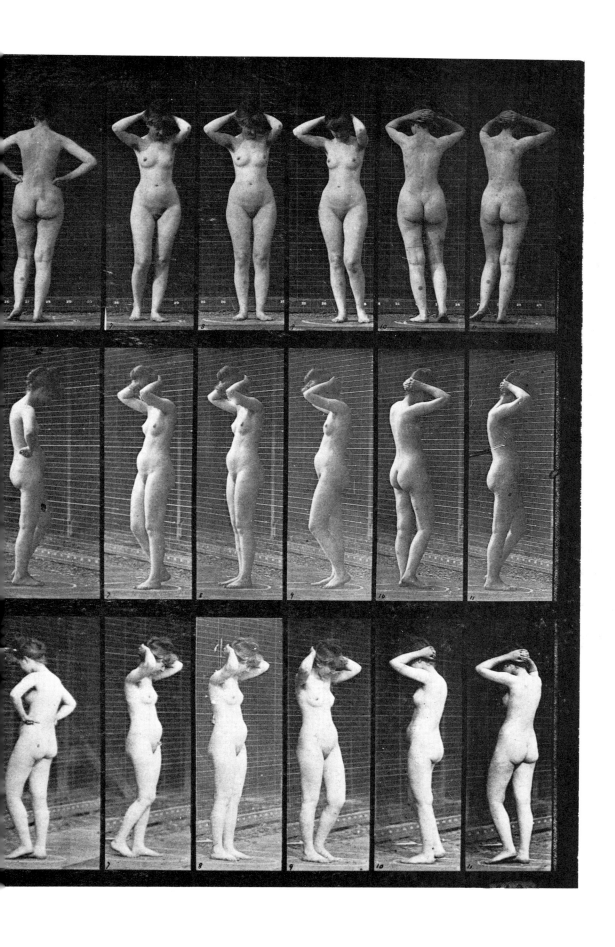